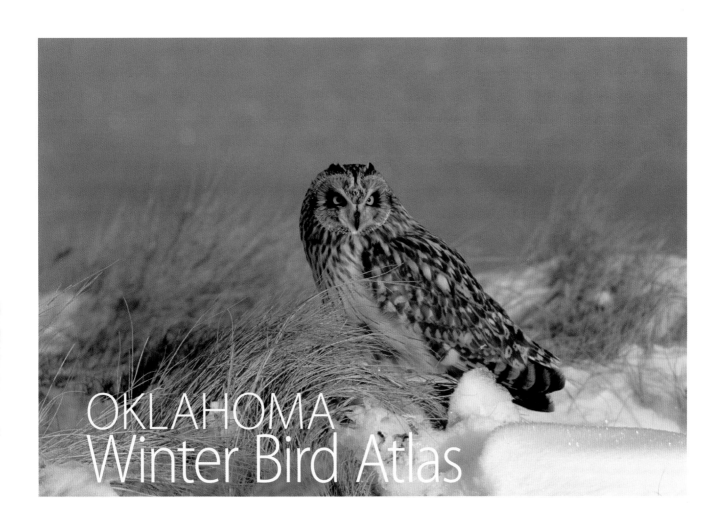

# OKLAHOMA
# Winter Bird Atlas

George Miksch Sutton Avian Research Center
P.O. Box 2007
Bartlesville, OK 74005
United States of America

(918) 336-7778
www.suttoncenter.org

*"finding cooperative conservation solutions for birds
and the natural world through science and education"*

Founded 1983

The Sutton Center is grateful for the support and guidance of its board of directors over the years, the current members of which are listed below.

# OKLAHOMA
# Winter Bird Atlas

**DAN L. REINKING**

*Project administered by the*
**George M. Sutton Avian Research Center**
*and the* **Oklahoma Biological Survey**

UNIVERSITY OF OKLAHOMA PRESS : NORMAN

The following photographs appear uncaptioned and uncredited on the pages noted:

Page i: Short-eared Owl, photograph by Bob Gress. (See species account photo, p. 272.)

Page 1: Mountain Bluebird, (adjusted) photograph by Bob Gress. (See species account photo, p. 392.)

Page 17: Swamp Sparrow, photograph by Bob Gress. (See species account photo, p. 494.)

Library of Congress Cataloging-in-Publication Data

Name: Reinking, Dan L., author.
  Title: Oklahoma winter bird atlas / Dan L. Reinking.
  Description: Norman : University of Oklahoma Press, 2017. | "Project
    administered by the George M. Sutton Avian Research Center and the
    Oklahoma Biological Survey." | Includes index.
  Identifiers: LCCN 2017010473 | ISBN 978-0-8061-5898-3 (hardcover : alk. paper) |
    ISBN 978-0-8061-5897-6 (pbk. : alk. paper)
  Subjects: LCSH: Birds—Wintering—Oklahoma. | Birds—Oklahoma—Geographical
    distribution. | Birds—Oklahoma—Geographical distribution—Maps.
  Classification: LCC QL684.O5 R45 2017 | DDC 598.09766—dc23
  LC record available at https://lccn.loc.gov/2017010473

The paper in this book meets the guidelines for permanence and durability of the Committee on
Production Guidelines for Book Longevity of the Council on Library Resources, Inc. ∞

1 2 3 4 5 6 7 8 9 10

*To the birds of Oklahoma*
*and the people who watch them*

# Contents

Acknowledgments   **ix**

Introduction   **3**
Species Accounts   **17**

18   ORDER ANSERIFORMES

90   ORDER GALLIFORMES

102   ORDER PODICIPEDIFORMES

112   ORDER COLUMBIFORMES

124   ORDER CUCULIFORMES

126   ORDER CAPRIMULGIFORMES

128   ORDER APODIFORMES

130   ORDER GRUIFORMES

144   ORDER CHARADRIIFORMES

198 ORDER GAVIIFORMES

206 ORDER SULIFORMES

210 ORDER PELECANIFORMES

226 ORDER CATHARTIFORMES

230 ORDER ACCIPITRIFORMES

256 ORDER STRIGIFORMES

274 ORDER CORACIIFORMES

276 ORDER PICIFORMES

298 ORDER FALCONIFORMES

308 ORDER PASSERIFORMES

Photography Credits **529**

Species Index **531**

# Acknowledgments

Funding for this project was provided by the Oklahoma State Wildlife Grants program, administered by the Oklahoma Department of Wildlife Conservation with Mark Howery as point of contact, with additional major support from the World Publishing Company, as well as contributions from individual donors. Both the Sutton Center and I are grateful for the financial support that made this project possible, and I thank Steve Sherrod for his private sector fund-raising efforts.

Fieldwork to survey the atlas blocks was completed by 82 individuals or groups. Approximately 70 percent of blocks were surveyed by volunteers, while the remaining surveys were done by project staff. These proportions clearly reflect the importance and generosity of volunteers to atlas projects, and this project could not have been achieved without these dedicated individuals, some of whom traveled from surrounding states to participate. Seasonal staff members Eric Beck and Doug Tozer also deserve special recognition for each spending two consecutive winter seasons camping in the back of a truck in various locations throughout the state while surveying remote blocks anywhere between the four corner towns of Tom, Kenton, Picher, and Hollis. They also performed data entry. The summary of survey participants below includes assistant observers in addition to the primary observers for each block.

**1–5 blocks:** Tom Alford, Amber Ausmus, Sally Barnes, Cleveland County Audubon Society, John Couch, Kathy Dawson, Melinda Droege, Phil Floyd, Gregg Friesen, David Gill, Kevin Groeneweg, Richard Gunn, Jim Harmon, Suzy Harris, Lawrence Herbert, Steve Hodge, Mark Howery, Amanda Husak, Jeff Kelly, June Ketchum, Mark Klippen, Nathan Kuhnert, Juanita Lansford, Brian Lockwood, Larry Mays, Scott McConnell, Hope McGaha, Lynn McRill, Patti Muzny, Mark Peterson, Mia Revels, Gary Schnell, Tom Shane, Eyal Shochat, Jana Singletary, Max Smith, Mark Steele, Eddie Stegall, Terri Underhill, Patricia Velte, Dora Webb, Ken Williams

**6–10 blocks:** Jeanette Bider, Jerry Cooper, Kenneth Dueck, Max Fuller, Aaron Gallagher, Walter Gerard, Claudia and Don Glass, Michael Husak, Pete Janzen, George and Marty Kamp, Esther Key, Glenda and Lloyd Leslie, Jeri McMahon,

Dennis Mullins, Christin Pruett, Pat Seibert, Brenda Smith-Patten, John Sterling, Nancy Wells, Doug Wood, Eugene Young

**11–30 blocks:** David Barrett (staff), Cyndie Browning, Bonnie Gall, Berlin Heck, Jo Loyd, Polly O'Malley, Michael Patten, Dan Reinking (staff), John Sterling, Richard Stuart, Don Varner, Kim Wiar

**Over 30 blocks:** Eric Beck (staff), Doug Tozer (staff), Nancy Vicars, Paul Wilson

I am also pleased by and grateful for the response I received to my call for area photographers to contribute the beautiful bird photos you see throughout this book. More than 80 percent of the included photographs were contributed by just seven photographers in Oklahoma (Duane Angles, James Arterburn, Brenda Carroll, Bill Horn, Steve Metz, Patricia Velte, and Warren Williams), and one from Kansas (Bob Gress), lending the project an additional spirit of local participation. Their skills, patience, and generosity with their craft make this book much more attractive and informative. Aside from two of my own photos, the remaining images were licensed from VIREO (vireo.ansp.org), an excellent source of bird photos.

I thank Richard Thomas, Todd Fagin, Jeremy Ross, and Karen Kilbourne for invaluable assistance with map preparation. This project was built on the solid footing of the *Oklahoma Breeding Bird Atlas* project, which in turn relied on the help of Dan Hough at the Oklahoma Biological Survey and numerous others previously acknowledged in that publication. Two anonymous reviewers helped improve the manuscript. Current and former staff of the Sutton Center have been supportive and have assisted in many ways over the course of this project, and I am lucky to have them as colleagues. I thank the Sutton Center's board of directors and the faculty and staff at the University of Oklahoma's Oklahoma Biological Survey. I am grateful to the editors and staff who helped produce this book. I also thank my family for their continued interest and support.

The Christmas Bird Count program and the birders who conduct Christmas Bird Counts, along with the birders who report their sightings all year, and the Oklahoma Bird Records Committee of the Oklahoma Ornithological Society, which reviews, compiles, and publishes these records, have all made foundational contributions to our knowledge of Oklahoma birds.

# OKLAHOMA
# Winter Bird Atlas

# Introduction

Bird atlas projects have been employed worldwide to provide systematic inventories of bird distribution, and sometimes abundance. These projects are designed and intended to be repeated at intervals, providing ongoing monitoring of changes to bird distributions resulting from natural and anthropogenic processes. Projects have been focused largely on the nesting season, resulting in many "breeding bird atlases" for given regions. In North America, most U.S. states and Canadian provinces, and in some cases smaller units such as counties, have conducted at least one breeding bird atlas survey, and many have recently completed or are in the process of completing a second round of breeding bird atlas surveys. Oklahoma's first such project was conducted from 1997 to 2001 and was published as the *Oklahoma Breeding Bird Atlas* (OBBA) (Reinking 2004).

For a variety of reasons likely including interesting territorial, courtship, nest-building, incubation, and chick-rearing behaviors, the obvious importance of nesting habitat to reproduction and population size, and perhaps even the more pleasant seasonal weather, studies of bird distribution using atlas methodology have thus far taken place largely during the nesting season. As the first Oklahoma breeding bird atlas project wound down, and I and the other staff members of the George Miksch Sutton Avian Research Center were considering future projects, we proposed to conduct a similar survey instead focused on winter bird distribution in Oklahoma. Bird distributions that change over time can change in the winter season as well as in the nesting season, and such changes may be important to understanding population trends. Information about winter bird distributions in Oklahoma suffered from the same limitations that had propelled the completion of the breeding bird atlas. Winter data consisted of opportunistic and anecdotal information collected over many decades; the data were not necessarily comprehensive or up to date, nor was it easy to recognize or monitor changes in the data over time. "Christmas Bird Counts" organized by the National Audubon Society offer valuable information on bird distributions, but the small number of these counts taking place in Oklahoma (about 20 at the time) did not provide the truly statewide coverage of an atlas project encompassing multiple survey sites in every county. This new

project under development would be called the "Oklahoma Winter Bird Atlas," or OWBA, one of the first statewide winter bird atlas projects—if not the first—to be completed in the United States.

Following the completion of Oklahoma's breeding bird atlas surveys, there was a survey design in place that could be easily shifted to a different season, and a corps of experienced volunteer observers who we hoped would be willing to participate again. All that remained in order to get started was to secure funding for the project and to develop a survey methodology, which would of necessity have to differ from that used during the nesting season. Breeding bird atlas methods involve observing behaviors indicative of nesting, or locating actual nests or recently fledged young to confirm nesting activity. None of this would apply to a winter survey. Instead, observers would simply need to note the presence of each species found, and ideally, to also record a measure of its abundance.

## Methods

The areas to be surveyed for the OWBA were the same as those described for the OBBA (Reinking 2004). Survey blocks were selected using a stratified random sampling design to better cover all regions of the state. These consisted of 583 blocks of land, each roughly five kilometers on a side and making up one-sixth of the area depicted by a U.S. Geological Survey 7.5-minute topographic map. The 97 percent survey completion rate of the OBBA indicated that this survey intensity was appropriate for the number of staff members and volunteers available.

Breeding seasons are relatively easy to define based on nesting initiation and completion dates. A key question in conducting a winter atlas project is how to define the winter season. Oklahoma's mid-South latitude means fall migration in many species continues well into November, and spring migration for some species begins in late February (Oklahoma Bird Records Committee 2009). Because the objective of accurately mapping distributions of wintering birds would be hampered (to an unknown extent) by the inclusion of migrants, the OWBA winter season was defined as December 1 to February 14, a period believed to capture wintering species with minimal data corruption from migrants. A major difference between the OBBA and the OWBA was that in contrast to the breeding season, when most individual birds remain on local territories, birds in winter may be more mobile in response to regional or local weather and foraging conditions. Thus, winter distributions may be more plastic, leading to distributional differences between early and late winter periods,

particularly for irruptive species (e.g., Snowy Owl, Red-breasted Nuthatch, Evening Grosbeak, or Pine Siskin) or "half-hardy" species (e.g., some shorebirds, Eastern Phoebe, etc.). To assess such intrawinter distributional patterns, the OWBA season and survey effort were equally divided into early winter (December 1–January 7) and late winter (January 8–February 14) periods.

The OBBA required observers to make a minimum of two visits totaling 10 hours of survey time in each block (Reinking 1998). Breeding bird atlas methodologies are based on the hierarchical classification of breeding evidence derived from observing bird behavior, and observers are instructed to attempt to elevate the known breeding status of each species in a block from Possible to Probable to Confirmed whenever possible. The significant amount of time spent during the OBBA in observing bird behavior in order to upgrade breeding status for each species was not required during the OWBA, which simply recorded the presence of a species in a block along with some measure of abundance. It was assumed that this would enable blocks to be surveyed effectively in less time than was required for the OBBA, a total of eight hours per block (minimum) instead of ten. Because of the desire to evaluate differences in bird distributions during early winter and late winter periods, at least four hours of surveys were required in each block during each of the two winter periods. In addition, the first early-period visit and the last late-period visit were required to be a minimum of 14 days apart.

Winter bird distributions and abundances often vary from year to year, and the bird species present in any one block may differ in years prior to or later than the year in which the block is surveyed. Survey efforts were directed to all regions of the state during each of the five survey years in order for the resulting mapped bird distributions to summarize as accurately as possible the statewide bird distributions over the project period despite annual variations. In other words, if an irruptive or transient species was not recorded in a specific block during one year, it was likely recorded in a nearby block in a previous or subsequent year.

Breeding bird atlas projects and winter bird atlas projects have differed in the collection of abundance data from blocks, ranging from no data collection at all to complete counts of each species. Most projects have used either an order of magnitude scale (1–9; 10–99; 100–999) or some other scale with several numerical range categories for the number of individuals observed (the OBBA used optional abundance categories of 1–2; 3–30; and > 30). Given the rather loose survey methods that have traditionally been used for atlas projects (e.g., broad latitude for timing and duration of visits, and free movement of an

observer within a block) and the wide variation in observer skills (including bird identification, bird finding, and estimating large numbers in flocks), an order of magnitude scale seemed best suited for the OWBA project. Observers recorded abundance in categories of 1–9 birds, 10–99 birds, 100–999 birds, or 1,000–9,999 birds for each species found in a survey block.

As with the OBBA and other atlas projects, the sampling design had an effect on the results. For many atlas projects, including the OBBA, the stratified random sampling design leads to poor detection of rare and local species, and in the case of the OWBA would also have led to poor detection of the many wintering waterbirds (loons, grebes, waterfowl, gulls, etc.) because few large lakes concentrating these species fell within the randomly selected atlas blocks. These sampling problems were to a significant extent overcome during the OBBA by requesting observers to submit observations of "special interest species" from anywhere in Oklahoma. This allowed data for rare and local species to be collected and mapped; these data would otherwise have gone unreported in the project publication. A list of special interest species was incorporated into the OWBA design, and bird reports from lakes across the state were also collected to enhance detection and reporting of aquatic species.

## Results

The surveys were successfully completed as intended. A total of 577 of the 583 blocks selected for sampling were actually surveyed, for a completion rate of 99 percent (fig. 1). This compares favorably to the 97 percent completion rate obtained during the OBBA, which surveyed the same set of blocks during the breeding season. Figures 2–6 show the survey results on a year-by-year basis. Efforts were made to geographically distribute the surveyed blocks as evenly as

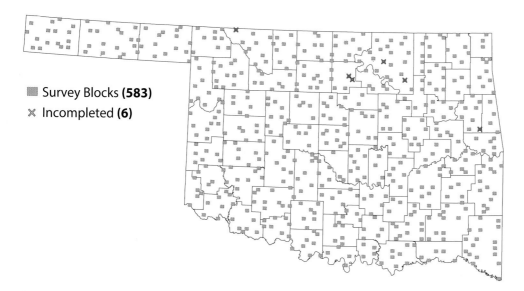

■ Survey Blocks **(583)**
✖ Incompleted **(6)**

FIGURE 1
**Distribution of the 583 blocks selected for surveys. Surveys were not completed in the six blocks marked with an ✖, yielding a survey completion rate of 99 percent.**

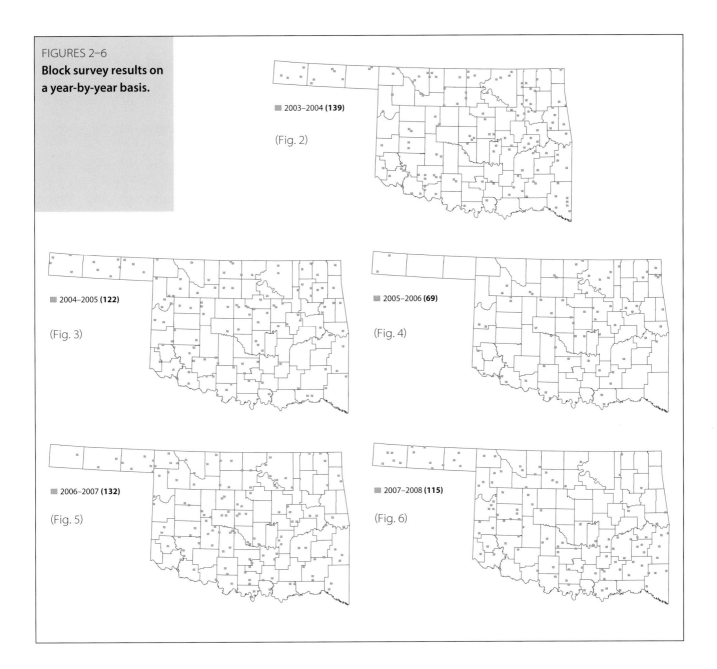

FIGURES 2–6
**Block survey results on a year-by-year basis.**

■ 2003–2004 **(139)**

(Fig. 2)

■ 2004–2005 **(122)**

(Fig. 3)

■ 2005–2006 **(69)**

(Fig. 4)

■ 2006–2007 **(132)**

(Fig. 5)

■ 2007–2008 **(115)**

(Fig. 6)

possible each year, although the constraints of using many volunteer surveyors meant that full control was not possible. More than 75 volunteers participated by surveying or helping to survey one or more atlas blocks. The significant time and travel commitment involved in performing these surveys indicates the high level of interest in and dedication to this project by Oklahoma birders.

More than 26,000 species observation records were collected from the 577 surveyed blocks, yielding an average of about 45 bird species per atlas block. The surveys resulted in 183 species being found within the survey blocks during the five winters of fieldwork. The resulting distribution map for each species is included in each species account. These maps represent the first and only standardized, statewide survey of winter bird distributions in Oklahoma. Taken

over a single five-year time frame, these survey results provide a snapshot of current winter bird distributions in the state and will provide a baseline from which to evaluate future changes in the abundance or distribution of Oklahoma's bird populations. Urban expansion, rural development, land use changes, climate change, and other factors are expected to modify habitats in the coming decades, and understanding how bird populations are responding to these changes is an essential first step before informed prioritization and implementation of research and conservation actions can be carried out. These data should be useful for evaluating future changes on a species-by-species basis as individual conservation questions arise, but atlas projects are also designed to be repeated at intervals of about 20 years, ultimately yielding a more comprehensive assessment of range or population changes for most species within the state.

In brief summary of some of the survey results, the most widely distributed species was Red-tailed Hawk, which was recorded in 551 blocks (over 95 percent of surveyed blocks). Dark-eyed Junco, Northern Flicker, American Crow, Northern Cardinal, and American Kestrel were also among the most widely distributed species (table 1). The type and intensity of stratified random samples used in this project are most effective for detecting species of high to moderate distribution and abundance, but this survey effort was clearly intensive enough to pick up a number of species of very limited winter occurrence in the state such as Blue-headed Vireo, Cassin's Finch, Lewis's Woodpecker, Woodhouse's Scrub-Jay, and Verdin. Not surprisingly, there were also a few species known to have very

TABLE 1

**Top ten species found in the largest percentage of 577 surveyed atlas blocks**

| SPECIES | PERCENTAGE | NO. OF BLOCKS RECORDED |
|---|---|---|
| 1. Red-tailed Hawk | 95.3% | 550 |
| 2. Dark-eyed Junco | 92.7% | 535 |
| 3. Northern Flicker | 92.2% | 532 |
| 4. American Crow | 91.5% | 528 |
| 5. Northern Cardinal | 90.3% | 521 |
| 6. American Kestrel | 89.3% | 515 |
| 7. Song Sparrow | 87.7% | 506 |
| 8. Red-bellied Woodpecker | 86.8% | 501 |
| 9. Downy Woodpecker | 85.8% | 495 |
| 10. Carolina Chickadee | 85.1% | 491 |

limited distribution in the state that surveys did not record, including Bushtit, Pinyon Jay, and Red-cockaded Woodpecker. As is typical of any large-scale effort to get skilled observers in the field and reporting their observations, several unusual (outside of normal winter range) records were unearthed, including a Green-tailed Towhee and Gray Catbird in central Oklahoma, a Sage Thrasher and Rufous Hummingbird in the northeast, a Say's Phoebe in the southeast, and a Pyrrhuloxia and Blue-gray Gnatcatcher in the southwest.

While the distribution maps included in the species accounts were the main objective of this project and were gathered through carefully designed, standardized surveys to ensure that the data were robust and the methods repeatable, we also recognized that having skilled observers in the field provided an opportunity to collect additional data that, while less structured, could still be of value. Two types of additional data were collected: (1) Because atlas survey blocks selected for sampling represented only about one-twelfth of Oklahoma's total geographic area, all or parts of many of Oklahoma's major reservoirs did not fall within the boundaries of survey blocks. This could have led to an incomplete picture of the distributions of many waterbird species (such as ducks, gulls, grebes, etc.) from the survey block data. To help overcome this limitation, observers were asked to visit Oklahoma lakes and record the aquatic-associated species present. These lake surveys were a voluntary side project and therefore varied in number and location each winter (figs. 7–11), but about 100 water bodies were surveyed at least once during the five years of fieldwork, and nearly 80 species were recorded (table 2). (2) Many species with very local distributions or that occur in only small numbers are not well recorded with atlas-style surveys. A list of such species was provided to project volunteers and staff, with a request that sightings of these species anywhere in the state be reported, along with any more-common species that were found outside their normal range. Nearly 1,000 records for nearly 130 species were received through this request (table 3). Both of these kinds of additional data help flesh out distributions for many aquatic or rare species that were not sampled as effectively by the standardized block surveys. Additional published reports of rare species recorded during the time of the OWBA that were not a result of OWBA surveys are also mentioned in the species accounts in the interest of providing a more comprehensive summary of winter bird distributions for the project period. Atlas project block surveys, lake surveys, and special interest species reports collectively documented 245 species during the five winters of the project. The additional 62 species reflected in this total but not recorded within atlas blocks consisted largely of aquatic-associated species found during

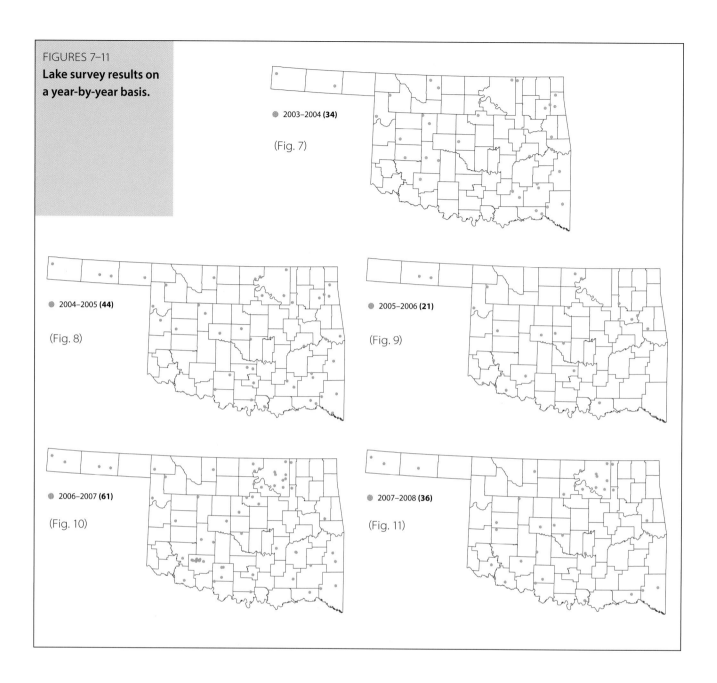

FIGURES 7–11
**Lake survey results on a year-by-year basis.**

2003–2004 **(34)**

(Fig. 7)

2004–2005 **(44)**

(Fig. 8)

2005–2006 **(21)**

(Fig. 9)

2006–2007 **(61)**

(Fig. 10)

2007–2008 **(36)**

(Fig. 11)

lake surveys, plus some rare or local species that were detected only outside survey blocks.

Additional objectives for the project included evaluating year-to-year variations in distribution and abundance of irruptive species, and looking for any changes in distribution from early winter to late winter in cold-sensitive species. Mountain Bluebird, Pine Siskin, Purple Finch, Red-breasted Nuthatch, and Townsend's Solitaire all showed strong patterns of year-to-year variation in their frequency of occurrence (with some years showing more than double the number seen in other years). A number of species were examined regarding early winter versus late winter distribution, but few patterns were detected. This may be because such patterns do not exist, or the sampling design may

TABLE 2

**Species recorded during lake surveys for the Oklahoma Winter Bird Atlas Project**

| SPECIES NAME | NUMBER OF RECORDS REPORTED FROM LAKES | SPECIES NAME | NUMBER OF RECORDS REPORTED FROM LAKES |
|---|---|---|---|
| American Avocet | 1 | Hooded Merganser | 91 |
| American Black Duck | 1 | Horned Grebe | 53 |
| American Coot | 104 | Killdeer | 28 |
| American Pipit | 11 | Laughing Gull | 2 |
| American White Pelican | 61 | Least Sandpiper | 15 |
| American Wigeon | 89 | Lesser Black-backed Gull | 1 |
| Bald Eagle | 100 | Lesser Scaup | 94 |
| Belted Kingfisher | 41 | Lesser Yellowlegs | 1 |
| Black-legged Kittiwake | 1 | Little Gull | 1 |
| Black Scoter | 1 | Long-billed Dowitcher | 1 |
| Blue-winged Teal | 9 | Long-tailed Duck | 3 |
| Bonaparte's Gull | 83 | Mallard | 168 |
| Brant | 2 | Marsh Wren | 8 |
| Brown Pelican | 1 | Mew Gull | 2 |
| Bufflehead | 121 | Northern Pintail | 72 |
| Cackling Goose | 51 | Northern Shoveler | 81 |
| Calidris species | 1 | Osprey | 2 |
| California Gull | 2 | Pacific Loon | 8 |
| Canada Goose | 134 | Pectoral Sandpiper | 1 |
| Canvasback | 52 | Pied-billed Grebe | 120 |
| Cinnamon Teal | 2 | Red-breasted Merganser | 48 |
| Clark's Grebe | 1 | Redhead | 46 |
| Common Goldeneye | 122 | Red-throated Loon | 5 |
| Common Loon | 40 | Ring-billed Gull | 144 |
| Common Merganser | 74 | Ring-necked Duck | 104 |
| Double-crested Cormorant | 124 | Ross's Goose | 35 |
| Duck species | 3 | Ruddy Duck | 32 |
| Dunlin | 4 | Sandhill Crane | 8 |
| Eared Grebe | 11 | Snow Goose | 51 |
| Forster's Tern | 29 | Sora | 1 |
| Franklin's Gull | 2 | Spotted Sandpiper | 6 |
| Gadwall | 138 | Swan species | 1 |
| Glaucous Gull | 6 | Thayer's Gull | 5 |
| Great Blue Heron | 143 | Trumpeter Swan | 4 |
| Great Egret | 1 | Tundra Swan | 6 |
| Greater Scaup | 15 | Virginia Rail | 4 |
| Greater White-fronted Goose | 35 | Western Grebe | 7 |
| Greater Yellowlegs | 19 | Western Sandpiper | 1 |
| Green-winged Teal | 90 | White-winged Scoter | 2 |
| Gull species | 3 | Wilson's Snipe | 5 |
| Herring Gull | 55 | Wood Duck | 18 |

## TABLE 3

**Special Interest Species (SIS) reports received during the Oklahoma Winter Bird Atlas Project**

| SPECIES NAME | NUMBER OF SIS REPORTS RECEIVED | SPECIES NAME | NUMBER OF SIS REPORTS RECEIVED |
|---|---|---|---|
| American Avocet | 4 | Gray Catbird | 2 |
| American Black Duck | 1 | Great Blue Heron | 2 |
| American Woodcock | 20 | Great Egret | 9 |
| Anhinga | 2 | Greater Prairie-Chicken | 14 |
| Ash-throated Flycatcher | 1 | Greater Scaup | 9 |
| Barn Owl | 2 | Greater Yellowlegs | 1 |
| Barn Swallow | 1 | Green-tailed Towhee | 1 |
| Barrow's Goldeneye | 3 | Harris's Hawk | 2 |
| Bewick's Wren | 1 | Harris's Sparrow | 2 |
| Black-and-White Warbler | 1 | Henslow's Sparrow | 3 |
| Black-bellied Plover | 1 | House Wren | 4 |
| Black-crested Titmouse | 10 | Inca Dove | 47 |
| Black-crowned Night-Heron | 2 | King Rail | 4 |
| Black-legged Kittiwake | 2 | Lapland Longspur | 1 |
| Black Phoebe | 7 | Lark Bunting | 29 |
| Black Scoter | 3 | Lark Sparrow | 1 |
| Blue-gray Gnatcatcher | 1 | Laughing Gull | 2 |
| Blue-headed Vireo | 6 | Least Sandpiper | 2 |
| Blue-winged Teal | 3 | Le Conte's Sparrow | 2 |
| Bohemian Waxwing | 2 | Lesser Black-backed Gull | 9 |
| Brant | 4 | Lesser Goldfinch | 1 |
| Brown-headed Nuthatch | 6 | Lesser Prairie-Chicken | 7 |
| Brown Pelican | 1 | Lesser Yellowlegs | 1 |
| Burrowing Owl | 7 | Lewis's Woodpecker | 5 |
| California Gull | 3 | Lincoln's Sparrow | 2 |
| Cassin's Finch | 4 | Long-billed Curlew | 2 |
| Cattle Egret | 3 | Long-billed Dowitcher | 3 |
| Chihuahuan Raven | 4 | Long-eared Owl | 4 |
| Cinnamon Teal | 2 | Long-tailed Duck | 10 |
| Clark's Grebe | 3 | Marsh Wren | 50 |
| Common Ground-Dove | 2 | Mew Gull | 3 |
| Common Moorhen | 2 | Mottled Duck | 1 |
| Common Yellowthroat | 3 | Mountain Chickadee | 4 |
| Dunlin | 4 | Northern Goshawk | 5 |
| Eared Grebe | 1 | Northern Shrike | 7 |
| Eurasian Wigeon | 1 | Osprey | 1 |
| Fish Crow | 57 | Pacific Loon | 14 |
| Forster's Tern | 37 | Palm Warbler | 1 |
| Franklin's Gull | 1 | Pectoral Sandpiper | 2 |
| Glaucous Gull | 11 | Peregrine Falcon | 1 |
| Golden Eagle | 6 | Pileated Woodpecker | 1 |
| | | Pine Grosbeak | 2 |

| SPECIES NAME | NUMBER OF SIS REPORTS RECEIVED | | SPECIES NAME | NUMBER OF SIS REPORTS RECEIVED |
| --- | --- | --- | --- | --- |
| Pine Siskin | 1 | | Sora | 7 |
| Pine Warbler | 1 | | Spotted Sandpiper | 11 |
| *Plegadis* ibis | 4 | | Spotted Towhee | 2 |
| Prairie Falcon | 3 | | Sprague's Pipit | 1 |
| Purple Finch | 188 | | Swan species | 1 |
| Pygmy Nuthatch | 2 | | Thayer's Gull | 10 |
| Pyrrhuloxia | 2 | | Trumpeter Swan | 21 |
| Red-breasted Merganser | 1 | | Tundra Swan | 9 |
| Red-cockaded Woodpecker | 1 | | Verdin | 3 |
| Red Crossbill | 10 | | Vesper Sparrow | 3 |
| Red-shouldered Hawk | 1 | | Virginia Rail | 15 |
| Red-throated Loon | 13 | | Western Bluebird | 1 |
| Rock Wren | 3 | | Western Grebe | 5 |
| Rufous Hummingbird | 1 | | Western Meadowlark | 1 |
| Rusty Blackbird | 3 | | Western Sandpiper | 1 |
| Sage Thrasher | 11 | | Western Screech-Owl | 4 |
| Sandhill Crane | 8 | | White Ibis | 4 |
| Say's Phoebe | 3 | | White-tailed Kite | 1 |
| Sedge Wren | 25 | | White-winged Dove | 24 |
| Short-eared Owl | 64 | | White-winged Scoter | 8 |
| Smith's Longspur | 3 | | Yellow-bellied Sapsucker | 1 |
| Snow Bunting | 1 | | Yellow-billed Loon | 3 |
| Snowy Owl | 1 | | Yellow Rail | 2 |

NOTE: These represent either species for which additional information was requested by the project organizer, or species that observers felt warranted a special report because of a perceived unusual date or location of observation. In some cases, multiple observers reported the same individual bird.

not have been rigorous enough to detect small differences in distribution, or perhaps the cutoff date for the early versus late winter record-keeping periods did not align well with any existing winter movements of "half-hardy" species.

Additional species documented by project volunteers but not included in the species accounts were a Barn Swallow, recorded in McCurtain County on December 4 and 19, 2007, and assumed to be a late migrant, and a Mute Swan in Alfalfa County in early 2005, considered to be of uncertain (potentially domestic) origin. A number of species that have been found in Oklahoma during the winter months but were not recorded during the five winters of atlas project surveys are not included here. Examples include Northern Saw-whet Owl (*Aegolius acadicus*) and Evening Grosbeak (*Coccothraustes vespertinus*).

# Weather

Winter bird distributions are influenced by weather conditions at local, regional, and even larger scales. Some of these influences are easy to see and to understand intuitively, such as open water beginning to freeze and forcing aquatic birds farther south as winter progresses. Other influences are more complex and involve delayed or protracted responses to environmental conditions. An example of a more complex response involves reactions to seed production in boreal forests. In years of good moisture and high conifer seed production, broods of several bird species may be large and experience high overwinter survival. If drought follows and the seed crop fails in a subsequent year, the large populations of birds such as Red-breasted Nuthatches, Red Crossbills, Pine Siskins, and others make observable irruptive movements well south of their typical winter ranges in search of food. In this example, weather conditions (precipitation, temperature, and/or other factors in combination) in the distant boreal forests of Canada during the previous two or more growing seasons are responsible for the presence or abundance of these species during

TABLE 4

**Statewide weather summary for five winter seasons (December through February) during which bird surveys took place**

| STATEWIDE | 2003–2004 | 2004–2005 | 2005–2006 | 2006–2007 | 2007–2008 |
|---|---|---|---|---|---|
| Average temperature (°F) | 40.1 | 41.7 | 41.5 | 38.4 | 39.1 |
| Departure from normal temperature (°F) | 1.2 | 2.8 | 2.6 | -0.5 | 0.2 |
| Temperature rank (since 1895) | 38th warmest | 15th warmest | 17th warmest | 41st coolest | 58th warmest |
| Precipitation (inches) | 5.22 | 6.12 | 1.56 | 7.11 | 6.18 |
| Departure from normal precipitation (inches) | 0.41 | 1.31 | -3.25 | 2.3 | 1.37 |
| Precipitation rank (since 1895) | 48th wettest | 30th wettest | 2nd driest | 15th wettest | 29th wettest |

SOURCE: Data are from the National Climatic Data Center of the National Oceanic and Atmospheric Administration website (www.ncdc.noaa.gov).

a subsequent winter in Oklahoma. Identifying and clarifying these relationships between weather and bird distribution at either hemispheric or local scales are beyond the scope of this book. Although the examples just described show that weather far removed from Oklahoma (not only in distance but also in time, in prior seasons) has significant impacts on winter bird distributions in Oklahoma, it nonetheless seems appropriate to briefly summarize weather conditions in Oklahoma during the five winters over which the bird surveys presented in this book took place (table 4). Winter weather during the time frame of the bird surveys was generally warmer than the historical average, and generally wetter except for the exceptionally dry winter of 2005–2006. A widespread ice storm in December 2007 was perhaps the most significant single winter weather event in Oklahoma during the survey period.

## Christmas Bird Counts

Christmas Bird Counts have been conducted annually by the National Audubon Society since 1900. These counts take place from the latter half of December to very early in January, and they rely on volunteer observers to survey circles 15 miles in diameter on a single day within the count period. The number of each species seen or heard is tallied. This program is the longest-running source of bird population information in North America. The number of counts conducted has fluctuated, generally growing over time both nationally and in Oklahoma. Currently, there are approximately 20 counts in Oklahoma. Despite the limitation of this relatively low number of survey locations in Oklahoma, the long-term nature of the surveys can provide some trend information for bird species wintering in Oklahoma. Results of these surveys for most species are provided in both graph format, showing a long-term trend for a 50-year period from 1960 to 2009 in birds per hour, and tabular format, showing count results during the same five winters in which the Winter Bird Atlas survey was conducted.

## References

National Audubon Society. 2011. The Christmas Bird Count historical results. www .christmasbirdcount.org.
Oklahoma Bird Records Committee. 2009. *Date Guide to the Occurrences of Birds in Oklahoma.* 5th ed. Norman: Oklahoma Ornithological Society.
Reinking, D. L., compiler. 1998. "Handbook for Atlasers." Rev. ed. Unpublished handbook.
———, ed. 2004. *Oklahoma Breeding Bird Atlas.* Norman: University of Oklahoma Press.

SPECIES ACCOUNTS

## Greater White-fronted Goose
### *Anser albifrons*

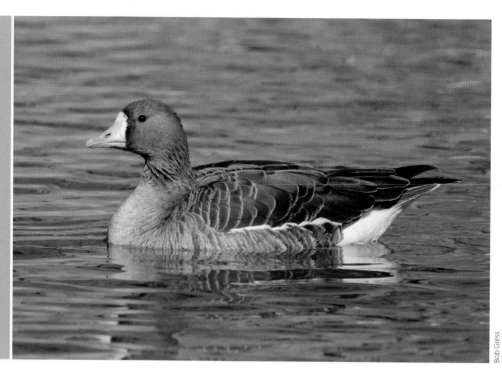

Bob Gress

**Occurrence:** October through mid-April.

**Habitat:** Lakes, marshes, and agricultural fields.

**North American distribution:** Breeds in arctic Alaska, Canada, and Greenland. Winters in California, parts of the south-central United States, and Mexico.

**Oklahoma distribution:** Recorded at scattered locations primarily in north-central and southwestern counties. Most blocks had relatively small numbers, although a few larger aggregations were noted.

**Behavior:** Greater White-fronted Geese typically stay in family groups through the winter, but these groups can congregate into flocks ranging from small to very large. The geese often associate with flocks of Snow Geese. Greater White-fronted Geese forage by grazing on grasses or by gleaning seeds and grains from the ground or from low plants.

### Christmas Bird Count (CBC) Results, 1960–2009

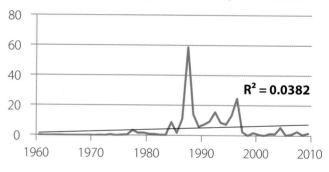

$R^2 = 0.0382$

### CBC Results, 2003–2008

| Winter | Number recorded | Counts reporting |
| --- | --- | --- |
| 2003–2004 | 1,214 | 8 |
| 2004–2005 | 5,750 | 8 |
| 2005–2006 | 340 | 8 |
| 2006–2007 | 853 | 8 |
| 2007–2008 | 2,743 | 9 |

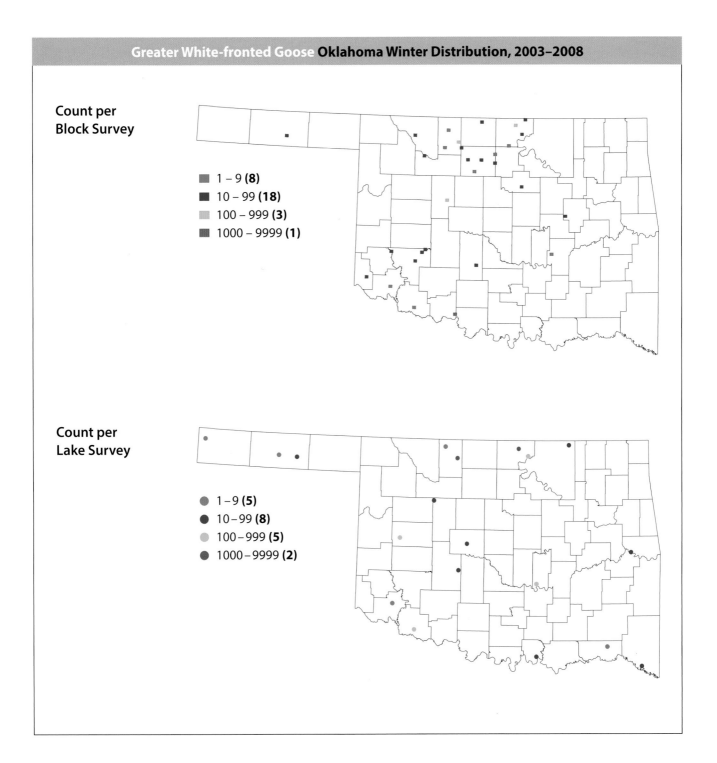

Count per
Block Survey

- 1 – 9 **(8)**
- 10 – 99 **(18)**
- 100 – 999 **(3)**
- 1000 – 9999 **(1)**

Count per
Lake Survey

- 1 – 9 **(5)**
- 10 – 99 **(8)**
- 100 – 999 **(5)**
- 1000 – 9999 **(2)**

### References

Ely, C. R., and A. X. Dzubin. 1994. Greater White-fronted Goose (*Anser albifrons*). *The Birds of North America Online*, edited by A. Poole. Ithaca, N.Y.: Cornell Laboratory of Ornithology. http://bna.birds.cornell.edu.

National Audubon Society. 2011. The Christmas Bird Count historical results. http://www .christmasbirdcount.org.

Oklahoma Bird Records Committee. 2009. *Date Guide to the Occurrences of Birds in Oklahoma*. 5th ed. Norman: Oklahoma Ornithological Society.

# Snow Goose
## *Chen caerulescens*

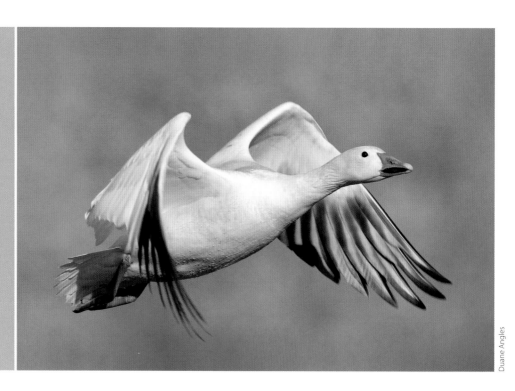

Duane Angles

**Occurrence:** October through mid-April.

**Habitat:** Lakes, wetlands, and grain fields.

**North American distribution:** Breeds in arctic Canada. Winters in parts of the eastern, western, and south-central United States and in Mexico.

**Oklahoma distribution:** Recorded statewide, frequently at high abundances, but somewhat more prevalent in western counties.

**Behavior:** Snow Geese are very gregarious, with pairs and family groups coalescing into flocks during migration and winter that can number in the many thousands of birds and may include Ross's Geese. They forage by gleaning waste grains and seeds from the ground or low vegetation, by grazing on grasses and other plant materials, and by grubbing for roots and tubers of marsh plants. They typically roost on water at night but do much of their foraging on land.

## Christmas Bird Count (CBC) Results, 1960–2009

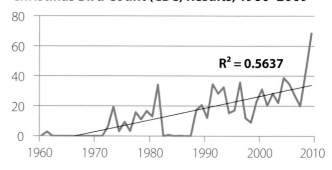

$R^2 = 0.5637$

## CBC Results, 2003–2008

| Winter | Number recorded | Counts reporting |
|---|---|---|
| 2003–2004 | 21,188 | 6 |
| 2004–2005 | 36,584 | 8 |
| 2005–2006 | 31,333 | 6 |
| 2006–2007 | 24,677 | 3 |
| 2007–2008 | 15,071 | 10 |

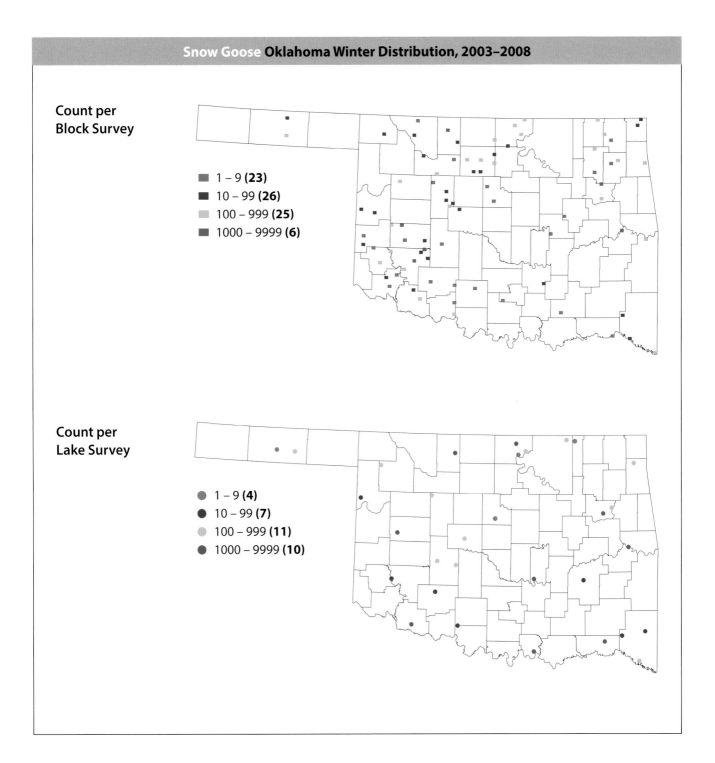

**Count per Block Survey**

■ 1 – 9 **(23)**
■ 10 – 99 **(26)**
■ 100 – 999 **(25)**
■ 1000 – 9999 **(6)**

**Count per Lake Survey**

● 1 – 9 **(4)**
● 10 – 99 **(7)**
● 100 – 999 **(11)**
● 1000 – 9999 **(10)**

**References**

Mowbray, Thomas B., Fred Cooke, and Barbara Ganter. 2000. Snow Goose (*Chen caerulescens*). *The Birds of North America Online*, edited by A. Poole. Ithaca, N.Y.: Cornell Laboratory of Ornithology. http://bna .birds.cornell.edu.

National Audubon Society. 2011. The Christmas Bird Count historical results. http://www .christmasbirdcount.org.

Oklahoma Bird Records Committee. 2009. *Date Guide to the Occurrences of Birds in Oklahoma*. 5th ed. Norman: Oklahoma Ornithological Society.

# Ross's Goose
## *Chen rossii*

Bob Gress

**Occurrence:** Early November through mid-April.

**Habitat:** Lakes, ponds, marshes, and agricultural fields.

**North American distribution:** Breeds in arctic Canada and winters along parts of the Atlantic Coast as well as in California, the south-central and southwestern United States, and Mexico.

**Oklahoma distribution:** Recorded in scattered survey blocks, with most records coming from north-central counties. Lake surveys suggest a more even statewide distribution.

**Behavior:** Ross's Geese are highly gregarious and are usually seen in flocks, often within much larger flocks of Snow Geese. They forage on grasses and grains while walking or standing.

## Christmas Bird Count (CBC) Results, 1960–2009

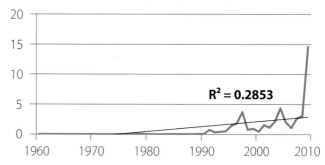

$R^2 = 0.2853$

## CBC Results, 2003–2008

| Winter | Number recorded | Counts reporting |
|--------|-----------------|------------------|
| 2003–2004 | 2,011 | 6 |
| 2004–2005 | 4,345 | 4 |
| 2005–2006 | 1,631 | 4 |
| 2006–2007 | 1,044 | 5 |
| 2007–2008 | 3,362 | 6 |

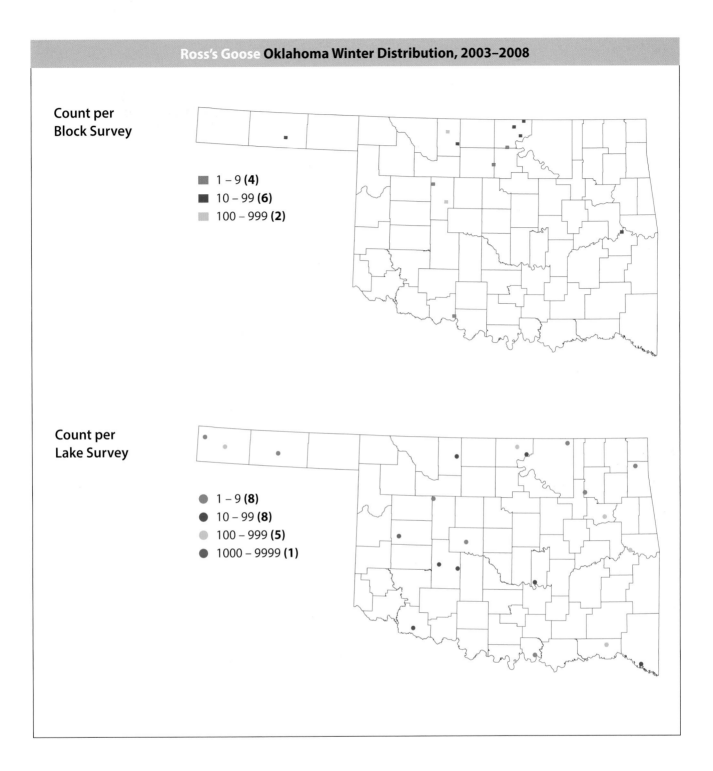

**Count per Block Survey**

- 1 – 9 **(4)**
- 10 – 99 **(6)**
- 100 – 999 **(2)**

**Count per Lake Survey**

- 1 – 9 **(8)**
- 10 – 99 **(8)**
- 100 – 999 **(5)**
- 1000 – 9999 **(1)**

**References**

Klett, E. V., and C. C. Heflebower. 1977. Ross's Goose on Washita National Wildlife Refuge, west-central Oklahoma. *Bulletin of the Oklahoma Ornithological Society* 10:30–31.

National Audubon Society. 2011. The Christmas Bird Count historical results. http://www .christmasbirdcount.org.

Oklahoma Bird Records Committee. 2009. *Date Guide to the Occurrences of Birds in Oklahoma*. 5th ed. Norman: Oklahoma Ornithological Society.

Ryder, John P., and Ray T. Alisauskas. 1995. Ross's Goose (*Chen rossii*). *The Birds of North America Online*, edited by A. Poole. Ithaca, N.Y.: Cornell Laboratory of Ornithology. http://bna.birds.cornell.edu.

Zahm, G. R. 1971. Ross's Goose in Johnston County, Oklahoma. *Bulletin of the Oklahoma Ornithological Society* 4:32–33.

# Brant
## *Branta bernicla*

Steve Metz

**Occurrence:** Rare in winter.

**Habitat:** Lakes and ponds.

**North American distribution:** Breeds in arctic Alaska and Canada. Winters along portions of the Pacific and Atlantic Coasts.

**Oklahoma distribution:** Not recorded in survey blocks. Reported from Caddo County in December 2004 (shot by hunter; Powell 2004), and as a special interest species from Cimarron County (Lake Carl Etling) in December 2007 and from Texas County (Sunset Lake in Guymon) in January 2004 and December 2004.

**Behavior:** Brant are gregarious outside the breeding season, but because of their rarity in Oklahoma, they are more likely to occur singly. They sometimes associate with diving ducks or other geese. They forage mostly on aquatic vegetation but also graze on terrestrial grasses.

**Count per
Block Survey**

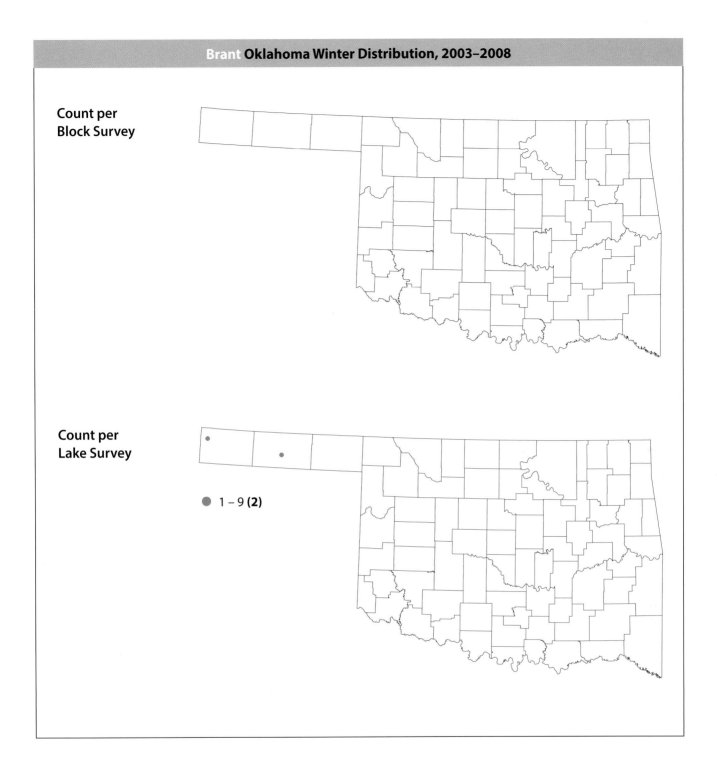

**Count per
Lake Survey**

● 1 – 9 **(2)**

**References**

National Audubon Society. 2011. The Christmas Bird Count historical results. http://www
    .christmasbirdcount.org.

Oklahoma Bird Records Committee. 2009. *Date Guide to the Occurrences of Birds in Oklahoma.* 5th ed.
    Norman: Oklahoma Ornithological Society.

Powell, S. 2004. Second-half seasons start. *Tulsa World*, December 19.

Reed, A., D. H. Ward, D. V. Derksen, and J. S. Sedinger. 1998. Brant (*Branta bernicla*). *The Birds of North
    America Online*, edited by A. Poole. Ithaca, N.Y.: Cornell Laboratory of Ornithology. http://bna.birds
    .cornell.edu.

# Cackling Goose
*Branta hutchinsii*

James Arterburn

**Occurrence:** Late September through early April.

**Habitat:** Lakes, ponds, and grain fields.

**North American distribution:** Breeds in arctic Canada and Alaska, and winters in the south-central United States and in local areas of the western and eastern United States.

**Oklahoma distribution:** Surveys indicate a statewide if scattered distribution, with the largest numbers recorded in north-central and northwestern counties. Prior to July 2004, this species was considered conspecific with Canada Goose, so Christmas Bird Counts and other records do not delineate distributions until subsequent winters.

**Behavior:** Cackling Geese are made up of the four smallest former subspecies of the Canada Goose. They are typically found in flocks and may occur with Canada Geese and other geese, but they often segregate into Cackling Goose subflocks within the larger group of other geese. They forage on grasses, winter wheat, and alfalfa, along with grains.

**Christmas Bird Count (CBC) Results, 1960–2009**

$R^2 = 0.2537$

**CBC Results, 2003–2008**

| Winter | Number recorded | Counts reporting |
|---|---|---|
| 2003–2004 | N/A | N/A |
| 2004–2005 | 143 | 4 |
| 2005–2006 | 533 | 9 |
| 2006–2007 | 337 | 6 |
| 2007–2008 | 873 | 10 |

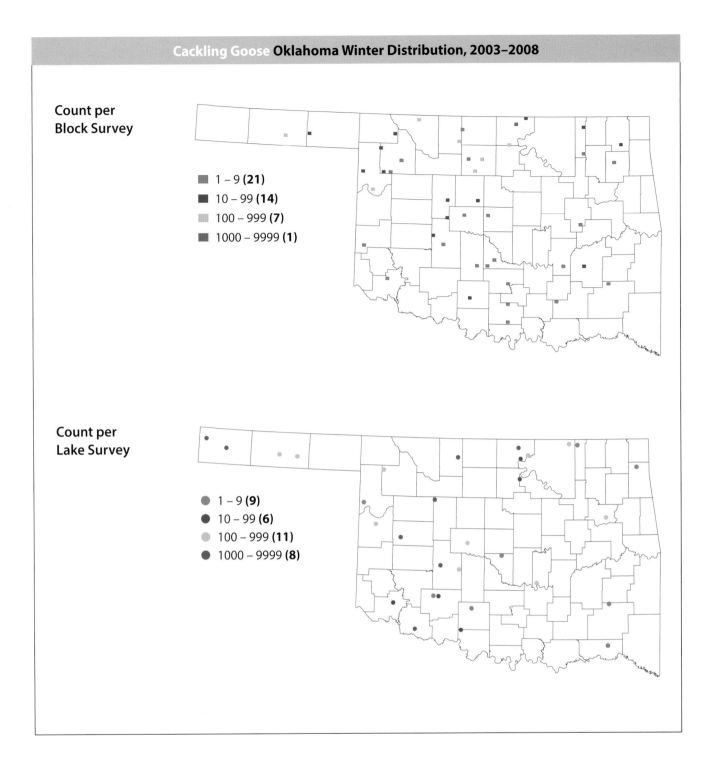

**Count per
Block Survey**

■ 1 – 9 **(21)**
■ 10 – 99 **(14)**
▦ 100 – 999 **(7)**
▦ 1000 – 9999 **(1)**

**Count per
Lake Survey**

● 1 – 9 **(9)**
● 10 – 99 **(6)**
● 100 – 999 **(11)**
● 1000 – 9999 **(8)**

**References**

Mowbray, Thomas B., Craig R. Ely, James S. Sedinger, and Robert E. Trost. 2002. Canada Goose (*Branta canadensis*). *The Birds of North America Online*, edited by A. Poole. Ithaca, N.Y.: Cornell Laboratory of Ornithology. http://bna.birds.cornell.edu.

National Audubon Society. 2011. The Christmas Bird Count historical results. http://www .christmasbirdcount.org.

Oklahoma Bird Records Committee. 2009. *Date Guide to the Occurrences of Birds in Oklahoma*. 5th ed. Norman: Oklahoma Ornithological Society.

# Canada Goose
*Branta canadensis*

Duane Angles

**Occurrence:** Year-round resident, but more numerous from fall through spring.

**Habitat:** Lakes, ponds, grain fields, golf courses, and parks.

**North American distribution:** Widespread breeder across Canada and Alaska, year-round resident in much of the lower 48 states, and a winter resident in the southernmost United States and in parts of northern Mexico.

**Oklahoma distribution:** Canada Geese were found in most surveyed blocks statewide, but they were least abundant in the forested southeastern counties and reached maximum abundance in the western half of the state, where blocks hosting over 1,000 birds were fairly common. Although they are a fairly common nesting species in most regions of the state, they were detected more often and over a larger geographic area during winter than during the Oklahoma Breeding Bird Atlas Project.

**Behavior:** Canada Geese are frequently seen in flocks ranging from a few birds to thousands, and they can associate with other geese species. They forage on grasses, winter wheat, and alfalfa, along with grains.

## Christmas Bird Count (CBC) Results, 1960–2009

$R^2 = 0.0091$

## CBC Results, 2003–2008

| Winter | Number recorded | Counts reporting |
|---|---|---|
| 2003–2004 | 113,510 | 20 |
| 2004–2005 | 33,283 | 15 |
| 2005–2006 | 70,967 | 16 |
| 2006–2007 | 91,690 | 17 |
| 2007–2008 | 41,756 | 18 |

**Count per
Block Survey**

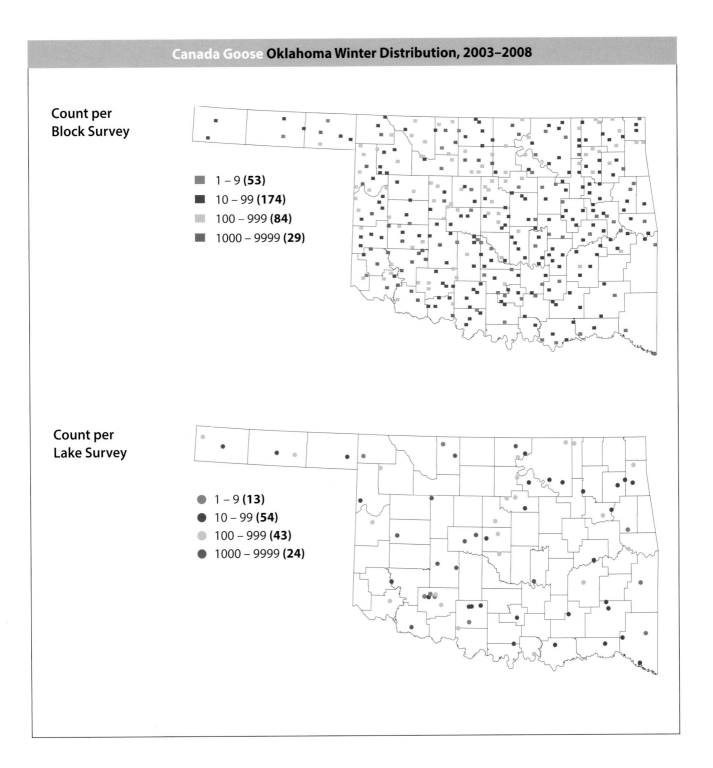

■ 1 – 9 **(53)**
■ 10 – 99 **(174)**
■ 100 – 999 **(84)**
■ 1000 – 9999 **(29)**

**Count per
Lake Survey**

● 1 – 9 **(13)**
● 10 – 99 **(54)**
● 100 – 999 **(43)**
● 1000 – 9999 **(24)**

### References

Mowbray, Thomas B., Craig R. Ely, James S. Sedinger, and Robert E. Trost. 2002. Canada Goose (*Branta canadensis*). *The Birds of North America Online*, edited by A. Poole. Ithaca, N.Y.: Cornell Laboratory of Ornithology. http://bna.birds.cornell.edu.

National Audubon Society. 2011. The Christmas Bird Count historical results. http://www.christmasbirdcount.org.

Oklahoma Bird Records Committee. 2009. *Date Guide to the Occurrences of Birds in Oklahoma*. 5th ed. Norman: Oklahoma Ornithological Society.

Orr, J. L. 1986. Canada Geese flying in formation with Sandhill Cranes. *Bulletin of the Oklahoma Ornithological Society* 19:12.

Reinking, D. L., ed. 2004. *Oklahoma Breeding Bird Atlas*. Norman: University of Oklahoma Press.

# Trumpeter Swan
*Cygnus buccinator*

Bill Horn

**Occurrence:** Mid-November through early March.

**Habitat:** Ponds and wetlands.

**North American distribution:** Breeds in Alaska, western Canada, and local areas in the northern lower 48 states. Resident locally in the northern and western lower 48 states. Winters in western Canada, the northwestern lower 48 states, and at scattered locations in the central United States. Reintroduction efforts in Iowa, Minnesota, and other parts of the upper Midwest are the source for at least some of the winter records of this species in Oklahoma, as determined by tracking the numbers from neck collars on marked birds.

**Oklahoma distribution:** Recorded in one Garfield County survey block. Additional special interest species reports were received from Alfalfa, Comanche, Craig, Delaware, Garfield, Garvin, McCurtain, Nowata, Osage, Payne, Tillman, Tulsa, and Washington Counties. Reports from multiple counties were received during each of the five winters surveyed for this project except for the winter of 2004–2005, when reports of three to six birds came only from Alfalfa County. A maximum group size of eight birds was reported from both Alfalfa and Comanche Counties.

**Behavior:** Trumpeter Swans are usually seen as pairs or in family groups consisting of an adult pair with one or more grayish young. Pairs of family groups sometimes coalesce into larger groups and may also associate with Tundra Swans. Foraging takes place both in the water, for leaves, stems, tubers, and roots of aquatic plants, and on land, where grasses and crops such as wheat are grazed.

## Christmas Bird Count (CBC) Results, 1960–2009

$R^2 = 0.1001$

## CBC Results, 2003–2008

| Winter | Number recorded | Counts reporting |
|---|---|---|
| 2003–2004 | 28 | 4 |
| 2004–2005 | 0 | — |
| 2005–2006 | 5 | 3 |
| 2006–2007 | 0 | — |
| 2007–2008 | 0 | — |

**Count per
Block Survey**

■ 1 – 9 **(1)**

**Count per
Lake Survey**

● 1 – 9 **(3)**

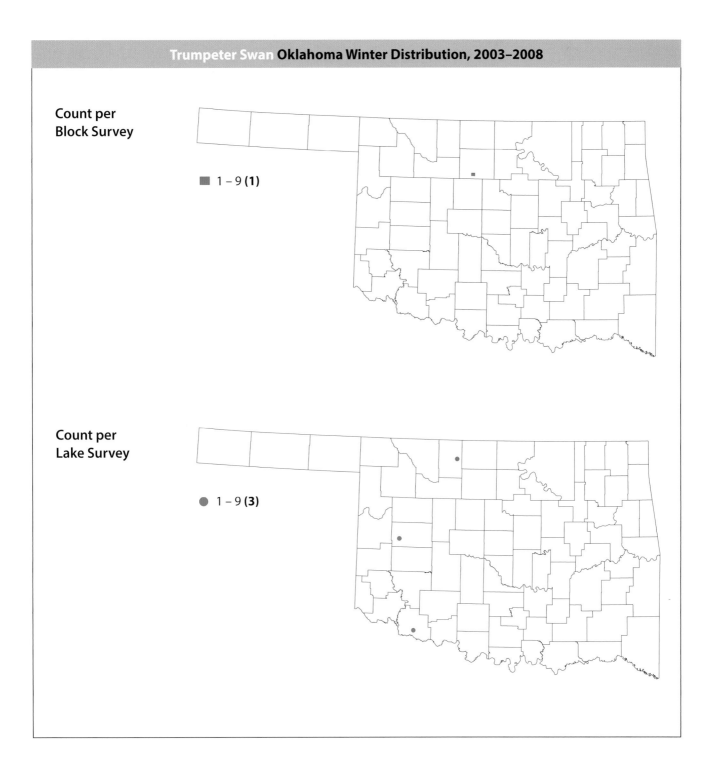

### References

Mitchell, Carl D., and Michael W. Eichholz. 2010. Trumpeter Swan (*Cygnus buccinator*). *The Birds of North America Online*, edited by A. Poole. Ithaca, N.Y.: Cornell Laboratory of Ornithology. http://bna.birds.cornell.edu.

National Audubon Society. 2011. The Christmas Bird Count historical results. http://www.christmasbirdcount.org.

Oklahoma Bird Records Committee. 2004. 2003–2004 winter season. *The Scissortail* 54:25–27.

———. 2005. 2004–2005 winter season. *The Scissortail* 55:18–20.

———. 2006. 2005–2006 winter season. *The Scissortail* 56:14–15.

———. 2007. 2006–2007 winter season. *The Scissortail* 57:24–27.

———. 2009a. 2007–2008 winter season. *The Scissortail* 59:4–8.

———. 2009b. *Date Guide to the Occurrences of Birds in Oklahoma*. 5th ed. Norman: Oklahoma Ornithological Society.

Webb, W. 1987. Trumpeter Swans in Greer County, southwestern Oklahoma. *Bulletin of the Oklahoma Ornithological Society* 20:12–14.

# Tundra Swan
## *Cygnus columbianus*

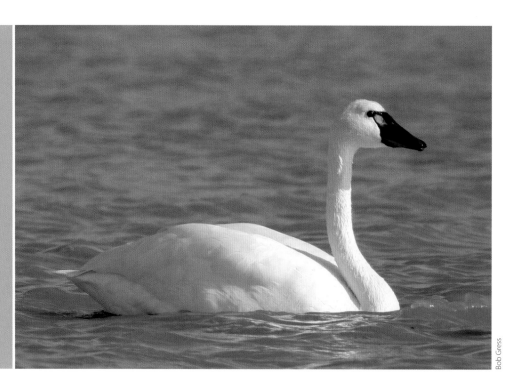

Bob Gress

**Occurrence:** Rare from November through mid-March.

**Habitat:** Lakes, ponds, and marshes.

**North American distribution:** Breeds in Alaska and northern Canada. Winters in parts of the western and eastern lower 48 states, and more rarely in central states.

**Oklahoma distribution:** Not recorded in survey blocks. Lake surveys recorded this species in Alfalfa, Cimarron, Custer, and Texas Counties (see lake survey map). Published reports during the project period also came from Comanche, Garvin, Kay, Kingfisher, McCurtain, Osage, and Tillman Counties, and this species was recorded in each of the five survey winters in small groups of up to 11 birds (Oklahoma Bird Records Committee 2004, 2005, 2006, 2007, 2009a).

**Behavior:** Tundra Swans typically occur in small flocks and sometimes associate with Trumpeter Swans. They forage on nearly all parts of aquatic plants as well as waste grains and growing cereal crops.

**Christmas Bird Count (CBC) Results, 1960–2009**

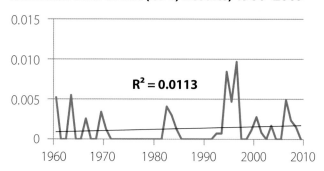

$R^2 = 0.0113$

**CBC Results, 2003–2008**

| Winter | Number recorded | Counts reporting |
|---|---|---|
| 2003–2004 | 2 | 1 |
| 2004–2005 | 0 | — |
| 2005–2006 | 0 | — |
| 2006–2007 | 5 | 1 |
| 2007–2008 | 4 | 1 |

**Count per Block Survey**

**Count per Lake Survey**

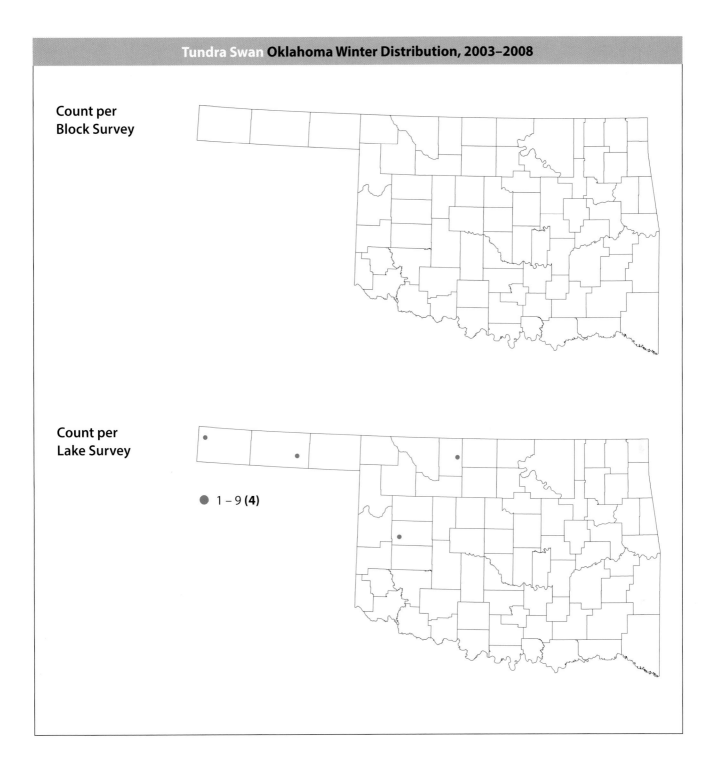

● 1 – 9 **(4)**

### References

Dixon, N. B. 1968. Whistling Swans wintering in central Oklahoma. *Bulletin of the Oklahoma Ornithological Society* 1:10–11.

Limpert, R. J., and S. L. Earnst. 1994. Tundra Swan (*Cygnus columbianus*). *The Birds of North America Online*, edited by A. Poole. Ithaca, N.Y.: Cornell Laboratory of Ornithology. http://bna.birds.cornell.edu.

National Audubon Society. 2011. The Christmas Bird Count historical results. http://www .christmasbirdcount.org.

Oklahoma Bird Records Committee. 2004. 2003–2004 winter season. *The Scissortail* 54:25–27.

———. 2005. 2004–2005 winter season. *The Scissortail* 55:18–20.

———. 2006. 2005–2006 winter season. *The Scissortail* 56:14–15.

———. 2007. 2006–2007 winter season. *The Scissortail* 57:24–27.

———. 2009a. 2007–2008 winter season. *The Scissortail* 59:4–8.

———. 2009b. *Date Guide to the Occurrences of Birds in Oklahoma.* 5th ed. Norman: Oklahoma Ornithological Society.

# Wood Duck
## *Aix sponsa*

Bob Gress

**Occurrence:** Year-round resident in most regions, but somewhat more common during spring and fall migration when additional individuals move through the state.

**Habitat:** Ponds, rivers, and streams.

**North American distribution:** Breeds in southern Canada and much of the northern and eastern lower 48 states. Resident in the southeastern United States and along parts of the Pacific Coast. Winters in parts of the southwestern United States and in Mexico.

**Oklahoma distribution:** Recorded in scattered survey blocks throughout the main body of the state, but most commonly reported in the southeastern fourth. The summer distribution recorded by the Oklahoma Breeding Bird Atlas Project was similar but included more records from northern and western counties, indicating some seasonal movements out of these areas for the winter.

**Behavior:** Wood Ducks are usually seen in pairs during the winter, and they often coalesce into small flocks and may associate with Mallards. They forage on the ground and from the surface of the water for seeds, fruits, and invertebrates.

### Christmas Bird Count (CBC) Results, 1960–2009

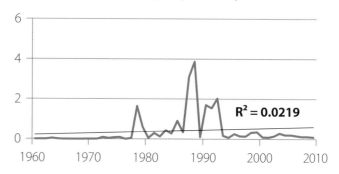

$R^2 = 0.0219$

### CBC Results, 2003–2008

| Winter | Number recorded | Counts reporting |
|--------|-----------------|------------------|
| 2003–2004 | 258 | 12 |
| 2004–2005 | 183 | 11 |
| 2005–2006 | 274 | 13 |
| 2006–2007 | 191 | 8 |
| 2007–2008 | 113 | 12 |

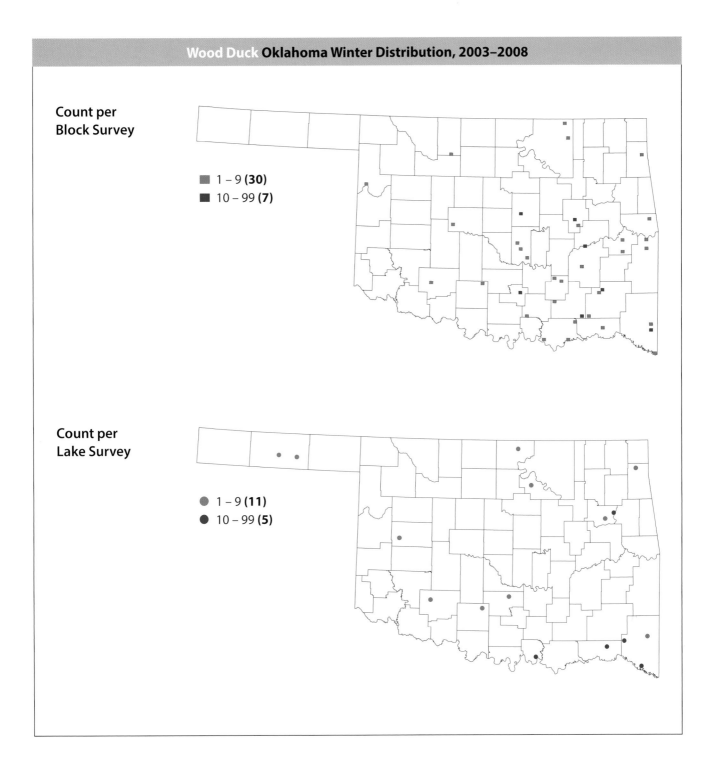

**Count per Block Survey**

■ 1 – 9 **(30)**
■ 10 – 99 **(7)**

**Count per Lake Survey**

● 1 – 9 **(11)**
● 10 – 99 **(5)**

**References**

Hepp, Gary R., and Frank C. Bellrose. 1995. Wood Duck (*Aix sponsa*). *The Birds of North America Online*, edited by A. Poole. Ithaca, N.Y.: Cornell Laboratory of Ornithology. http://bna.birds.cornell.edu.

National Audubon Society. 2011. The Christmas Bird Count historical results. http://www.christmasbirdcount.org.

Oklahoma Bird Records Committee. 2009. *Date Guide to the Occurrences of Birds in Oklahoma*. 5th ed. Norman: Oklahoma Ornithological Society.

Reinking, D. L., ed. 2004. *Oklahoma Breeding Bird Atlas*. Norman: University of Oklahoma Press.

# Gadwall
## *Anas strepera*

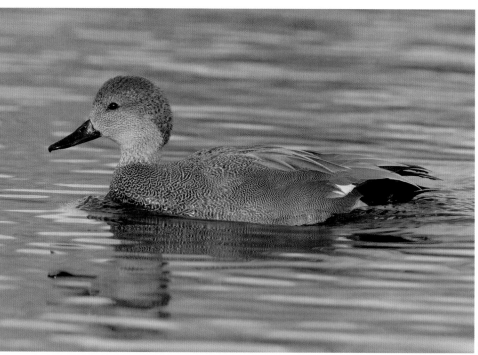

Bob Gress

**Occurrence:** Present year-round in parts of the state, but far more widespread and numerous from fall through spring.

**Habitat:** Lakes and ponds.

**North American distribution:** Present over much of the United States and southern Canada as a breeding, resident, or wintering species, depending on the location.

**Oklahoma distribution:** Widely recorded statewide, with fewer records from the southeastern and Panhandle counties. Summer distribution as recorded by the Oklahoma Breeding Bird Atlas Project was limited to the Panhandle.

**Behavior:** Gadwalls are typically seen in small to large flocks and often associate with other species such as American Wigeon and American Coot. They forage using a technique known as dabbling, in which they tilt their heads down under the water with their tails pointing up as they gather aquatic plants and seeds.

**Christmas Bird Count (CBC) Results, 1960–2009**

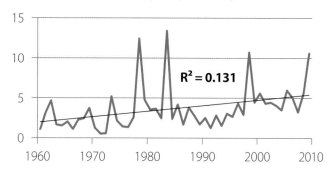

$R^2 = 0.131$

**CBC Results, 2003–2008**

| Winter | Number recorded | Counts reporting |
|--------|-----------------|------------------|
| 2003–2004 | 4,422 | 20 |
| 2004–2005 | 3,608 | 20 |
| 2005–2006 | 5,836 | 19 |
| 2006–2007 | 5,251 | 19 |
| 2007–2008 | 3,275 | 19 |

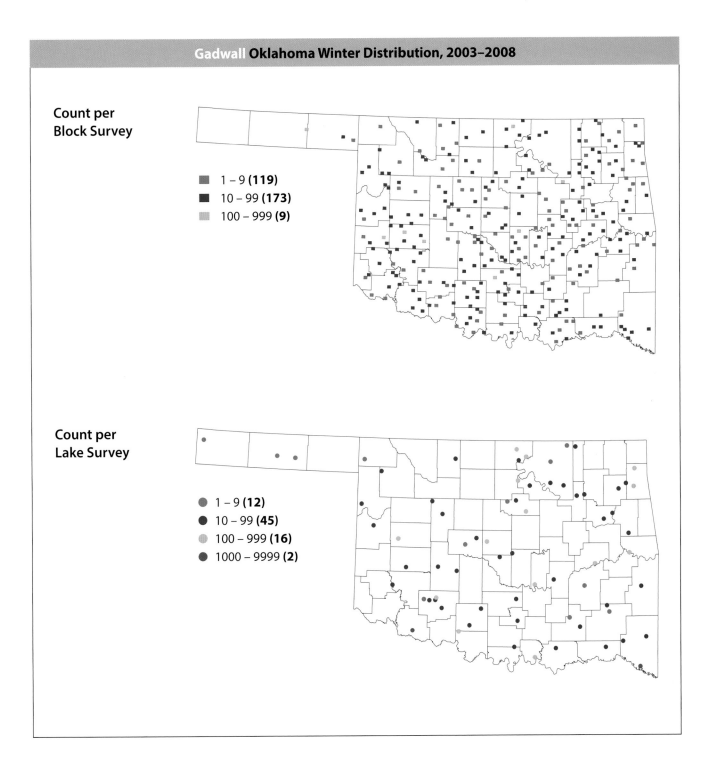

**Count per
Block Survey**

- ■ 1 – 9 **(119)**
- ■ 10 – 99 **(173)**
- ▨ 100 – 999 **(9)**

**Count per
Lake Survey**

- ● 1 – 9 **(12)**
- ● 10 – 99 **(45)**
- ● 100 – 999 **(16)**
- ● 1000 – 9999 **(2)**

**References**

Leschack, C. R., S. K. McKnight, and G. R. Hepp. 1997. Gadwall (*Anas strepera*). *The Birds of North America Online*, edited by A. Poole. Ithaca, N.Y.: Cornell Laboratory of Ornithology. http://bna.birds.cornell.edu.

National Audubon Society. 2011. The Christmas Bird Count historical results. http://www.christmasbirdcount.org.

Oklahoma Bird Records Committee. 2009. *Date Guide to the Occurrences of Birds in Oklahoma*. 5th ed. Norman: Oklahoma Ornithological Society.

Reinking, D. L., ed. 2004. *Oklahoma Breeding Bird Atlas*. Norman: University of Oklahoma Press.

# Eurasian Wigeon

*Anas penelope*

Steve Metz

**Occurrence:** Rare in winter.

**Habitat:** Lakes and ponds.

**North American distribution:** Rare in winter along the Pacific Coast and parts of the Atlantic Coast.

**Oklahoma distribution:** Not recorded in survey blocks. Reported from Texas County (Sunset Lake) in December 2003 and January 2004 (Oklahoma Bird Records Committee 2004).

**Behavior:** Eurasian Wigeon will associate with American Wigeon and other ducks. They forage by grazing on aquatic and terrestrial plants.

**Count per
Block Survey**

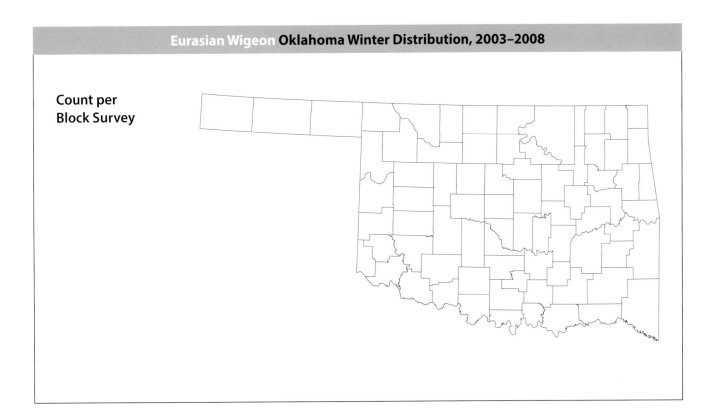

### References

National Audubon Society. 2011. The Christmas Bird Count historical results. http://www
.christmasbirdcount.org.
Oklahoma Bird Records Committee. 2004. 2003–2004 winter season. *The Scissortail* 54:25–27.
———. 2009. *Date Guide to the Occurrences of Birds in Oklahoma*. 5th ed. Norman: Oklahoma
Ornithological Society.

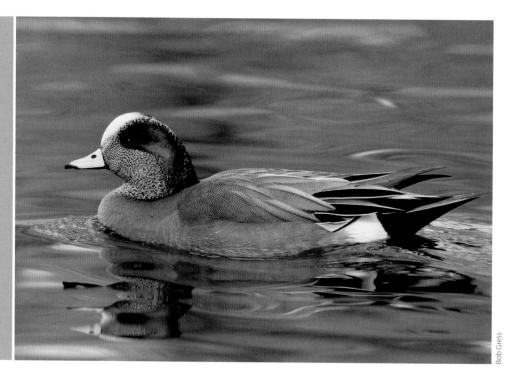

# American Wigeon

## *Anas americana*

Bob Gress

**Occurrence:** Can be present in small numbers year round but is primarily a migrant and wintering species.

**Habitat:** Ponds, lakes, and marshes.

**North American distribution:** Breeds in Alaska, parts of Canada, and parts of the northern United States. Winters broadly across large portions of the lower 48 states and Mexico.

**Oklahoma distribution:** American Wigeon were distributed almost uniformly across Oklahoma except in the heavily forested southeast and in the arid western end of the Panhandle. They were most abundant in central and southwestern Oklahoma.

**Behavior:** Wigeon are frequently found in groups that may include other duck species as well as American Coots. They are dabbling ducks, which tip headfirst into the water to forage rather than diving below the surface. Their winter diet includes aquatic plant material, although they also graze on plants growing near ponds and lakes.

## Christmas Bird Count (CBC) Results, 1960–2009

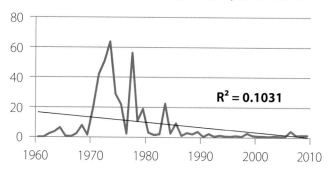

$R^2 = 0.1031$

## CBC Results, 2003–2008

| Winter | Number recorded | Counts reporting |
|--------|----------------|------------------|
| 2003–2004 | 1,103 | 14 |
| 2004–2005 | 802 | 14 |
| 2005–2006 | 746 | 15 |
| 2006–2007 | 4,399 | 15 |
| 2007–2008 | 1,393 | 14 |

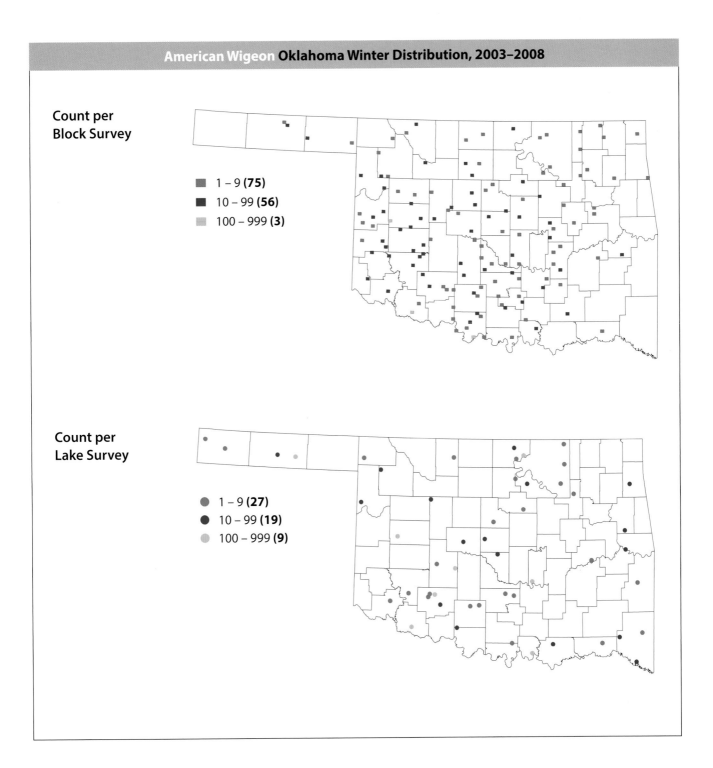

**Count per Block Survey**

- ■ 1 – 9 **(75)**
- ■ 10 – 99 **(56)**
- ▦ 100 – 999 **(3)**

**Count per Lake Survey**

- ● 1 – 9 **(27)**
- ● 10 – 99 **(19)**
- ● 100 – 999 **(9)**

### References

Mowbray, Thomas. 1999. American Wigeon (*Anas americana*). *The Birds of North America Online*, edited by A. Poole. Ithaca, N.Y.: Cornell Laboratory of Ornithology. http://bna.birds.cornell.edu.

National Audubon Society. 2011. The Christmas Bird Count historical results. http://www.christmasbirdcount.org.

Oklahoma Bird Records Committee. 2009. *Date Guide to the Occurrences of Birds in Oklahoma*. 5th ed. Norman: Oklahoma Ornithological Society.

# American Black Duck

*Anas rubripes*

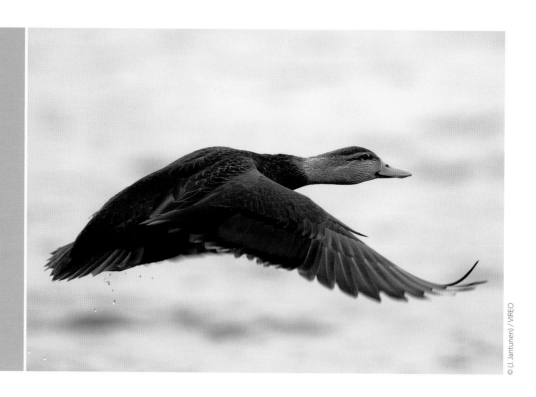

© (J. Jantunen) / VIREO

**Occurrence:** Rare from November through mid-March.

**Habitat:** Marshes, lakes, and ponds.

**North American distribution:** Breeds in eastern Canada and the northeastern United States. Winters throughout much of the eastern United States.

**Oklahoma distribution:** No records from survey blocks. One record from Payne County at Lake Carl Blackwell in December 2005 (see lake survey map). Christmas Bird Count reports came from Arcadia in December 2003 (two birds) and Stillwater in December 2005. The spike in the Christmas Bird Count graph is from a report of 25 birds at Sequoyah National Wildlife Refuge in December 1983.

**Behavior:** Although the Black Duck is gregarious during winter, its rarity in Oklahoma makes sightings of single birds most likely. Black Ducks often associate with Mallards. They forage by dabbling in shallow water in search of a wide range of aquatic plants and invertebrates.

**Christmas Bird Count (CBC) Results, 1960–2009**

$R^2 = 0.0492$

**CBC Results, 2003–2008**

| Winter | Number recorded | Counts reporting |
|---|---|---|
| 2003–2004 | 2 | 1 |
| 2004–2005 | 0 | — |
| 2005–2006 | 1 | 1 |
| 2006–2007 | 0 | — |
| 2007–2008 | 0 | — |

Count per
Block Survey

Count per
Lake Survey

● 1 – 9 **(1)**

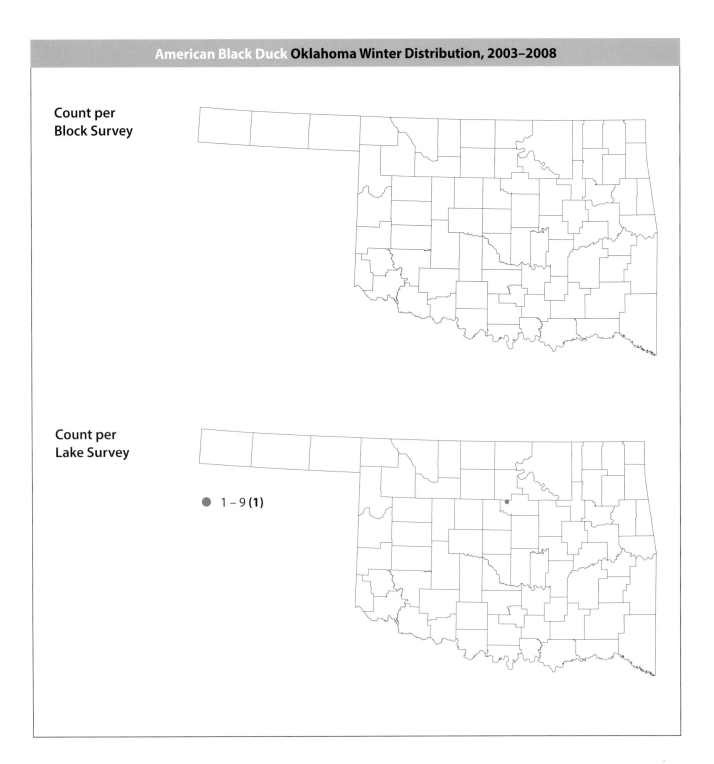

### References

Longcore, Jerry R., Daniel G. McAuley, Gary R. Hepp, and Judith M. Rhymer. 2000. American Black Duck
(*Anas rubripes*). *The Birds of North America Online*, edited by A. Poole. Ithaca, N.Y.: Cornell Laboratory of
Ornithology. http://bna.birds.cornell.edu.

National Audubon Society. 2011. The Christmas Bird Count historical results. http://www
.christmasbirdcount.org.

Oklahoma Bird Records Committee. 2009. *Date Guide to the Occurrences of Birds in Oklahoma*. 5th ed.
Norman: Oklahoma Ornithological Society.

# Mallard
## *Anas platyrhynchos*

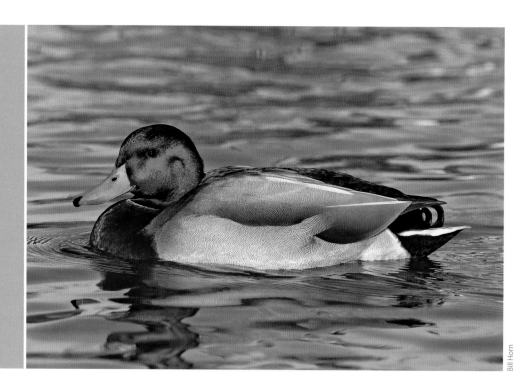

Bill Horn

**Occurrence:** Present year round, but much more numerous from fall through spring, when northern breeders move into the state.

**Habitat:** Lakes, ponds, rivers, and marshes.

**North American distribution:** Breeds in Alaska and much of Canada. Resident across most of the lower 48 states except for south-central portions, and in much of Mexico. Also winters in most portions of the United States and Mexico, where it does not breed.

**Oklahoma distribution:** Recorded in most survey blocks statewide, with slightly fewer records from heavily forested southeastern counties and the arid western end of the Panhandle. Most blocks contained low to moderate densities, but several very large concentrations were noted in Kay and Rogers Counties. The summer distribution recorded during the Oklahoma Breeding Bird Atlas Project was also widespread but less dense overall and was more heavily concentrated in the northwestern half of the state.

**Behavior:** Mallards are gregarious from late summer through early spring and can often be seen in small to very large flocks with many other species of ducks. They forage by dabbling at the surface of the water or by submerging their head for aquatic plants and seeds. They also consume waste grain from agricultural fields.

**Christmas Bird Count (CBC) Results, 1960–2009**

$R^2 = 0.2473$

**CBC Results, 2003–2008**

| Winter | Number recorded | Counts reporting |
| --- | --- | --- |
| 2003–2004 | 12,380 | 20 |
| 2004–2005 | 8,674 | 20 |
| 2005–2006 | 29,353 | 20 |
| 2006–2007 | 15,533 | 19 |
| 2007–2008 | 18,528 | 20 |

**Count per Block Survey**

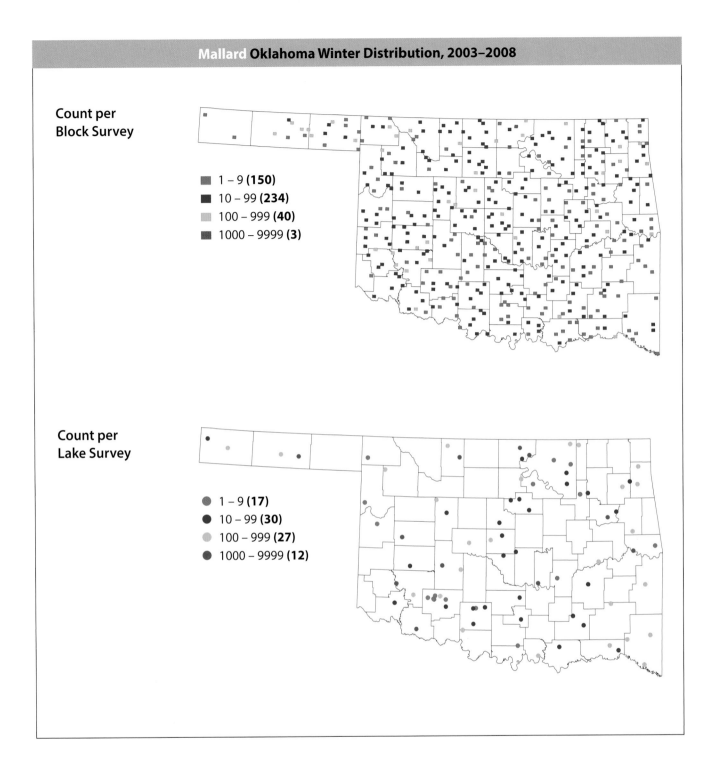

■ 1 – 9 **(150)**
■ 10 – 99 **(234)**
■ 100 – 999 **(40)**
■ 1000 – 9999 **(3)**

**Count per Lake Survey**

● 1 – 9 **(17)**
● 10 – 99 **(30)**
● 100 – 999 **(27)**
● 1000 – 9999 **(12)**

## References

Drilling, Nancy, Rodger Titman, and Frank McKinney. 2002. Mallard (*Anas platyrhynchos*). *The Birds of North America Online*, edited by A. Poole. Ithaca, N.Y.: Cornell Laboratory of Ornithology. http://bna.birds.cornell.edu.

National Audubon Society. 2011. The Christmas Bird Count historical results. http://www.christmasbirdcount.org.

Oklahoma Bird Records Committee. 2009. *Date Guide to the Occurrences of Birds in Oklahoma*. 5th ed. Norman: Oklahoma Ornithological Society.

Reinking, D. L., ed. 2004. *Oklahoma Breeding Bird Atlas*. Norman: University of Oklahoma Press.

# Mottled Duck
## *Anas fulvigula*

Bob Gress

**Occurrence:** Rare.

**Habitat:** Wetlands.

**North American distribution:** Resident along parts of the Gulf and southern Atlantic Coasts. Occasionally wanders northward into the south-central United States.

**Oklahoma distribution:** Not recorded in survey blocks. One special interest species report came from McCurtain County (Red Slough Wildlife Management Area) in January and February 2005.

**Behavior:** Mottled Ducks are less gregarious than many other ducks, and because of their rarity in Oklahoma they are usually seen singly. They forage for grass seeds, aquatic plants, and aquatic invertebrates by searching the surface of the water or by tipping forward to submerge their heads.

### CBC Results, 2003–2008

| Winter | Number recorded | Counts reporting |
|---|---|---|
| 2003–2004 | 0 | — |
| 2004–2005 | 0 | — |
| 2005–2006 | 0 | — |
| 2006–2007 | 0 | — |
| 2007–2008 | 0 | — |

**Count per
Block Survey**

### References

Bielefeld, Ronald R., Michael G. Brasher, T. E. Moorman, and P. N. Gray. 2010. Mottled Duck (*Anas fulvigula*). *The Birds of North America Online*, edited by A. Poole. Ithaca, N.Y.: Cornell Laboratory of Ornithology. http://bna.birds.cornell.edu.

National Audubon Society. 2011. The Christmas Bird Count historical results. http://www .christmasbirdcount.org.

Oklahoma Bird Records Committee. 2009. *Date Guide to the Occurrences of Birds in Oklahoma*. 5th ed. Norman: Oklahoma Ornithological Society.

Sutton, G. M. 1971. A new bird for Oklahoma: Mottled Duck. *Bulletin of the Oklahoma Ornithological Society* 4:29–31.

# Blue-winged Teal
## *Anas discors*

James Arterburn

**Occurrence:** Spring through fall in the Panhandle region, February through December in the main body of the state, and all year in McCurtain County. Most numerous during spring and fall migrations.

**Habitat:** Ponds and wetlands.

**North American distribution:** Breeds across much of Canada and the northern three-fourths of the lower 48 states. Winters along southern portions of the East and West Coasts and along the Gulf Coast.

**Oklahoma distribution:** Recorded at relatively few scattered locations across the main body of the state, reflecting the somewhat limited winter occurrence of this species compared to breeding or migration seasons. This pattern differs from the more extensive breeding distribution, which was concentrated in the western portion of the state and in the Panhandle region. Little difference in distribution between early winter and late winter periods was detected.

**Behavior:** Often seen in small groups or in mixed-species flocks with other ducks. Pairs form by late winter. Blue-winged Teal feed on aquatic plants and invertebrates, seeds, algae, and grain. They dabble with their bill underwater, or sometimes with their whole head submerged.

### Christmas Bird Count (CBC) Results, 1960–2009

$R^2 = 0.0227$

### CBC Results, 2003–2008

| Winter | Number recorded | Counts reporting |
|---|---|---|
| 2003–2004 | 16 | 2 |
| 2004–2005 | 21 | 2 |
| 2005–2006 | 86 | 7 |
| 2006–2007 | 34 | 5 |
| 2007–2008 | 146 | 9 |

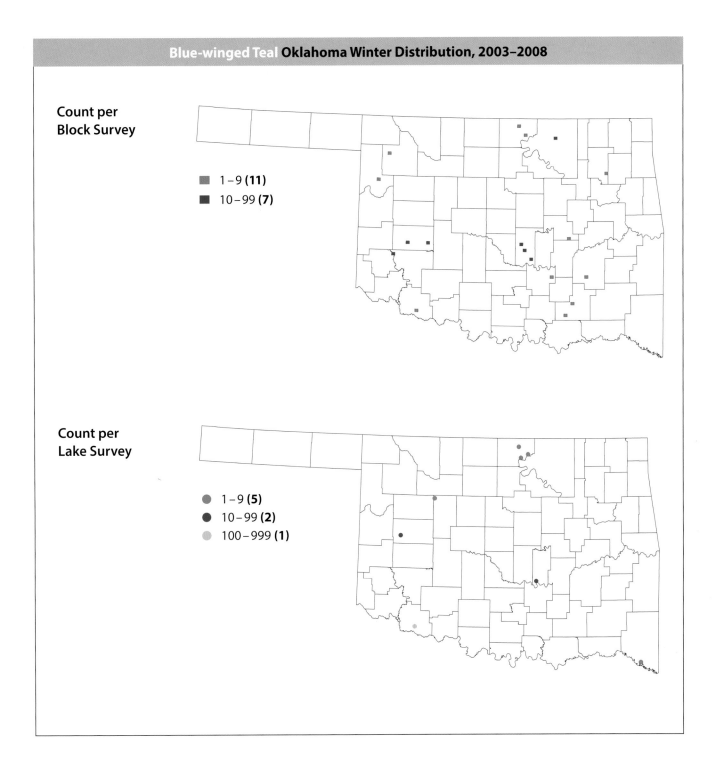

Count per
Block Survey

▨ 1–9 **(11)**
■ 10–99 **(7)**

Count per
Lake Survey

● 1–9 **(5)**
● 10–99 **(2)**
● 100–999 **(1)**

**References**

National Audubon Society. 2011. The Christmas Bird Count historical results. http://www
.christmasbirdcount.org.

Oklahoma Bird Records Committee. 2009. *Date Guide to the Occurrences of Birds in Oklahoma.* 5th ed.
Norman: Oklahoma Ornithological Society.

Reinking, D. L., ed. 2004. *Oklahoma Breeding Bird Atlas.* Norman: University of Oklahoma Press.

Rohwer, Frank C., William P. Johnson, and Elizabeth R. Loos. 2002. Blue-winged Teal (*Anas discors*). *The
Birds of North America Online*, edited by A. Poole. Ithaca, N.Y.: Cornell Laboratory of Ornithology.
http://bna.birds.cornell.edu.

# Cinnamon Teal
*Anas cyanoptera*

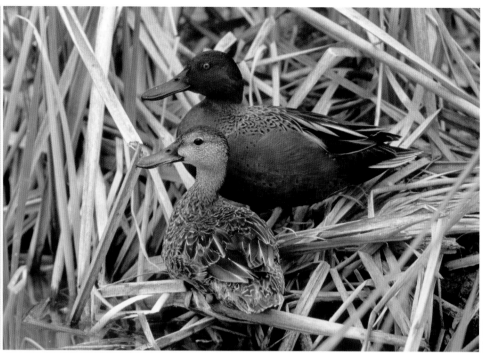

Bob Gress

**Occurrence:** Primarily during spring and fall in western counties, and early spring in central counties.

**Habitat:** Marshes and ponds.

**North American distribution:** Breeds in southwestern Canada and the western lower 48 states. Resident in parts of California and Mexico. Winters in southwestern Texas and in Mexico.

**Oklahoma distribution:** Not recorded in survey blocks. Reported from Tillman County (up to 17 birds at Hackberry Flat Wildlife Management Area) during the winter of 2007–2008, and at Optima Lake in Texas County in late winter 2005–2006 (see lake survey map). Also reported from Comanche County (two birds at Cache Lagoons) in late February 2006 (Oklahoma Bird Records Committee 2006), and Tillman County (two birds) in late February 2007 (Oklahoma Bird Records Committee 2007). These latter two records are typical of early spring movements rather than being wintering records. The summer distribution recorded by the Oklahoma Breeding Bird Atlas Project was limited to one Texas County survey block.

**Behavior:** Cinnamon Teal are commonly seen in pairs or small groups, and they often associate with other teal, Northern Shovelers, and Gadwalls.

### Christmas Bird Count (CBC) Results, 1960–2009

$R^2 = 0.0002$

### CBC Results, 2003–2008

| Winter | Number recorded | Counts reporting |
|---|---|---|
| 2003–2004 | 1 | 1 |
| 2004–2005 | 0 | — |
| 2005–2006 | 0 | — |
| 2006–2007 | 0 | — |
| 2007–2008 | 0 | — |

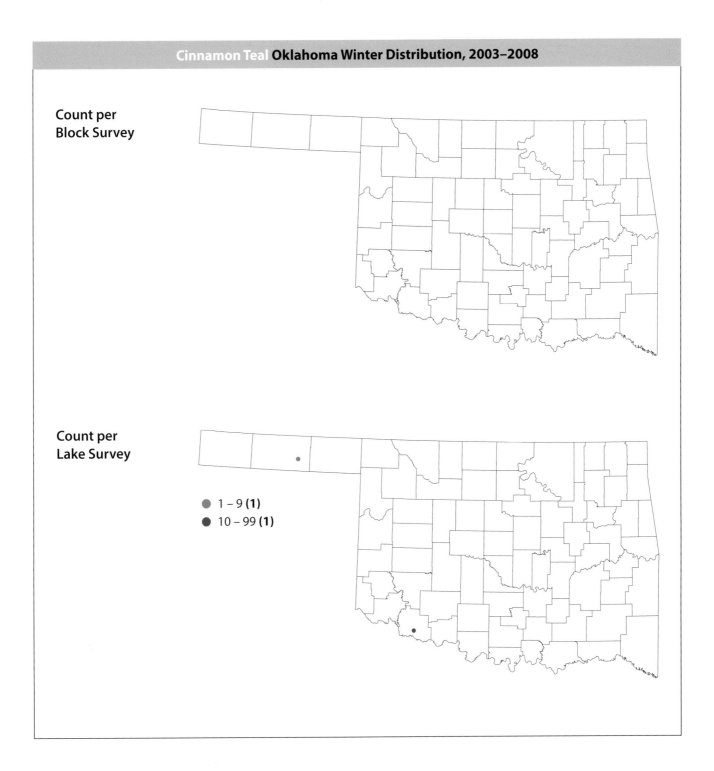

Count per
Block Survey

Count per
Lake Survey

● 1 – 9 **(1)**
● 10 – 99 **(1)**

### References

Cole, D. D. 1970. Winter record of Cinnamon Teal in Oklahoma. *Bulletin of the Oklahoma Ornithological Society* 3:29.

Davis, W. M. 1970. Cinnamon Teal in Oklahoma in winter. *Bulletin of the Oklahoma Ornithological Society* 3:29.

Gammonley, James H. 1996. Cinnamon Teal (*Anas cyanoptera*). *The Birds of North America Online*, edited by A. Poole. Ithaca, N.Y.: Cornell Laboratory of Ornithology. http://bna.birds.cornell.edu.

National Audubon Society. 2011. The Christmas Bird Count historical results. http://www .christmasbirdcount.org.

Oklahoma Bird Records Committee. 2006. 2005–2006 winter season. *The Scissortail* 56:14–15.

———. 2007. 2006–2007 winter season. *The Scissortail* 57:24–27.

———. 2009. *Date Guide to the Occurrences of Birds in Oklahoma*. 5th ed. Norman: Oklahoma Ornithological Society.

Reinking, D. L., ed. 2004. *Oklahoma Breeding Bird Atlas*. Norman: University of Oklahoma Press.

# Northern Shoveler
*Anas clypeata*

Bill Horn

**Occurrence:** Present year round, but more numerous from fall through spring.

**Habitat:** Lakes, ponds, and marshes.

**North American distribution:** Breeds in Alaska, much of Canada, and a large part of the northern lower 48 states. Resident in parts of the western United States, and winters broadly across the southern United States and Mexico.

**Oklahoma distribution:** Commonly recorded at low to moderate abundance in survey blocks statewide, with somewhat fewer records from heavily forested southeastern counties and arid western Panhandle counties. The summer distribution recorded by the Oklahoma Breeding Bird Atlas Project was also widespread but much less dense, with this species occurring in only 13 survey blocks.

**Behavior:** Northern Shovelers are often seen in pairs, which can form small, loose groups. They use their wide, spoon-shaped bills to strain small invertebrates and seeds from the water.

### Christmas Bird Count (CBC) Results, 1960–2009

$R^2 = 0.4525$

### CBC Results, 2003–2008

| Winter | Number recorded | Counts reporting |
|---|---|---|
| 2003–2004 | 1,043 | 16 |
| 2004–2005 | 727 | 17 |
| 2005–2006 | 937 | 17 |
| 2006–2007 | 1,366 | 17 |
| 2007–2008 | 849 | 16 |

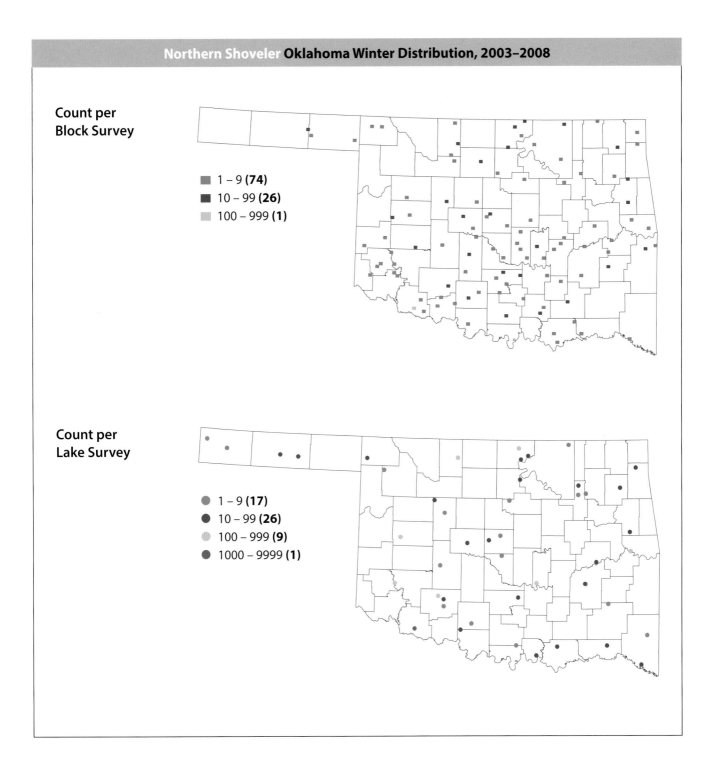

**Count per Block Survey**

- 1 – 9 **(74)**
- 10 – 99 **(26)**
- 100 – 999 **(1)**

**Count per Lake Survey**

- 1 – 9 **(17)**
- 10 – 99 **(26)**
- 100 – 999 **(9)**
- 1000 – 9999 **(1)**

**References**

Dubowy, Paul J. 1996. Northern Shoveler (*Anas clypeata*). *The Birds of North America Online*, edited by A. Poole. Ithaca, N.Y.: Cornell Laboratory of Ornithology. http://bna.birds.cornell.edu.

National Audubon Society. 2011. The Christmas Bird Count historical results. http://www .christmasbirdcount.org.

Oklahoma Bird Records Committee. 2009. *Date Guide to the Occurrences of Birds in Oklahoma.* 5th ed. Norman: Oklahoma Ornithological Society.

Reinking, D. L., ed. 2004. *Oklahoma Breeding Bird Atlas.* Norman: University of Oklahoma Press.

# Northern Pintail

*Anas acuta*

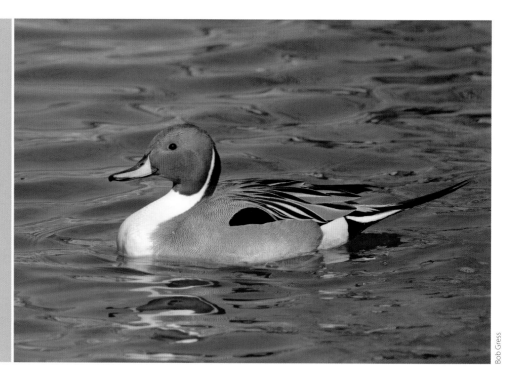

Bob Gress

**Occurrence:** Present in small numbers year round in western counties, and from September through late May in other areas.

**Habitat:** Lakes, ponds, marshes, and grain fields.

**North American distribution:** Breeds in Alaska, most of Canada, and parts of the northern lower 48 states. Resident in parts of the western United States, and winters broadly across the southern United States, along the Atlantic Coast, and in Mexico.

**Oklahoma distribution:** Recorded in scattered survey blocks statewide, suggesting that habitat availability more than latitude or longitude influences its winter distribution. It was least common in heavily forested southeastern counties. The summer distribution recorded by the Oklahoma Breeding Bird Atlas Project was limited to eight survey blocks located mostly in western counties.

**Behavior:** Northern Pintails typically form pair bonds in the fall and early winter, and the pairs frequently occur together in small to large flocks. They forage for waste grains by walking through fields, and in shallow water by dabbling for aquatic plants and seeds with their bill at or below the surface of the water.

## Christmas Bird Count (CBC) Results, 1960–2009

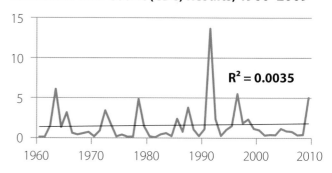

$R^2 = 0.0035$

## CBC Results, 2003–2008

| Winter | Number recorded | Counts reporting |
|---|---|---|
| 2003–2004 | 386 | 16 |
| 2004–2005 | 1,091 | 8 |
| 2005–2006 | 785 | 11 |
| 2006–2007 | 729 | 12 |
| 2007–2008 | 463 | 14 |

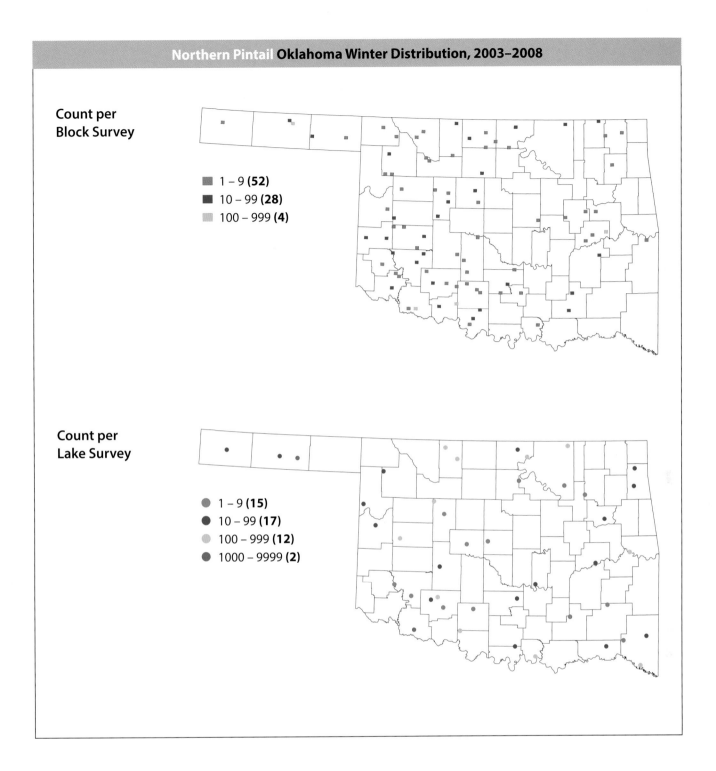

Count per
Block Survey

■ 1 – 9 **(52)**
■ 10 – 99 **(28)**
■ 100 – 999 **(4)**

Count per
Lake Survey

● 1 – 9 **(15)**
● 10 – 99 **(17)**
● 100 – 999 **(12)**
● 1000 – 9999 **(2)**

**References**

Austin, Jane E., and Michael R. Miller. 1995. Northern Pintail (*Anas acuta*). *The Birds of North America Online*, edited by A. Poole. Ithaca, N.Y.: Cornell Laboratory of Ornithology. http://bna.birds.cornell.edu.

National Audubon Society. 2011. The Christmas Bird Count historical results. http://www .christmasbirdcount.org.

Oklahoma Bird Records Committee. 2009. *Date Guide to the Occurrences of Birds in Oklahoma*. 5th ed. Norman: Oklahoma Ornithological Society.

Reinking, D. L., ed. 2004. *Oklahoma Breeding Bird Atlas*. Norman: University of Oklahoma Press.

# Green-winged Teal

*Anas crecca*

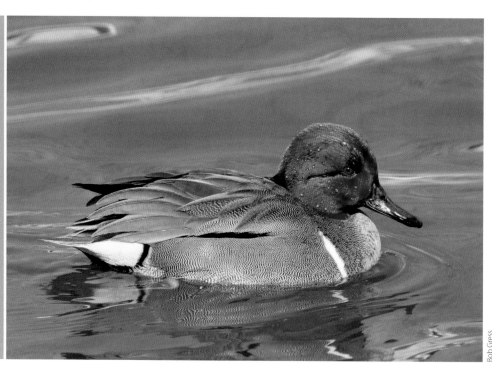

Bob Gress

**Occurrence:** Mid-August through mid-May.

**Habitat:** Lakes, ponds, and marshes.

**North American distribution:** Breeds in Alaska, much of Canada, and in parts of the northern lower 48 states. Resident across parts of the western United States, and winters broadly across the southern half of the lower 48 states and in Mexico.

**Oklahoma distribution:** Recorded at numerous but scattered locations and mostly in small numbers statewide.

**Behavior:** Green-winged Teal are gregarious during fall and winter. Breeding pairs form during winter, but each pair is often part of a larger flock. They frequently associate with other duck species. Foraging for aquatic plant seeds and aquatic invertebrates is done by dabbling, in which the bill is used to gather food items at or slightly below the surface of the water.

**Christmas Bird Count (CBC) Results, 1960–2009**

$R^2 = 0.0231$

**CBC Results, 2003–2008**

| Winter | Number recorded | Counts reporting |
|--------|-----------------|------------------|
| 2003–2004 | 374 | 7 |
| 2004–2005 | 276 | 7 |
| 2005–2006 | 245 | 9 |
| 2006–2007 | 1,551 | 7 |
| 2007–2008 | 623 | 8 |

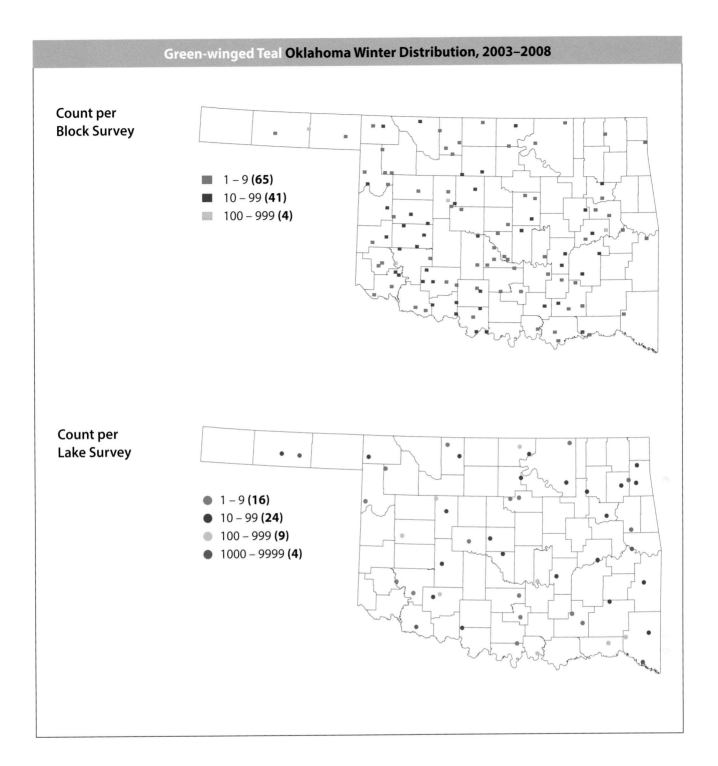

Count per
Block Survey

■ 1 – 9 **(65)**
■ 10 – 99 **(41)**
▩ 100 – 999 **(4)**

Count per
Lake Survey

● 1 – 9 **(16)**
● 10 – 99 **(24)**
● 100 – 999 **(9)**
● 1000 – 9999 **(4)**

### References

Johnson, Kevin. 1995. Green-winged Teal (*Anas crecca*). *The Birds of North America Online*, edited by
 A. Poole. Ithaca, N.Y.: Cornell Laboratory of Ornithology. http://bna.birds.cornell.edu.
National Audubon Society. 2011. The Christmas Bird Count historical results. http://www
 .christmasbirdcount.org.
Oklahoma Bird Records Committee. 2009. *Date Guide to the Occurrences of Birds in Oklahoma*. 5th ed.
 Norman: Oklahoma Ornithological Society.

# Canvasback
*Aythya valisineria*

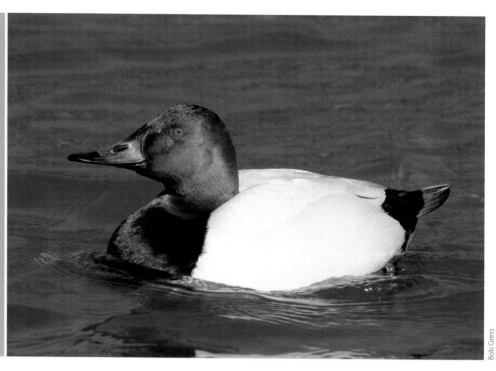

Bob Gress

**Occurrence:** October through April.

**Habitat:** Lakes and ponds.

**North American distribution:** Breeds in Alaska, western Canada, and the northwestern United States. Winters broadly across much of the lower 48 states.

**Oklahoma distribution:** Canvasbacks were detected in small numbers at scattered locations across the main body of the state, suggesting a widespread distribution despite the likelihood that many of the surveyed blocks lacked suitable habitat for this species.

**Behavior:** Canvasbacks are gregarious from fall through spring, often forming flocks that can become quite large. They are capable divers, sometimes going over two meters down to forage on buds, tubers, and roots of aquatic plants. Most dives last 10–20 seconds.

## Christmas Bird Count (CBC) Results, 1960–2009

$R^2 = 0.0897$

## CBC Results, 2003–2008

| Winter | Number recorded | Counts reporting |
|--------|-----------------|------------------|
| 2003–2004 | 254 | 10 |
| 2004–2005 | 268 | 9 |
| 2005–2006 | 322 | 12 |
| 2006–2007 | 165 | 13 |
| 2007–2008 | 333 | 12 |

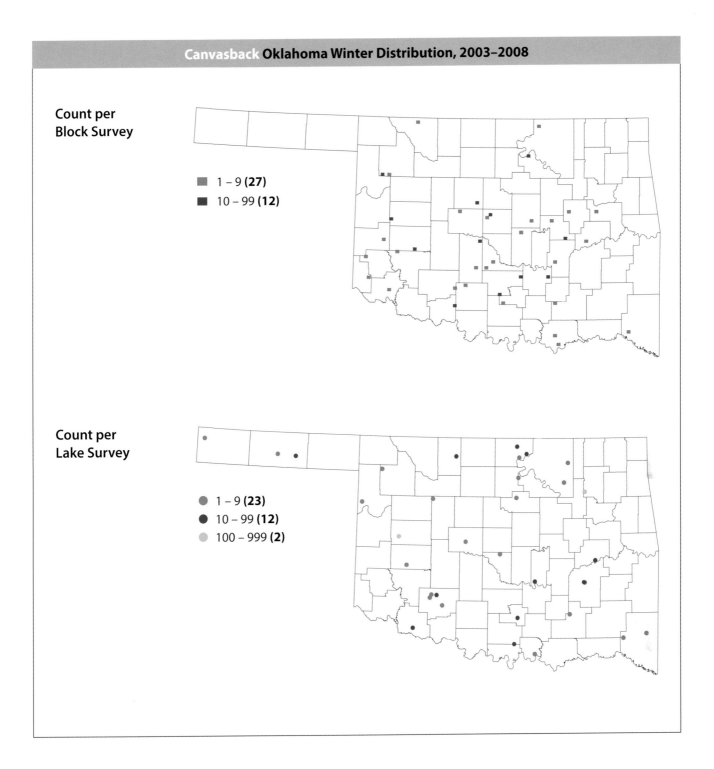

Count per
Block Survey

■ 1 – 9 **(27)**
■ 10 – 99 **(12)**

Count per
Lake Survey

● 1 – 9 **(23)**
● 10 – 99 **(12)**
● 100 – 999 **(2)**

### References

Mowbray, Thomas B. 2002. Canvasback (*Aythya valisineria*). *The Birds of North America Online*, edited by A. Poole. Ithaca, N.Y.: Cornell Laboratory of Ornithology. http://bna.birds.cornell.edu.

National Audubon Society. 2011. The Christmas Bird Count historical results. http://www .christmasbirdcount.org.

Oklahoma Bird Records Committee. 2009. *Date Guide to the Occurrences of Birds in Oklahoma*. 5th ed. Norman: Oklahoma Ornithological Society.

# Redhead
## *Aythya americana*

Bob Gress

**Occurrence:** Present year round in western counties, and from October through mid-May in eastern counties.

**Habitat:** Lakes and marshes.

**North American distribution:** Breeds in Alaska, parts of Canada, and parts of the northern and western lower 48 states. Winters broadly across the southern United States and in Mexico.

**Oklahoma distribution:** Recorded in scattered survey blocks nearly statewide, with most reports and the single very large concentration of birds coming from the southwestern half of the state. The summer distribution recorded by the Oklahoma Breeding Bird Atlas Project encompassed just 14 blocks in the western half of the state.

**Behavior:** Redheads are very gregarious during the winter, occurring in flocks of a few to thousands of birds. They are often seen with Canvasbacks, Lesser Scaup, and other duck species. They forage in several ways including diving, dipping their head underwater, tipping into the water with head down and tail up, and gleaning from the surface of the water. Major food items include aquatic plants, seeds, and invertebrates.

**Christmas Bird Count (CBC) Results, 1960–2009**

$R^2 = 0.1048$

**CBC Results, 2003–2008**

| Winter | Number recorded | Counts reporting |
|---|---|---|
| 2003–2004 | 192 | 10 |
| 2004–2005 | 566 | 10 |
| 2005–2006 | 295 | 10 |
| 2006–2007 | 453 | 12 |
| 2007–2008 | 120 | 10 |

**Count per
Block Survey**

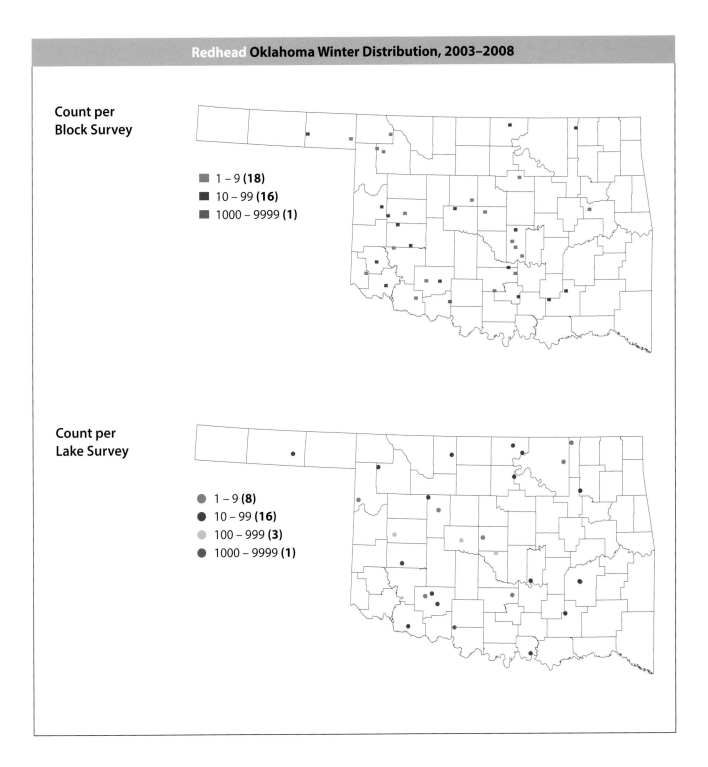

■ 1 – 9 **(18)**
■ 10 – 99 **(16)**
■ 1000 – 9999 **(1)**

**Count per
Lake Survey**

● 1 – 9 **(8)**
● 10 – 99 **(16)**
● 100 – 999 **(3)**
● 1000 – 9999 **(1)**

**References**

National Audubon Society. 2011. The Christmas Bird Count historical results. http://www
    .christmasbirdcount.org.

Oklahoma Bird Records Committee. 2009. *Date Guide to the Occurrences of Birds in Oklahoma*. 5th ed.
    Norman: Oklahoma Ornithological Society.

Reinking, D. L., ed. 2004. *Oklahoma Breeding Bird Atlas*. Norman: University of Oklahoma Press.

Woodin, Marc C., and Thomas C. Michot. 2002. Redhead (*Aythya americana*). *The Birds of North America
    Online*, edited by A. Poole. Ithaca, N.Y.: Cornell Laboratory of Ornithology. http://bna.birds.cornell.edu.

# Ring-necked Duck

*Aythya collaris*

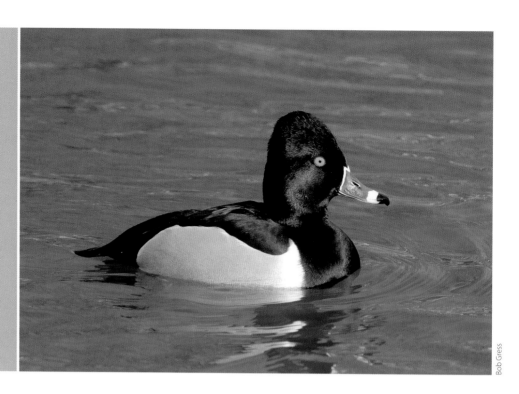

Bob Gress

**Occurrence:** Early October through late May.

**Habitat:** Lakes, ponds, and marshes.

**North American distribution:** Breeds in Alaska, much of Canada, and parts of the northern lower 48 states. Winters broadly across the central and southern United States and in Mexico.

**Oklahoma distribution:** Commonly recorded in survey blocks statewide at low to moderate abundances. Gaps in distribution are likely due to a lack of aquatic habitat within some survey blocks. An unusually large group of 2,000 was estimated at A. B. Jewell Reservoir in Tulsa on January 3, 2006 (Oklahoma Bird Records Committee 2006).

**Behavior:** Ring-necked Ducks are somewhat gregarious from fall through early spring and are often seen in small groups. They frequently associate with other duck species. Foraging is accomplished mainly through diving, but also by dabbling just below or at the surface of the water. Aquatic plant seeds and tubers along with aquatic invertebrates make up most of their diet.

### Christmas Bird Count (CBC) Results, 1960–2009

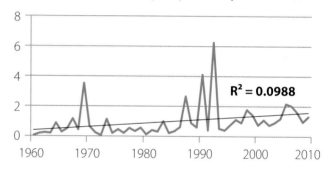

$R^2 = 0.0988$

### CBC Results, 2003–2008

| Winter | Number recorded | Counts reporting |
|--------|-----------------|------------------|
| 2003–2004 | 1,083 | 18 |
| 2004–2005 | 1,252 | 17 |
| 2005–2006 | 2,383 | 16 |
| 2006–2007 | 1,752 | 18 |
| 2007–2008 | 1,961 | 16 |

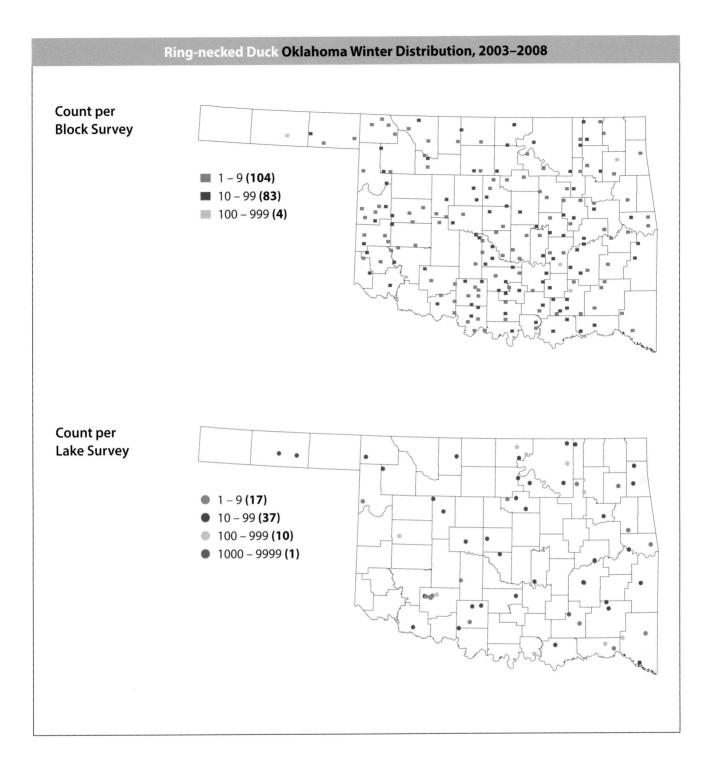

**Count per Block Survey**

■ 1 – 9 **(104)**
■ 10 – 99 **(83)**
■ 100 – 999 **(4)**

**Count per Lake Survey**

● 1 – 9 **(17)**
● 10 – 99 **(37)**
● 100 – 999 **(10)**
● 1000 – 9999 **(1)**

**References**

Hohman, William L., and Robert T. Eberhardt. 1998. Ring-necked Duck (*Aythya collaris*). *The Birds of North America Online*, edited by A. Poole. Ithaca, N.Y.: Cornell Laboratory of Ornithology. http://bna.birds .cornell.edu.

National Audubon Society. 2011. The Christmas Bird Count historical results. http://www .christmasbirdcount.org.

Oklahoma Bird Records Committee. 2006. 2005–2006 winter season. *The Scissortail* 56:14–15.

———. 2009. *Date Guide to the Occurrences of Birds in Oklahoma*. 5th ed. Norman: Oklahoma Ornithological Society.

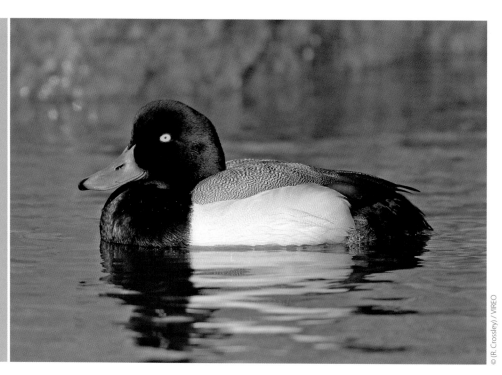

# Greater Scaup
## *Aythya marila*

**Occurrence:** Mid-October through mid-May.

**Habitat:** Lakes.

**North American distribution:** Breeds in Alaska and northern Canada. Winters along the Atlantic and Pacific Coasts and in scattered inland locations where large, ice-free water bodies are available.

**Oklahoma distribution:** Recorded in just three blocks in central and northeastern counties. While most survey blocks lack suitable habitat for this species, this cursory distribution pattern nonetheless corresponds to the regions of the state where this relatively uncommon species is most frequently seen. The lake survey map does show a wider pattern of distribution within the state. An additional published report during the project period described an unusual concentration of 400 birds at Sooner Lake in Noble County on February 19, 2008 (Oklahoma Bird Records Committee 2009a). Some occurrences of this species may be overlooked because of the close resemblance of the Greater Scaup to the more common and widespread Lesser Scaup.

**Behavior:** Greater Scaup are very social, frequently occurring in flocks that can sometimes be large. They typically do not mix with other duck species, although sometimes flocks of Lesser Scaup can be seen nearby. They forage by diving and probing muddy lake bottoms for insects, crustaceans, and mollusks as well as leaves, stems, and seeds of aquatic plants.

## Christmas Bird Count (CBC) Results, 1960–2009

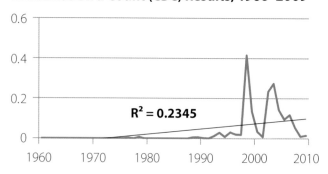

$R^2 = 0.2345$

## CBC Results, 2003–2008

| Winter | Number recorded | Counts reporting |
| --- | --- | --- |
| 2003–2004 | 127 | 4 |
| 2004–2005 | 66 | 6 |
| 2005–2006 | 51 | 5 |
| 2006–2007 | 83 | 3 |
| 2007–2008 | 54 | 4 |

Count per
Block Survey

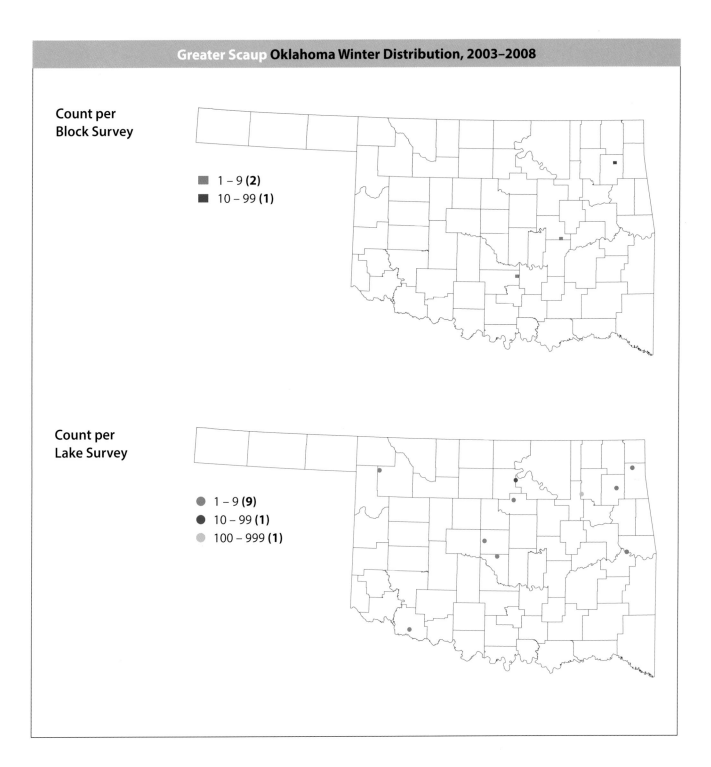

■ 1 – 9 **(2)**
■ 10 – 99 **(1)**

Count per
Lake Survey

● 1 – 9 **(9)**
● 10 – 99 **(1)**
● 100 – 999 **(1)**

### References

Kessel, Brina, Deborah A. Rocque, and John S. Barclay. 2002. Greater Scaup (*Aythya marila*). *The Birds of North America Online*, edited by A. Poole. Ithaca, N.Y.: Cornell Laboratory of Ornithology. http://bna .birds.cornell.edu.

National Audubon Society. 2011. The Christmas Bird Count historical results. http://www .christmasbirdcount.org.

Oklahoma Bird Records Committee. 2009a. 2007–2008 winter season. *The Scissortail* 59:4–8.

———. 2009b. *Date Guide to the Occurrences of Birds in Oklahoma*. 5th ed. Norman: Oklahoma Ornithological Society.

# Lesser Scaup
*Aythya affinis*

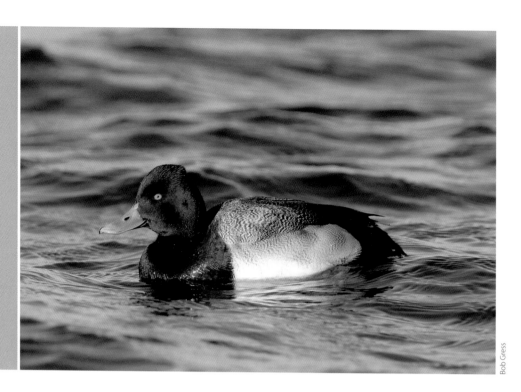

Bob Gress

**Occurrence:** Late September through late May.

**Habitat:** Lakes, ponds, and marshes.

**North American distribution:** Breeds in Alaska, much of Canada, and parts of the northern and western lower 48 states. Resident in parts of the northwestern lower 48 states, and winters broadly across the lower 48 states and Mexico.

**Oklahoma distribution:** Recorded in numerous survey blocks statewide in low to moderate abundance.

**Behavior:** Lesser Scaup are gregarious from fall through spring and are frequently seen in groups ranging from dozens to hundreds. They are often seen associating with other duck species. Scaup are excellent foot-propelled swimmers and divers, and they forage underwater and on muddy bottoms for aquatic insects, crustaceans, mollusks, and plant seeds.

### Christmas Bird Count (CBC) Results, 1960–2009

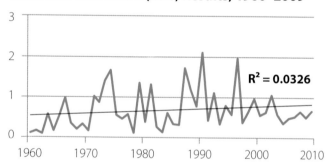

$R^2 = 0.0326$

### CBC Results, 2003–2008

| Winter | Number recorded | Counts reporting |
| --- | --- | --- |
| 2003–2004 | 573 | 16 |
| 2004–2005 | 469 | 14 |
| 2005–2006 | 441 | 15 |
| 2006–2007 | 559 | 18 |
| 2007–2008 | 598 | 12 |

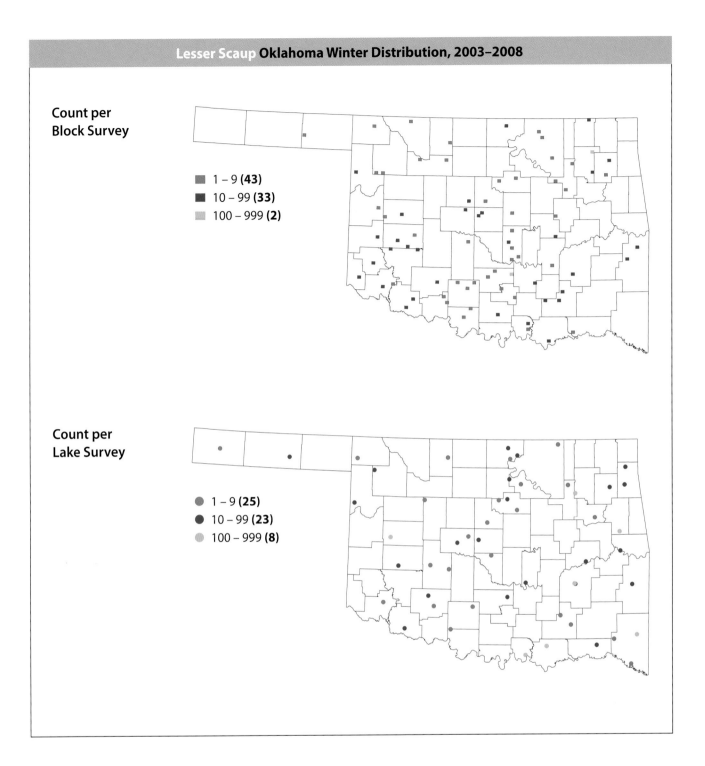

**Count per
Block Survey**

■ 1 – 9 **(43)**
■ 10 – 99 **(33)**
■ 100 – 999 **(2)**

**Count per
Lake Survey**

● 1 – 9 **(25)**
● 10 – 99 **(23)**
● 100 – 999 **(8)**

**References**
Austin, Jane E., Christine M. Custer, and Alan D. Afton. 1998. Lesser Scaup (*Aythya affinis*). *The Birds of North America Online*, edited by A. Poole. Ithaca, N.Y.: Cornell Laboratory of Ornithology. http://bna.birds
.cornell.edu.
National Audubon Society. 2011. The Christmas Bird Count historical results. http://www
.christmasbirdcount.org.
Oklahoma Bird Records Committee. 2009. *Date Guide to the Occurrences of Birds in Oklahoma*. 5th ed.
Norman: Oklahoma Ornithological Society.

# Surf Scoter
## *Melanitta perspicillata*

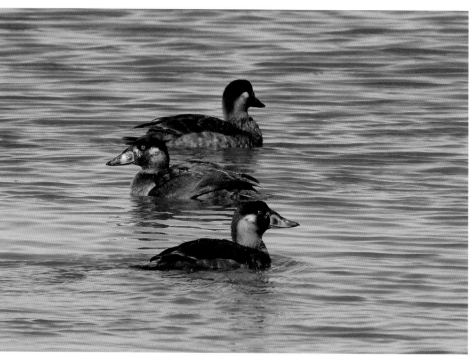

James Arterburn

**Occurrence:** Rare from November through mid-April.

**Habitat:** Lakes.

**North American distribution:** Breeds in Alaska and northern Canada. Winters along the Pacific and Atlantic Coasts.

**Oklahoma distribution:** Not recorded in survey blocks. Published reports during the project period were from Creek County (Lake Keystone) on January 9, 2005 (Oklahoma Bird Records Committee 2005), and from Noble County (Sooner Lake) in late February 2008 (two birds; Oklahoma Bird Records Committee 2009a). The Sooner Lake Christmas Bird Count reported three birds in December 2007.

**Behavior:** While Surf Scoters often form large groups from fall through spring, their rarity in Oklahoma means that one or two birds every few winters is the norm here, though they can occur with other scoters and other ducks. They dive below the surface to forage for mussels and swimming invertebrates.

## Christmas Bird Count (CBC) Results, 1960–2009

$R^2 = 0.1066$

## CBC Results, 2003–2008

| Winter | Number recorded | Counts reporting |
|--------|-----------------|------------------|
| 2003–2004 | 0 | — |
| 2004–2005 | 0 | — |
| 2005–2006 | 0 | — |
| 2006–2007 | 0 | — |
| 2007–2008 | 3 | 1 |

Count per
Block Survey

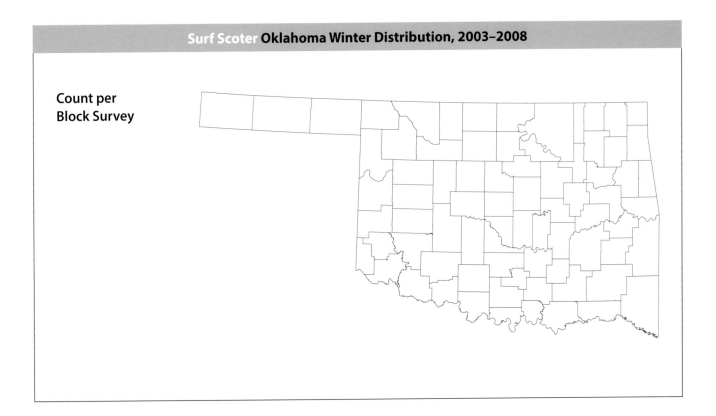

### References

National Audubon Society. 2011. The Christmas Bird Count historical results. http://www
.christmasbirdcount.org.

Oklahoma Bird Records Committee. 2005. 2004–2005 winter season. *The Scissortail* 55:18–20.

———. 2009a. 2007–2008 winter season. *The Scissortail* 59:4–8.

———. 2009b. *Date Guide to the Occurrences of Birds in Oklahoma.* 5th ed. Norman: Oklahoma
Ornithological Society.

Savard, Jean-Pierre L., Daniel Bordage, and Austin Reed. 1998. Surf Scoter (*Melanitta perspicillata*). *The Birds
of North America Online,* edited by A. Poole. Ithaca, N.Y.: Cornell Laboratory of Ornithology. http://bna
.birds.cornell.edu.

# White-winged Scoter
## *Melanitta fusca*

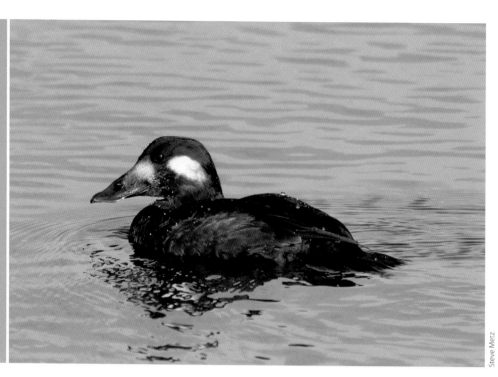

Steve Metz

**Occurrence:** Rare from early November through late March.

**Habitat:** Lakes.

**North American distribution:** Breeds in Alaska and a large portion of Canada. Winters along the Pacific and Atlantic Coasts and in some inland and Gulf Coast locations.

**Oklahoma distribution:** Not recorded in survey blocks. Lake survey reports came from Kay County (Kaw Lake) in January 2007 (three birds) and from Tulsa County (A. B. Jewell Reservoir) in December 2005 (up to seven birds). Additional special interest species reports came from Nowata County (Oologah Lake) in January 2008, and from Tulsa County (Lake Keystone and Lake Yahola) in February 2007.

**Behavior:** White-winged Scoters are gregarious, but because of their rarity in Oklahoma, single birds or small groups are typical. They forage on or near lake bottoms for mollusks, crustaceans, and insects, and most foraging dives last about 30 seconds.

### Christmas Bird Count (CBC) Results, 1960–2009

$R^2 = 0.0827$

### CBC Results, 2003–2008

| Winter | Number recorded | Counts reporting |
|---|---|---|
| 2003–2004 | 0 | — |
| 2004–2005 | 0 | — |
| 2005–2006 | 1 | 1 |
| 2006–2007 | 0 | — |
| 2007–2008 | 0 | — |

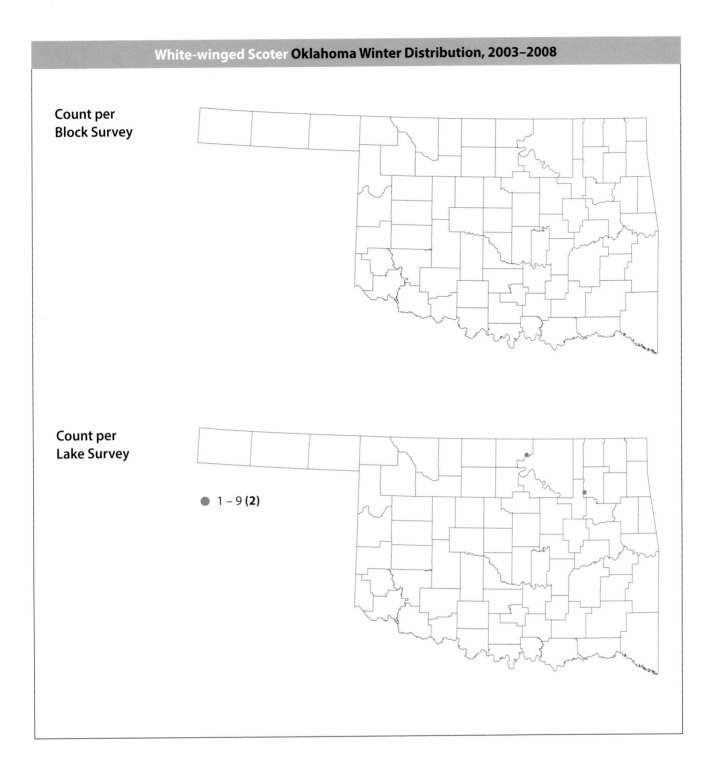

**Count per Block Survey**

**Count per Lake Survey**

● 1 – 9 **(2)**

**References**

Brown, Patrick W., and Leigh H. Fredrickson. 1997. White-winged Scoter (*Melanitta fusca*). *The Birds of North America Online*, edited by A. Poole. Ithaca, N.Y.: Cornell Laboratory of Ornithology. http://bna.birds.cornell.edu.

National Audubon Society. 2011. The Christmas Bird Count historical results. http://www.christmasbirdcount.org.

Oklahoma Bird Records Committee. 2007. 2006–2007 winter season. *The Scissortail* 57:24–27.

———. 2009. *Date Guide to the Occurrences of Birds in Oklahoma*. 5th ed. Norman: Oklahoma Ornithological Society.

# Black Scoter
## *Melanitta americana*

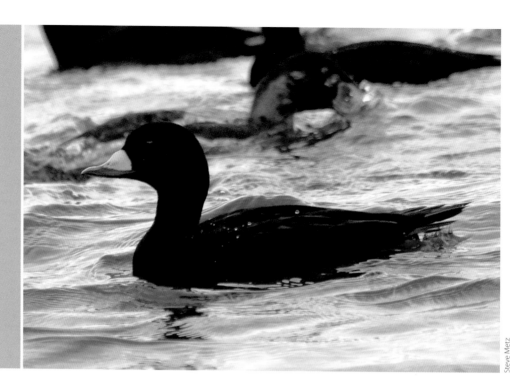

Steve Metz

**Occurrence:** Mid-November through late March.

**Habitat:** Lakes.

**North American distribution:** Breeds in Alaska and northeastern Canada. Winters along the Pacific, Atlantic, and Gulf Coasts and occasionally inland.

**Oklahoma distribution:** Not recorded in survey blocks. Reported from A. B. Jewell Reservoir in east Tulsa in December 2005 and January 2006 (see lake survey map), from Keystone Lake west of Tulsa in December 2006 and February 2007 (Oklahoma Bird Records Committee 2007), and from Sooner Lake in Noble County at the end of February 2008 (Oklahoma Bird Records Committee 2009a).

**Behavior:** Black Scoters are gregarious during winter, but because of their rarity in Oklahoma, they are more likely to be seen singly. They forage by diving underwater after aquatic insects and other invertebrates.

## Christmas Bird Count (CBC) Results, 1960–2009

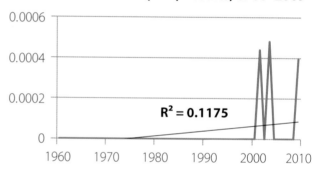

$R^2 = 0.1175$

## CBC Results, 2003–2008

| Winter | Number recorded | Counts reporting |
|---|---|---|
| 2003–2004 | 1 | 1 |
| 2004–2005 | 0 | — |
| 2005–2006 | 0 | — |
| 2006–2007 | 0 | — |
| 2007–2008 | 0 | — |

Count per
Block Survey

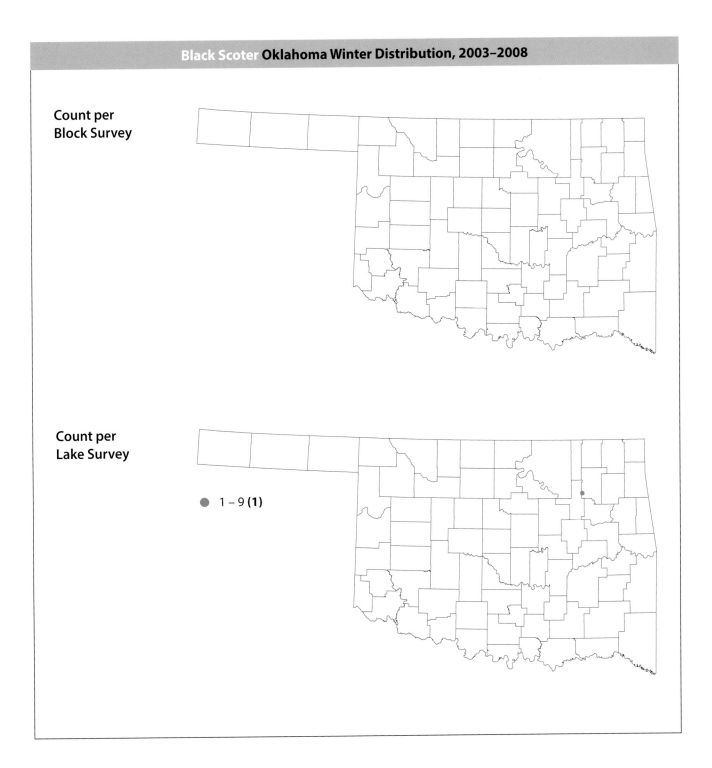

Count per
Lake Survey

● 1 – 9 **(1)**

**References**

Bordage, Daniel, and Jean-Pierre L. Savard. 1995. American Scoter (*Melanitta americana*). *The Birds of North America Online*, edited by A. Poole. Ithaca, N.Y.: Cornell Laboratory of Ornithology. http://bna.birds .cornell.edu.

Carden, J., and R. C. Rushing. 1987. Black Scoter: A new bird for Oklahoma. *Bulletin of the Oklahoma Ornithological Society* 20:1–2.

National Audubon Society. 2011. The Christmas Bird Count historical results. http://www .christmasbirdcount.org.

Oklahoma Bird Records Committee. 2007. 2006–2007 winter season. *The Scissortail* 57:24–27.

———. 2009a. 2007–2008 winter season. *The Scissortail* 59:4–8.

———. 2009b. *Date Guide to the Occurrences of Birds in Oklahoma*. 5th ed. Norman: Oklahoma Ornithological Society.

# Long-tailed Duck

*Clangula hyemalis*

James Arterburn

**Occurrence:** Rare from late November through mid-April.

**Habitat:** Lakes.

**North American distribution:** Breeds in Alaska and northern Canada. Winters primarily along the Pacific and Atlantic Coasts and on the Great Lakes. Less common at other inland locations.

**Oklahoma distribution:** Not recorded in survey blocks. Lake surveys provided single bird records from Canton Lake in Blaine County in December 2003, February 2004, and January 2005, and from Lake Yahola in Tulsa County in January 2005. Special interest species reports of single birds were received from Lake Overholser in Canadian County in January 2008, Boomer Lake in Payne County in December 2003, and Hackberry Flat Wildlife Management Area in Tillman County in February 2005, while two birds were reported from the Skiatook sewage ponds in Tulsa County in December 2004. Additional published reports during the project period came from Cherokee County in January 2008 (Oklahoma Bird Records Committee [OBRC] 2009); Noble County in January 2008 (four birds; OBRC 2009a); Roger Mills County in December 2007 (OBRC 2009a); Tulsa County from December 2003 through February 2004 (OBRC 2004), December 2004 through February 2005 (OBRC 2005), December 2006 through February 2007 (OBRC 2007), and December 2007 through February 2008 (OBRC 2009a); and Washington County in January 2008 (OBRC 2009a). Birds were often present at multiple locations in Tulsa County.

**Behavior:** Long-tailed Ducks can be found singly or in small groups, and they sometimes associate with other ducks. Foraging for invertebrates and fish in the water column and on lake bottoms is accomplished by diving.

## Christmas Bird Count (CBC) Results, 1960–2009

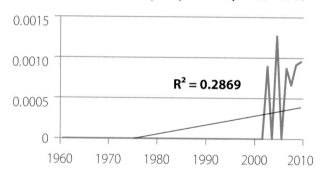

$R^2 = 0.2869$

## CBC Results, 2003–2008

| Winter | Number recorded | Counts reporting |
| --- | --- | --- |
| 2003–2004 | 0 | — |
| 2004–2005 | 3 | 1 |
| 2005–2006 | 0 | — |
| 2006–2007 | 2 | 1 |
| 2007–2008 | 1 | 1 |

Count per
Block Survey

Count per
Lake Survey

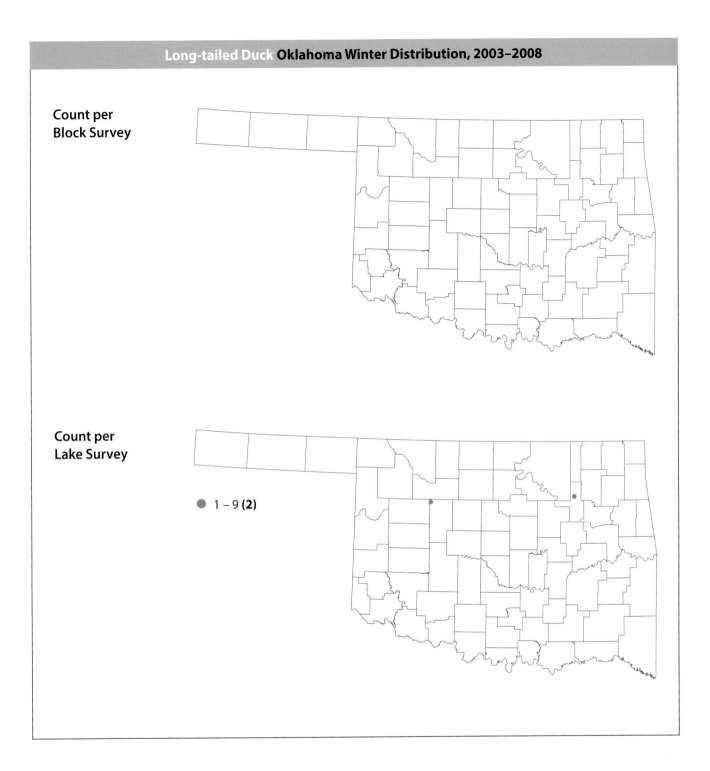

● 1 – 9 **(2)**

**References**

National Audubon Society. 2011. The Christmas Bird Count historical results. http://www
.christmasbirdcount.org.

Oklahoma Bird Records Committee. 2004. 2003–2004 winter season. *The Scissortail* 54:25–27.

———. 2005. 2004–2005 winter season. *The Scissortail* 55:18–20.

———. 2007. 2006–2007 winter season. *The Scissortail* 57:24–27.

———. 2009a. 2007–2008 winter season. *The Scissortail* 59:4–8.

———. 2009b. *Date Guide to the Occurrences of Birds in Oklahoma*. 5th ed. Norman: Oklahoma
Ornithological Society.

Robertson, Gregory J., and Jean-Pierre L. Savard. 2002. Long-tailed Duck (*Clangula hyemalis*). *The Birds of
North America Online*, edited by A. Poole. Ithaca, N.Y.: Cornell Laboratory of Ornithology. http://bna
.birds.cornell.edu.

Tyler, J. D. 1981. The Oldsquaw in Oklahoma. *Bulletin of the Oklahoma Ornithological Society* 14:25–28.

# Bufflehead
*Bucephala albeola*

Bob Gress

**Occurrence:** Late October through early May.

**Habitat:** Lakes and ponds.

**North American distribution:** Breeds across Canada and Alaska. Present year round in many northern states, and winters across most of the United States except in parts of the southeast.

**Oklahoma distribution:** Survey results suggest a nearly statewide distribution even though many survey blocks probably did not contain suitable habitat.

**Behavior:** Buffleheads are usually seen in pairs or small groups rather than in large flocks. Unlike many ducks, pairs remain together year round. They forage underwater by diving in search of aquatic insects and aquatic plant seeds.

### Christmas Bird Count (CBC) Results, 1960–2009

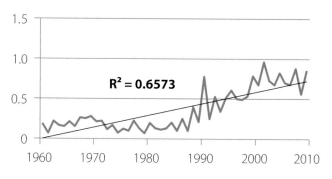

$R^2 = 0.6573$

### CBC Results, 2003–2008

| Winter | Number recorded | Counts reporting |
|--------|-----------------|------------------|
| 2003–2004 | 701 | 17 |
| 2004–2005 | 791 | 17 |
| 2005–2006 | 805 | 17 |
| 2006–2007 | 627 | 17 |
| 2007–2008 | 885 | 16 |

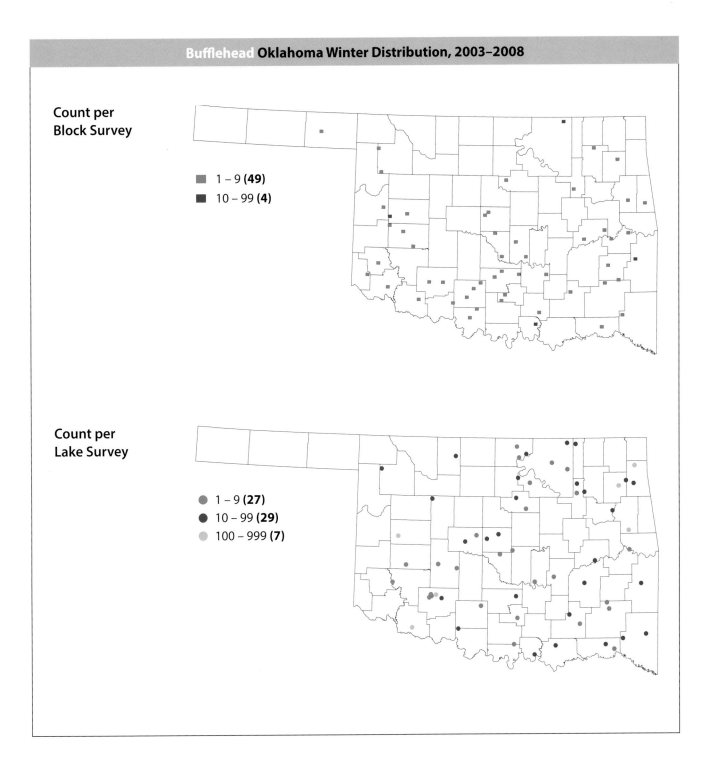

## Bufflehead Oklahoma Winter Distribution, 2003–2008

**Count per Block Survey**

■ 1 – 9 **(49)**
■ 10 – 99 **(4)**

**Count per Lake Survey**

● 1 – 9 **(27)**
● 10 – 99 **(29)**
● 100 – 999 **(7)**

**References**

Gauthier, Gilles. 1993. Bufflehead (*Bucephala albeola*). *The Birds of North America Online*, edited by A. Poole. Ithaca, N.Y.: Cornell Laboratory of Ornithology. http://bna.birds.cornell.edu.

National Audubon Society. 2011. The Christmas Bird Count historical results. http://www .christmasbirdcount.org.

Oklahoma Bird Records Committee. 2009. *Date Guide to the Occurrences of Birds in Oklahoma*. 5th ed. Norman: Oklahoma Ornithological Society.

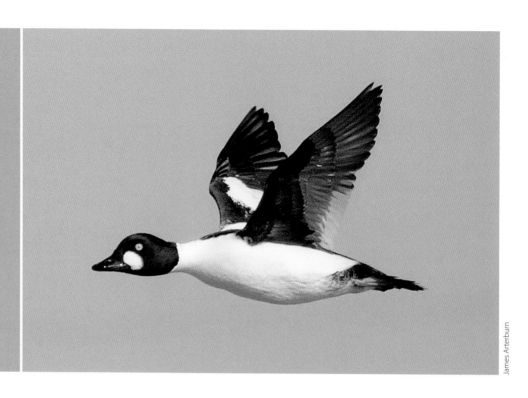

# Common Goldeneye
*Bucephala clangula*

James Arterburn

**Occurrence:** November through mid-April.

**Habitat:** Lakes and ponds.

**North American distribution:** Breeds in Alaska and much of Canada. Present year round in parts of the northernmost lower 48 states, and winters over most of the lower 48 states.

**Oklahoma distribution:** Recorded evenly across the state, although in a fairly low proportion of blocks. Many blocks may have lacked suitable habitat for this species. The tendency for this species to occur in pairs or small flocks is reflected in the scarcity of large concentrations being recorded.

**Behavior:** Common Goldeneyes begin forming pairs in December, so they are frequently seen in pairs or small groups. They dive to forage for aquatic insects, mollusks, crustaceans, and plants and typically spend 10–20 seconds underwater with each dive.

## Christmas Bird Count (CBC) Results, 1960–2009

$R^2 = 0.0038$

## CBC Results, 2003–2008

| Winter | Number recorded | Counts reporting |
|---|---|---|
| 2003–2004 | 1,313 | 17 |
| 2004–2005 | 380 | 15 |
| 2005–2006 | 749 | 17 |
| 2006–2007 | 721 | 15 |
| 2007–2008 | 633 | 17 |

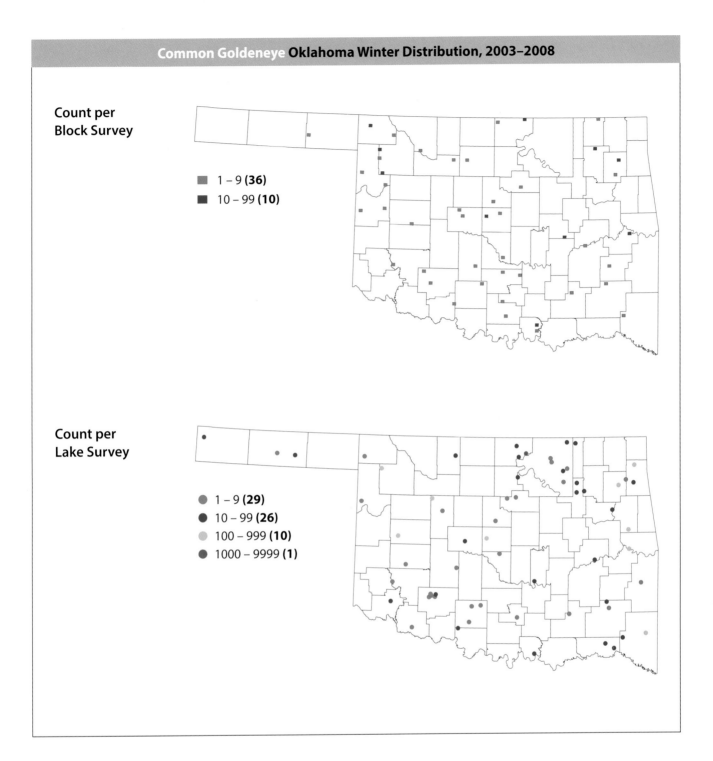

# Common Goldeneye Oklahoma Winter Distribution, 2003–2008

**Count per Block Survey**

■ 1 – 9 **(36)**
■ 10 – 99 **(10)**

**Count per Lake Survey**

● 1 – 9 **(29)**
● 10 – 99 **(26)**
● 100 – 999 **(10)**
● 1000 – 9999 **(1)**

### References

Eadie, J. M., M. L. Mallory, and H. G. Lumsden. 1995. Common Goldeneye (*Bucephala clangula*). *The Birds of North America Online*, edited by A. Poole. Ithaca, N.Y.: Cornell Laboratory of Ornithology. http://bna .birds.cornell.edu.

National Audubon Society. 2011. The Christmas Bird Count historical results. http://www .christmasbirdcount.org.

Oklahoma Bird Records Committee. 2009. *Date Guide to the Occurrences of Birds in Oklahoma.* 5th ed. Norman: Oklahoma Ornithological Society.

# Barrow's Goldeneye
*Bucephala islandica*

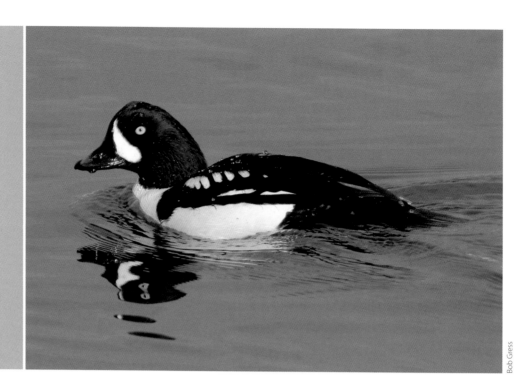

Bob Gress

**Occurrence:** Rare in winter.

**Habitat:** Lakes.

**North American distribution:** Breeds in southern Alaska, western Canada, and parts of eastern Canada and the northwestern lower 48 states. Winters along the northern Pacific Coast, northern Atlantic Coast, and at scattered inland locations in the western United States.

**Oklahoma distribution:** Not recorded in survey blocks. Special interest species reports were received from Alfalfa County (Salt Plains National Wildlife Refuge in December 2007), Custer County (Foss Reservoir in December 2003), and Woodward County (Fort Supply Lake in December 2007). Additional records of hybrids between Barrow's and Common Goldeneyes exist as well (including in Blaine County at Canton Lake in February 2004), and all purported Barrow's Goldeneyes should be closely examined for evidence of hybridization.

**Behavior:** Although gregarious during the winter, Barrow's Goldeneyes are likely to be seen singly because of their rarity in Oklahoma. They sometimes associate with Common Goldeneyes and scoters during the winter. They forage by diving for aquatic invertebrates and some plant materials.

## Christmas Bird Count (CBC) Results, 1960–2009

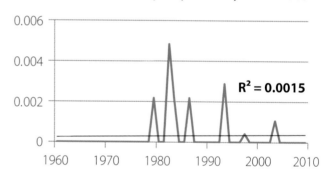

$R^2 = 0.0015$

## CBC Results, 2003–2008

| Winter | Number recorded | Counts reporting |
|---|---|---|
| 2003–2004 | 1 | 1 |
| 2004–2005 | 0 | — |
| 2005–2006 | 0 | — |
| 2006–2007 | 0 | — |
| 2007–2008 | 0 | — |

**Count per Block Survey**

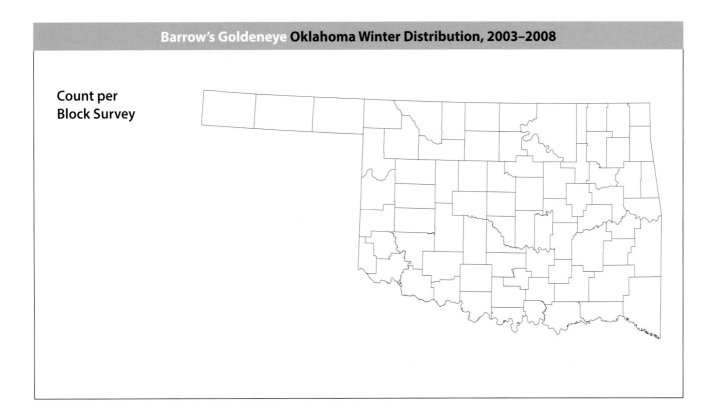

### References

Eadie, John M., Jean-Pierre L. Savard, and Mark L. Mallory. 2000. Barrow's Goldeneye (*Bucephala islandica*). *The Birds of North America Online*, edited by A. Poole. Ithaca, N.Y.: Cornell Laboratory of Ornithology. http://bna.birds.cornell.edu.

National Audubon Society. 2011. The Christmas Bird Count historical results. http://www .christmasbirdcount.org.

Oklahoma Bird Records Committee. 2009. *Date Guide to the Occurrences of Birds in Oklahoma*. 5th ed. Norman: Oklahoma Ornithological Society.

Patti, S. T. 1983. Barrow's Goldeneye in Cimarron County, Oklahoma. *Bulletin of the Oklahoma Ornithological Society* 16:29–30.

Rushing, R. C., and J. D. Tyler. 1984. A new bird for Oklahoma: Barrow's Goldeneye. *Bulletin of the Oklahoma Ornithological Society* 17:25–26.

# Hooded Merganser
## *Lophodytes cucullatus*

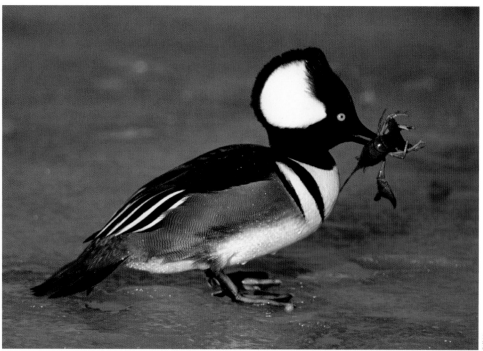

Bill Horn

**Occurrence:** Year-round resident, but more numerous during the winter as migrants from northern regions arrive here.

**Habitat:** Lakes, ponds, rivers, and wetlands.

**North American distribution:** Breeds in western Canada and a large portion of eastern Canada and the eastern United States. Resident in parts of the western United States and Canada and parts of the southeastern United States. Winters in the southeastern United States and in scattered portions of the western United States.

**Oklahoma distribution:** Recorded at scattered locations statewide. Most of the larger concentrations were from central and western Oklahoma. The willingness of this species to utilize smaller ponds probably resulted in the fairly large number of blocks in which it was recorded. Its winter distribution is much more extensive than the localized breeding distribution recorded during the Oklahoma Breeding Bird Atlas Project.

**Behavior:** Hooded Mergansers are usually seen in pairs or in groups of up to several dozen. They are sometimes seen among other duck species. They forage by diving after fish, crayfish, and aquatic insects, which they grasp with their serrated bills. They have eye adaptations, including adjustable lenses and a retractable and transparent protective membrane, which provide enhanced vision for hunting underwater.

## Christmas Bird Count (CBC) Results, 1960–2009

$R^2 = 0.2759$

## CBC Results, 2003–2008

| Winter | Number recorded | Counts reporting |
|---|---|---|
| 2003–2004 | 1,254 | 18 |
| 2004–2005 | 306 | 16 |
| 2005–2006 | 918 | 16 |
| 2006–2007 | 672 | 17 |
| 2007–2008 | 649 | 17 |

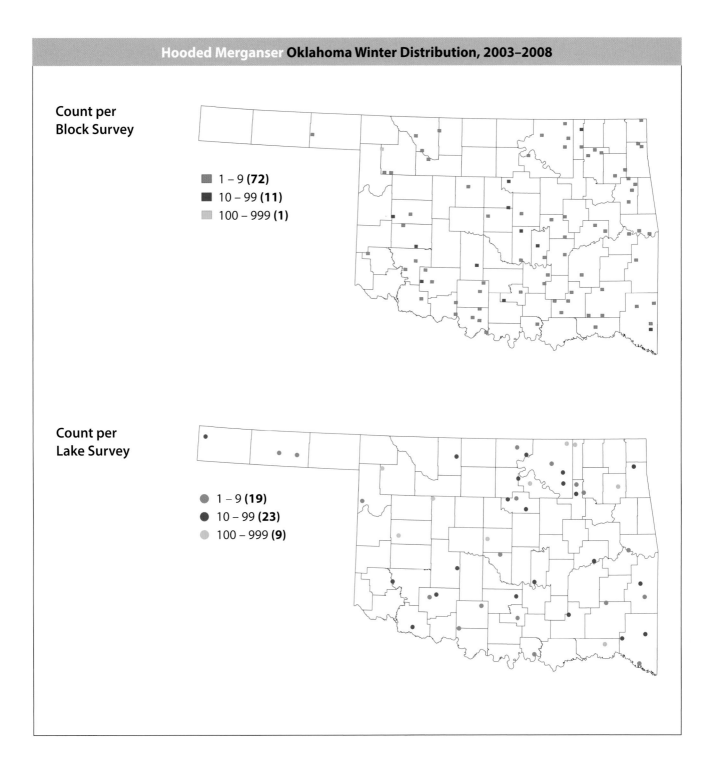

## Hooded Merganser Oklahoma Winter Distribution, 2003–2008

**Count per Block Survey**

- ■ 1 – 9 **(72)**
- ■ 10 – 99 **(11)**
- ■ 100 – 999 **(1)**

**Count per Lake Survey**

- ● 1 – 9 **(19)**
- ● 10 – 99 **(23)**
- ● 100 – 999 **(9)**

### References

Dugger, B. D., K. M. Dugger, and L. H. Fredrickson. 2009. Hooded Merganser (*Lophodytes cucullatus*). *The Birds of North America Online*, edited by A. Poole. Ithaca, N.Y.: Cornell Laboratory of Ornithology. http://bna.birds.cornell.edu.

National Audubon Society. 2011. The Christmas Bird Count historical results. http://www.christmasbirdcount.org.

Oklahoma Bird Records Committee. 2009. *Date Guide to the Occurrences of Birds in Oklahoma*. 5th ed. Norman: Oklahoma Ornithological Society.

Reinking, D. L., ed. 2004. *Oklahoma Breeding Bird Atlas*. Norman: University of Oklahoma Press.

# Common Merganser

*Mergus merganser*

James Arterburn

**Occurrence:** November through April.

**Habitat:** Lakes.

**North American distribution:** Breeds across much of Alaska and Canada. Year-round resident in the northeastern United States and in parts of the western United States. Winters broadly across much of the lower 48 states except for the southeast region.

**Oklahoma distribution:** Recorded in few blocks, mainly because deepwater lake habitat was scarce in survey blocks. One Rogers County block with suitable lake habitat did demonstrate the propensity this species has for forming very large flocks. An estimated group of 10,000 was reported on February 3, 2007, on Canton Lake in Blaine County.

**Behavior:** Common Mergansers are gregarious during the winter, with some flocks numbering in the thousands. They are skilled swimmers and divers, pursuing small fish and aquatic invertebrates, which they capture using their serrated bills.

## Christmas Bird Count (CBC) Results, 1960–2009

$R^2 = 0.3264$

## CBC Results, 2003–2008

| Winter | Number recorded | Counts reporting |
|--------|-----------------|------------------|
| 2003–2004 | 562 | 9 |
| 2004–2005 | 429 | 13 |
| 2005–2006 | 2,591 | 9 |
| 2006–2007 | 562 | 10 |
| 2007–2008 | 601 | 11 |

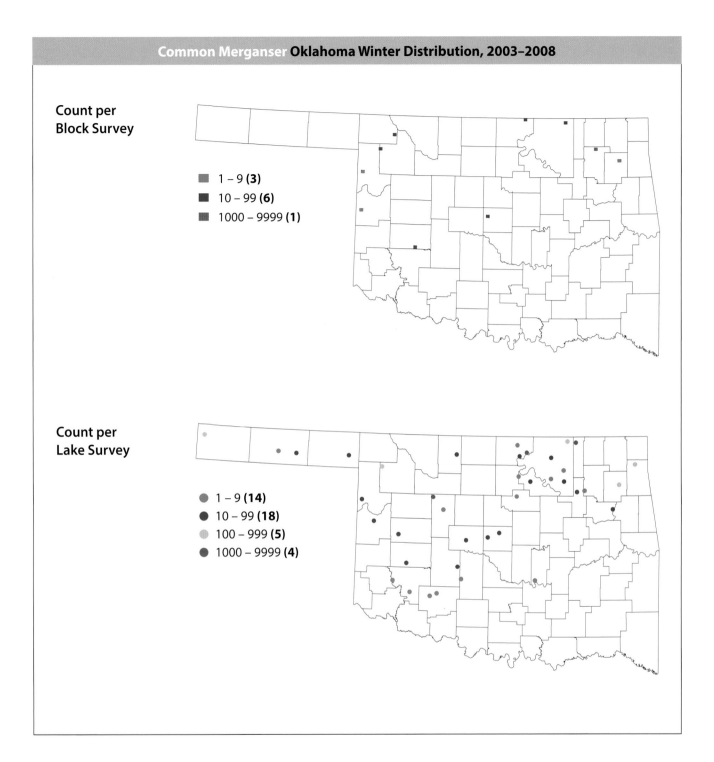

**Count per Block Survey**

- 1 – 9 **(3)**
- 10 – 99 **(6)**
- 1000 – 9999 **(1)**

**Count per Lake Survey**

- 1 – 9 **(14)**
- 10 – 99 **(18)**
- 100 – 999 **(5)**
- 1000 – 9999 **(4)**

## References

Anderson, B. W., and M. G. Reeder. 1977. Food habits of the Common Merganser in winter. *Bulletin of the Oklahoma Ornithological Society* 10:3–6.

Mallory, Mark, and Karen Metz. 1999. Common Merganser (*Mergus merganser*). *The Birds of North America Online*, edited by A. Poole. Ithaca, N.Y.: Cornell Laboratory of Ornithology. http://bna.birds.cornell.edu.

National Audubon Society. 2011. The Christmas Bird Count historical results. http://www.christmasbirdcount.org.

Oklahoma Bird Records Committee. 2007. 2006–2007 winter season. *The Scissortail* 57:24–27.

———. 2009. *Date Guide to the Occurrences of Birds in Oklahoma*. 5th ed. Norman: Oklahoma Ornithological Society.

# Red-breasted Merganser
## *Mergus serrator*

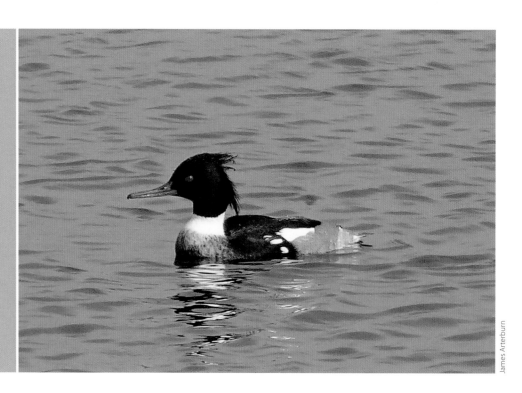

James Arterburn

**Occurrence:** Late October through early May.

**Habitat:** Large lakes.

**North American distribution:** Breeds in Alaska, much of Canada, and parts of the northeastern United States. Winters along the Pacific, Atlantic, and Gulf Coasts as well as in scattered inland locations.

**Oklahoma distribution:** Recorded in just three widely scattered survey blocks; few blocks have habitat suitable for this open-water species.

**Behavior:** Red-breasted Mergansers are gregarious throughout the year, but flocks tend to be much smaller than those of Common Mergansers. They forage at the surface of the water and dive after fish, crustaceans, and insects.

## Christmas Bird Count (CBC) Results, 1960–2009

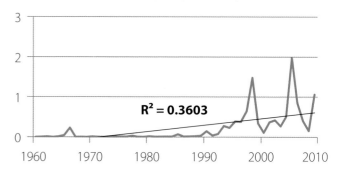

$R^2 = 0.3603$

## CBC Results, 2003–2008

| Winter | Number recorded | Counts reporting |
|---|---|---|
| 2003–2004 | 229 | 5 |
| 2004–2005 | 343 | 8 |
| 2005–2006 | 1,876 | 7 |
| 2006–2007 | 1,045 | 9 |
| 2007–2008 | 471 | 4 |

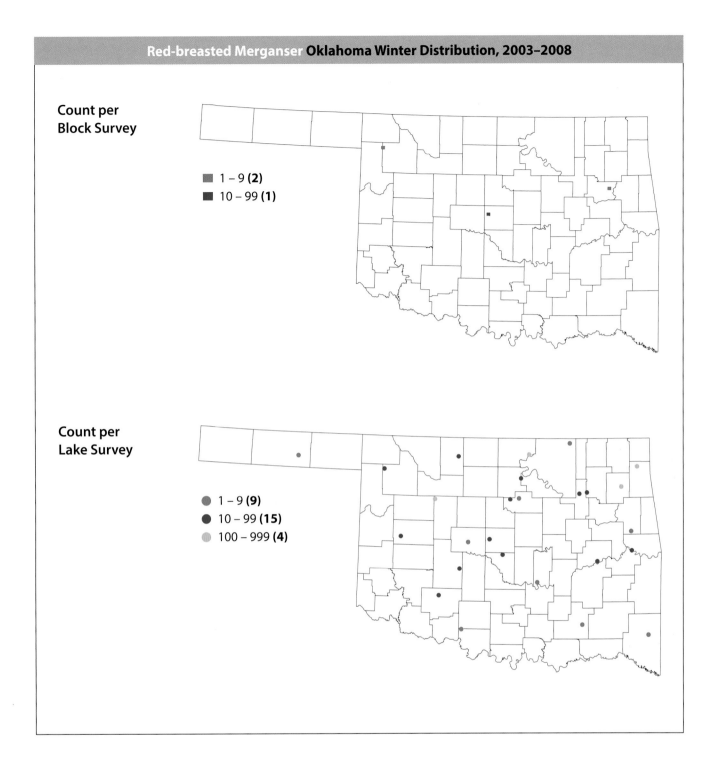

**Count per Block Survey**

- 1 – 9 **(2)**
- 10 – 99 **(1)**

**Count per Lake Survey**

- 1 – 9 **(9)**
- 10 – 99 **(15)**
- 100 – 999 **(4)**

### References

Keating, P. 1972. Courtship behavior of Red-breasted Merganser in February. *Bulletin of the Oklahoma Ornithological Society* 5:28.

National Audubon Society. 2011. The Christmas Bird Count historical results. http://www .christmasbirdcount.org.

Oklahoma Bird Records Committee. 2009. *Date Guide to the Occurrences of Birds in Oklahoma.* 5th ed. Norman: Oklahoma Ornithological Society.

Titman, Rodger D. 1999. Red-breasted Merganser (*Mergus serrator*). *The Birds of North America Online,* edited by A. Poole. Ithaca, N.Y.: Cornell Laboratory of Ornithology. http://bna.birds.cornell.edu.

# Ruddy Duck
*Oxyura jamaicensis*

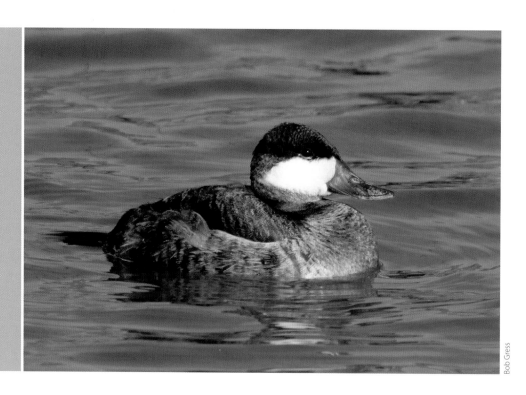

Bob Gress

**Occurrence:** Present year round in western counties, and from October through mid-May in the rest of the state.

**Habitat:** Lakes, ponds, and marshes.

**North American distribution:** Breeds in southern Alaska, western Canada, and parts of the northeastern and western lower 48 states. Resident across much of the western United States and western Mexico, and winters across the southeastern United States and eastern Mexico.

**Oklahoma distribution:** Recorded in scattered survey blocks in central and western counties. The summer distribution recorded by the Oklahoma Breeding Bird Atlas Project was also very thinly scattered across the state and included a few eastern records. This species is more common during migration than it is during either summer or winter.

**Behavior:** Ruddy Ducks are often seen in small groups and sometimes associate with other duck species. They have large feet on legs set well back on their body, making them capable divers but very poor walkers, and they seldom leave the water for land. Taking flight requires a paddling start across the surface of the water. They forage by diving for insects and other aquatic invertebrates.

## Christmas Bird Count (CBC) Results, 1960–2009

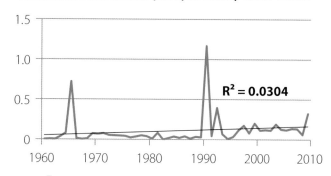

$R^2 = 0.0304$

## CBC Results, 2003–2008

| Winter | Number recorded | Counts reporting |
| --- | --- | --- |
| 2003–2004 | 381 | 6 |
| 2004–2005 | 226 | 7 |
| 2005–2006 | 180 | 9 |
| 2006–2007 | 212 | 12 |
| 2007–2008 | 193 | 10 |

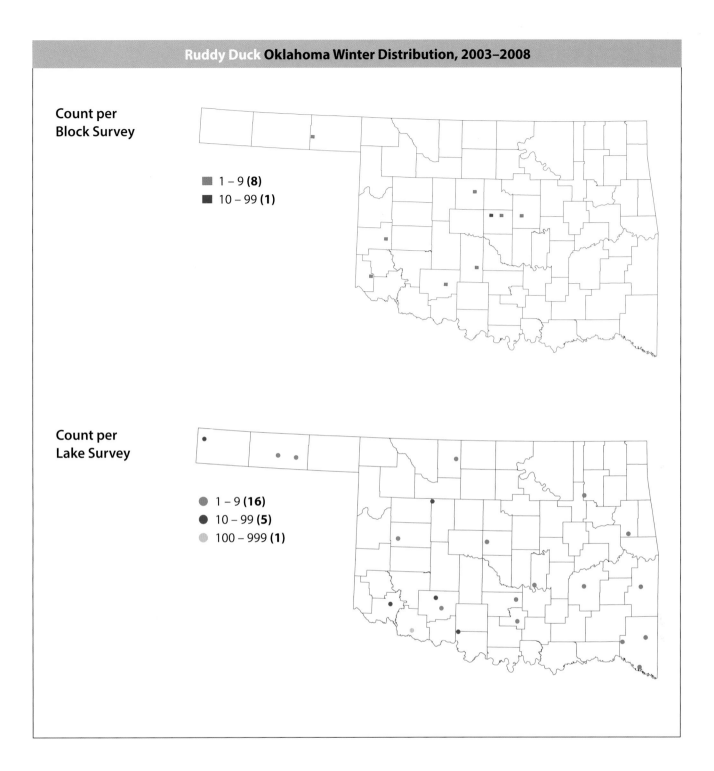

**Count per Block Survey**

■ 1 – 9 **(8)**
■ 10 – 99 **(1)**

**Count per Lake Survey**

● 1 – 9 **(16)**
● 10 – 99 **(5)**
● 100 – 999 **(1)**

**References**

Brua, Robert B. 2002. Ruddy Duck (*Oxyura jamaicensis*). *The Birds of North America Online*, edited by A. Poole. Ithaca, N.Y.: Cornell Laboratory of Ornithology. http://bna.birds.cornell.edu.

National Audubon Society. 2011. The Christmas Bird Count historical results. http://www .christmasbirdcount.org.

Oklahoma Bird Records Committee. 2009. *Date Guide to the Occurrences of Birds in Oklahoma.* 5th ed. Norman: Oklahoma Ornithological Society.

Reinking, D. L., ed. 2004. *Oklahoma Breeding Bird Atlas.* Norman: University of Oklahoma Press.

## Northern Bobwhite
*Colinus virginianus*

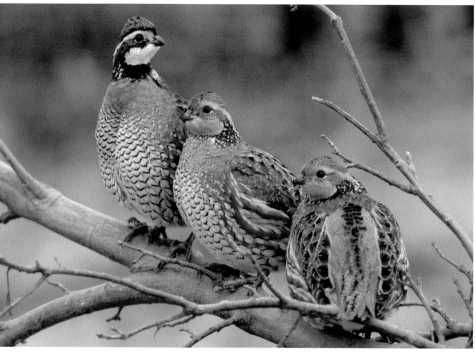

Bob Gress

**Occurrence:** Year-round resident.

**Habitat:** Brushy grasslands and woodland edges.

**North American distribution:** Resident in much of the eastern United States and Mexico.

**Oklahoma distribution:** Recorded statewide, but much more frequently in the western half of the state. Although quail are year-round residents, the summer distribution recorded by the Oklahoma Breeding Bird Atlas Project was more even and widespread in the east, perhaps because the birds' spring and summer vocalizations made them easier to detect than they are during the winter (even where they occur at lower densities).

**Behavior:** Northern Bobwhites are social during the winter months and typically occur in small coveys. Each covey roosts on the ground at night by forming a tight circle with birds facing outward. Foraging takes place on the ground as they search for seeds and waste grains.

### Christmas Bird Count (CBC) Results, 1960–2009

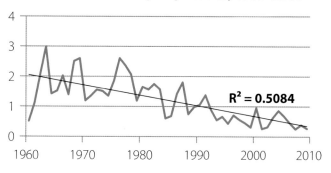

$R^2 = 0.5084$

### CBC Results, 2003–2008

| Winter | Number recorded | Counts reporting |
| --- | --- | --- |
| 2003–2004 | 664 | 15 |
| 2004–2005 | 846 | 18 |
| 2005–2006 | 613 | 15 |
| 2006–2007 | 492 | 15 |
| 2007–2008 | 262 | 13 |

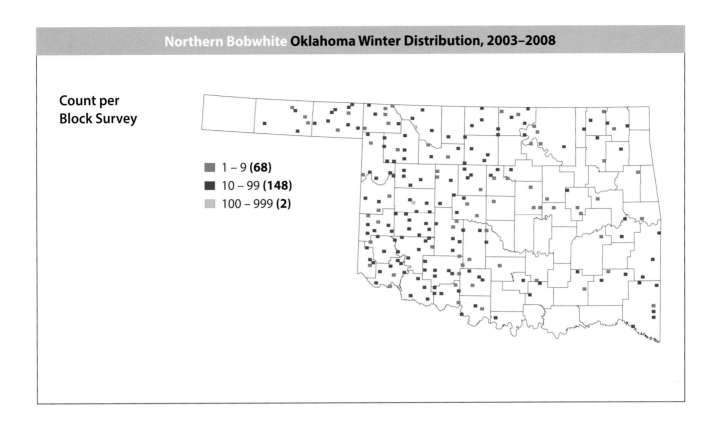

**Count per Block Survey**

- 1 – 9 **(68)**
- 10 – 99 **(148)**
- 100 – 999 **(2)**

### References

Brennan, Leonard A. 1999. Northern Bobwhite (*Colinus virginianus*). *The Birds of North America Online*, edited by A. Poole. Ithaca, N.Y.: Cornell Laboratory of Ornithology. http://bna.birds.cornell.edu.

National Audubon Society. 2011. The Christmas Bird Count historical results. http://www.christmasbirdcount.org.

Oklahoma Bird Records Committee. 2009. *Date Guide to the Occurrences of Birds in Oklahoma*. 5th ed. Norman: Oklahoma Ornithological Society.

Reinking, D. L., ed. 2004. *Oklahoma Breeding Bird Atlas*. Norman: University of Oklahoma Press.

ORDER **GALLIFORMES**

# Scaled Quail
## *Callipepla squamata*

Steve Metz

**Occurrence:** Year-round resident.

**Habitat:** Brushy areas and sand-sage prairies.

**North American distribution:** Resident in parts of the southwestern United States and Mexico.

**Oklahoma distribution:** Recorded in moderate abundance in all Panhandle counties, and in one survey block in the southwestern region. The summer distribution recorded by the Oklahoma Breeding Bird Atlas Project was similar, although this species was recorded in more survey blocks during summer, perhaps because the increased vocalizations of birds during that season made them easier to locate.

**Behavior:** Scaled Quail are gregarious during winter, with coveys of several dozen birds being typical. They roost at night in small, tight circles, with each bird facing outward. They forage on the ground for seeds and waste grain.

**Christmas Bird Count (CBC) Results, 1960–2009**

$R^2 = 0.0339$

**CBC Results, 2003–2008**

| Winter | Number recorded | Counts reporting |
|---|---|---|
| 2003–2004 | 82 | 1 |
| 2004–2005 | 44 | 1 |
| 2005–2006 | 12 | 1 |
| 2006–2007 | 0 | — |
| 2007–2008 | 4 | 1 |

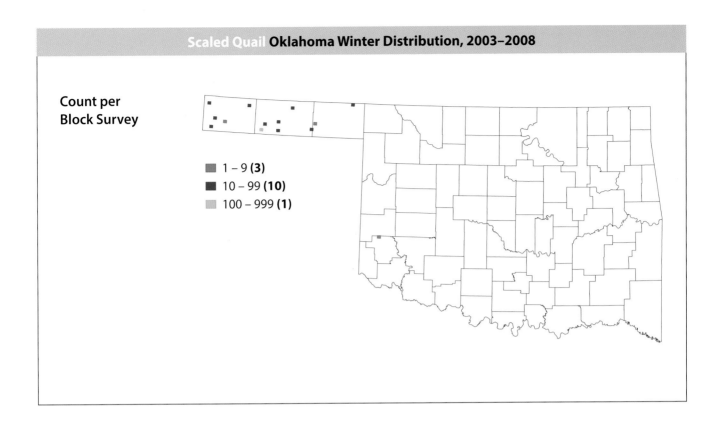

Count per
Block Survey

■ 1 – 9 **(3)**
■ 10 – 99 **(10)**
■ 100 – 999 **(1)**

### References

Dabbert, C. Brad, Greg Pleasant, and Sanford D. Schemnitz. 2009. Scaled Quail (*Callipepla squamata*). *The Birds of North America Online*, edited by A. Poole. Ithaca, N.Y.: Cornell Laboratory of Ornithology. http://bna.birds.cornell.edu.

Giezentanner, J. B. 1976. Scaled Quail in Custer County, Oklahoma. *Bulletin of the Oklahoma Ornithological Society* 9:6.

National Audubon Society. 2011. The Christmas Bird Count historical results. http://www .christmasbirdcount.org.

Oklahoma Bird Records Committee. 2009. *Date Guide to the Occurrences of Birds in Oklahoma*. 5th ed. Norman: Oklahoma Ornithological Society.

# Ring-necked Pheasant
*Phasianus colchicus*

© (R. Curtis) / VIREO

**Occurrence:** Year-round resident.

**Habitat:** Grain fields, pastures, and brushy areas.

**North American distribution:** Introduced from Asia. Now resident across parts of southern Canada and the northern and western lower 48 states.

**Oklahoma distribution:** Commonly recorded in survey blocks across northern counties from Kay County westward to Cimarron County. Other scattered records may be escaped or released captive birds. This distribution is unchanged from the summer distribution recorded during the Oklahoma Breeding Bird Atlas Project.

**Behavior:** Ring-necked Pheasants are gregarious from fall through spring, with females often seen together in larger groups than males. They forage on the ground for waste grains, seeds, fruits, nuts, and other plant materials, along with insects when available.

**Christmas Bird Count (CBC) Results, 1960–2009**

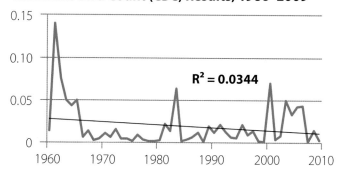

$R^2 = 0.0344$

**CBC Results, 2003–2008**

| Winter | Number recorded | Counts reporting |
|--------|-----------------|------------------|
| 2003–2004 | 55 | 2 |
| 2004–2005 | 37 | 3 |
| 2005–2006 | 49 | 3 |
| 2006–2007 | 48 | 3 |
| 2007–2008 | 1 | 2 |

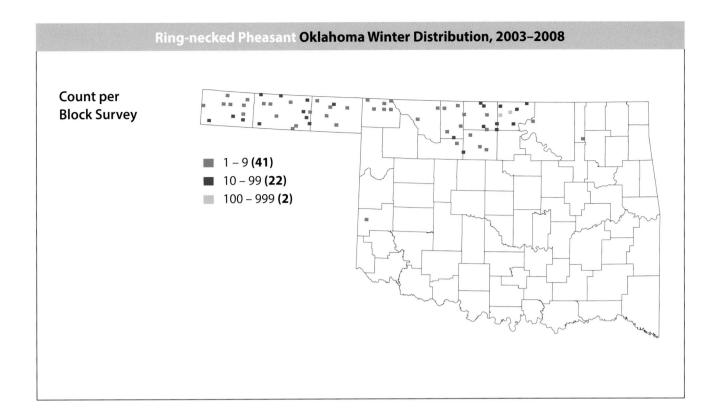

**Count per
Block Survey**

- ◼ 1 – 9 **(41)**
- ◼ 10 – 99 **(22)**
- ◻ 100 – 999 **(2)**

### References

Giudice, John H., and John T. Ratti. 2001. Ring-necked Pheasant (*Phasianus colchicus*). *The Birds of North America Online*, edited by A. Poole. Ithaca, N.Y.: Cornell Laboratory of Ornithology. http://bna.birds .cornell.edu.

National Audubon Society. 2011. The Christmas Bird Count historical results. http://www .christmasbirdcount.org.

Oklahoma Bird Records Committee. 2009. *Date Guide to the Occurrences of Birds in Oklahoma*. 5th ed. Norman: Oklahoma Ornithological Society.

Reinking, D. L., ed. 2004. *Oklahoma Breeding Bird Atlas*. Norman: University of Oklahoma Press.

# Greater Prairie-Chicken
*Tympanuchus cupido*

Patricia Velte

**Occurrence:** Year-round resident.

**Habitat:** Tallgrass prairie and nearby grain fields.

**North American distribution:** Resident in parts of the midwestern and central U.S. tallgrass prairies.

**Oklahoma distribution:** Recorded in survey blocks in four northeastern counties. Also reported from Tulsa County (one bird) on January 15, 2004 (Oklahoma Bird Records Committee [OBRC] 2004), and from Payne County (one bird at Stillwater airport) in January and February 2005 (OBRC 2005). The distribution found in survey blocks is fairly similar to that found during the Oklahoma Breeding Bird Atlas Project in summer, and Osage County is still home to the largest remaining populations in the state.

**Behavior:** Greater Prairie-Chickens are very social and typically form the largest flocks in the fall and winter. They forage mostly in the morning and evening, primarily on the ground, for leaves, seeds, grains, and insects. Foraging is typically done by walking, but travel between feeding, loafing, and roosting sites is often accomplished by flight.

## Christmas Bird Count (CBC) Results, 1960–2009

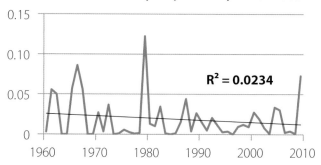

$R^2 = 0.0234$

## CBC Results, 2003–2008

| Winter | Number recorded | Counts reporting |
|---|---|---|
| 2003–2004 | 1 | 1 |
| 2004–2005 | 42 | 2 |
| 2005–2006 | 35 | 1 |
| 2006–2007 | 3 | 1 |
| 2007–2008 | 5 | 1 |

**Count per Block Survey**

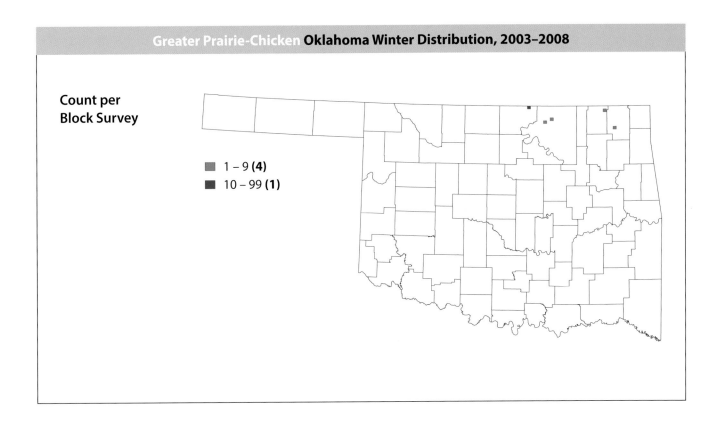

■ 1 – 9 **(4)**
■ 10 – 99 **(1)**

### References

Johnson, Jeff A., M. A. Schroeder, and L. A. Robb. 2011. Greater Prairie-Chicken (*Tympanuchus cupido*). *The Birds of North America Online*, edited by A. Poole. Ithaca, N.Y.: Cornell Laboratory of Ornithology. http://bna.birds.cornell.edu.

National Audubon Society. 2011. The Christmas Bird Count historical results. http://www .christmasbirdcount.org.

Oklahoma Bird Records Committee. 2004. 2003–2004 winter season. *The Scissortail* 54:25–27.

———. 2005. 2004–2005 winter season. *The Scissortail* 55:18–20.

———. 2009. *Date Guide to the Occurrences of Birds in Oklahoma*. 5th ed. Norman: Oklahoma Ornithological Society.

Reinking, D. L., ed. 2004. *Oklahoma Breeding Bird Atlas*. Norman: University of Oklahoma Press.

# Lesser Prairie-Chicken

## *Tympanuchus pallidicinctus*

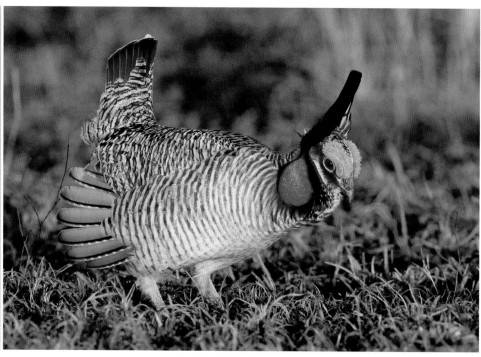

Bob Gress

**Occurrence:** Year-round resident.

**Habitat:** Open grasslands, shinnery oak prairies, and grain fields.

**North American distribution:** Resident in small portions of Kansas, Colorado, New Mexico, Texas, and Oklahoma.

**Oklahoma distribution:** Recorded in three blocks in Ellis and Beaver Counties. Four additional records were received from special interest species reports: three from Harper County and one from Beaver County. As expected for a resident species, the summer distribution recorded by the Oklahoma Breeding Bird Atlas Project was similar.

**Behavior:** Lesser Prairie-Chickens are social in all seasons and often gather in flocks during the winter to feed, especially early and late in the day. Foraging takes place mostly on the ground as they search for grains, seeds, shinnery oak acorns, leaves, and insects. They fly low and fast, especially when being pursued by predators, and collisions with fences are a significant source of mortality. Marking fences to increase their visibility appears to be effective in reducing collisions. They have an innate aversion to tall objects as potential raptor perches, and turbines and transmission lines associated with current wind energy development may threaten much of the remaining habitat for this declining species.

**Christmas Bird Count (CBC) Results, 1960–2009**

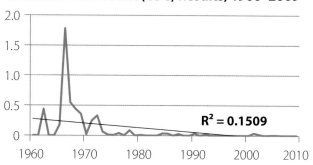

$R^2 = 0.1509$

**CBC Results, 2003–2008**

| Winter | Number recorded | Counts reporting |
|---|---|---|
| 2003–2004 | 0 | — |
| 2004–2005 | 1 | 1 |
| 2005–2006 | 2 | 1 |
| 2006–2007 | 0 | — |
| 2007–2008 | 0 | — |

**Count per
Block Survey**

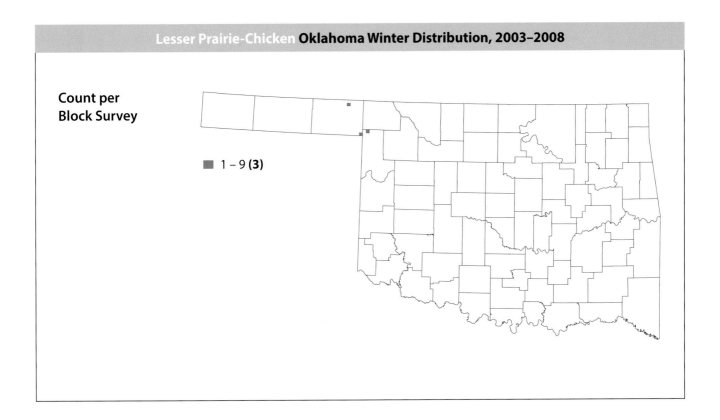

■ 1 – 9 **(3)**

### References

Elmore, D., T. Bidwell, R. Ranft, and D. Wolfe. 2009. *Habitat Evaluation Guide for the Lesser Prairie-Chicken*. Oklahoma Cooperative Extension Service Publication E-1014. Stillwater: Oklahoma State University.

Hagen, Christian A., and Kenneth M. Giesen. 2005. Lesser Prairie-Chicken (*Tympanuchus pallidicinctus*). *The Birds of North America Online*, edited by A. Poole. Ithaca, N.Y.: Cornell Laboratory of Ornithology. http://bna.birds.cornell.edu.

Horton, R., L. Bell, C. M. O'Meilia, M. McLachlan, C. Hise, D. Wolfe, D. Elmore, and J. D. Strong. 2010. *A Spatially-Based Planning Tool Designed to Reduce Negative Effects of Development on the Lesser Prairie-Chicken (*Tympanuchus pallidicinctus*) in Oklahoma: A Multi-Entity Collaboration to Promote Lesser Prairie-Chicken Voluntary Habitat Conservation and Prioritized Management Actions*. Oklahoma City: Oklahoma Department of Wildlife Conservation. http://www.wildlifedepartment.com /lepcdevelopmentplanning.htm.

National Audubon Society. 2011. The Christmas Bird Count historical results. http://www .christmasbirdcount.org.

Oklahoma Bird Records Committee. 2009. *Date Guide to the Occurrences of Birds in Oklahoma*. 5th ed. Norman: Oklahoma Ornithological Society.

Pruett, C. L., M. A. Patten, and D. H. Wolfe. 2009a. Avoidance behavior by prairie grouse: Implications for wind energy development. *Conservation Biology* 23:1253–59.

———. 2009b. It's not easy being green: Wind energy and a declining grassland bird. *Bioscience* 59:257–62.

Reinking, D. L., ed. 2004. *Oklahoma Breeding Bird Atlas*. Norman: University of Oklahoma Press.

Wolfe, D. H., M. A. Patten, and S. K. Sherrod 2009. Reducing grouse collision mortality by marking fences. *Ecological Restoration* 27:141–43.

Wolfe, D. H., M. A. Patten, E. Shochat, C. L. Pruett, and S. K. Sherrod. 2007. Causes and patterns of mortality in lesser prairie-chickens *Tympanuchus pallidicinctus* and implications for management. *Wildlife Biology* 13 (Suppl. 1): 95–104.

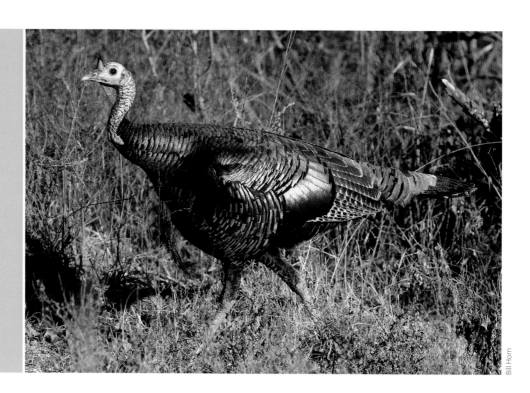

ORDER **GALLIFORMES**

# Wild Turkey
## *Meleagris gallopavo*

Bill Horn

**Occurrence:** Year-round resident.

**Habitat:** Woodlands and brushy areas.

**North American distribution:** Resident throughout much of the lower 48 states and parts of Mexico.

**Oklahoma distribution:** Recorded in scattered survey blocks statewide, but most widespread and abundant in western counties. As expected for a resident species, the summer distribution recorded by the Oklahoma Breeding Bird Atlas Project was similar.

**Behavior:** Wild Turkeys are gregarious throughout the year and are often seen in flocks of variable size. They forage mostly on the ground, scratching leaf litter in search of acorns and other nuts, seeds, and additional plant materials, as well as insects and waste grain when available.

**Christmas Bird Count (CBC) Results, 1960–2009**

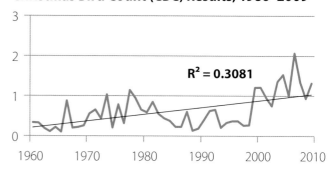

$R^2 = 0.3081$

**CBC Results, 2003–2008**

| Winter | Number recorded | Counts reporting |
|--------|-----------------|------------------|
| 2003–2004 | 852 | 12 |
| 2004–2005 | 971 | 14 |
| 2005–2006 | 719 | 15 |
| 2006–2007 | 990 | 14 |
| 2007–2008 | 1,093 | 14 |

**Count per Block Survey**

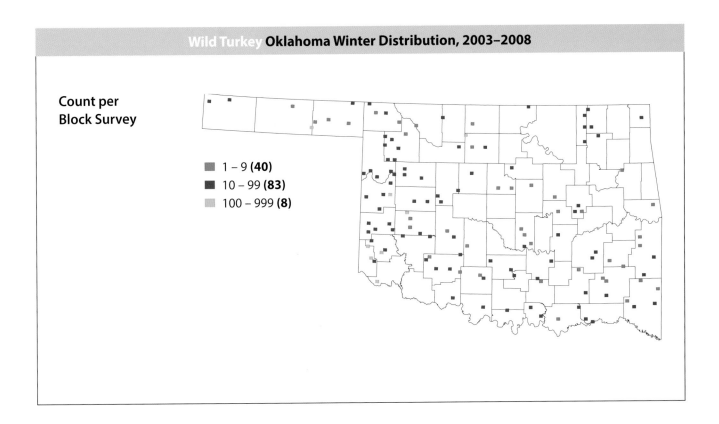

1 – 9 **(40)**
10 – 99 **(83)**
100 – 999 **(8)**

### References

Eaton, Stephen W. 1992. Wild Turkey (*Meleagris gallopavo*). *The Birds of North America Online*, edited by A. Poole. Ithaca, N.Y.: Cornell Laboratory of Ornithology. http://bna.birds.cornell.edu.

National Audubon Society. 2011. The Christmas Bird Count historical results. http://www .christmasbirdcount.org.

Oklahoma Bird Records Committee. 2009. *Date Guide to the Occurrences of Birds in Oklahoma*. 5th ed. Norman: Oklahoma Ornithological Society.

Reinking, D. L., ed. 2004. *Oklahoma Breeding Bird Atlas*. Norman: University of Oklahoma Press.

## Pied-billed Grebe
*Podilymbus podiceps*

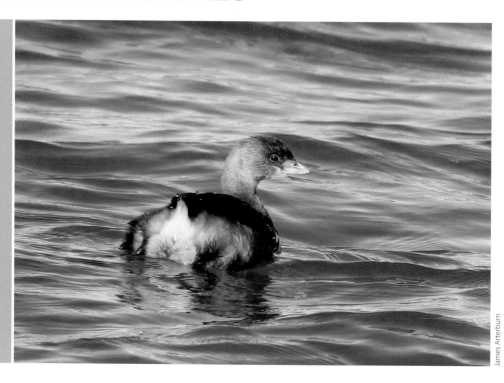

James Arterburn

**Occurrence:** Year-round resident.

**Habitat:** Lakes, ponds, and marshes.

**North American distribution:** Breeds across much of Canada and the northern lower 48 states. Resident across the southern half of the United States and in Mexico.

**Oklahoma distribution:** Recorded in scattered survey blocks statewide, wherever suitable habitat was found. The summer distribution recorded by the Oklahoma Breeding Bird Atlas Project was similarly widespread but somewhat sparser, suggesting an increase in winter numbers as northern breeding birds migrate into the state.

**Behavior:** Pied-billed Grebes are usually seen singly or in pairs, although small groups can occasionally be found during fall through early spring. Foraging is done primarily by diving underwater in search of fish, crayfish, and aquatic insects, although food items are also plucked from the surface of the water.

**Christmas Bird Count (CBC) Results, 1960–2009**

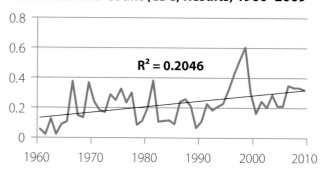

$R^2 = 0.2046$

**CBC Results, 2003–2008**

| Winter | Number recorded | Counts reporting |
|---|---|---|
| 2003–2004 | 305 | 15 |
| 2004–2005 | 224 | 16 |
| 2005–2006 | 236 | 16 |
| 2006–2007 | 370 | 16 |
| 2007–2008 | 311 | 18 |

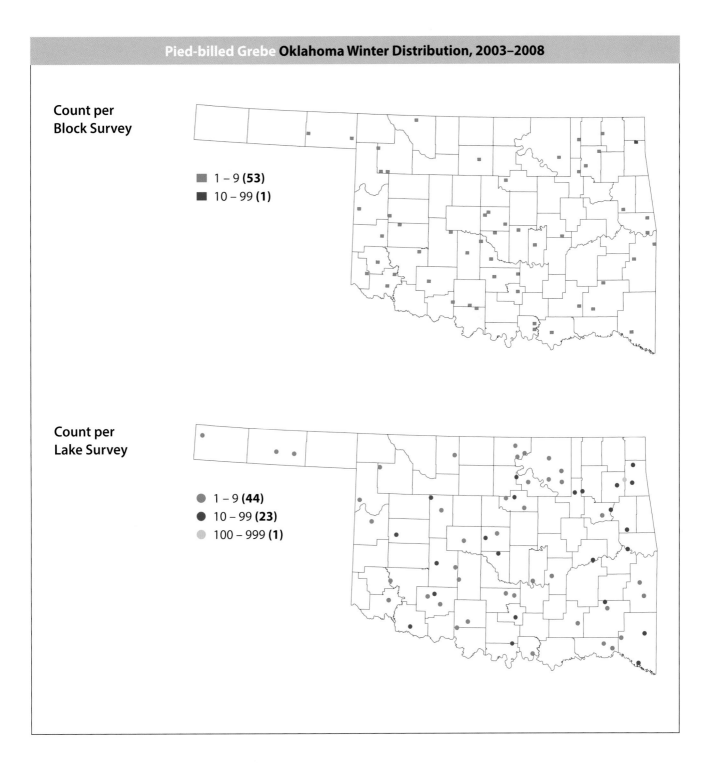

**Count per Block Survey**

- ■ 1 – 9 **(53)**
- ■ 10 – 99 **(1)**

**Count per Lake Survey**

- ● 1 – 9 **(44)**
- ● 10 – 99 **(23)**
- ● 100 – 999 **(1)**

### References

Muller, Martin J., and Robert W. Storer. 1999. Pied-billed Grebe (*Podilymbus podiceps*). *The Birds of North America Online*, edited by A. Poole. Ithaca, N.Y.: Cornell Laboratory of Ornithology. http://bna.birds .cornell.edu.

National Audubon Society. 2011. The Christmas Bird Count historical results. http://www .christmasbirdcount.org.

Oklahoma Bird Records Committee. 2009. *Date Guide to the Occurrences of Birds in Oklahoma*. 5th ed. Norman: Oklahoma Ornithological Society.

Reinking, D. L., ed. 2004. *Oklahoma Breeding Bird Atlas*. Norman: University of Oklahoma Press.

Scott, C. M. 1977. Food stealing behavior in the Ring-billed Gull. *Bulletin of the Oklahoma Ornithological Society* 10:33.

# Horned Grebe
*Podiceps auritus*

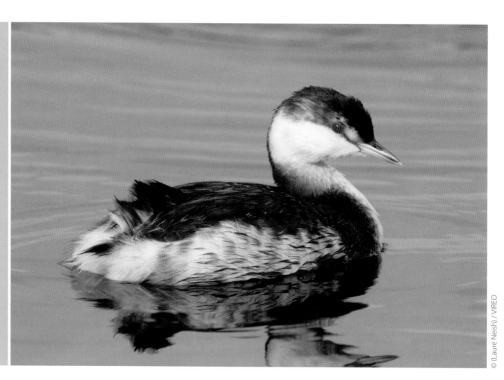

© (Laure Neish) / VIREO

**Occurrence:** Late September through early May.

**Habitat:** Lakes.

**North American distribution:** Breeds in Alaska and much of Canada. Winters along the Pacific and Atlantic Coasts and in the southeastern United States.

**Oklahoma distribution:** Recorded at a few scattered locations in the main body of the state. Most survey blocks lack habitat for this open-water species. High counts published during the project period include 467 birds on January 21, 2006, at Fort Gibson Lake in Wagoner County (Oklahoma Bird Records Committee [OBRC] 2006), and 461 birds on December 20, 2007, at Lake Tenkiller in Cherokee County (OBRC 2009a).

**Behavior:** Horned Grebes may be seen singly but also in groups of up to several dozen or more. They may be seen associating with flocks of American Coots or other aquatic birds. They forage by diving for fish and crustaceans, swallowing small prey underwater but bringing larger prey to the surface.

**Christmas Bird Count (CBC) Results, 1960–2009**

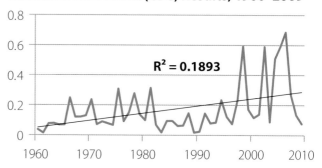

$R^2 = 0.1893$

**CBC Results, 2003–2008**

| Winter | Number recorded | Counts reporting |
|---|---|---|
| 2003–2004 | 81 | 7 |
| 2004–2005 | 443 | 7 |
| 2005–2006 | 578 | 6 |
| 2006–2007 | 762 | 10 |
| 2007–2008 | 216 | 7 |

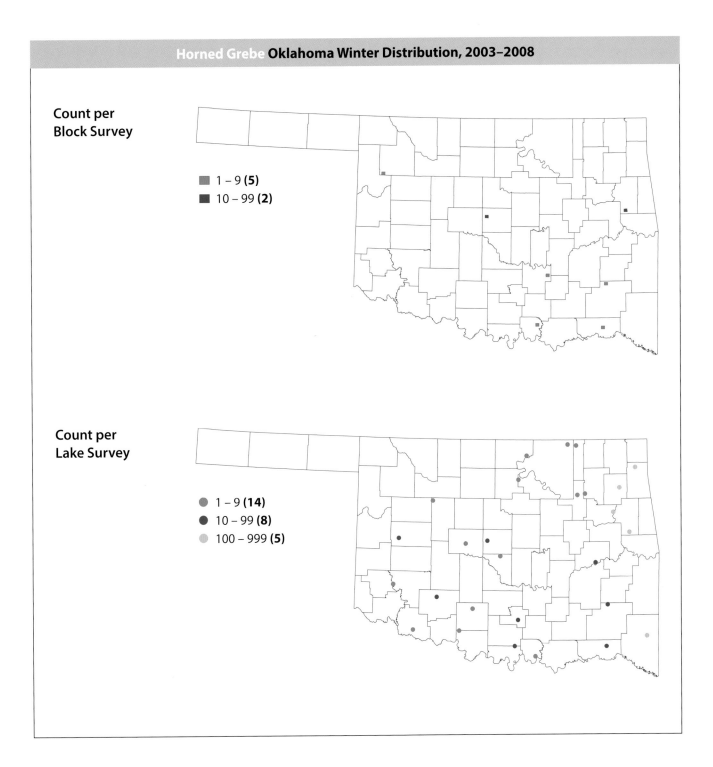

**Count per Block Survey**

- 1 – 9 **(5)**
- 10 – 99 **(2)**

**Count per Lake Survey**

- 1 – 9 **(14)**
- 10 – 99 **(8)**
- 100 – 999 **(5)**

**References**

National Audubon Society. 2011. The Christmas Bird Count historical results. http://www
.christmasbirdcount.org.

Oklahoma Bird Records Committee. 2006. 2005–2006 winter season. *The Scissortail* 56:14–15.

———. 2009a. 2007–2008 winter season. *The Scissortail* 59:4–8.

———. 2009b. *Date Guide to the Occurrences of Birds in Oklahoma*. 5th ed. Norman: Oklahoma
Ornithological Society.

Stedman, Stephen J. 2000. Horned Grebe (*Podiceps auritus*). *The Birds of North America Online*, edited by
A. Poole. Ithaca, N.Y.: Cornell Laboratory of Ornithology. http://bna.birds.cornell.edu.

# Eared Grebe
*Podiceps nigricollis*

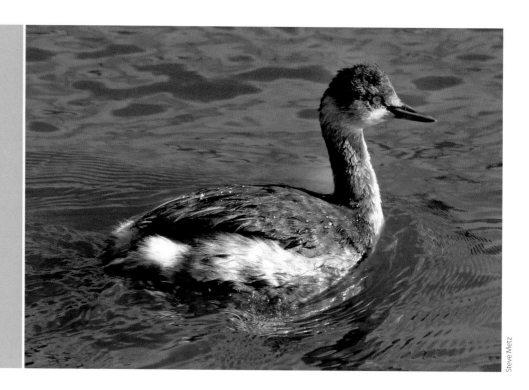

Steve Metz

**Occurrence:** September through early January and April through May. Uncommon throughout winter in southwestern counties.

**Habitat:** Lakes.

**North American distribution:** Breeds in southwestern Canada and the western lower 48 states. Winters in California, the southwestern United States, and parts of the southeastern United States.

**Oklahoma distribution:** Not recorded in survey blocks. Reported from lakes in Cherokee, Comanche, Custer, Kay, McCurtain, Osage, Sequoyah, Tillman, and Tulsa Counties (see lake survey map), as well as in Oklahoma County (Oklahoma Bird Records Committee 2005).

**Behavior:** Eared Grebes are gregarious during migration but are usually seen singly or in small groups during winter in Oklahoma.

## Christmas Bird Count (CBC) Results, 1960–2009

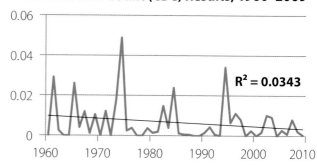

$R^2 = 0.0343$

## CBC Results, 2003–2008

| Winter | Number recorded | Counts reporting |
|---|---|---|
| 2003–2004 | 9 | 4 |
| 2004–2005 | 0 | — |
| 2005–2006 | 2 | 1 |
| 2006–2007 | 2 | 1 |
| 2007–2008 | 9 | 3 |

Count per
Block Survey

Count per
Lake Survey

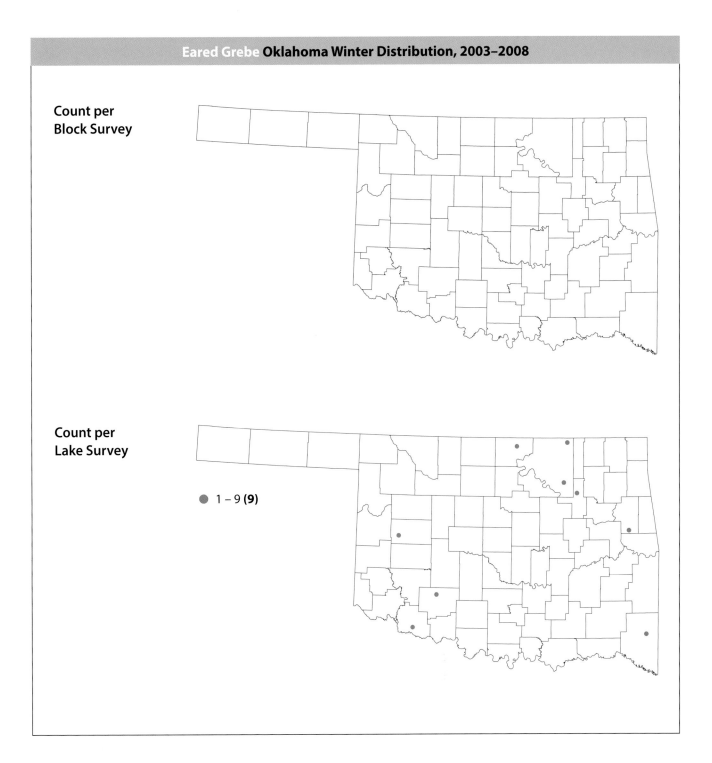

● 1 – 9 **(9)**

### References

Cullen, S. A., J. R. Jehl Jr., and G. L. Nuechterlein. 1999. Eared Grebe (*Podiceps nigricollis*). *The Birds of North America Online*, edited by A. Poole. Ithaca, N.Y.: Cornell Laboratory of Ornithology. http://bna.birds .cornell.edu.

National Audubon Society. 2011. The Christmas Bird Count historical results. http://www .christmasbirdcount.org.

Oklahoma Bird Records Committee. 2005. 2004–2005 winter season. *The Scissortail* 55:18–20.

———. 2009a. 2007–2008 winter season. *The Scissortail* 59:4–8.

———. 2009b. *Date Guide to the Occurrences of Birds in Oklahoma.* 5th ed. Norman: Oklahoma Ornithological Society.

# Western Grebe
*Aechmophorus occidentalis*

Duane Angles

**Occurrence:** Mid-October through mid-May, primarily in central and western counties.

**Habitat:** Lakes.

**North American distribution:** Breeds in much of southwestern Canada and the western lower 48 states. Resident and/or winters in parts of the southwestern United States and Mexico.

**Oklahoma distribution:** Not recorded in survey blocks. Lake survey reports or special interest species reports came from Blaine, Caddo, Cherokee, Comanche, Garvin, Oklahoma, and Sequoyah Counties. Additional published reports during the project period came from Murray and Payne Counties (Oklahoma Bird Records Committee 2004, 2007, 2009a).

**Behavior:** Western Grebes are usually seen singly or in small flocks during winter in Oklahoma. They forage underwater for fish, which they pursue and capture either by spearing them or grabbing them with their bill.

## Christmas Bird Count (CBC) Results, 1960–2009

$R^2 = 0.0546$

## CBC Results, 2003–2008

| Winter | Number recorded | Counts reporting |
|---|---|---|
| 2003–2004 | 0 | — |
| 2004–2005 | 0 | — |
| 2005–2006 | 0 | — |
| 2006–2007 | 0 | — |
| 2007–2008 | 5 | 2 |

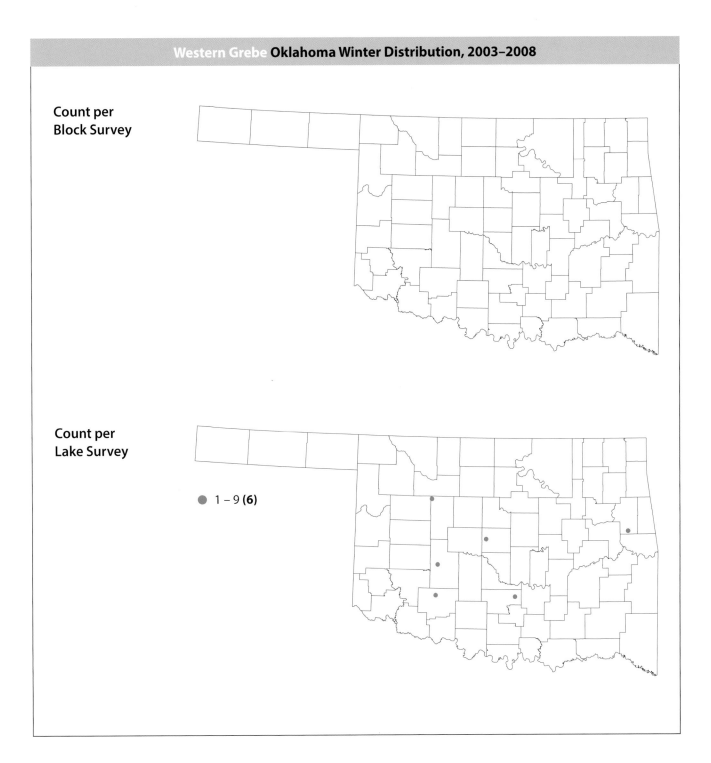

Count per
Block Survey

Count per
Lake Survey

● 1 – 9 **(6)**

**References**

National Audubon Society. 2011. The Christmas Bird Count historical results. http://www
.christmasbirdcount.org.

Oklahoma Bird Records Committee. 2004. 2003–2004 winter season. *The Scissortail* 54:25–27.

———. 2007. 2006–2007 winter season. *The Scissortail* 57:24–27.

———. 2009a. 2007–2008 winter season. *The Scissortail* 59:4–8.

———. 2009b. *Date Guide to the Occurrences of Birds in Oklahoma.* 5th ed. Norman: Oklahoma
Ornithological Society.

Storer, R. W., and G. L. Nuechterlein. 1992. Western Grebe (*Aechmophorus occidentalis*). *The Birds of North
America Online*, edited by A. Poole. Ithaca, N.Y.: Cornell Laboratory of Ornithology. http://bna.birds
.cornell.edu.

# Clark's Grebe
*Aechmophorus clarkii*

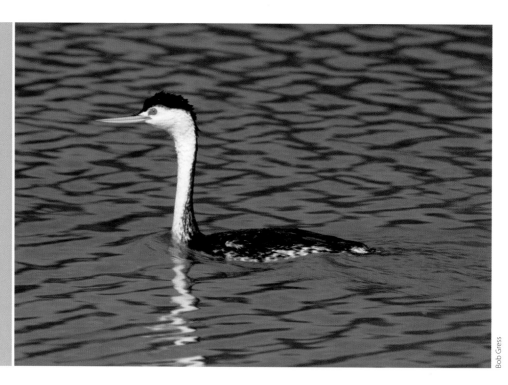

Bob Gress

**Occurrence:** Rare.

**Habitat:** Lakes.

**North American distribution:** Breeds in south-central Canada and a large portion of the western lower 48 states. Resident in parts of the western United States and in Mexico. Winters in parts of the southwestern United States and in Mexico.

**Oklahoma distribution:** Not recorded in survey blocks. Reported from Comanche County (Lake Lawtonka) in December 2003 (special interest species report) and in January and February 2007 (see lake survey map).

**Behavior:** Although Clark's Grebes tend to be gregarious, because of their rarity in Oklahoma, reports of single birds are most common, but they often associate with Western Grebes. Clarke's Grebes forage by diving and swimming underwater, where they capture fish by spearing them or grabbing them with their bills.

## Christmas Bird Count (CBC) Results, 1960–2009

$R^2 = 0.0267$

## CBC Results, 2003–2008

| Winter | Number recorded | Counts reporting |
|---|---|---|
| 2003–2004 | 0 | — |
| 2004–2005 | 0 | — |
| 2005–2006 | 0 | — |
| 2006–2007 | 0 | — |
| 2007–2008 | 0 | — |

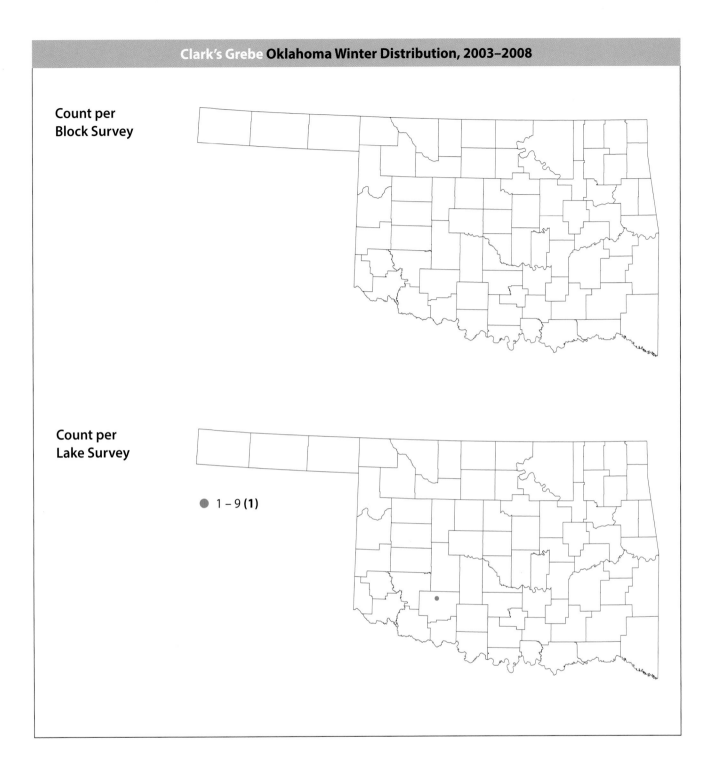

Count per
Block Survey

Count per
Lake Survey

● 1 – 9 **(1)**

### References

National Audubon Society. 2011. The Christmas Bird Count historical results. http://www
.christmasbirdcount.org.

Oklahoma Bird Records Committee. 2006. 2005–2006 winter season. *The Scissortail* 56:14–15.

———. 2009. *Date Guide to the Occurrences of Birds in Oklahoma.* 5th ed. Norman: Oklahoma
Ornithological Society.

Storer, R. W., and G. L. Nuechterlein. 1992. Clark's Grebe (*Aechmophorus clarkii*). *The Birds of North America
Online,* edited by A. Poole. Ithaca, N.Y.: Cornell Laboratory of Ornithology. http://bna.birds.cornell.edu.

# ORDER **COLUMBIFORMES**

## Rock Pigeon
*Columba livia*

James Arterburn

**Occurrence:** Year-round resident.

**Habitat:** Urban areas, farm buildings, dams, and large bridges.

**North American distribution:** Introduced by early European colonists and now resident from southern Canada south through Mexico.

**Oklahoma distribution:** Recorded statewide in survey blocks in low to moderate abundance, with a few blocks having higher abundances. Noticeably less common in Osage County tallgrass prairies and heavily forested southeastern counties. As expected for a resident species, the summer distribution recorded by the Oklahoma Breeding Bird Atlas Project was similar.

**Behavior:** Rock Pigeons may be seen singly but are often seen roosting, feeding, or flying in groups. They forage mostly on the ground for seeds and fruits. They can nest during any month of the year.

### Christmas Bird Count (CBC) Results, 1960–2009

$R^2 = 0.7388$

### CBC Results, 2003–2008

| Winter | Number recorded | Counts reporting |
|--------|-----------------|------------------|
| 2003–2004 | 2,347 | 18 |
| 2004–2005 | 4,037 | 18 |
| 2005–2006 | 3,059 | 18 |
| 2006–2007 | 4,389 | 17 |
| 2007–2008 | 1,211 | 18 |

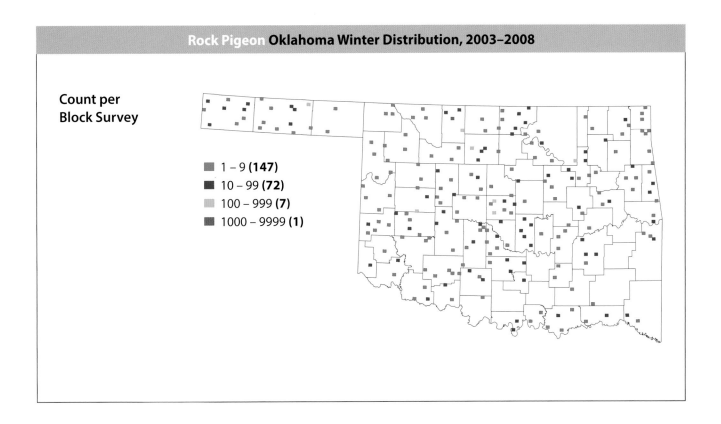

**Count per
Block Survey**

■ 1 – 9 **(147)**
■ 10 – 99 **(72)**
▩ 100 – 999 **(7)**
▦ 1000 – 9999 **(1)**

### References

Johnston, Richard F. 1992. Rock Pigeon (*Columba livia*). *The Birds of North America Online*, edited by
A. Poole. Ithaca, N.Y.: Cornell Laboratory of Ornithology. http://bna.birds.cornell.edu.
National Audubon Society. 2011. The Christmas Bird Count historical results. http://www
.christmasbirdcount.org.
Oklahoma Bird Records Committee. 2009. *Date Guide to the Occurrences of Birds in Oklahoma*. 5th ed.
Norman: Oklahoma Ornithological Society.
Reinking, D. L., ed. 2004. *Oklahoma Breeding Bird Atlas*. Norman: University of Oklahoma Press.

# Eurasian Collared-Dove

*Streptopelia decaocto*

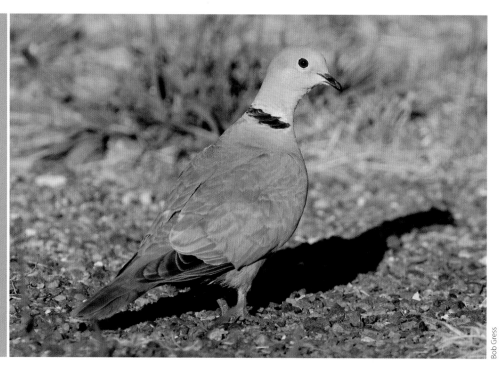

Bob Gress

**Occurrence:** Year-round resident.

**Habitat:** Cities and towns and open country with trees or shrubs.

**North American distribution:** Resident across the majority of the lower 48 states and parts of southern Canada after expanding its range during the past 30 years following its establishment in Florida in the 1980s.

**Oklahoma distribution:** Recorded at numerous but scattered locations across the state, with a slightly higher concentration in central and western counties. Its dramatic expansion across Oklahoma during the past decade is clearly shown by a comparison of these results with the summer distribution recorded by the Oklahoma Breeding Bird Atlas Project, in which only two blocks with this species were noted.

**Behavior:** Eurasian Collared-Doves are gregarious, particularly during the fall and winter. They may be seen singly or in flocks, especially at food sources. They forage on the ground for waste grain and for spilled seeds under bird feeders.

## Christmas Bird Count (CBC) Results, 1960–2009

$R^2 = 0.3065$

## CBC Results, 2003–2008

| Winter | Number recorded | Counts reporting |
|---|---|---|
| 2003–2004 | 46 | 5 |
| 2004–2005 | 95 | 11 |
| 2005–2006 | 201 | 12 |
| 2006–2007 | 205 | 12 |
| 2007–2008 | 203 | 12 |

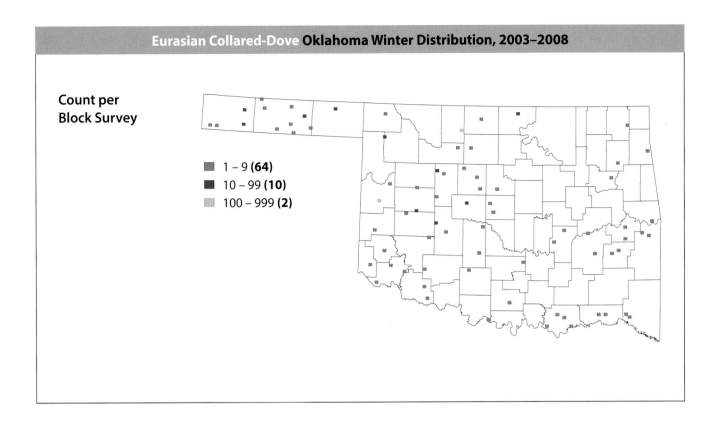

Count per
Block Survey

■ 1 – 9 **(64)**
■ 10 – 99 **(10)**
▦ 100 – 999 **(2)**

### References

Brown, M. B., and J. S. Tomer. 2002. The status of the Eurasian Collared-Dove in Oklahoma. *Bulletin of the Oklahoma Ornithological Society* 35:5–8.

National Audubon Society. 2011. The Christmas Bird Count historical results. http://www.christmasbirdcount.org.

Oklahoma Bird Records Committee. 2009. *Date Guide to the Occurrences of Birds in Oklahoma*. 5th ed. Norman: Oklahoma Ornithological Society.

Reinking, D. L., ed. 2004. *Oklahoma Breeding Bird Atlas*. Norman: University of Oklahoma Press.

Romagosa, Christina Margarita. 2002. Eurasian Collared-Dove (*Streptopelia decaocto*). *The Birds of North America Online*, edited by A. Poole. Ithaca, N.Y.: Cornell Laboratory of Ornithology. http://bna.birds.cornell.edu.

# Inca Dove
## *Columbina inca*

Bob Gress

**Occurrence:** Year-round resident.

**Habitat:** Cities, towns, and farmsteads where areas of short grass such as lawns are present.

**North American distribution:** Resident in parts of the southwestern United States and in Mexico.

**Oklahoma distribution:** Recorded in just three survey blocks in the southern half of the state. Special interest species reports were also received from McCurtain County in December 2003 through February 2004 (up to 17 birds in Eagletown and 1 in Broken Bow); McCurtain County in December 2004 and January 2005 (up to 21 birds in Eagletown and 1 in Broken Bow); McCurtain County in February 2006 (up to 4 birds at two locations); McCurtain County in December 2007 (7 birds); at Norman in Cleveland County in January 2005 (3 birds); at El Dorado in Jackson County in February 2006 (2 birds); at Blackwell in Alfalfa County in December 2005 (1 bird); at Pauls Valley in Garvin County throughout the winter of 2006–2007 (5 birds); and at Lawton in Comanche County in December 2006 and January 2007 (up to 3 birds) and in January 2008 (2 birds). An additional published record from Tulsa County occurred in January and February 2008 (up to 6 birds in two locations; Oklahoma Bird Records Committee 2009a). Two summer records were collected during the Oklahoma Breeding Bird Atlas Project. This species remains fairly uncommon and locally distributed in the state but may be on the increase.

**Behavior:** Inca Doves are gregarious in winter, although the small numbers present in Oklahoma make it more likely to see one or a few rather than a large flock. They forage on the ground, often on lawns, for grains and grass seeds. They will readily visit backyard bird feeders for spilled seeds and may be seen foraging with other doves as well as blackbirds or starlings.

### Christmas Bird Count (CBC) Results, 1960–2009

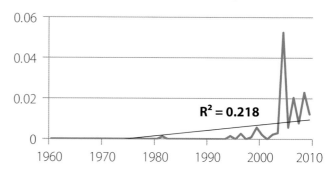

$R^2 = 0.218$

### CBC Results, 2003–2008

| Winter | Number recorded | Counts reporting |
|---|---|---|
| 2003–2004 | 3 | 1 |
| 2004–2005 | 59 | 4 |
| 2005–2006 | 6 | 5 |
| 2006–2007 | 21 | 4 |
| 2007–2008 | 6 | 3 |

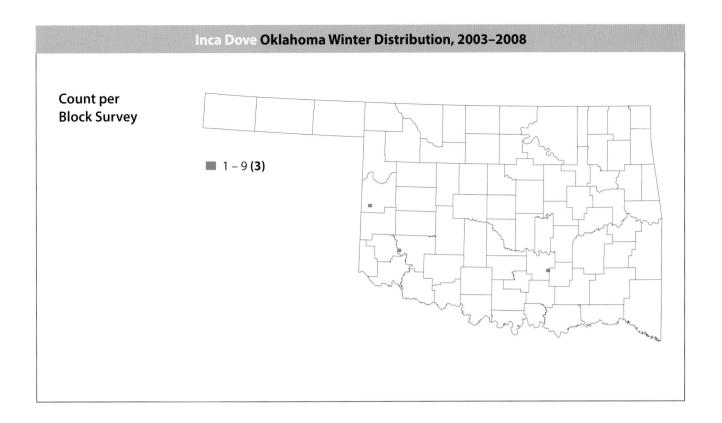

Count per
Block Survey

■ 1 – 9 **(3)**

### References

Bartnicki, E. A. 1979. Inca Dove in Comanche County, Oklahoma. *Bulletin of the Oklahoma Ornithological Society* 12:31–32.

Meisenzahl, K. A., and S. Meisenzahl. 1992. Another Inca Dove in Comanche County, Oklahoma. *Bulletin of the Oklahoma Ornithological Society* 25:33.

Mueller, Allan, and Allan J. Mueller. 2004. Inca Dove (*Columbina inca*). *The Birds of North America Online*, edited by A. Poole. Ithaca, N.Y.: Cornell Laboratory of Ornithology. http://bna.birds.cornell.edu.

National Audubon Society. 2011. The Christmas Bird Count historical results. http://www .christmasbirdcount.org.

Oklahoma Bird Records Committee. 2004. 2003–2004 winter season. *The Scissortail* 54:25–27.

———. 2006. 2005–2006 winter season. *The Scissortail* 56:14–15.

———. 2009a. 2007–2008 winter season. *The Scissortail* 59:4–8.

———. 2009b. *Date Guide to the Occurrences of Birds in Oklahoma*. 5th ed. Norman: Oklahoma Ornithological Society.

Reinking, D. L., ed. 2004. *Oklahoma Breeding Bird Atlas*. Norman: University of Oklahoma Press.

Tyler, J. D. 1974. Inca dove in Jackson County, Oklahoma. *Bulletin of the Oklahoma Ornithological Society* 7:63.

# Common Ground-Dove
*Columbina passerina*

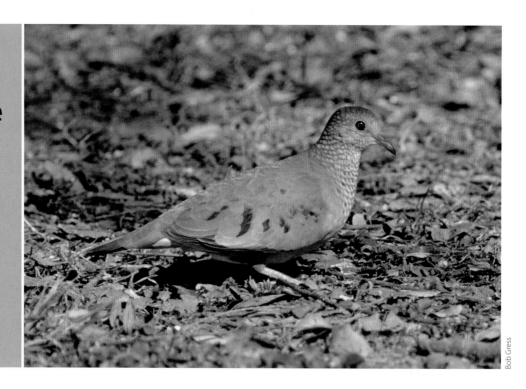

Bob Gress

**Occurrence:** Rare.

**Habitat:** Open woodlands and old fields.

**North American distribution:** Resident in parts of the southeastern and southwestern United States and in Mexico.

**Oklahoma distribution:** Not recorded in survey blocks. One pair reported throughout the winter of 2004–2005 in McCurtain County at Red Slough Wildlife Management Area.

**Behavior:** Common Ground-Doves are usually seen singly or in pairs. They forage on the ground for seeds, berries, and insects and will visit bird feeders for spilled seeds.

## Christmas Bird Count (CBC) Results, 1960–2009

$R^2 = 0.0453$

## CBC Results, 2003–2008

| Winter | Number recorded | Counts reporting |
|--------|-----------------|------------------|
| 2003–2004 | 0 | — |
| 2004–2005 | 0 | — |
| 2005–2006 | 0 | — |
| 2006–2007 | 3 | 1 |
| 2007–2008 | 0 | — |

# Common Ground-Dove Oklahoma Winter Distribution, 2003–2008

**Count per
Block Survey**

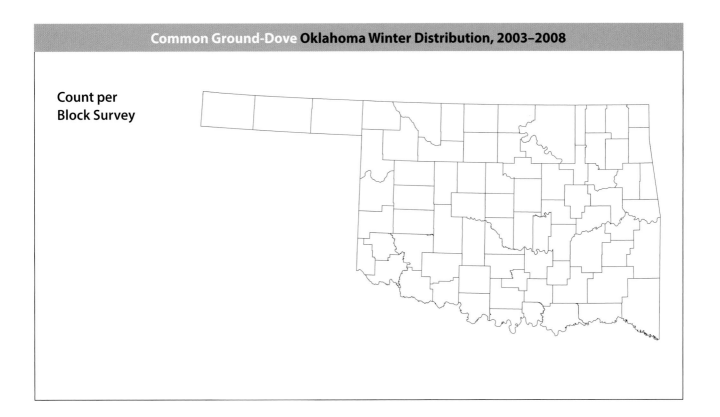

### References

Bowman, Reed. 2002. Common Ground-Dove (*Columbina passerina*). *The Birds of North America Online*, edited by A. Poole. Ithaca, N.Y.: Cornell Laboratory of Ornithology. http://bna.birds.cornell.edu.

National Audubon Society. 2011. The Christmas Bird Count historical results. http://www.christmasbirdcount.org.

Norman, J. L. 1971. Ground Dove in Wagoner County, Oklahoma. *Bulletin of the Oklahoma Ornithological Society* 4:34.

Oklahoma Bird Records Committee. 2009. *Date Guide to the Occurrences of Birds in Oklahoma*. 5th ed. Norman: Oklahoma Ornithological Society.

ORDER **COLUMBIFORMES**

# White-winged Dove

*Zenaida asiatica*

Bob Gress

**Occurrence:** Year-round resident.

**Habitat:** Most often in cities and towns, but also in agricultural areas.

**North American distribution:** Breeding and resident populations are widespread in the southwestern United States and in Mexico, with both wintering and resident populations present along the Gulf Coast of the United States.

**Oklahoma distribution:** Recorded in two Oklahoma County survey blocks and in two Cimarron County blocks. This species has expanded its range northward in recent years to include Oklahoma. It was not detected during the Oklahoma Breeding Bird Atlas Project.

**Behavior:** White-winged Doves can be seen singly or in flocks, and they often associate with other species such as Mourning Doves. They forage both on the ground for seeds and fruit and aboveground on grain seed heads or on bird feeders.

## Christmas Bird Count (CBC) Results, 1960–2009

$R^2 = 0.2152$

## CBC Results, 2003–2008

| Winter | Number recorded | Counts reporting |
|--------|-----------------|------------------|
| 2003–2004 | 3 | 2 |
| 2004–2005 | 4 | 1 |
| 2005–2006 | 3 | 1 |
| 2006–2007 | 10 | 3 |
| 2007–2008 | 18 | 2 |

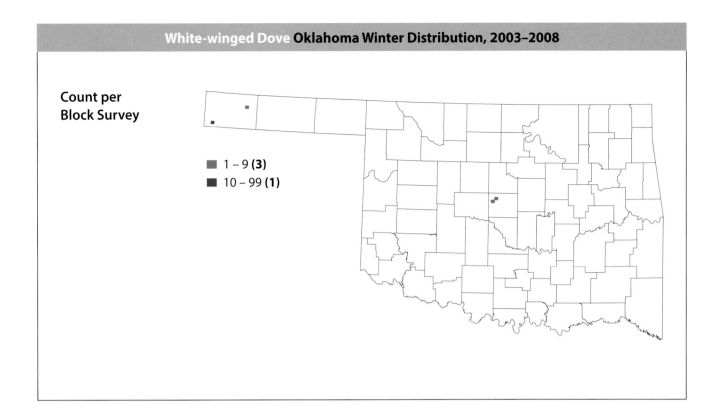

**Count per Block Survey**

■ 1 – 9 **(3)**
■ 10 – 99 **(1)**

### References

Brewer, M. 1987. White-winged Dove: A new bird for Oklahoma. *Bulletin of the Oklahoma Ornithological Society* 20:25–26.

National Audubon Society. 2011. The Christmas Bird Count historical results. http://www .christmasbirdcount.org.

Oklahoma Bird Records Committee. 2009. *Date Guide to the Occurrences of Birds in Oklahoma*. 5th ed. Norman: Oklahoma Ornithological Society.

Schwertner, T. W., H. A. Mathewson, J. A. Roberson, M. Small, and G. L. Waggerman. 2002. White-winged Dove (*Zenaida asiatica*). *The Birds of North America Online*, edited by A. Poole. Ithaca, N.Y.: Cornell Laboratory of Ornithology. http://bna.birds.cornell.edu.

ORDER COLUMBIFORMES

# Mourning Dove

*Zenaida macroura*

Bob Gress

**Occurrence:** Generally a year-round resident, although some partial, short-distance migration takes place. In addition, many more individuals pass through the state during spring and fall migrations to and from northern breeding grounds.

**Habitat:** Very wide variety, including grasslands, open woodlands, farmsteads, and cities and towns.

**North American distribution:** Breeds in southern Canada and the northern United States, and resident across the rest of the United States and much of Mexico.

**Oklahoma distribution:** Recorded statewide in most survey blocks, with the highest abundances generally found in the southwestern counties. As expected for a largely resident species, the summer distribution recorded by the Oklahoma Breeding Bird Atlas Project was similar. Partial migration was apparent, however, in that it ranked first in the number of blocks in which it occurred during summer (556), but only 20th during winter (446).

**Behavior:** Mourning Doves are often seen in groups containing several birds to hundreds of birds during the winter. They forage for seeds on bare or sparsely vegetated ground, and they will visit bird feeders for spilled seeds.

### Christmas Bird Count (CBC) Results, 1960–2009

$R^2 = 0.1244$

### CBC Results, 2003–2008

| Winter | Number recorded | Counts reporting |
|--------|-----------------|------------------|
| 2003–2004 | 1,530 | 19 |
| 2004–2005 | 1,520 | 20 |
| 2005–2006 | 2,863 | 20 |
| 2006–2007 | 1,487 | 17 |
| 2007–2008 | 1,431 | 18 |

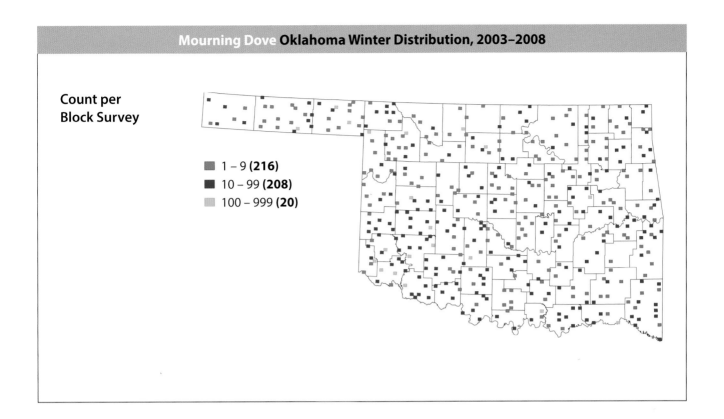

**Count per Block Survey**

- 1 – 9 **(216)**
- 10 – 99 **(208)**
- 100 – 999 **(20)**

### References

National Audubon Society. 2011. The Christmas Bird Count historical results. http://www
.christmasbirdcount.org.

Oklahoma Bird Records Committee. 2009. *Date Guide to the Occurrences of Birds in Oklahoma*. 5th ed.
Norman: Oklahoma Ornithological Society.

Otis, David L., John H. Schulz, David Miller, R. E. Mirarchi, and T. S. Baskett. 2008. Mourning Dove (*Zenaida
macroura*). *The Birds of North America Online*, edited by A. Poole. Ithaca, N.Y.: Cornell Laboratory of
Ornithology. http://bna.birds.cornell.edu.

Reinking, D. L., ed. 2004. *Oklahoma Breeding Bird Atlas*. Norman: University of Oklahoma Press.

# ORDER **CUCULIFORMES**

**Greater Roadrunner**

*Geococcyx californianus*

James Arterburn

**Occurrence:** Year-round resident.

**Habitat:** Rugged country and brushy areas.

**North American distribution:** Resident in a large portion of the south-central and southwestern United States.

**Oklahoma distribution:** Recorded across much of the state, with the highest concentrations of records in the central, southwestern, and northwestern counties. The summer distribution recorded by the Oklahoma Breeding Bird Atlas Project was similar.

**Behavior:** Greater Roadrunners can be seen singly or in pairs. Although capable of limited flight, they accomplish most of their travel on foot. They sometimes sunbathe on cold mornings, holding their wings drooped away from their bodies and allowing the warming rays to reach their black skin. They chase down prey including insects, lizards, snakes, small mammals, and even small birds by grabbing them in their bill. Roadrunners are sometimes attracted to bird feeders because of the small birds available there as prey, and they may also eat dog and cat food placed out for pets.

**Christmas Bird Count (CBC) Results, 1960–2009**

$R^2 = 0.0024$

**CBC Results, 2003–2008**

| Winter | Number recorded | Counts reporting |
| --- | --- | --- |
| 2003–2004 | 17 | 9 |
| 2004–2005 | 14 | 8 |
| 2005–2006 | 14 | 9 |
| 2006–2007 | 25 | 8 |
| 2007–2008 | 20 | 10 |

**Count per
Block Survey**

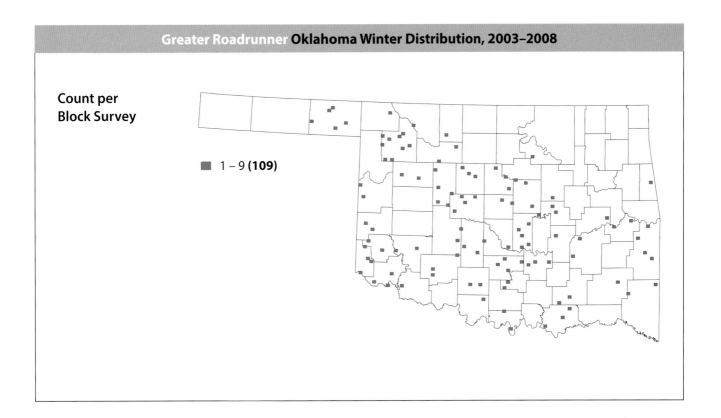

■ 1 – 9 **(109)**

### References

Beal, K. G. 1981. Winter foraging habits of the roadrunner. *Bulletin of the Oklahoma Ornithological Society* 14:5–7.

Geluso, K. N. 1969. Food and survival problems of Oklahoma roadrunners in winter. *Bulletin of the Oklahoma Ornithological Society* 2:5–6.

———. 1970a. Additional notes on food and fat of roadrunners in winter. *Bulletin of the Oklahoma Ornithological Society* 3:6.

———. 1970b. Feeding behavior of a roadrunner in winter. *Bulletin of the Oklahoma Ornithological Society* 3:32.

Hughes, Janice M. 1996. Greater Roadrunner (*Geococcyx californianus*). *The Birds of North America Online*, edited by A. Poole. Ithaca, N.Y.: Cornell Laboratory of Ornithology. http://bna.birds.cornell.edu.

National Audubon Society. 2011. The Christmas Bird Count historical results. http://www.christmasbirdcount.org.

Oklahoma Bird Records Committee. 2009. *Date Guide to the Occurrences of Birds in Oklahoma*. 5th ed. Norman: Oklahoma Ornithological Society.

Reinking, D. L., ed. 2004. *Oklahoma Breeding Bird Atlas*. Norman: University of Oklahoma Press.

Shetlar, D. J. 1971. Winter food of a central Oklahoma roadrunner. *Bulletin of the Oklahoma Ornithological Society* 4:35.

Sutton, G. M. 1972. Winter food of a central Oklahoma roadrunner. *Bulletin of the Oklahoma Ornithological Society* 5:30.

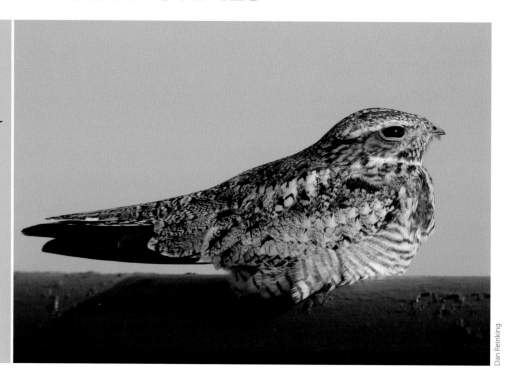

## Common Nighthawk
### *Chordeiles minor*

Dan Reinking

**Occurrence:** Late April through late October.

**Habitat:** Open prairies, as well as cities and towns.

**North American distribution:** Breeds over much of Canada, the lower 48 states, and parts of Mexico. Winters in South America.

**Oklahoma distribution:** Not recorded in survey blocks and not a regular wintering species. Recorded in Tulsa on December 5, 2004 (Oklahoma Bird Records Committee 2005). The Oklahoma Breeding Bird Atlas Project recorded it nearly statewide in summer, though most commonly in northern and western counties.

**Behavior:** Common Nighthawks frequently occur in large flocks during fall migration, but because they are extremely unusual in Oklahoma in winter, a single bird as reported above is more likely. Nighthawks forage by capturing insects in flight.

### Christmas Bird Count (CBC) Results, 1960–2009

$R^2 = 0.0267$

### CBC Results, 2003–2008

| Winter | Number recorded | Counts reporting |
|---|---|---|
| 2003–2004 | 0 | — |
| 2004–2005 | 0 | — |
| 2005–2006 | 1 | 1 |
| 2006–2007 | 0 | — |
| 2007–2008 | 0 | — |

Count per
Block Survey

### References

National Audubon Society. 2011. The Christmas Bird Count historical results. http://www
    .christmasbirdcount.org.
Oklahoma Bird Records Committee. 2005. 2004–2005 winter season. *The Scissortail* 55:18–20.
———. 2009. *Date Guide to the Occurrences of Birds in Oklahoma.* 5th ed. Norman: Oklahoma
    Ornithological Society.
Poulin, R. G., S. D. Grindal, and R. M. Brigham. 1996. Common Nighthawk (*Chordeiles minor*). *The Birds of
    North America Online,* edited by A. Poole. Ithaca, N.Y.: Cornell Laboratory of Ornithology. http://bna
    .birds.cornell.edu.
Reinking, D. L., ed. 2004. *Oklahoma Breeding Bird Atlas.* Norman: University of Oklahoma Press.

# ORDER **APODIFORMES**

## Rufous Hummingbird
### *Selasphorus rufus*

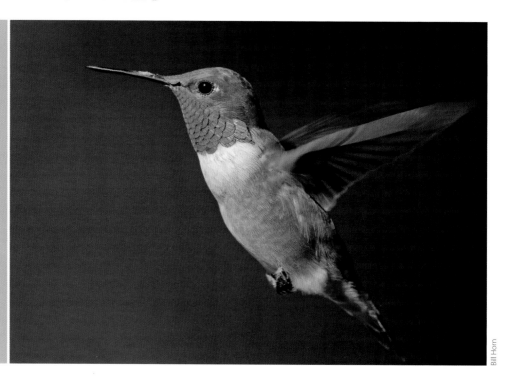

Bill Horn

**Occurrence:** Rare visitor, mostly from late July through late November.

**Habitat:** Typically discovered at hummingbird feeders.

**North American distribution:** Breeds in southern Alaska, western Canada, and the northwestern United States. Winters in the southeastern United States and in Mexico.

**Oklahoma distribution:** Recorded in one Tulsa County survey block in December 2004. Also reported from Oklahoma County December 5–12, 2004 (Oklahoma Bird Records Committee [OBRC] 2005). A *Selasphorus* hummingbird was reported in Tulsa County, and another in Comanche County, throughout the winter of 2003–2004 (OBRC 2004). Another was reported during January 2008 in Pittsburg County (OBRC 2009a). Seldom present during December through February.

**Behavior:** Because of their rarity in Oklahoma, Rufous Hummingbirds are usually seen singly, visiting hummingbird feeders for sugar syrup. Early in the fall, Ruby-throated or Black-chinned Hummingbirds may also be present, depending on the location, but in late fall and winter the Rufous Hummingbird is more likely to be the only individual hummingbird present at a feeder.

**CBC Results, 2003–2008**

| Winter | Number recorded | Counts reporting |
| --- | --- | --- |
| 2003–2004 | 0 | — |
| 2004–2005 | 0 | — |
| 2005–2006 | 0 | — |
| 2006–2007 | 0 | — |
| 2007–2008 | 0 | — |

**Count per Block Survey**

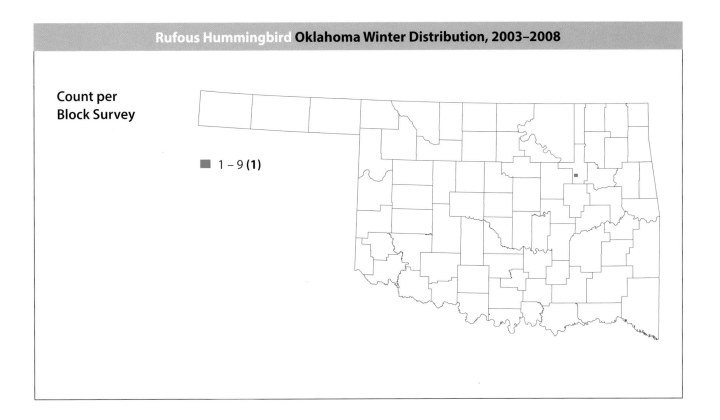

■ 1 – 9 **(1)**

### References

Goard, D. M. 1975. Rufous Hummingbird winters again in northeastern Oklahoma. *Bulletin of the Oklahoma Ornithological Society* 8:36–37.

Hayes, E. 1979. Rufous Hummingbird again in Tulsa. *Bulletin of the Oklahoma Ornithological Society* 12:21–23.

Healy, Susan, and William A. Calder. 2006. Rufous Hummingbird (*Selasphorus rufus*). *The Birds of North America Online*, edited by A. Poole. Ithaca, N.Y.: Cornell Laboratory of Ornithology. http://bna.birds .cornell.edu.

McMahon, J. 1983. Rufous Hummingbird in Muskogee County, Oklahoma. *Bulletin of the Oklahoma Ornithological Society* 16:5.

National Audubon Society. 2011. The Christmas Bird Count historical results. http://www .christmasbirdcount.org.

Oklahoma Bird Records Committee. 2004. 2003–2004 winter season. *The Scissortail* 54:25–27.

———. 2005. 2004–2005 winter season. *The Scissortail* 55:18–20.

———. 2009a. 2007–2008 winter season. *The Scissortail* 59:4–8.

———. 2009b. *Date Guide to the Occurrences of Birds in Oklahoma.* 5th ed. Norman: Oklahoma Ornithological Society.

Tomer, J. S. 1972. Rufous Hummingbird in Oklahoma in winter. *Bulletin of the Oklahoma Ornithological Society* 5:20.

## Yellow Rail
*Coturnicops noveboracensis*

© (Brian E. Small) / VIREO

**Occurrence:** Early October through January in southeastern McCurtain County.

**Habitat:** Marshes and wet grasslands.

**North American distribution:** Breeds in Canada and parts of the northern and western lower 48 states. Winters along the Atlantic and Gulf Coasts of the southeastern United States.

**Oklahoma distribution:** Not recorded in survey blocks. Only recently found to be wintering in Oklahoma at one location. Special interest species reports came from McCurtain County (Red Slough Wildlife Management Area) in December 2004 (up to 22 birds), December 2005 (4 birds), and January 2008.

**Behavior:** Multiple Yellow Rails can be found occupying suitable habitat during fall and winter, but whether they actually associate with one another is not clear. They forage for snails, insects, and seeds in shallow water with concealing vegetation.

### CBC Results, 2003–2008

| Winter | Number recorded | Counts reporting |
|---|---|---|
| 2003–2004 | 0 | — |
| 2004–2005 | 0 | — |
| 2005–2006 | 0 | — |
| 2006–2007 | 0 | — |
| 2007–2008 | 0 | — |

Count per
Block Survey

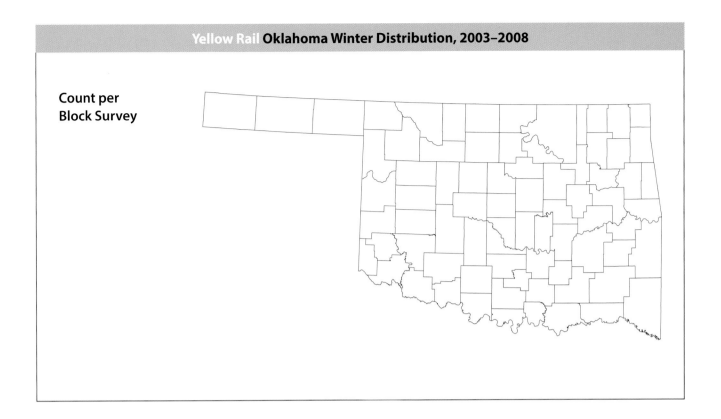

### References

Bookhout, Theodore A. 1995. Yellow Rail (*Coturnicops noveboracensis*). *The Birds of North America Online*, edited by A. Poole. Ithaca, N.Y.: Cornell Laboratory of Ornithology. http://bna.birds.cornell.edu.

Heck, B. A., and D. Arbour. 2008. The Yellow Rail in Oklahoma. *Bulletin of the Oklahoma Ornithological Society* 41:13–15.

National Audubon Society. 2011. The Christmas Bird Count historical results. http://www .christmasbirdcount.org.

Oklahoma Bird Records Committee. 2006. 2005–2006 winter season. *The Scissortail* 56:14–15.

———. 2009. *Date Guide to the Occurrences of Birds in Oklahoma*. 5th ed. Norman: Oklahoma Ornithological Society.

# King Rail
*Rallus elegans*

Bob Gress

**Occurrence:** Present year round in southeastern McCurtain County, and from mid-March to late November in the rest of the state, excluding the Panhandle.

**Habitat:** Marshes and wet, weedy areas.

**North American distribution:** Breeds in widely scattered locations in the eastern half of the United States. Resident along the Gulf Coast and southeastern Atlantic Coast.

**Oklahoma distribution:** Not recorded in survey blocks. Special interest species reports were received for the winters of 2003–2004 and 2004–2005 at Red Slough Wildlife Management Area in McCurtain County. Summer records from Hackberry Flat Wildlife Management Area in Tillman County and Red Slough were reported during the Oklahoma Breeding Bird Atlas Project.

**Behavior:** King Rails are usually seen singly during the winter. They forage by wading through shallow water near cover in search of crayfish and aquatic insects.

## CBC Results, 2003–2008

| Winter | Number recorded | Counts reporting |
| --- | --- | --- |
| 2003–2004 | 0 | — |
| 2004–2005 | 0 | — |
| 2005–2006 | 0 | — |
| 2006–2007 | 0 | — |
| 2007–2008 | 0 | — |

**Count per
Block Survey**

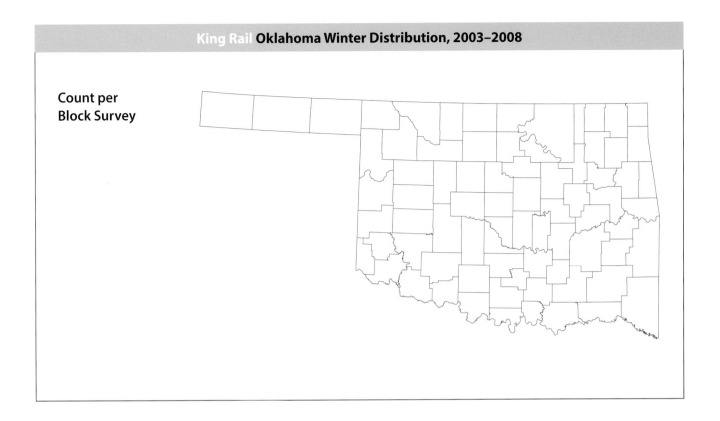

### References

National Audubon Society. 2011. The Christmas Bird Count historical results. http://www
.christmasbirdcount.org.

Oklahoma Bird Records Committee. 2009. *Date Guide to the Occurrences of Birds in Oklahoma*. 5th ed.
Norman: Oklahoma Ornithological Society.

Poole, Alan F., L. R. Bevier, C. A. Marantz, and Brooke Meanley. 2005. King Rail (*Rallus elegans*). *The Birds of
North America Online*, edited by A. Poole. Ithaca, N.Y.: Cornell Laboratory of Ornithology. http://bna
.birds.cornell.edu.

Reinking, D. L., ed. 2004. *Oklahoma Breeding Bird Atlas*. Norman: University of Oklahoma Press.

# Virginia Rail
## *Rallus limicola*

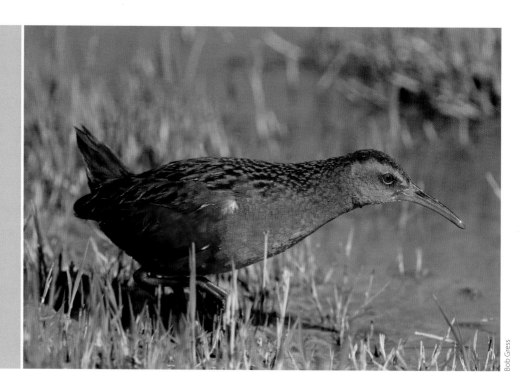

Bob Gress

**Occurrence:** September through mid-May.

**Habitat:** Marshes.

**North American distribution:** Breeds in southern Canada and parts of the western and northern lower 48 states. Resident in parts of the northeastern and western United States and winters in the southeastern United States and Mexico.

**Oklahoma distribution:** Recorded in just three survey blocks in northwestern counties. The standard block surveys were not effective in recording this species because of its preference for wetland habitat, which is uncommon and local in its distribution. Additional special interest species reports were received from Blaine, Cleveland, Ellis, McCurtain, Roger Mills, and Woodward Counties, indicating a more widespread distribution of this species if appropriate habitat is sought and searched. No summer records were recorded during the Oklahoma Breeding Bird Atlas Project.

**Behavior:** Virginia Rails are usually seen singly. Their strong legs and long toes help them walk through and over emergent marsh vegetation. They forage for invertebrates as well as aquatic plants and seeds.

## Christmas Bird Count (CBC) Results, 1960–2009

$R^2 = 0.2369$

## CBC Results, 2003–2008

| Winter | Number recorded | Counts reporting |
|--------|-----------------|------------------|
| 2003–2004 | 2 | 1 |
| 2004–2005 | 10 | 4 |
| 2005–2006 | 3 | 2 |
| 2006–2007 | 5 | 2 |
| 2007–2008 | 7 | 2 |

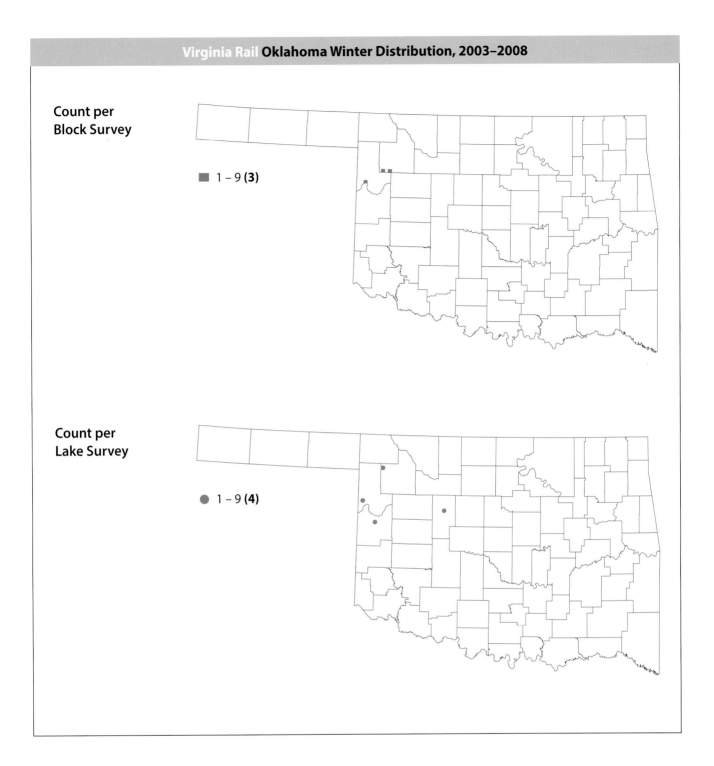

**Count per Block Survey**

■ 1 – 9 **(3)**

**Count per Lake Survey**

● 1 – 9 **(4)**

### References

Conway, Courtney J. 1995. Virginia Rail (*Rallus limicola*). *The Birds of North America Online*, edited by A. Poole. Ithaca, N.Y.: Cornell Laboratory of Ornithology. http://bna.birds.cornell.edu.

National Audubon Society. 2011. The Christmas Bird Count historical results. http://www .christmasbirdcount.org.

Oklahoma Bird Records Committee. 2009. *Date Guide to the Occurrences of Birds in Oklahoma*. 5th ed. Norman: Oklahoma Ornithological Society.

Reinking, D. L., ed. 2004. *Oklahoma Breeding Bird Atlas*. Norman: University of Oklahoma Press.

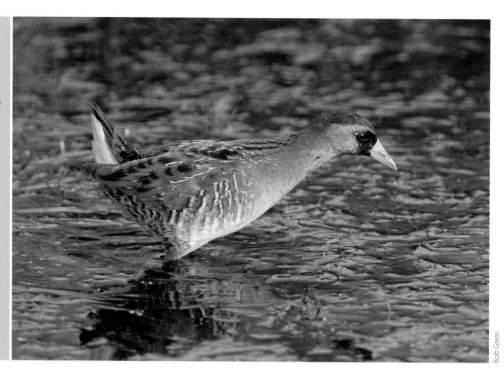

ORDER **GRUIFORMES**

# Sora
*Porzana carolina*

Bob Gress

**Occurrence:** Mid-August through mid-May in southeastern Oklahoma.

**Habitat:** Wetlands.

**North American distribution:** Breeds across much of Canada and the lower 48 states except for southeastern and southwestern portions. Winters in southern California, the southeastern United States, and Mexico.

**Oklahoma distribution:** Not recorded in survey blocks. Special interest species reports came from Blaine County (Roman Nose State Park) on January 28, 2005; Cleveland County (near the Canadian River) on December 30, 2007; McCurtain County (Red Slough Wildlife Management Area) throughout the winters of 2004–2005 (two birds) and 2007–2008 (up to nine birds); and McCurtain County (Grassy Slough Wildlife Management Area) in January 2008. The summer distribution recorded by the Oklahoma Breeding Bird Atlas Project consisted of one mid-July observation of multiple birds in Texas County.

**Behavior:** Soras are usually seen (or more often heard) singly, but multiple birds may occupy suitable habitat. They forage for aquatic invertebrates and plant seeds from within emergent wetland vegetation.

## Christmas Bird Count (CBC) Results, 1960–2009

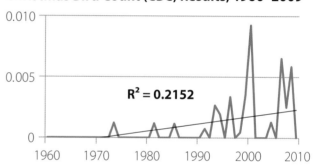

$R^2 = 0.2152$

## CBC Results, 2003–2008

| Winter | Number recorded | Counts reporting |
| --- | --- | --- |
| 2003–2004 | 0 | — |
| 2004–2005 | 1 | 1 |
| 2005–2006 | 0 | — |
| 2006–2007 | 3 | 2 |
| 2007–2008 | 2 | 2 |

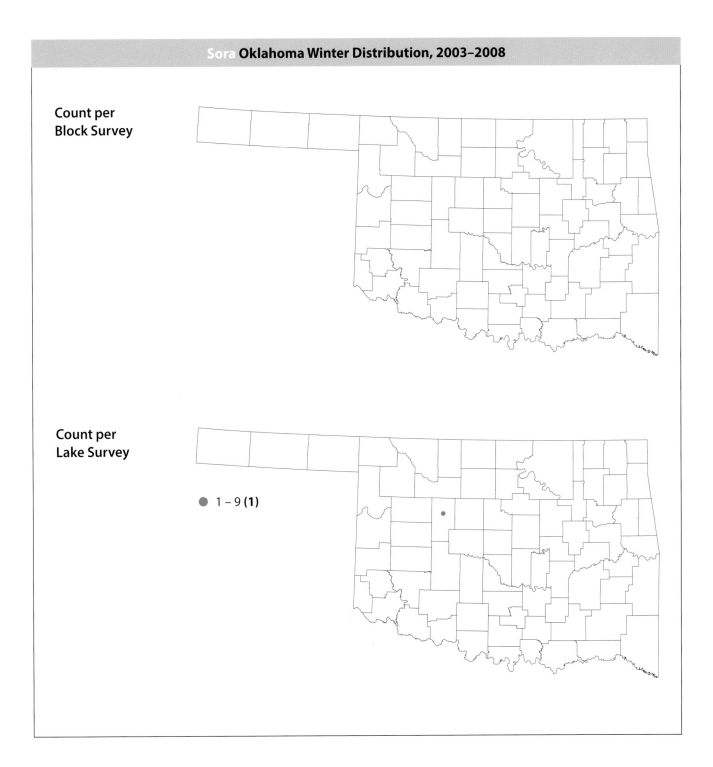

Count per
Block Survey

Count per
Lake Survey

● 1 – 9 **(1)**

### References

Carter, W. A. 1969. Winter records for the Sora rail in Oklahoma. *Bulletin of the Oklahoma Ornithological Society* 2:21.

Melvin, Scott M., and James P. Gibbs. 1996. Sora (*Porzana carolina*). *The Birds of North America Online*, edited by A. Poole. Ithaca, N.Y.: Cornell Laboratory of Ornithology. http://bna.birds.cornell.edu.

National Audubon Society. 2011. The Christmas Bird Count historical results. http://www .christmasbirdcount.org.

Oklahoma Bird Records Committee. 2009. *Date Guide to the Occurrences of Birds in Oklahoma*. 5th ed. Norman: Oklahoma Ornithological Society.

Reinking, D. L., ed. 2004. *Oklahoma Breeding Bird Atlas*. Norman: University of Oklahoma Press.

Tyler, J. D. 1972. Sora rail in southwestern Oklahoma in winter. *Bulletin of the Oklahoma Ornithological Society* 5:28–29.

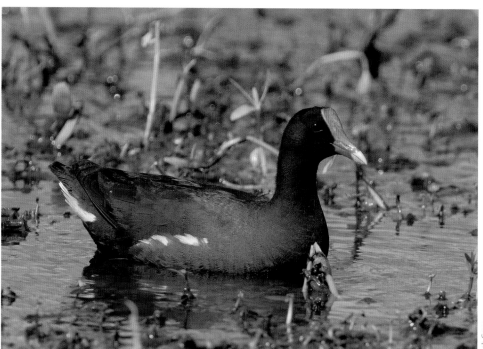

# Common Gallinule

*Gallinula galeata*

**Occurrence:** Late March through mid-November. Rare in winter.

**Habitat:** Marshes.

**North American distribution:** Breeds over scattered portions of the lower 48 states. Resident in the southernmost United States and in Mexico.

**Oklahoma distribution:** Not recorded in survey blocks. Reported from McCurtain County (Red Slough Wildlife Management Area) in December 2004 (two birds) and December 2007. The summer distribution recorded by the Oklahoma Breeding Bird Atlas Project was limited to Kingfisher, Major, and McCurtain Counties.

**Behavior:** Common Gallinules often form small flocks during the winter. They forage primarily on the seeds of grasses and sedges but also eat snails.

## CBC Results, 2003–2008

| Winter | Number recorded | Counts reporting |
|---|---|---|
| 2003–2004 | 0 | — |
| 2004–2005 | 0 | — |
| 2005–2006 | 0 | — |
| 2006–2007 | 0 | — |
| 2007–2008 | 0 | — |

**Count per
Block Survey**

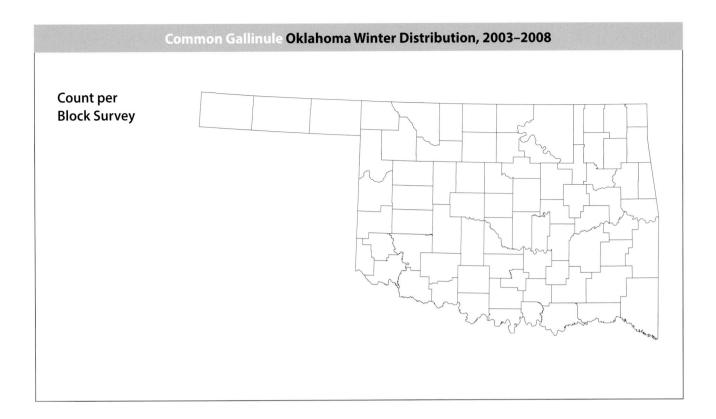

### References

Bannor, Brett K., and Erik Kiviat. 2002. Common Moorhen (*Gallinula chloropus*). *The Birds of North America Online*, edited by A. Poole. Ithaca, N.Y.: Cornell Laboratory of Ornithology. http://bna.birds.cornell.edu.

National Audubon Society. 2011. The Christmas Bird Count historical results. http://www .christmasbirdcount.org.

Oklahoma Bird Records Committee. 2009. *Date Guide to the Occurrences of Birds in Oklahoma*. 5th ed. Norman: Oklahoma Ornithological Society.

Reinking, D. L., ed. 2004. *Oklahoma Breeding Bird Atlas*. Norman: University of Oklahoma Press.

# American Coot
## *Fulica americana*

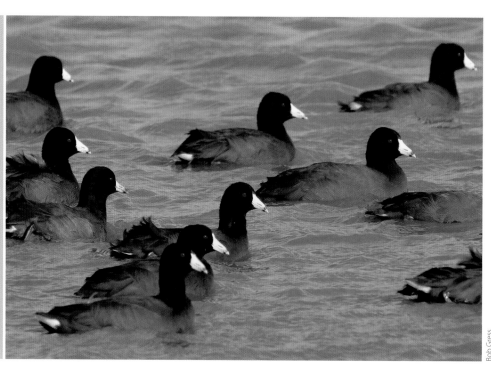

Bob Gress

**Occurrence:** Found in Oklahoma year round but is most abundant during spring and fall migration.

**Habitat:** Ponds, lakes, and marshes.

**North American distribution:** Breeds widely in the northern and western United States and parts of Canada as well as in Mexico and Florida. Winter range includes much of the breeding range, as well as most of the eastern United States.

**Oklahoma distribution:** Coots were recorded at widely scattered locations throughout the state but were most abundant in central and southwestern Oklahoma. Fewer blocks with coots were found during the Oklahoma Breeding Bird Atlas Project, but their overall distribution was similar to that found in the winter surveys.

**Behavior:** Coots are gregarious, and during migration and winter they are frequently seen in flocks numbering in the dozens or even hundreds of birds, although individuals and small groups are also commonly seen. Although they are rails and not ducks, coots often associate with various duck species. Coots obtain aquatic plants and small aquatic animals by pecking the surface of the water or by diving. They also graze on grasses and sprouting plants. They use a running start across the surface of the water to take flight.

## Christmas Bird Count (CBC) Results, 1960–2009

$R^2 = 0.0412$

## CBC Results, 2003–2008

| Winter | Number recorded | Counts reporting |
|--------|-----------------|------------------|
| 2003–2004 | 6,386 | 14 |
| 2004–2005 | 2,316 | 15 |
| 2005–2006 | 4,864 | 17 |
| 2006–2007 | 4,588 | 13 |
| 2007–2008 | 2,177 | 18 |

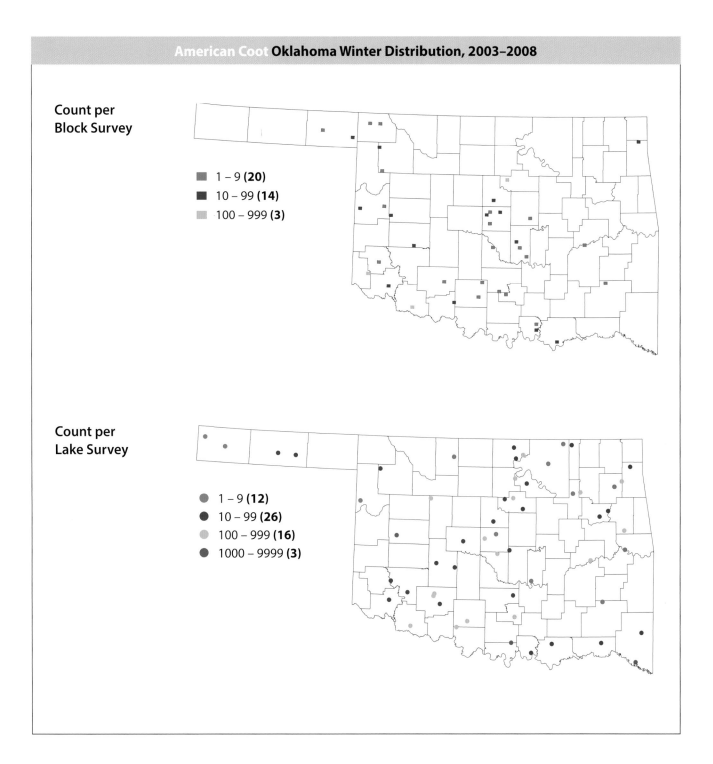

**Count per
Block Survey**

■ 1 – 9 **(20)**
■ 10 – 99 **(14)**
■ 100 – 999 **(3)**

**Count per
Lake Survey**

● 1 – 9 **(12)**
● 10 – 99 **(26)**
● 100 – 999 **(16)**
● 1000 – 9999 **(3)**

**References**

Brisbin, I. Lehr, Jr., and Thomas B. Mowbray. 2002. American Coot (*Fulica americana*). *The Birds of North America Online*, edited by A. Poole. Ithaca, N.Y.: Cornell Laboratory of Ornithology. http://bna.birds .cornell.edu.

Henderson, C. L. 1974. Coots observed eating dead ducks. *Bulletin of the Oklahoma Ornithological Society* 7:62–63.

National Audubon Society. 2011. The Christmas Bird Count historical results. http://www .christmasbirdcount.org.

Reinking, D. L., ed. 2004. *Oklahoma Breeding Bird Atlas*. Norman: University of Oklahoma Press.

# Sandhill Crane
*Antigone canadensis*

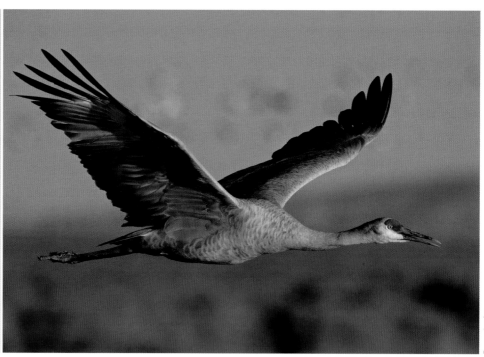

Duane Angles

**Occurrence:** Late September through late April in southern counties, and mainly a fall and spring migrant in northern counties.

**Habitat:** Marshes and grain fields.

**North American distribution:** Breeds in Alaska, much of Canada, and parts of the northeastern and northwestern United States. Resident populations occur in several Gulf Coast states. Winters in parts of the southern United States and in Mexico.

**Oklahoma distribution:** Recorded fairly commonly in survey blocks throughout the western half of the state, with several very large aggregations noted. Some but not all records for northern counties occurred only in the early winter survey period, suggesting the possibility that protracted fall migration was not completed by early December, or that local movements continued throughout the winter. Special interest species reports came from McCurtain County in early February 2004 (five birds), late December 2004 (two birds), and early February 2006 (four birds); and from Osage County on December 18, 2004.

**Behavior:** Pairs and family groups of Sandhill Cranes aggregate into larger flocks during migration and winter. Foraging takes place on the ground or in shallow water, and a variety of winter food items are sought, including mainly grains but also insects and other invertebrates when available.

## Christmas Bird Count (CBC) Results, 1960–2009

$R^2 = 0.1439$

## CBC Results, 2003–2008

| Winter | Number recorded | Counts reporting |
|---|---|---|
| 2003–2004 | 8,100 | 2 |
| 2004–2005 | 5,526 | 3 |
| 2005–2006 | 2,690 | 2 |
| 2006–2007 | 314 | 5 |
| 2007–2008 | 10,758 | 3 |

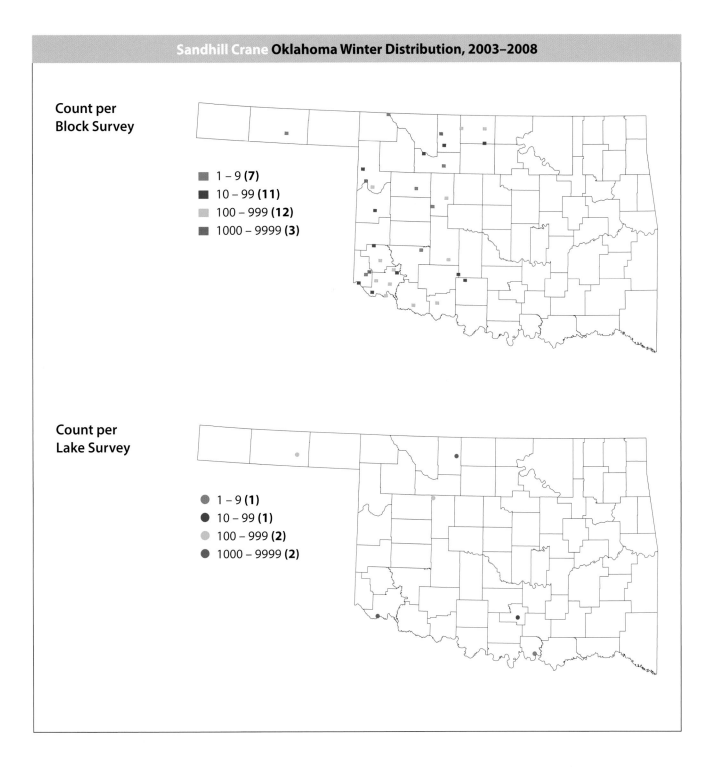

**Count per Block Survey**

- ■ 1 – 9 **(7)**
- ■ 10 – 99 **(11)**
- ■ 100 – 999 **(12)**
- ■ 1000 – 9999 **(3)**

**Count per Lake Survey**

- ● 1 – 9 **(1)**
- ● 10 – 99 **(1)**
- ● 100 – 999 **(2)**
- ● 1000 – 9999 **(2)**

### References

Lewis, J. C. 1970. Sandhill Cranes wintering in Jackson County, Oklahoma. *Bulletin of the Oklahoma Ornithological Society* 3:1–4.

National Audubon Society. 2011. The Christmas Bird Count historical results. http://www .christmasbirdcount.org.

Oklahoma Bird Records Committee. 2004. 2003–2004 winter season. *The Scissortail* 54:25–27.

———. 2005. 2004–2005 winter season. *The Scissortail* 55:18–20.

———. 2006. 2005–2006 winter season. *The Scissortail* 56:14–15.

———. 2009. *Date Guide to the Occurrences of Birds in Oklahoma.* 5th ed. Norman: Oklahoma Ornithological Society.

Orr, J. L. 1986. Canada Geese flying in formation with Sandhill Cranes. *Bulletin of the Oklahoma Ornithological Society* 19:12.

Tacha, T. C., S. A. Nesbitt, and P. A. Vohs. 1992. Sandhill Crane (*Grus canadensis*). *The Birds of North America Online*, edited by A. Poole. Ithaca, N.Y.: Cornell Laboratory of Ornithology. http://bna.birds.cornell.edu.

# ORDER **CHARADRIIFORMES**

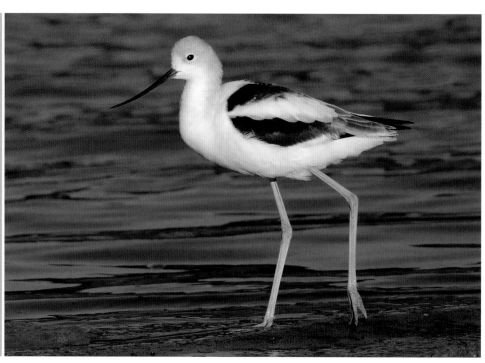

## American Avocet
### *Recurvirostra americana*

Warren Williams

**Occurrence:** Present primarily in spring through fall. A few individuals have recently begun to linger into the winter.

**Habitat:** Marshes and lakeshores.

**North American distribution:** Breeds in southwestern Canada and parts of the western lower 48 states. Winters in California, along the Gulf and southern Atlantic Coasts, and in Mexico.

**Oklahoma distribution:** No records from survey blocks. One bird found during lake surveys is mapped and listed below. Four December records of single birds were received as well as additional reports to the Oklahoma Bird Records Committee, including Alfalfa County (Salt Plains National Wildlife Refuge in December 2003), Comanche County (Lawton in December 2005), McCurtain County (Red Slough Wildlife Management Area in December 2004), Oklahoma County (Lake Hefner from December 2003 through February 2004), and Tillman County (Hackberry Flat Wildlife Management Area in February 2005 and December 2006). The summer distribution recorded by the Oklahoma Breeding Bird Atlas Project included Alfalfa and Tillman Counties, as well as all three Panhandle counties.

**Behavior:** American Avocets are rare in Oklahoma in winter and are likely to be seen singly if found. They forage in shallow water, mainly using a technique known as scything in which they sweep their long bill back and forth to detect and capture invertebrates and small fish. They also capture prey through picking or plunging bill movements.

## Christmas Bird Count (CBC) Results, 1960–2009

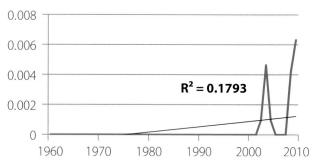

$R^2 = 0.1793$

## CBC Results, 2003–2008

| Winter | Number recorded | Counts reporting |
| --- | --- | --- |
| 2003–2004 | 5 | 1 |
| 2004–2005 | 2 | 1 |
| 2005–2006 | 0 | — |
| 2006–2007 | 0 | — |
| 2007–2008 | 0 | — |

**Count per
Block Survey**

**Count per
Lake Survey**

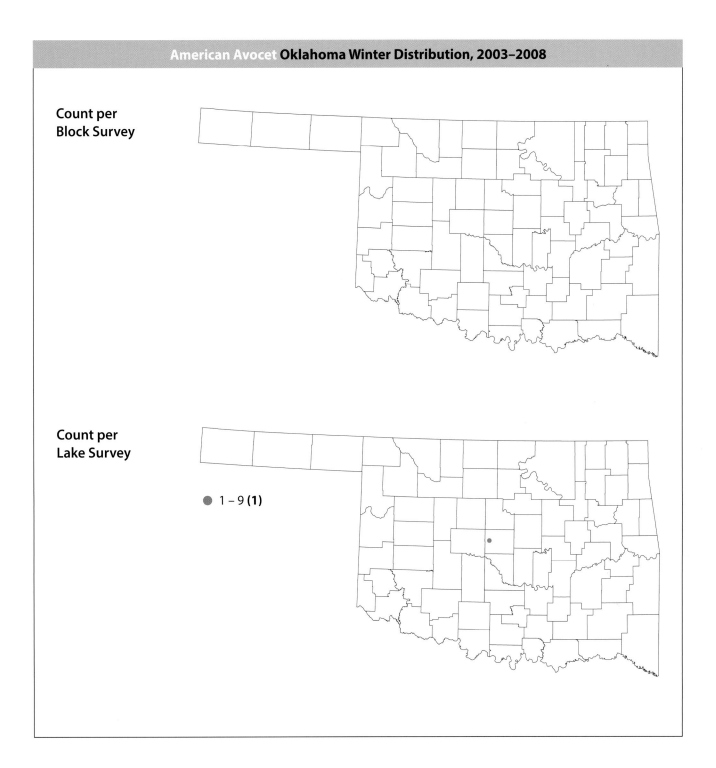

● 1 – 9 **(1)**

## References

National Audubon Society. 2011. The Christmas Bird Count historical results. http://www
.christmasbirdcount.org.

Oklahoma Bird Records Committee. 2004. 2003–2004 winter season. *The Scissortail* 54:25–27.

———. 2005. 2004–2005 winter season. *The Scissortail* 55:18–20.

———. 2006. 2005–2006 winter season. *The Scissortail* 56:14–15.

———. 2009. *Date Guide to the Occurrences of Birds in Oklahoma.* 5th ed. Norman: Oklahoma
Ornithological Society.

Reinking, D. L., ed. 2004. *Oklahoma Breeding Bird Atlas.* Norman: University of Oklahoma Press.

Robinson, Julie A., Lewis W. Oring, Joseph P. Skorupa, and Ruth Boettcher. 1997. American Avocet
(*Recurvirostra americana*). *The Birds of North America Online*, edited by A. Poole. Ithaca, N.Y.: Cornell
Laboratory of Ornithology. http://bna.birds.cornell.edu.

# Black-bellied Plover
## *Pluvialis squatarola*

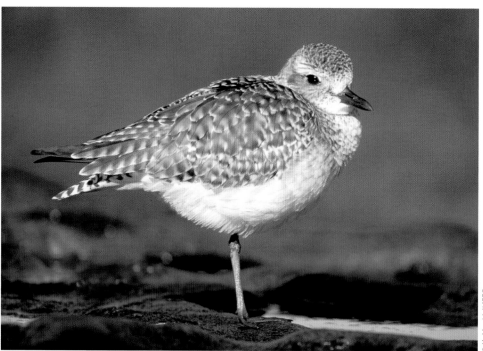

© (A. Morris) / VIREO

**Occurrence:** Spring and fall migrant from mid-April through May, and August through mid-November.

**Habitat:** Wetlands, mudflats, and shorelines.

**North American distribution:** Breeds in arctic Alaska and Canada. Winters along the Pacific, Atlantic, and Gulf Coasts.

**Oklahoma distribution:** Not a regular wintering species. Recorded at Tishomingo National Wildlife Refuge in Johnston County on December 8, 2003 (two birds; Oklahoma Bird Records Committee 2004), and at Hackberry Flat in Tillman County on December 4, 2004 (Oklahoma Bird Records Committee 2005).

**Behavior:** Black-bellied Plovers roost in large flocks during the winter, but because of their rarity here as a wintering species, even one or two birds are noteworthy. They forage by running, stopping, and pecking when worms, crustaceans, or insects are seen.

### Christmas Bird Count (CBC) Results, 1960–2009

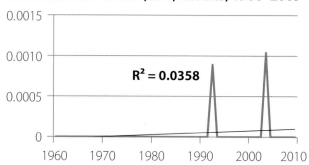

$R^2 = 0.0358$

### CBC Results, 2003–2008

| Winter | Number recorded | Counts reporting |
|---|---|---|
| 2003–2004 | 1 | 1 |
| 2004–2005 | 0 | — |
| 2005–2006 | 0 | — |
| 2006–2007 | 0 | — |
| 2007–2008 | 0 | — |

**Count per Block Survey**

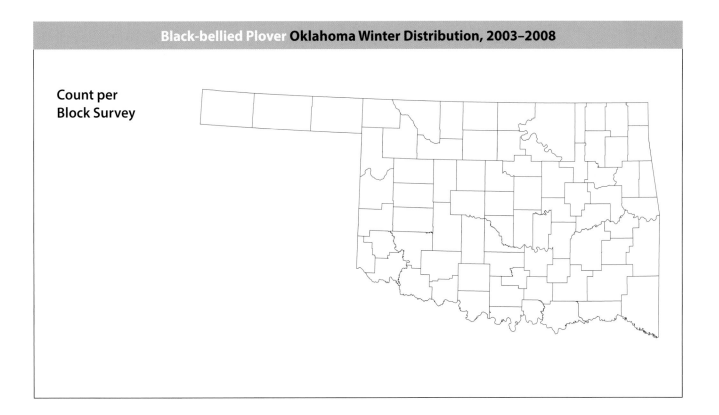

### References

National Audubon Society. 2011. The Christmas Bird Count historical results. http://www .christmasbirdcount.org.

Oklahoma Bird Records Committee. 2004. 2003–2004 winter season. *The Scissortail* 54:25–27.

———. 2005. 2004–2005 winter season. *The Scissortail* 55:18–20.

———. 2009. *Date Guide to the Occurrences of Birds in Oklahoma.* 5th ed. Norman: Oklahoma Ornithological Society.

Paulson, Dennis R. 1995. Black-bellied Plover (*Pluvialis squatarola*). *The Birds of North America Online,* edited by A. Poole. Ithaca, N.Y.: Cornell Laboratory of Ornithology. http://bna.birds.cornell.edu.

# Killdeer
## *Charadrius vociferus*

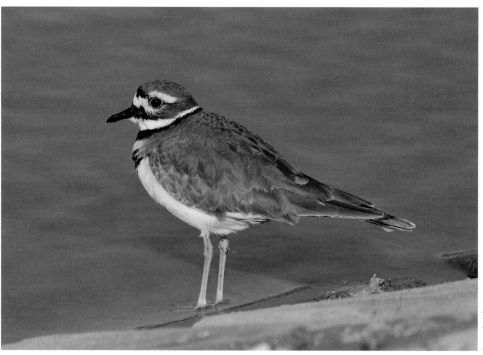

James Arterburn

**Occurrence:** Present year round, although some turnover of individuals results from seasonal movements, and spring and fall migrations bring many additional individuals passing through the state.

**Habitat:** Shorelines, wetlands, agricultural areas, roadsides, and grassy areas such as airports and golf courses.

**North American distribution:** Breeds from southern Alaska across most of Canada and into the northern half of the lower 48 states. Resident from the southern half of the United States into Mexico.

**Oklahoma distribution:** Recorded statewide but encountered most often in the southeastern half of the state. The summer distribution recorded by the Oklahoma Breeding Bird Atlas Project was more extensive, indicating that many individuals breeding in northern and northwestern Oklahoma vacate the breeding grounds during the winter. Noteworthy for winter is a report of two downy young on December 15, 2004, in McCurtain County.

**Behavior:** Killdeer can be seen singly but often occur in small, loose groups during the fall and winter. They forage on the ground, seeking earthworms, insects, snails, and occasionally seeds.

## Christmas Bird Count (CBC) Results, 1960–2009

$R^2 = 0.0272$

## CBC Results, 2003–2008

| Winter | Number recorded | Counts reporting |
|--------|-----------------|------------------|
| 2003–2004 | 574 | 16 |
| 2004–2005 | 451 | 16 |
| 2005–2006 | 325 | 17 |
| 2006–2007 | 287 | 16 |
| 2007–2008 | 214 | 16 |

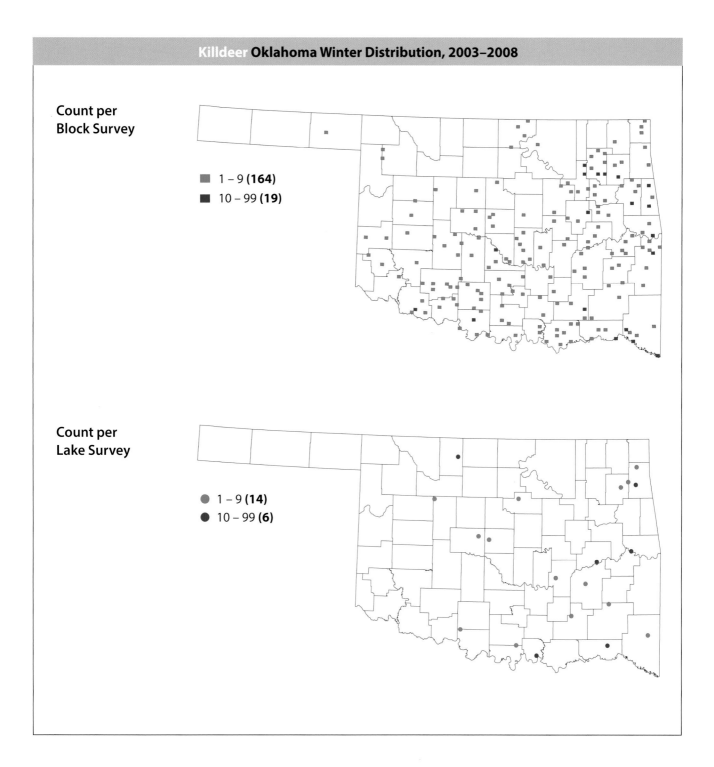

**Count per Block Survey**

■ 1 – 9 **(164)**
■ 10 – 99 **(19)**

**Count per Lake Survey**

● 1 – 9 **(14)**
● 10 – 99 **(6)**

### References

Heck, B. A., III, and B. A. Heck Jr. 2008. Fall nesting Killdeer in McCurtain County, Oklahoma. *Bulletin of the Oklahoma Ornithological Society* 41:3–4.

Jackson, Bette J., and Jerome A. Jackson. 2000. Killdeer (*Charadrius vociferus*). *The Birds of North America Online*, edited by A. Poole. Ithaca, N.Y.: Cornell Laboratory of Ornithology. http://bna.birds.cornell.edu.

National Audubon Society. 2011. The Christmas Bird Count historical results. http://www.christmasbirdcount.org.

Oklahoma Bird Records Committee. 2005. 2004–2005 winter season. *The Scissortail* 55:18–20.

———. 2009. *Date Guide to the Occurrences of Birds in Oklahoma*. 5th ed. Norman: Oklahoma Ornithological Society.

Reinking, D. L., ed. 2004. *Oklahoma Breeding Bird Atlas*. Norman: University of Oklahoma Press.

# Long-billed Curlew
## *Numenius americanus*

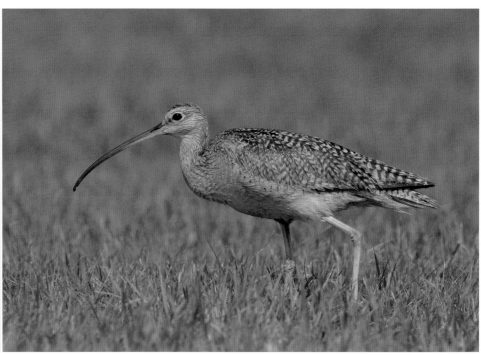

Bob Gress

**Occurrence:** Not a regular wintering species. Typically present in western and central counties in spring and fall and throughout the summer in the Panhandle.

**Habitat:** Grasslands and wetlands.

**North American distribution:** Breeds in southwestern Canada and parts of the western United States. Winters in California, the southwestern United States, and Mexico.

**Oklahoma distribution:** Not recorded in survey blocks. Reported from Tillman County (Hackberry Flat Wildlife Management Area) in late February 2007 (26 birds), December 2007 (up to 51 birds), and February 2008 (up to 8 birds; Oklahoma Bird Records Committee 2007, 2009a). The summer distribution recorded by the Oklahoma Breeding Bird Atlas Project included all three Panhandle counties.

**Behavior:** Long-billed Curlews are typically seen singly or in small groups. They use their long bills to probe moist soil for burrowing invertebrates such as earthworms and crustaceans, but they also eat insects such as beetles and grasshoppers.

### CBC Results, 2003–2008

| Winter | Number recorded | Counts reporting |
|---|---|---|
| 2003–2004 | 0 | — |
| 2004–2005 | 0 | — |
| 2005–2006 | 0 | — |
| 2006–2007 | 0 | — |
| 2007–2008 | 0 | — |

Count per
Block Survey

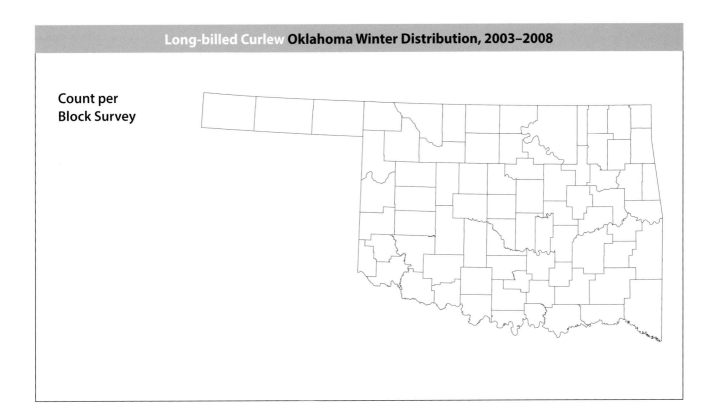

### References

Dugger, Bruce D., and Katie M. Dugger. 2002. Long-billed Curlew (*Numenius americanus*). *The Birds of North America Online*, edited by A. Poole. Ithaca, N.Y.: Cornell Laboratory of Ornithology. http://bna.birds.cornell.edu.

National Audubon Society. 2011. The Christmas Bird Count historical results. http://www .christmasbirdcount.org.

Oklahoma Bird Records Committee. 2007. 2006–2007 winter season. *The Scissortail* 57:24–27.

———. 2009a. 2007–2008 winter season. *The Scissortail* 59:4–8.

———. 2009b. *Date Guide to the Occurrences of Birds in Oklahoma*. 5th ed. Norman: Oklahoma Ornithological Society.

Reinking, D. L., ed. 2004. *Oklahoma Breeding Bird Atlas*. Norman: University of Oklahoma Press.

# Dunlin
## *Calidris alpina*

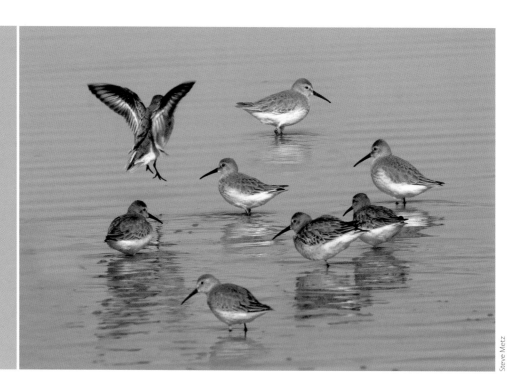

Steve Metz

**Occurrence:** Early October through May, but most common during fall and spring migrations.

**Habitat:** Mudflats and shorelines.

**North American distribution:** Breeds in arctic Alaska and Canada. Winters along the Pacific, Atlantic, and Gulf Coasts and in some southern inland areas.

**Oklahoma distribution:** Not recorded in survey blocks. Reported from Alfalfa County (Salt Plains National Wildlife Refuge) in December 2004 (35 birds) and January 2008 (7 birds); Osage County (Hulah Lake) in January and December 2007 (2 birds each); and Tillman County (Hackberry Flat Wildlife Management Area) in December 2006 (2 birds; see lake survey map).

**Behavior:** Dunlins are gregarious during migration and winter. They forage by picking and probing at mud for aquatic and terrestrial invertebrates.

### Christmas Bird Count (CBC) Results, 1960–2009

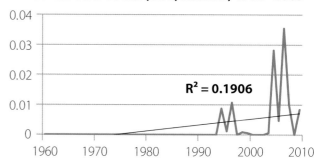

$R^2 = 0.1906$

### CBC Results, 2003–2008

| Winter | Number recorded | Counts reporting |
|--------|-----------------|------------------|
| 2003–2004 | 1 | 1 |
| 2004–2005 | 30 | 1 |
| 2005–2006 | 4 | 1 |
| 2006–2007 | 34 | 2 |
| 2007–2008 | 17 | 1 |

Count per
Block Survey

Count per
Lake Survey

● 1 – 9 **(2)**
● 10 – 99 **(1)**

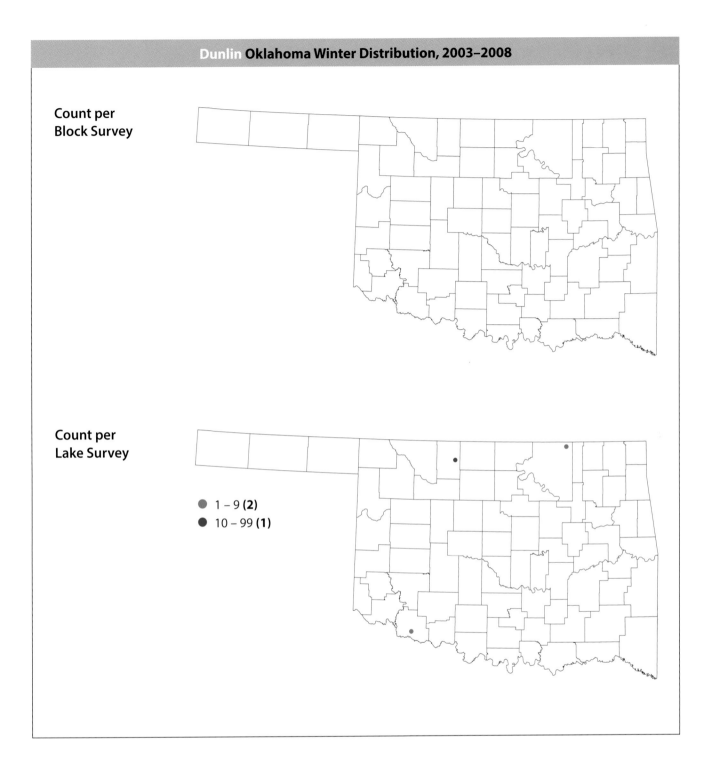

**References**

National Audubon Society. 2011. The Christmas Bird Count historical results. http://www
.christmasbirdcount.org.

Oklahoma Bird Records Committee. 2009. *Date Guide to the Occurrences of Birds in Oklahoma*. 5th ed.
Norman: Oklahoma Ornithological Society.

Shackford, J. S. 1977. The Dunlin in Oklahoma. *Bulletin of the Oklahoma Ornithological Society* 10:1–3.

Warnock, Nils D., and Robert E. Gill. 1996. Dunlin (*Calidris alpina*). *The Birds of North America Online*, edited
by A. Poole. Ithaca, N.Y.: Cornell Laboratory of Ornithology. http://bna.birds.cornell.edu.

# Least Sandpiper
## *Calidris minutilla*

Bob Gress

**Occurrence:** Winters throughout the main body of the state but is most numerous during protracted spring and fall migrations.

**Habitat:** Shorelines and river sandbars.

**North American distribution:** Breeds in Alaska and northern Canada. Winters along much of the Pacific and Atlantic Coasts, in the southeastern United States, and in Mexico.

**Oklahoma distribution:** Recorded in five survey blocks scattered throughout the main body of the state. Special interest species reports came from Logan and McCurtain Counties in December 2006. Additional records came from lake survey reports for the following lakes: Eufaula, Fort Supply, Grand, Great Salt Plains, Guthrie, Hefner, Kerr, Lawtonka, Texoma, and Waurika (see lake survey map). This distribution suggests that they can be present in winter wherever suitable habitat exists in the main body of the state.

**Behavior:** Least Sandpipers often occur in small, loose flocks during the winter. They forage for aquatic and terrestrial invertebrates by pecking and probing the mud.

### Christmas Bird Count (CBC) Results, 1960–2009

$R^2 = 0.3244$

### CBC Results, 2003–2008

| Winter | Number recorded | Counts reporting |
|--------|-----------------|------------------|
| 2003–2004 | 201 | 6 |
| 2004–2005 | 102 | 8 |
| 2005–2006 | 280 | 6 |
| 2006–2007 | 310 | 11 |
| 2007–2008 | 53 | 4 |

Count per
Block Survey

1 – 9 **(3)**
10 – 99 **(2)**

Count per
Lake Survey

1 – 9 **(5)**
10 – 99 **(5)**

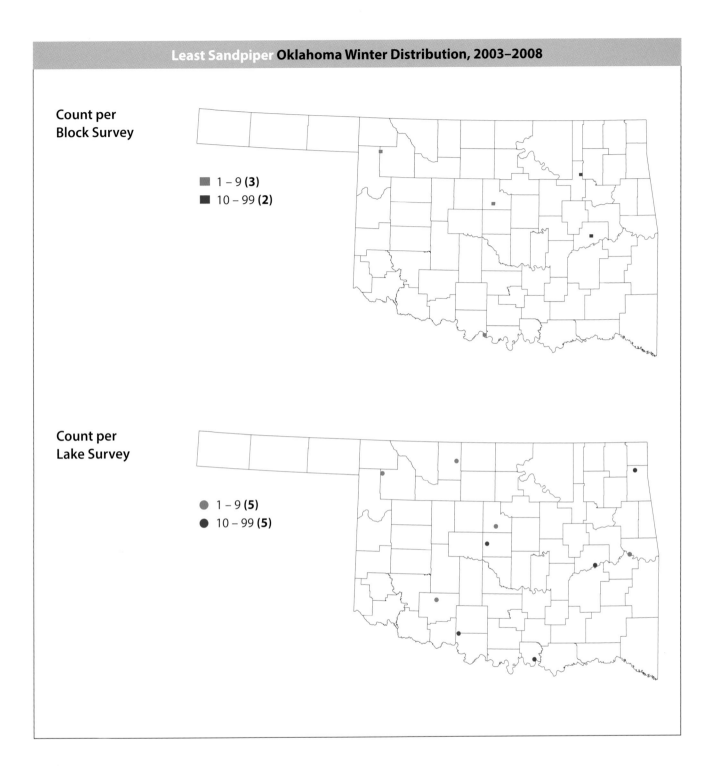

### References

National Audubon Society. 2011. The Christmas Bird Count historical results. http://www
.christmasbirdcount.org.
Nebel, Silke, and John M. Cooper. 2008. Least Sandpiper (*Calidris minutilla*). *The Birds of North America
Online*, edited by A. Poole. Ithaca, N.Y.: Cornell Laboratory of Ornithology. http://bna.birds.cornell.edu.
Oklahoma Bird Records Committee. 2009. *Date Guide to the Occurrences of Birds in Oklahoma*. 5th ed.
Norman: Oklahoma Ornithological Society.

# Pectoral Sandpiper
## *Calidris melanotos*

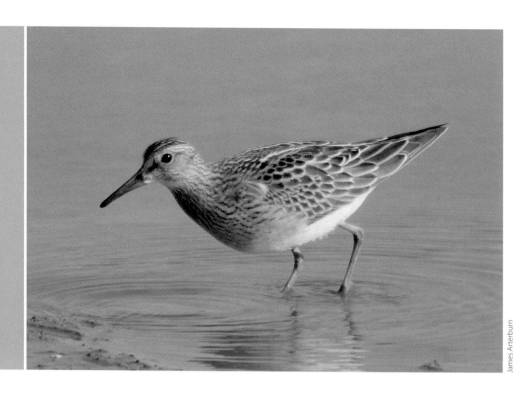

James Arterburn

**Occurrence:** Spring and fall migrant, but not a regular wintering species.

**Habitat:** Wetlands and shorelines.

**North American distribution:** Breeds in northern Alaska and Canada. Does not typically winter in North America, instead migrating to South America.

**Oklahoma distribution:** Not recorded in survey blocks. Special interest species reports came from Osage County (Hulah Lake) on January 16, 2006 (see lake survey map), and Tillman County (two birds at Hackberry Flat Wildlife Management Area) on January 1, 2007.

**Behavior:** Pectoral Sandpipers can be seen singly or in small groups. They forage by probing and pecking for invertebrates.

## Christmas Bird Count (CBC) Results, 1960–2009

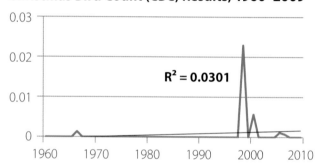

$R^2 = 0.0301$

## CBC Results, 2003–2008

| Winter | Number recorded | Counts reporting |
|--------|-----------------|------------------|
| 2003–2004 | 0 | — |
| 2004–2005 | 0 | — |
| 2005–2006 | 1 | 1 |
| 2006–2007 | 1 | 1 |
| 2007–2008 | 0 | — |

Count per
Block Survey

Count per
Lake Survey

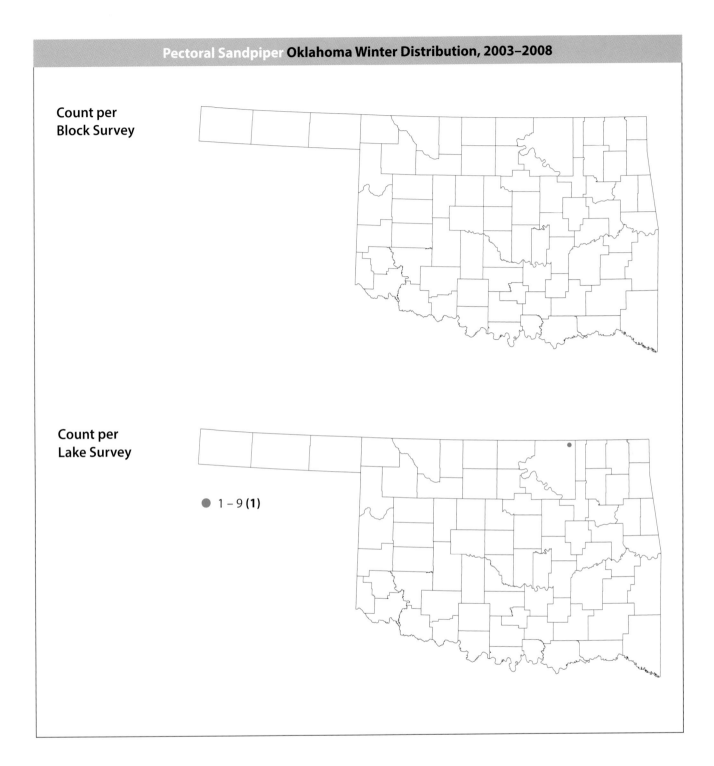

● 1 – 9 **(1)**

### References

Holmes, Richard T., and Frank A. Pitelka. 1998. Pectoral Sandpiper (*Calidris melanotos*). *The Birds of North America Online*, edited by A. Poole. Ithaca, N.Y.: Cornell Laboratory of Ornithology. http://bna.birds .cornell.edu.

National Audubon Society. 2011. The Christmas Bird Count historical results. http://www .christmasbirdcount.org.

Oklahoma Bird Records Committee. 2009. *Date Guide to the Occurrences of Birds in Oklahoma*. 5th ed. Norman: Oklahoma Ornithological Society.

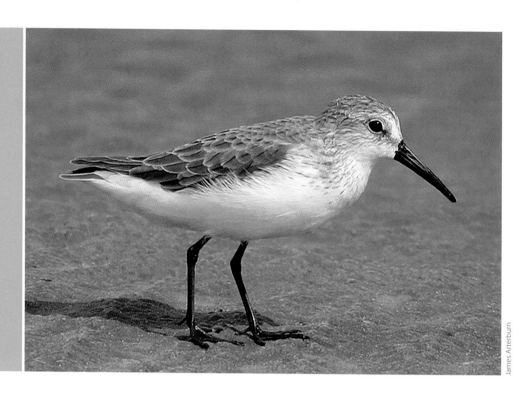

James Arterburn

## ORDER CHARADRIIFORMES

# Western Sandpiper
*Calidris mauri*

**Occurrence:** Spring and fall migrant, but not a regular wintering species.

**Habitat:** Marshes and shorelines.

**North American distribution:** Breeds in Alaska and winters along the Pacific, Atlantic, and Gulf Coasts and in Mexico.

**Oklahoma distribution:** Not recorded in survey blocks. A lake survey report came from Alfalfa County (Salt Plains National Wildlife Refuge) on January 5, 2008.

**Behavior:** Western Sandpipers often occur in flocks during migration, but their rarity during the winter in Oklahoma makes sightings of multiple birds less likely. They glean and probe muddy shorelines for invertebrates.

## Christmas Bird Count (CBC) Results, 1960–2009

$R^2 = 0.054$

## CBC Results, 2003–2008

| Winter | Number recorded | Counts reporting |
|---|---|---|
| 2003–2004 | 1 | 1 |
| 2004–2005 | 32 | 1 |
| 2005–2006 | 2 | 1 |
| 2006–2007 | 0 | — |
| 2007–2008 | 2 | 1 |

**158**   ORDER **CHARADRIIFORMES**

**Count per
Block Survey**

**Count per
Lake Survey**

● 1 – 9 **(1)**

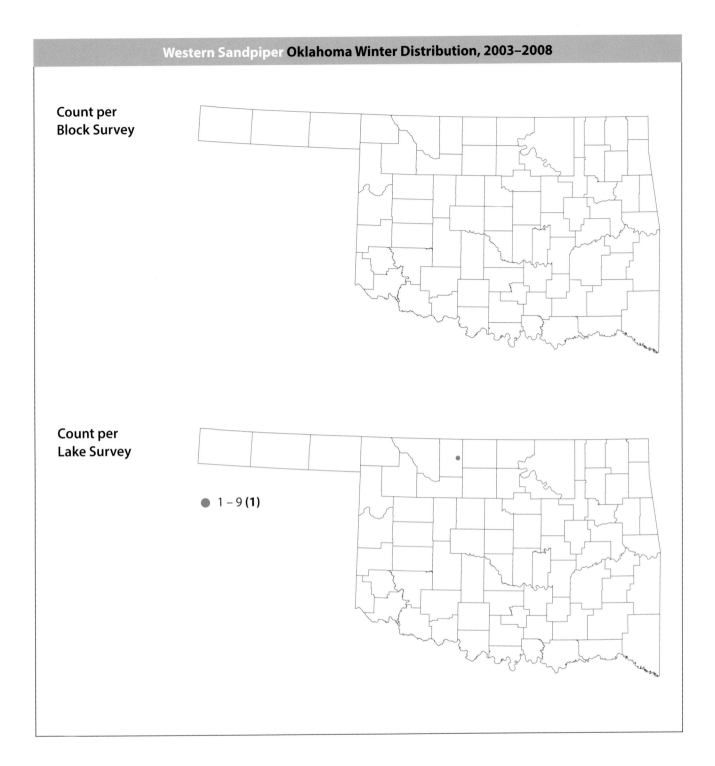

### References

National Audubon Society. 2011. The Christmas Bird Count historical results. http://www
.christmasbirdcount.org.

Oklahoma Bird Records Committee. 2009. *Date Guide to the Occurrences of Birds in Oklahoma*. 5th ed.
Norman: Oklahoma Ornithological Society.

Purdue, J. R. 1969. The Western Sandpiper in Oklahoma. *Bulletin of the Oklahoma Ornithological Society*
2:17–21.

Wilson, W. Herbert. 1994. Western Sandpiper (*Calidris mauri*). *The Birds of North America Online*, edited by
A. Poole. Ithaca, N.Y.: Cornell Laboratory of Ornithology. http://bna.birds.cornell.edu.

# Long-billed Dowitcher

## *Limnodromus scolopaceus*

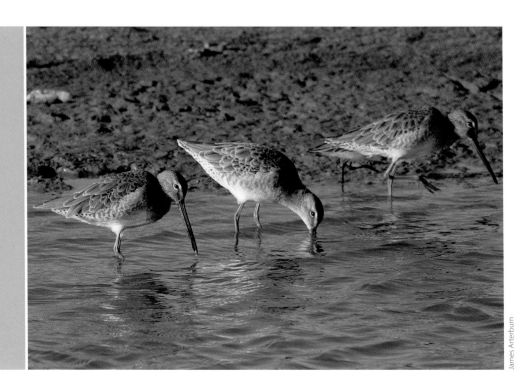

James Arterburn

**Occurrence:** Mid-July through late May.

**Habitat:** Shorelines and wetlands.

**North American distribution:** Breeds in northern Alaska and northwestern Canada. Winters along the Pacific Coast south of Canada, along the southern Atlantic Coast, in the southernmost United States, and in Mexico.

**Oklahoma distribution:** Not recorded in survey blocks. Reported from Tillman County (Hackberry Flat Wildlife Management Area) in December 2004 (140 birds), February 2005 (up to 29 birds), December 2006 (1 bird), February 2007 (62 birds), and January 2008 (8 birds; Oklahoma Bird Records Committee 2005, 2007, 2009); also reported as a special interest species from McCurtain County (Red Slough Wildlife Management Area) in December 2007 (22 birds).

**Behavior:** Long-billed Dowitchers are usually seen in groups and often associate with other shorebirds. They feed on insects, insect larvae, and small crustaceans, often probing with their bills in a characteristic up-and-down "sewing machine" motion. Their bill tips are sensitive to touch, allowing them to identify and capture prey in mud.

## Christmas Bird Count (CBC) Results, 1960–2009

$R^2 = 0.0068$

## CBC Results, 2003–2008

| Winter | Number recorded | Counts reporting |
|--------|-----------------|------------------|
| 2003–2004 | 0 | — |
| 2004–2005 | 0 | — |
| 2005–2006 | 15 | 1 |
| 2006–2007 | 0 | — |
| 2007–2008 | 1 | 1 |

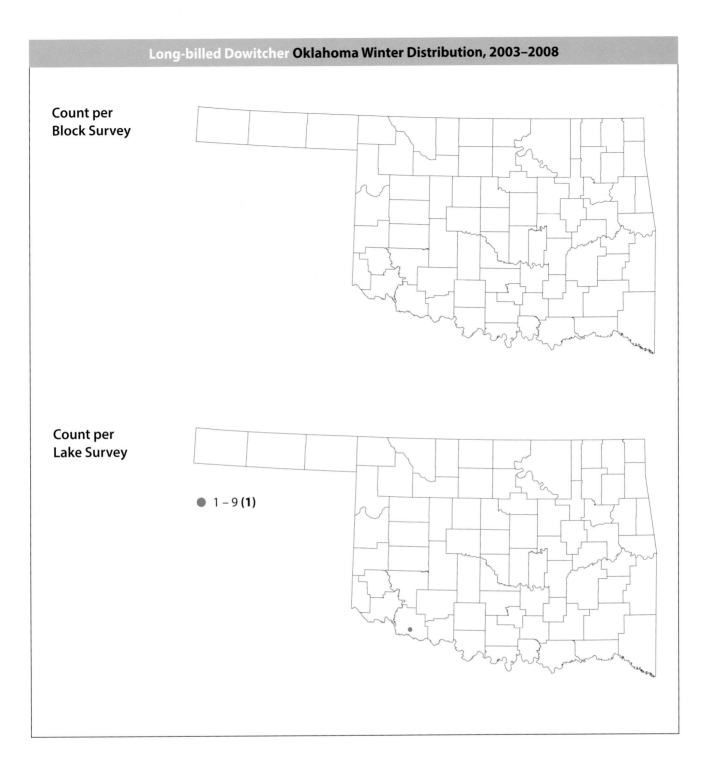

Count per
Block Survey

Count per
Lake Survey

● 1 – 9 **(1)**

### References

National Audubon Society. 2011. The Christmas Bird Count historical results. http://www
.christmasbirdcount.org.

Oklahoma Bird Records Committee. 2005. 2004–2005 winter season. *The Scissortail* 55:18–20.

———. 2007. 2006–2007 winter season. *The Scissortail* 57:24–27.

———. 2009. *Date Guide to the Occurrences of Birds in Oklahoma*. 5th ed. Norman: Oklahoma
Ornithological Society.

Takekawa, John Y., and Nils Warnock. 2000. Long-billed Dowitcher (*Limnodromus scolopaceus*). *The
Birds of North America Online*, edited by A. Poole. Ithaca, N.Y.: Cornell Laboratory of Ornithology.
http://bna.birds.cornell.edu.

Tyler, J. D. 1977. Long-billed Dowitcher in Caddo County, Oklahoma in winter. *Bulletin of the Oklahoma
Ornithological Society* 10:8.

# Wilson's Snipe
## *Gallinago delicata*

Bob Gress

**Occurrence:** Late August through mid-May.

**Habitat:** Shallow wetlands and shorelines of lakes and ponds.

**North American distribution:** Breeds in Alaska, most of Canada, and parts of the northern lower 48 states. Winters broadly across the southern two-thirds of the United States and in Mexico.

**Oklahoma distribution:** Recorded in scattered survey blocks throughout the main body of the state, but reported most often in the eastern half.

**Behavior:** Wilson's Snipe are basically solitary, although several may be found near each other in suitable habitat. They forage for larval insects, crustaceans, and seeds by probing moist soil on land or in shallow water.

## Christmas Bird Count (CBC) Results, 1960–2009

$R^2 = 0.0032$

## CBC Results, 2003–2008

| Winter | Number recorded | Counts reporting |
|--------|-----------------|------------------|
| 2003–2004 | 203 | 13 |
| 2004–2005 | 276 | 12 |
| 2005–2006 | 173 | 13 |
| 2006–2007 | 131 | 7 |
| 2007–2008 | 100 | 11 |

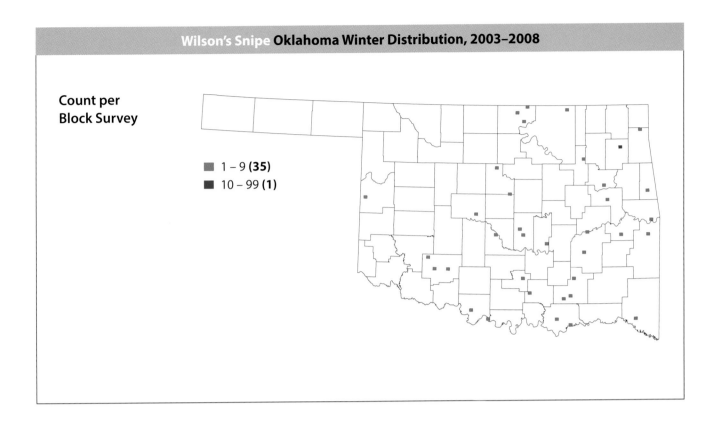

Count per
Block Survey

■ 1 – 9 **(35)**
■ 10 – 99 **(1)**

**References**

Mueller, Helmut. 1999. Wilson's Snipe (*Gallinago delicata*). *The Birds of North America Online*, edited by
A. Poole. Ithaca, N.Y.: Cornell Laboratory of Ornithology. http://bna.birds.cornell.edu.

National Audubon Society. 2011. The Christmas Bird Count historical results. http://www
.christmasbirdcount.org.

Oklahoma Bird Records Committee. 2009. *Date Guide to the Occurrences of Birds in Oklahoma*. 5th ed.
Norman: Oklahoma Ornithological Society.

# American Woodcock
## *Scolopax minor*

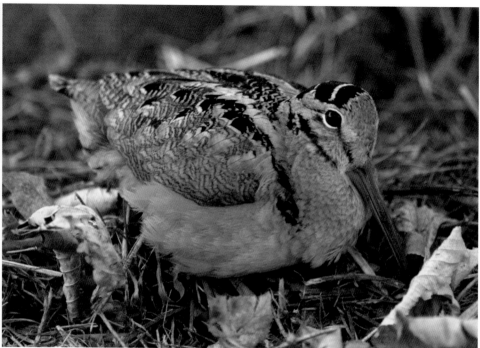

© (S. J. Lang) / VIREO

**Occurrence:** Present in the state year round, but rather locally distributed.

**Habitat:** Moist woodlands.

**North American distribution:** Breeds in the United States and southern Canada to the north and east of northeastern Oklahoma. Present year round from southeastern Oklahoma eastward. Present only in winter in much of eastern Texas and adjacent to the Gulf Coast.

**Oklahoma distribution:** Woodcock were recorded in several southeastern counties where forested habitat is plentiful and winter temperatures (and soil temperatures) are moderate. They can be difficult to detect during winter unless they happen to flush, and they may have been overlooked in additional survey blocks.

**Behavior:** Woodcock may be observed singly or in loose clusters. They forage by probing moist soil with their long bill, and their main prey of earthworms is grasped with a flexible bill tip. The breeding season may start as early as February in Oklahoma, with well-known and captivating courtship flight displays.

## Christmas Bird Count (CBC) Results, 1960–2009

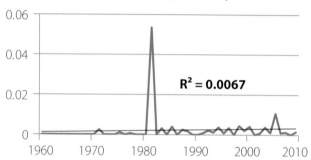

$R^2 = 0.0067$

## CBC Results, 2003–2008

| Winter | Number recorded | Counts reporting |
|--------|-----------------|------------------|
| 2003–2004 | 4 | 3 |
| 2004–2005 | 1 | 2 |
| 2005–2006 | 9 | 3 |
| 2006–2007 | 1 | 1 |
| 2007–2008 | 1 | 1 |

**Count per Block Survey**

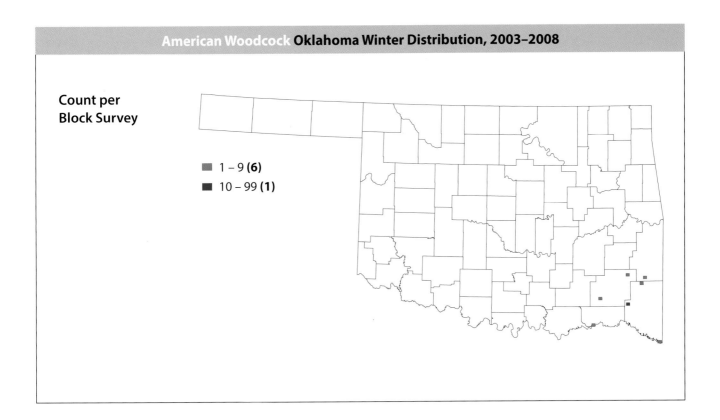

- 1 – 9 **(6)**
- 10 – 99 **(1)**

### References

Keppie, D. M., and R. M. Whiting Jr. 1994. American Woodcock (*Scolopax minor*). *The Birds of North America Online*, edited by A. Poole. Ithaca, N.Y.: Cornell Laboratory of Ornithology. http://bna.birds.cornell.edu.

National Audubon Society. 2011. The Christmas Bird Count historical results. http://www.christmasbirdcount.org.

Reinking, D. L., ed. 2004. *Oklahoma Breeding Bird Atlas*. Norman: University of Oklahoma Press.

Tyler, J. D. 1972. American Woodcock in Comanche County, Oklahoma, in winter. *Bulletin of the Oklahoma Ornithological Society* 5:29.

# Greater Yellowlegs
## *Tringa melanoleuca*

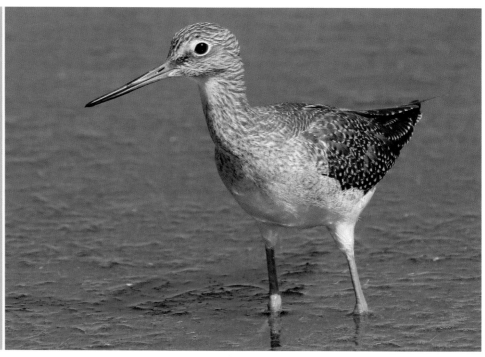

Bob Gress

**Occurrence:** July through May.

**Habitat:** Shorelines and wetlands.

**North American distribution:** Breeds in southern Alaska and much of Canada. Winters along the Pacific and Atlantic Coasts and across much of the southern United States.

**Oklahoma distribution:** Recorded at scattered locations over much of the state, with the highest concentrations of reports in south-central and southwestern counties. A detectable southward shift in distribution occurred from early winter to late winter survey periods, with northern Oklahoma blocks being mostly vacated. This species could be expected wherever suitable habitat is found, especially early in the winter, and many survey blocks may have lacked such habitat.

**Behavior:** Greater Yellowlegs are usually seen singly or in small, loose groups. Other shorebird species are sometimes seen nearby, but mostly during migration, as relatively few shorebird species regularly winter in Oklahoma. Foraging takes place in shallow water along shorelines, where invertebrates and small fish are captured with quick bill stabs.

## Christmas Bird Count (CBC) Results, 1960–2009

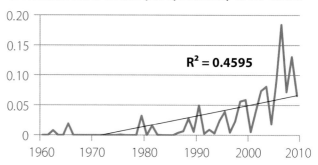

$R^2 = 0.4595$

## CBC Results, 2003–2008

| Winter | Number recorded | Counts reporting |
|---|---|---|
| 2003–2004 | 83 | 7 |
| 2004–2005 | 24 | 7 |
| 2005–2006 | 89 | 10 |
| 2006–2007 | 192 | 12 |
| 2007–2008 | 80 | 6 |

## References

Elphick, Chris S., and T. Lee Tibbitts. 1998. Greater Yellowlegs (*Tringa melanoleuca*). *The Birds of North America Online*, edited by A. Poole. Ithaca, N.Y.: Cornell Laboratory of Ornithology. http://bna.birds.cornell.edu.

Key, E. M. 1991. Greater Yellowlegs in central Oklahoma in winter. *Bulletin of the Oklahoma Ornithological Society* 24:31–32.

National Audubon Society. 2011. The Christmas Bird Count historical results. http://www.christmasbirdcount.org.

Oklahoma Bird Records Committee. 2009. *Date Guide to the Occurrences of Birds in Oklahoma.* 5th ed. Norman: Oklahoma Ornithological Society.

Shackford, J. S. 1976. Greater Yellowlegs in central Oklahoma in winter. *Bulletin of the Oklahoma Ornithological Society* 9:33.

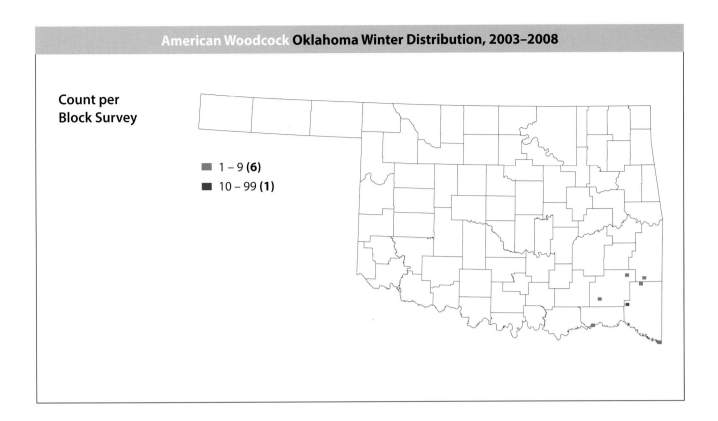

**Count per Block Survey**

■ 1 – 9 **(6)**
■ 10 – 99 **(1)**

**References**

Keppie, D. M., and R. M. Whiting Jr. 1994. American Woodcock (*Scolopax minor*). *The Birds of North America Online*, edited by A. Poole. Ithaca, N.Y.: Cornell Laboratory of Ornithology. http://bna.birds.cornell.edu.

National Audubon Society. 2011. The Christmas Bird Count historical results. http://www.christmasbirdcount.org.

Reinking, D. L., ed. 2004. *Oklahoma Breeding Bird Atlas*. Norman: University of Oklahoma Press.

Tyler, J. D. 1972. American Woodcock in Comanche County, Oklahoma, in winter. *Bulletin of the Oklahoma Ornithological Society* 5:29.

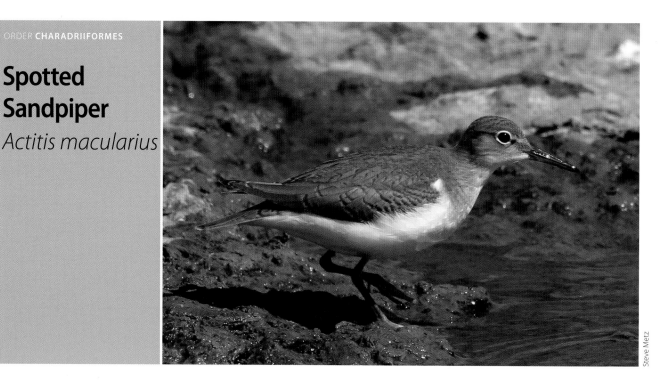

ORDER CHARADRIIFORMES

# Spotted Sandpiper
## *Actitis macularius*

Steve Metz

**Occurrence:** Most common as a spring and fall migrant, with a few lingering to breed and even fewer present during winter.

**Habitat:** Lakeshores, riverbanks, and stream banks.

**North American distribution:** Breeds in Alaska, much of Canada, and the northern two-thirds of the lower 48 states. Resident along the Pacific Coast. Winters in the southernmost lower 48 states and Mexico.

**Oklahoma distribution:** Recorded in one survey block straddling McClain and Grady Counties. Also reported from Blaine County in December 2004; Cherokee County in December 2003, January 2004, and December 2004 (two birds); McCurtain County in December 2004; McCurtain County in December 2006 and January 2007; Oklahoma County in February 2008; and Wagoner County in December 2004. The summer distribution recorded by the Oklahoma Breeding Bird Atlas Project included records from eight survey blocks scattered throughout the main body of the state.

**Behavior:** Spotted Sandpipers are usually seen singly during winter but sometimes roost together. They forage by walking or wading with an unusual teetering gait in search of aquatic and terrestrial invertebrates.

## Christmas Bird Count (CBC) Results, 1960–2009

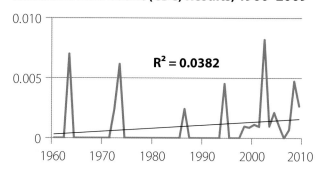

$R^2 = 0.0382$

## CBC Results, 2003–2008

| Winter | Number recorded | Counts reporting |
|--------|-----------------|------------------|
| 2003–2004 | 1 | 1 |
| 2004–2005 | 2 | 2 |
| 2005–2006 | 1 | 1 |
| 2006–2007 | 0 | — |
| 2007–2008 | 1 | 3 |

**Count per
Block Survey**

■ 1 – 9 **(1)**

**Count per
Lake Survey**

● 1 – 9 **(3)**

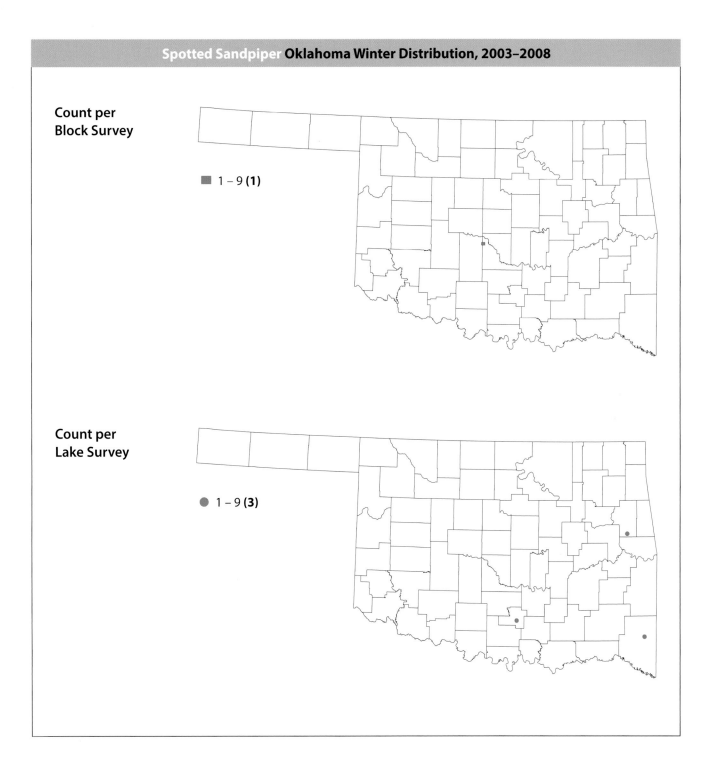

## References

National Audubon Society. 2011. The Christmas Bird Count historical results. http://www
.christmasbirdcount.org.

Oklahoma Bird Records Committee. 2004. 2003–2004 winter season. *The Scissortail* 54:25–27.

———. 2005. 2004–2005 winter season. *The Scissortail* 55:18–20.

———. 2007. 2006–2007 winter season. *The Scissortail* 57:24–27.

———. 2009a. 2007–2008 winter season. *The Scissortail* 59:4–8.

———. 2009b. *Date Guide to the Occurrences of Birds in Oklahoma.* 5th ed. Norman: Oklahoma
Ornithological Society.

Oring, Lewis W., Elizabeth M. Gray, and J. Michael Reed. 1997. Spotted Sandpiper (*Actitis macularius*).
*The Birds of North America Online*, edited by A. Poole. Ithaca, N.Y.: Cornell Laboratory of Ornithology.
http://bna.birds.cornell.edu.

Reinking, D. L., ed. 2004. *Oklahoma Breeding Bird Atlas.* Norman: University of Oklahoma Press.

# Greater Yellowlegs
## *Tringa melanoleuca*

Bob Gress

**Occurrence:** July through May.

**Habitat:** Shorelines and wetlands.

**North American distribution:** Breeds in southern Alaska and much of Canada. Winters along the Pacific and Atlantic Coasts and across much of the southern United States.

**Oklahoma distribution:** Recorded at scattered locations over much of the state, with the highest concentrations of reports in south-central and southwestern counties. A detectable southward shift in distribution occurred from early winter to late winter survey periods, with northern Oklahoma blocks being mostly vacated. This species could be expected wherever suitable habitat is found, especially early in the winter, and many survey blocks may have lacked such habitat.

**Behavior:** Greater Yellowlegs are usually seen singly or in small, loose groups. Other shorebird species are sometimes seen nearby, but mostly during migration, as relatively few shorebird species regularly winter in Oklahoma. Foraging takes place in shallow water along shorelines, where invertebrates and small fish are captured with quick bill stabs.

## Christmas Bird Count (CBC) Results, 1960–2009

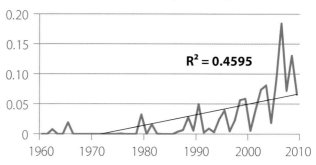

$R^2 = 0.4595$

## CBC Results, 2003–2008

| Winter | Number recorded | Counts reporting |
|---|---|---|
| 2003–2004 | 83 | 7 |
| 2004–2005 | 24 | 7 |
| 2005–2006 | 89 | 10 |
| 2006–2007 | 192 | 12 |
| 2007–2008 | 80 | 6 |

## References

Elphick, Chris S., and T. Lee Tibbitts. 1998. Greater Yellowlegs (*Tringa melanoleuca*). *The Birds of North America Online*, edited by A. Poole. Ithaca, N.Y.: Cornell Laboratory of Ornithology. http://bna.birds.cornell.edu.

Key, E. M. 1991. Greater Yellowlegs in central Oklahoma in winter. *Bulletin of the Oklahoma Ornithological Society* 24:31–32.

National Audubon Society. 2011. The Christmas Bird Count historical results. http://www.christmasbirdcount.org.

Oklahoma Bird Records Committee. 2009. *Date Guide to the Occurrences of Birds in Oklahoma*. 5th ed. Norman: Oklahoma Ornithological Society.

Shackford, J. S. 1976. Greater Yellowlegs in central Oklahoma in winter. *Bulletin of the Oklahoma Ornithological Society* 9:33.

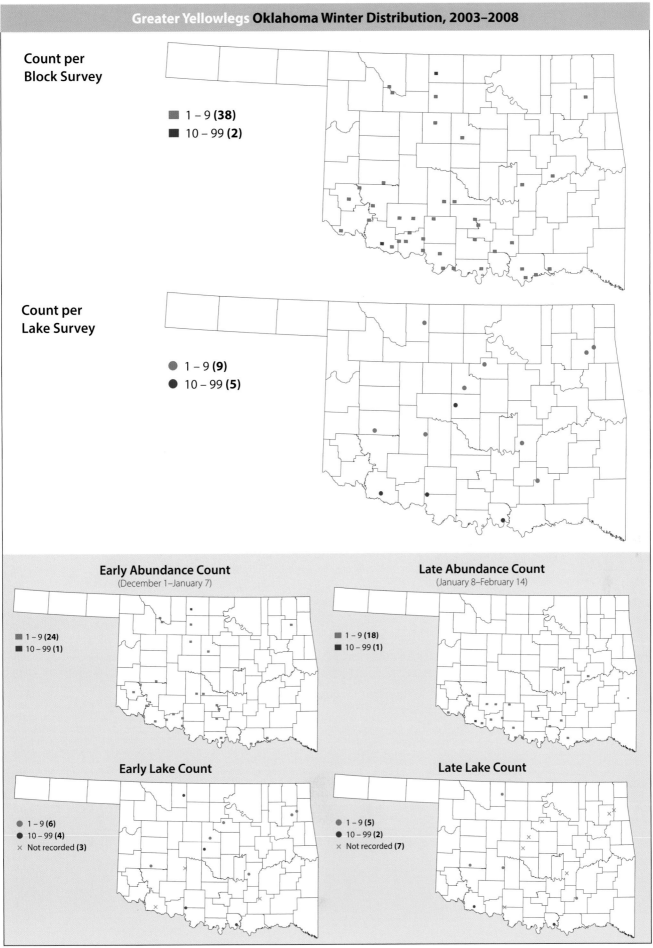

# Greater Yellowlegs Oklahoma Winter Distribution, 2003–2008

**Count per Block Survey**

- ■ 1 – 9 **(38)**
- ■ 10 – 99 **(2)**

**Count per Lake Survey**

- ● 1 – 9 **(9)**
- ● 10 – 99 **(5)**

## Early Abundance Count
(December 1–January 7)

- ■ 1 – 9 **(24)**
- ■ 10 – 99 **(1)**

## Late Abundance Count
(January 8–February 14)

- ■ 1 – 9 **(18)**
- ■ 10 – 99 **(1)**

## Early Lake Count

- ● 1 – 9 **(6)**
- ● 10 – 99 **(4)**
- × Not recorded **(3)**

## Late Lake Count

- ● 1 – 9 **(5)**
- ● 10 – 99 **(2)**
- × Not recorded **(7)**

# Lesser Yellowlegs
*Tringa flavipes*

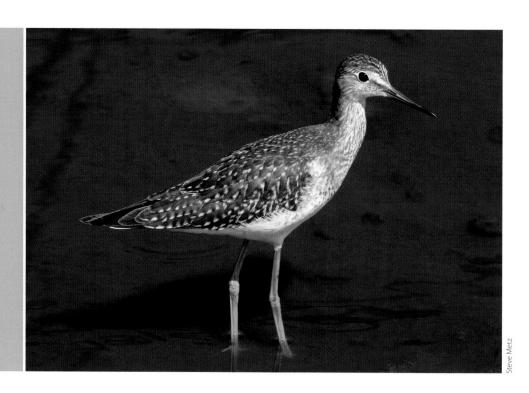

Steve Metz

**Occurrence:** Late June through early December, and early February through early June.

**Habitat:** Wetlands, flooded pastures, and shorelines.

**North American distribution:** Breeds in Alaska and much of Canada. Winters in the southern United States and in Mexico.

**Oklahoma distribution:** Not recorded in survey blocks. Up to four birds reported as special interest species from Tillman County (Hackberry Flat Wildlife Management Area) in January 2004 and February 2005. One report on December 12, 2006, came from Holdenville Lake in Hughes County (see lake survey map).

**Behavior:** Lesser Yellowlegs are often seen in small flocks, and they frequently associate with Greater Yellowlegs and other sandpipers. They forage in wet fields and along shorelines for flies, beetles, and other invertebrates.

## Christmas Bird Count (CBC) Results, 1960–2009

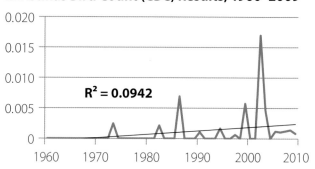

$R^2 = 0.0942$

## CBC Results, 2003–2008

| Winter | Number recorded | Counts reporting |
|---|---|---|
| 2003–2004 | 5 | 2 |
| 2004–2005 | 0 | — |
| 2005–2006 | 1 | 1 |
| 2006–2007 | 1 | 1 |
| 2007–2008 | 1 | 1 |

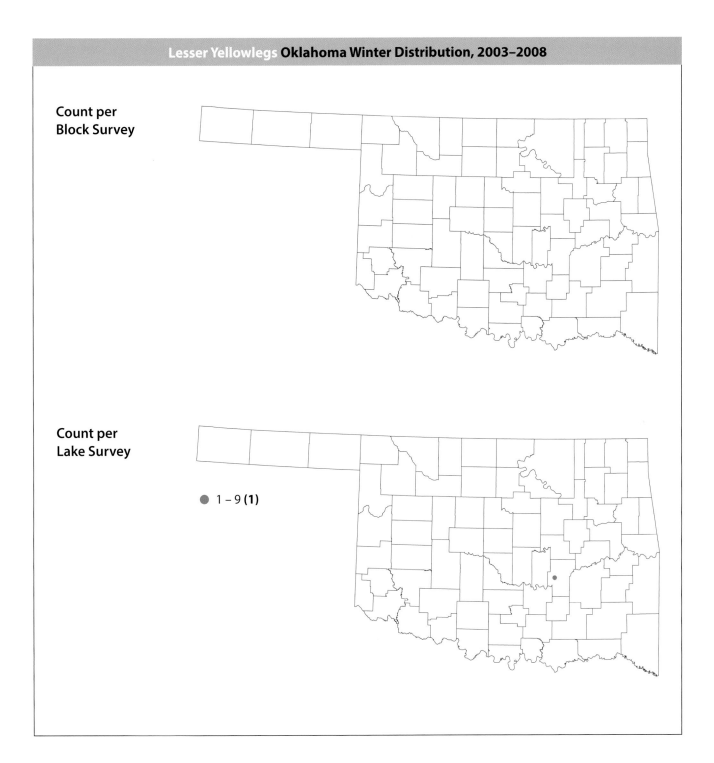

Count per
Block Survey

Count per
Lake Survey

● 1 – 9 **(1)**

**References**

National Audubon Society. 2011. The Christmas Bird Count historical results. http://www
.christmasbirdcount.org.

Oklahoma Bird Records Committee. 2004. 2003–2004 winter season. *The Scissortail* 54:25–27.

———. 2005. 2004–2005 winter season. *The Scissortail* 55:18–20.

———. 2009. *Date Guide to the Occurrences of Birds in Oklahoma*. 5th ed. Norman: Oklahoma
Ornithological Society.

Tibbitts, T. Lee, and William Moskoff. 1999. Lesser Yellowlegs (*Tringa flavipes*). *The Birds of North America
Online*, edited by A. Poole. Ithaca, N.Y.: Cornell Laboratory of Ornithology. http://bna.birds.cornell.edu.

# Black-legged Kittiwake
## *Rissa tridactyla*

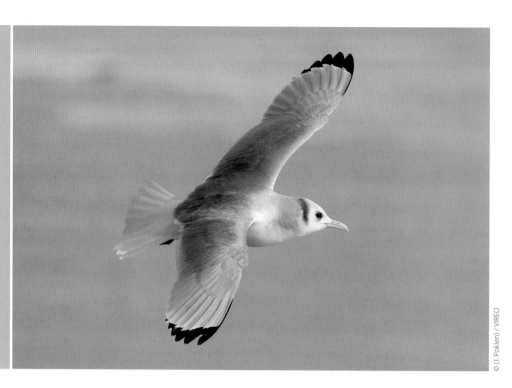

© (J. Poklen) / VIREO

**Occurrence:** Rare from fall through spring.

**Habitat:** Lakes and large rivers.

**North American distribution:** Breeds along the coasts of western Alaska and northeastern Canada. Winters offshore along the Pacific Coast from Alaska to Baja California, and along the Atlantic Coast from Newfoundland to the Carolinas.

**Oklahoma distribution:** Not a regular wintering species. Recorded in a Sequoyah County portion of Lake Tenkiller on February 10, 2006 (see lake survey map and Oklahoma Bird Records Committee 2007).

**Behavior:** The rarity of the Black-legged Kittiwake in Oklahoma makes single birds most likely to be seen. They forage for fish and invertebrates, which they harvest at the surface of the water.

### Christmas Bird Count (CBC) Results, 1960–2009

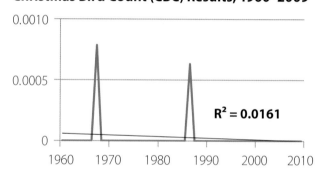

$R^2 = 0.0161$

### CBC Results, 2003–2008

| Winter | Number recorded | Counts reporting |
|---|---|---|
| 2003–2004 | 0 | — |
| 2004–2005 | 0 | — |
| 2005–2006 | 0 | — |
| 2006–2007 | 0 | — |
| 2007–2008 | 0 | — |

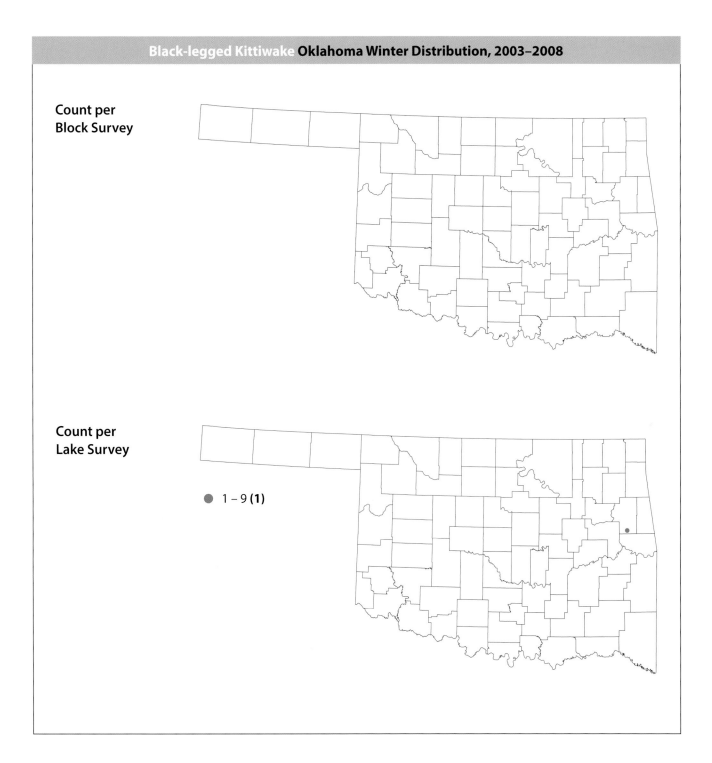

Count per
Block Survey

Count per
Lake Survey

● 1 – 9 **(1)**

## References

Hatch, Scott A., Gregory J. Robertson, and Pat Herron Baird. 2009. Black-legged Kittiwake (*Rissa tridactyla*). *The Birds of North America Online*, edited by A. Poole. Ithaca, N.Y.: Cornell Laboratory of Ornithology. http://bna.birds.cornell.edu.

National Audubon Society. 2011. The Christmas Bird Count historical results. http://www.christmasbirdcount.org.

Oklahoma Bird Records Committee. 2007. 2006–2007 winter season. *The Scissortail* 57:24–27.

———. 2009. *Date Guide to the Occurrences of Birds in Oklahoma*. 5th ed. Norman: Oklahoma Ornithological Society.

Oliphant, M. 1990. The Black-legged Kittiwake in Oklahoma. *Bulletin of the Oklahoma Ornithological Society* 22:3–5.

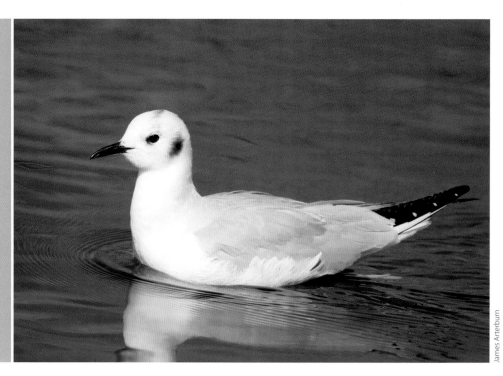

# Bonaparte's Gull

*Chroicocephalus philadelphia*

James Arterburn

**Occurrence:** Mid-October through April.

**Habitat:** Rivers, lakes, and dam spillways.

**North American distribution:** Breeds over much of Alaska and Canada. Winters along the East, West, and Gulf Coasts, in the southeastern United States, and in parts of Mexico.

**Oklahoma distribution:** Recorded at relatively few, widely scattered locations in the main body of the state, reflecting the limited presence of large water bodies within the randomly selected survey blocks. Unusual concentrations estimated at 3,000 birds were reported from Fort Gibson Lake in Wagoner County in January and February 2006 (see lake survey map). Additional published observations during the project period include 3,000 birds at Lake Keystone in Tulsa and Osage Counties in January 2008 (Oklahoma Bird Records Committee 2009a), and another group estimated at 5,000 birds from Fort Gibson Lake in Cherokee County on January 27, 2008 (Oklahoma Bird Records Committee 2009a).

**Behavior:** Bonaparte's Gulls are small and graceful fliers and swimmers. They form winter flocks that can number in the hundreds or even thousands. Winter foods include small fish and a variety of aquatic invertebrates acquired by plunge-diving from flight or by bill-dipping while flying or swimming.

## Christmas Bird Count (CBC) Results, 1960–2009

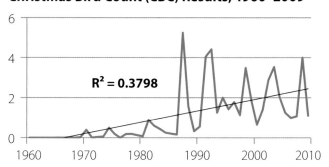

$R^2 = 0.3798$

## CBC Results, 2003–2008

| Winter | Number recorded | Counts reporting |
|---|---|---|
| 2003–2004 | 3,585 | 13 |
| 2004–2005 | 2,202 | 14 |
| 2005–2006 | 1,938 | 12 |
| 2006–2007 | 1,167 | 15 |
| 2007–2008 | 1,192 | 14 |

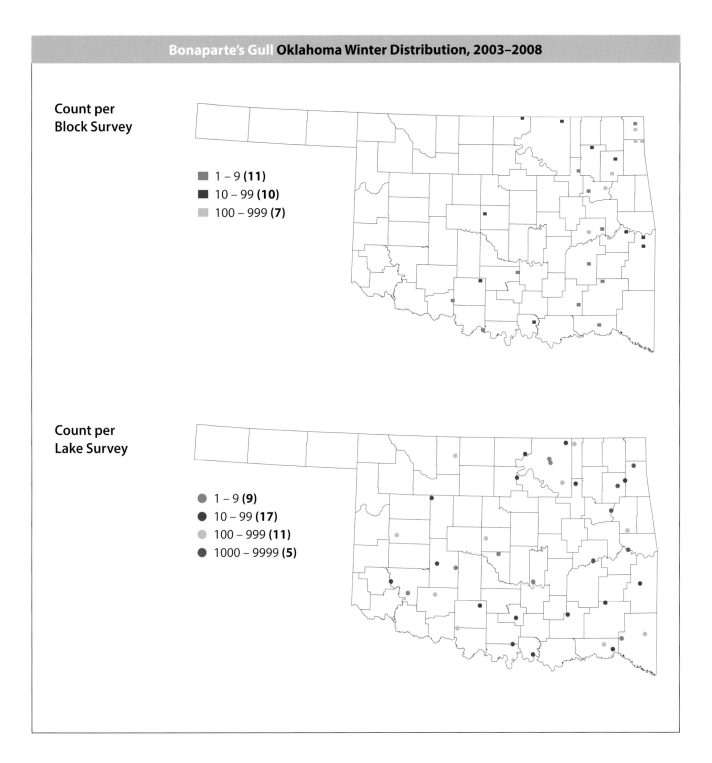

**Count per Block Survey**

- ■ 1 – 9 **(11)**
- ■ 10 – 99 **(10)**
- ■ 100 – 999 **(7)**

**Count per Lake Survey**

- ● 1 – 9 **(9)**
- ● 10 – 99 **(17)**
- ● 100 – 999 **(11)**
- ● 1000 – 9999 **(5)**

### References

Burger, Joanna, and Michael Gochfeld. 2002. Bonaparte's Gull (*Larus philadelphia*). *The Birds of North America Online*, edited by A. Poole. Ithaca, N.Y.: Cornell Laboratory of Ornithology. http://bna.birds .cornell.edu.

National Audubon Society. 2011. The Christmas Bird Count historical results. http://www .christmasbirdcount.org.

Oklahoma Bird Records Committee. 2006. 2005–2006 winter season. *The Scissortail* 56:14–15.

———. 2009a. 2007–2008 winter season. *The Scissortail* 59:4–8.

———. 2009b. *Date Guide to the Occurrences of Birds in Oklahoma*. 5th ed. Norman: Oklahoma Ornithological Society.

# Little Gull
## *Hydrocoloeus minutus*

Bill Horn

**Occurrence:** Rare visitor between mid-October and late March.

**Habitat:** Lakes and ponds.

**North American distribution:** Has nested near the Great Lakes and in eastern Canada. Winters in small numbers along the central Atlantic Coast of the United States. Rare inland in winter.

**Oklahoma distribution:** Not recorded in survey blocks. Reported from Tulsa County (Skiatook sewage ponds) in December 2007 as part of this project's lake surveys (see lake survey map), and one additional published observation during this project period came from Noble County (Kaw Lake) in January 2008 (Oklahoma Bird Records Committee 2009a). The total number of records prior to the atlas project exceeds two dozen.

**Behavior:** This rare species is likely to be seen singly if at all. It often associates with other, more common gulls such as Ring-billed and Bonaparte's Gulls. It is the smallest gull species in the world and has an unusually buoyant, fluttering flight pattern. Foraging for aquatic insects and small fish is done in flight by dipping down to the surface of the water or by plunge-diving, and also by picking at the water's surface while swimming.

## Christmas Bird Count (CBC) Results, 1960–2009

$R^2 = 0.0505$

## CBC Results, 2003–2008

| Winter | Number recorded | Counts reporting |
|--------|-----------------|------------------|
| 2003–2004 | 0 | — |
| 2004–2005 | 0 | — |
| 2005–2006 | 0 | — |
| 2006–2007 | 0 | — |
| 2007–2008 | 0 | — |

**Count per Block Survey**

**Count per Lake Survey**

● 1 – 9 **(1)**

### References

Brown, M. B. 2000. Status of the Little Gull in Oklahoma. *Bulletin of the Oklahoma Ornithological Society* 33:13–20.

Ewins, Peter J., and D. V. Weseloh. 1999. Little Gull (*Larus minutus*). *The Birds of North America Online*, edited by A. Poole. Ithaca, N.Y.: Cornell Laboratory of Ornithology. http://bna.birds.cornell.edu.

National Audubon Society. 2011. The Christmas Bird Count historical results. http://www.christmasbirdcount.org.

Newell, J. G. 1991. First record of Little Gull for Oklahoma. *Bulletin of the Oklahoma Ornithological Society* 24:17–18.

Oklahoma Bird Records Committee. 2009a. 2007–2008 winter season. *The Scissortail* 59:4–8.

———. 2009b. *Date Guide to the Occurrences of Birds in Oklahoma*. 5th ed. Norman: Oklahoma Ornithological Society.

Withgott, J. H. 1992. Common Black-headed Gull and Little Gull in Oklahoma. *Bulletin of the Oklahoma Ornithological Society* 25:31–33.

# Laughing Gull
## *Leucophaeus atricilla*

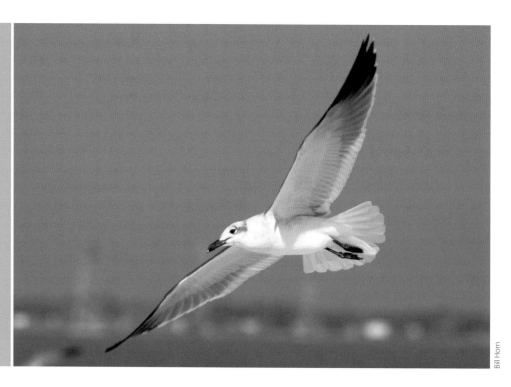

Bill Horn

**Occurrence:** Rare from mid-May through October.

**Habitat:** Lakes and rivers.

**North American distribution:** Breeds along the upper Atlantic Coast of the United States and in northwestern Mexico. Year-round resident along the southern Atlantic and Gulf Coasts.

**Oklahoma distribution:** Not a regular wintering species. Special interest species reports came from Fort Gibson Dam in Cherokee County on February 10, 2004; Kerr Lock and Dam in Le Flore County in January through February 2004 (Oklahoma Bird Records Committee 2004); and Kerr Lock and Dam in Sequoyah County on December 21–23, 2004 (Oklahoma Bird Records Committee 2005).

**Behavior:** Laughing Gulls often associate with other gull species. They forage in the water and along shorelines for fish, crustaceans, worms, insects, and garbage.

## Christmas Bird Count (CBC) Results, 1960–2009

$R^2 = 0.0041$

## CBC Results, 2003–2008

| Winter | Number recorded | Counts reporting |
|--------|-----------------|------------------|
| 2003–2004 | 0 | — |
| 2004–2005 | 0 | — |
| 2005–2006 | 0 | — |
| 2006–2007 | 0 | — |
| 2007–2008 | 0 | — |

**Count per
Block Survey**

**Count per
Lake Survey**

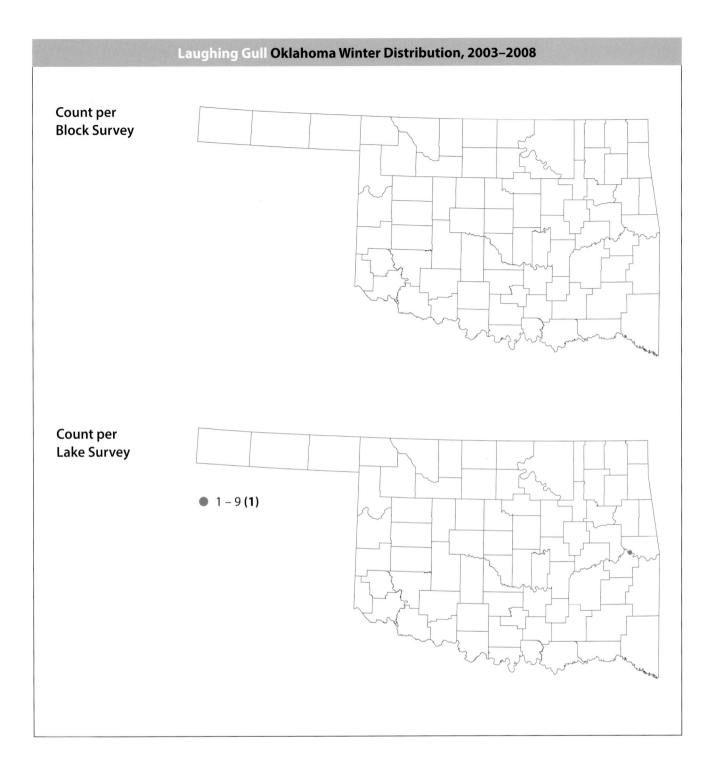

● 1 – 9 **(1)**

**References**

Burger, Joanna. 1996. Laughing Gull (*Leucophaeus atricilla*). *The Birds of North America Online*, edited by
    A. Poole. Ithaca, N.Y.: Cornell Laboratory of Ornithology. http://bna.birds.cornell.edu.
National Audubon Society. 2011. The Christmas Bird Count historical results. http://www
    .christmasbirdcount.org.
Oklahoma Bird Records Committee. 2004. 2003–2004 winter season. *The Scissortail* 54:25–27.
———. 2005. 2004–2005 winter season. *The Scissortail* 55:18–20.
———. 2009. *Date Guide to the Occurrences of Birds in Oklahoma.* 5th ed. Norman: Oklahoma
    Ornithological Society.

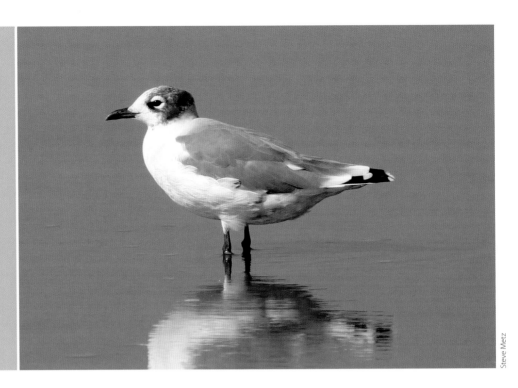

# Franklin's Gull
## *Leucophaeus pipixcan*

Steve Metz

**Occurrence:** March through early December, but most common during spring and fall migrations. A few linger into the winter season.

**Habitat:** Lakes, rivers, and fields.

**North American distribution:** Breeds in parts of central Canada and the western United States. Winters in South America, so it is rarely present here in winter.

**Oklahoma distribution:** Recorded in just one survey block in December 2002. Lake survey reports include observations from Lake Lawtonka in Comanche County in 2007 and two birds at Lake Texoma on December 7, 2004 (see lake survey map). Additional published reports from the project period include Johnston County (two birds at Tishomingo National Wildlife Refuge) on December 7, 2004 (Oklahoma Bird Records Committee [OBRC] 2005); Tulsa County in December 2003 and February 2004 (two birds at two separate locations; OBRC 2004); Tulsa County in December 2005 (OBRC 2006); and Tulsa County in late February 2008 (two birds; OBRC 2009a).

**Behavior:** Franklin's Gulls are highly gregarious in all seasons, although it is usually a lone individual that might remain in Oklahoma for all or part of the winter. Franklin's Gulls forage on insects, fish, snails, or seeds while walking or swimming.

## Christmas Bird Count (CBC) Results, 1960–2009

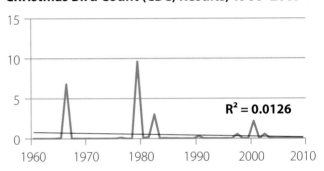

$R^2 = 0.0126$

## CBC Results, 2003–2008

| Winter | Number recorded | Counts reporting |
|--------|-----------------|------------------|
| 2003–2004 | 35 | 3 |
| 2004–2005 | 13 | 2 |
| 2005–2006 | 6 | 1 |
| 2006–2007 | 3 | 2 |
| 2007–2008 | 1 | 1 |

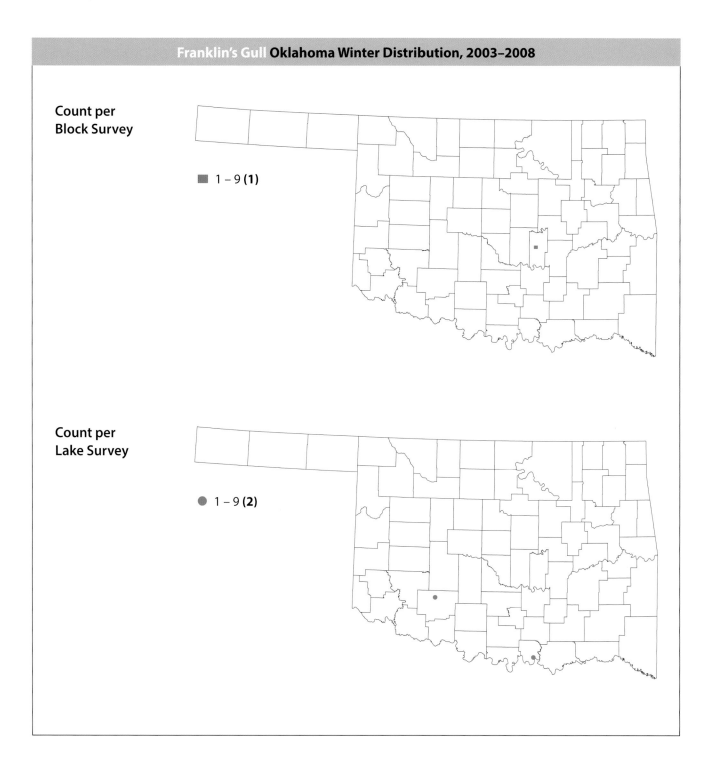

**Count per
Block Survey**

■ 1 – 9 **(1)**

**Count per
Lake Survey**

● 1 – 9 **(2)**

### References

Burger, Joanna, and Michael Gochfeld. 2009. Franklin's Gull (*Leucophaeus pipixcan*). *The Birds of North America Online*, edited by A. Poole. Ithaca, N.Y.: Cornell Laboratory of Ornithology. http://bna.birds.cornell.edu.

National Audubon Society. 2011. The Christmas Bird Count historical results. http://www.christmasbirdcount.org.

Oklahoma Bird Records Committee. 2004. 2003–2004 winter season. *The Scissortail* 54:25–27.

———. 2005. 2004–2005 winter season. *The Scissortail* 55:18–20.

———. 2006. 2005–2006 winter season. *The Scissortail* 56:14–15.

———. 2009a. 2007–2008 winter season. *The Scissortail* 59:4–8.

———. 2009b. *Date Guide to the Occurrences of Birds in Oklahoma*. 5th ed. Norman: Oklahoma Ornithological Society.

# Mew Gull
*Larus canus*

Steve Metz

**Occurrence:** Rare.

**Habitat:** Lakes and rivers.

**North American distribution:** Breeds in Alaska and northwestern Canada. Winters along the Pacific Coast.

**Oklahoma distribution:** Not recorded in survey blocks. Reported from Blaine County (Canton Lake) in February 2004 (special interest species report); the Le Flore/Sequoyah County border (below Kerr Dam) in December 2007 (special interest species report); and Oklahoma County (Lake Hefner) in January 2008 (Oklahoma Bird Records Committee 2009a). First documented for Oklahoma in January 2002 (Arterburn 2002), but also reported on the Oklahoma City Christmas Bird Count in December 1987.

**Behavior:** Because of their rarity in Oklahoma, Mew Gulls are usually seen singly, but they often associate with other gulls. They forage on land and in the water for crustaceans, fish, insects, and garbage.

**Christmas Bird Count (CBC) Results, 1960–2009**

$R^2 = 0.0006$

**CBC Results, 2003–2008**

| Winter | Number recorded | Counts reporting |
| --- | --- | --- |
| 2003–2004 | 0 | — |
| 2004–2005 | 0 | — |
| 2005–2006 | 0 | — |
| 2006–2007 | 0 | — |
| 2007–2008 | 0 | — |

Count per
Block Survey

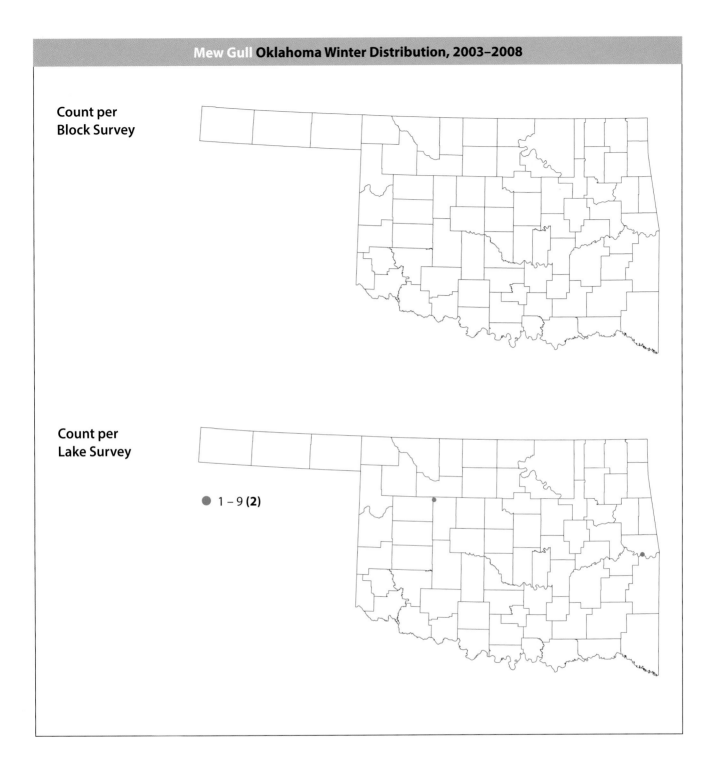

Count per
Lake Survey

● 1 – 9 **(2)**

### References

Arterburn, J. W. 2002. First record of the Mew Gull for Oklahoma. *Bulletin of the Oklahoma Ornithological Society* 35:1–2.

Beck, E. J., D. L. Reinking, and M. Husak. 2008. Oklahoma's first winter bird atlas project produces two new Mew Gull records. *Bulletin of the Oklahoma Ornithological Society* 41:10–11.

Moskoff, William, and Louis R. Bevier. 2002. Mew Gull (*Larus canus*). *The Birds of North America Online*, edited by A. Poole. Ithaca, N.Y.: Cornell Laboratory of Ornithology. http://bna.birds.cornell.edu.

National Audubon Society. 2011. The Christmas Bird Count historical results. http://www .christmasbirdcount.org.

Oklahoma Bird Records Committee. 2009a. 2007–2008 winter season. *The Scissortail* 59:4–8.

———. 2009b. *Date Guide to the Occurrences of Birds in Oklahoma*. 5th ed. Norman: Oklahoma Ornithological Society.

# Ring-billed Gull
## *Larus delawarensis*

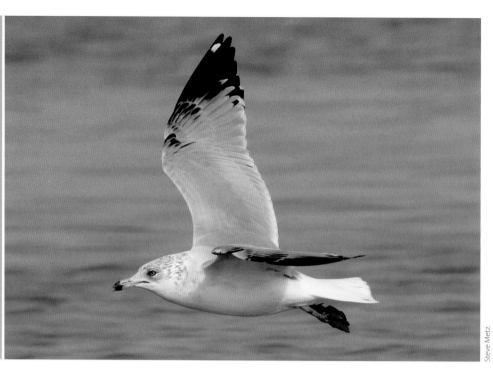

Steve Metz

**Occurrence:** Most common from fall through spring, with small numbers lingering through summer.

**Habitat:** Lakes, rivers, and landfills.

**North American distribution:** Breeds in Canada and the northern United States. Winters across much of the lower 48 states and Mexico.

**Oklahoma distribution:** Recorded fairly commonly in survey blocks within the main body of the state, and occasionally at high abundance. Many survey blocks lack habitat for this typically aquatic species.

**Behavior:** Ring-billed Gulls are gregarious year round and are usually seen in small to very large groups. They often associate with other gull species. Foraging takes place on the water or on the ground and targets a variety of items including fish, insects, grains, and garbage.

### Christmas Bird Count (CBC) Results, 1960–2009

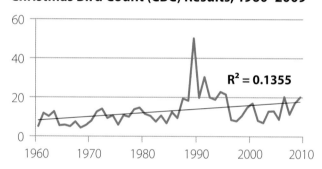

$R^2 = 0.1355$

### CBC Results, 2003–2008

| Winter | Number recorded | Counts reporting |
|--------|-----------------|------------------|
| 2003–2004 | 15,964 | 15 |
| 2004–2005 | 18,216 | 16 |
| 2005–2006 | 11,022 | 17 |
| 2006–2007 | 24,979 | 17 |
| 2007–2008 | 12,282 | 16 |

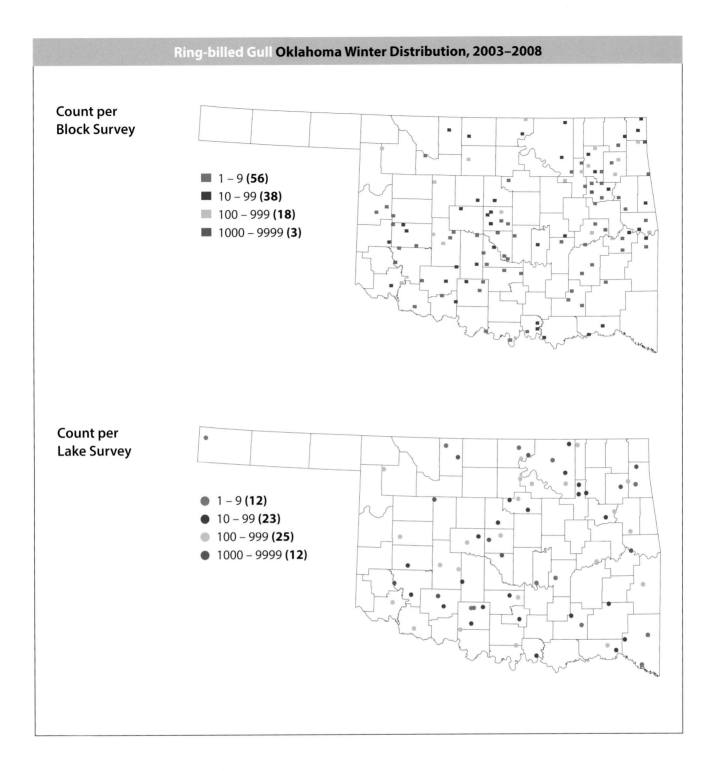

**Count per Block Survey**

- ■ 1 – 9 **(56)**
- ■ 10 – 99 **(38)**
- ■ 100 – 999 **(18)**
- ■ 1000 – 9999 **(3)**

**Count per Lake Survey**

- ● 1 – 9 **(12)**
- ● 10 – 99 **(23)**
- ● 100 – 999 **(25)**
- ● 1000 – 9999 **(12)**

### References

Landreth, H. F. 1975. The Ring-billed Gull in Oklahoma in winter. *Bulletin of the Oklahoma Ornithological Society* 8:1–3.

National Audubon Society. 2011. The Christmas Bird Count historical results. http://www.christmasbirdcount.org.

Oklahoma Bird Records Committee. 2009. *Date Guide to the Occurrences of Birds in Oklahoma*. 5th ed. Norman: Oklahoma Ornithological Society.

Ryder, John P. 1993. Ring-billed Gull (*Larus delawarensis*). *The Birds of North America Online*, edited by A. Poole. Ithaca, N.Y.: Cornell Laboratory of Ornithology. http://bna.birds.cornell.edu.

Scott, C. M. 1977. Food stealing behavior in the Ring-billed Gull. *Bulletin of the Oklahoma Ornithological Society* 10:33.

# California Gull
## *Larus californicus*

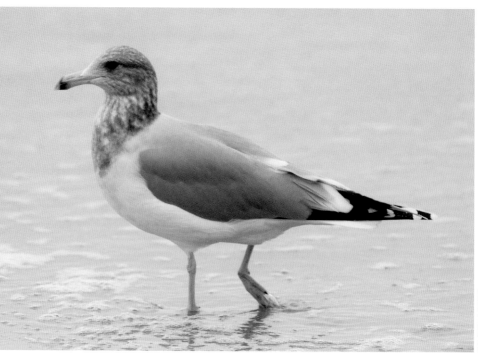

© (J. Poklen) / VIREO

**Occurrence:** Rare from mid-August through mid-May.

**Habitat:** Lakes and rivers.

**North American distribution:** Breeds in western Canada and parts of the western lower 48 states. Winters primarily along the Pacific Coast and in a few inland locations.

**Oklahoma distribution:** Not recorded in survey blocks. Reported as a special interest species from Greer County (Lake Altus) in December 2005 and from Oklahoma County (Lake Hefner) in December 2003 and January 2004. Also reported from Wagoner County (Fort Gibson Lake) in late February 2005 (Oklahoma Bird Records Committee [OBRC] 2005); Oklahoma County (Lake Overholser in December 2006 and Lake Hefner [two birds] in February 2007 [OBRC 2007]); Tulsa County (Lake Yahola) in December 2006 (OBRC 2007); Le Flore County (Kerr Lock and Dam) in January and December 2007 and January 2008 (OBRC 2009a); and Noble County (Sooner Lake) in December 2007 (OBRC 2009a).

**Behavior:** California Gulls are gregarious, but because of their rarity in Oklahoma, they are more likely to be seen singly. They often associate with other species including Ring-billed Gulls. They forage on land and in the water for a wide variety of items including fish, insects, carrion, and garbage.

## Christmas Bird Count (CBC) Results, 1960–2009

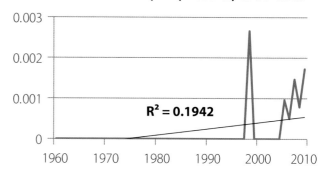

$R^2 = 0.1942$

## CBC Results, 2003–2008

| Winter | Number recorded | Counts reporting |
|---|---|---|
| 2003–2004 | 0 | — |
| 2004–2005 | 0 | — |
| 2005–2006 | 2 | 1 |
| 2006–2007 | 1 | 2 |
| 2007–2008 | 1 | 1 |

Count per
Block Survey

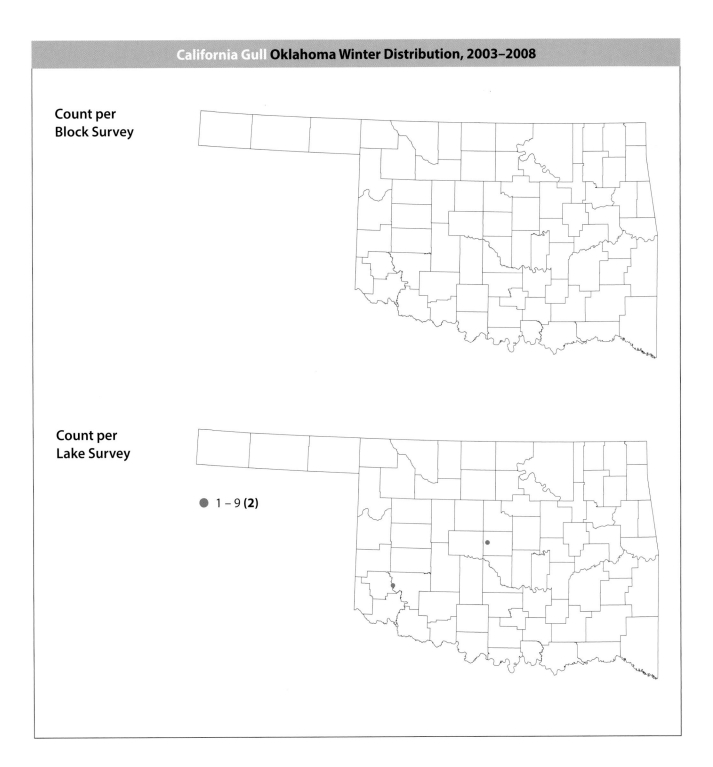

Count per
Lake Survey

● 1 – 9 **(2)**

### References

National Audubon Society. 2011. The Christmas Bird Count historical results. http://www
.christmasbirdcount.org.

Oklahoma Bird Records Committee. 2005. 2004–2005 winter season. *The Scissortail* 55:18–20.

———. 2007. 2006–2007 winter season. *The Scissortail* 57:24–27.

———. 2009a. 2007–2008 winter season. *The Scissortail* 59:4–8.

———. 2009b. *Date Guide to the Occurrences of Birds in Oklahoma*. 5th ed. Norman: Oklahoma
Ornithological Society.

Winkler, David W. 1996. California Gull (*Larus californicus*). *The Birds of North America Online*, edited by
A. Poole. Ithaca, N.Y.: Cornell Laboratory of Ornithology. http://bna.birds.cornell.edu.

# Herring Gull
## *Larus argentatus*

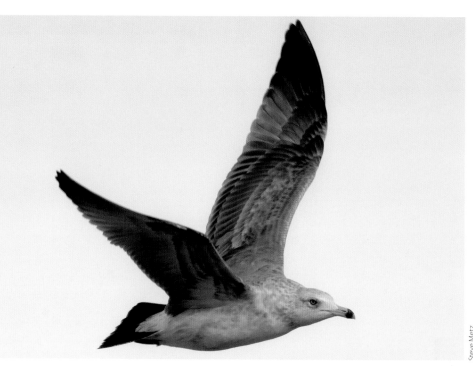

Steve Metz

**Occurrence:** Early October through mid-April.

**Habitat:** Lakes and larger rivers.

**North American distribution:** Breeds across much of Alaska and Canada. Resident in parts of the Great Lakes and Atlantic Coast regions, and winters broadly in parts of the eastern and western United States and Mexico.

**Oklahoma distribution:** Recorded at scattered locations throughout the main body of the state. Few blocks had habitat suitable for this species.

**Behavior:** Herring Gulls often loaf, roost, and forage together during the winter, and they are often seen with other gull species such as the Ring-billed Gull. Foraging is done along shorelines or in the water, and aquatic invertebrates, fish, and garbage are consumed.

## Christmas Bird Count (CBC) Results, 1960–2009

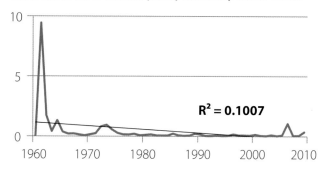

$R^2 = 0.1007$

## CBC Results, 2003–2008

| Winter | Number recorded | Counts reporting |
|--------|-----------------|------------------|
| 2003–2004 | 185 | 10 |
| 2004–2005 | 54 | 8 |
| 2005–2006 | 180 | 7 |
| 2006–2007 | 911 | 5 |
| 2007–2008 | 78 | 12 |

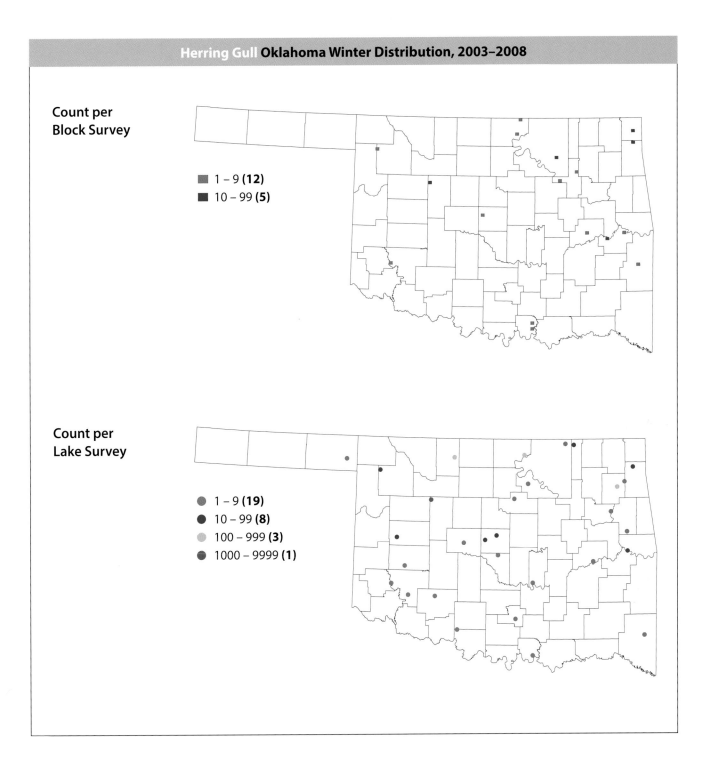

**Count per Block Survey**

■ 1 – 9 **(12)**
■ 10 – 99 **(5)**

**Count per Lake Survey**

● 1 – 9 **(19)**
● 10 – 99 **(8)**
○ 100 – 999 **(3)**
● 1000 – 9999 **(1)**

**References**

National Audubon Society. 2011. The Christmas Bird Count historical results. http://www .christmasbirdcount.org.

Oklahoma Bird Records Committee. 2009. *Date Guide to the Occurrences of Birds in Oklahoma*. 5th ed. Norman: Oklahoma Ornithological Society.

Pierotti, R. J., and T. P. Good. 1994. Herring Gull (*Larus argentatus*). *The Birds of North America Online*, edited by A. Poole. Ithaca, N.Y.: Cornell Laboratory of Ornithology. http://bna.birds.cornell.edu.

# Thayer's Gull
## *Larus glaucoides*

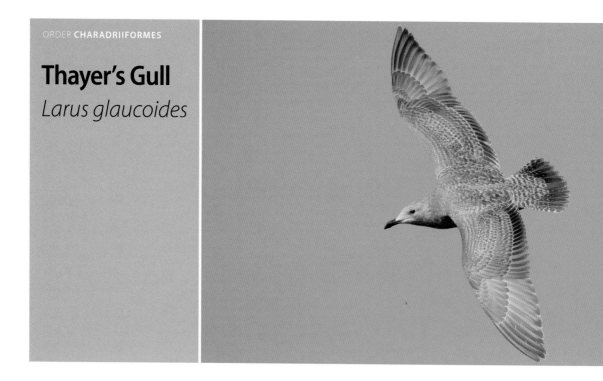

James Arterburn

**Occurrence:** Rare from mid-November through late March.

**Habitat:** Lakes and rivers.

**North American distribution:** Breeds in arctic Canada and Greenland. Winters along the Pacific Coast and the Great Lakes, and in scattered inland locations.

**Oklahoma distribution:** Not recorded in survey blocks. Special interest species reports were received for Alfalfa, Blaine, Le Flore, Oklahoma, Sequoyah, and Washington Counties, and it was recorded in four out of five of the winters surveyed (2005–2006 being the exception). Single birds were most common, but up to four were recorded at Salt Plains National Wildlife Refuge in January 2008 (Oklahoma Bird Records Committee 2009a).

**Behavior:** Thayer's Gulls often associate with other gull species. They forage for fish, aquatic invertebrates, and garbage from the surface of the water and from shorelines.

## Christmas Bird Count (CBC) Results, 1960–2009

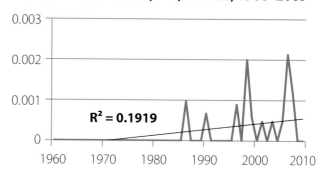

$R^2 = 0.1919$

## CBC Results, 2003–2008

| Winter | Number recorded | Counts reporting |
|---|---|---|
| 2003–2004 | 1 | 1 |
| 2004–2005 | 0 | — |
| 2005–2006 | 1 | 1 |
| 2006–2007 | 2 | 1 |
| 2007–2008 | 2 | 1 |

**Count per
Block Survey**

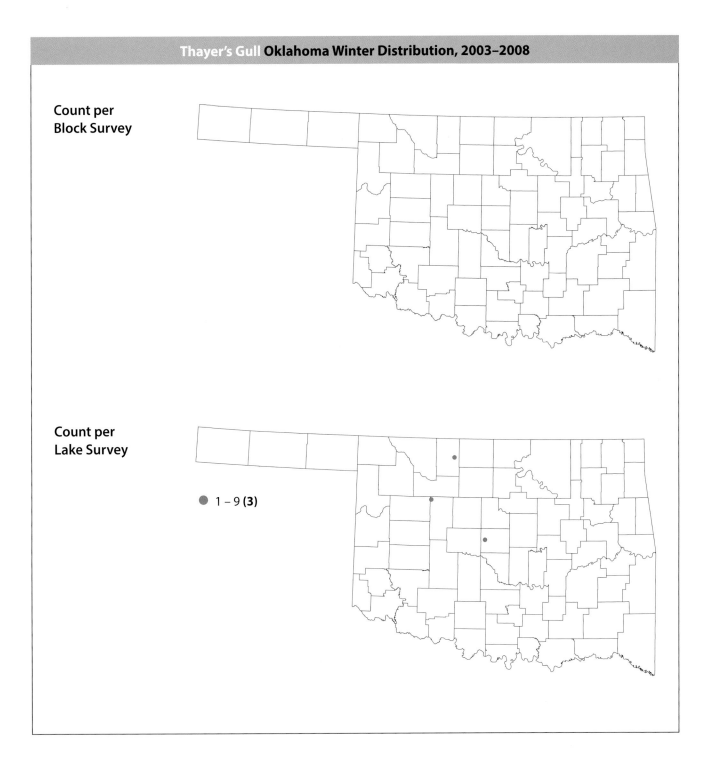

**Count per
Lake Survey**

● 1 – 9 **(3)**

**References**

National Audubon Society. 2011. The Christmas Bird Count historical results. http://www
.christmasbirdcount.org.

Oklahoma Bird Records Committee. 2004. 2003–2004 winter season. *The Scissortail* 54:25–27.

———. 2005. 2004–2005 winter season. *The Scissortail* 55:18–20.

———. 2006. 2005–2006 winter season. *The Scissortail* 56:14–15.

———. 2007. 2006–2007 winter season. *The Scissortail* 57:24–27.

———. 2009a. 2007–2008 winter season. *The Scissortail* 59:4–8.

———. 2009b. *Date Guide to the Occurrences of Birds in Oklahoma.* 5th ed. Norman: Oklahoma
Ornithological Society.

Snell, Richard R. 2002. Thayer's Gull (*Larus glaucoides*). *The Birds of North America Online*, edited by A. Poole.
Ithaca, N.Y.: Cornell Laboratory of Ornithology. http://bna.birds.cornell.edu.

# Lesser Black-backed Gull
*Larus fuscus*

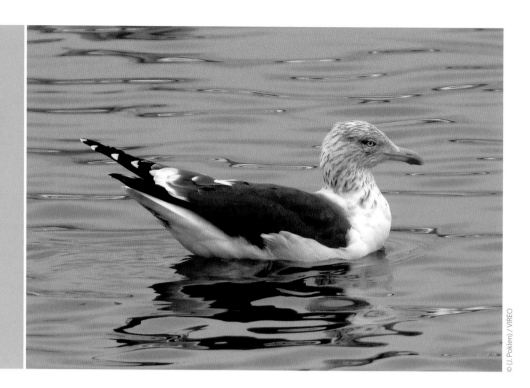

© (J. Poklen) / VIREO

**Occurrence:** Rare but regular in winter.

**Habitat:** Lakes.

**North American distribution:** Winters along the Atlantic and Gulf Coasts and at scattered inland locations in the eastern United States.

**Oklahoma distribution:** Not recorded in survey blocks. One to four individuals reported from Lake Hefner in Oklahoma City during each of the five project winters (Oklahoma Bird Records Committee [OBRC] 2003, 2004, 2005, 2006, 2007, 2009a). Also reported from Lake Overholser in Oklahoma City during the winters of 2003–2004 (OBRC 2004) and 2007–2008 (OBRC 2009a), and from Boomer Lake in Payne County during January and February 2008 (special interest species report and OBRC 2009a).

**Behavior:** Lesser Black-backed Gulls often associate with other gull species. They forage on the water and along shorelines for invertebrates, carrion, and other items.

## Christmas Bird Count (CBC) Results, 1960–2009

$R^2 = 0.201$

## CBC Results, 2003–2008

| Winter | Number recorded | Counts reporting |
|--------|-----------------|------------------|
| 2003–2004 | 1 | 1 |
| 2004–2005 | 0 | — |
| 2005–2006 | 1 | 1 |
| 2006–2007 | 0 | — |
| 2007–2008 | 0 | — |

Count per
Block Survey

Count per
Lake Survey

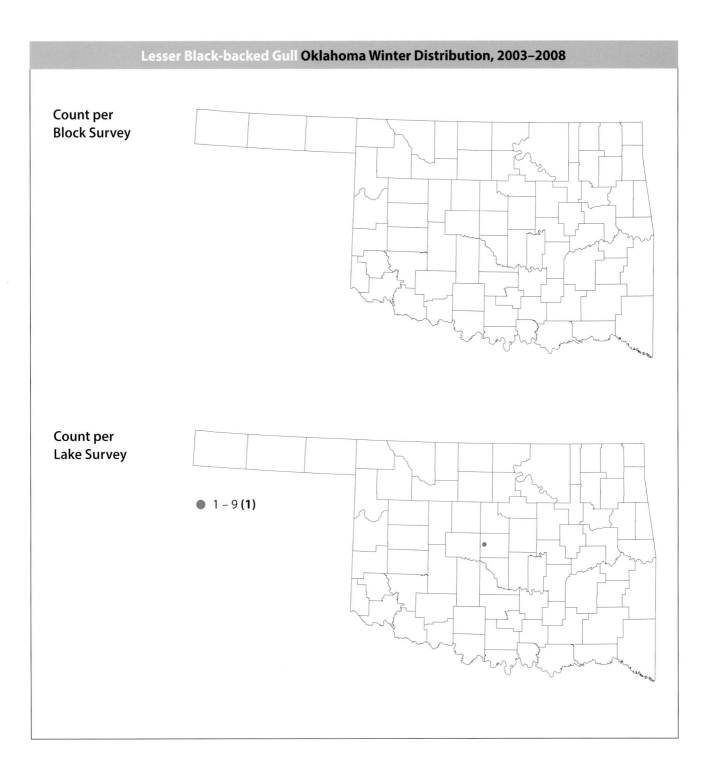

● 1 – 9 **(1)**

## References

National Audubon Society. 2011. The Christmas Bird Count historical results. http://www
.christmasbirdcount.org.

Newell, J. G. 1984. A new bird for Oklahoma: Lesser Black-backed Gull. *Bulletin of the Oklahoma
Ornithological Society* 17:17–20.

Oklahoma Bird Records Committee. 2004. 2003–2004 winter season. *The Scissortail* 54:25–27.

———. 2005. 2004–2005 winter season. *The Scissortail* 55:18–20.

———. 2006. 2005–2006 winter season. *The Scissortail* 56:14–15.

———. 2007. 2006–2007 winter season. *The Scissortail* 57:24–27.

———. 2009a. 2007–2008 winter season. *The Scissortail* 59:4–8.

———. 2009b. *Date Guide to the Occurrences of Birds in Oklahoma.* 5th ed. Norman: Oklahoma
Ornithological Society.

# Glaucous Gull
## *Larus hyperboreus*

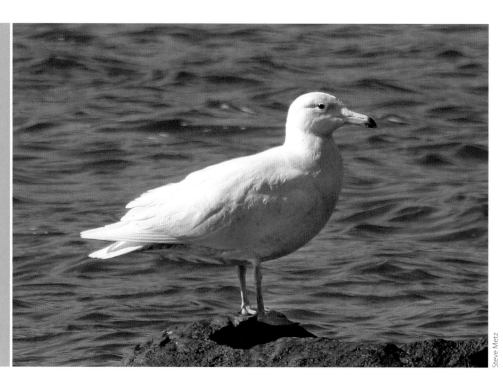

Steve Metz

**Occurrence:** Mid-November through early March.

**Habitat:** Lakes and rivers.

**North American distribution:** Breeds in arctic Alaska and Canada. Winters along the northern Pacific and Atlantic Coasts, in the Great Lakes region, and at scattered inland locations.

**Oklahoma distribution:** Not recorded in survey blocks. Reported from lakes in Alfalfa, Blaine, Oklahoma, Sequoyah, and Tulsa Counties (see lake survey map). Published reports during the project period also came from Canadian, Le Flore, and Mayes Counties (Oklahoma Bird Records Committee 2004, 2005, 2009a).

**Behavior:** Because of their relative rarity in the state, Glaucous Gulls are usually seen singly in Oklahoma, although occasionally more than one individual may be present at a lake. They often associate with other gull species, and they forage while swimming or walking along shorelines in search of invertebrates, fish, carrion, and garbage.

## Christmas Bird Count (CBC) Results, 1960–2009

$R^2 = 0.0202$

## CBC Results, 2003–2008

| Winter | Number recorded | Counts reporting |
|--------|-----------------|------------------|
| 2003–2004 | 1 | 1 |
| 2004–2005 | 2 | 2 |
| 2005–2006 | 0 | — |
| 2006–2007 | 2 | 2 |
| 2007–2008 | 2 | 2 |

**Count per Block Survey**

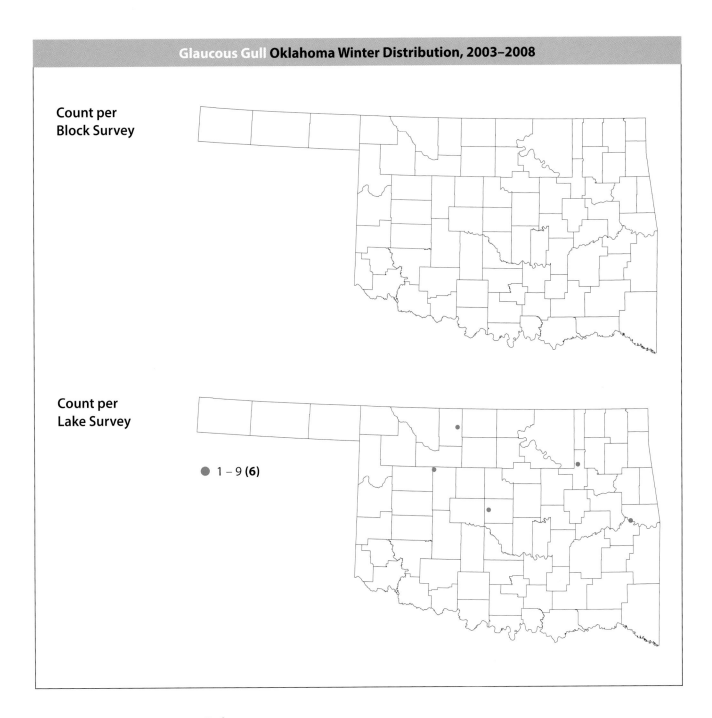

**Count per Lake Survey**

● 1 – 9 **(6)**

### References

Anderson, B. W. 1971. The Glaucous Gull in Oklahoma. *Bulletin of the Oklahoma Ornithological Society* 4:31–32.

Gilchrist, H. Grant. 2001. Glaucous Gull (*Larus hyperboreus*). *The Birds of North America Online*, edited by A. Poole. Ithaca, N.Y.: Cornell Laboratory of Ornithology. http://bna.birds.cornell.edu.

Haller, K. W. 1984. A Glaucous Gull in Bryan County, Oklahoma and Grayson County, Texas. *Bulletin of the Oklahoma Ornithological Society* 17:27–28.

National Audubon Society. 2011. The Christmas Bird Count historical results. http://www .christmasbirdcount.org.

Oklahoma Bird Records Committee. 2004. 2003–2004 winter season. *The Scissortail* 54:25–27.

———. 2005. 2004–2005 winter season. *The Scissortail* 55:18–20.

———. 2006. 2005–2006 winter season. *The Scissortail* 56:14–15.

———. 2007. 2006–2007 winter season. *The Scissortail* 57:24–27.

———. 2009a. 2007–2008 winter season. *The Scissortail* 59:4–8.

———. 2009b. *Date Guide to the Occurrences of Birds in Oklahoma*. 5th ed. Norman: Oklahoma Ornithological Society.

Ports, M. 1976. Third specimen of Glaucous Gull for Oklahoma. *Bulletin of the Oklahoma Ornithological Society* 9:6–7.

Tomer, J. S., and J. A. Grzybowski. 1995. Re-evaluation of possible Iceland Gull record for Tulsa County, Oklahoma. *Bulletin of the Oklahoma Ornithological Society* 28:14–15.

# Forster's Tern
## *Sterna forsteri*

James Arterburn

**Occurrence:** Most common during spring and fall migration, but a few linger through the summer and spend the winter.

**Habitat:** Lakes, rivers, and wetlands.

**North American distribution:** Breeds at widely scattered locations in the lower 48 states and Canada. Resident along portions of three coasts, and winters in parts of California, the southeastern United States, and Mexico.

**Oklahoma distribution:** Recorded at scattered locations in the eastern half of the state. Relatively few survey blocks would have had suitable habitat. Lake surveys produced an additonal three locations west of Interstate 35.

**Behavior:** Forster's Terns are often seen in small to large groups, either flying or perched along the edge of the water. They forage by plunging into the water from flight to grab small fish in their bills.

### Christmas Bird Count (CBC) Results, 1960–2009

$R^2 = 0.4439$

### CBC Results, 2003–2008

| Winter | Number recorded | Counts reporting |
|---|---|---|
| 2003–2004 | 73 | 5 |
| 2004–2005 | 228 | 5 |
| 2005–2006 | 45 | 4 |
| 2006–2007 | 92 | 3 |
| 2007–2008 | 44 | 4 |

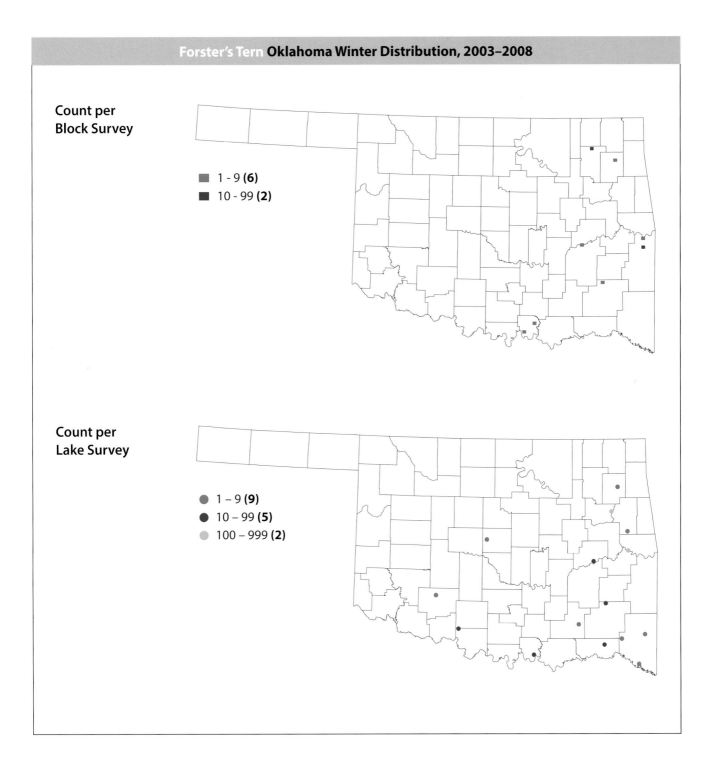

**Count per Block Survey**

■ 1 - 9 **(6)**
■ 10 - 99 **(2)**

**Count per Lake Survey**

● 1 – 9 **(9)**
● 10 – 99 **(5)**
● 100 – 999 **(2)**

**References**

McNicholl, Martin K., Peter E. Lowther, and John A. Hall. 2001. Forster's Tern (*Sterna forsteri*). *The Birds of North America Online*, edited by A. Poole. Ithaca, N.Y.: Cornell Laboratory of Ornithology. http://bna .birds.cornell.edu.

National Audubon Society. 2011. The Christmas Bird Count historical results. http://www .christmasbirdcount.org.

Oklahoma Bird Records Committee. 2009. *Date Guide to the Occurrences of Birds in Oklahoma.* 5th ed. Norman: Oklahoma Ornithological Society.

# ORDER GAVIIFORMES

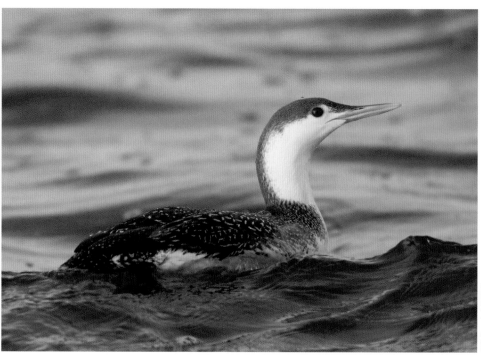

## Red-throated Loon
### *Gavia stellata*

© (R. Crossley / VIREO)

**Occurrence:** Rare from early November through early May.

**Habitat:** Lakes.

**North American distribution:** Breeds in Alaska and northern Canada. Winters along the Pacific and Atlantic Coasts and uncommonly inland.

**Oklahoma distribution:** Not recorded in survey blocks. One to eight birds reported from Sequoyah and Cherokee Counties (Lake Tenkiller) during each of the five winters surveyed for this project (see lake survey map). Special interest species reports were also received from Marshall County (Lake Texoma) in February 2007; Oklahoma County (Lake Hefner) in December 2003, January 2004, and February 2007; and Tulsa County (Lake Yahola) in February 2005.

**Behavior:** Red-throated Loons often congregate during fall and winter, although their rarity in Oklahoma makes finding single birds more likely than finding a group. They are often seen in association with other loon species as they forage for fish by diving below the surface of the water.

### Christmas Bird Count (CBC) Results, 1960–2009

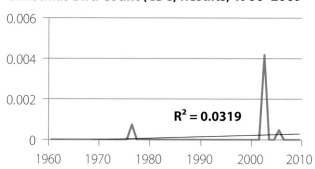

$R^2 = 0.0319$

### CBC Results, 2003–2008

| Winter | Number recorded | Counts reporting |
|--------|-----------------|------------------|
| 2003–2004 | 0 | — |
| 2004–2005 | 0 | — |
| 2005–2006 | 1 | 1 |
| 2006–2007 | 0 | — |
| 2007–2008 | 0 | — |

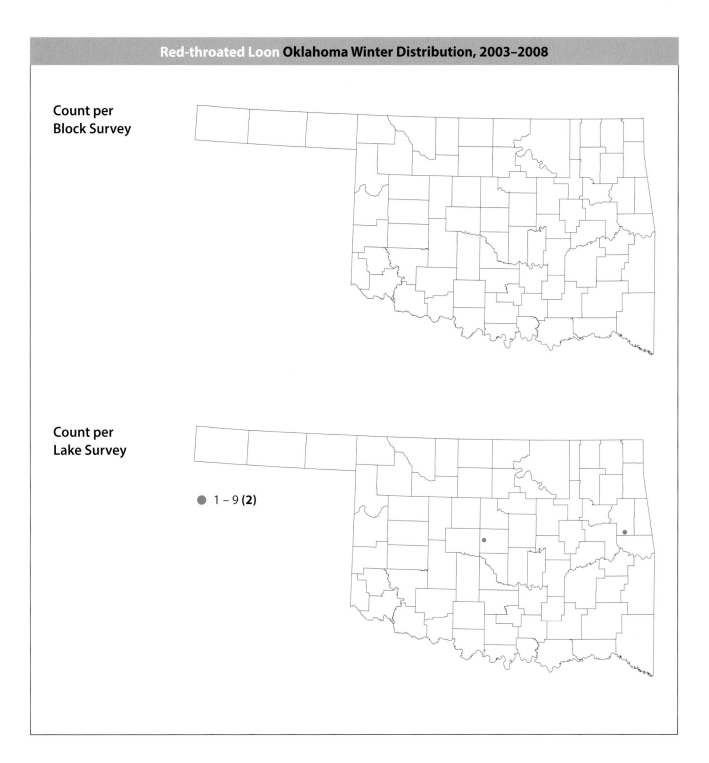

Count per
Block Survey

Count per
Lake Survey

● 1 – 9 **(2)**

## References

Barr, Jack F., Christine Eberl, and Judith W. McIntyre. 2000. Red-throated Loon (*Gavia stellata*). *The Birds of North America Online*, edited by A. Poole. Ithaca, N.Y.: Cornell Laboratory of Ornithology. http://bna .birds.cornell.edu.

National Audubon Society. 2011. The Christmas Bird Count historical results. http://www .christmasbirdcount.org.

Oklahoma Bird Records Committee. 2004. 2003–2004 winter season. *The Scissortail* 54:25–27.

———. 2007. 2006–2007 winter season. *The Scissortail* 57:24–27.

———. 2009. *Date Guide to the Occurrences of Birds in Oklahoma*. 5th ed. Norman: Oklahoma Ornithological Society.

# Pacific Loon
## *Gavia pacifica*

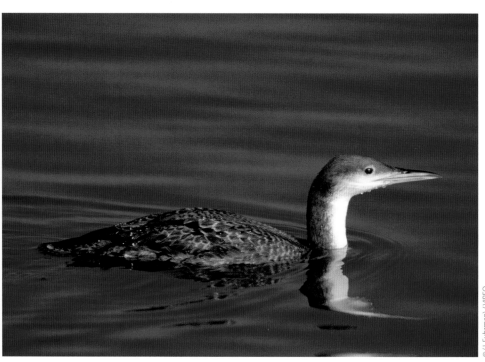

© (J. Fuhrman) / VIREO

**Occurrence:** Rare from early November through early May.

**Habitat:** Lakes.

**North American distribution:** Breeds in Alaska and northern Canada. Winters along the Pacific Coast.

**Oklahoma distribution:** Not recorded in survey blocks. One to five birds were reported from Lake Tenkiller (Sequoyah and Cherokee Counties) in each of the five winters of this project. Additional special interest species reports came from Carter (January 2005), Cherokee (January 2004), Custer (December 2003), Marshall (February 2007), Murray (January 2005), and Wagoner (January 2006) Counties.

**Behavior:** Pacific Loons are rare in Oklahoma and as such are usually seen singly, but small groups can occasionally be found, and they often associate with other loon species. Foraging takes places underwater, where their webbed feet propel them very effectively in pursuit of fish.

## Christmas Bird Count (CBC) Results, 1960–2009

$R^2 = 0.1139$

## CBC Results, 2003–2008

| Winter | Number recorded | Counts reporting |
|---|---|---|
| 2003–2004 | 1 | 1 |
| 2004–2005 | 1 | 1 |
| 2005–2006 | 3 | 1 |
| 2006–2007 | 0 | — |
| 2007–2008 | 0 | — |

Count per
Block Survey

Count per
Lake Survey

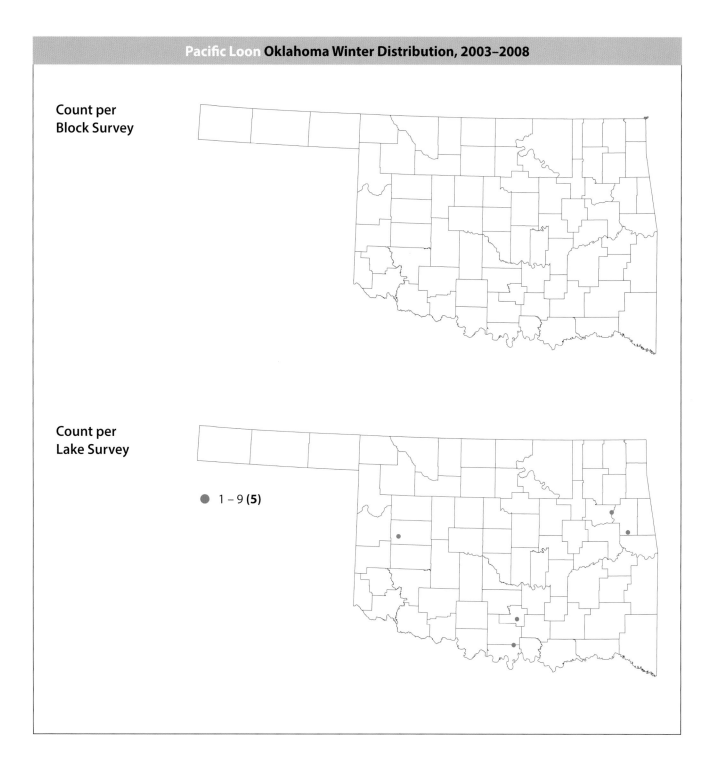

● 1 – 9 **(5)**

### References

National Audubon Society. 2011. The Christmas Bird Count historical results. http://www
.christmasbirdcount.org.

Oklahoma Bird Records Committee. 2004. 2003–2004 winter season. *The Scissortail* 54:25–27.

———. 2009. *Date Guide to the Occurrences of Birds in Oklahoma*. 5th ed. Norman: Oklahoma
Ornithological Society.

Oliphant, M. 1990. A new bird for Oklahoma: Pacific Loon. *Bulletin of the Oklahoma Ornithological
Society* 23:17–20.

Russell, Robert W. 2002. Pacific Loon (*Gavia pacifica*). *The Birds of North America Online*, edited by
A. Poole. Ithaca, N.Y.: Cornell Laboratory of Ornithology. http://bna.birds.cornell.edu.

# Common Loon
*Gavia immer*

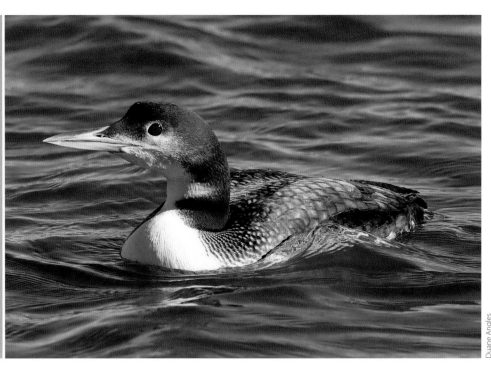

Duane Angles

**Occurrence:** October through mid-May.

**Habitat:** Lakes.

**North American distribution:** Breeds throughout most of Alaska and Canada and parts of the northernmost lower 48 states. Winters along the East and West Coasts and in much of the southern United States.

**Oklahoma distribution:** Recorded in just three survey blocks. Few blocks had suitable lake habitat. Lake surveys showed a sparse but uniform distribution throughout the main body of the state. Lake Tenkiller in Cherokee and Sequoyah Counties typically hosts the largest concentration of this species in the state, with 428 birds counted on January 22, 2004.

**Behavior:** Common Loons are generally solitary during winter but sometimes forage in groups. Their legs are set far back on their bodies, making them excellent swimmers and divers, but they need a long, paddling takeoff on water to take flight. They are capable of diving for minutes at a time, although most of their foraging dives for fish are shorter than that.

**Christmas Bird Count (CBC) Results, 1960–2009**

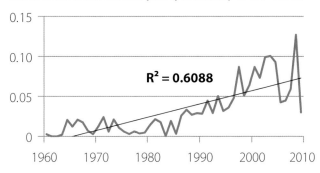

$R^2 = 0.6088$

**CBC Results, 2003–2008**

| Winter | Number recorded | Counts reporting |
| --- | --- | --- |
| 2003–2004 | 83 | 9 |
| 2004–2005 | 87 | 8 |
| 2005–2006 | 36 | 8 |
| 2006–2007 | 48 | 10 |
| 2007–2008 | 51 | 8 |

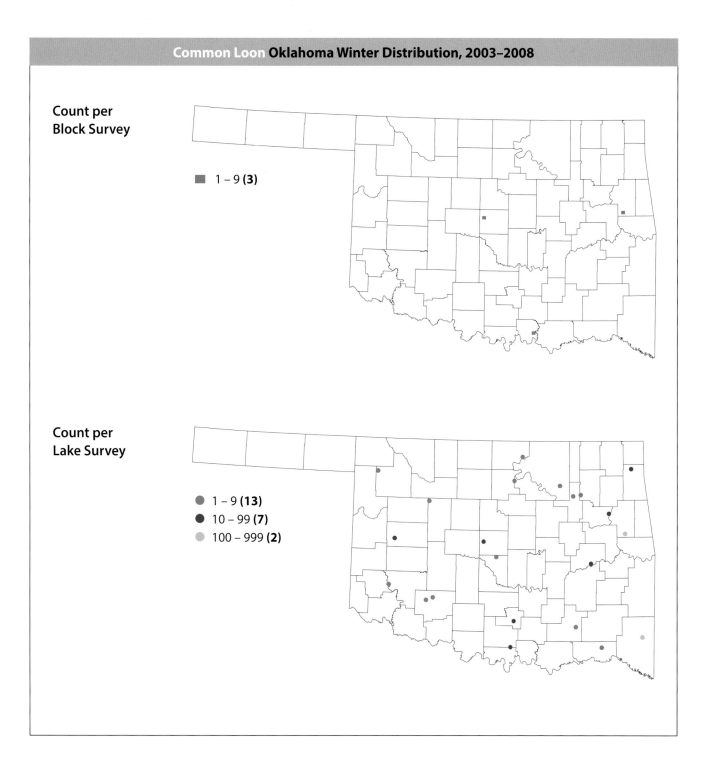

Count per
Block Survey

■ 1 – 9 **(3)**

Count per
Lake Survey

● 1 – 9 **(13)**
● 10 – 99 **(7)**
● 100 – 999 **(2)**

## References

Evers, David C., James D. Paruk, Judith W. McIntyre, and Jack F. Barr. 2010. Common Loon (*Gavia immer*). *The Birds of North America Online*, edited by A. Poole. Ithaca, N.Y.: Cornell Laboratory of Ornithology. http://bna.birds.cornell.edu.

McMahon, J. A. 1991. Exceptionally large numbers of Common Loons on Lake Tenkiller, Oklahoma. *Bulletin of the Oklahoma Ornithological Society* 24:4.

National Audubon Society. 2011. The Christmas Bird Count historical results. http://www .christmasbirdcount.org.

Oklahoma Bird Records Committee. 2004. 2003–2004 winter season. *The Scissortail* 54:25–27.

———. 2009. *Date Guide to the Occurrences of Birds in Oklahoma.* 5th ed. Norman: Oklahoma Ornithological Society.

# Yellow-billed Loon
## *Gavia adamsii*

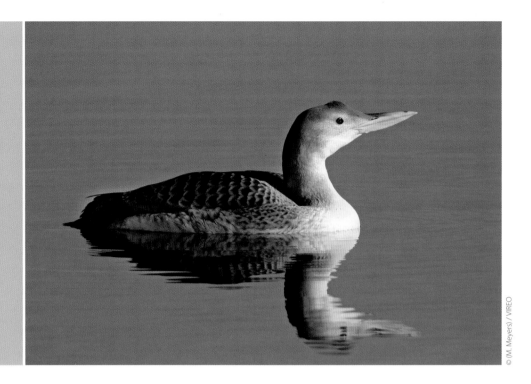

© (M. Meyers) / VIREO

**Occurrence:** Rare in winter.

**Habitat:** Lakes.

**North American distribution:** Breeds in northern Alaska and northern Canada. Winters along the northern Pacific Coast from Alaska to Washington.

**Oklahoma distribution:** Not recorded in survey blocks. Special interest species reports came from Cherokee County (Lake Tenkiller) in February 2007; Sequoyah County (Lake Tenkiller) in January and February 2004 (two birds), February 2006, and January 2007.

**Behavior:** Yellow-billed Loons sometimes form loose groups, although their rarity in Oklahoma makes single birds more likely. They often associate with other loon species, and like other loons they dive in search of fish.

## Christmas Bird Count (CBC) Results, 1960–2009

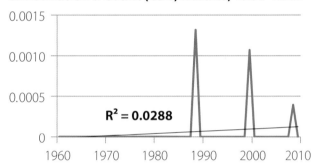

$R^2 = 0.0288$

## CBC Results, 2003–2008

| Winter | Number recorded | Counts reporting |
|---|---|---|
| 2003–2004 | 0 | — |
| 2004–2005 | 0 | — |
| 2005–2006 | 0 | — |
| 2006–2007 | 0 | — |
| 2007–2008 | 0 | — |

**Count per Block Survey**

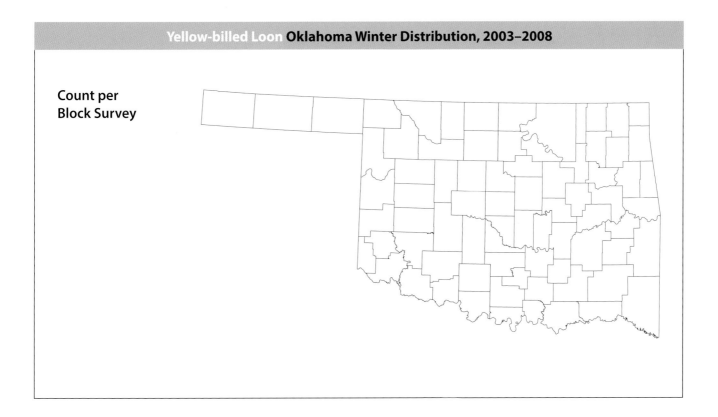

### References

Loyd, J., and P. Seibert. 1989. Yellow-billed Loon: First sighting in Oklahoma. *Bulletin of the Oklahoma Ornithological Society* 22:9–10.

National Audubon Society. 2011. The Christmas Bird Count historical results. http://www.christmasbirdcount.org.

North, Michael R. 1994. Yellow-billed Loon (*Gavia adamsii*). *The Birds of North America Online*, edited by A. Poole. Ithaca, N.Y.: Cornell Laboratory of Ornithology. http://bna.birds.cornell.edu.

Oklahoma Bird Records Committee. 2006. 2005–2006 winter season. *The Scissortail* 56:14–15.

———. 2007. 2006–2007 winter season. *The Scissortail* 57:24–27.

———. 2009. *Date Guide to the Occurrences of Birds in Oklahoma*. 5th ed. Norman: Oklahoma Ornithological Society.

# ORDER SULIFORMES

## Double-crested Cormorant
### *Phalacrocorax auritus*

Bill Horn

**Occurrence:** Present year round, but turnover of individuals as a result of migration is likely. Most numerous during spring and fall migrations.

**Habitat:** Lakes.

**North American distribution:** Patchy and complex distribution pattern, with breeding, resident, or wintering populations located over large portions of the continent.

**Oklahoma distribution:** Recorded at widespread and evenly distributed locations throughout the state, except for the Panhandle and northwestern counties. The gregarious nature of cormorants is reflected in the number of blocks in which they were recorded at high to very high densities. The summer distribution recorded by the Oklahoma Breeding Bird Atlas Project was very similar, although there were more records from the northwestern region.

**Behavior:** Double-crested Cormorants are gregarious during all seasons and may be seen in large flocks, but they are also frequently seen foraging alone. They are skilled swimmers and divers and typically dive for 20–30 seconds at a time as they pursue small fish. They are also frequently seen perched in tree limbs or on floating structures with wings spread to dry their feathers.

### Christmas Bird Count (CBC) Results, 1960–2009

$R^2 = 0.5066$

### CBC Results, 2003–2008

| Winter | Number recorded | Counts reporting |
|--------|-----------------|------------------|
| 2003–2004 | 4,772 | 16 |
| 2004–2005 | 8,710 | 17 |
| 2005–2006 | 10,099 | 14 |
| 2006–2007 | 14,655 | 17 |
| 2007–2008 | 18,394 | 17 |

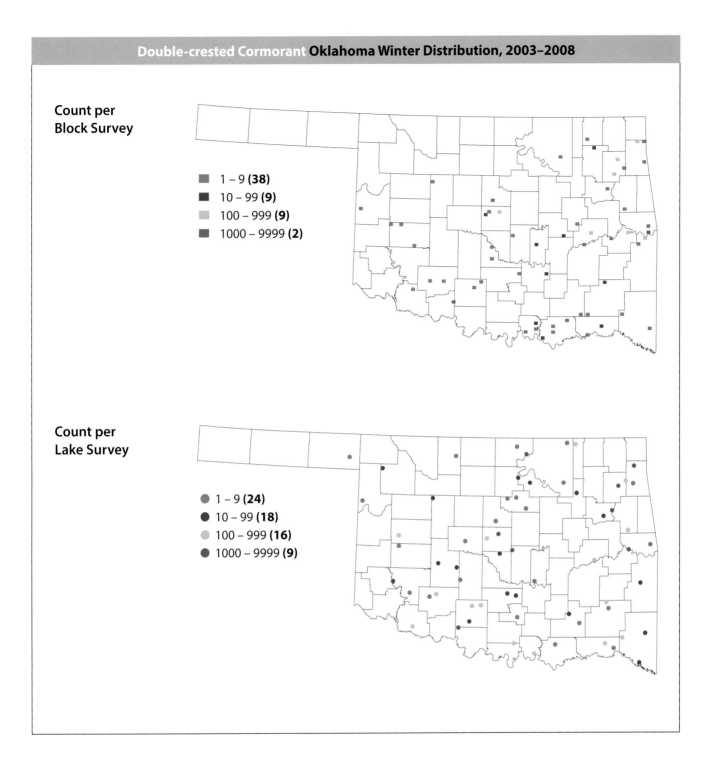

**Count per Block Survey**

■ 1 – 9 **(38)**
■ 10 – 99 **(9)**
■ 100 – 999 **(9)**
■ 1000 – 9999 **(2)**

**Count per Lake Survey**

● 1 – 9 **(24)**
● 10 – 99 **(18)**
● 100 – 999 **(16)**
● 1000 – 9999 **(9)**

**References**

Hatch, Jeremy J., and D. V. Weseloh. 1999. Double-crested Cormorant (*Phalacrocorax auritus*). *The Birds of North America Online*, edited by A. Poole. Ithaca, N.Y.: Cornell Laboratory of Ornithology. http://bna .birds.cornell.edu.

National Audubon Society. 2011. The Christmas Bird Count historical results. http://www .christmasbirdcount.org.

Oklahoma Bird Records Committee. 2009. *Date Guide to the Occurrences of Birds in Oklahoma*. 5th ed. Norman: Oklahoma Ornithological Society.

Reinking, D. L., ed. 2004. *Oklahoma Breeding Bird Atlas*. Norman: University of Oklahoma Press.

# Anhinga
## *Anhinga anhinga*

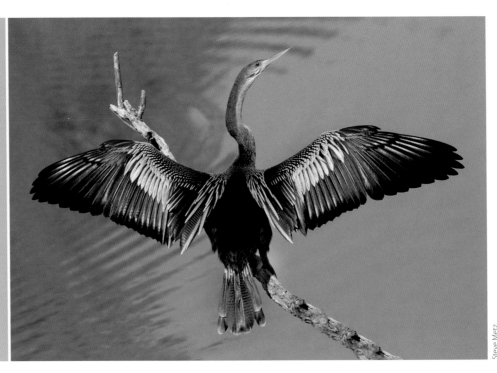

Steve Metz

**Occurrence:** Generally April through October. Rarely lingers into the winter.

**Habitat:** Marshes, lakes, and sluggish backwaters.

**North American distribution:** Breeds in parts of the southeastern United States and is resident along the Gulf Coast and in Mexico.

**Oklahoma distribution:** Not recorded in survey blocks. Recorded as a special interest species in December 2007 (three birds) and January 2008 (one bird) at Red Slough Wildlife Management Area in McCurtain County. The summer distribution recorded by the Oklahoma Breeding Bird Atlas Project was also limited to McCurtain County.

**Behavior:** Although gregarious, Anhingas are rare in Oklahoma during winter and are likely to be seen only in small numbers. They forage for fish and aquatic invertebrates by swimming and diving underwater and spearing prey with their sharply pointed bills. After swimming, they perch over or near the water and spread their wings to dry.

### CBC Results, 2003–2008

| Winter | Number recorded | Counts reporting |
|---|---|---|
| 2003–2004 | 0 | — |
| 2004–2005 | 0 | — |
| 2005–2006 | 0 | — |
| 2006–2007 | 0 | — |
| 2007–2008 | 0 | — |

**Count per
Block Survey**

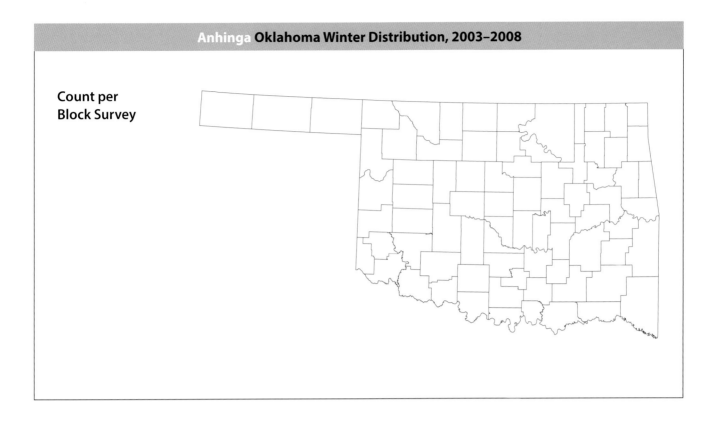

### References

Frederick, Peter C., and Douglas Siegel-Causey. 2000. Anhinga (*Anhinga anhinga*). *The Birds of North America Online*, edited by A. Poole. Ithaca, N.Y.: Cornell Laboratory of Ornithology. http://bna.birds .cornell.edu.

National Audubon Society. 2011. The Christmas Bird Count historical results. http://www .christmasbirdcount.org.

Oklahoma Bird Records Committee. 2009. *Date Guide to the Occurrences of Birds in Oklahoma*. 5th ed. Norman: Oklahoma Ornithological Society.

Reinking, D. L., ed. 2004. *Oklahoma Breeding Bird Atlas*. Norman: University of Oklahoma Press.

# ORDER **PELECANIFORMES**

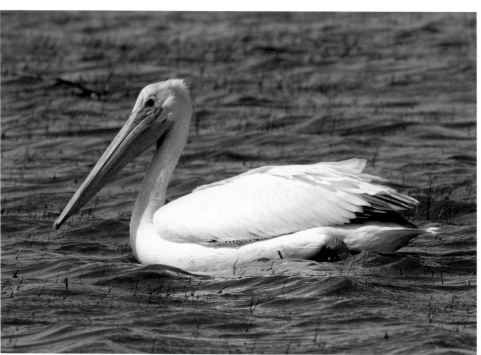

## American White Pelican
*Pelecanus erythrorhynchos*

Bob Gress

**Occurrence:** Small numbers of pelicans linger during both the summer and winter months, although they are most numerous during spring and fall migration.

**Habitat:** Large bodies of water and spillways below dams.

**North American distribution:** Pelicans nest in scattered portions of interior western North America and winter primarily in California, Mexico, and the Gulf Coast states as well as in Oklahoma and Arkansas.

**Oklahoma distribution:** Despite the randomly located atlas blocks offering poor survey coverage of Oklahoma's reservoirs, pelicans were recorded in a number of blocks, primarily in the east. The largest numbers were found at large reservoirs in northeastern Oklahoma. Lake surveys indicate a more widespread distribution throughout the main body of the state.

**Behavior:** While pelicans are often seen soaring high overhead during migration, in winter they are most often observed swimming. They are usually gregarious, although lone birds are occasionally seen. They feed primarily on fish species that are of little interest to anglers, and they are known for the cooperative foraging behavior of encircling a school of fish to make scooping them up with their large bills easier.

## Christmas Bird Count (CBC) Results, 1960–2009

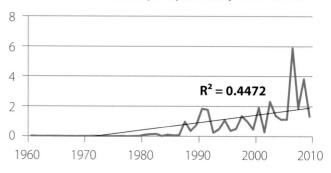

$R^2 = 0.4472$

## CBC Results, 2003–2008

| Winter | Number recorded | Counts reporting |
| --- | --- | --- |
| 2003–2004 | 1,290 | 10 |
| 2004–2005 | 1,032 | 12 |
| 2005–2006 | 1,115 | 10 |
| 2006–2007 | 5,852 | 13 |
| 2007–2008 | 2,025 | 13 |

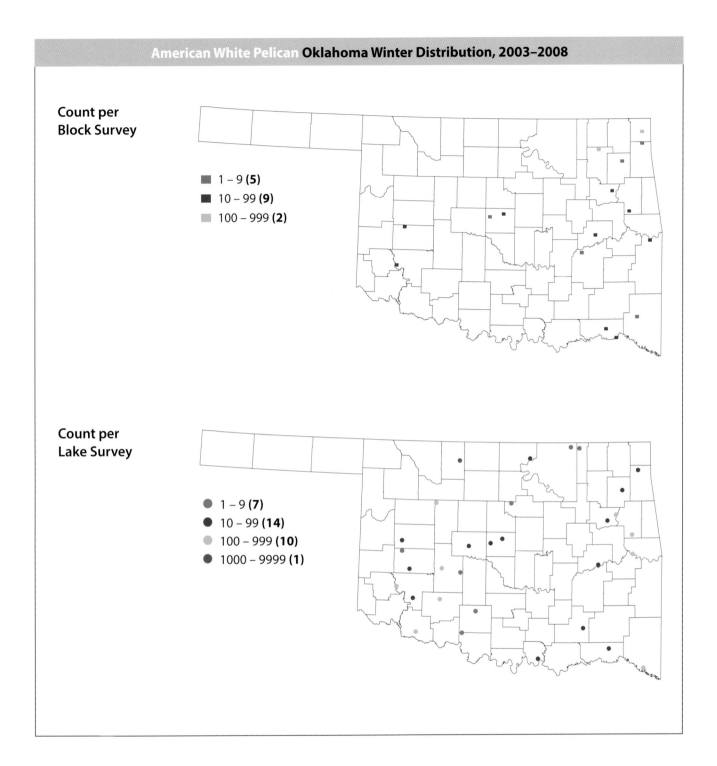

**Count per Block Survey**

- ◼ 1 – 9 **(5)**
- ◼ 10 – 99 **(9)**
- ◼ 100 – 999 **(2)**

**Count per Lake Survey**

- ● 1 – 9 **(7)**
- ● 10 – 99 **(14)**
- ● 100 – 999 **(10)**
- ● 1000 – 9999 **(1)**

**References**

Knopf, Fritz L., and Roger M. Evans. 2004. American White Pelican (*Pelecanus erythrorhynchos*). *The Birds of North America Online*, edited by A. Poole. Ithaca, N.Y.: Cornell Laboratory of Ornithology. http://bna .birds.cornell.edu.

National Audubon Society. 2011. The Christmas Bird Count historical results. www.christmasbirdcount.org.

Oklahoma Bird Records Committee. 2009. *Date Guide to the Occurrences of Birds in Oklahoma*. 5th ed. Norman: Oklahoma Ornithological Society.

# Brown Pelican
## *Pelecanus occidentalis*

Steve Metz

**Occurrence:** Rare.

**Habitat:** Lakes.

**North American distribution:** Occurs as a breeder or year-round resident along much of the Pacific, Atlantic, and Gulf Coasts.

**Oklahoma distribution:** Not recorded in survey blocks. Reported as a special interest species from Alfalfa County (Salt Plains State Park) in early January 2008 (see lake survey map), and from Wagoner/Cherokee Counties (Fort Gibson Lake) in December 2004 (Oklahoma Bird Records Committee 2005).

**Behavior:** Brown Pelicans are gregarious, but because of their rarity in Oklahoma, sightings of single birds are the norm. They forage by plunge-diving into the water from flight to capture fish along with a large volume of water in an expanding gular pouch. The water is allowed to drain from the pouch before the fish are swallowed.

## Christmas Bird Count (CBC) Results, 1960–2009

$R^2 = 0.0442$

## CBC Results, 2003–2008

| Winter | Number recorded | Counts reporting |
|---|---|---|
| 2003–2004 | 0 | — |
| 2004–2005 | 1 | 1 |
| 2005–2006 | 0 | — |
| 2006–2007 | 0 | — |
| 2007–2008 | 1 | 1 |

**Count per Block Survey**

**Count per Lake Survey**

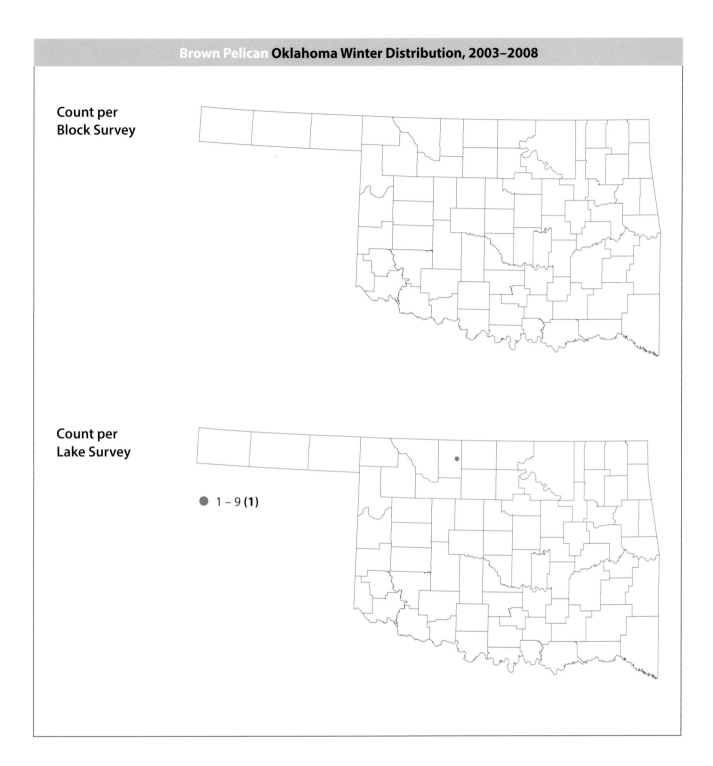

● 1 – 9 **(1)**

## References

National Audubon Society. 2011. The Christmas Bird Count historical results. http://www .christmasbirdcount.org.

Oklahoma Bird Records Committee. 2005. 2004–2005 winter season. *The Scissortail* 55:18–20.

———. 2009. *Date Guide to the Occurrences of Birds in Oklahoma*. 5th ed. Norman: Oklahoma Ornithological Society.

Shields, Mark. 2002. Brown Pelican (*Pelecanus occidentalis*). *The Birds of North America Online*, edited by A. Poole. Ithaca, N.Y.: Cornell Laboratory of Ornithology. http://bna.birds.cornell.edu.

# American Bittern

*Botaurus lentiginosus*

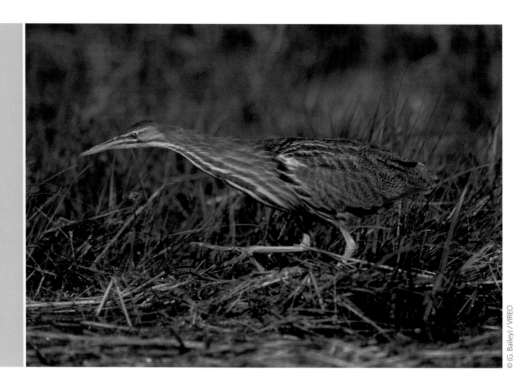

© (G. Bailey) / VIREO

**Occurrence:** Primarily a spring and fall migrant, except in McCurtain County, where it can be present year round, and in northwestern counties, where there are several breeding records.

**Habitat:** Wetlands and wet prairies.

**North American distribution:** Breeds across much of Canada and northern parts of the lower 48 states. Winters along the Pacific, Atlantic, and Gulf Coasts as well as inland in southern states and Mexico.

**Oklahoma distribution:** Not recorded in survey blocks. Recorded in Rogers County on January 14, 2005 (Oklahoma Bird Records Committee 2005). A number of records also exist for Red Slough Wildlife Management Area in McCurtain County for winters just prior to and just after this project's survey time frame. The Oklahoma Breeding Bird Atlas Project recorded several summer observations in central and northwestern counties, and breeding records from northwestern counties have been reported since.

**Behavior:** American Bitterns are usually seen singly. They forage in shallow water or damp areas for insects, amphibians, fish, and other animal prey.

## Christmas Bird Count (CBC) Results, 1960–2009

$R^2 = 0.0731$

## CBC Results, 2003–2008

| Winter | Number recorded | Counts reporting |
|---|---|---|
| 2003–2004 | 0 | — |
| 2004–2005 | 0 | — |
| 2005–2006 | 0 | — |
| 2006–2007 | 1 | 1 |
| 2007–2008 | 0 | — |

**Count per
Block Survey**

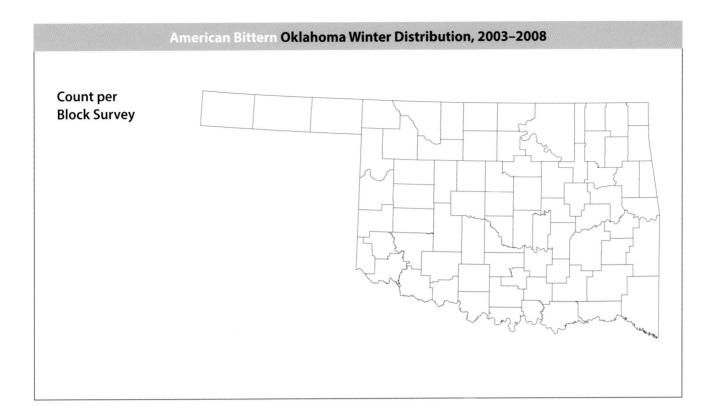

### References

Lowther, Peter, Alan F. Poole, J. P. Gibbs, S. Melvin, and F. A. Reid. 2009. American Bittern (*Botaurus lentiginosus*). *The Birds of North America Online*, edited by A. Poole. Ithaca, N.Y.: Cornell Laboratory of Ornithology. http://bna.birds.cornell.edu.

National Audubon Society. 2011. The Christmas Bird Count historical results. http://www.christmasbirdcount.org.

Oklahoma Bird Records Committee. 2005. 2004–2005 winter season. *The Scissortail* 55:18–20.

———. 2009. *Date Guide to the Occurrences of Birds in Oklahoma*. 5th ed. Norman: Oklahoma Ornithological Society.

Reinking, D. L., ed. 2004. *Oklahoma Breeding Bird Atlas*. Norman: University of Oklahoma Press.

# Great Blue Heron
## *Ardea herodias*

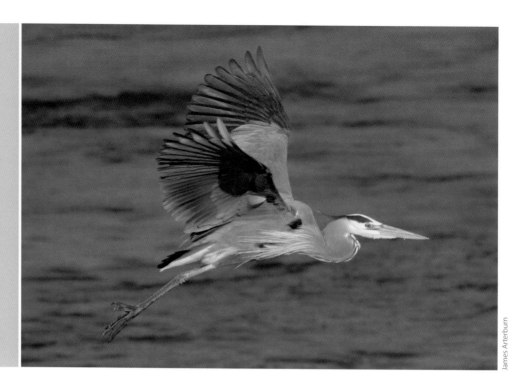

James Arterburn

**Occurrence:** Present year round, although seasonal movements may create some turnover of individuals.

**Habitat:** Lakes, ponds, streams, and marshes.

**North American distribution:** Breeds in southern Canada and the northern United States. Resident along most of the Pacific Coast of the United States and Canada, in much of the western United States, and in much of the Midwest and South. Winters in Mexico.

**Oklahoma distribution:** Recorded statewide in most survey blocks, with slightly lower concentrations in southeastern counties, northwestern counties, and the Panhandle. This closely matches the summer distribution recorded by the Oklahoma Breeding Bird Atlas Project.

**Behavior:** Great Blue Herons are usually seen singly in the winter but sometimes forage or roost in loose groups. They hunt for fish, amphibians, invertebrates, and other small animals by standing or stalking in shallow water and capturing prey in their bills before swallowing it whole.

### Christmas Bird Count (CBC) Results, 1960–2009

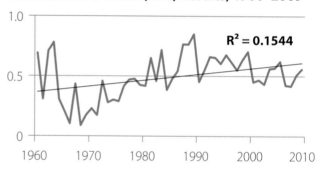

$R^2 = 0.1544$

### CBC Results, 2003–2008

| Winter | Number recorded | Counts reporting |
|---|---|---|
| 2003–2004 | 622 | 20 |
| 2004–2005 | 615 | 20 |
| 2005–2006 | 760 | 18 |
| 2006–2007 | 488 | 18 |
| 2007–2008 | 392 | 18 |

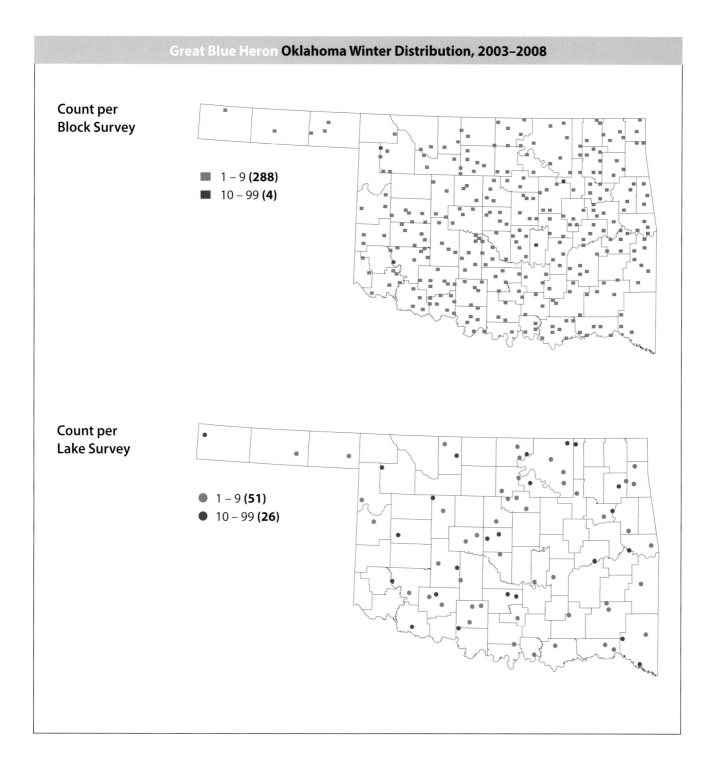

Count per
Block Survey

■ 1 – 9 **(288)**
■ 10 – 99 **(4)**

Count per
Lake Survey

● 1 – 9 **(51)**
● 10 – 99 **(26)**

### References

Butler, Robert W. 1992. Great Blue Heron (*Ardea herodias*). *The Birds of North America Online*, edited by
    A. Poole. Ithaca, N.Y.: Cornell Laboratory of Ornithology. http://bna.birds.cornell.edu.
National Audubon Society. 2011. The Christmas Bird Count historical results. http://www
    .christmasbirdcount.org.
Oklahoma Bird Records Committee. 2009. *Date Guide to the Occurrences of Birds in Oklahoma.* 5th ed.
    Norman: Oklahoma Ornithological Society.
Reinking, D. L., ed. 2004. *Oklahoma Breeding Bird Atlas.* Norman: University of Oklahoma Press.
Sutton, G. M. 1974. Did this Great Blue Heron die of starvation? *Bulletin of the Oklahoma Ornithological
    Society* 7:60–61.
Tyler, J. D. 1992. Unusual feeding behavior of Great Blue Heron. *Bulletin of the Oklahoma Ornithological
    Society* 25:3.

# Great Egret
## *Ardea alba*

**Occurrence:** Present year round, but in much smaller numbers during the winter.

**Habitat:** Lakes, marshes, and ponds.

**North American distribution:** Breeds in scattered locations throughout the lower 48 states and parts of southern Canada. Resident in parts of the southern United States and Mexico. Winters along the Pacific Coast and in Mexico.

**Oklahoma distribution:** Not recorded in survey blocks. Reported from Choctaw County in December 2007 (see lake survey map). Special interest species reports came from Marshall County in December 2007; McCurtain County in February 2004, December 2004, and throughout the winters of 2006–2007 and 2007–2008; and Washington County in December 2004. An additional published report from the project period came from Oklahoma County in December 2003 (Oklahoma Bird Records Committee 2004). The summer distribution recorded by the Oklahoma Breeding Bird Atlas Project showed it to be common throughout the main body of the state. Most individuals migrate out of the state for the winter.

**Behavior:** Great Egrets can occur singly or in loose foraging groups during the winter. They search for fish and invertebrates by walking or standing in shallow water.

### Christmas Bird Count (CBC) Results, 1960–2009

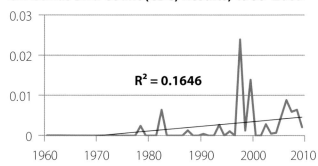

$R^2 = 0.1646$

### CBC Results, 2003–2008

| Winter | Number recorded | Counts reporting |
|--------|-----------------|------------------|
| 2003–2004 | 1 | 1 |
| 2004–2005 | 1 | 1 |
| 2005–2006 | 10 | 2 |
| 2006–2007 | 10 | 4 |
| 2007–2008 | 6 | 4 |

**Count per
Block Survey**

**Count per
Lake Survey**

● 1 – 9 **(1)**

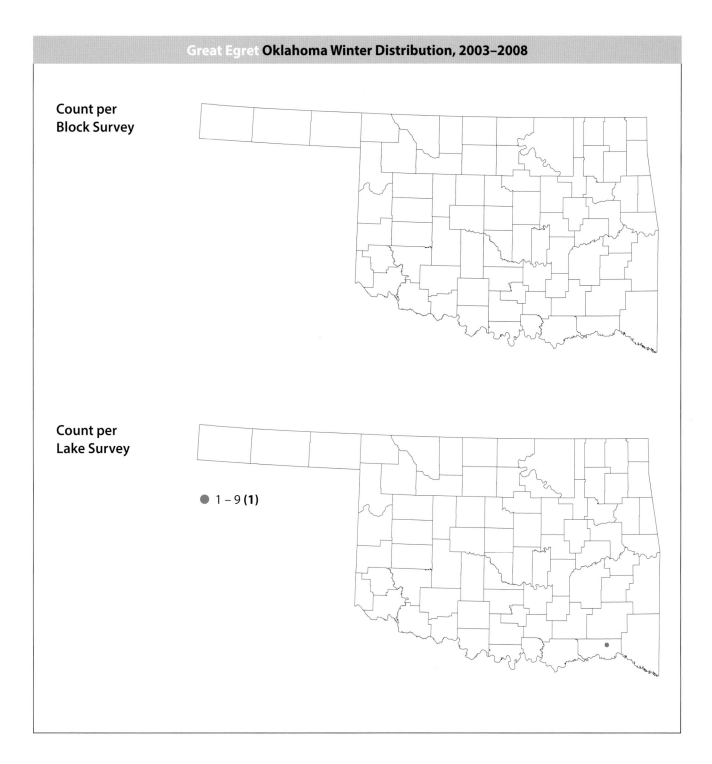

### References

McCrimmon, Donald A., Jr., John C. Ogden, and G. Thomas Bancroft. 2001. Great Egret (*Ardea alba*). *The Birds of North America Online*, edited by A. Poole. Ithaca, N.Y.: Cornell Laboratory of Ornithology. http://bna.birds.cornell.edu.

McMahon, J. 1984. Great Egret in Muskogee County, Oklahoma, in winter. *Bulletin of the Oklahoma Ornithological Society* 17:29–30.

National Audubon Society. 2011. The Christmas Bird Count historical results. http://www .christmasbirdcount.org.

Oklahoma Bird Records Committee. 2004. 2003–2004 winter season. *The Scissortail* 54:25–27.

———. 2009. *Date Guide to the Occurrences of Birds in Oklahoma*. 5th ed. Norman: Oklahoma Ornithological Society.

Reinking, D. L., ed. 2004. *Oklahoma Breeding Bird Atlas*. Norman: University of Oklahoma Press.

ORDER **PELECANIFORMES**

# Cattle Egret
## *Bubulcus ibis*

Steve Metz

**Occurrence:** Late March through early November. Rarely lingering into winter.

**Habitat:** Marshes, pastures, and other open, grassy areas.

**North American distribution:** Breeds in many widely scattered locations in the lower 48 states. Resident along the Gulf Coast and in parts of the southwestern United States and Mexico.

**Oklahoma distribution:** Not recorded in survey blocks. Single birds reported as special interest species from McCurtain County (Red Slough Wildlife Management Area) in January 2004 and December 2007; also from Tillman County in December 2004. The summer distribution recorded by the Oklahoma Breeding Bird Atlas Project was statewide.

**Behavior:** Cattle Egrets are gregarious, but because of their rarity in the state during winter, they are most likely to be seen singly. They forage on the ground or near water for insects, fish, and other items.

## Christmas Bird Count (CBC) Results, 1960–2009

$R^2 = 0.0466$

## CBC Results, 2003–2008

| Winter | Number recorded | Counts reporting |
|--------|-----------------|------------------|
| 2003–2004 | 0 | — |
| 2004–2005 | 0 | — |
| 2005–2006 | 0 | — |
| 2006–2007 | 0 | — |
| 2007–2008 | 6 | 1 |

**Count per Block Survey**

### References

Carlton, B. 1972. Cattle Egret in Oklahoma in winter. *Bulletin of the Oklahoma Ornithological Society* 5:27.

Moorman, Z. 1974. Cattle Egret in Payne County in winter. *Bulletin of the Oklahoma Ornithological Society* 7:61.

National Audubon Society. 2011. The Christmas Bird Count historical results. http://www .christmasbirdcount.org.

Oklahoma Bird Records Committee. 2009. *Date Guide to the Occurrences of Birds in Oklahoma.* 5th ed. Norman: Oklahoma Ornithological Society.

Reinking, D. L., ed. 2004. *Oklahoma Breeding Bird Atlas.* Norman: University of Oklahoma Press.

Telfair, Raymond C., II 2006. Cattle Egret (*Bubulcus ibis*). *The Birds of North America Online*, edited by A. Poole. Ithaca, N.Y.: Cornell Laboratory of Ornithology. http://bna.birds.cornell.edu.

# Black-crowned Night-Heron

*Nycticorax nycticorax*

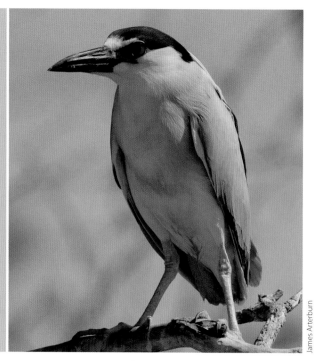

James Arterburn

**Occurrence:** Mid-March through November in northern counties, and year round in southern counties.

**Habitat:** Marshes, lakes, and ponds.

**North American distribution:** Breeds in south-central and southeastern Canada and in much of the lower 48 states and Mexico. Resident in scattered locations in the eastern, western, and southern United States and Mexico.

**Oklahoma distribution:** Not recorded in survey blocks. Reported in McCurtain County at Red Slough Wildlife Management Area in December 2007 (one bird) and January 2008 (four birds).

**Behavior:** Black-crowned Night-Herons are gregarious and often roost communally, although they forage alone. They use their bills to grab a wide variety of prey items including insects, crayfish, clams, fish, amphibians, and other small animals.

### Christmas Bird Count (CBC) Results, 1960–2009

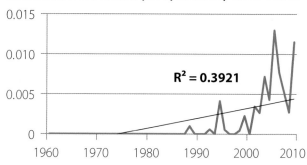

$R^2 = 0.3921$

### CBC Results, 2003–2008

| Winter | Number recorded | Counts reporting |
|---|---|---|
| 2003–2004 | 13 | 3 |
| 2004–2005 | 10 | 1 |
| 2005–2006 | 27 | 1 |
| 2006–2007 | 15 | 2 |
| 2007–2008 | 8 | 1 |

Count per
Block Survey

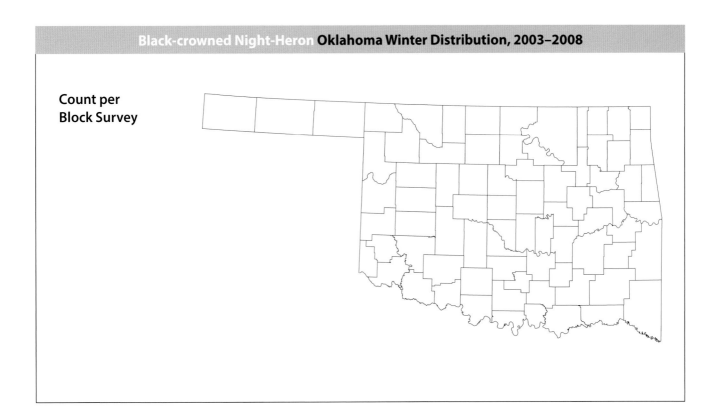

### References

Hothem, Roger L., Brianne E. Brussee, and William E. Davis Jr. 2010. Black-crowned Night-Heron
　　(*Nycticorax nycticorax*). *The Birds of North America Online*, edited by A. Poole. Ithaca, N.Y.: Cornell
　　Laboratory of Ornithology. http://bna.birds.cornell.edu.
National Audubon Society. 2011. The Christmas Bird Count historical results. http://www
　　.christmasbirdcount.org.
Newell, J. G. 1992. Wintering Black-crowned Night-Herons in Oklahoma City, Oklahoma. *Bulletin of the
　　Oklahoma Ornithological Society* 25:19.
Oklahoma Bird Records Committee. 2009. *Date Guide to the Occurrences of Birds in Oklahoma*. 5th ed.
　　Norman: Oklahoma Ornithological Society.

# White Ibis
## *Eudocimus albus*

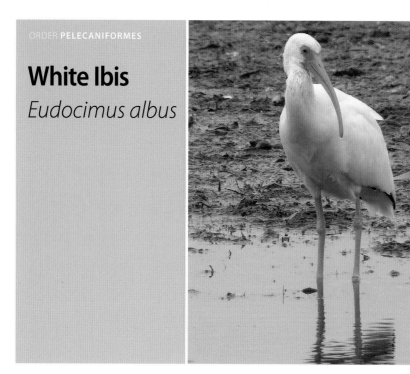

James Arterburn

**Occurrence:** March through October.

**Habitat:** Marshes.

**North American distribution:** Breeds in scattered locations in the western lower 48 states. Resident along the Texas coast and in parts of Mexico. Winters in parts of the southwestern United States and Mexico.

**Oklahoma distribution:** Not recorded in survey blocks. Special interest species reports came from McCurtain County (Red Slough Wildlife Management Area) in December 2005 (2 birds), December 2007 (80 birds), and January and February 2008 (up to 49 birds). The summer distribution recorded by the Oklahoma Breeding Bird Atlas Project consisted of three nest records from McCurtain County.

**Behavior:** White Ibis are gregarious and are typically seen in flocks. They forage by wading in shallow water and probing mud for aquatic crustaceans and insects.

## CBC Results, 2003–2008

| Winter | Number recorded | Counts reporting |
|---|---|---|
| 2003–2004 | 0 | — |
| 2004–2005 | 0 | — |
| 2005–2006 | 0 | — |
| 2006–2007 | 0 | — |
| 2007–2008 | 0 | — |

Count per
Block Survey

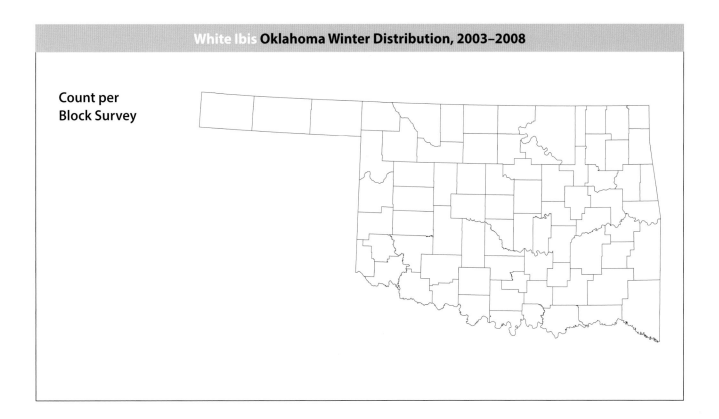

### References

Heath, Julie A., Peter Frederick, James A. Kushlan, and Keith L. Bildstein. 2009. White Ibis (*Eudocimus albus*). *The Birds of North America Online*, edited by A. Poole. Ithaca, N.Y.: Cornell Laboratory of Ornithology. http://bna.birds.cornell.edu.

National Audubon Society. 2011. The Christmas Bird Count historical results. http://www .christmasbirdcount.org.

Oklahoma Bird Records Committee. 2006. 2005–2006 winter season. *The Scissortail* 56:14–15.

———. 2009a. 2007–2008 winter season. *The Scissortail* 59:4–8.

———. 2009b. *Date Guide to the Occurrences of Birds in Oklahoma*. 5th ed. Norman: Oklahoma Ornithological Society.

# ORDER CATHARTIFORMES

## Black Vulture
### *Coragyps atratus*

Duane Angles

**Occurrence:** Year-round resident.

**Habitat:** Open country for foraging and trees for roosting.

**North American distribution:** Resident in approximately the southeastern quarter of the United States and in Mexico.

**Oklahoma distribution:** Widely distributed across south-central and southeastern Oklahoma, and slightly less so in northeastern Oklahoma. The summer distribution recorded by the Oklahoma Breeding Bird Atlas Project was very similar, although the winter surveys suggest a range expansion of one or two counties to the north and northwest over the past decade.

**Behavior:** The social nature of Black Vultures is hinted at by the number of blocks with more than ten individuals recorded. Small family groups often occur together, and larger communal roosts can last for years. Black Vultures are also often seen with Turkey Vultures, which have a better sense of smell for helping locate the carrion that both species feed upon.

### Christmas Bird Count (CBC) Results, 1960–2009

$R^2 = 0.7273$

### CBC Results, 2003–2008

| Winter | Number recorded | Counts reporting |
|---|---|---|
| 2003–2004 | 646 | 6 |
| 2004–2005 | 356 | 7 |
| 2005–2006 | 681 | 6 |
| 2006–2007 | 908 | 7 |
| 2007–2008 | 465 | 8 |

**Count per Block Survey**

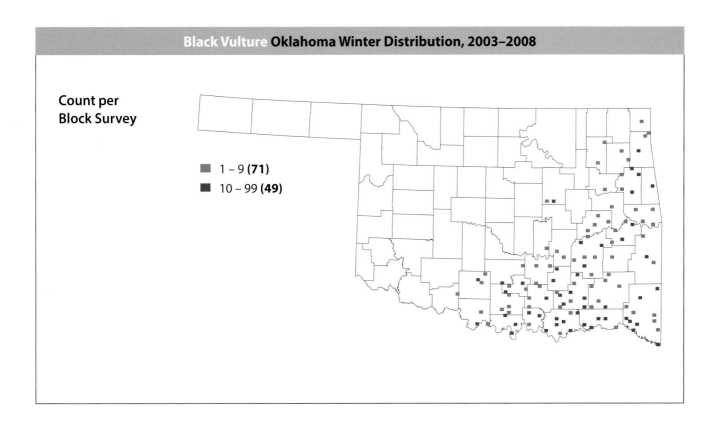

■ 1 – 9 **(71)**
■ 10 – 99 **(49)**

**References**

Buckley, Neil J. 1999. Black Vulture (*Coragyps atratus*). *The Birds of North America Online*, edited by A. Poole. Ithaca, N.Y.: Cornell Laboratory of Ornithology. http://bna.birds.cornell.edu.

National Audubon Society. 2011. The Christmas Bird Count historical results. http://www .christmasbirdcount.org.

Oklahoma Bird Records Committee. 2009. *Date Guide to the Occurrences of Birds in Oklahoma*. 5th ed. Norman: Oklahoma Ornithological Society.

Reinking, D. L., ed. 2004. *Oklahoma Breeding Bird Atlas*. Norman: University of Oklahoma Press.

# Turkey Vulture
## *Cathartes aura*

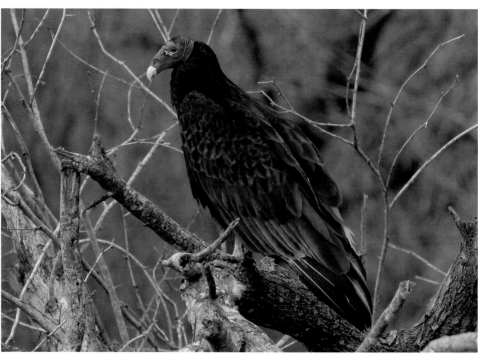

Bob Gress

**Occurrence:** Present year round in the southeastern half of the state, but birds breeding in northern and western regions migrate south for the winter and are absent from mid-November through mid-February.

**Habitat:** Occupies a wide variety of habitats including open woodlands, grasslands, and agricultural areas.

**North American distribution:** Breeds across southern Canada and most of the lower 48 states. Resident along the Pacific Coast of California, in the southeastern United States, and throughout Mexico.

**Oklahoma distribution:** Recorded commonly in survey blocks throughout the southeastern half of the state. The summer distribution recorded by the Oklahoma Breeding Bird Atlas Project was statewide, and the contrast between these maps clearly indicates the regions of the state from which this species evacuates seasonally.

**Behavior:** Turkey Vultures are usually seen singly while they search for food, but additional individuals may gather at a food source as well as roost together communally at night. They scavenge for dead animals using a well-developed sense of smell. Black Vultures, which lack advanced olfactory ability, often follow Turkey Vultures to a carcass and may even aggressively displace them from feeding.

**Christmas Bird Count (CBC) Results, 1960–2009**

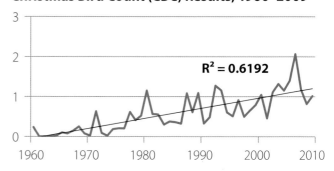

$R^2 = 0.6192$

**CBC Results, 2003–2008**

| Winter | Number recorded | Counts reporting |
|---|---|---|
| 2003–2004 | 1,252 | 9 |
| 2004–2005 | 1,077 | 8 |
| 2005–2006 | 1,239 | 10 |
| 2006–2007 | 1,943 | 12 |
| 2007–2008 | 804 | 8 |

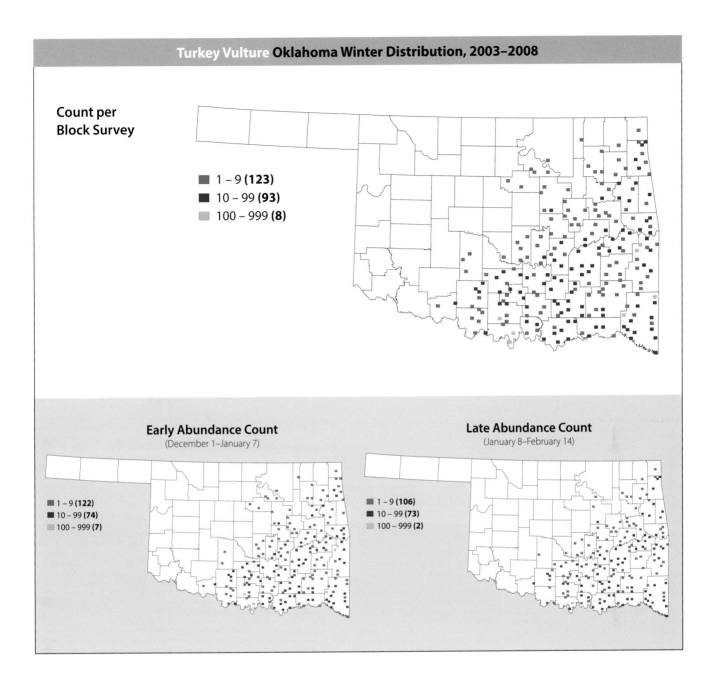

## Turkey Vulture Oklahoma Winter Distribution, 2003–2008

### Count per Block Survey

- 1 – 9 **(123)**
- 10 – 99 **(93)**
- 100 – 999 **(8)**

### Early Abundance Count
(December 1–January 7)

- 1 – 9 **(122)**
- 10 – 99 **(74)**
- 100 – 999 **(7)**

### Late Abundance Count
(January 8–February 14)

- 1 – 9 **(106)**
- 10 – 99 **(73)**
- 100 – 999 **(2)**

### References

Kirk, David A., and Michael J. Mossman. 1998. Turkey Vulture (*Cathartes aura*). *The Birds of North America Online*, edited by A. Poole. Ithaca, N.Y.: Cornell Laboratory of Ornithology. http://bna.birds.cornell.edu.

National Audubon Society. 2011. The Christmas Bird Count historical results. http://www.christmasbirdcount.org.

Neeld, F. 1987. Turkey Vultures in southwestern Oklahoma in winter. *Bulletin of the Oklahoma Ornithological Society* 20:14.

Oklahoma Bird Records Committee. 2009. *Date Guide to the Occurrences of Birds in Oklahoma*. 5th ed. Norman: Oklahoma Ornithological Society.

Reinking, D. L., ed. 2004. *Oklahoma Breeding Bird Atlas*. Norman: University of Oklahoma Press.

## **Osprey**
*Pandion haliaetus*

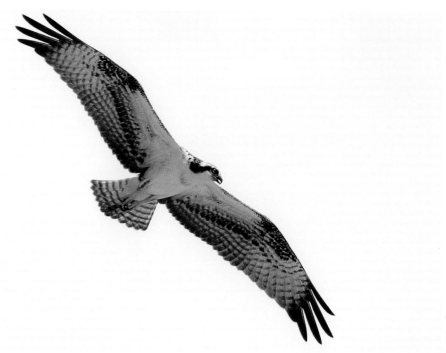

**Occurrence:** Primarily a spring and fall migrant and not a regular wintering species.

**Habitat:** Lakes.

**North American distribution:** Breeds across large portions of Alaska, Canada, and the lower 48 states. Resident in the southeastern United States and in parts of Mexico. Winters in southern California, southern Texas, and parts of Mexico.

**Oklahoma distribution:** Not recorded in survey blocks. A special interest species report came from Bryan County (Durant State Fish Hatchery) on January 19, 2006; a lake survey report came from Grady County (Lake Louis Burtschi) on December 6, 2007; and an additional published report during the project period came from Tulsa County on December 18, 2004 (Oklahoma Bird Records Committee 2005).

**Behavior:** Ospreys are usually seen singly. They forage by catching fish after plunging feet first into the water from flight.

### Christmas Bird Count (CBC) Results, 1960–2009

$R^2 = 0.0205$

### CBC Results, 2003–2008

| Winter | Number recorded | Counts reporting |
| --- | --- | --- |
| 2003–2004 | 1 | 1 |
| 2004–2005 | 1 | 1 |
| 2005–2006 | 0 | — |
| 2006–2007 | 0 | — |
| 2007–2008 | 1 | 1 |

# Osprey **Oklahoma Winter Distribution, 2003–2008**

**Count per Block Survey**

**Count per Lake Survey**

● 1 – 9 **(2)**

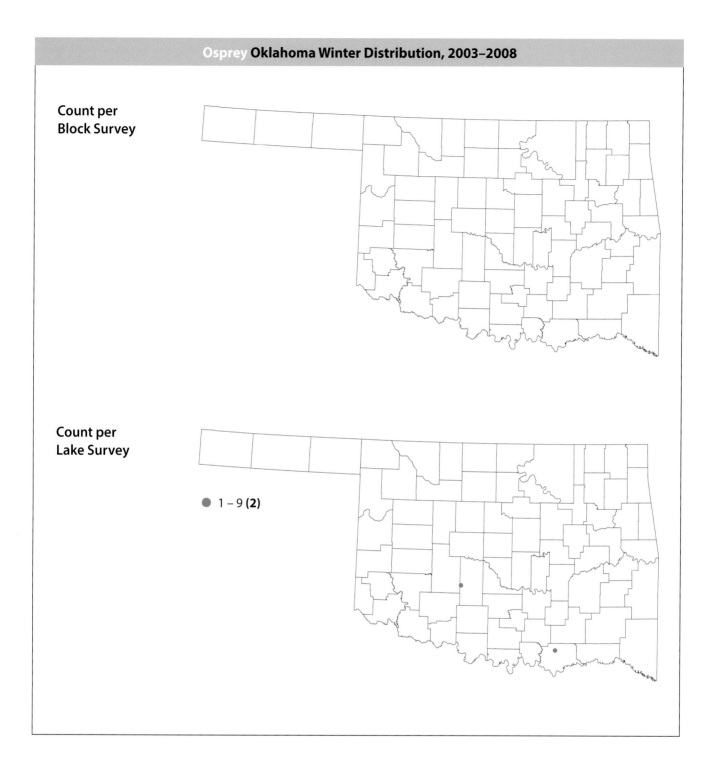

### References

National Audubon Society. 2011. The Christmas Bird Count historical results. http://www
     .christmasbirdcount.org.

Oklahoma Bird Records Committee. 2005. 2004–2005 winter season. *The Scissortail* 55:18–20.

———. 2009. *Date Guide to the Occurrences of Birds in Oklahoma.* 5th ed. Norman: Oklahoma
     Ornithological Society.

Poole, Alan F., Rob O. Bierregaard, and Mark S. Martell. 2002. Osprey (*Pandion haliaetus*). *The Birds of North
     America Online*, edited by A. Poole. Ithaca, N.Y.: Cornell Laboratory of Ornithology. http://bna.birds
     .cornell.edu.

# White-tailed Kite

*Elanus leucurus*

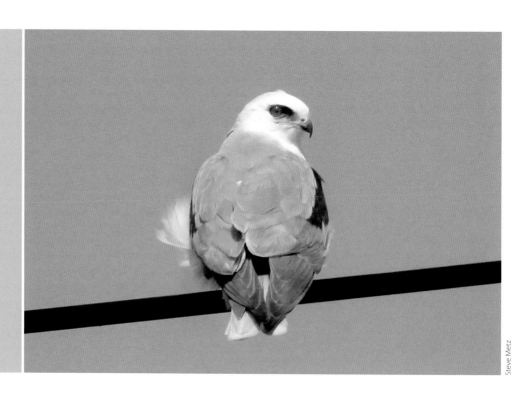

Steve Metz

**Occurrence:** Rare.

**Habitat:** Open grasslands or wetlands.

**North American distribution:** Breeds in eastern Texas. Resident in California, southern Florida, southern Texas, and parts of Mexico.

**Oklahoma distribution:** Not recorded in survey blocks. A special interest species report came from Oklahoma County (Lake Overholser) on February 6, 2007.

**Behavior:** White-tailed Kites are rare in Oklahoma in winter, and if found they are likely to be seen singly. They hunt small mammals by hovering above open areas.

### Christmas Bird Count (CBC) Results, 1960–2009

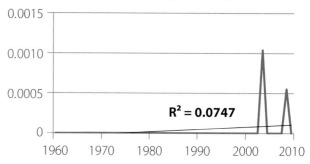

$R^2 = 0.0747$

### CBC Results, 2003–2008

| Winter | Number recorded | Counts reporting |
|--------|-----------------|------------------|
| 2003–2004 | 0 | — |
| 2004–2005 | 0 | — |
| 2005–2006 | 0 | — |
| 2006–2007 | 0 | — |
| 2007–2008 | 2 | 1 |

**Count per Block Survey**

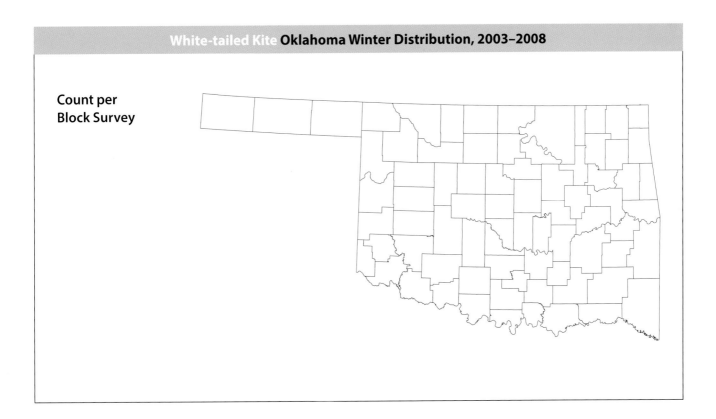

### References

Dunk, Jeffrey R. 1995. White-tailed Kite (*Elanus leucurus*). *The Birds of North America Online*, edited by A. Poole. Ithaca, N.Y.: Cornell Laboratory of Ornithology. http://bna.birds.cornell.edu.

National Audubon Society. 2011. The Christmas Bird Count historical results. http://www.christmasbirdcount.org.

Oklahoma Bird Records Committee. 2009. *Date Guide to the Occurrences of Birds in Oklahoma*. 5th ed. Norman: Oklahoma Ornithological Society.

# Bald Eagle
## *Haliaeetus leucocephalus*

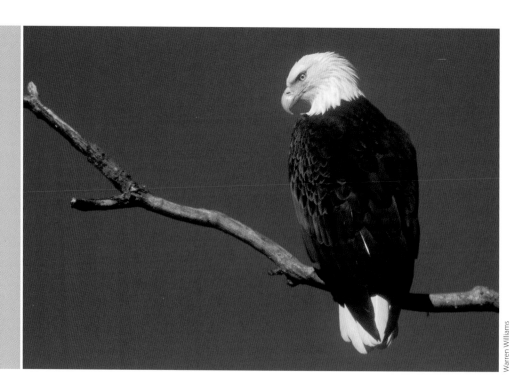

Warren Williams

**Occurrence:** About 130 pairs currently nest in Oklahoma, but the population swells into the thousands from October to March as northern nesting eagles move south in search of open water for foraging.

**Habitat:** Lakes, rivers, ponds, dam spillways, and surrounding open country with scattered trees.

**North American distribution:** Breeds widely in Alaska and Canada, and since its population recovery during the past two to three decades, it also breeds widely in the lower 48 states.

**Oklahoma distribution:** Much more numerous and widespread in winter than in summer. Breeding distribution is expanding in the state but is concentrated in the northeastern region. Winter distribution is also the most dense in the northeast but spans the entire state.

**Behavior:** Wintering eagles may be seen singly but are also often gregarious, sometimes concentrating in the dozens around lakes or dam spillways where food is abundant. Fish, waterfowl, and carrion make up most of their winter diet. As one of the earliest-nesting species in the state, resident breeding Bald Eagles can start laying eggs in December. The numerous migratory eagles that are present in winter leave the state by spring.

## Christmas Bird Count (CBC) Results, 1960–2009

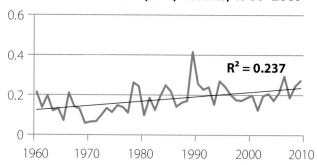

$R^2 = 0.237$

## CBC Results, 2003–2008

| Winter | Number recorded | Counts reporting |
|--------|-----------------|------------------|
| 2003–2004 | 197 | 19 |
| 2004–2005 | 171 | 19 |
| 2005–2006 | 198 | 18 |
| 2006–2007 | 259 | 17 |
| 2007–2008 | 177 | 17 |

**Count per Block Survey**

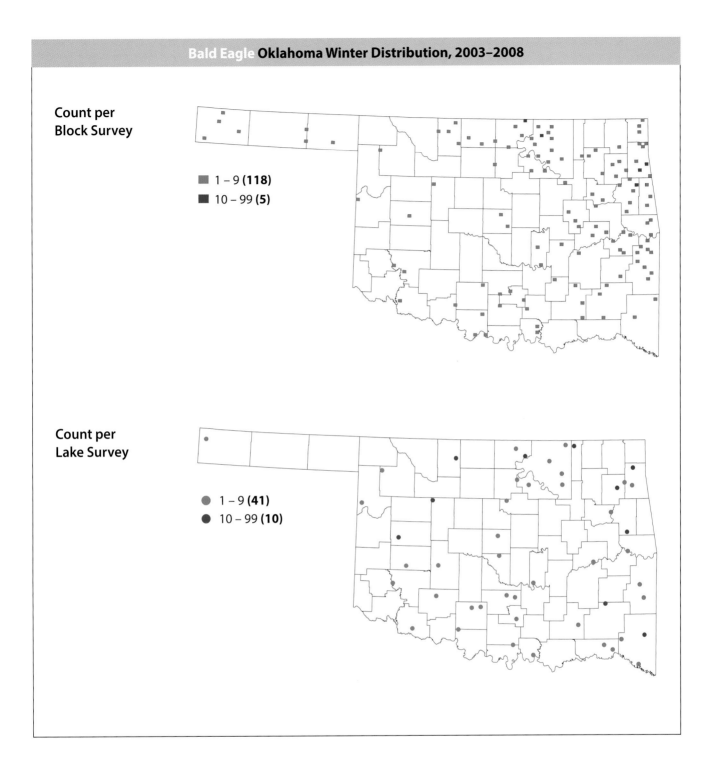

■ 1 – 9 **(118)**

■ 10 – 99 **(5)**

**Count per Lake Survey**

● 1 – 9 **(41)**

● 10 – 99 **(10)**

### References

Buehler, David A. 2000. Bald Eagle (*Haliaeetus leucocephalus*). *The Birds of North America Online*, edited by A. Poole. Ithaca, N.Y.: Cornell Laboratory of Ornithology. http://bna.birds.cornell.edu.

Jenkins, M. A., and S. K. Sherrod. 1993. Recent Bald Eagle nest records in Oklahoma. *Bulletin of the Oklahoma Ornithological Society* 26:25–28.

Lish, J. W. 1973. Bald Eagles wintering on the Neosho River, Oklahoma. *Bulletin of the Oklahoma Ornithological Society* 6:25–30.

———. 1997. Diet, population size, and high-use areas of Bald Eagles wintering at Grand Lake, Oklahoma. *Bulletin of the Oklahoma Ornithological Society* 30:1–6.

National Audubon Society. 2011. The Christmas Bird Count historical results. http://www.christmasbirdcount.org.

Reinking, D. L., ed. 2004. *Oklahoma Breeding Bird Atlas*. Norman: University of Oklahoma Press.

Sallee, G. W. 1974. Marsh Hawks feeding peaceably with Bald Eagles. *Bulletin of the Oklahoma Ornithological Society* 7:62.

Tyler, D. C. 1974. Wintering Bald Eagles in north-central Oklahoma. *Bulletin of the Oklahoma Ornithological Society* 7:61–62.

# Northern Harrier
## *Circus cyaneus*

Duane Angles

**Occurrence:** Present year round, but much more numerous from September through April, when additional individuals migrate here for the winter.

**Habitat:** Open grasslands and marshes.

**North American distribution:** Breeds in Alaska and much of Canada and the northern lower 48 states. Resident across the midlatitudes of the lower 48 states, and winters in the southern United States and in Mexico.

**Oklahoma distribution:** Recorded in most survey blocks statewide, but at slightly lower frequencies in heavily forested eastern counties, and in somewhat larger numbers in northern and western counties. The summer distribution recorded by the Oklahoma Breeding Bird Atlas Project showed only a few scattered records, mostly in the Panhandle.

**Behavior:** Northern Harriers are usually seen singly while foraging, but they sometimes roost together or in association with Short-eared Owls. They hunt small mammals and birds by flying low over grassy cover while both looking and listening for prey.

**Christmas Bird Count (CBC) Results, 1960–2009**

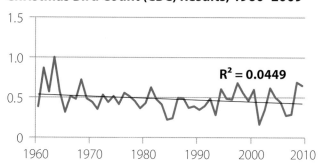

$R^2 = 0.0449$

**CBC Results, 2003–2008**

| Winter | Number recorded | Counts reporting |
|---|---|---|
| 2003–2004 | 557 | 19 |
| 2004–2005 | 493 | 19 |
| 2005–2006 | 440 | 18 |
| 2006–2007 | 285 | 18 |
| 2007–2008 | 306 | 20 |

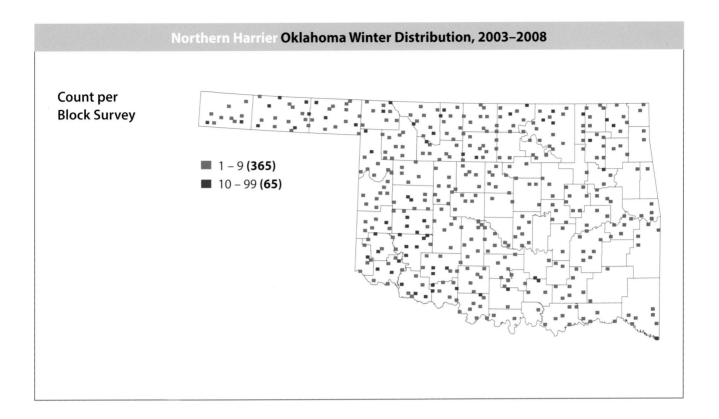

Count per
Block Survey

■ 1 – 9 **(365)**
■ 10 – 99 **(65)**

**References**

Macwhirter, R. Bruce, and Keith L. Bildstein. 1996. Northern Harrier (*Circus cyaneus*). *The Birds of North America Online*, edited by A. Poole. Ithaca, N.Y.: Cornell Laboratory of Ornithology. http://bna.birds .cornell.edu.

McCurdy, K. M., S. J. Orr, and T. M. Hodgkins. 1995. A large Northern Harrier roost at Fort Sill, Oklahoma. *Bulletin of the Oklahoma Ornithological Society* 28:25–27.

National Audubon Society. 2011. The Christmas Bird Count historical results. http://www .christmasbirdcount.org.

Oklahoma Bird Records Committee. 2009. *Date Guide to the Occurrences of Birds in Oklahoma*. 5th ed. Norman: Oklahoma Ornithological Society.

Reinking, D. L., ed. 2004. *Oklahoma Breeding Bird Atlas*. Norman: University of Oklahoma Press.

Sallee, G. W. 1974. Marsh Hawks feeding peaceably with Bald Eagles. *Bulletin of the Oklahoma Ornithological Society* 7:62.

# Sharp-shinned Hawk
## *Accipiter striatus*

© (J. Schumacher) / VIREO

**Occurrence:** Mid-September through mid-May.

**Habitat:** Woodlands in both rural and suburban areas.

**North American distribution:** Breeds in Alaska, much of Canada, and parts of the northern lower 48 states. Resident in parts of the eastern and western United States and Mexico and winters broadly across the United States and Mexico.

**Oklahoma distribution:** Recorded fairly commonly at low abundance statewide except in the western Panhandle.

**Behavior:** Sharp-shinned Hawks are usually seen singly. They hunt small birds using their long tails and short, rounded wings to provide agility while rapidly pursuing prey through trees or other cover. They occasionally turn up at backyard bird feeders to take advantage of the concentration of small songbirds there.

### Christmas Bird Count (CBC) Results, 1960–2009

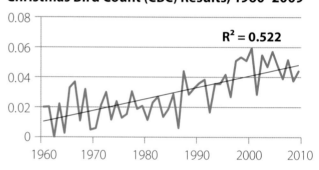

$R^2 = 0.522$

### CBC Results, 2003–2008

| Winter | Number recorded | Counts reporting |
|---|---|---|
| 2003–2004 | 59 | 16 |
| 2004–2005 | 71 | 16 |
| 2005–2006 | 60 | 15 |
| 2006–2007 | 47 | 14 |
| 2007–2008 | 50 | 18 |

**Count per
Block Survey**

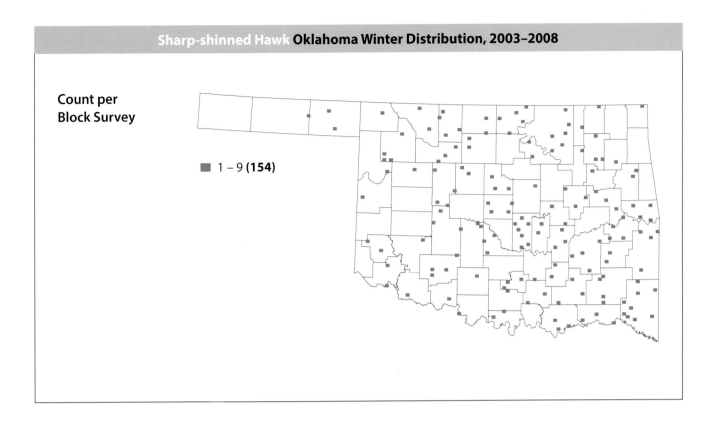

■ 1 – 9 **(154)**

### References

Bildstein, Keith L., and Ken Meyer. 2000. Sharp-shinned Hawk (*Accipiter striatus*). *The Birds of North America Online*, edited by A. Poole. Ithaca, N.Y.: Cornell Laboratory of Ornithology. http://bna.birds.cornell.edu.

National Audubon Society. 2011. The Christmas Bird Count historical results. http://www .christmasbirdcount.org.

Oklahoma Bird Records Committee. 2009. *Date Guide to the Occurrences of Birds in Oklahoma*. 5th ed. Norman: Oklahoma Ornithological Society.

# Cooper's Hawk
## *Accipiter cooperii*

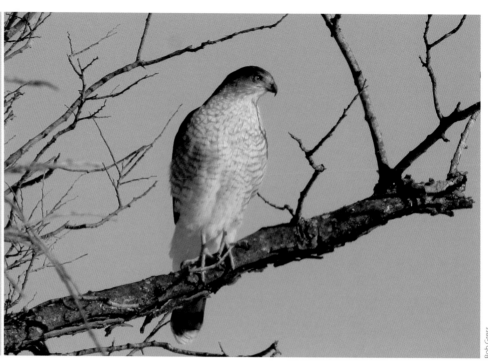

Bob Gress

**Occurrence:** Present year round, but an influx of migrants from the north makes them more numerous during the winter.

**Habitat:** Forests, woodlands, and neighborhoods with mature trees.

**North American distribution:** Breeds across southern Canada and parts of the northern lower 48 states. Resident across a large portion of the lower 48 states and Mexico and winters in parts of the western plains and Mexico.

**Oklahoma distribution:** Recorded in low numbers but at a fairly dense and even distribution statewide, though somewhat less common in the Panhandle. This distribution is much more extensive than the summer distribution recorded during the Oklahoma Breeding Bird Atlas Project, in which only widely scattered records occurred.

**Behavior:** Cooper's Hawks are usually seen singly, either perched in a tree or flying with a series of quick flaps followed by a glide, or sometimes in impressively fast pursuit of prey. They hunt small to medium-sized birds, effectively using their short, rounded wings and long tail to counter evasive maneuvers and avoid collisions with branches. The concentrations of songbirds at bird feeders sometimes attract them to backyards.

### Christmas Bird Count (CBC) Results, 1960–2009

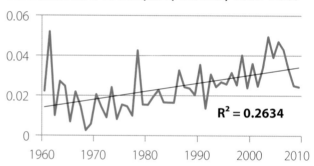

$R^2 = 0.2634$

### CBC Results, 2003–2008

| Winter | Number recorded | Counts reporting |
|---|---|---|
| 2003–2004 | 60 | 16 |
| 2004–2005 | 48 | 17 |
| 2005–2006 | 53 | 18 |
| 2006–2007 | 53 | 14 |
| 2007–2008 | 35 | 13 |

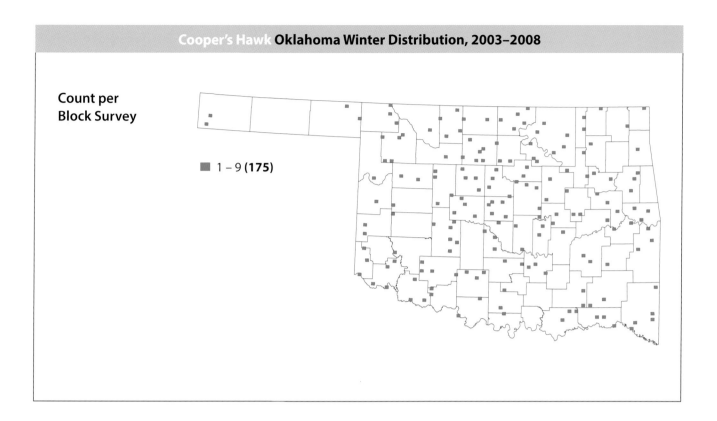

**Count per Block Survey**

■ 1 – 9 **(175)**

### References

Curtis, Odette E., R. N. Rosenfield, and J. Bielefeldt. 2006. Cooper's Hawk (*Accipiter cooperii*). *The Birds of North America Online*, edited by A. Poole. Ithaca, N.Y.: Cornell Laboratory of Ornithology. http://bna .birds.cornell.edu.

National Audubon Society. 2011. The Christmas Bird Count historical results. http://www .christmasbirdcount.org.

Oklahoma Bird Records Committee. 2009. *Date Guide to the Occurrences of Birds in Oklahoma*. 5th ed. Norman: Oklahoma Ornithological Society.

Reinking, D. L., ed. 2004. *Oklahoma Breeding Bird Atlas*. Norman: University of Oklahoma Press.

# Northern Goshawk
## *Accipiter gentilis*

© (D. Grall) / VIREO

**Occurrence:** Rare from late November through February.

**Habitat:** Woodlands and riparian areas.

**North American distribution:** Resident in Alaska and much of Canada as well as in parts of the northeastern and western United States and in Mexico. Winters somewhat south and east of this range.

**Oklahoma distribution:** Recorded in three survey blocks, with special interest species reports coming from one additional location in Cimarron County in December 2006 and in Harper County in January 2007.

**Behavior:** Northern Goshawks are seen singly during the winter. They hunt a variety of mammals and birds by both watching from a perch and flying to startle prey. If unseen by prey, goshawks can glide in for a capture, but they can also rapidly pursue fleeing prey, even into branches and vegetation.

## Christmas Bird Count (CBC) Results, 1960–2009

$R^2 = 0.0016$

## CBC Results, 2003–2008

| Winter | Number recorded | Counts reporting |
|--------|-----------------|------------------|
| 2003–2004 | 0 | — |
| 2004–2005 | 0 | — |
| 2005–2006 | 1 | 1 |
| 2006–2007 | 1 | 1 |
| 2007–2008 | 0 | — |

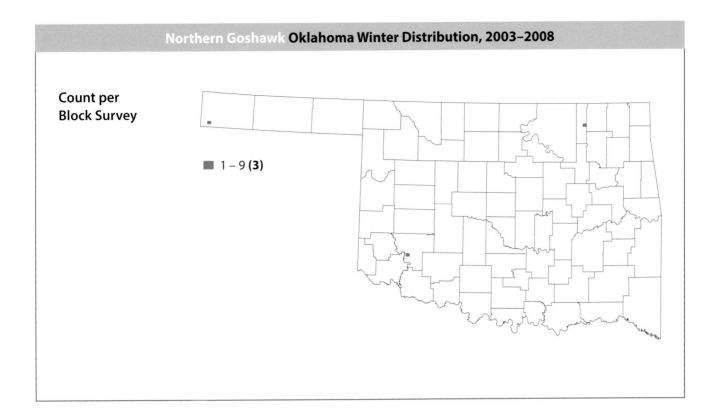

**Count per Block Survey**

■ 1 – 9 **(3)**

### References

Nanney, K. 1983. Goshawk in southern Oklahoma. *Bulletin of the Oklahoma Ornithological Society* 16:31.

National Audubon Society. 2011. The Christmas Bird Count historical results. http://www
.christmasbirdcount.org.

Oklahoma Bird Records Committee. 2009. *Date Guide to the Occurrences of Birds in Oklahoma*. 5th ed.
Norman: Oklahoma Ornithological Society.

Squires, John R., and Richard T. Reynolds. 1997. Northern Goshawk (*Accipiter gentilis*). *The Birds of North
America Online*, edited by A. Poole. Ithaca, N.Y.: Cornell Laboratory of Ornithology. http://bna.birds
.cornell.edu.

# Harris's Hawk
## *Parabuteo unicinctus*

Steve Metz

**Occurrence:** Rare.

**Habitat:** Open country with scattered trees.

**North American distribution:** Resident in parts of the southwestern United States and Mexico.

**Oklahoma distribution:** Not recorded in survey blocks. Special interest species reports were received for two birds in Texas County throughout the winter of 2004–2005. An additional published report during the project period came from McCurtain County in December 2005 (Oklahoma Bird Records Committee 2006).

**Behavior:** Harris's Hawks are social, particularly outside the breeding season, but because of their rarity in Oklahoma, single birds are most likely to be seen. They forage for mammals and birds and are known to hunt cooperatively. One bird may flush prey while one or more birds wait to capture it, or they may take turns in a long pursuit.

### Christmas Bird Count (CBC) Results, 1960–2009

$R^2 = 0.0226$

### CBC Results, 2003–2008

| Winter | Number recorded | Counts reporting |
|---|---|---|
| 2003–2004 | 0 | — |
| 2004–2005 | 0 | — |
| 2005–2006 | 0 | — |
| 2006–2007 | 0 | — |
| 2007–2008 | 0 | — |

Count per
Block Survey

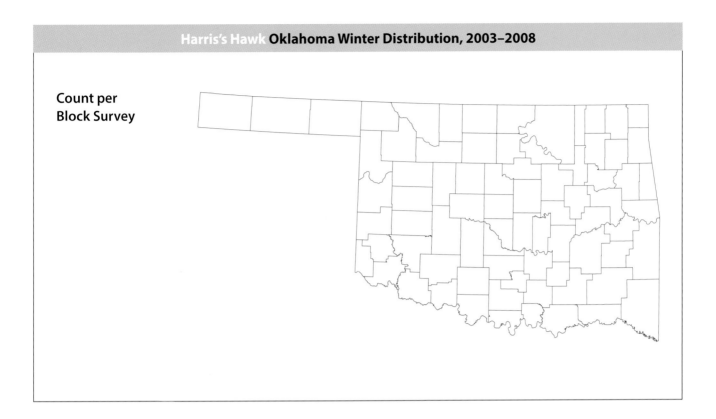

### References

Banta, J. K., and J. McMahon. 1987. Harris' Hawks in Oklahoma during fall and winter, 1986–87. *Bulletin of the Oklahoma Ornithological Society* 20:29–31.

Barker, K. 1996. Recent records for Harris's Hawk in Oklahoma. *Bulletin of the Oklahoma Ornithological Society* 29:21–22.

Bednarz, James C. 1995. Harris's Hawk (*Parabuteo unicinctus*). *The Birds of North America Online*, edited by A. Poole. Ithaca, N.Y.: Cornell Laboratory of Ornithology. http://bna.birds.cornell.edu.

National Audubon Society. 2011. The Christmas Bird Count historical results. http://www.christmasbirdcount.org.

Oklahoma Bird Records Committee. 2006. 2005–2006 winter season. *The Scissortail* 56:14–15.

———. 2009. *Date Guide to the Occurrences of Birds in Oklahoma.* 5th ed. Norman: Oklahoma Ornithological Society.

ORDER **ACCIPITRIFORMES**

# Red-shouldered Hawk
*Buteo lineatus*

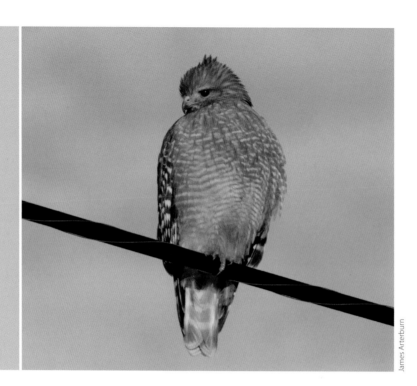

James Arterburn

**Occurrence:** Year-round resident here, but northern populations migrate.

**Habitat:** Mature woodlands near water in both rural and suburban areas.

**North American distribution:** Breeds in southeastern Canada and the northeastern United States. Resident across much of the eastern United States and in parts of California. Winters in Mexico.

**Oklahoma distribution:** Recorded commonly at low density throughout the eastern two-thirds of the state. The summer distribution recorded by the Oklahoma Breeding Bird Atlas Project was largely similar, but with fewer records at the western edge of its range, suggesting a recent increase in numbers in central and marginally western counties.

**Behavior:** Red-shouldered Hawks are usually seen singly or in pairs. They hunt primarily from a perch, keeping watch for a variety of animals including small mammals, reptiles, and amphibians, and invertebrates such as crayfish.

## Christmas Bird Count (CBC) Results, 1960–2009

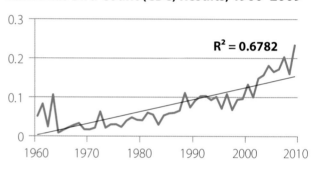

$R^2 = 0.6782$

## CBC Results, 2003–2008

| Winter | Number recorded | Counts reporting |
|--------|-----------------|------------------|
| 2003–2004 | 193 | 15 |
| 2004–2005 | 221 | 16 |
| 2005–2006 | 221 | 16 |
| 2006–2007 | 216 | 15 |
| 2007–2008 | 172 | 16 |

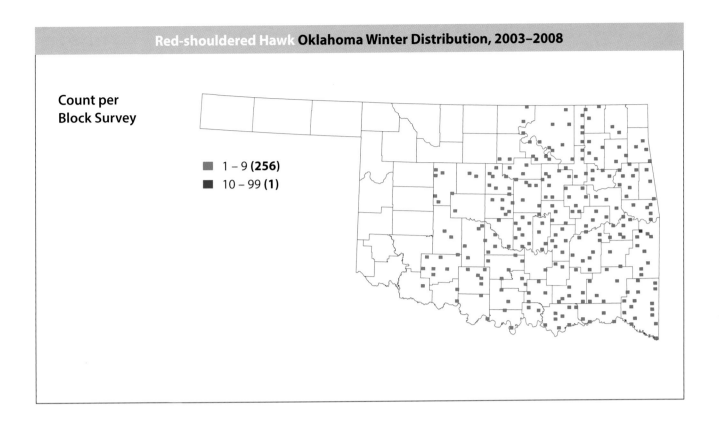

Count per
Block Survey

■ 1 – 9 **(256)**
■ 10 – 99 **(1)**

### References

Dykstra, Cheryl R., Jeffrey L. Hays, and Scott T. Crocoll. 2008. Red-shouldered Hawk (*Buteo lineatus*). *The Birds of North America Online*, edited by A. Poole. Ithaca, N.Y.: Cornell Laboratory of Ornithology. http://bna.birds.cornell.edu.

National Audubon Society. 2011. The Christmas Bird Count historical results. http://www .christmasbirdcount.org.

Oklahoma Bird Records Committee. 2009. *Date Guide to the Occurrences of Birds in Oklahoma*. 5th ed. Norman: Oklahoma Ornithological Society.

Reinking, D. L., ed. 2004. *Oklahoma Breeding Bird Atlas*. Norman: University of Oklahoma Press.

Tyler, J. D., S. J. Orr, and J. K. Banta. 1989. The Red-shouldered Hawk in southwestern Oklahoma. *Bulletin of the Oklahoma Ornithological Society* 22:17–21.

# Red-tailed Hawk
## *Buteo jamaicensis*

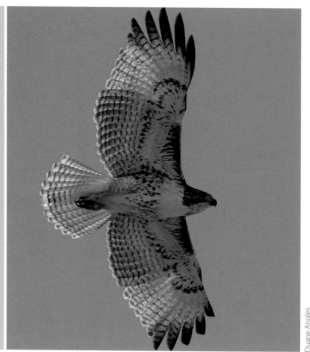

Duane Angles

**Occurrence:** Year-round resident, but many additional individuals from northern breeding areas winter here.

**Habitat:** Wide variety of open areas with scattered trees.

**North American distribution:** Breeds in Alaska, much of Canada, and the northern lower 48 states. Resident across most of the lower 48 states and in Mexico.

**Oklahoma distribution:** Recorded at low to moderate abundance in 550 survey blocks statewide, ranking first among all species. The summer distribution recorded by the Oklahoma Breeding Bird Atlas Project was similar.

**Behavior:** Red-tailed Hawks are usually seen singly or in pairs during the winter, although they can be numerous in some areas, and therefore multiple individuals can be seen not very far apart. The majority of hunting is done by watching for small to medium-sized mammals and birds from an elevated perch.

## Christmas Bird Count (CBC) Results, 1960–2009

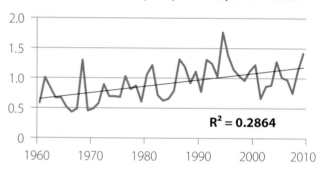

$R^2 = 0.2864$

## CBC Results, 2003–2008

| Winter | Number recorded | Counts reporting |
|---|---|---|
| 2003–2004 | 972 | 19 |
| 2004–2005 | 1,242 | 20 |
| 2005–2006 | 1,081 | 19 |
| 2006–2007 | 1,025 | 18 |
| 2007–2008 | 706 | 20 |

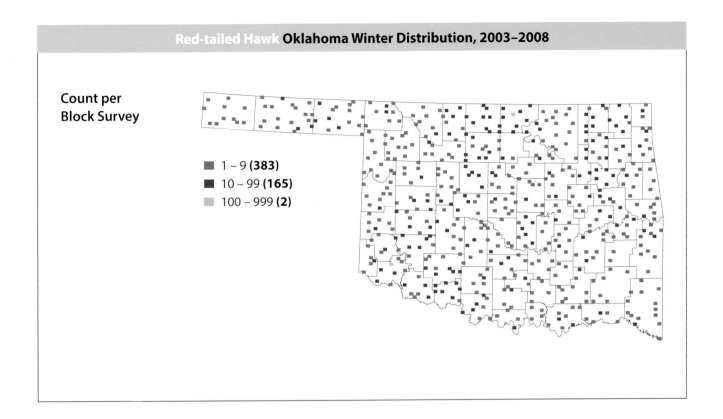

**Count per Block Survey**

- ■ 1 – 9 **(383)**
- ■ 10 – 99 **(165)**
- ▨ 100 – 999 **(2)**

### References

Clyde, G. A. 1990. Red-tailed Hawk captures Great-tailed Grackle in mid-air. *Bulletin of the Oklahoma Ornithological Society* 23:12–13.

National Audubon Society. 2011. The Christmas Bird Count historical results. http://www .christmasbirdcount.org.

Oklahoma Bird Records Committee. 2009. *Date Guide to the Occurrences of Birds in Oklahoma*. 5th ed. Norman: Oklahoma Ornithological Society.

Preston, C. R., and R. D. Beane. 2009. Red-tailed Hawk (*Buteo jamaicensis*). *The Birds of North America Online*, edited by A. Poole. Ithaca, N.Y.: Cornell Laboratory of Ornithology. http://bna.birds.cornell.edu.

Reinking, D. L., ed. 2004. *Oklahoma Breeding Bird Atlas*. Norman: University of Oklahoma Press.

Sutton, G. M. 1969. Harlan's Hawk in Roger Mills County, Oklahoma. *Bulletin of the Oklahoma Ornithological Society* 2:4.

# Rough-legged Hawk
*Buteo lagopus*

© (G. Schneider) / VIREO

**Occurrence:** October through mid-April.

**Habitat:** Open grasslands.

**North American distribution:** Breeds in Alaska and northern Canada. Winters broadly across the northern two-thirds of the lower 48 states.

**Oklahoma distribution:** Recorded in scattered survey blocks nearly statewide, with heavy concentrations of records in northern and southwestern counties.

**Behavior:** Rough-legged Hawks are usually seen singly, and they often defend winter territories from other individuals. They hunt by soaring or hovering in search of small mammals, rabbits, and birds.

## Christmas Bird Count (CBC) Results, 1960–2009

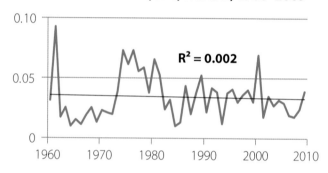

$R^2 = 0.002$

## CBC Results, 2003–2008

| Winter | Number recorded | Counts reporting |
|--------|-----------------|------------------|
| 2003–2004 | 32 | 7 |
| 2004–2005 | 39 | 6 |
| 2005–2006 | 31 | 7 |
| 2006–2007 | 17 | 7 |
| 2007–2008 | 12 | 9 |

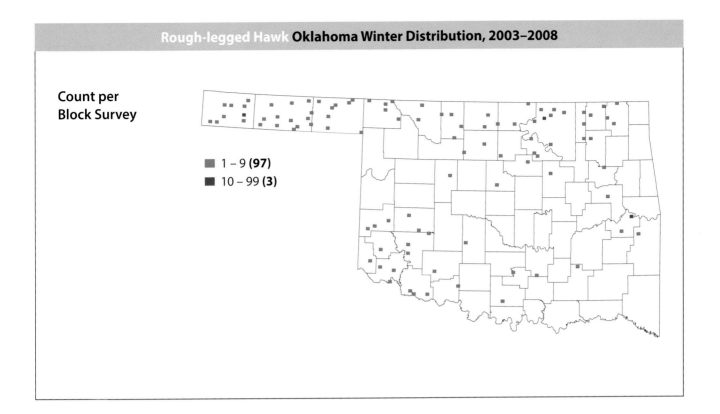

Count per
Block Survey

■ 1 – 9 **(97)**
■ 10 – 99 **(3)**

### References

Bechard, Marc J., and Theodor R. Swem. 2002. Rough-legged Hawk (*Buteo lagopus*). *The Birds of North America Online*, edited by A. Poole. Ithaca, N.Y.: Cornell Laboratory of Ornithology. http://bna.birds.cornell.edu.

National Audubon Society. 2011. The Christmas Bird Count historical results. http://www.christmasbirdcount.org.

Oklahoma Bird Records Committee. 2009. *Date Guide to the Occurrences of Birds in Oklahoma*. 5th ed. Norman: Oklahoma Ornithological Society.

## Ferruginous Hawk
*Buteo regalis*

Bob Gress

**Occurrence:** Mid-October through March in most regions of the state, and year round in the Panhandle.

**Habitat:** Open grasslands.

**North American distribution:** Found in the western half of North America from southern Canada to northern Mexico, with various populations being either resident or migratory.

**Oklahoma distribution:** Recorded in the western two-thirds of the state, with the highest concentration occurring in the Panhandle. The summer distribution recorded by the Oklahoma Breeding Bird Atlas Project was restricted largely to the Panhandle. Fall migratory movements bring Ferruginous Hawks into the main body of the state from western breeding grounds.

**Behavior:** Ferruginous Hawks are usually seen singly, although they may gather loosely near food sources such as prairie dog towns. They hunt small mammals including rabbits and prairie dogs from a perch, from the ground, or from flight.

### Christmas Bird Count (CBC) Results, 1960–2009

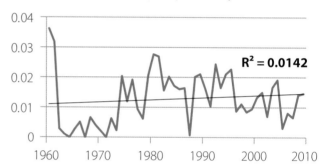

$R^2 = 0.0142$

### CBC Results, 2003–2008

| Winter | Number recorded | Counts reporting |
|---|---|---|
| 2003–2004 | 11 | 5 |
| 2004–2005 | 18 | 5 |
| 2005–2006 | 4 | 3 |
| 2006–2007 | 9 | 6 |
| 2007–2008 | 8 | 4 |

**Count per
Block Survey**

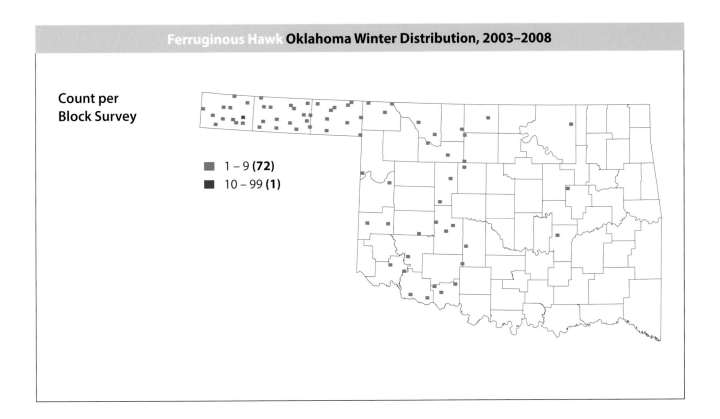

1 – 9 **(72)**
10 – 99 **(1)**

**References**

Bechard, Marc J., and Josef K. Schmutz. 1995. Ferruginous Hawk (*Buteo regalis*). *The Birds of North America Online*, edited by A. Poole. Ithaca, N.Y.: Cornell Laboratory of Ornithology. http://bna.birds.cornell.edu.

National Audubon Society. 2011. The Christmas Bird Count historical results. http://www .christmasbirdcount.org.

Oklahoma Bird Records Committee. 2009. *Date Guide to the Occurrences of Birds in Oklahoma*. 5th ed. Norman: Oklahoma Ornithological Society.

Reinking, D. L., ed. 2004. *Oklahoma Breeding Bird Atlas*. Norman: University of Oklahoma Press.

# Golden Eagle
## *Aquila chrysaetos*

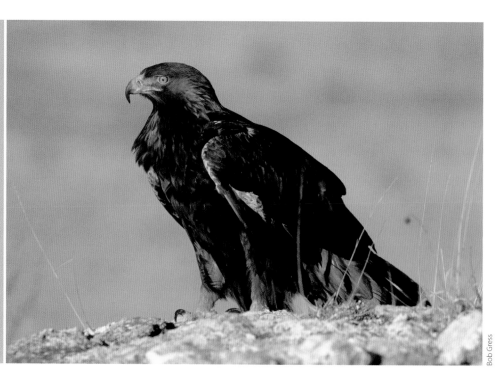

Bob Gress

**Occurrence:** Present year round, but more widespread during the winter.

**Habitat:** Open country.

**North American distribution:** Breeds in Alaska and parts of Canada, resident across much of the western United States and Mexico, and winters at scattered locations in the eastern United States.

**Oklahoma distribution:** Recorded at a few scattered locations nearly statewide, with most records coming from the Panhandle. This winter distribution is much more extensive than the summer distribution recorded during the Oklahoma Breeding Bird Atlas Project, in which this species was found in only one Panhandle block.

**Behavior:** Golden Eagles are usually seen singly. They forage for mammals, especially rabbits and prairie dogs. Three styles of hunting are used, including soaring, watching from a perch, and flying low to the ground to surprise prey.

### Christmas Bird Count (CBC) Results, 1960–2009

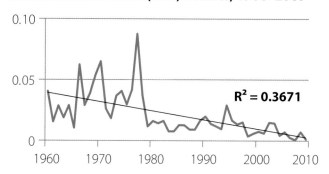

$R^2 = 0.3671$

### CBC Results, 2003–2008

| Winter | Number recorded | Counts reporting |
|---|---|---|
| 2003–2004 | 15 | 3 |
| 2004–2005 | 4 | 4 |
| 2005–2006 | 8 | 4 |
| 2006–2007 | 3 | 2 |
| 2007–2008 | 1 | 1 |

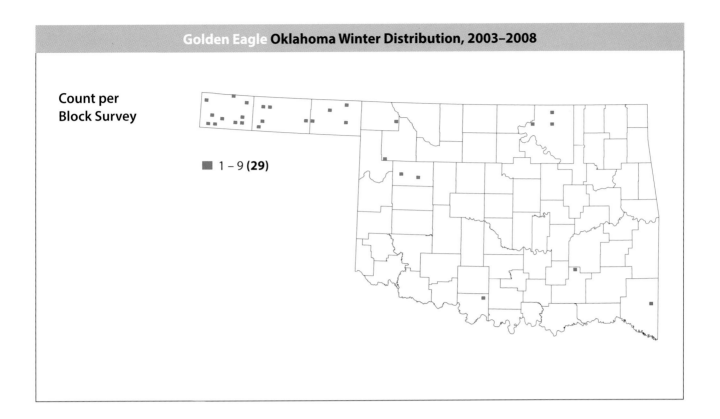

**Count per Block Survey**

■ 1 – 9 **(29)**

### References

Kochert, M. N., K. Steenhof, C. L. McIntyre, and E. H. Craig. 2002. Golden Eagle (*Aquila chrysaetos*). *The Birds of North America Online*, edited by A. Poole. Ithaca, N.Y.: Cornell Laboratory of Ornithology. http://bna .birds.cornell.edu.

National Audubon Society. 2011. The Christmas Bird Count historical results. http://www .christmasbirdcount.org.

Oklahoma Bird Records Committee. 2009. *Date Guide to the Occurrences of Birds in Oklahoma.* 5th ed. Norman: Oklahoma Ornithological Society.

Reinking, D. L., ed. 2004. *Oklahoma Breeding Bird Atlas.* Norman: University of Oklahoma Press.

# ORDER **STRIGIFORMES**

## Barn Owl
*Tyto alba*

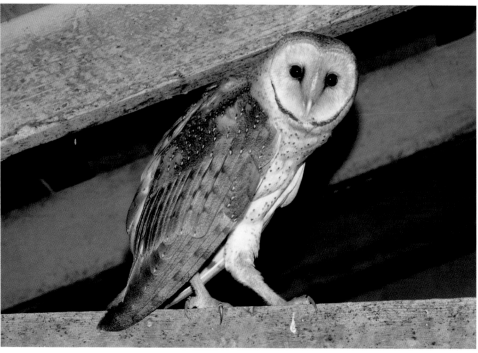

Bob Gress

**Occurrence:** Year-round resident.

**Habitat:** Open country with cliffs, embankments, caves, trees, or old buildings to provide nesting and roosting cavities.

**North American distribution:** Resident across much of the lower 48 states except in parts of the northern plains, Great Lakes, and New England regions.

**Oklahoma distribution:** Documented at highest density in the southwest and Panhandle regions, consistent with the distribution found for the Oklahoma Breeding Bird Atlas Project. Also occurred at low density in the central and northeastern regions, but its nocturnal habits make it difficult to locate during surveys and it may be somewhat more widespread than results indicate.

**Behavior:** Barn owls typically pair for life and defend nesting areas, but not foraging areas, so multiple birds can occasionally be seen in grasslands or agricultural areas. They have highly adapted vision and hearing for night hunting and pursue primarily small mammals.

### Christmas Bird Count (CBC) Results, 1960–2009

$R^2 = 0.4438$

### CBC Results, 2003–2008

| Winter | Number recorded | Counts reporting |
| --- | --- | --- |
| 2003–2004 | 20 | 7 |
| 2004–2005 | 20 | 6 |
| 2005–2006 | 14 | 6 |
| 2006–2007 | 8 | 3 |
| 2007–2008 | 4 | 3 |

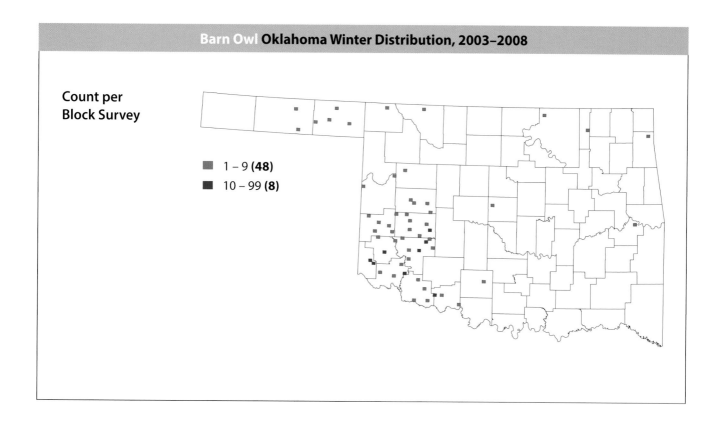

Count per
Block Survey

■ 1 – 9 **(48)**
■ 10 – 99 **(8)**

### References

Marti, Carl D., Alan F. Poole, and L. R. Bevier. 2005. Barn Owl (*Tyto alba*). *The Birds of North America Online*, edited by A. Poole. Ithaca, N.Y.: Cornell Laboratory of Ornithology. http://bna.birds.cornell.edu.

National Audubon Society. 2011. The Christmas Bird Count historical results. http://www .christmasbirdcount.org.

Oklahoma Bird Records Committee. 2009. *Date Guide to the Occurrences of Birds in Oklahoma*. 5th ed. Norman: Oklahoma Ornithological Society.

Reinking, D. L., ed. 2004. *Oklahoma Breeding Bird Atlas*. Norman: University of Oklahoma Press.

# Western Screech-Owl
## *Megascops kennicottii*

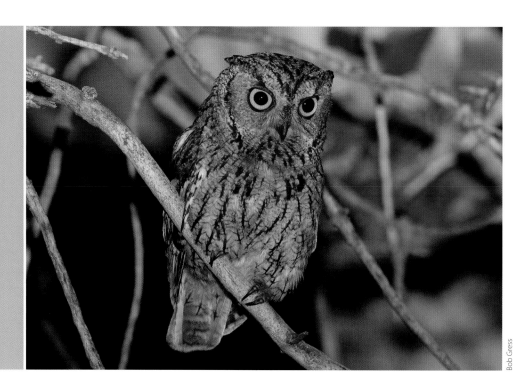

Bob Gress

**Occurrence:** Year-round resident of northwestern Cimarron County.

**Habitat:** Riparian woodlands with mature trees.

**North American distribution:** Resident in far western Canada and much of the western lower 48 states and Mexico.

**Oklahoma distribution:** Not recorded in survey blocks. Special interest species reports came from at least three locations in Cimarron County. The summer distribution recorded by the Oklahoma Breeding Bird Atlas Project included one Cimarron County block.

**Behavior:** Western Screech-Owls are seen singly or in pairs during the winter. They forage for small mammals and birds, watching from a perch before flying out to capture prey once it is sighted.

### Christmas Bird Count (CBC) Results, 1960–2009

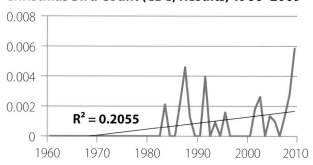

$R^2 = 0.2055$

### CBC Results, 2003–2008

| Winter | Number recorded | Counts reporting |
|--------|-----------------|------------------|
| 2003–2004 | 0 | — |
| 2004–2005 | 1 | 1 |
| 2005–2006 | 1 | 1 |
| 2006–2007 | 0 | — |
| 2007–2008 | 1 | 1 |

Count per
Block Survey

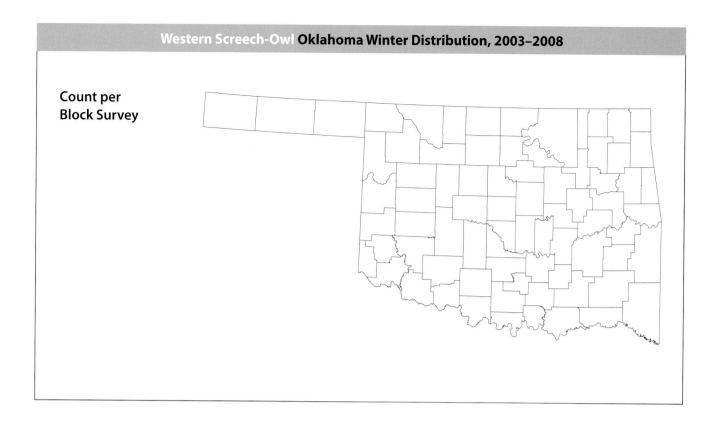

**References**

Cannings, Richard J., and Tony Angell. 2001. Western Screech-Owl (*Megascops kennicottii*). *The Birds of North America Online*, edited by A. Poole. Ithaca, N.Y.: Cornell Laboratory of Ornithology. http://bna .birds.cornell.edu.

Grzybowski, J. A. 1983. Western Screech-Owl: A "new" bird for Oklahoma. *Bulletin of the Oklahoma Ornithological Society* 16:17–20.

National Audubon Society. 2011. The Christmas Bird Count historical results. http://www .christmasbirdcount.org.

Oklahoma Bird Records Committee. 2009. *Date Guide to the Occurrences of Birds in Oklahoma*. 5th ed. Norman: Oklahoma Ornithological Society.

Reinking, D. L., ed. 2004. *Oklahoma Breeding Bird Atlas*. Norman: University of Oklahoma Press.

# Eastern Screech-Owl
## *Megascops asio*

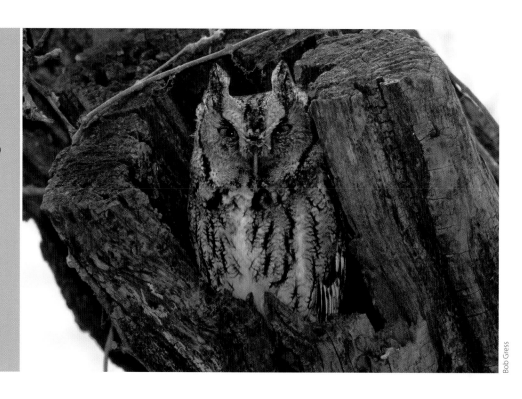

Bob Gress

**Occurrence:** Year-round resident.

**Habitat:** Forests and woodlands in both rural and suburban areas.

**North American distribution:** Resident across parts of southeastern Canada, the eastern two-thirds of the lower 48 states, and northwestern Mexico.

**Oklahoma distribution:** Recorded at scattered locations throughout the main body of the state. The summer distribution recorded during the Oklahoma Breeding Bird Atlas Project was quite similar, despite atlas-style surveys not being ideal for detecting this nocturnal species.

**Behavior:** Eastern Screech-Owls typically mate for life, and males defend nesting and roosting cavities year round. Most foraging is done nocturnally and consists of watching from a perch for a songbird, small mammal, insect, or crayfish and flying out to capture it with talons.

## Christmas Bird Count (CBC) Results, 1960–2009

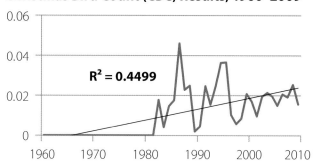

$R^2 = 0.4499$

## CBC Results, 2003–2008

| Winter | Number recorded | Counts reporting |
| --- | --- | --- |
| 2003–2004 | 34 | 7 |
| 2004–2005 | 26 | 8 |
| 2005–2006 | 20 | 8 |
| 2006–2007 | 22 | 13 |
| 2007–2008 | 24 | 9 |

**Count per Block Survey**

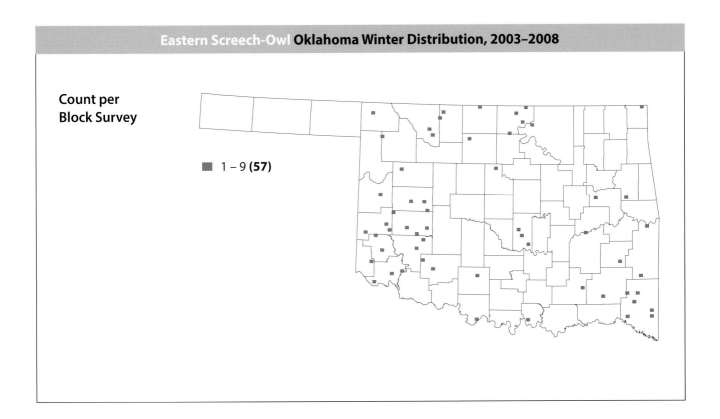

■ 1 – 9 **(57)**

## References

Gehlbach, Frederick R. 1995. Eastern Screech-Owl (*Megascops asio*). *The Birds of North America Online*, edited by A. Poole. Ithaca, N.Y.: Cornell Laboratory of Ornithology. http://bna.birds.cornell.edu.

National Audubon Society. 2011. The Christmas Bird Count historical results. http://www .christmasbirdcount.org.

Oklahoma Bird Records Committee. 2009. *Date Guide to the Occurrences of Birds in Oklahoma*. 5th ed. Norman: Oklahoma Ornithological Society.

Reinking, D. L., ed. 2004. *Oklahoma Breeding Bird Atlas*. Norman: University of Oklahoma Press.

Sutton, G. M. 1986. Dichromatism of the screech owl in central Oklahoma. *Bulletin of the Oklahoma Ornithological Society* 19:17–20.

# Great Horned Owl

*Bubo virginianus*

Bob Gress

**Occurrence:** Year-round resident.

**Habitat:** Woodlands, riparian areas, rural areas, and wooded suburban areas.

**North American distribution:** Resident across nearly all of North America.

**Oklahoma distribution:** Recorded statewide, with the highest concentration of records in the western half. As would be expected for a resident species, the summer distribution recorded during the Oklahoma Breeding Bird Atlas Project was similar.

**Behavior:** Great Horned Owls maintain long-term pair bonds, although they are usually seen singly during the winter. Many other species such as crows, jays, and blackbirds will actively mob a Great Horned Owl if they see one during daylight hours. Great Horned Owls hunt mostly at night and mostly from a perch, watching for a wide variety of potential prey items but taking mostly mammals and lesser numbers of birds, reptiles, and invertebrates.

## Christmas Bird Count (CBC) Results, 1960–2009

$R^2 = 0.1447$

## CBC Results, 2003–2008

| Winter | Number recorded | Counts reporting |
|---|---|---|
| 2003–2004 | 94 | 19 |
| 2004–2005 | 128 | 18 |
| 2005–2006 | 98 | 19 |
| 2006–2007 | 62 | 17 |
| 2007–2008 | 65 | 16 |

**Count per
Block Survey**

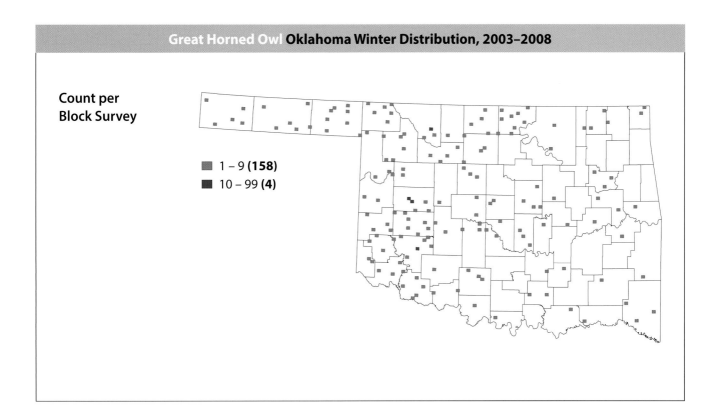

1 – 9 **(158)**
10 – 99 **(4)**

**References**

Houston, C. Stuart, Dwight G. Smith, and Christoph Rohner. 1998. Great Horned Owl (*Bubo virginianus*). *The Birds of North America Online*, edited by A. Poole. Ithaca, N.Y.: Cornell Laboratory of Ornithology. http://bna.birds.cornell.edu.

National Audubon Society. 2011. The Christmas Bird Count historical results. http://www.christmasbirdcount.org.

Oklahoma Bird Records Committee. 2009. *Date Guide to the Occurrences of Birds in Oklahoma*. 5th ed. Norman: Oklahoma Ornithological Society.

Reinking, D. L., ed. 2004. *Oklahoma Breeding Bird Atlas*. Norman: University of Oklahoma Press.

Seibert, P. 1995. Early nesting date for Great Horned Owl in Oklahoma. *Bulletin of the Oklahoma Ornithological Society* 28:21–22.

Voelker, W. G. 1979. Early nesting of Great Horned Owls in Oklahoma. *Bulletin of the Oklahoma Ornithological Society* 12:5–6.

# Snowy Owl
## *Bubo scandiacus*

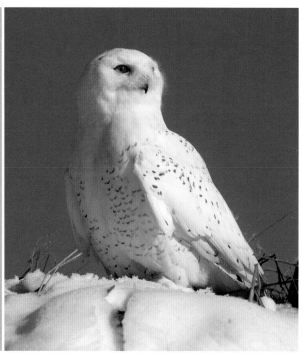

Bob Gress

**Occurrence:** Rare in December and January.

**Habitat:** Open grasslands.

**North American distribution:** Breeds in Greenland and northernmost Canada. Resident in Alaska and northern Canada. Winters across much of Canada and parts of the northern lower 48 states. Occasionally wanders farther south during winter.

**Oklahoma distribution:** Not recorded in survey blocks. A special interest species report came from Rogers County on January 28, 2004. Additional published reports from the project period came from Alfalfa County on January 9, 2007 (Oklahoma Bird Records Committee 2007), and from Osage County from mid to late December 2005 (Oklahoma Bird Records Committee 2006).

**Behavior:** Snowy Owls are usually seen singly. They forage for rabbits, rodents, and birds using their excellent eyesight and hearing to locate prey. Shortages of food in their normal wintering range are thought to contribute to their wandering as far south as Oklahoma.

**Christmas Bird Count (CBC) Results, 1960–2009**

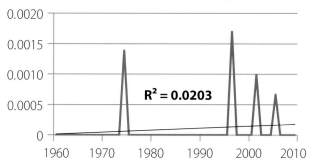

$R^2 = 0.0203$

**CBC Results, 2003–2008**

| Winter | Number recorded | Counts reporting |
|---|---|---|
| 2003–2004 | 0 | — |
| 2004–2005 | 0 | — |
| 2005–2006 | 1 | 1 |
| 2006–2007 | 0 | — |
| 2007–2008 | 0 | — |

Count per
Block Survey

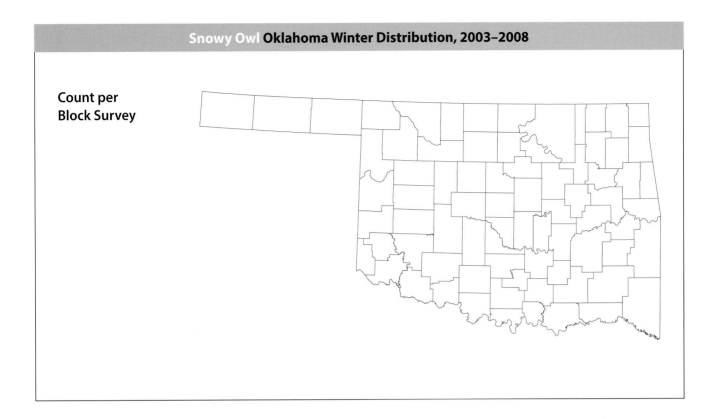

### References

Isaacs, W. S. 1979. A Snowy Owl at Oklahoma City's airport. *Bulletin of the Oklahoma Ornithological Society* 12:4–5.

Morgan, J. M. 1985. A Snowy Owl in Comanche County, Oklahoma. *Bulletin of the Oklahoma Ornithological Society* 18:29–30.

National Audubon Society. 2011. The Christmas Bird Count historical results. http://www .christmasbirdcount.org.

Oklahoma Bird Records Committee. 2006. 2005–2006 winter season. *The Scissortail* 56:14–15.

———. 2007. 2006–2007 winter season. *The Scissortail* 57:24–27.

———. 2009. *Date Guide to the Occurrences of Birds in Oklahoma.* 5th ed. Norman: Oklahoma Ornithological Society.

Parmelee, David F. 1992. Snowy Owl (*Bubo scandiacus*). *The Birds of North America Online*, edited by A. Poole. Ithaca, N.Y.: Cornell Laboratory of Ornithology. http://bna.birds.cornell.edu.

Shackford, J. S. 1975. The Snowy Owl in Oklahoma. *Bulletin of the Oklahoma Ornithological Society* 8:29–34.

———. 1981. Snowy Owl again in central Oklahoma. *Bulletin of the Oklahoma Ornithological Society* 14:33.

Sheffield, S. R. 1995. Occurrence of Snowy Owls at Sooner Lake, Oklahoma, with notes on their ecology and behavior. *Bulletin of the Oklahoma Ornithological Society* 28:27–30.

# Burrowing Owl
## *Athene cunicularia*

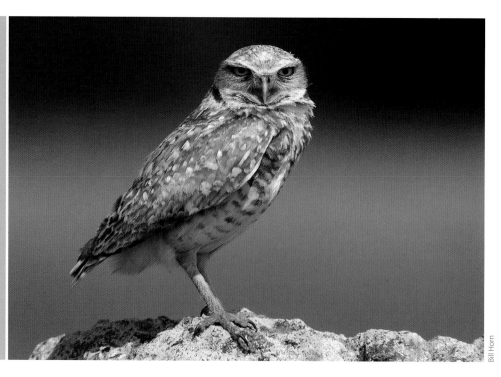

Bill Horn

**Occurrence:** Year-round resident, although the vast majority of individuals leave the state for winter.

**Habitat:** Shortgrass plains with resident populations of burrowing mammals such as prairie dogs.

**North American distribution:** Breeds across a large portion of the western United States. Resident in the southwestern United States and Mexico, as well as in Florida.

**Oklahoma distribution:** Burrowing Owls were recorded in just two blocks in the Panhandle, this small number indicating the winter exodus of most individuals in the state. In contrast, they were widely recorded in the Panhandle and several southwestern Oklahoma counties during the Oklahoma Breeding Bird Atlas Project in the summer months.

**Behavior:** Burrowing Owls may be seen singly but may also be observed in loose colonies associated with prairie dog towns, where they utilize unoccupied prairie dog burrows for nesting and roosting. Burrowing Owls hunt by walking, running, flying from a perch, or even by hovering while they search for insects, small mammals, and small birds.

## Christmas Bird Count (CBC) Results, 1960–2009

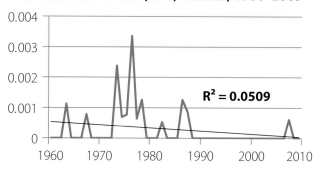

$R^2 = 0.0509$

## CBC Results, 2003–2008

| Winter | Number recorded | Counts reporting |
|--------|-----------------|------------------|
| 2003–2004 | 0 | — |
| 2004–2005 | 0 | — |
| 2005–2006 | 0 | — |
| 2006–2007 | 0 | — |
| 2007–2008 | 1 | 1 |

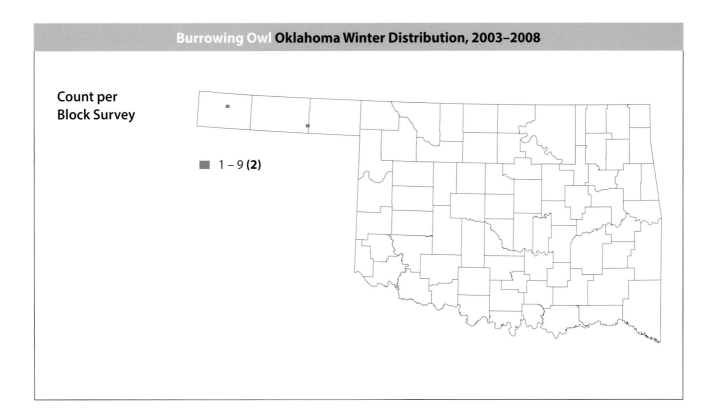

**Count per
Block Survey**

■ 1 – 9 **(2)**

## References

Haug, E. A., B. A. Millsap, and M. S. Martell. 1993. Burrowing Owl (*Athene cunicularia*). *The Birds of North America Online*, edited by A. Poole. Ithaca, N.Y.: Cornell Laboratory of Ornithology. http://bna.birds.cornell.edu.

National Audubon Society. 2011. The Christmas Bird Count historical results. http://www.christmasbirdcount.org.

Oklahoma Bird Records Committee. 2009. *Date Guide to the Occurrences of Birds in Oklahoma*. 5th ed. Norman: Oklahoma Ornithological Society.

Reinking, D. L., ed. 2004. *Oklahoma Breeding Bird Atlas*. Norman: University of Oklahoma Press.

# Barred Owl
## *Strix varia*

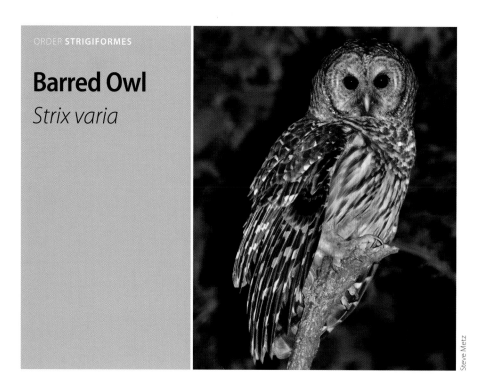

Steve Metz

**Occurrence:** Year-round resident.

**Habitat:** Dense woodlands and river bottoms in both rural and suburban areas.

**North American distribution:** Resident throughout the eastern United States, much of southern Canada, and parts of the northwestern United States.

**Oklahoma distribution:** Present throughout most of the main body of the state and not recorded in the Panhandle region. Western, southwestern, and northwestern counties with little dense woodland habitat had fewer records. As would be expected for a nonmigratory species, its winter distribution closely resembles the breeding distribution documented during the Oklahoma Breeding Bird Atlas Project.

**Behavior:** Barred Owls live as monogamous pairs and are territorial all year. Their "who cooks for you" calls can be heard in any month, but the owls are most vocal in February and March. They are seen more frequently during the day than most other owl species. Their diet includes a broad range of animals, from birds and small mammals to reptiles and amphibians.

## Christmas Bird Count (CBC) Results, 1960–2009

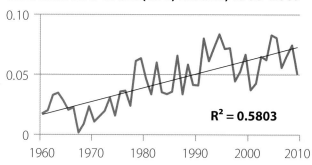

$R^2 = 0.5803$

## CBC Results, 2003–2008

| Winter | Number recorded | Counts reporting |
|--------|-----------------|------------------|
| 2003–2004 | 64 | 16 |
| 2004–2005 | 83 | 17 |
| 2005–2006 | 87 | 19 |
| 2006–2007 | 56 | 17 |
| 2007–2008 | 60 | 17 |

**Count per
Block Survey**

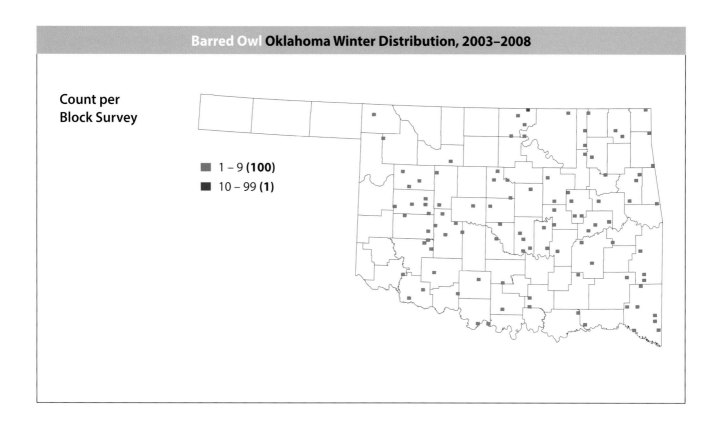

■ 1 – 9 **(100)**
■ 10 – 99 **(1)**

### References

Mazur, Kurt M., and Paul C. James. 2000. Barred Owl (*Strix varia*). *The Birds of North America Online*, edited
    by A. Poole. Ithaca, N.Y.: Cornell Laboratory of Ornithology. http://bna.birds.cornell.edu.
National Audubon Society. 2011. The Christmas Bird Count historical results. http://www
    .christmasbirdcount.org.
Oklahoma Bird Records Committee. 2009. *Date Guide to the Occurrences of Birds in Oklahoma*. 5th ed.
    Norman: Oklahoma Ornithological Society.
Reinking, D. L., ed. 2004. *Oklahoma Breeding Bird Atlas*. Norman: University of Oklahoma Press.

# Long-eared Owl

## *Asio otus*

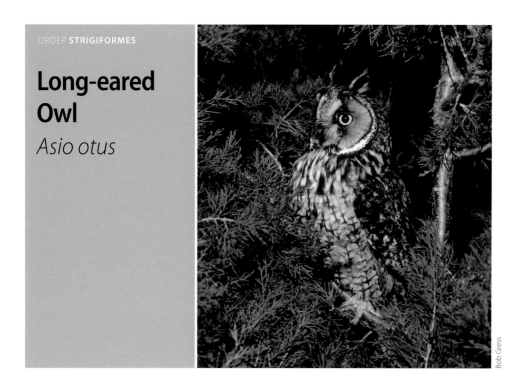

Bob Gress

**Occurrence:** Mid-October through mid-April in northern counties, and mid-December through mid-April in southern counties. There are several historical nesting records as well.

**Habitat:** Hunts in open areas but roosts in wooded areas, especially in dense cedar groves.

**North American distribution:** Breeds in southern Canada and the northern United States. Resident in large parts of the western United States and in the northeastern United States. Winters south of this range in the central and southwestern United States and northern Mexico.

**Oklahoma distribution:** Recorded in two survey blocks in western Oklahoma. Three additional records came from special interest species reports in Cimarron, Ottawa, and Rogers Counties in the winter of 2003–2004. No summer records were reported during the Oklahoma Breeding Bird Atlas Project.

**Behavior:** Long-eared Owls can be discovered singly or roosting in small groups in which they may perch quite close together. They forage mostly at night by coursing low over the ground and locating small mammals or birds using both sight and hearing.

## Christmas Bird Count (CBC) Results, 1960–2009

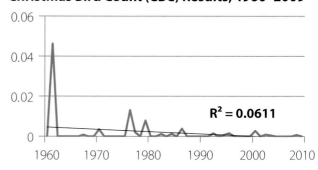

$R^2 = 0.0611$

## CBC Results, 2003–2008

| Winter | Number recorded | Counts reporting |
| --- | --- | --- |
| 2003–2004 | 1 | 1 |
| 2004–2005 | 0 | — |
| 2005–2006 | 0 | — |
| 2006–2007 | 0 | — |
| 2007–2008 | 0 | — |

Count per
Block Survey

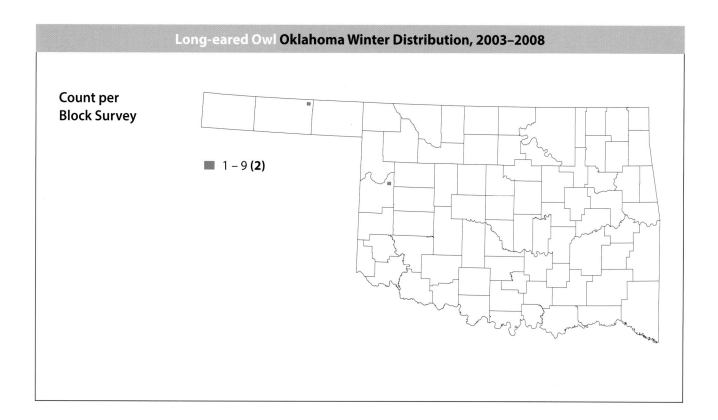

■ 1 – 9 **(2)**

### References

Dillon, D. O. 1972. Long-eared Owl in Johnston County, Oklahoma. *Bulletin of the Oklahoma Ornithological Society* 5:31.

Marks, J. S., D. L. Evans, and D. W. Holt. 1994. Long-eared Owl (*Asio otus*). *The Birds of North America Online*, edited by A. Poole. Ithaca, N.Y.: Cornell Laboratory of Ornithology. http://bna.birds.cornell.edu.

National Audubon Society. 2011. The Christmas Bird Count historical results. http://www .christmasbirdcount.org.

Oklahoma Bird Records Committee. 2009. *Date Guide to the Occurrences of Birds in Oklahoma.* 5th ed. Norman: Oklahoma Ornithological Society.

Reinking, D. L., ed. 2004. *Oklahoma Breeding Bird Atlas.* Norman: University of Oklahoma Press.

# Short-eared Owl

## *Asio flammeus*

Bob Gress

**Occurrence:** Mid-October through late April.

**Habitat:** Open grasslands.

**North American distribution:** Breeds in Alaska, much of Canada, and parts of the northern lower 48 states. Resident in parts of the northern and western lower 48 states, and winters across much of the lower 48 states.

**Oklahoma distribution:** Recorded in scattered survey blocks statewide, with the highest concentration of records in northeastern tallgrass prairies.

**Behavior:** Short-eared Owls can be seen singly, although they often roost communally on the ground, sometimes with dozens of individuals sharing the same plot of grassland. They can be active day or night, but most hunting is done at dawn and dusk, typically by flying buoyantly low over the ground to listen for small mammals, but sometimes hovering higher.

## Christmas Bird Count (CBC) Results, 1960–2009

$R^2 = 0.0019$

## CBC Results, 2003–2008

| Winter | Number recorded | Counts reporting |
|---|---|---|
| 2003–2004 | 47 | 5 |
| 2004–2005 | 55 | 6 |
| 2005–2006 | 50 | 8 |
| 2006–2007 | 30 | 3 |
| 2007–2008 | 4 | 4 |

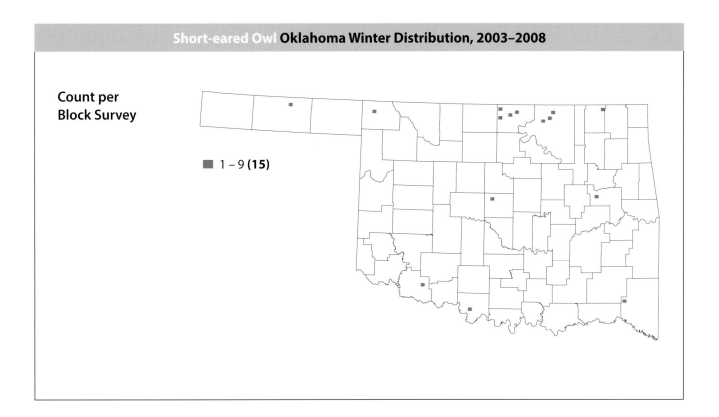

Count per
Block Survey

■ 1 – 9 **(15)**

## References

McMahon, J. 1989. Unusually high number of Short-eared Owls in northeastern Oklahoma in winter. *Bulletin of the Oklahoma Ornithological Society* 22:7.

National Audubon Society. 2011. The Christmas Bird Count historical results. http://www .christmasbirdcount.org.

Oklahoma Bird Records Committee. 2009. *Date Guide to the Occurrences of Birds in Oklahoma*. 5th ed. Norman: Oklahoma Ornithological Society.

Wiggins, D. A., D. W. Holt, and S. M. Leasure. 2006. Short-eared Owl (*Asio flammeus*). *The Birds of North America Online*, edited by A. Poole. Ithaca, N.Y.: Cornell Laboratory of Ornithology. http://bna.birds .cornell.edu.

# ORDER CORACIIFORMES

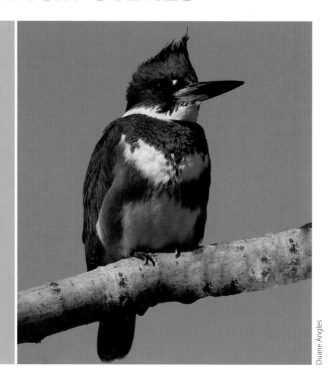

## Belted Kingfisher
### *Megaceryle alcyon*

Duane Angles

**Occurrence:** Present year round if open water remains available, although it is unclear to what extent there may be turnover of individuals because of the southward migration for the winter months that occurs across much of the species' overall range.

**Habitat:** Rivers, streams, lakes, and ponds.

**North American distribution:** Breeds across much of Alaska and Canada, is present year round across a broad swath of the lower 48 states, and winters in the southwestern United States and in Mexico.

**Oklahoma distribution:** Widely distributed at low density across the main body of the state, but not recorded in the Panhandle region. This closely matches the distribution documented by the Oklahoma Breeding Bird Atlas Project, although that survey did include several Panhandle records.

**Behavior:** Kingfishers are usually seen singly in winter, and males can defend winter territories. Kingfishers eat small fish as well as other aquatic prey such as crawfish. They hunt either from a perch over water or by hovering over water, and then plunging in to grab prey with their bill. Captured fish are often beaten against a branch before being swallowed headfirst.

### Christmas Bird Count (CBC) Results, 1960–2009

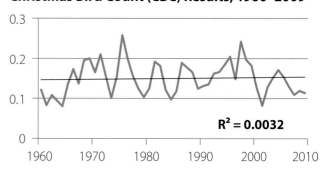

$R^2 = 0.0032$

### CBC Results, 2003–2008

| Winter | Number recorded | Counts reporting |
|--------|-----------------|------------------|
| 2003–2004 | 156 | 20 |
| 2004–2005 | 178 | 19 |
| 2005–2006 | 174 | 19 |
| 2006–2007 | 143 | 19 |
| 2007–2008 | 105 | 17 |

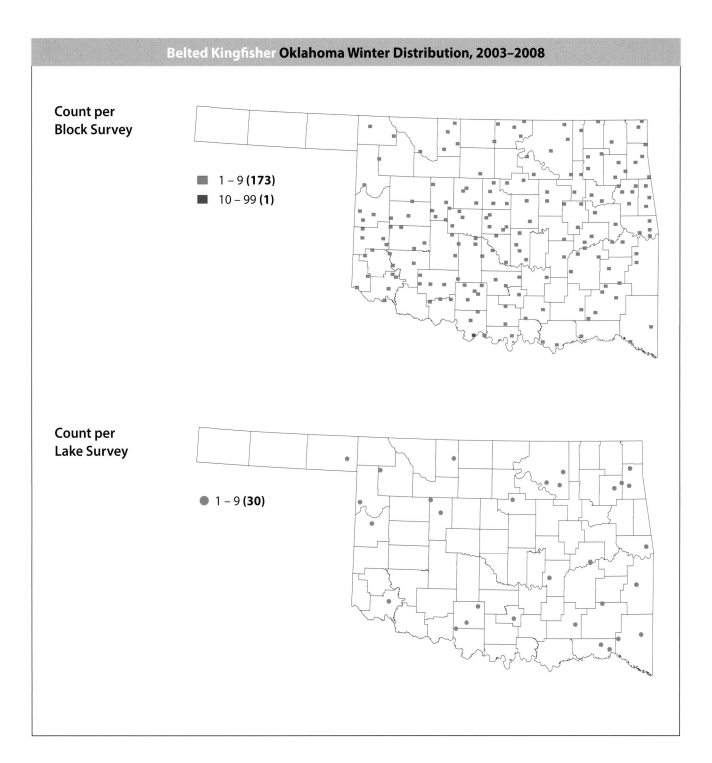

**Count per Block Survey**

- ■ 1 – 9 **(173)**
- ■ 10 – 99 **(1)**

**Count per Lake Survey**

- ● 1 – 9 **(30)**

**References**

Kelly, Jeffrey F., Eli S. Bridge, and Michael J. Hamas. 2009. Belted Kingfisher (*Megaceryle alcyon*). *The Birds of North America Online*, edited by A. Poole. Ithaca, N.Y.: Cornell Laboratory of Ornithology. http://bna .birds.cornell.edu.

National Audubon Society. 2011. The Christmas Bird Count historical results. http://www .christmasbirdcount.org.

Oklahoma Bird Records Committee. 2009. *Date Guide to the Occurrences of Birds in Oklahoma*. 5th ed. Norman: Oklahoma Ornithological Society.

Reinking, D. L., ed. 2004. *Oklahoma Breeding Bird Atlas*. Norman: University of Oklahoma Press.

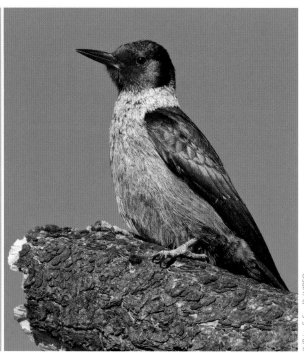

## Lewis's Woodpecker
### *Melanerpes lewis*

© (Brian E. Small) / VIREO

**Occurrence:** Year-round resident.

**Habitat:** Riparian trees, especially cottonwoods, in northwestern Cimarron County.

**North American distribution:** Breeds in much of the western United States and southwestern Canada. Resident in some of its range, including part of the southwestern United States. Winters somewhat south of its breeding range, but mostly north of Mexico.

**Oklahoma distribution:** Recorded in one survey block in northwestern Cimarron County, the only part of the state in which it normally occurs. This same block was the only one in which a summer record of the species was documented during the Oklahoma Breeding Bird Atlas Project. Vagrants were also reported as a special interest species from Comanche County (up to three birds at Wichita Mountains Wildlife Refuge) during mid-December 2003 through late February 2004, and there were two undocumented reports from east of Lexington in Cleveland County in December 2004 and January 2005.

**Behavior:** Lewis's Woodpeckers are usually seen singly during the winter. They often defend their feeding areas from other woodpeckers, even those of a different species. They forage on tree trunks, branches, and the ground for nuts, fruits, and insects.

**Christmas Bird Count (CBC) Results, 1960–2009**

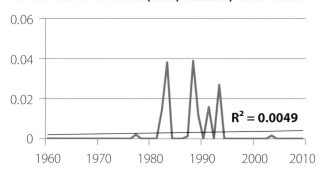

$R^2 = 0.0049$

**CBC Results, 2003–2008**

| Winter | Number recorded | Counts reporting |
| --- | --- | --- |
| 2003–2004 | 3 | 1 |
| 2004–2005 | 0 | — |
| 2005–2006 | 0 | — |
| 2006–2007 | 0 | — |
| 2007–2008 | 0 | — |

**Count per
Block Survey**

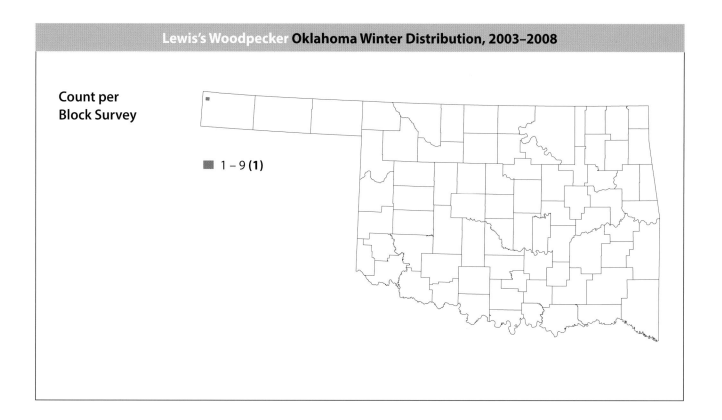

■ 1 – 9 **(1)**

### References

National Audubon Society. 2011. The Christmas Bird Count historical results. http://www
.christmasbirdcount.org.

Neeld, F. 1975. Lewis's Woodpecker in Stephens County, Oklahoma. *Bulletin of the Oklahoma
Ornithological Society* 8:37.

Oklahoma Bird Records Committee. 2004. 2003–2004 winter season. *The Scissortail* 54:25–27.

———. 2009. *Date Guide to the Occurrences of Birds in Oklahoma*. 5th ed. Norman: Oklahoma
Ornithological Society.

Reinking, D. L., ed. 2004. *Oklahoma Breeding Bird Atlas*. Norman: University of Oklahoma Press.

Tobalske, Bret W. 1997. Lewis's Woodpecker (*Melanerpes lewis*). *The Birds of North America Online*, edited by
A. Poole. Ithaca, N.Y.: Cornell Laboratory of Ornithology. http://bna.birds.cornell.edu.

# Red-headed Woodpecker

*Melanerpes erythrocephalus*

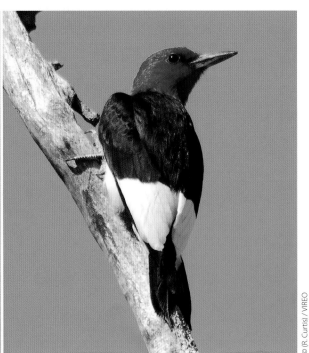

© (R. Curtis) / VIREO

**Occurrence:** Year-round resident in much of the state, but leaves northwestern Oklahoma from late October through mid-April.

**Habitat:** Mature, open woodlands and riparian areas with large trees.

**North American distribution:** Breeds in south-central Canada and much of the eastern United States. Resident across much of the southeastern United States.

**Oklahoma distribution:** Recorded commonly in survey blocks within the southeastern half of the state, tapering off rapidly north and west of Oklahoma City. The summer distribution recorded by the Oklahoma Breeding Bird Atlas Project was virtually statewide, clearly indicating the differences in summer versus winter range in the state. The Spavinaw Christmas Bird Count in Mayes County on December 17, 2006, reported a remarkable 365 birds, while the other four Spavinaw counts during the five-year atlas project ranged from 9 to 92 birds.

**Behavior:** Red-headed Woodpeckers are usually seen singly during the winter, although their winter territories are small and several birds can live near each other. They are often aggressive toward other species including Red-bellied Woodpeckers, Downy Woodpeckers, White-breasted Nuthatches, Tufted Titmice, and Brown Creepers. Their winter diet is made up largely of seeds and nuts, but fruits and insects are also taken when available. They frequently store nuts and other foods by cramming them tightly into crevices.

## Christmas Bird Count (CBC) Results, 1960–2009

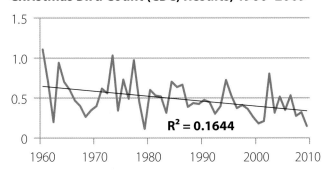

$R^2 = 0.1644$

## CBC Results, 2003–2008

| Winter | Number recorded | Counts reporting |
|--------|----------------|------------------|
| 2003–2004 | 368 | 18 |
| 2004–2005 | 655 | 16 |
| 2005–2006 | 443 | 15 |
| 2006–2007 | 583 | 14 |
| 2007–2008 | 251 | 16 |

Count per
Block Survey

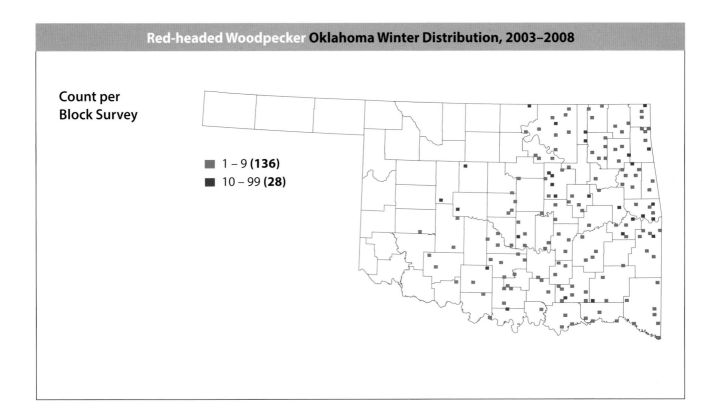

■ 1 – 9 **(136)**
■ 10 – 99 **(28)**

### References

National Audubon Society. 2011. The Christmas Bird Count historical results. http://www .christmasbirdcount.org.

Oklahoma Bird Records Committee. 2007. 2006–2007 winter season. *The Scissortail* 57:24–27.

———. 2009. *Date Guide to the Occurrences of Birds in Oklahoma*. 5th ed. Norman: Oklahoma Ornithological Society.

Reinking, D. L., ed. 2004. *Oklahoma Breeding Bird Atlas*. Norman: University of Oklahoma Press.

Smith, Kimberly G., James H. Withgott, and Paul G. Rodewald. 2000. Red-headed Woodpecker (*Melanerpes erythrocephalus*). *The Birds of North America Online*, edited by A. Poole. Ithaca, N.Y.: Cornell Laboratory of Ornithology. http://bna.birds.cornell.edu.

# Golden-fronted Woodpecker
*Melanerpes aurifrons*

Steve Metz

**Occurrence:** Year-round resident.

**Habitat:** Riparian woodlands and mesquite brushlands.

**North American distribution:** Resident in southwestern Oklahoma and large parts of Texas and Mexico.

**Oklahoma distribution:** Recorded in four southwestern Oklahoma counties, closely matching the summer distribution found during the Oklahoma Breeding Bird Atlas Project, although the latter did not record the species in Tillman County.

**Behavior:** Golden-fronted Woodpeckers are usually seen singly or in pairs. They forage on tree trunks and branches as well as on the ground, looking for insects and their larvae, fruits, and nuts.

## Christmas Bird Count (CBC) Results, 1960–2009

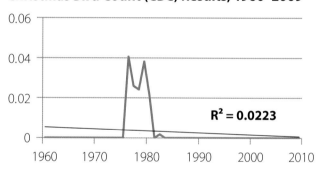

$R^2 = 0.0223$

## CBC Results, 2003–2008

| Winter | Number recorded | Counts reporting |
|---|---|---|
| 2003–2004 | 0 | — |
| 2004–2005 | 0 | — |
| 2005–2006 | 0 | — |
| 2006–2007 | 0 | — |
| 2007–2008 | 0 | — |

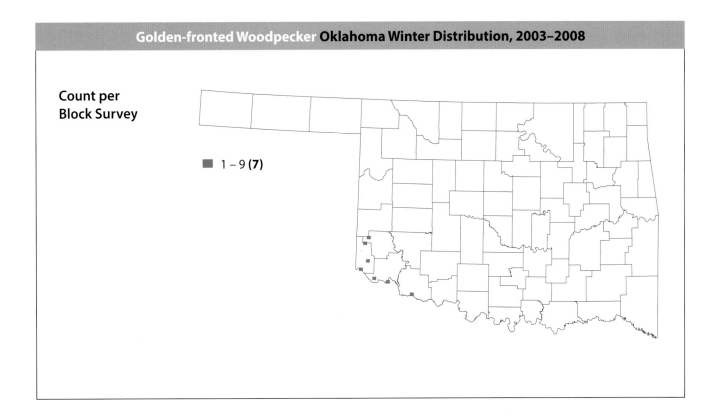

**Count per
Block Survey**

■ 1 – 9 **(7)**

### References

Husak, Michael S., and Terry C. Maxwell. 1998. Golden-fronted Woodpecker (*Melanerpes aurifrons*). *The Birds of North America Online*, edited by A. Poole. Ithaca, N.Y.: Cornell Laboratory of Ornithology. http://bna.birds.cornell.edu.

National Audubon Society. 2011. The Christmas Bird Count historical results. http://www .christmasbirdcount.org.

Oklahoma Bird Records Committee. 2009. *Date Guide to the Occurrences of Birds in Oklahoma*. 5th ed. Norman: Oklahoma Ornithological Society.

Reinking, D. L., ed. 2004. *Oklahoma Breeding Bird Atlas*. Norman: University of Oklahoma Press.

# Red-bellied Woodpecker
## *Melanerpes carolinus*

© Brenda Carroll

**Occurrence:** Year-round resident.

**Habitat:** Mature woodlands, riparian areas, farmsteads, and towns.

**North American distribution:** Resident over most of the eastern United States.

**Oklahoma distribution:** Recorded statewide at low to moderate abundances except in Cimarron County. Reported from 501 blocks, it ranked eighth in distribution. As expected for a resident species, the summer distribution recorded by the Oklahoma Breeding Bird Atlas Project was similar.

**Behavior:** Red-bellied Woodpeckers are usually seen singly during the winter and maintain loose territories, although foraging territories of a mate may overlap somewhat. Foraging takes place mostly on tree trunks and limbs, and nuts and fruit are sought during the winter, along with insects when available. Red-bellied Woodpeckers will also visit bird feeders for sunflower seeds, peanuts, and suet. They are known to store food items in crevices for later retrieval.

**Christmas Bird Count (CBC) Results, 1960–2009**

$R^2 = 0.3723$

**CBC Results, 2003–2008**

| Winter | Number recorded | Counts reporting |
|---|---|---|
| 2003–2004 | 923 | 19 |
| 2004–2005 | 1,108 | 20 |
| 2005–2006 | 1,134 | 20 |
| 2006–2007 | 906 | 19 |
| 2007–2008 | 759 | 19 |

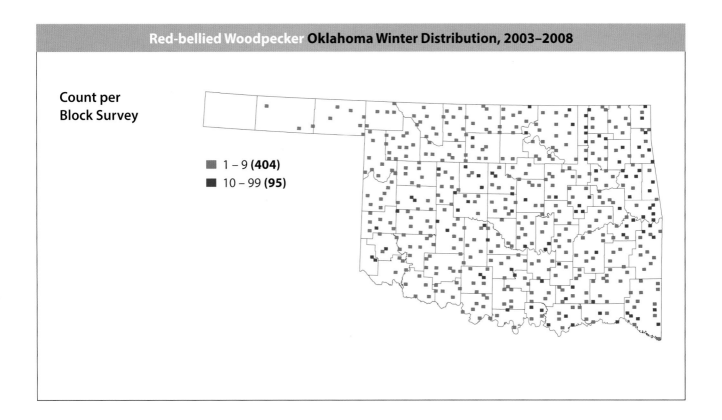

**Count per
Block Survey**

■ 1 – 9 **(404)**
■ 10 – 99 **(95)**

**References**

National Audubon Society. 2011. The Christmas Bird Count historical results. http://www
.christmasbirdcount.org.

Oklahoma Bird Records Committee. 2009. *Date Guide to the Occurrences of Birds in Oklahoma*. 5th ed.
Norman: Oklahoma Ornithological Society.

Reinking, D. L., ed. 2004. *Oklahoma Breeding Bird Atlas*. Norman: University of Oklahoma Press.

Shackelford, Clifford E., Raymond E. Brown, and Richard N. Conner. 2000. Red-bellied Woodpecker
(*Melanerpes carolinus*). *The Birds of North America Online*, edited by A. Poole. Ithaca, N.Y.: Cornell
Laboratory of Ornithology. http://bna.birds.cornell.edu.

# Yellow-bellied Sapsucker
*Sphyrapicus varius*

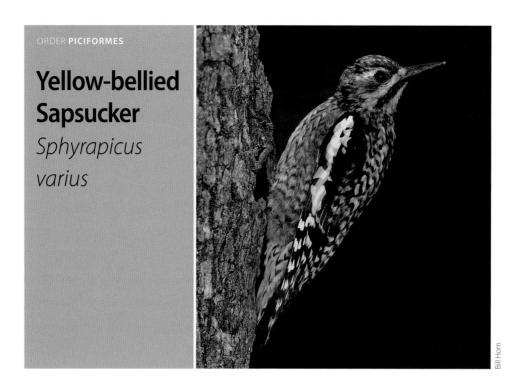

Bill Horn

**Occurrence:** October through late April.

**Habitat:** Woodlands, parks, and yards.

**North American distribution:** Breeds across much of Canada and parts of the northeastern United States. Winters in the southeastern United States and Mexico.

**Oklahoma distribution:** Recorded at low abundances in survey blocks throughout the main body of the state, but most widespread in the eastern two-thirds. Several blocks in southeastern counties had higher abundances than were reported in the rest of the state.

**Behavior:** Yellow-bellied Sapsuckers are usually seen singly. They drill rows of small sap wells into the trunks of live trees to feed on the exuded sap. Fruits and insects are also consumed.

## Christmas Bird Count (CBC) Results, 1960–2009

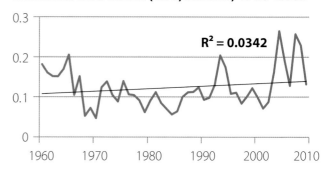

$R^2 = 0.0342$

## CBC Results, 2003–2008

| Winter | Number recorded | Counts reporting |
|--------|-----------------|------------------|
| 2003–2004 | 175 | 16 |
| 2004–2005 | 268 | 17 |
| 2005–2006 | 217 | 17 |
| 2006–2007 | 138 | 17 |
| 2007–2008 | 175 | 17 |

**Count per
Block Survey**

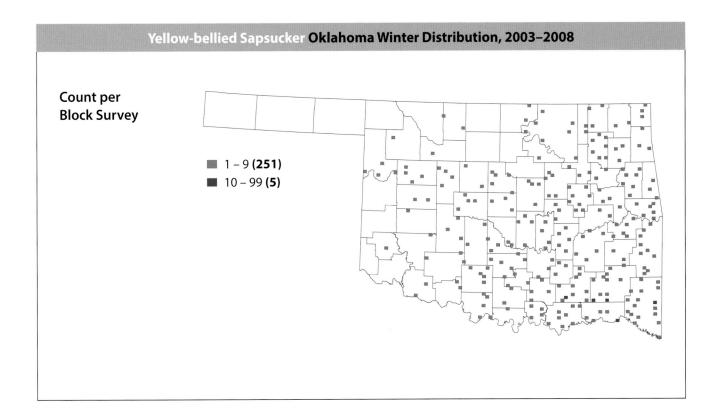

■ 1 – 9 **(251)**
■ 10 – 99 **(5)**

### References

National Audubon Society. 2011. The Christmas Bird Count historical results. http://www
.christmasbirdcount.org.

Oklahoma Bird Records Committee. 2009. *Date Guide to the Occurrences of Birds in Oklahoma*. 5th ed.
Norman: Oklahoma Ornithological Society.

Walters, Eric L., Edward H. Miller, and Peter E. Lowther. 2002. Yellow-bellied Sapsucker (*Sphyrapicus varius*).
*The Birds of North America Online*, edited by A. Poole. Ithaca, N.Y.: Cornell Laboratory of Ornithology.
http://bna.birds.cornell.edu.

## ORDER PICIFORMES

# Ladder-backed Woodpecker
## *Picoides scalaris*

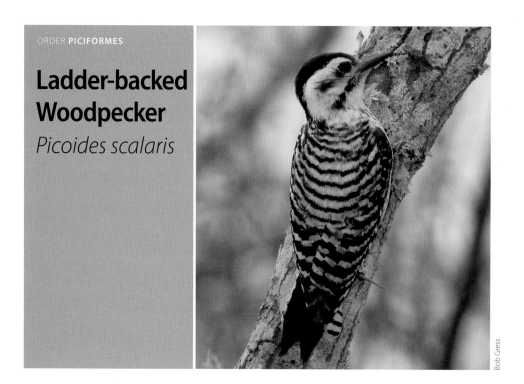

Bob Gress

**Occurrence:** Year-round resident.

**Habitat:** Mesquite grasslands, farmsteads, riparian areas, and areas with cacti.

**North American distribution:** Resident throughout much of the southwestern United States and Mexico.

**Oklahoma distribution:** Recorded at scattered locations in the western half of the state, mostly in southwestern counties and the Panhandle. As expected for a resident species, the summer distribution recorded by the Oklahoma Breeding Bird Atlas Project was similar.

**Behavior:** Ladder-backed Woodpeckers are usually seen singly or in pairs. They forage by probing and gleaning for insects and spiders on cacti, including cholla and prickly pear, and on trees such as mesquite, cottonwoods, and willows.

**Christmas Bird Count (CBC) Results, 1960–2009**

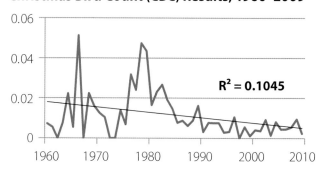

$R^2 = 0.1045$

**CBC Results, 2003–2008**

| Winter | Number recorded | Counts reporting |
|---|---|---|
| 2003–2004 | 1 | 1 |
| 2004–2005 | 6 | 1 |
| 2005–2006 | 6 | 2 |
| 2006–2007 | 4 | 1 |
| 2007–2008 | 6 | 4 |

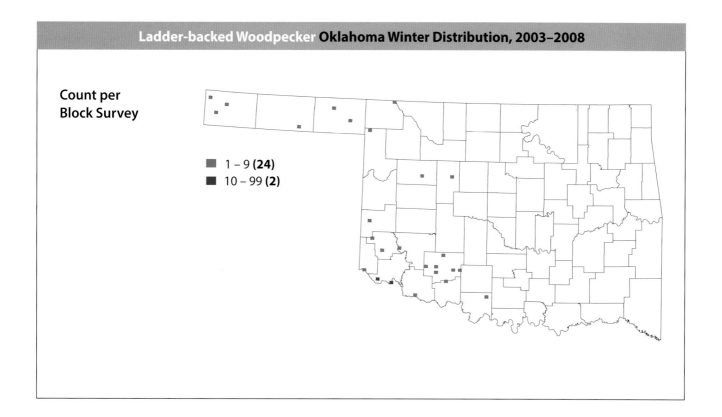

**Count per
Block Survey**

■ 1 – 9 **(24)**
■ 10 – 99 **(2)**

**References**

Lowther, Peter E. 2001. Ladder-backed Woodpecker (*Picoides scalaris*). *The Birds of North America Online*, edited by A. Poole. Ithaca, N.Y.: Cornell Laboratory of Ornithology. http://bna.birds.cornell.edu.

National Audubon Society. 2011. The Christmas Bird Count historical results. http://www .christmasbirdcount.org.

Oklahoma Bird Records Committee. 2009. *Date Guide to the Occurrences of Birds in Oklahoma*. 5th ed. Norman: Oklahoma Ornithological Society.

Reinking, D. L., ed. 2004. *Oklahoma Breeding Bird Atlas*. Norman: University of Oklahoma Press.

# Downy Woodpecker
## *Picoides pubescens*

Bob Gress

**Occurrence:** Year-round resident.

**Habitat:** Forests, woodlands, homesteads, and neighborhoods with mature trees.

**North American distribution:** Year-round resident from Alaska southeast across nearly all of Canada and the United States, except for portions of the southwestern United States.

**Oklahoma distribution:** Recorded in most blocks statewide, with slightly fewer observations in the Panhandle, where trees are less common. Downy Woodpecker ranked ninth overall, occurring in 495 blocks. The summer distribution recorded by the Oklahoma Breeding Bird Atlas Project was very similar, although there were no records from Cimarron or Texas Counties. This difference is unexpected for a resident species, and it could indicate either a range expansion or perhaps seasonal dispersal movements.

**Behavior:** Downy Woodpeckers are usually seen singly or in pairs. They often join mixed-species foraging flocks of chickadees, titmice, kinglets, and other species. They forage by clinging to tree trunks or branches and other plant stems, using their stiff tails to brace themselves as they search for insects, fruit, and seeds. They will visit bird feeders for sunflower seeds or suet.

### Christmas Bird Count (CBC) Results, 1960–2009

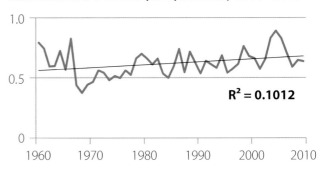

$R^2 = 0.1012$

### CBC Results, 2003–2008

| Winter | Number recorded | Counts reporting |
|--------|-----------------|------------------|
| 2003–2004 | 899 | 20 |
| 2004–2005 | 985 | 20 |
| 2005–2006 | 965 | 20 |
| 2006–2007 | 774 | 19 |
| 2007–2008 | 501 | 20 |

**Count per
Block Survey**

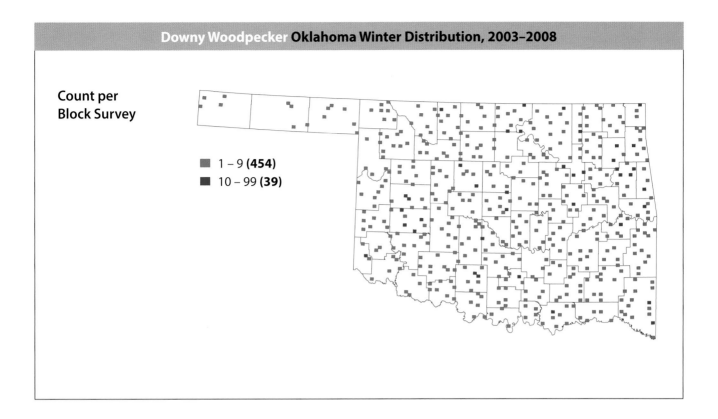

■ 1 – 9 **(454)**
■ 10 – 99 **(39)**

**References**

Jackson, Jerome A., and Henri R. Ouellet. 2002. Downy Woodpecker (*Picoides pubescens*). *The Birds of North America Online*, edited by A. Poole. Ithaca, N.Y.: Cornell Laboratory of Ornithology. http://bna .birds.cornell.edu.

National Audubon Society. 2011. The Christmas Bird Count historical results. http://www .christmasbirdcount.org.

Oklahoma Bird Records Committee. 2009. *Date Guide to the Occurrences of Birds in Oklahoma*. 5th ed. Norman: Oklahoma Ornithological Society.

Reinking, D. L., ed. 2004. *Oklahoma Breeding Bird Atlas*. Norman: University of Oklahoma Press.

# Hairy Woodpecker
## *Picoides villosus*

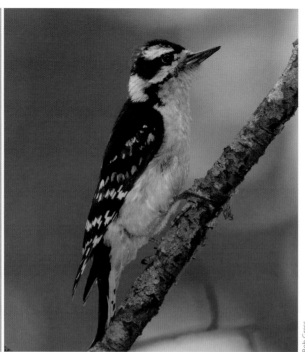

Bob Gress

**Occurrence:** Year-round resident.

**Habitat:** Forests, woodlands, farmsteads, and neighborhoods with mature trees.

**North American distribution:** Resident across most of North America.

**Oklahoma distribution:** Recorded frequently across the northeastern three-fourths of the state, with fewer records in the southwestern and Panhandle counties. As expected for a resident species, the summer distribution recorded by the Oklahoma Breeding Bird Atlas Project was similar.

**Behavior:** Hairy Woodpeckers are usually seen singly, but occasionally in pairs. They forage for insects and larvae on tree trunks and large limbs by gleaning them from the bark, scaling away bits of bark, or excavating. They also eat fruits and seeds and will come to bird feeders for sunflower seeds and suet.

## Christmas Bird Count (CBC) Results, 1960–2009

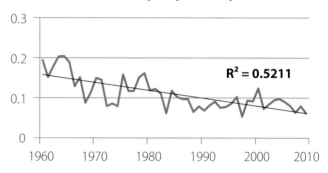

$R^2 = 0.5211$

## CBC Results, 2003–2008

| Winter | Number recorded | Counts reporting |
|---|---|---|
| 2003–2004 | 101 | 18 |
| 2004–2005 | 98 | 19 |
| 2005–2006 | 99 | 20 |
| 2006–2007 | 87 | 18 |
| 2007–2008 | 58 | 17 |

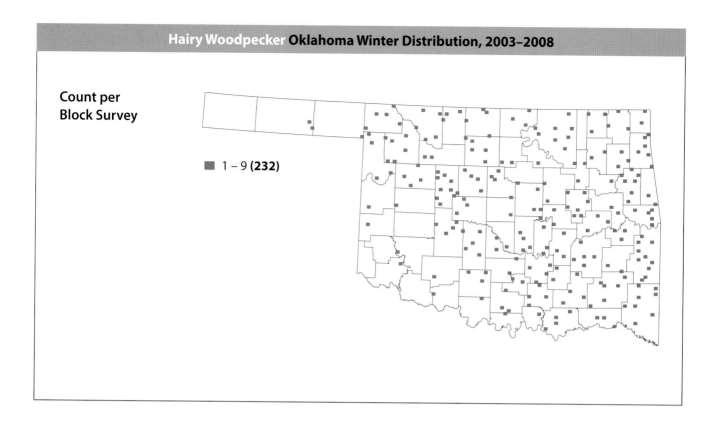

Count per
Block Survey

■ 1 – 9 **(232)**

### References

Jackson, Jerome A., Henri R. Ouellet, and Bette J. Jackson. 2002. Hairy Woodpecker (*Picoides villosus*).
    *The Birds of North America Online*, edited by A. Poole. Ithaca, N.Y.: Cornell Laboratory of Ornithology.
    http://bna.birds.cornell.edu.
National Audubon Society. 2011. The Christmas Bird Count historical results. http://www
    .christmasbirdcount.org.
Oklahoma Bird Records Committee. 2009. *Date Guide to the Occurrences of Birds in Oklahoma*. 5th ed.
    Norman: Oklahoma Ornithological Society.
Reinking, D. L., ed. 2004. *Oklahoma Breeding Bird Atlas*. Norman: University of Oklahoma Press.

# Red-cockaded Woodpecker
## *Picoides borealis*

© (G. Lasley) / VIREO

**Occurrence:** Year-round resident in McCurtain County.

**Habitat:** Old-growth pine-hardwood forests.

**North American distribution:** This endangered species is restricted to portions of the southeastern United States, where it is a year-round resident.

**Oklahoma distribution:** Not recorded in survey blocks. This species occurs in McCurtain County within the McCurtain County Wilderness Area, where it both nests and winters.

**Behavior:** Red-cockaded Woodpeckers live in small family groups, and their bark-removal foraging technique sometimes attracts Eastern Bluebirds or Brown-headed Nuthatches. They forage on trunks and branches of pine trees, scaling away bark in search of insects as well as insect larvae and eggs.

## Christmas Bird Count (CBC) Results, 1960–2009

$R^2 = 0.0573$

## CBC Results, 2003–2008

| Winter | Number recorded | Counts reporting |
|---|---|---|
| 2003–2004 | 0 | — |
| 2004–2005 | 0 | — |
| 2005–2006 | 1 | 1 |
| 2006–2007 | 0 | — |
| 2007–2008 | 0 | — |

**Count per
Block Survey**

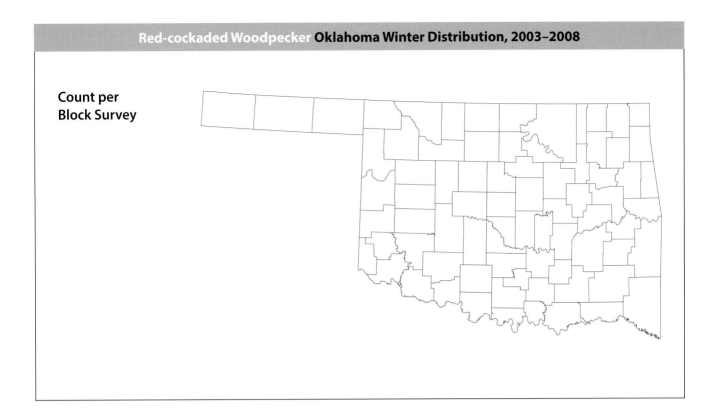

## References

Jackson, Jerome A. 1994. Red-cockaded Woodpecker (*Picoides borealis*). *The Birds of North America Online*, edited by A. Poole. Ithaca, N.Y.: Cornell Laboratory of Ornithology. http://bna.birds.cornell.edu.

National Audubon Society. 2011. The Christmas Bird Count historical results. http://www.christmasbirdcount.org.

Oklahoma Bird Records Committee. 2009. *Date Guide to the Occurrences of Birds in Oklahoma*. 5th ed. Norman: Oklahoma Ornithological Society.

Reinking, D. L., ed. 2004. *Oklahoma Breeding Bird Atlas*. Norman: University of Oklahoma Press.

# Northern Flicker
## *Colaptes auratus*

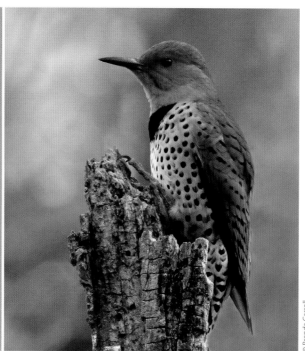

© Brenda Carroll

**Occurrence:** Year-round resident, but more numerous from fall through spring as additional northern and western breeders move into the state.

**Habitat:** Open woodlands, riparian areas, parks, and towns.

**North American distribution:** Breeds in Alaska and much of Canada. Resident across most of the lower 48 states and parts of Mexico.

**Oklahoma distribution:** Recorded statewide in 532 survey blocks (ranking third) with low to moderate abundance. The summer distribution recorded by the Oklahoma Breeding Bird Atlas was also statewide, but much less dense (160 survey blocks), indicating that the increased winter numbers here were the result of seasonal movements of birds nesting in other parts of the country. Both red-shafted and yellow-shafted forms are present during the winter, through red-shafted are less common eastward.

**Behavior:** Northern Flickers are generally solitary during the winter but are occasionally seen foraging in loose groups. They forage on the ground for ants and beetles when available, but they expand their diet to include fruits and seeds during the winter.

## Christmas Bird Count (CBC) Results, 1960–2009

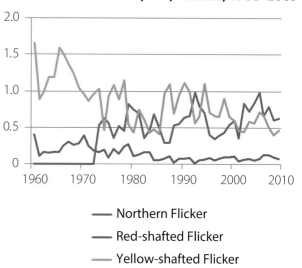

—— Northern Flicker
—— Red-shafted Flicker
—— Yellow-shafted Flicker

## CBC Results, 2003–2008

| Winter | Number recorded (yellow / red) | Counts reporting (yellow / red) |
|---|---|---|
| 2003–2004 | 719 / 92 | 14 / 9 |
| 2004–2005 | 583 / 55 | 11 / 9 |
| 2005–2006 | 940 / 63 | 12 / 9 |
| 2006–2007 | 759 / 119 | 14 / 10 |
| 2007–2008 | 528 / 108 | 14 / 10 |

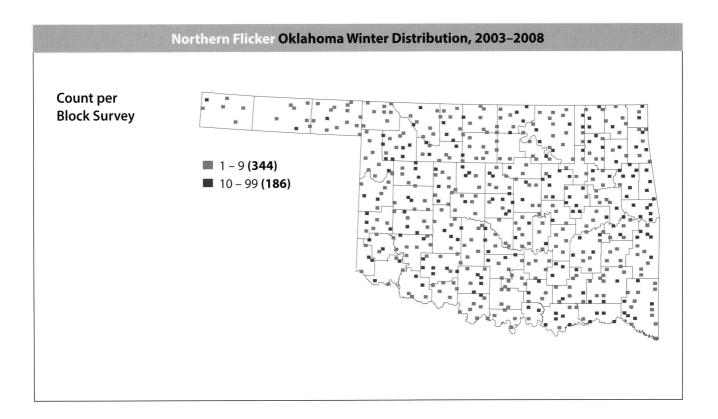

## Northern Flicker Oklahoma Winter Distribution, 2003–2008

**Count per Block Survey**

1 – 9 **(344)**
10 – 99 **(186)**

### References

National Audubon Society. 2011. The Christmas Bird Count historical results. http://www
.christmasbirdcount.org.

Oklahoma Bird Records Committee. 2009. *Date Guide to the Occurrences of Birds in Oklahoma*. 5th ed.
Norman: Oklahoma Ornithological Society.

Reinking, D. L., ed. 2004. *Oklahoma Breeding Bird Atlas*. Norman: University of Oklahoma Press.

Self, J. T. 1980. On winter food of Common Flicker in central Oklahoma. *Bulletin of the Oklahoma
Ornithological Society* 13:29–31.

Wiebe, Karen L., and William S. Moore. 2008. Northern Flicker (*Colaptes auratus*). *The Birds of North America
Online*, edited by A. Poole. Ithaca, N.Y.: Cornell Laboratory of Ornithology. http://bna.birds.cornell.edu.

# Pileated Woodpecker

*Dryocopus pileatus*

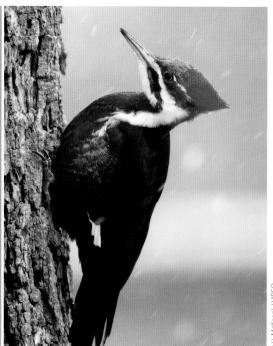

**Occurrence:** Year-round resident.

**Habitat:** Forests and woodlands with mature trees.

**North American distribution:** Resident in parts of the northwestern United States, across much of Canada, and in the eastern United States.

**Oklahoma distribution:** Recorded in most survey blocks east of Interstate 35 and in a few scattered blocks slightly west of this line, with reports of the highest abundance coming mostly from southeastern counties. As expected for a resident species, the summer distribution recorded by the Oklahoma Breeding Bird Atlas Project was similar.

**Behavior:** Pileated Woodpeckers remain paired and territorial year round, so they are usually seen one or two at a time during the winter. They forage on stumps, fallen logs, tree trunks, and large branches in search of carpenter ants and wood-boring beetle larvae, but they will also eat nuts and fruit.

## Christmas Bird Count (CBC) Results, 1960–2009

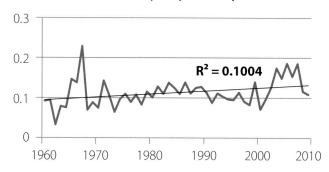

$R^2 = 0.1004$

## CBC Results, 2003–2008

| Winter | Number recorded | Counts reporting |
|--------|-----------------|------------------|
| 2003–2004 | 182 | 16 |
| 2004–2005 | 154 | 16 |
| 2005–2006 | 183 | 15 |
| 2006–2007 | 159 | 16 |
| 2007–2008 | 116 | 14 |

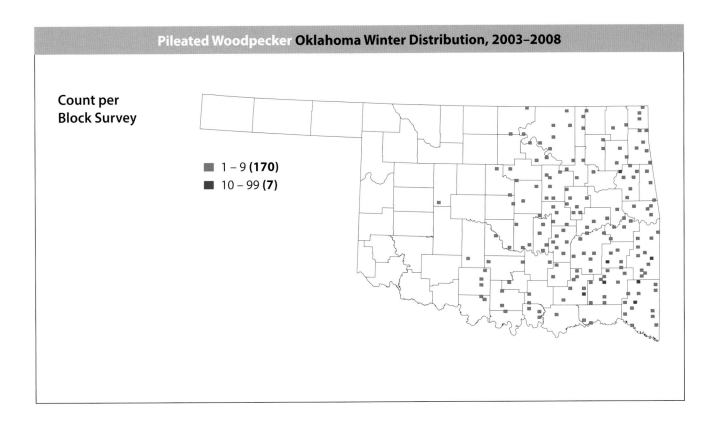

Count per
Block Survey

■ 1 – 9 **(170)**
■ 10 – 99 **(7)**

### References

Bull, Evelyn L., and Jerome A. Jackson. 1995. Pileated Woodpecker (*Dryocopus pileatus*). *The Birds of North America Online*, edited by A. Poole. Ithaca, N.Y.: Cornell Laboratory of Ornithology. http://bna.birds .cornell.edu.

McGee, L. E., and F. Neeld. 1972. The western limits of the Pileated Woodpecker's range in Oklahoma. *Bulletin of the Oklahoma Ornithological Society* 5:5–7.

National Audubon Society. 2011. The Christmas Bird Count historical results. http://www .christmasbirdcount.org.

Oklahoma Bird Records Committee. 2009. *Date Guide to the Occurrences of Birds in Oklahoma*. 5th ed. Norman: Oklahoma Ornithological Society.

Powders, V. N. 1986. Pileated Woodpecker in Woodward County, Oklahoma. *Bulletin of the Oklahoma Ornithological Society* 19:27–28.

Reinking, D. L., ed. 2004. *Oklahoma Breeding Bird Atlas*. Norman: University of Oklahoma Press.

## Crested Caracara
### *Caracara cheriway*

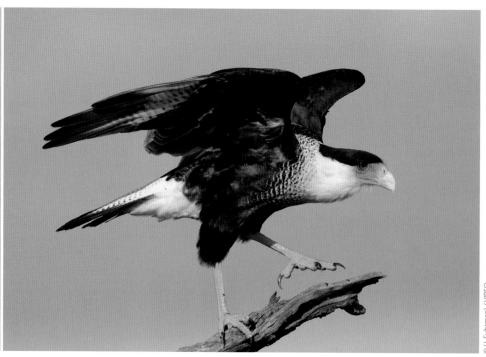

© (J. Fuhrman) / VIREO

**Occurrence:** Rare in any season.

**Habitat:** Open areas with scattered trees.

**North American distribution:** Year-round resident in parts of Florida, Texas, southern Arizona, and Mexico.

**Oklahoma distribution:** Not a regular wintering species. Published reports during the project period include records from McCurtain County at Red Slough Wildlife Management Area on January 18, 2006, and near Broken Bow on February 14, 2006 (Oklahoma Bird Records Committee 2006).

**Behavior:** Because of the rarity of Crested Caracaras in Oklahoma, single birds are most likely. They forage by running and flying after prey, including large insects, reptiles, birds, and small mammals. They also readily scavenge carrion, often feeding with vultures. Caracaras typically dominate one or a few vultures at a carcass but usually back off if a large group of Black Vultures is present.

### CBC Results, 2003–2008

| Winter | Number recorded | Counts reporting |
|---|---|---|
| 2003–2004 | 0 | — |
| 2004–2005 | 0 | — |
| 2005–2006 | 0 | — |
| 2006–2007 | 0 | — |
| 2007–2008 | 0 | — |

**Count per
Block Survey**

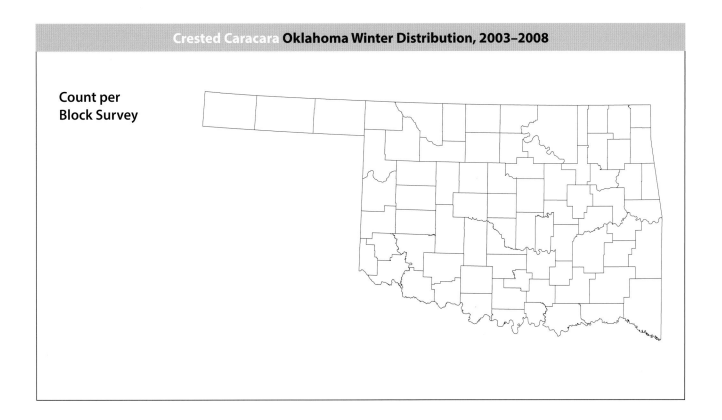

### References

Morrison, Joan L. 1996. Crested Caracara (*Caracara cheriway*). *The Birds of North America Online*, edited by
   A. Poole. Ithaca, N.Y.: Cornell Laboratory of Ornithology. http://bna.birds.cornell.edu.

National Audubon Society. 2011. The Christmas Bird Count historical results. http://www
   .christmasbirdcount.org.

Oklahoma Bird Records Committee. 2006. 2005–2006 winter season. *The Scissortail* 56:14–15.

———. 2009. *Date Guide to the Occurrences of Birds in Oklahoma*. 5th ed. Norman: Oklahoma
   Ornithological Society.

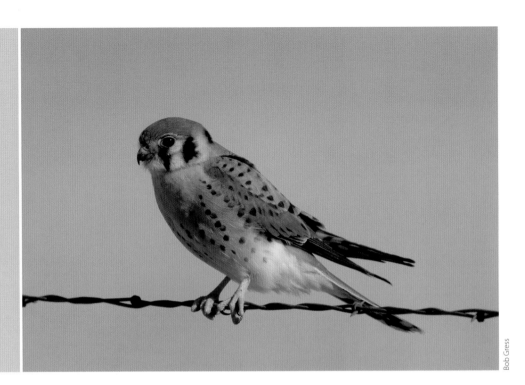

ORDER **FALCONIFORMES**

# American Kestrel
*Falco sparverius*

Bob Gress

**Occurrence:** Year-round resident.

**Habitat:** Open country with scattered trees, including city parks and even urban areas.

**North American distribution:** Breeds in Alaska, Canada, and the northern United States; is a year-round resident across most of the lower 48 states and Mexico; and is a winter resident in southern Texas and parts of Mexico.

**Oklahoma distribution:** Kestrels had a more widespread distribution in winter than they did during the Oklahoma Breeding Bird Atlas surveys, likely reflecting an influx of northern breeders moving into the state for the winter. They ranked sixth overall, being recorded in 515 blocks. Their distribution was fairly uniform, but there were fewer records from the largely forested southeast. Scattered blocks had higher densities, especially in the southwest.

**Behavior:** Kestrels are usually observed singly in the winter months because of winter territorial protection of individual foraging areas. They hunt for large insects, small mammals, and small birds by watching from a perch such as a utility pole or wire, and also by occasional hovering flights over open areas with low vegetation.

## Christmas Bird Count (CBC) Results, 1960–2009

$R^2 = 0.3007$

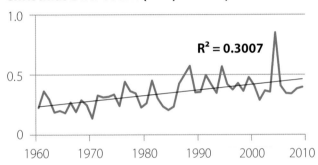

## CBC Results, 2003–2008

| Winter | Number recorded | Counts reporting |
| --- | --- | --- |
| 2003–2004 | 378 | 19 |
| 2004–2005 | 605 | 20 |
| 2005–2006 | 445 | 20 |
| 2006–2007 | 402 | 18 |
| 2007–2008 | 308 | 20 |

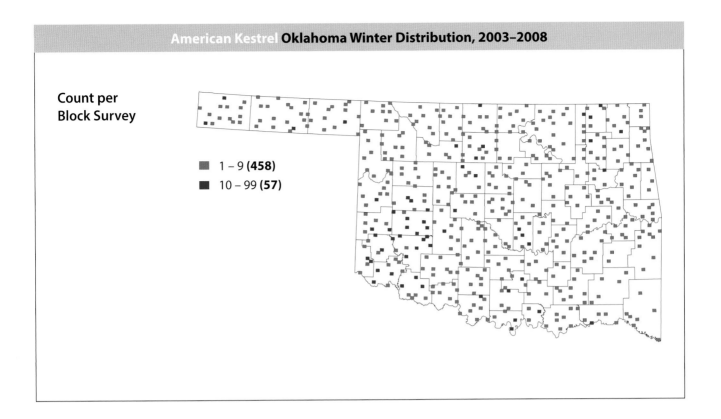

**Count per Block Survey**

■ 1 – 9 **(458)**
■ 10 – 99 **(57)**

### References

National Audubon Society. 2011. The Christmas Bird Count historical results. http://www
    .christmasbirdcount.org.
Oklahoma Bird Records Committee. 2009. *Date Guide to the Occurrences of Birds in Oklahoma*. 5th ed.
    Norman: Oklahoma Ornithological Society.
Reinking, D. L., ed. 2004. *Oklahoma Breeding Bird Atlas*. Norman: University of Oklahoma Press.
Smallwood, John A., and David M. Bird. 2002. American Kestrel (*Falco sparverius*). *The Birds of North
    America Online*, edited by A. Poole. Ithaca, N.Y.: Cornell Laboratory of Ornithology. http://bna.birds
    .cornell.edu.

# Merlin
## *Falco columbarius*

Bob Gress

**Occurrence:** September through April.

**Habitat:** Grasslands, open woodlands, and towns.

**North American distribution:** Breeds in Alaska and much of Canada, resident in the north-central United States, and winters across the western United States and along the Gulf and Atlantic Coasts.

**Oklahoma distribution:** Recorded at scattered locations statewide, with most records in the western half of the state.

**Behavior:** Merlins are usually seen singly during the winter. They hunt small birds mainly early and late in the day, either by watching from a perch or by flying along and flushing surprised prey. In either case, prey is usually captured in flight after a stoop or rapid chase.

**Christmas Bird Count (CBC) Results, 1960–2009**

$R^2 = 0.492$

**CBC Results, 2003–2008**

| Winter | Number recorded | Counts reporting |
|---|---|---|
| 2003–2004 | 10 | 8 |
| 2004–2005 | 9 | 6 |
| 2005–2006 | 14 | 9 |
| 2006–2007 | 17 | 9 |
| 2007–2008 | 14 | 7 |

**Count per
Block Survey**

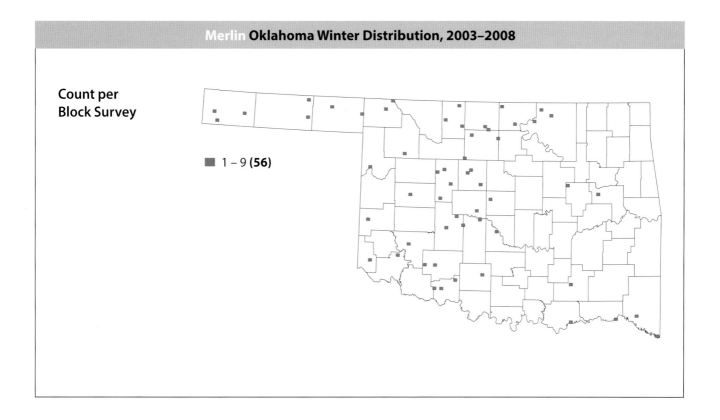

■ 1 – 9 **(56)**

### References

Muzny, P. L. 1981. Another Merlin specimen from Payne County, Oklahoma. *Bulletin of the Oklahoma Ornithological Society* 14:31–32.

National Audubon Society. 2011. The Christmas Bird Count historical results. http://www .christmasbirdcount.org.

Oklahoma Bird Records Committee. 2009. *Date Guide to the Occurrences of Birds in Oklahoma.* 5th ed. Norman: Oklahoma Ornithological Society.

Shackford, J. S. 1988. Merlin preys on Savannah Sparrow. *Bulletin of the Oklahoma Ornithological Society* 21:31.

Warkentin, I. G., N. S. Sodhi, R. H. M. Espie, Alan F. Poole, L. W. Oliphant, and P. C. James. 2005. Merlin (*Falco columbarius*). *The Birds of North America Online,* edited by A. Poole. Ithaca, N.Y.: Cornell Laboratory of Ornithology. http://bna.birds.cornell.edu.

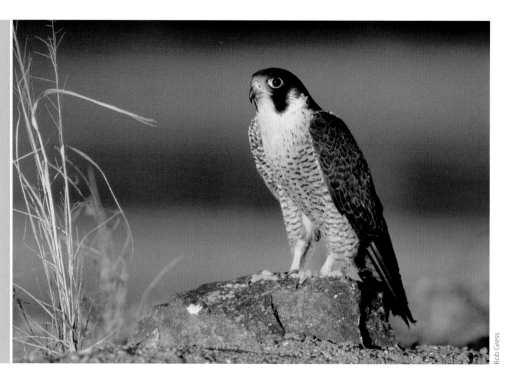

# Peregrine Falcon

## *Falco peregrinus*

Bob Gress

**Occurrence:** Primarily a spring and fall migrant. Seen only rarely during the winter.

**Habitat:** Typically seen near large lakes, rivers, and marshes, or within urban downtowns.

**North American distribution:** Breeds across arctic Alaska and Canada as well as in parts of the lower 48 states. Resident along the Pacific Coast and in much of Mexico, and winters along the Atlantic and Gulf Coasts.

**Oklahoma distribution:** Recorded in just three northern Oklahoma survey blocks. Additional published reports during the project period came from downtown Tulsa throughout the winters of 2005–2006 (Oklahoma Bird Records Committee [OBRC] 2006) and 2006–2007 (OBRC 2007) and on January 11, 2008 (ORBC 2009a), as well as in Oklahoma County (Lake Overholser) on December 16, 2006 (OBRC 2007). Most individuals have moved south during November through late March.

**Behavior:** Peregrine Falcons are usually seen singly in the winter. Their well-known and spectacular hunting style involves stooping from great heights at speeds of over 200 miles per hour before colliding with a duck, shorebird, or other species of bird in flight. Peregrines will also hunt Rock Pigeons in downtown environments amid tall buildings.

### Christmas Bird Count (CBC) Results, 1960–2009

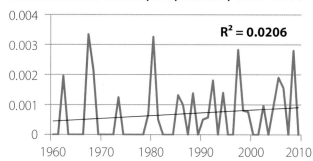

$R^2 = 0.0206$

### CBC Results, 2003–2008

| Winter | Number recorded | Counts reporting |
|---|---|---|
| 2003–2004 | 0 | — |
| 2004–2005 | 1 | 1 |
| 2005–2006 | 1 | 1 |
| 2006–2007 | 2 | 2 |
| 2007–2008 | 0 | — |

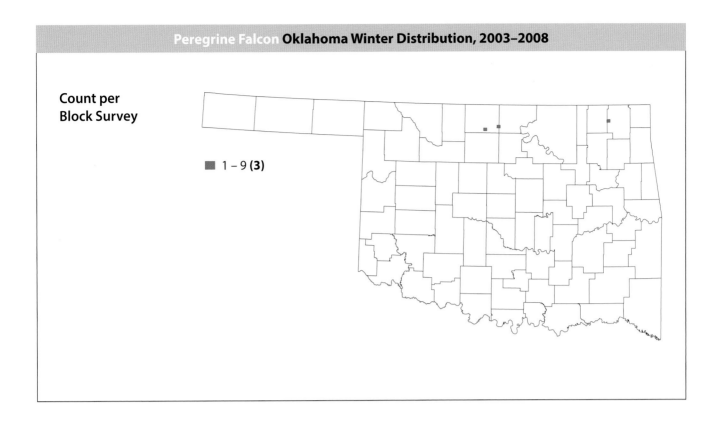

**Count per
Block Survey**

■ 1 – 9 **(3)**

### References

Carlton, B. 1971. Peregrine in Grant County, Oklahoma. *Bulletin of the Oklahoma Ornithological Society* 4:33.

National Audubon Society. 2011. The Christmas Bird Count historical results. http://www
.christmasbirdcount.org.

Oklahoma Bird Records Committee. 2006. 2005–2006 winter season. *The Scissortail* 56:14–15.

———. 2007. 2006–2007 winter season. *The Scissortail* 57:24–27.

———. 2009a. 2007–2008 winter season. *The Scissortail* 59:4–8.

———. 2009b. *Date Guide to the Occurrences of Birds in Oklahoma*. 5th ed. Norman: Oklahoma
Ornithological Society.

White, Clayton M., Nancy J. Clum, Tom J. Cade, and W. Grainger Hunt. 2002. Peregrine Falcon (*Falco
peregrinus*). *The Birds of North America Online*, edited by A. Poole. Ithaca, N.Y.: Cornell Laboratory of
Ornithology. http://bna.birds.cornell.edu.

# Prairie Falcon
*Falco mexicanus*

ORDER **FALCONIFORMES**

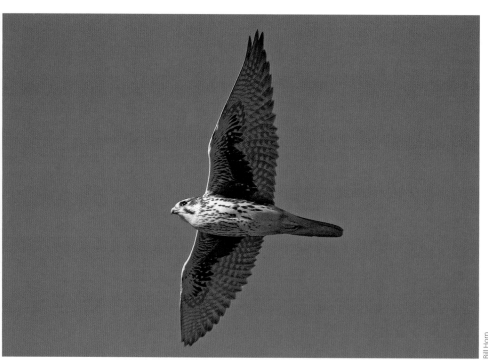

Bill Horn

**Occurrence:** Late September through late March. Present year round in the western Panhandle.

**Habitat:** Open grasslands.

**North American distribution:** Resident throughout much of the western United States and Mexico. Winters slightly east of its breeding range.

**Oklahoma distribution:** Recorded nearly statewide in survey blocks, although very sparsely in eastern and central counties and very commonly in western and north-central counties. The Oklahoma Breeding Bird Atlas Project failed to turn up any summer records, but intensive raptor surveys in the western Panhandle conducted prior to that project found several nesting territories there.

**Behavior:** Prairie Falcons are seen singly during the winter. They hunt small birds such as Horned Larks, either by watching from a perch, soaring in search of prey, or flying low over the ground in an attempt to startle prey.

### Christmas Bird Count (CBC) Results, 1960–2009

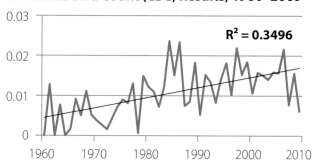

$R^2 = 0.3496$

### CBC Results, 2003–2008

| Winter | Number recorded | Counts reporting |
|---|---|---|
| 2003–2004 | 13 | 7 |
| 2004–2005 | 15 | 8 |
| 2005–2006 | 17 | 9 |
| 2006–2007 | 20 | 11 |
| 2007–2008 | 8 | 4 |

**Count per
Block Survey**

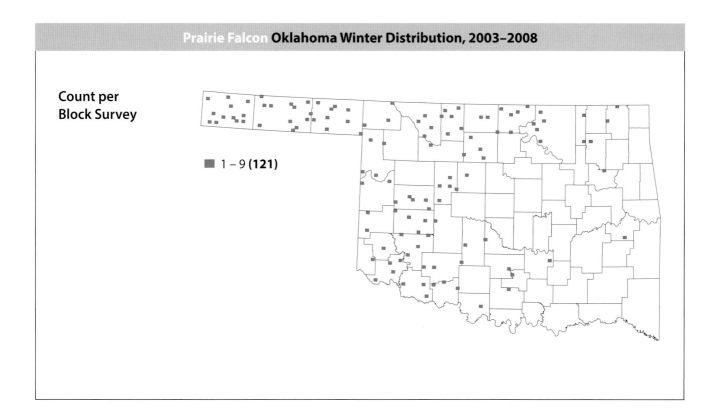

■ 1 – 9 **(121)**

### References

National Audubon Society. 2011. The Christmas Bird Count historical results. http://www
.christmasbirdcount.org.

Oklahoma Bird Records Committee. 2009. *Date Guide to the Occurrences of Birds in Oklahoma*. 5th ed.
Norman: Oklahoma Ornithological Society.

Reinking, D. L., ed. 2004. *Oklahoma Breeding Bird Atlas*. Norman: University of Oklahoma Press.

Seibert, P., and J. Loyd. 1989. Notes on a Prairie Falcon. *Bulletin of the Oklahoma Ornithological Society*
22:6–7.

Steenhof, Karen. 1998. Prairie Falcon (*Falco mexicanus*). *The Birds of North America Online*, edited by
A. Poole. Ithaca, N.Y.: Cornell Laboratory of Ornithology. http://bna.birds.cornell.edu.

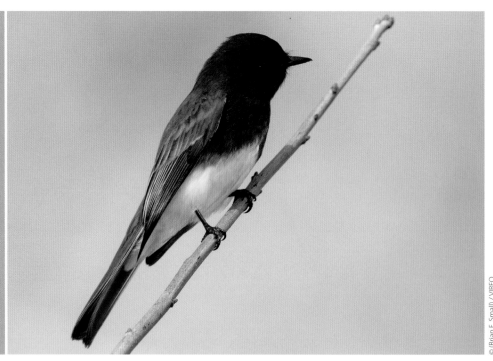

**Black Phoebe**

*Sayornis nigricans*

© (Brian E. Small) / VIREO

**Occurrence:** Rare.

**Habitat:** Near water at bridges, dams, or marshes.

**North American distribution:** Resident in parts of the western and southwestern United States and Mexico.

**Oklahoma distribution:** Not a regular wintering species and not recorded in survey blocks. Reported from a dam at Broken Bow Reservoir in Beavers Bend State Park in McCurtain County throughout the winters of 2004–2005, 2005–2006, and 2006–2007. This was presumably the same individual exhibiting an unusual but consistent seasonal migration to southeastern Oklahoma, well outside the species' normal range.

**Behavior:** Black Phoebes are usually solitary outside the breeding season. Their diet consists mainly of flying insects, which are captured in flight after being observed from a perch.

**CBC Results, 2003–2008**

| Winter | Number recorded | Counts reporting |
| --- | --- | --- |
| 2003–2004 | 0 | — |
| 2004–2005 | 1 | 1 |
| 2005–2006 | 1 | 1 |
| 2006–2007 | 1 | 1 |
| 2007–2008 | 0 | — |

Count per
Block Survey

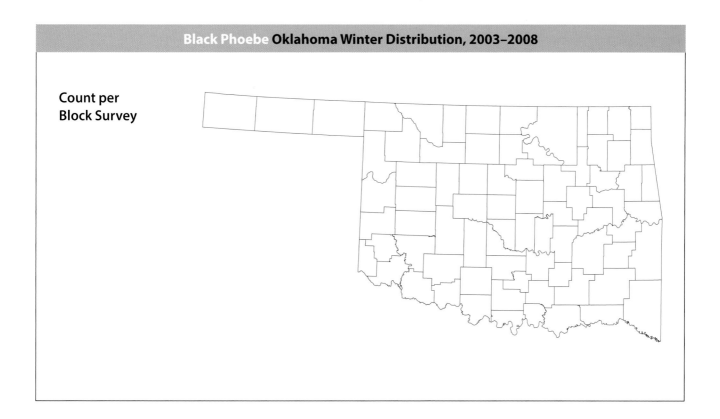

### References

McMahon, J. A. 2000. First record of the Black Phoebe for Oklahoma. *Bulletin of the Oklahoma Ornithological Society* 33:21–23.

National Audubon Society. 2011. The Christmas Bird Count historical results. http://www.christmasbirdcount.org.

Oklahoma Bird Records Committee. 2009. *Date Guide to the Occurrences of Birds in Oklahoma*. 5th ed. Norman: Oklahoma Ornithological Society.

Wolf, Blair O. 1997. Black Phoebe (*Sayornis nigricans*). *The Birds of North America Online*, edited by A. Poole. Ithaca, N.Y.: Cornell Laboratory of Ornithology. http://bna.birds.cornell.edu.

# Eastern Phoebe
*Sayornis phoebe*

Bill Horn

**Occurrence:** Present year round, although there is considerable movement south from the northern counties in late fall and early winter.

**Habitat:** Woodlands near streams, bridges, and areas of human habitation including homes, barns, and sheds.

**North American distribution:** Breeds from central Canada to nearly all of the eastern United States. Resident in much of the southeastern United States, and winters in the far southeastern states, Texas, and Mexico.

**Oklahoma distribution:** Recorded primarily in the southeastern half of the main body of the state, with fewer and more scattered records from the northern and western regions. Eastern Phoebes were much more evenly distributed in summer as recorded by the Oklahoma Breeding Bird Atlas Project, with only the Panhandle showing somewhat scarce records.

**Behavior:** Eastern Phoebes are usually seen singly, foraging by watching for flying insects from a perch and sallying out to capture them with their bill. When insects are not available, they eat small fruits.

## Christmas Bird Count (CBC) Results, 1960–2009

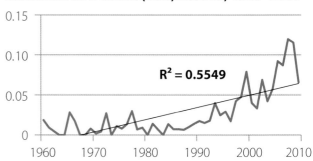

$R^2 = 0.5549$

## CBC Results, 2003–2008

| Winter | Number recorded | Counts reporting |
|---|---|---|
| 2003–2004 | 44 | 12 |
| 2004–2005 | 62 | 12 |
| 2005–2006 | 97 | 15 |
| 2006–2007 | 94 | 14 |
| 2007–2008 | 99 | 13 |

Count per
Block Survey

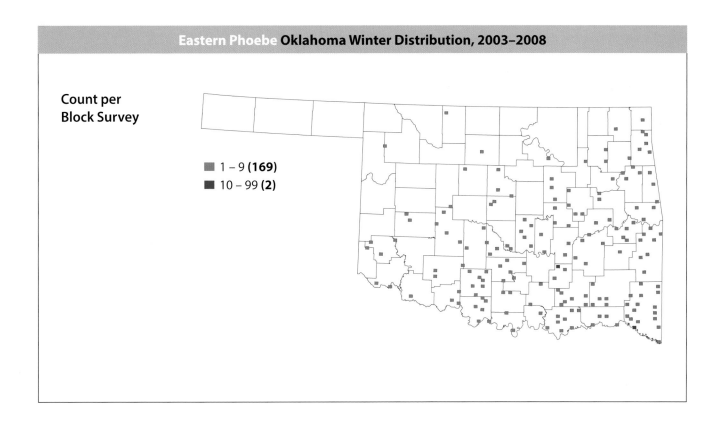

■ 1 – 9 **(169)**
■ 10 – 99 **(2)**

### References

National Audubon Society. 2011. The Christmas Bird Count historical results. http://www
.christmasbirdcount.org.

Oklahoma Bird Records Committee. 2009. *Date Guide to the Occurrences of Birds in Oklahoma*. 5th ed.
Norman: Oklahoma Ornithological Society.

Reinking, D. L., ed. 2004. *Oklahoma Breeding Bird Atlas*. Norman: University of Oklahoma Press.

Weeks, Harmon P., Jr. 1994. Eastern Phoebe (*Sayornis phoebe*). *The Birds of North America Online*, edited by
A. Poole. Ithaca, N.Y.: Cornell Laboratory of Ornithology. http://bna.birds.cornell.edu.

# Say's Phoebe
## *Sayornis saya*

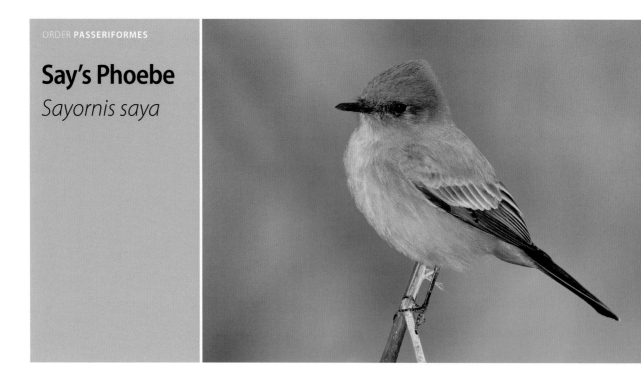

© (A. Morris) / VIREO

**Occurrence:** Not a typical wintering species. Rare in spring in western counties, and breeds in the Panhandle. Rarely found eastward in winter.

**Habitat:** Open areas with fences or shrubs for perch sites. Also near farm buildings.

**North American distribution:** Breeds in Alaska, western Canada, and much of the western lower 48 states. Resident in parts of the southwestern United States and in Mexico.

**Oklahoma distribution:** Recorded in one Bryan County survey block in early December 2006. Special interest species reports also came from Cimarron County in December 2003 (two birds) and early January 2005 (two birds), and from Washington County in mid-December 2007. This species breeds throughout the Panhandle and was recorded in 25 survey blocks during the Oklahoma Breeding Bird Atlas Project.

**Behavior:** Solitary by nature and rare in Oklahoma during winter, Say's Phoebes are typically seen singly. They forage in low vegetation or by hovering near the ground while searching for insects below.

## Christmas Bird Count (CBC) Results, 1960–2009

$R^2 = 0.0505$

## CBC Results, 2003–2008

| Winter | Number recorded | Counts reporting |
|---|---|---|
| 2003–2004 | 1 | 1 |
| 2004–2005 | 1 | 1 |
| 2005–2006 | 2 | 1 |
| 2006–2007 | 0 | — |
| 2007–2008 | 0 | — |

**Count per Block Survey**

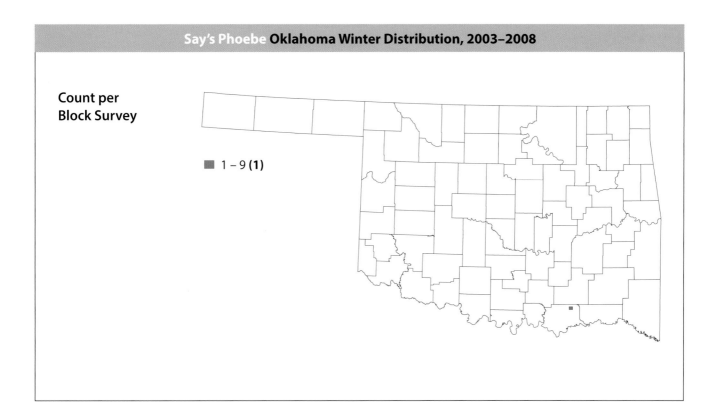

■ 1 – 9 **(1)**

### References

Carlton, B. 1973. Say's Phoebe in Oklahoma in February. *Bulletin of the Oklahoma Ornithological Society* 7:8.

National Audubon Society. 2011. The Christmas Bird Count historical results. http://www
.christmasbirdcount.org.

Oklahoma Bird Records Committee. 2004. 2003–2004 winter season. *The Scissortail* 54:25–27.

———. 2005. 2004–2005 winter season. *The Scissortail* 55:18–20.

———. 2009. *Date Guide to the Occurrences of Birds in Oklahoma.* 5th ed. Norman: Oklahoma
Ornithological Society.

Reinking, D. L., ed. 2004. *Oklahoma Breeding Bird Atlas.* Norman: University of Oklahoma Press.

Schukman, John M., and Blair O. Wolf. 1998. Say's Phoebe (*Sayornis saya*). *The Birds of North America Online,*
edited by A. Poole. Ithaca, N.Y.: Cornell Laboratory of Ornithology. http://bna.birds.cornell.edu.

# Ash-throated Flycatcher

*Myiarchus cinerascens*

© (Brian E. Small) / VIREO

**Occurrence:** Mid-April through August.

**Habitat:** Open woodlands in arid country.

**North American distribution:** Breeds throughout a large part of the western and southwestern United States and in much of Mexico. Present year round in southwestern Arizona, southern Texas, and northwestern Mexico, occasionally wintering along the Texas coast to Louisiana.

**Oklahoma distribution:** Not a typical wintering species in the state. Recorded in Murray County on January 15, 2004 (Oklahoma Bird Records Committee 2004). The Oklahoma Breeding Bird Atlas Project recorded Ash-throated Flycatchers during summer in the Panhandle counties as well as Beckham, Comanche, Greer, Harmon, Harper, Jackson, and Roger Mills Counties.

**Behavior:** Ash-throated Flycatchers forage for insects as well as small fruit, especially during the winter when insects are less available. These food items are generally taken from low trees or shrubs as well as from the ground.

## CBC Results, 2003–2008

| Winter | Number recorded | Counts reporting |
|---|---|---|
| 2003–2004 | 0 | — |
| 2004–2005 | 0 | — |
| 2005–2006 | 0 | — |
| 2006–2007 | 0 | — |
| 2007–2008 | 0 | — |

**Count per
Block Survey**

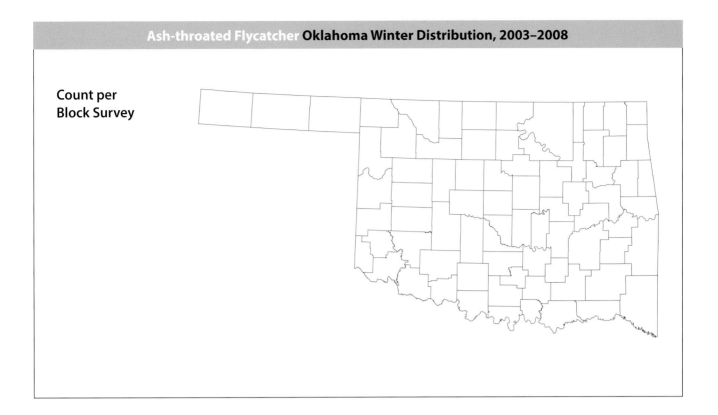

### References

Cardiff, Steven W., and Donna L. Dittmann. 2002. Ash-throated Flycatcher (*Myiarchus cinerascens*). *The Birds of North America Online*, edited by A. Poole. Ithaca, N.Y.: Cornell Laboratory of Ornithology. http://bna.birds.cornell.edu.

National Audubon Society. 2011. The Christmas Bird Count historical results. http://www .christmasbirdcount.org.

Oklahoma Bird Records Committee. 2004. 2003–2004 winter season. *The Scissortail* 54:25–27.

———. 2009. *Date Guide to the Occurrences of Birds in Oklahoma*. 5th ed. Norman: Oklahoma Ornithological Society.

Reinking, D. L., ed. 2004. *Oklahoma Breeding Bird Atlas*. Norman: University of Oklahoma Press.

# Loggerhead Shrike

*Lanius ludovicianus*

Bob Gress

**Occurrence:** Year-round resident, although additional individuals from more northern breeding areas pass through during migration as well as winter here.

**Habitat:** Open country with scattered trees. Often seen perched on fences or utility lines.

**North American distribution:** Breeds in south-central Canada and the north-central United States. Resident across the southern half of the lower 48 states and in Mexico.

**Oklahoma distribution:** Recorded statewide in most survey blocks, though markedly less frequently in heavily forested southeastern counties. Northeastern and southwestern counties had several blocks with somewhat higher abundance than the rest of the state. As expected for a resident species, the summer distribution recorded during the Oklahoma Breeding Bird Atlas Project was similar.

**Behavior:** Loggerhead Shrikes are usually seen singly, although a mate may be nearby. During winter, small mammals and small birds make up much of the diet and are captured and killed with a bite to the neck. Lacking the strong talons of hawks, shrikes impale prey on thorns or barbed wire to hold it firmly while they feed from it.

## Christmas Bird Count (CBC) Results, 1960–2009

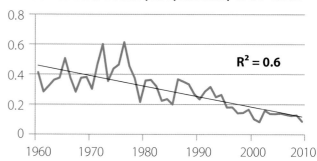

$R^2 = 0.6$

## CBC Results, 2003–2008

| Winter | Number recorded | Counts reporting |
|---|---|---|
| 2003–2004 | 146 | 16 |
| 2004–2005 | 123 | 19 |
| 2005–2006 | 145 | 19 |
| 2006–2007 | 144 | 18 |
| 2007–2008 | 110 | 18 |

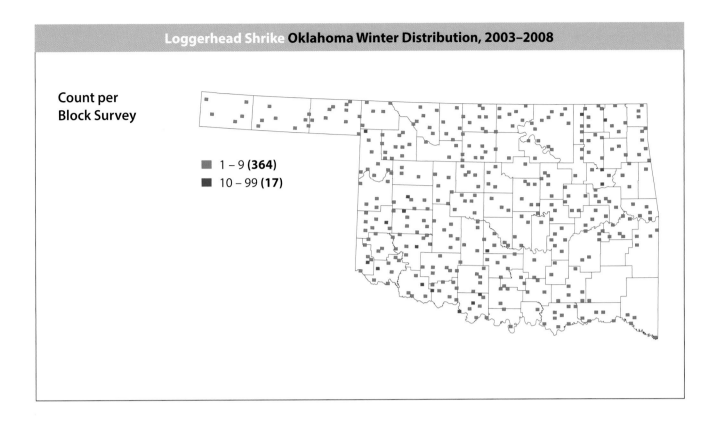

## Loggerhead Shrike Oklahoma Winter Distribution, 2003–2008

Count per
Block Survey

■ 1 – 9 **(364)**
■ 10 – 99 **(17)**

### References

Chabot, A. A. 2011. The impact of migration on the evolution and conservation of an endemic North America passerine: Loggerhead Shrike (*Lanius ludovicianus*). PhD diss., Queen's University, Kingston, Ontario, Canada.

Dirck, M. 1986. Loggerhead Shrike takes American Goldfinch. *Bulletin of the Oklahoma Ornithological Society* 19:29–30.

Mays, L. P. 1988. Loggerhead Shrike preys on Horned Lark. *Bulletin of the Oklahoma Ornithological Society* 21:7.

National Audubon Society. 2011. The Christmas Bird Count historical results. http://www .christmasbirdcount.org.

Oklahoma Bird Records Committee. 2009. *Date Guide to the Occurrences of Birds in Oklahoma*. 5th ed. Norman: Oklahoma Ornithological Society.

Reinking, D. L., ed. 2004. *Oklahoma Breeding Bird Atlas*. Norman: University of Oklahoma Press.

Tyler, J. D., and J. Bechtold. 1996. Statuses of four avian species in southwestern Oklahoma. *Bulletin of the Oklahoma Ornithological Society* 29:27–34.

Yosef, Reuven. 1996. Loggerhead Shrike (*Lanius ludovicianus*). *The Birds of North America Online*, edited by A. Poole. Ithaca, N.Y.: Cornell Laboratory of Ornithology. http://bna.birds.cornell.edu.

# Northern Shrike

*Lanius excubitor*

Patricia Velte

**Occurrence:** Late November through early March.

**Habitat:** Open country with scattered trees.

**North American distribution:** Breeds in Alaska and northern Canada. Winters across southern Canada and roughly the northern half of the lower 48 states.

**Oklahoma distribution:** Recorded in seven survey blocks in the northern half of the state, although only the records from Beaver, Woods, and Woodward Counties were documented with identification details to distinguish this species from the similar Loggerhead Shrike. Additional special interest species reports came from the Panhandle, where this species is most likely to occur, including Cimarron County in December 2003, January 2005, and December 2007, and Texas County in December 2004.

**Behavior:** Northern Shrikes are usually seen singly, both because of their rarity in most of Oklahoma and because they are intolerant of and aggressive toward neighboring shrikes and other bird species. During winter, small mammals and small to medium-sized birds make up much of the diet and are captured and killed with a bite to the neck. Lacking the strong talons of hawks, shrikes impale prey on thorns or barbed wire to hold it firmly while they feed from it. They are capable of carrying prey of equal or greater weight than themselves.

### Christmas Bird Count (CBC) Results, 1960–2009

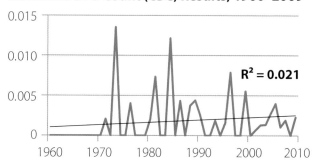

$R^2 = 0.021$

### CBC Results, 2003–2008

| Winter | Number recorded | Counts reporting |
|--------|-----------------|------------------|
| 2003–2004 | 1 | 1 |
| 2004–2005 | 2 | 1 |
| 2005–2006 | 4 | 1 |
| 2006–2007 | 1 | 1 |
| 2007–2008 | 2 | 2 |

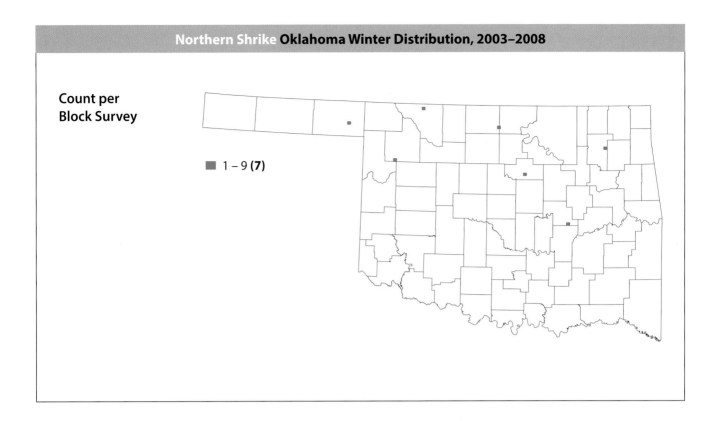

Count per
Block Survey

■ 1 – 9 **(7)**

**References**

Cade, Tom J., and Eric C. Atkinson. 2002. Northern Shrike (*Lanius excubitor*). *The Birds of North America Online*, edited by A. Poole. Ithaca, N.Y.: Cornell Laboratory of Ornithology. http://bna.birds.cornell.edu.

National Audubon Society. 2011. The Christmas Bird Count historical results. http://www .christmasbirdcount.org.

Oklahoma Bird Records Committee. 2009. *Date Guide to the Occurrences of Birds in Oklahoma*. 5th ed. Norman: Oklahoma Ornithological Society.

Seltman, S. 1987. An invasion of Northern Shrikes in Cimarron County, Oklahoma. *Bulletin of the Oklahoma Ornithological Society* 20:7–8.

# Blue-headed Vireo
## *Vireo solitarius*

Bob Gress

**Occurrence:** Winter resident in McCurtain County, and spring and fall migrant elsewhere.

**Habitat:** Mixed hardwood and pine woodlands.

**North American distribution:** Breeds across much of southern Canada, the northeastern United States, and Appalachia. Winters in the southeastern United States, in a broad band along the Gulf Coast states, and in eastern Mexico.

**Oklahoma distribution:** Winters locally in McCurtain County, having been recorded in just two atlas blocks. This location is the northernmost point of the species' winter range. It migrates through the main body of the state, except in the Panhandle region.

**Behavior:** Blue-headed Vireos are usually seen singly in winter, although they may join mixed-species flocks. They forage by moving deliberately through midheight branches in search of insects and spiders. Fruits may be eaten occasionally.

## Christmas Bird Count (CBC) Results, 1960–2009

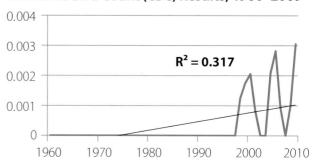

$R^2 = 0.317$

## CBC Results, 2003–2008

| Winter | Number recorded | Counts reporting |
|---|---|---|
| 2003–2004 | 0 | — |
| 2004–2005 | 2 | 1 |
| 2005–2006 | 2 | 1 |
| 2006–2007 | 1 | 1 |
| 2007–2008 | 0 | — |

**Count per
Block Survey**

■ 1 – 9 **(2)**

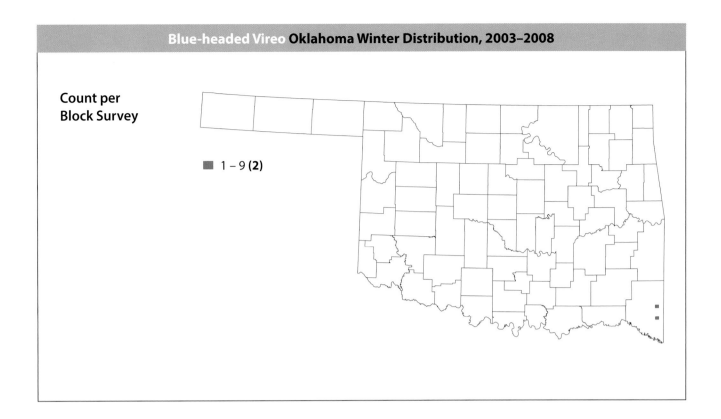

### References

James, Ross D. 1998. Blue-headed Vireo (*Vireo solitarius*). *The Birds of North America Online*, edited by
A. Poole. Ithaca, N.Y.: Cornell Laboratory of Ornithology. http://bna.birds.cornell.edu.

National Audubon Society. 2011. The Christmas Bird Count historical results. http://www
.christmasbirdcount.org.

Oklahoma Bird Records Committee. 2009. *Date Guide to the Occurrences of Birds in Oklahoma*. 5th ed.
Norman: Oklahoma Ornithological Society.

# Pinyon Jay
## *Gymnorhinus cyanocephalus*

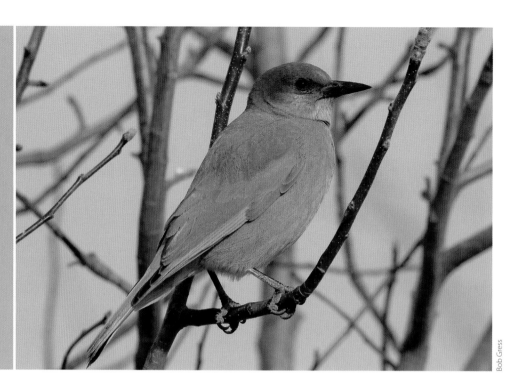

Bob Gress

**Occurrence:** Year-round resident of northwestern Cimarron County.

**Habitat:** Pinyon-juniper woodlands.

**North American distribution:** Resident in parts of the western lower 48 states and northwestern Mexico.

**Oklahoma distribution:** Not recorded in survey blocks. The Kenton Christmas Bird Count recorded 100, 2, 5, 0, and 2 birds in each of the five winters of this survey project, respectively. The summer distribution recorded by the Oklahoma Breeding Bird Atlas Project included one survey block in northwestern Cimarron County.

**Behavior:** Pinyon Jays typically occur in flocks. They forage on the ground as well as in trees and shrubs for seeds and fruits, and they will come to bird feeders for sunflower seeds.

## Christmas Bird Count (CBC) Results, 1960–2009

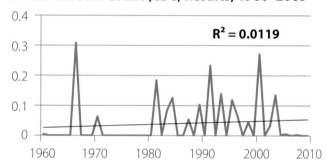

$R^2 = 0.0119$

## CBC Results, 2003–2008

| Winter | Number recorded | Counts reporting |
|--------|-----------------|------------------|
| 2003–2004 | 100 | 1 |
| 2004–2005 | 2 | 1 |
| 2005–2006 | 5 | 1 |
| 2006–2007 | 0 | — |
| 2007–2008 | 2 | 1 |

**Count per Block Survey**

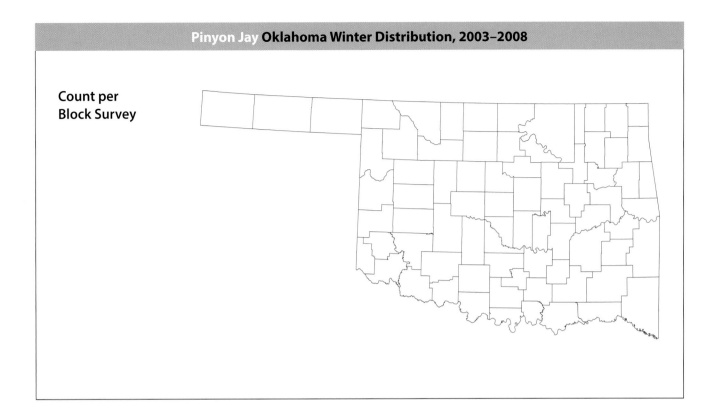

### References

Balda, Russell P. 2002. Pinyon Jay (*Gymnorhinus cyanocephalus*). *The Birds of North America Online*, edited by A. Poole. Ithaca, N.Y.: Cornell Laboratory of Ornithology. http://bna.birds.cornell.edu.

National Audubon Society. 2011. The Christmas Bird Count historical results. http://www.christmasbirdcount.org.

Oklahoma Bird Records Committee. 2009. *Date Guide to the Occurrences of Birds in Oklahoma*. 5th ed. Norman: Oklahoma Ornithological Society.

Reinking, D. L., ed. 2004. *Oklahoma Breeding Bird Atlas*. Norman: University of Oklahoma Press.

# Steller's Jay
*Cyanocitta stelleri*

Bob Gress

**Occurrence:** Rare from late October through mid-March in northwestern Cimarron County.

**Habitat:** Pinyon-pine woodlands and bird feeders.

**North American distribution:** Resident in southeastern Alaska, parts of western Canada, and parts of the western United States and Mexico. Sporadic fall and winter movements slightly south or east of its normal range occur as well.

**Oklahoma distribution:** Not recorded in survey blocks. No reports were received during the five winters in which atlas surveys were being conducted. Previous records are mostly from Cimarron County.

**Behavior:** Steller's Jays often form flocks during fall irruptions, but the rarity of this species in Oklahoma means that single birds are more typical than larger groups. They forage on the ground and in trees for nuts, seeds, berries, and insects. They will also visit bird feeders for sunflower seeds, suet, and other items.

## Christmas Bird Count (CBC) Results, 1960–2009

$R^2 = 0.0009$

## CBC Results, 2003–2008

| Winter | Number recorded | Counts reporting |
|--------|-----------------|------------------|
| 2003–2004 | 0 | — |
| 2004–2005 | 0 | — |
| 2005–2006 | 0 | — |
| 2006–2007 | 0 | — |
| 2007–2008 | 0 | — |

**Count per
Block Survey**

### References

Greene, Erick, William Davison, and Vincent R. Muehter. 1998. Steller's Jay (*Cyanocitta stelleri*). *The Birds of North America Online*, edited by A. Poole. Ithaca, N.Y.: Cornell Laboratory of Ornithology. http://bna .birds.cornell.edu.

National Audubon Society. 2011. The Christmas Bird Count historical results. http://www .christmasbirdcount.org.

Oklahoma Bird Records Committee. 2009. *Date Guide to the Occurrences of Birds in Oklahoma*. 5th ed. Norman: Oklahoma Ornithological Society.

Oliphant, M. 1991. An invasion of the Steller's Jay into the Oklahoma Panhandle. *Bulletin of the Oklahoma Ornithological Society* 24:14–15.

# Blue Jay
*Cyanocitta cristata*

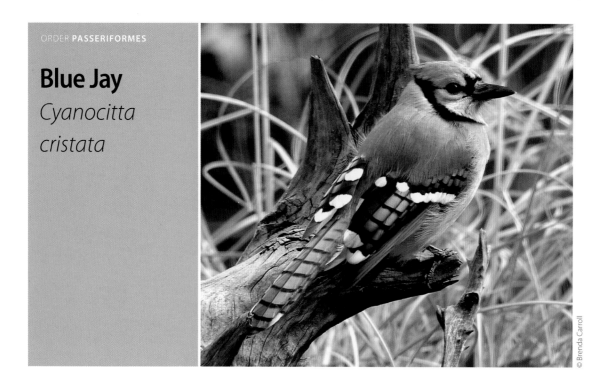

© Brenda Carroll

**Occurrence:** Year-round resident, with some turnover due to migration.

**Habitat:** A variety of wooded habitats, including both rural and suburban areas.

**North American distribution:** Breeds across much of southernmost Canada, and largely resident across the eastern two-thirds of the lower 48 states.

**Oklahoma distribution:** Widely distributed across the main body of the state, but less so in the Panhandle region. Occurred at noticeably higher density in the eastern half of the main body of the state. The breeding distribution recorded during the Oklahoma Breeding Bird Atlas Project was more extensive in the northwestern and Panhandle counties.

**Behavior:** Blue Jays are frequently seen in pairs, members of which remain together for years. They can also form groups of a few to several dozen birds during migration and winter. Such groups may roost or forage together, although they are only loosely aligned. Winter foods include insect larvae, nuts, seeds, and fruit, and Blue Jays will readily come to bird feeders for seeds or suet. They are often the first species to sound an alarm at the sight of a hawk or cat.

### Christmas Bird Count (CBC) Results, 1960–2009

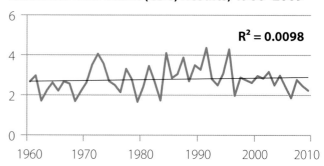

$R^2 = 0.0098$

### CBC Results, 2003–2008

| Winter | Number recorded | Counts reporting |
|---|---|---|
| 2003–2004 | 2,902 | 19 |
| 2004–2005 | 3,565 | 19 |
| 2005–2006 | 2,667 | 19 |
| 2006–2007 | 2,079 | 19 |
| 2007–2008 | 2,380 | 18 |

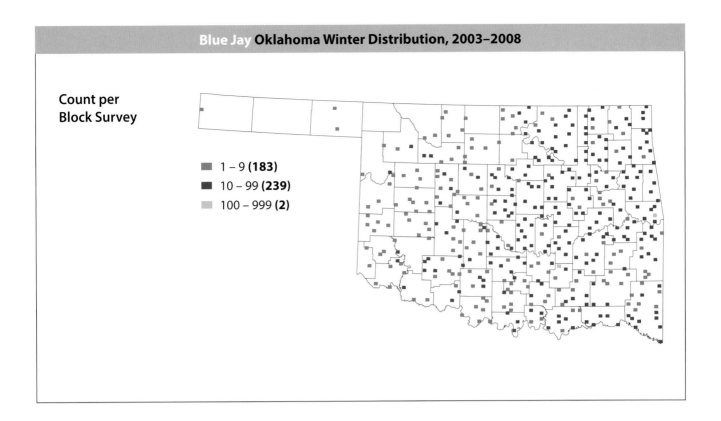

Count per
Block Survey

1 – 9 **(183)**
10 – 99 **(239)**
100 – 999 **(2)**

### References

Davis, W. M. 1971. Blue Jay near Kenton, Oklahoma. *Bulletin of the Oklahoma Ornithological Society* 4:35–36.

National Audubon Society. 2011. The Christmas Bird Count historical results. http://www
.christmasbirdcount.org.

Oklahoma Bird Records Committee. 2009. *Date Guide to the Occurrences of Birds in Oklahoma.* 5th ed.
Norman: Oklahoma Ornithological Society.

Reinking, D. L., ed. 2004. *Oklahoma Breeding Bird Atlas.* Norman: University of Oklahoma Press.

Tarvin, Keith A., and Glen E. Woolfenden. 1999. Blue Jay (*Cyanocitta cristata*). *The Birds of North America
Online,* edited by A. Poole. Ithaca, N.Y.: Cornell Laboratory of Ornithology. http://bna.birds.cornell.edu.

Wint, G. B. 1981. Blue Jay killed by fox squirrel. *Bulletin of the Oklahoma Ornithological Society* 14:34–35.

# Woodhouse's Scrub-Jay
*Aphelocoma woodhouseii*

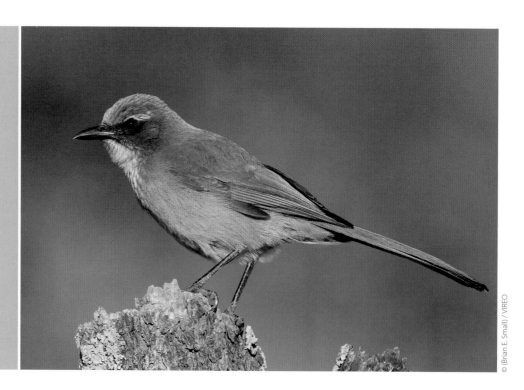

© (Brian E. Small) / VIREO

**Occurrence:** Year-round resident in northwestern Cimarron County.

**Habitat:** Pinyon-juniper woodlands, oak and pine woodlands.

**North American distribution:** Resident across parts of the western United States and Mexico.

**Oklahoma distribution:** Recorded in two Cimarron County survey blocks. Unsurprisingly for a resident species with a very limited range in the state, the Oklahoma Breeding Bird Atlas Project recorded birds in the same two survey blocks during the summer.

**Behavior:** Woodhouse's Scrub-Jay pairs remain together throughout the year and often form small winter flocks with other individuals. They forage both on the ground and in trees for seeds of oaks and pines.

**Christmas Bird Count (CBC) Results, 1960–2009**

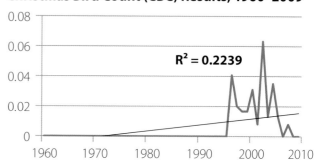

$R^2 = 0.2239$

**CBC Results, 2003–2008**

| Winter | Number recorded | Counts reporting |
|---|---|---|
| 2003–2004 | 10 | 2 |
| 2004–2005 | 26 | 1 |
| 2005–2006 | 13 | 1 |
| 2006–2007 | 0 | — |
| 2007–2008 | 6 | 1 |

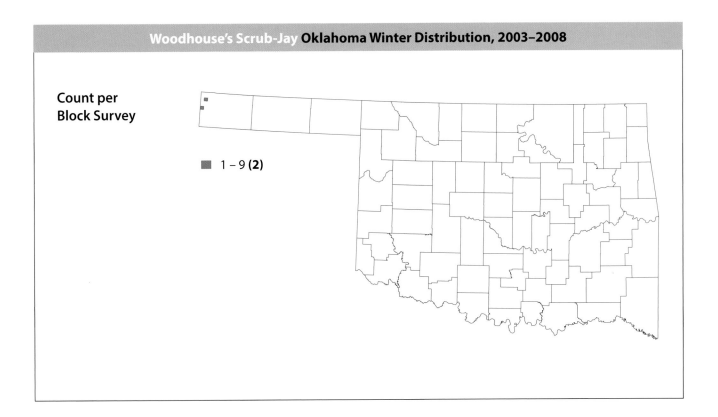

**Count per
Block Survey**

■ 1 – 9 **(2)**

**References**

Briley, J. 1982. Scrub Jay in Greer County, Oklahoma. *Bulletin of the Oklahoma Ornithological Society* 15:31–32.

Curry, Robert L., A. Townsend Peterson, and Tom A. Langen. 2002. Woodhouse's Scrub-Jay (*Aphelocoma woodhouseii*). *The Birds of North America Online*, edited by A. Poole. Ithaca, N.Y.: Cornell Laboratory of Ornithology. http://bna.birds.cornell.edu.

National Audubon Society. 2011. The Christmas Bird Count historical results. http://www .christmasbirdcount.org.

Oklahoma Bird Records Committee. 2009. *Date Guide to the Occurrences of Birds in Oklahoma*. 5th ed. Norman: Oklahoma Ornithological Society.

Reinking, D. L., ed. 2004. *Oklahoma Breeding Bird Atlas*. Norman: University of Oklahoma Press.

# Black-billed Magpie
## *Pica hudsonia*

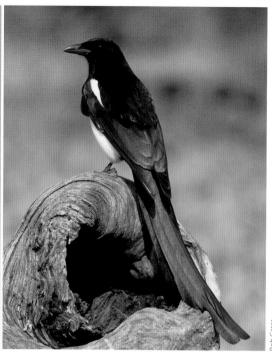

Bob Gress

**Occurrence:** Year-round resident.

**Habitat:** Riparian areas and open areas with scattered trees.

**North American distribution:** Resident in Alaska, western Canada, and much of the western lower 48 states.

**Oklahoma distribution:** Recorded in all three Panhandle counties, but sparsely distributed and in small numbers. This pattern closely matches the breeding season distribution recorded during the Oklahoma Breeding Bird Atlas Project.

**Behavior:** Often forms small winter foraging and roosting flocks, although roosting birds space themselves rather than huddling. These groups sometimes mob predators such as hawks. Foraging takes place on the ground, and carrion, small mammals, grains, and fruits are all consumed.

**Christmas Bird Count (CBC) Results, 1960–2009**

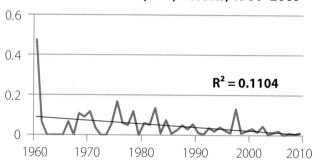

$R^2 = 0.1104$

**CBC Results, 2003–2008**

| Winter | Number recorded | Counts reporting |
|---|---|---|
| 2003–2004 | 3 | 1 |
| 2004–2005 | 9 | 1 |
| 2005–2006 | 21 | 1 |
| 2006–2007 | 0 | — |
| 2007–2008 | 7 | 1 |

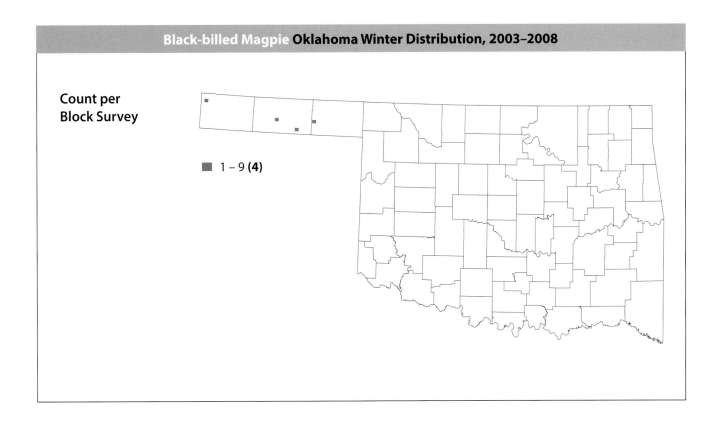

Count per
Block Survey

■ 1 – 9 **(4)**

**References**

National Audubon Society. 2011. The Christmas Bird Count historical results. http://www
.christmasbirdcount.org.

Oklahoma Bird Records Committee. 2009. *Date Guide to the Occurrences of Birds in Oklahoma*. 5th ed.
Norman: Oklahoma Ornithological Society.

Reinking, D. L., ed. 2004. *Oklahoma Breeding Bird Atlas*. Norman: University of Oklahoma Press.

Trost, Charles H. 1999. Black-billed Magpie (*Pica hudsonia*). *The Birds of North America Online*, edited by
A. Poole. Ithaca, N.Y.: Cornell Laboratory of Ornithology. http://bna.birds.cornell.edu.

# American Crow
## *Corvus brachyrhynchos*

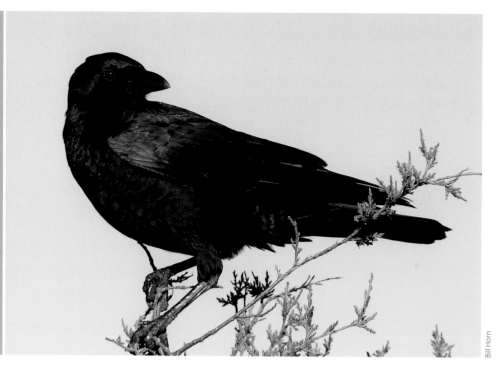

Bill Horn

**Occurrence:** Year-round resident.

**Habitat:** Wide variety including urban, suburban, forested, grassland, and agricultural areas.

**North American distribution:** Breeds across much of Canada and is either a winter or year-round resident across nearly all of the lower 48 states.

**Oklahoma distribution:** American Crows were nearly uniformly distributed across the state, with lower numbers in the western two Panhandle counties. The three blocks in which exceptionally high numbers were reported likely represent communal winter roost locations that happened to occur in or near these three blocks. American Crow ranked fourth overall, being recorded in 528 blocks. As expected for a resident species, its summer distribution recorded during the Oklahoma Breeding Bird Atlas Project was very similar.

**Behavior:** Crows may be seen singly or in groups ranging from small to very large. They often form communal night roosts during the winter, some of which can contain many thousands of birds. One roost near Fort Cobb, Oklahoma, was thought to contain over 10 million birds in the late 1960s. Crow diets are widely variable, depending on what is locally available, and can include seeds, grains, insects, fruits, small animals, carrion, and human food waste.

## Christmas Bird Count (CBC) Results, 1960–2009

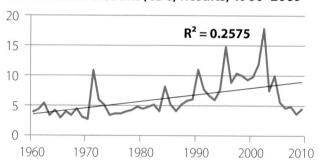

$R^2 = 0.2575$

## CBC Results, 2003–2008

| Winter | Number recorded | Counts reporting |
|---|---|---|
| 2003–2004 | 7,620 | 20 |
| 2004–2005 | 9,856 | 20 |
| 2005–2006 | 6,947 | 20 |
| 2006–2007 | 4,866 | 19 |
| 2007–2008 | 4,246 | 20 |

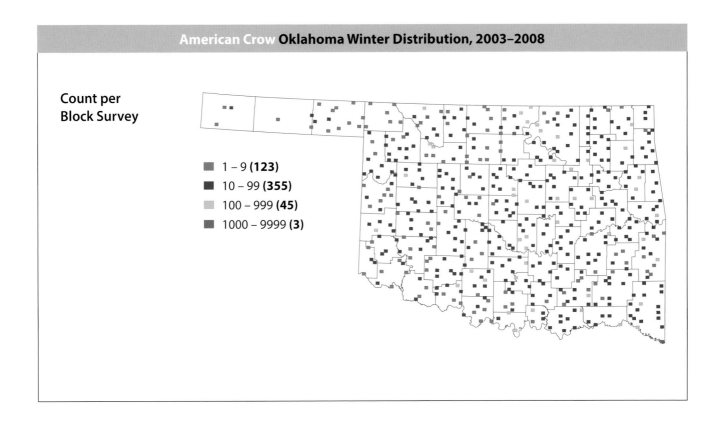

**Count per Block Survey**

- 1 – 9 **(123)**
- 10 – 99 **(355)**
- 100 – 999 **(45)**
- 1000 – 9999 **(3)**

**References**

National Audubon Society. 2011. The Christmas Bird Count historical results. http://www
.christmasbirdcount.org.

Verbeek, N. A., and C. Caffrey. 2002. American Crow (*Corvus brachyrhynchos*). *The Birds of North America
Online*, edited by A. Poole. Ithaca, N.Y.: Cornell Laboratory of Ornithology. http://bna.birds.cornell.edu.

# Fish Crow
*Corvus ossifragus*

© (M. Hyett) / VIREO

**Occurrence:** Present in the state year round, although substantial movements south occur in the fall.

**Habitat:** Woodlands along rivers and streams.

**North American distribution:** Resident in the southeastern United States and along much of the Atlantic Coast north to New England. Breeding range extends slightly north and west of year-round range.

**Oklahoma distribution:** Recorded at just a few locations in eastern counties, with the greatest concentration in McCurtain County. The summer distribution recorded during the Oklahoma Breeding Bird Atlas Project was fairly widespread throughout the eastern third of the state, indicating seasonal movements in which it withdraws from most nesting areas during the winter.

**Behavior:** Fish Crows are very gregarious in the winter, when they can form foraging flocks of dozens or hundreds and roosting flocks that may be even larger. They freely associate with American Crows during the winter. They forage on the ground, in trees, or in parking lots for a wide range of items including grains, seeds, fruits, nuts, insects, and garbage.

**Christmas Bird Count (CBC) Results, 1960–2009**

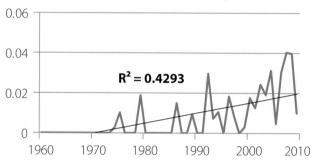

$R^2 = 0.4293$

**CBC Results, 2003–2008**

| Winter | Number recorded | Counts reporting |
|--------|-----------------|------------------|
| 2003–2004 | 19 | 1 |
| 2004–2005 | 30 | 1 |
| 2005–2006 | 6 | 3 |
| 2006–2007 | 32 | 3 |
| 2007–2008 | 27 | 1 |

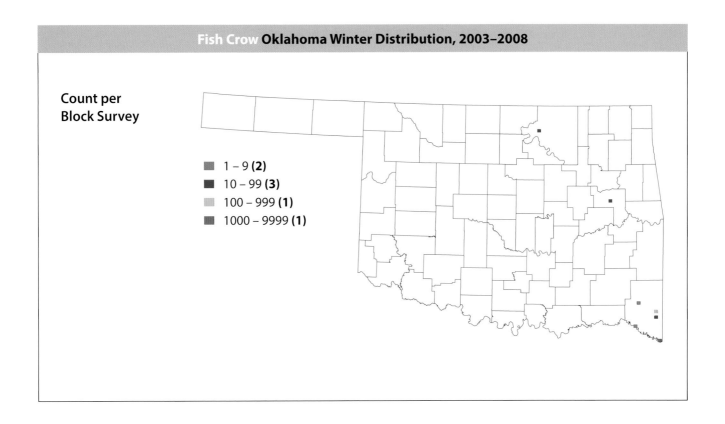

**Count per
Block Survey**

■ 1 – 9 **(2)**
■ 10 – 99 **(3)**
□ 100 – 999 **(1)**
▦ 1000 – 9999 **(1)**

**References**

McGowan, Kevin J. 2001. Fish Crow (*Corvus ossifragus*). *The Birds of North America Online*, edited by A. Poole. Ithaca, N.Y.: Cornell Laboratory of Ornithology. http://bna.birds.cornell.edu.

National Audubon Society. 2011. The Christmas Bird Count historical results. http://www .christmasbirdcount.org.

Oklahoma Bird Records Committee. 2009. *Date Guide to the Occurrences of Birds in Oklahoma*. 5th ed. Norman: Oklahoma Ornithological Society.

Reinking, D. L., ed. 2004. *Oklahoma Breeding Bird Atlas*. Norman: University of Oklahoma Press.

# Chihuahuan Raven
*Corvus cryptoleucus*

© (D. and M. Zimmerman) / VIREO

**Occurrence:** Year-round resident, although some individuals may move south for the winter.

**Habitat:** Shortgrass plains and agricultural areas.

**North American distribution:** Occupies parts of the southwestern United States and Mexico.

**Oklahoma distribution:** Recorded in 3 blocks in Cimarron County. This compares to 13 blocks in three counties in which it was recorded during summer for the Oklahoma Breeding Bird Atlas Project, suggesting some seasonal migration out of the state. Range contractions in the Chihuahuan Raven, and possible expansions in the Common Raven, complicate the identification of these two similar species in Oklahoma (David A. Wiggins, pers. comm.). Two additional raven sightings in blocks in southwestern Texas County and south-central Beaver County were of uncertain identity.

**Behavior:** Chihuahuan Ravens are somewhat social and may be seen singly or in small groups, although in other parts of their range where they are more common, flocks of tens of thousands of birds have been reported. Ravens have a varied diet that can include insects, grains, cacti fruit, carrion, and small animals, and most foraging is done on the ground.

## Christmas Bird Count (CBC) Results, 1960–2009

$R^2 = 0.0083$

## CBC Results, 2003–2008

| Winter | Number recorded | Counts reporting |
|--------|-----------------|------------------|
| 2003–2004 | 1 | 1 |
| 2004–2005 | 7 | 1 |
| 2005–2006 | 12 | 1 |
| 2006–2007 | 0 | — |
| 2007–2008 | 1 | 1 |

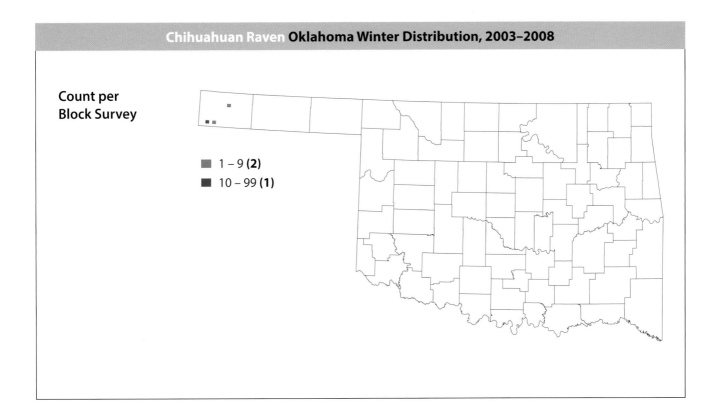

Count per
Block Survey

■ 1 – 9 **(2)**
■ 10 – 99 **(1)**

### References

Bednarz, James C., and Ralph J. Raitt. 2002. Chihuahuan Raven (*Corvus cryptoleucus*). *The Birds of North America Online*, edited by A. Poole. Ithaca, N.Y.: Cornell Laboratory of Ornithology. http://bna.birds .cornell.edu.

Brown, I. S. 1981. Winter records of White-necked Raven in eastern Beckham County, Oklahoma. *Bulletin of the Oklahoma Ornithological Society* 14:7–8.

National Audubon Society. 2011. The Christmas Bird Count historical results. http://www .christmasbirdcount.org.

Oklahoma Bird Records Committee. 2009. *Date Guide to the Occurrences of Birds in Oklahoma*. 5th ed. Norman: Oklahoma Ornithological Society.

Reinking, D. L., ed. 2004. *Oklahoma Breeding Bird Atlas*. Norman: University of Oklahoma Press.

# Common Raven
*Corvus corax*

© (A. Morris) / VIREO

**Occurrence:** Year-round resident.

**Habitat:** Rocky mesas, shortgrass plains, agricultural areas, and roadsides.

**North American distribution:** Resident across Alaska and Canada, parts of the northeastern United States, and most of the western United States and Mexico.

**Oklahoma distribution:** Widespread in Cimarron County, in contrast to the summer distribution recorded by the Oklahoma Breeding Bird Atlas Project, during which it was recorded in only one Cimarron County block. This suggests some eastward dispersal during the winter months. Range contractions in the Chihuahuan Raven, and possible expansions in the Common Raven, complicate the identification of these two similar species in Oklahoma (David A. Wiggins, pers. comm.). Two additional raven sightings in blocks in southwestern Texas County and south-central Beaver County were of uncertain identity.

**Behavior:** Common Ravens are usually seen singly or in pairs, although larger communal roosts may form, especially during fall and winter. Such roosts serve as information clearinghouses, and new members are led to nearby food resources. Ravens have an omnivorous diet that includes insects, small animals, grains, fruits, nuts, and carrion.

## Christmas Bird Count (CBC) Results, 1960–2009

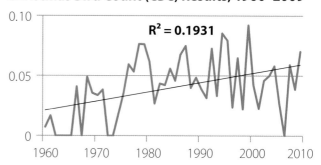

$R^2 = 0.1931$

## CBC Results, 2003–2008

| Winter | Number recorded | Counts reporting |
| --- | --- | --- |
| 2003–2004 | 37 | 1 |
| 2004–2005 | 43 | 1 |
| 2005–2006 | 26 | 1 |
| 2006–2007 | 0 | — |
| 2007–2008 | 45 | 1 |

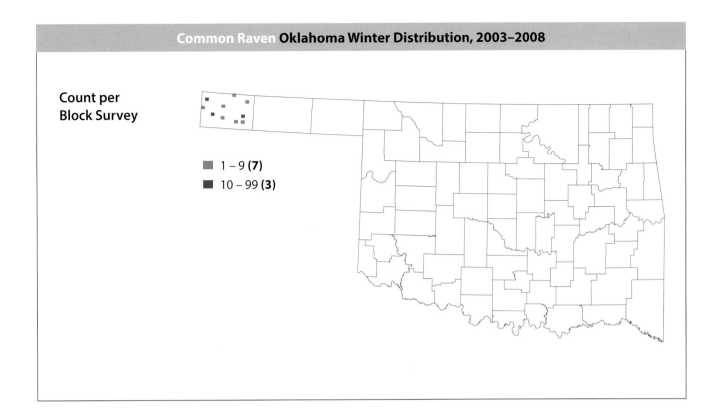

Count per
Block Survey

■ 1 – 9 **(7)**
■ 10 – 99 **(3)**

### References

Boarman, William I., and Bernd Heinrich. 1999. Common Raven (*Corvus corax*). *The Birds of North America Online*, edited by A. Poole. Ithaca, N.Y.: Cornell Laboratory of Ornithology. http://bna.birds.cornell.edu.

National Audubon Society. 2011. The Christmas Bird Count historical results. http://www .christmasbirdcount.org.

Oklahoma Bird Records Committee. 2009. *Date Guide to the Occurrences of Birds in Oklahoma*. 5th ed. Norman: Oklahoma Ornithological Society.

Reinking, D. L., ed. 2004. *Oklahoma Breeding Bird Atlas*. Norman: University of Oklahoma Press.

# Horned Lark
*Eremophila alpestris*

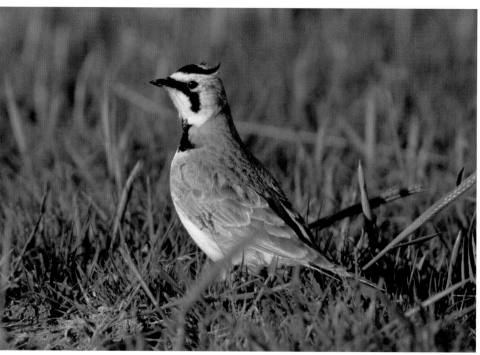

Bob Gress

**Occurrence:** Year-round resident, but more numerous during the winter as northern breeders move into Oklahoma.

**Habitat:** Sparsely vegetated prairies and agricultural fields.

**North American distribution:** Breeds in Alaska and large parts of Canada. Resident across much of the lower 48 states except for the southeast.

**Oklahoma distribution:** Recorded in moderate to high numbers statewide, but generally more common in the north and west, while least common in heavily forested southeastern counties and some central counties. The largest concentrations occurred in north-central and Panhandle counties. The summer distribution recorded during the Oklahoma Breeding Bird Atlas Project was similar, although with somewhat fewer records, especially in northeastern counties.

**Behavior:** Horned Larks are gregarious during the winter and may occur in flocks of hundreds or more. They often associate with longspurs. Foraging is done on bare or sparsely vegetated ground while walking in search of seeds.

### Christmas Bird Count (CBC) Results, 1960–2009

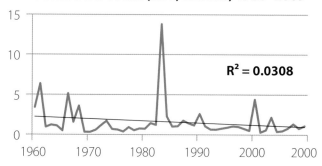

$R^2 = 0.0308$

### CBC Results, 2003–2008

| Winter | Number recorded | Counts reporting |
|--------|-----------------|------------------|
| 2003–2004 | 1,849 | 16 |
| 2004–2005 | 379 | 12 |
| 2005–2006 | 462 | 15 |
| 2006–2007 | 912 | 14 |
| 2007–2008 | 1,681 | 16 |

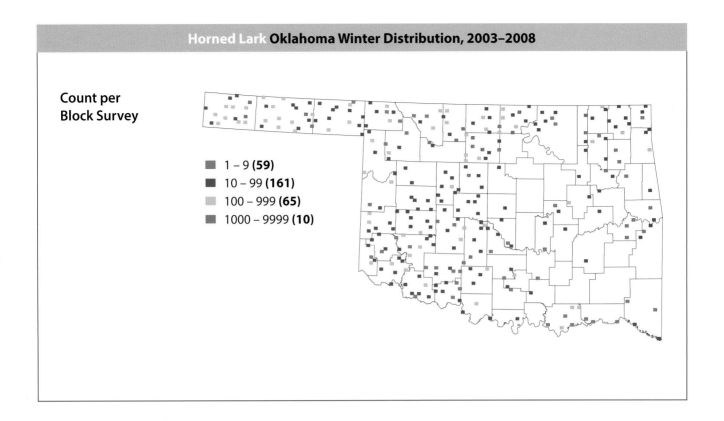

Count per
Block Survey

■ 1 – 9 **(59)**
■ 10 – 99 **(161)**
▨ 100 – 999 **(65)**
▥ 1000 – 9999 **(10)**

### References

Beason, Robert C. 1995. Horned Lark (*Eremophila alpestris*). *The Birds of North America Online*, edited by
    A. Poole. Ithaca, N.Y.: Cornell Laboratory of Ornithology. http://bna.birds.cornell.edu.

Mays, L. P. 1988. Loggerhead Shrike preys on Horned Lark. *Bulletin of the Oklahoma Ornithological Society*
    21:7.

National Audubon Society. 2011. The Christmas Bird Count historical results. http://www
    .christmasbirdcount.org.

Oklahoma Bird Records Committee. 2009. *Date Guide to the Occurrences of Birds in Oklahoma*. 5th ed.
    Norman: Oklahoma Ornithological Society.

Reinking, D. L., ed. 2004. *Oklahoma Breeding Bird Atlas*. Norman: University of Oklahoma Press.

# Carolina Chickadee
## *Poecile carolinensis*

Bob Gress

**Occurrence:** Year-round resident.

**Habitat:** Forests, woodlands, parks, and neighborhoods or farmsteads with mature trees.

**North American distribution:** Broadly distributed resident across the southeastern United States.

**Oklahoma distribution:** Recorded in almost all blocks east of the Panhandle and in several blocks in the eastern half of the Panhandle, the Carolina Chickadee ranked tenth for the number of blocks in which it was recorded (491). As expected for a common resident species, the summer distribution recorded during the Oklahoma Breeding Bird Atlas Project was very similar, although there were fewer records from Harper County and the Panhandle.

**Behavior:** Carolina Chickadees form small winter flocks and frequently associate with nuthatches, woodpeckers, titmice, kinglets, and other species. Pairs sometimes remain together for more than one nesting season but otherwise typically form during the autumn or winter. Chickadees forage for insects, spiders, seeds, and fruit, primarily by gleaning from tree branches. They are frequent visitors to bird feeders, especially for sunflower seeds and suet.

### Christmas Bird Count (CBC) Results, 1960–2009

$R^2 = 0.1128$

### CBC Results, 2003–2008

| Winter | Number recorded | Counts reporting |
|--------|-----------------|------------------|
| 2003–2004 | 3,654 | 19 |
| 2004–2005 | 3,621 | 19 |
| 2005–2006 | 3,460 | 19 |
| 2006–2007 | 3,026 | 19 |
| 2007–2008 | 2,035 | 19 |

**Count per
Block Survey**

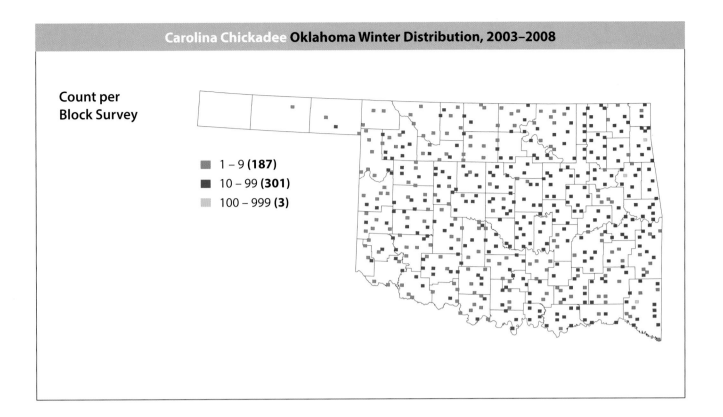

■ 1 – 9 **(187)**
■ 10 – 99 **(301)**
■ 100 – 999 **(3)**

### References

Mostrom, Alison M., Robert L. Curry, and Bernard Lohr. 2002. Carolina Chickadee (*Poecile carolinensis*). *The Birds of North America Online*, edited by A. Poole. Ithaca, N.Y.: Cornell Laboratory of Ornithology. http://bna.birds.cornell.edu.

National Audubon Society. 2011. The Christmas Bird Count historical results. http://www .christmasbirdcount.org.

Oklahoma Bird Records Committee. 2009. *Date Guide to the Occurrences of Birds in Oklahoma*. 5th ed. Norman: Oklahoma Ornithological Society.

Reinking, D. L., ed. 2004. *Oklahoma Breeding Bird Atlas*. Norman: University of Oklahoma Press.

# Mountain Chickadee
*Poecile gambeli*

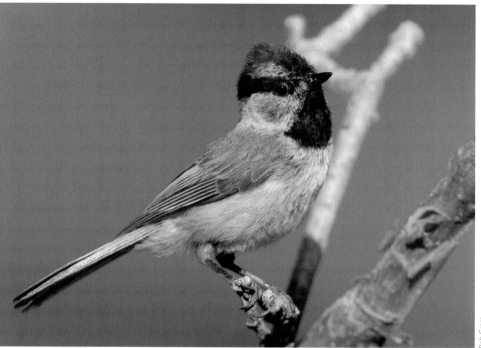

Bob Gress

**Occurrence:** Rare from late September through late April, primarily in Cimarron County.

**Habitat:** Pinyon-juniper woodlands and broad-leaved trees.

**North American distribution:** Resident in parts of western Canada and much of the western lower 48 states. Occasionally wanders somewhat eastward during the winter.

**Oklahoma distribution:** Not recorded in survey blocks. Special interest species reports documented one to five individuals from four locations in Cimarron County during December 2007 (near Boise City, Felt, Kenton, and Keyes). Up to four individuals were also reported from Texas County (Sunset Lake in Guymon) in December 2007 (Oklahoma Bird Records Committee 2009a).

**Behavior:** Mountain Chickadees are usually seen in small groups, although because of their rarity in Oklahoma, single birds may be seen. They forage primarily in conifer trees for insects, spiders, and conifer seeds, but they occasionally visit bird feeders for sunflower seeds.

## Christmas Bird Count (CBC) Results, 1960–2009

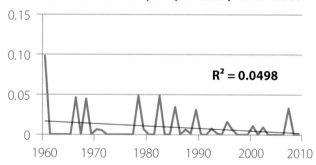

$R^2 = 0.0498$

## CBC Results, 2003–2008

| Winter | Number recorded | Counts reporting |
|---|---|---|
| 2003–2004 | 0 | — |
| 2004–2005 | 0 | — |
| 2005–2006 | 0 | — |
| 2006–2007 | 0 | — |
| 2007–2008 | 25 | 1 |

Count per
Block Survey

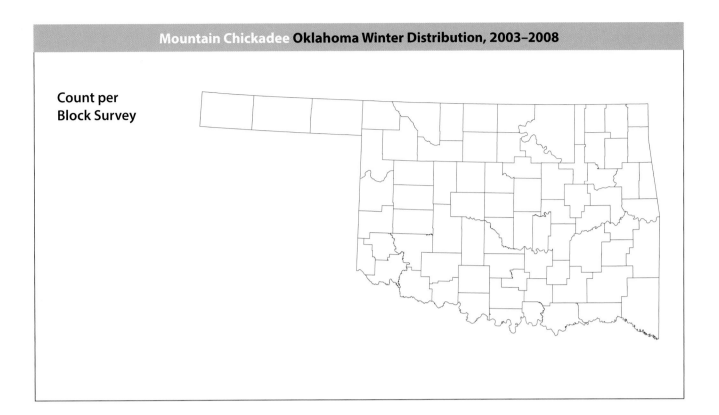

## References

McCallum, D. Archibald, Ralph Grundel, and Donald L. Dahlsten. 1999. Mountain Chickadee (*Poecile gambeli*). *The Birds of North America Online*, edited by A. Poole. Ithaca, N.Y.: Cornell Laboratory of Ornithology. http://bna.birds.cornell.edu.

National Audubon Society. 2011. The Christmas Bird Count historical results. http://www
.christmasbirdcount.org.

Oklahoma Bird Records Committee. 2009a. 2007–2008 winter season. *The Scissortail* 59:4–8.

———. 2009b. *Date Guide to the Occurrences of Birds in Oklahoma*. 5th ed. Norman: Oklahoma Ornithological Society.

# Juniper Titmouse
*Baeolophus ridgwayi*

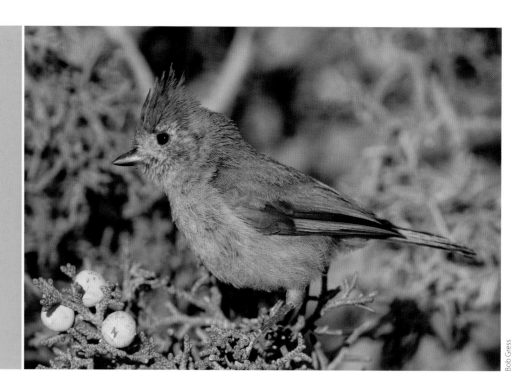

Bob Gress

**Occurrence:** Year-round resident.

**Habitat:** Pinyon-juniper woodlands.

**North American distribution:** Resident in a large portion of the interior western United States.

**Oklahoma distribution:** Not recorded in any survey blocks, but known to occur in the northwestern corner of Cimarron County, where the only suitable habitat for this species exists in the state. The Oklahoma Breeding Bird Atlas Project noted several nesting records from this area.

**Behavior:** Juniper Titmice are usually seen singly or in pairs. They forage mainly in trees, favoring seeds during the winter months, especially those of pinyon pines. They also eat berries and will visit bird feeders for sunflower seeds.

## Christmas Bird Count (CBC) Results, 1960–2009

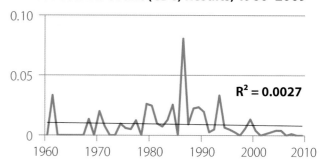

$R^2 = 0.0027$

## CBC Results, 2003–2008

| Winter | Number recorded | Counts reporting |
|---|---|---|
| 2003–2004 | 2 | 1 |
| 2004–2005 | 3 | 1 |
| 2005–2006 | 4 | 1 |
| 2006–2007 | 0 | — |
| 2007–2008 | 1 | 1 |

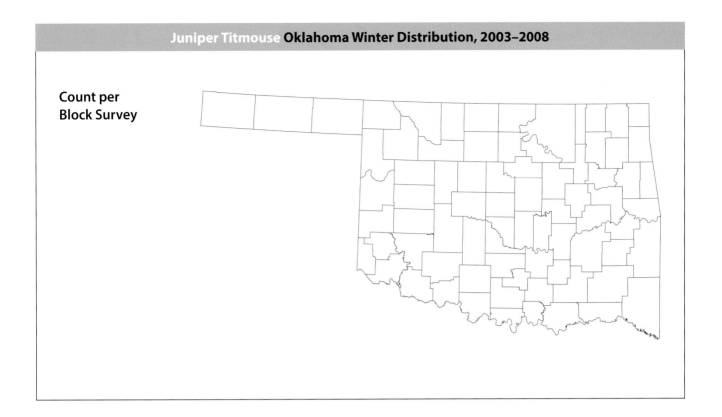

Count per
Block Survey

### References

Cicero, Carla. 2000. Juniper Titmouse (*Baeolophus ridgwayi*). *The Birds of North America Online*, edited by
A. Poole. Ithaca, N.Y.: Cornell Laboratory of Ornithology. http://bna.birds.cornell.edu.

National Audubon Society. 2011. The Christmas Bird Count historical results. http://www
.christmasbirdcount.org.

Oklahoma Bird Records Committee. 2009. *Date Guide to the Occurrences of Birds in Oklahoma*. 5th ed.
Norman: Oklahoma Ornithological Society.

Reinking, D. L., ed. 2004. *Oklahoma Breeding Bird Atlas*. Norman: University of Oklahoma Press.

Wiggins, D. A. 1978. The Plain Titmouse in Oklahoma. *Bulletin of the Oklahoma Ornithological Society*
11:9–11.

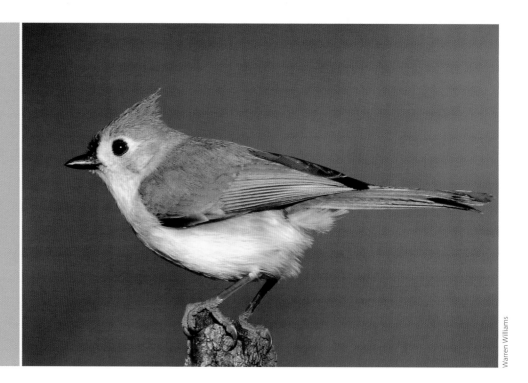

Warren Williams

## Tufted Titmouse
### *Baeolophus bicolor*

**Occurrence:** Year-round resident.

**Habitat:** A wide variety of woodlands in both rural and suburban areas.

**North American distribution:** Resident throughout most of the eastern United States.

**Oklahoma distribution:** Recorded commonly in survey blocks throughout the main body of the state, with records ending abruptly in northwestern counties. Noticeably more widespread and abundant in the eastern half of the state, where woodland habitats are most extensive. As expected for a resident species, the summer distribution recorded by the Oklahoma Breeding Bird Atlas Project was similar.

**Behavior:** Tufted Titmice are often seen in small flocks during the winter, and they frequently associate with larger foraging groups that may include chickadees, woodpeckers, kinglets, and other species. Nuts and seeds make up most of their winter diet, and they gather these items on the ground and in trees. They will readily come to bird feeders for seeds.

### Christmas Bird Count (CBC) Results, 1960–2009

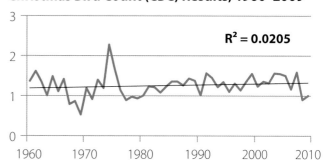

$R^2 = 0.0205$

### CBC Results, 2003–2008

| Winter | Number recorded | Counts reporting |
|---|---|---|
| 2003–2004 | 1,718 | 17 |
| 2004–2005 | 1,722 | 17 |
| 2005–2006 | 1,705 | 17 |
| 2006–2007 | 1,349 | 16 |
| 2007–2008 | 1,236 | 19 |

Count per
Block Survey

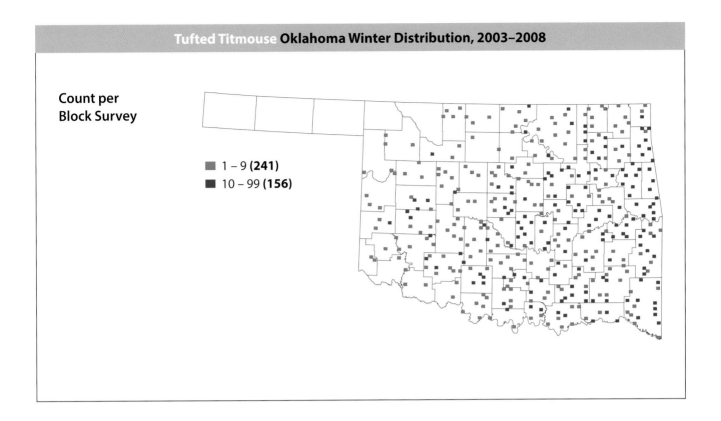

■ 1 – 9 **(241)**
■ 10 – 99 **(156)**

**References**

Grubb, T. C., Jr., and V. V. Pravasudov. 1994. Tufted Titmouse (*Baeolophus bicolor*). *The Birds of North America Online*, edited by A. Poole. Ithaca, N.Y.: Cornell Laboratory of Ornithology. http://bna.birds.cornell.edu.

National Audubon Society. 2011. The Christmas Bird Count historical results. http://www.christmasbirdcount.org.

Oklahoma Bird Records Committee. 2009. *Date Guide to the Occurrences of Birds in Oklahoma*. 5th ed. Norman: Oklahoma Ornithological Society.

Reinking, D. L., ed. 2004. *Oklahoma Breeding Bird Atlas*. Norman: University of Oklahoma Press.

# Black-crested Titmouse

*Baeolophus atricristatus*

**Occurrence:** Year-round resident.

**Habitat:** Riparian areas and oak and mesquite woodlands.

**North American distribution:** Widespread in central and western Texas as well as in eastern Mexico.

**Oklahoma distribution:** Found in just three southwestern Oklahoma counties, a distribution consistent with that documented by the Oklahoma Bird Records Committee (2009). This area forms the northern extent of the species' range.

**Behavior:** Often seen in small groups or in mixed-species flocks in winter. Insect larvae and a variety of nuts, seeds, and fruits are gathered primarily from tree trunks and branches, but also occasionally from the ground or from bird feeders.

## Christmas Bird Count (CBC) Results, 1960–2009

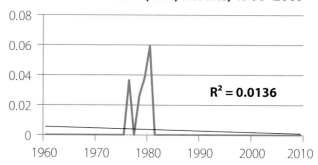

$R^2 = 0.0136$

## CBC Results, 2003–2008

| Winter | Number recorded | Counts reporting |
|---|---|---|
| 2003–2004 | 0 | — |
| 2004–2005 | 0 | — |
| 2005–2006 | 0 | — |
| 2006–2007 | 0 | — |
| 2007–2008 | 0 | — |

**Count per Block Survey**

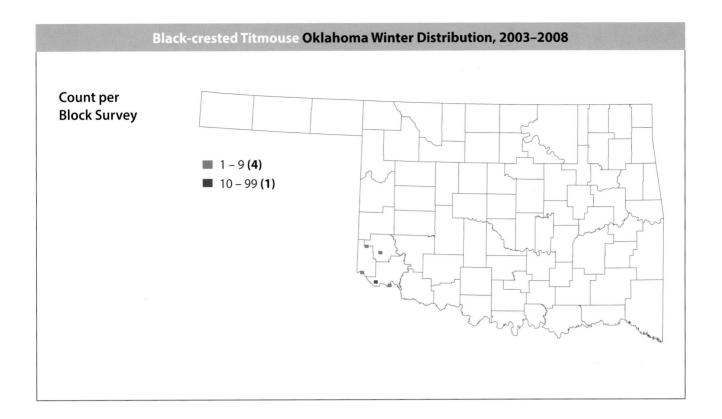

■ 1 – 9 **(4)**
■ 10 – 99 **(1)**

**References**

National Audubon Society. 2011. The Christmas Bird Count historical results. http://www
.christmasbirdcount.org.

Oklahoma Bird Records Committee. 2009. *Date Guide to the Occurrences of Birds in Oklahoma*. 5th ed.
Norman: Oklahoma Ornithological Society.

Patten, Michael A., and Brenda D. Smith-Patten. 2008. Black-crested Titmouse (*Baeolophus atricristatus*).
*The Birds of North America Online*, edited by A. Poole. Ithaca, N.Y.: Cornell Laboratory of Ornithology.
http://bna.birds.cornell.edu.

# Verdin
*Auriparus flaviceps*

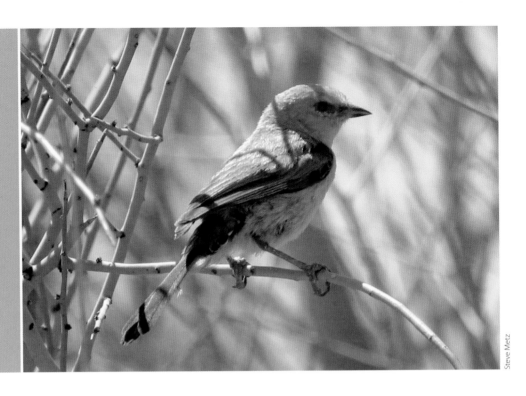

Steve Metz

**Occurrence:** Year-round resident.

**Habitat:** Brushy areas with mesquite trees or other thorny plants.

**North American distribution:** Resident in parts of the southwestern United States and Mexico, barley extending into southwestern Oklahoma.

**Oklahoma distribution:** Recorded in one Jackson County survey block in December 2005. Three additional special interest species reports in January came from the same general area south of El Dorado in Jackson County in 2007 and 2008. This species went undetected during the Oklahoma Breeding Bird Atlas Project.

**Behavior:** Verdins are usually seen singly or in pairs. They forage in leafy foliage for insects, spiders, and berries. The large spherical nests built by Verdins for nesting and roosting indicate their recent presence in an area.

## Christmas Bird Count (CBC) Results, 1960–2009

$R^2 = 0.0067$

## CBC Results, 2003–2008

| Winter | Number recorded | Counts reporting |
|--------|-----------------|------------------|
| 2003–2004 | 0 | — |
| 2004–2005 | 0 | — |
| 2005–2006 | 0 | — |
| 2006–2007 | 0 | — |
| 2007–2008 | 0 | — |

## Verdin Oklahoma Winter Distribution, 2003–2008

**Count per Block Survey**

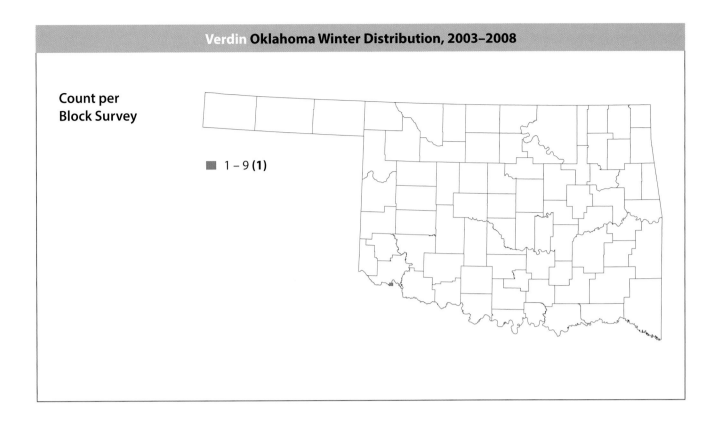

■ 1 – 9 **(1)**

### References

National Audubon Society. 2011. The Christmas Bird Count historical results. http://www
 .christmasbirdcount.org.

Oklahoma Bird Records Committee. 2009. *Date Guide to the Occurrences of Birds in Oklahoma*. 5th ed.
 Norman: Oklahoma Ornithological Society.

Reinking, D. L., ed. 2004. *Oklahoma Breeding Bird Atlas*. Norman: University of Oklahoma Press.

Webster, Marcus D. 1999. Verdin (*Auriparus flaviceps*). *The Birds of North America Online*, edited by A. Poole.
 Ithaca, N.Y.: Cornell Laboratory of Ornithology. http://bna.birds.cornell.edu.

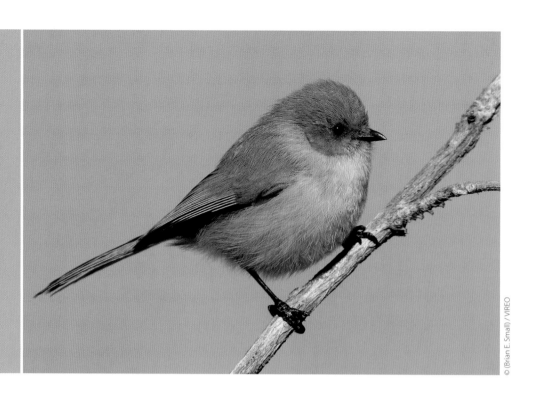

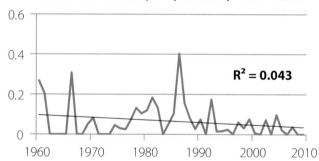

# Bushtit
## *Psaltriparus minimus*

**Occurrence:** Year-round resident of northwestern Cimarron County.

**Habitat:** Pinyon-juniper woodlands, oaks, and pines.

**North American distribution:** Resident in parts of the western lower 48 states and Mexico.

**Oklahoma distribution:** Not recorded in survey blocks. Reported from Cimarron County in December 2003 near Black Mesa State Park (11 birds) and in December 2004 at Keyes (3 birds), and from Texas County (Sunset Lake in Guymon) on December 13, 2007 (up to 12 birds). The Kenton Christmas Bird Count recorded Bushtits in numbers ranging from 22 to 72 during the following winters: 2004–2005, 2005–2006, and 2007–2008. The summer distribution recorded by the Oklahoma Breeding Bird Atlas Project was similar, with several nests located in northwestern Cimarron County near Kenton.

**Behavior:** Bushtits are gregarious at all seasons and sometimes join with foraging flocks that include other species such as kinglets and nuthatches. They forage mainly for insects and spiders in tree branches.

**Christmas Bird Count (CBC) Results, 1960–2009**

$R^2 = 0.043$

**CBC Results, 2003–2008**

| Winter | Number recorded | Counts reporting |
|--------|-----------------|------------------|
| 2003–2004 | 0 | — |
| 2004–2005 | 72 | 1 |
| 2005–2006 | 22 | 1 |
| 2006–2007 | 0 | — |
| 2007–2008 | 28 | 1 |

Count per
Block Survey

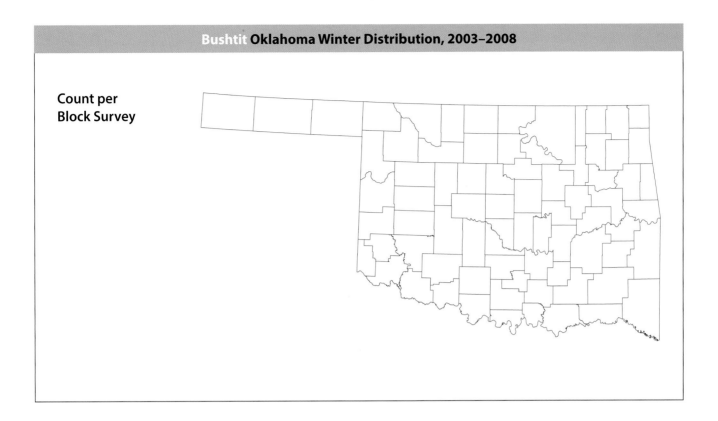

## References

National Audubon Society. 2011. The Christmas Bird Count historical results. http://www
.christmasbirdcount.org.

Oklahoma Bird Records Committee. 2004. 2003–2004 winter season. *The Scissortail* 54:25–27.

———. 2005. 2004–2005 winter season. *The Scissortail* 55:18–20.

———. 2009a. 2007–2008 winter season. *The Scissortail* 59:4–8.

———. 2009b. *Date Guide to the Occurrences of Birds in Oklahoma.* 5th ed. Norman: Oklahoma
Ornithological Society.

Reinking, D. L., ed. 2004. *Oklahoma Breeding Bird Atlas.* Norman: University of Oklahoma Press.

Sloane, Sarah A. 2001. Bushtit (*Psaltriparus minimus*). *The Birds of North America Online,* edited by A. Poole.
Ithaca, N.Y.: Cornell Laboratory of Ornithology. http://bna.birds.cornell.edu.

# Red-breasted Nuthatch

## *Sitta canadensis*

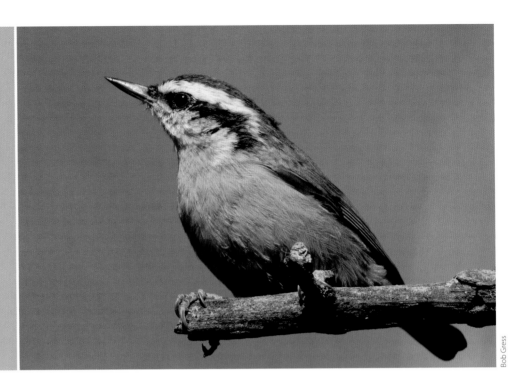

Bob Gress

**Occurrence:** Mid-September through early May.

**Habitat:** Pines, mixed woodlands, and bird feeders.

**North American distribution:** Resident in southeastern Alaska and much of Canada. Winters broadly across most of the United States.

**Oklahoma distribution:** Recorded within scattered survey blocks throughout the main body of the state. This species occurs irruptively in some years and is scarce or absent in others. Surveys captured year-to-year variation in the number and distribution of blocks recording this species. While there is at least one historical nest record, the Oklahoma Breeding Bird Atlas Project did not record any contemporary summer records.

**Behavior:** Red-breasted Nuthatches can be seen singly or in small flocks. They often join mixed-species winter foraging flocks that can include chickadees, titmice, kinglets, and others. They forage for conifer seeds and will readily visit bird feeders for sunflower seeds and suet.

### Christmas Bird Count (CBC) Results, 1960–2009

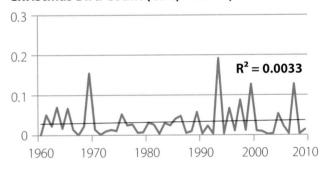

$R^2 = 0.0033$

### CBC Results, 2003–2008

| Winter | Number recorded | Counts reporting |
| --- | --- | --- |
| 2003–2004 | 5 | 4 |
| 2004–2005 | 61 | 13 |
| 2005–2006 | 21 | 8 |
| 2006–2007 | 4 | 4 |
| 2007–2008 | 140 | 16 |

# Red-breasted Nuthatch Oklahoma Winter Distribution, Counts per Block Survey

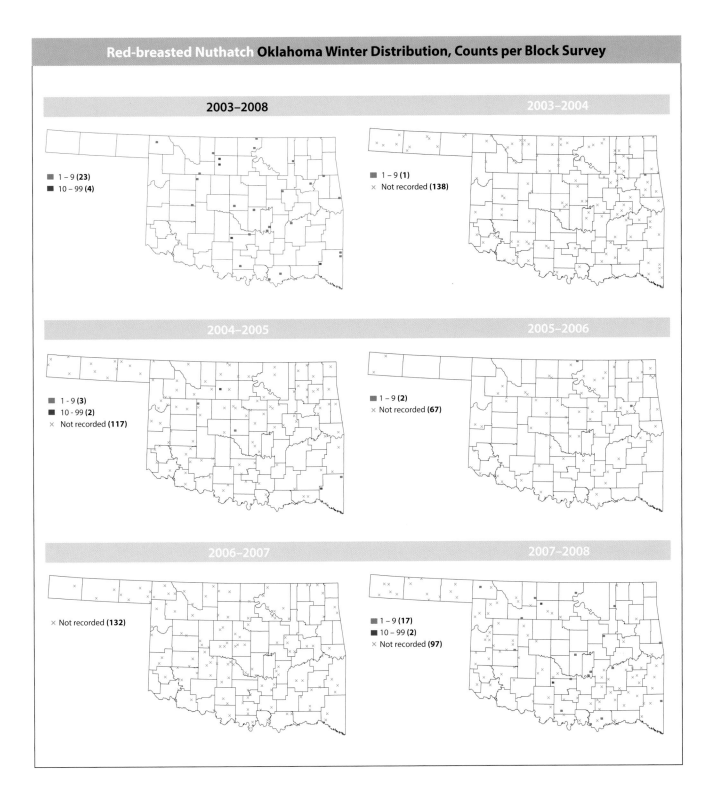

## 2003–2008

■ 1 – 9 **(23)**
■ 10 – 99 **(4)**

## 2003–2004

■ 1 – 9 **(1)**
× Not recorded **(138)**

## 2004–2005

■ 1 - 9 **(3)**
■ 10 - 99 **(2)**
× Not recorded **(117)**

## 2005–2006

■ 1 – 9 **(2)**
× Not recorded **(67)**

## 2006–2007

× Not recorded **(132)**

## 2007–2008

■ 1 – 9 **(17)**
■ 10 – 99 **(2)**
× Not recorded **(97)**

## References

Ghalambor, Cameron K., and Thomas E. Martin. 1999. Red-breasted Nuthatch (*Sitta canadensis*). *The Birds of North America Online*, edited by A. Poole. Ithaca, N.Y.: Cornell Laboratory of Ornithology. http://bna .birds.cornell.edu.

National Audubon Society. 2011. The Christmas Bird Count historical results. http://www .christmasbirdcount.org.

Oklahoma Bird Records Committee. 2009. *Date Guide to the Occurrences of Birds in Oklahoma*. 5th ed. Norman: Oklahoma Ornithological Society.

Reinking, D. L., ed. 2004. *Oklahoma Breeding Bird Atlas*. Norman: University of Oklahoma Press.

# White-breasted Nuthatch
## *Sitta carolinensis*

Dan Reinking

**Occurrence:** Year-round resident except in Cimarron County, where it can occur from September through February.

**Habitat:** Mature deciduous or coniferous woodlands in both rural and suburban areas.

**North American distribution:** Resident across large portions of southern Canada, the lower 48 states, and Mexico. Winters in small portions of several western states in areas where it does not breed.

**Oklahoma distribution:** Recorded in survey blocks statewide, but by far the most widespread and abundant in the eastern half of the state, where woodland habitats are more prevalent. The summer distribution recorded by the Oklahoma Breeding Bird Atlas Project extended as far west as Harper County but was also heavily concentrated in the eastern half of the state. Winter records from the western Panhandle are likely to be the Rocky Mountain subspecies, S. c. nelsoni, which is being proposed for full species status.

**Behavior:** White-breasted Nuthatches are usually seen singly or in pairs. They often join mixed-species winter foraging flocks that include chickadees, titmice, Downy Woodpeckers, and others. They forage along trunks and main branches of trees and often descend a vertical trunk headfirst. Winter foods include a variety of seeds, insects, and insect larvae. They will readily visit bird feeders for sunflower seeds and suet.

### Christmas Bird Count (CBC) Results, 1960–2009

$R^2 = 0.0314$

### CBC Results, 2003–2008

| Winter | Number recorded | Counts reporting |
|---|---|---|
| 2003–2004 | 337 | 19 |
| 2004–2005 | 257 | 19 |
| 2005–2006 | 320 | 17 |
| 2006–2007 | 337 | 18 |
| 2007–2008 | 264 | 19 |

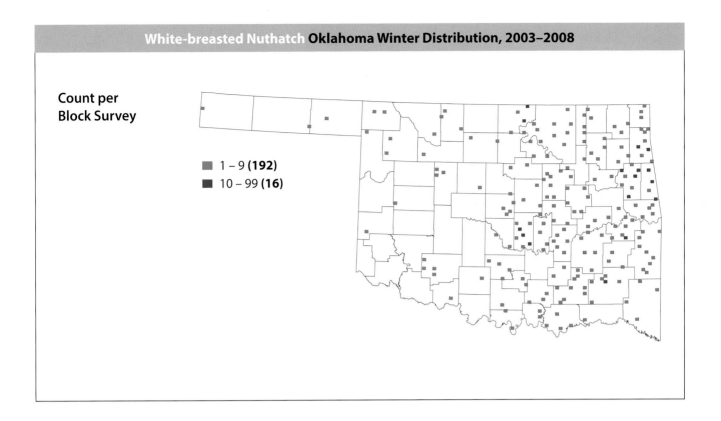

**Count per
Block Survey**

■ 1 – 9 **(192)**
■ 10 – 99 **(16)**

### References

Grubb, T. C., Jr., and V. V. Pravosudov. 2008. White-breasted Nuthatch (*Sitta carolinensis*). *The Birds of North America Online*, edited by A. Poole. Ithaca, N.Y.: Cornell Laboratory of Ornithology. http://bna.birds.cornell.edu.

National Audubon Society. 2011. The Christmas Bird Count historical results. http://www.christmasbirdcount.org.

Oklahoma Bird Records Committee. 2009. *Date Guide to the Occurrences of Birds in Oklahoma*. 5th ed. Norman: Oklahoma Ornithological Society.

Reinking, D. L., ed. 2004. *Oklahoma Breeding Bird Atlas*. Norman: University of Oklahoma Press.

Sutton, G. M. 1967. *Oklahoma Birds*. Norman: University of Oklahoma Press.

# Pygmy Nuthatch
## *Sitta pygmaea*

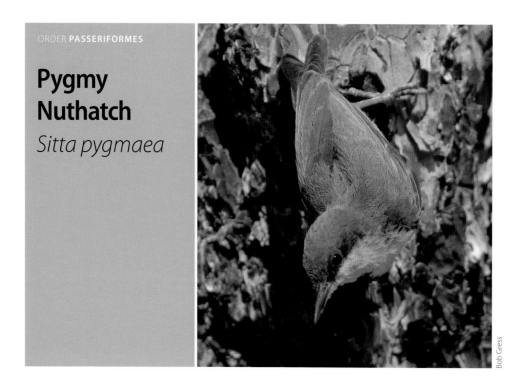

Bob Gress

**Occurrence:** Rare in fall and winter.

**Habitat:** Coniferous woodlands.

**North American distribution:** Resident in southwestern Canada, parts of the western lower 48 states, and parts of Mexico. Rarely wanders east during fall and winter.

**Oklahoma distribution:** Not recorded in survey blocks. Special interest species reports documented up to three birds in Texas County (Sunset Lake in Guymon) in December 2007.

**Behavior:** Pygmy Nuthatches are usually seen in flocks. They forage in pine trees for pine seeds and insects.

### Christmas Bird Count (CBC) Results, 1960–2009

$R^2 = 0.0206$

### CBC Results, 2003–2008

| Winter | Number recorded | Counts reporting |
| --- | --- | --- |
| 2003–2004 | 0 | — |
| 2004–2005 | 0 | — |
| 2005–2006 | 0 | — |
| 2006–2007 | 0 | — |
| 2007–2008 | 0 | — |

Count per
Block Survey

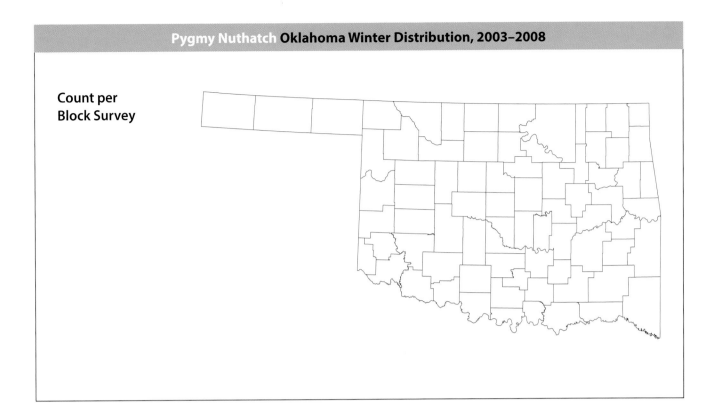

### References

Kingery, Hugh E., and Cameron K. Ghalambor. 2001. Pygmy Nuthatch (*Sitta pygmaea*). *The Birds of North America Online*, edited by A. Poole. Ithaca, N.Y.: Cornell Laboratory of Ornithology. http://bna.birds .cornell.edu.

McMahon, J. A., and M. M. Droege. 2009. First record of Pygmy Nuthatch in Texas County, Oklahoma. *Bulletin of the Oklahoma Ornithological Society* 42:21–23.

National Audubon Society. 2011. The Christmas Bird Count historical results. http://www .christmasbirdcount.org.

Oklahoma Bird Records Committee. 2009. *Date Guide to the Occurrences of Birds in Oklahoma*. 5th ed. Norman: Oklahoma Ornithological Society.

# Brown-headed Nuthatch
## *Sitta pusilla*

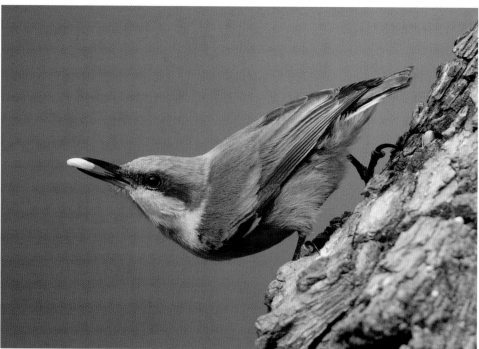

© (P. Bannick) / VIREO

**Occurrence:** Year-round resident.

**Habitat:** Mature pine woodlands.

**North American distribution:** Resident throughout much of the southeastern United States.

**Oklahoma distribution:** Thought to be locally present in five southeastern Oklahoma counties, though recorded in only two counties during winter atlas surveys (with Latimer, Le Flore, and Pushmataha being the counties where they might have been expected but were not found). The winter surveys were more successful, yielding seven blocks with birds in two counties, than the Oklahoma Breeding Bird Atlas surveys, which recorded just two blocks with birds in a single county. It is not clear whether this is due to a population increase in the intervening years, better block coverage, or easier detection during the winter months.

**Behavior:** Brown-headed Nuthatches are frequently seen in pairs or small groups during the winter and are often found in mixed-species flocks including chickadees, kinglets, woodpeckers, and Pine Warblers. They forage on pine tree trunks, limbs, and cones in search of pine seeds, insects, insect larvae, and spiders.

## Christmas Bird Count (CBC) Results, 1960–2009

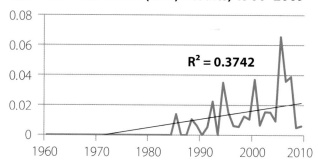

$R^2 = 0.3742$

## CBC Results, 2003–2008

| Winter | Number recorded | Counts reporting |
|--------|-----------------|------------------|
| 2003–2004 | 15 | 1 |
| 2004–2005 | 9 | 1 |
| 2005–2006 | 56 | 2 |
| 2006–2007 | 26 | 2 |
| 2007–2008 | 13 | 2 |

**Count per
Block Survey**

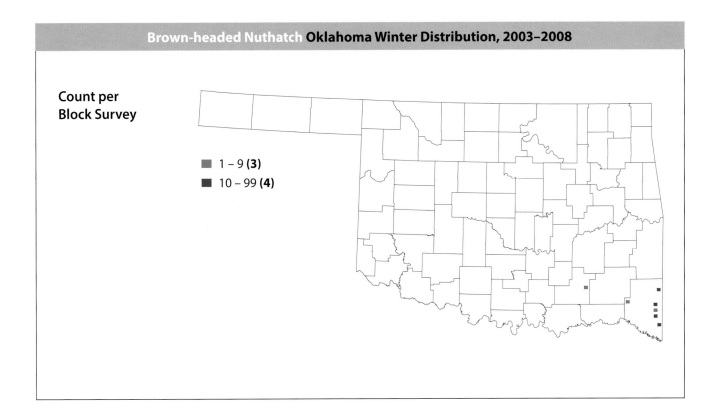

■ 1 – 9 **(3)**
■ 10 – 99 **(4)**

### References

National Audubon Society. 2011. The Christmas Bird Count historical results. http://www
.christmasbirdcount.org.

Oklahoma Bird Records Committee. 2009. *Date Guide to the Occurrences of Birds in Oklahoma.* 5th ed.
Norman: Oklahoma Ornithological Society.

Reinking, D. L., ed. 2004. *Oklahoma Breeding Bird Atlas.* Norman: University of Oklahoma Press.

Withgott, James H., and Kimberly G. Smith. 1998. Brown-headed Nuthatch (*Sitta pusilla*). *The Birds of North
America Online,* edited by A. Poole. Ithaca, N.Y.: Cornell Laboratory of Ornithology. http://bna.birds
.cornell.edu.

# Brown Creeper
## *Certhia americana*

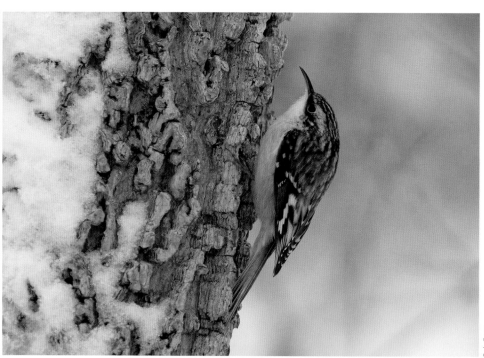

Bob Gress

**Occurrence:** October through mid-April.

**Habitat:** Woodlands, city parks, and rural or suburban residences with mature trees.

**North American distribution:** A patchwork of breeding and year-round distribution in southern Canada, the northeastern and eastern United States, and the western United States and Mexico. Winters in a large central and southeastern portion of the United States.

**Oklahoma distribution:** Widely but somewhat sparsely distributed across the main body of the state, with a noticeably higher frequency of occurrence in the more heavily wooded eastern half. Not recorded in the Panhandle counties.

**Behavior:** Very inconspicuous and usually seen singly, but sometimes found in mixed-species flocks with chickadees, nuthatches, kinglets, and woodpeckers. Brown Creepers forage on tree trunks, often starting near the ground and circling the trunk as they climb. They use their stiff tail to brace themselves against the trunk in the same manner as woodpeckers, and their thin, curved bill to extract insect larvae and spider eggs from deep bark crevices. Their extremely high-pitched call is often the first indication of their presence nearby.

**Christmas Bird Count (CBC) Results, 1960–2009**

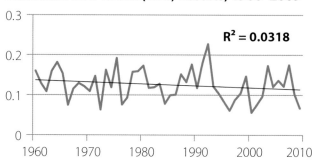

$R^2 = 0.0318$

**CBC Results, 2003–2008**

| Winter | Number recorded | Counts reporting |
|---|---|---|
| 2003–2004 | 169 | 16 |
| 2004–2005 | 115 | 14 |
| 2005–2006 | 140 | 18 |
| 2006–2007 | 134 | 17 |
| 2007–2008 | 120 | 17 |

**Count per
Block Survey**

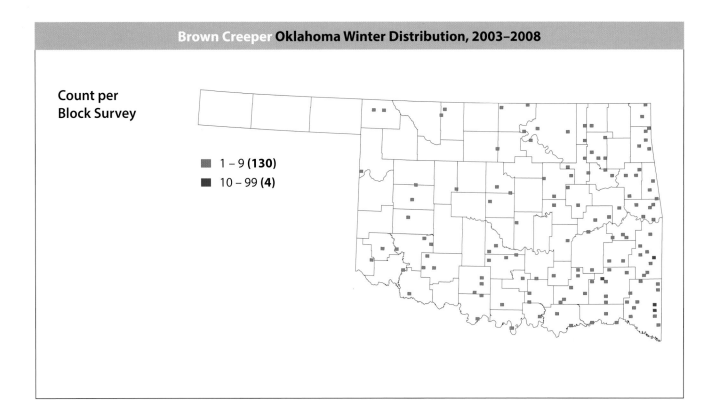

■ 1 – 9 **(130)**
■ 10 – 99 **(4)**

### References

Hejl, S. J., K. R. Newlon, M. E. McFadzen, J. S. Young, and C. K. Ghalambor. 2002. Brown Creeper (*Certhia americana*). *The Birds of North America Online*, edited by A. Poole. Ithaca, N.Y.: Cornell Laboratory of Ornithology. http://bna.birds.cornell.edu.

National Audubon Society. 2011. The Christmas Bird Count historical results. http://www
.christmasbirdcount.org.

Oklahoma Bird Records Committee. 2009. *Date Guide to the Occurrences of Birds in Oklahoma*. 5th ed. Norman: Oklahoma Ornithological Society.

Sutton, G. M. 1977. How often does the Brown Creeper sing in Oklahoma? *Bulletin of the Oklahoma Ornithological Society* 10:33–34.

# Rock Wren
## *Salpinctes obsoletus*

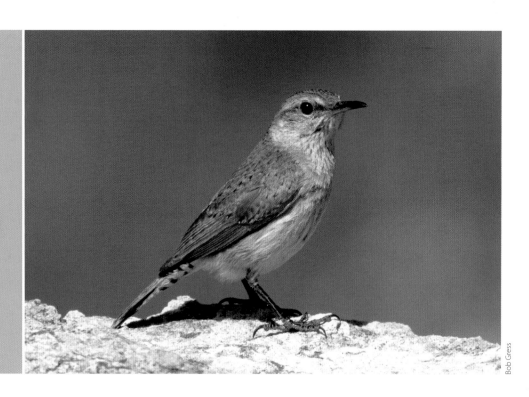

Bob Gress

**Occurrence:** Year-round resident.

**Habitat:** Rock outcrops and steep, rocky slopes. Occasionally riprap below dams.

**North American distribution:** Breeds in southwestern Canada and parts of the western lower 48 states. Resident across parts of the western and southwestern United States and Mexico.

**Oklahoma distribution:** Recorded in seven scattered survey blocks in the western third of the state. Two additional special interest species reports came from two locations in McCurtain County in the winter of 2006–2007, indicating the occasional eastward wandering they are known for during the winter. An additional published report during the project period came from Cherokee County in December 2003 through February 2004 (up to two birds; Oklahoma Bird Records Committee 2004). The summer distribution recorded by the Oklahoma Breeding Bird Atlas Project was similar though slightly more extensive, probably because breeding-season singing made birds more detectable than they were during the winter.

**Behavior:** Rock Wrens are usually seen singly or in pairs. They forage primarily on the ground for insects and arthropods.

## Christmas Bird Count (CBC) Results, 1960–2009

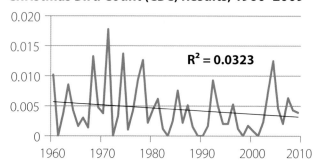

$R^2 = 0.0323$

## CBC Results, 2003–2008

| Winter | Number recorded | Counts reporting |
|---|---|---|
| 2003–2004 | 9 | 3 |
| 2004–2005 | 13 | 2 |
| 2005–2006 | 7 | 2 |
| 2006–2007 | 2 | 2 |
| 2007–2008 | 8 | 2 |

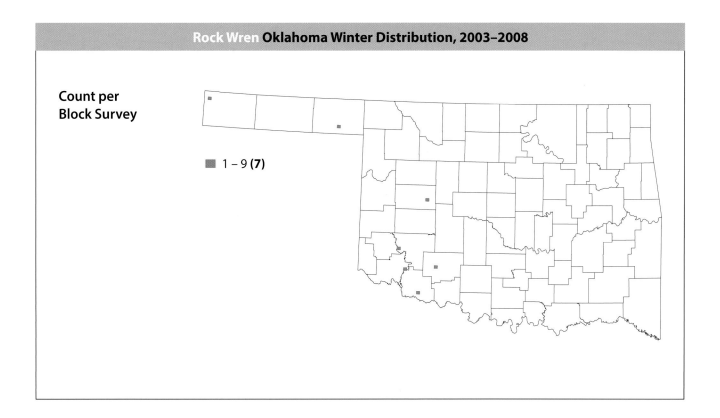

Count per
Block Survey

■ 1 – 9 **(7)**

### References

Lowther, Peter E., Donald E. Kroodsma, and Greg H. Farley. 2000. Rock Wren (*Salpinctes obsoletus*). *The Birds of North America Online*, edited by A. Poole. Ithaca, N.Y.: Cornell Laboratory of Ornithology. http://bna.birds.cornell.edu.

National Audubon Society. 2011. The Christmas Bird Count historical results. http://www .christmasbirdcount.org.

Oklahoma Bird Records Committee. 2004. 2003–2004 winter season. *The Scissortail* 54:25–27.

———. 2009. *Date Guide to the Occurrences of Birds in Oklahoma*. 5th ed. Norman: Oklahoma Ornithological Society.

Reinking, D. L., ed. 2004. *Oklahoma Breeding Bird Atlas*. Norman: University of Oklahoma Press.

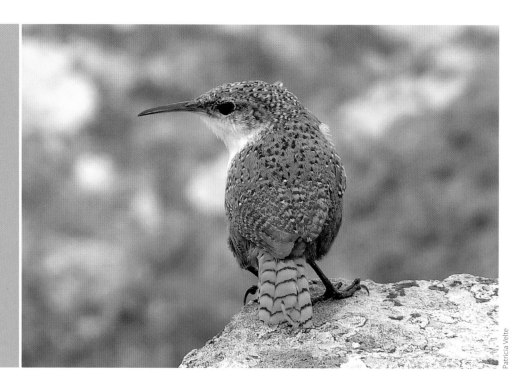

ORDER **PASSERIFORMES**

# Canyon Wren
## *Catherpes mexicanus*

**Occurrence:** Year-round resident.

**Habitat:** Rock outcrops and cliffs.

**North American distribution:** Widely distributed across the western lower 48 states and Mexico.

**Oklahoma distribution:** Recorded in Kiowa and Comanche Counties, although known to occur in several others in the southwest as well as Cimarron in the Panhandle. The very specific habitat requirements and resulting local distribution means that this species is not well surveyed by atlas project sampling methods. The summer distribution recorded during the Oklahoma Breeding Bird Atlas Project captured additional locations slightly better, likely because increased vocalizations during the breeding season made detection of this species easier.

**Behavior:** Canyon Wrens remain paired and territorial year round, although winter territories may be larger. They forage for insects and spiders, probing crevices with their long, slender bills. Their short legs and large feet enable them to nimbly scramble across their rocky habitat.

**Christmas Bird Count (CBC) Results, 1960–2009**

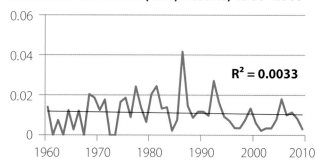

$R^2 = 0.0033$

**CBC Results, 2003–2008**

| Winter | Number recorded | Counts reporting |
|--------|-----------------|------------------|
| 2003–2004 | 5 | 2 |
| 2004–2005 | 14 | 2 |
| 2005–2006 | 27 | 2 |
| 2006–2007 | 9 | 1 |
| 2007–2008 | 14 | 2 |

**368** ORDER **PASSERIFORMES**

**Count per
Block Survey**

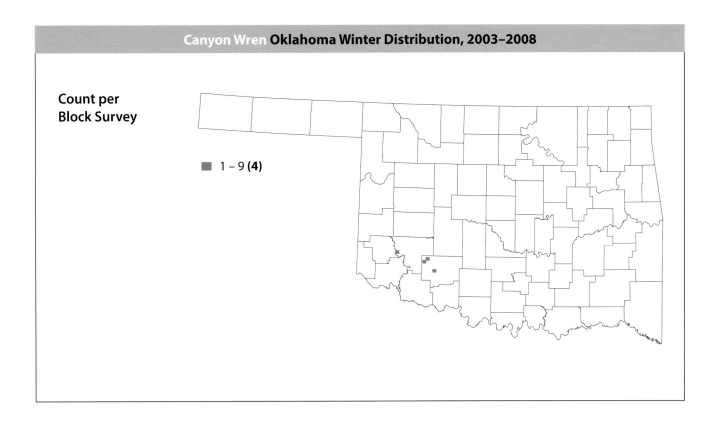

■ 1 – 9 **(4)**

### References

Jones, Stephanie L., and Joseph Scott Dieni. 1995. Canyon Wren (*Catherpes mexicanus*). *The Birds of North America Online*, edited by A. Poole. Ithaca, N.Y.: Cornell Laboratory of Ornithology. http://bna.birds .cornell.edu.

National Audubon Society. 2011. The Christmas Bird Count historical results. http://www .christmasbirdcount.org.

Oklahoma Bird Records Committee. 2009. *Date Guide to the Occurrences of Birds in Oklahoma*. 5th ed. Norman: Oklahoma Ornithological Society.

Reinking, D. L., ed. 2004. *Oklahoma Breeding Bird Atlas*. Norman: University of Oklahoma Press.

# House Wren
## *Troglodytes aedon*

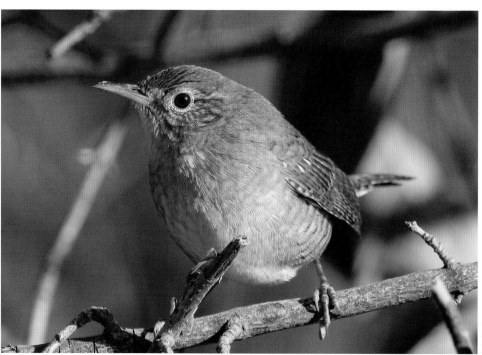

Bob Gress

**Occurrence:** Highly variable by region because of migration. Present spring through fall in the Panhandle, spring through midwinter in the central and northeastern regions, fall through spring in the south-central and southeastern regions, and all year in the southwest.

**Habitat:** Brushy woodlands, parks, gardens, and backyards.

**North American distribution:** Breeds from central Canada south across the width of the lower 48 states to a line from Arizona to northern Oklahoma to North Carolina. Resident at the southern edge of this breeding range in California, the southeastern United States, and central Mexico. Winters south of this breeding range into Mexico.

**Oklahoma distribution:** Sparsely recorded in the eastern two-thirds of the state, with most records coming from the southeastern counties. The summer distribution recorded by the Oklahoma Breeding Bird Atlas Project was concentrated in the northern half of the state, especially in the northwestern counties.

**Behavior:** House Wrens are usually seen singly during the winter. They forage for insects and larvae in trees and shrubs or on the ground.

## Christmas Bird Count (CBC) Results, 1960–2009

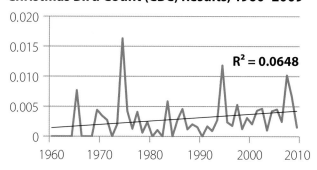

$R^2 = 0.0648$

## CBC Results, 2003–2008

| Winter | Number recorded | Counts reporting |
| --- | --- | --- |
| 2003–2004 | 1 | 1 |
| 2004–2005 | 5 | 3 |
| 2005–2006 | 6 | 4 |
| 2006–2007 | 3 | 3 |
| 2007–2008 | 8 | 4 |

**Count per
Block Survey**

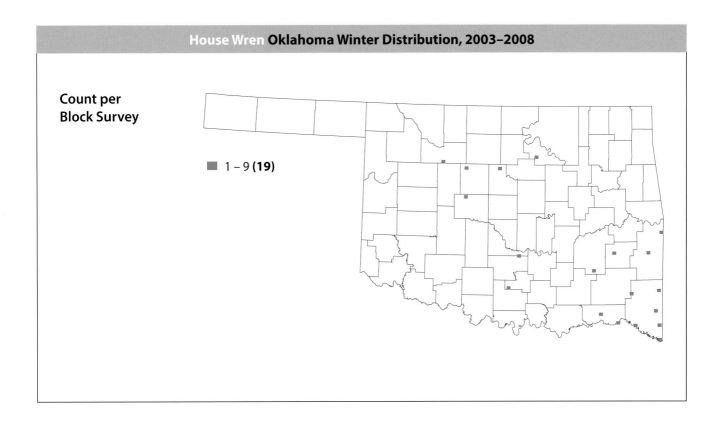

■ 1 – 9 **(19)**

**References**

Johnson, L. Scott. 1998. House Wren (*Troglodytes aedon*). *The Birds of North America Online*, edited by
   A. Poole. Ithaca, N.Y.: Cornell Laboratory of Ornithology. http://bna.birds.cornell.edu.

National Audubon Society. 2011. The Christmas Bird Count historical results. http://www
   .christmasbirdcount.org.

Oklahoma Bird Records Committee. 2009. *Date Guide to the Occurrences of Birds in Oklahoma*. 5th ed.
   Norman: Oklahoma Ornithological Society.

Reinking, D. L., ed. 2004. *Oklahoma Breeding Bird Atlas*. Norman: University of Oklahoma Press.

# Winter Wren
## *Troglodytes hiemalis*

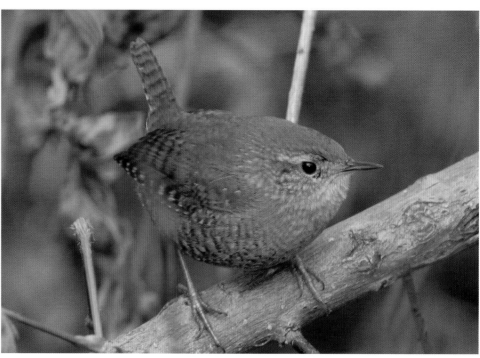

Bob Gress

**Occurrence:** October through mid-April.

**Habitat:** Dense, brushy, wooded areas, especially near streams where tree root balls are exposed by erosion or toppling.

**North American distribution:** Breeds across much of Canada and parts of the northern lower 48 states. Resident in the Appalachian Mountains. Winters throughout much of the southeastern United States.

**Oklahoma distribution:** Recorded in scattered survey blocks statewide, but reported most often in southeastern counties.

**Behavior:** Winter Wrens are usually seen singly. They forage for insects and spiders on the ground and in low vegetation.

## Christmas Bird Count (CBC) Results, 1960–2009

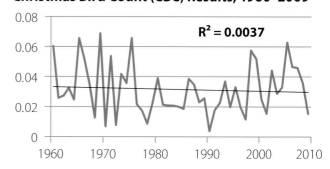

$R^2 = 0.0037$

## CBC Results, 2003–2008

| Winter | Number recorded | Counts reporting |
|---|---|---|
| 2003–2004 | 36 | 12 |
| 2004–2005 | 36 | 14 |
| 2005–2006 | 66 | 15 |
| 2006–2007 | 51 | 11 |
| 2007–2008 | 42 | 13 |

**Count per Block Survey**

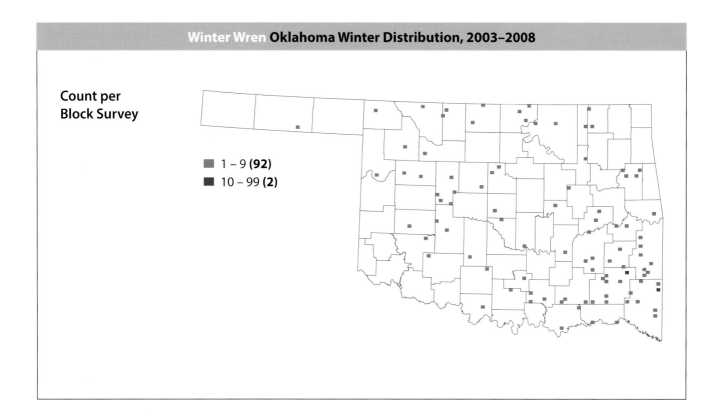

- ■ 1 – 9 **(92)**
- ■ 10 – 99 **(2)**

### References

Heck, B. A. 1994. Underwater foraging by a Winter Wren. *Bulletin of the Oklahoma Ornithological Society* 27:15–16.

Hejl, Sallie J., Jennifer A. Holmes, and Donald E. Kroodsma. 2002. Winter Wren (*Troglodytes hiemalis*). *The Birds of North America Online*, edited by A. Poole. Ithaca, N.Y.: Cornell Laboratory of Ornithology. http://bna.birds.cornell.edu.

National Audubon Society. 2011. The Christmas Bird Count historical results. http://www .christmasbirdcount.org.

Oklahoma Bird Records Committee. 2009. *Date Guide to the Occurrences of Birds in Oklahoma*. 5th ed. Norman: Oklahoma Ornithological Society.

# Sedge Wren
## *Cistothorus platensis*

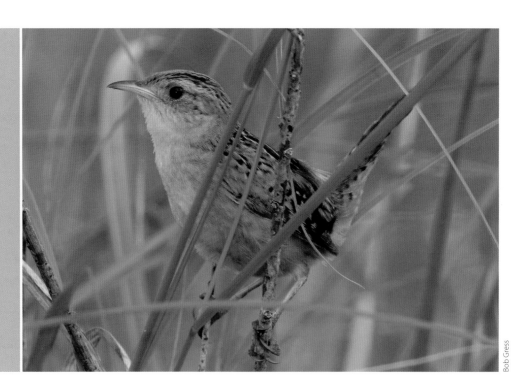

Bob Gress

**Occurrence:** Late July through mid-May in eastern counties, and a spring and protracted fall migrant (late September through early January) in central and western counties.

**Habitat:** Grasslands or sedge meadows with tall, dense vegetation.

**North American distribution:** Breeds in parts of central Canada and the northeastern and north-central United States. Winters in the southeastern United States.

**Oklahoma distribution:** Recorded in just two survey blocks in Osage and Alfalfa Counties. Additional special interest species records were received from Tulsa County in February 2004, Noble County in December 2005 and February 2006, Osage County in early January 2008, and McCurtain County (multiple records) throughout the full winter season in each of the five winters of the project, primarily from Red Slough Wildlife Management Area. Three summer records during the Oklahoma Breeding Bird Atlas Project did not confirm nesting.

**Behavior:** Little is known about the winter behavior of Sedge Wrens. They typically flush and fly a short distance before landing and running through thick cover, making their relocation difficult for observers. They forage on or near the ground for insects and spiders.

## Christmas Bird Count (CBC) Results, 1960–2009

$R^2 = 0.1183$

## CBC Results, 2003–2008

| Winter | Number recorded | Counts reporting |
|---|---|---|
| 2003–2004 | 4 | 3 |
| 2004–2005 | 8 | 5 |
| 2005–2006 | 5 | 1 |
| 2006–2007 | 1 | 1 |
| 2007–2008 | 3 | 2 |

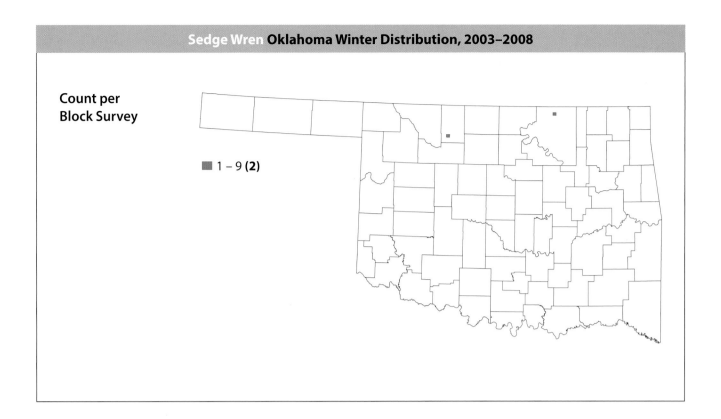

Count per
Block Survey

■ 1 – 9 **(2)**

**References**

Herkert, James R., Donald E. Kroodsma, and James P. Gibbs. 2001. Sedge Wren (*Cistothorus platensis*). *The Birds of North America Online*, edited by A. Poole. Ithaca, N.Y.: Cornell Laboratory of Ornithology. http://bna.birds.cornell.edu.

National Audubon Society. 2011. The Christmas Bird Count historical results. http://www .christmasbirdcount.org.

Oklahoma Bird Records Committee. 2009. *Date Guide to the Occurrences of Birds in Oklahoma*. 5th ed. Norman: Oklahoma Ornithological Society.

Reinking, D. L., ed. 2004. *Oklahoma Breeding Bird Atlas*. Norman: University of Oklahoma Press.

# Marsh Wren
*Cistothorus palustris*

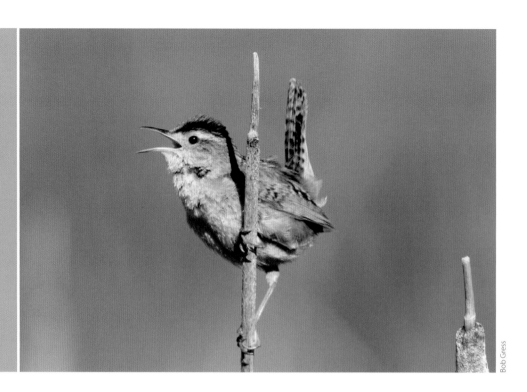

Bob Gress

**Occurrence:** Late September through early May.

**Habitat:** Cattail marshes.

**North American distribution:** Breeds in southern Canada and the northern United States. Resident in some coastal areas and in parts of the western United States. Winters in the southern United States and in Mexico.

**Oklahoma distribution:** Recorded mostly in the western half of the state, especially in northwestern counties. Most survey blocks lack habitat for this species.

**Behavior:** Marsh Wrens are usually seen singly. They forage for insects and spiders in vegetation near the surface of the water.

## Christmas Bird Count (CBC) Results, 1960–2009

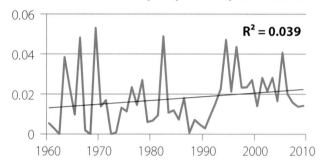

$R^2 = 0.039$

## CBC Results, 2003–2008

| Winter | Number recorded | Counts reporting |
|---|---|---|
| 2003–2004 | 20 | 8 |
| 2004–2005 | 17 | 7 |
| 2005–2006 | 25 | 8 |
| 2006–2007 | 9 | 4 |
| 2007–2008 | 13 | 6 |

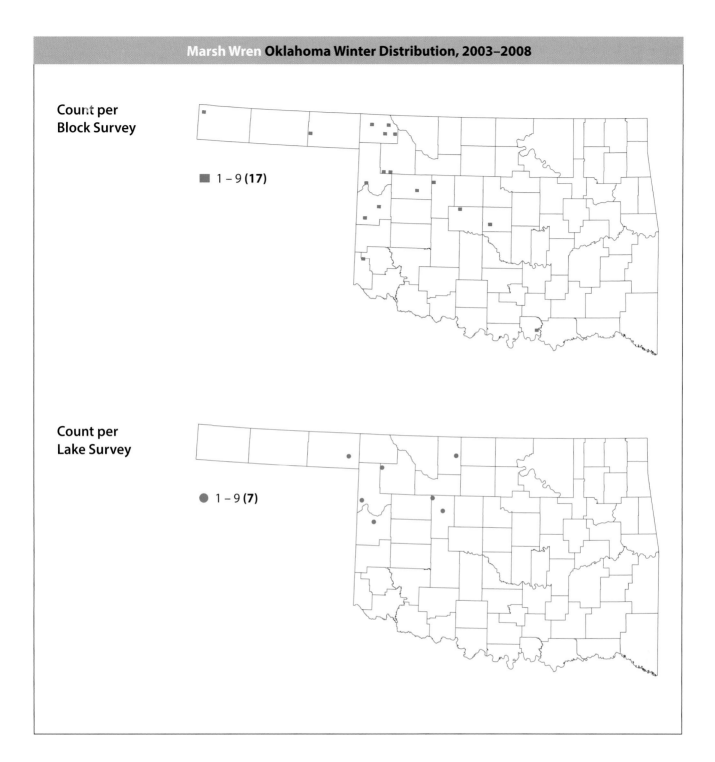

Count per
Block Survey

■ 1 – 9 **(17)**

Count per
Lake Survey

● 1 – 9 **(7)**

### References

Kroodsma, Donald E., and Jared Verner. 1997. Marsh Wren (*Cistothorus palustris*). *The Birds of North America Online*, edited by A. Poole. Ithaca, N.Y.: Cornell Laboratory of Ornithology. http://bna.birds.cornell.edu.

National Audubon Society. 2011. The Christmas Bird Count historical results. http://www.christmasbirdcount.org.

Oklahoma Bird Records Committee. 2009. *Date Guide to the Occurrences of Birds in Oklahoma*. 5th ed. Norman: Oklahoma Ornithological Society.

# Carolina Wren
*Thryothorus ludovicianus*

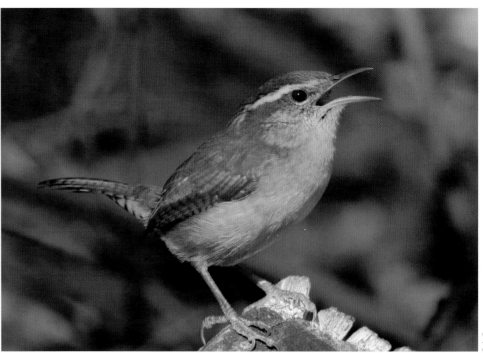

Bob Gress

**Occurrence:** Year-round resident.

**Habitat:** Moist woodlands, parks, and near areas of human habitation.

**North American distribution:** Resident across the southeastern United States and in eastern Mexico.

**Oklahoma distribution:** Recorded across the main body of the state but absent from the Panhandle. Noticeably more widespread and abundant in the moister, more heavily wooded eastern half of the state. As expected for a common, resident species, its summer distribution recorded during the Oklahoma Breeding Bird Atlas Project was very similar.

**Behavior:** Carolina Wren pairs remain together and maintain territories year round. Unlike most songbirds, they sing year round as well. They forage primarily on or near the ground for insects and spiders. This diet makes them susceptible to starvation during extreme, prolonged ice and snow events when the ground remains covered, and recent northward expansions of their range can be set back after such storms.

## Christmas Bird Count (CBC) Results, 1960–2009

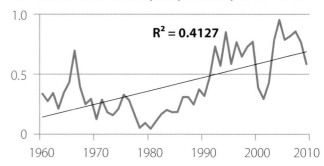

$R^2 = 0.4127$

## CBC Results, 2003–2008

| Winter | Number recorded | Counts reporting |
|--------|-----------------|------------------|
| 2003–2004 | 787 | 17 |
| 2004–2005 | 1,047 | 17 |
| 2005–2006 | 883 | 18 |
| 2006–2007 | 901 | 19 |
| 2007–2008 | 697 | 18 |

**Count per Block Survey**

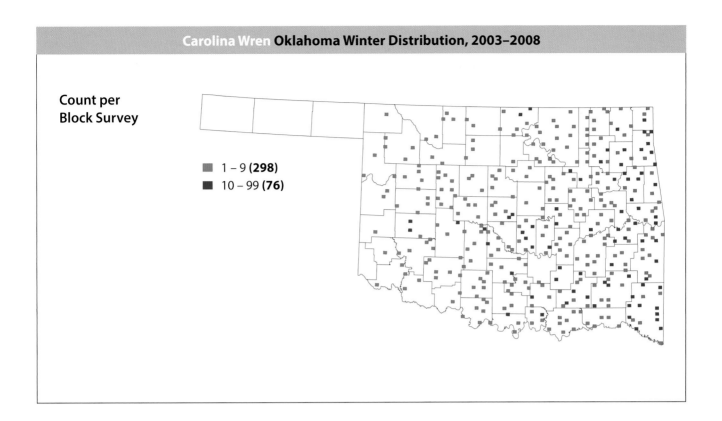

■ 1 – 9 **(298)**
■ 10 – 99 **(76)**

### References

Haggerty, Thomas M., and Eugene S. Morton. 1995. Carolina Wren (*Thryothorus ludovicianus*). *The Birds of North America Online*, edited by A. Poole. Ithaca, N.Y.: Cornell Laboratory of Ornithology. http://bna.birds.cornell.edu.

National Audubon Society. 2011. The Christmas Bird Count historical results. http://www .christmasbirdcount.org.

Oklahoma Bird Records Committee. 2009. *Date Guide to the Occurrences of Birds in Oklahoma*. 5th ed. Norman: Oklahoma Ornithological Society.

Reinking, D. L., ed. 2004. *Oklahoma Breeding Bird Atlas*. Norman: University of Oklahoma Press.

# Bewick's Wren
## *Thryomanes bewickii*

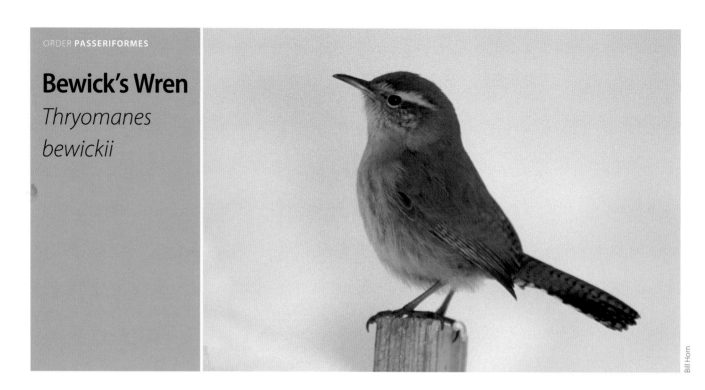

Bill Horn

**Occurrence:** Year-round resident, with some seasonal movements possible in the east.

**Habitat:** Brushy prairie edges, woodlands, rural homesteads, and towns.

**North American distribution:** Resident across much of the southwestern and western United States. Occurs locally as a breeder in parts of the Midwest and mid-South.

**Oklahoma distribution:** Occurred widely across the state, but sparsest in the easternmost counties and the Panhandle region. As expected for a largely nonmigratory species, its winter distribution closely matched the breeding season distribution recorded during the Oklahoma Breeding Bird Atlas Project.

**Behavior:** Usually seen singly or in pairs in territories that are maintained year round. Bewick's Wrens are very active, seldom sitting still for more than a few seconds as they forage for insects and insect larvae. They roost alone at night in tree cavities, dense foliage, nest boxes, or buildings.

### Christmas Bird Count (CBC) Results, 1960–2009

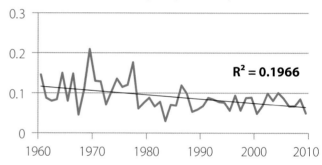

$R^2 = 0.1966$

### CBC Results, 2003–2008

| Winter | Number recorded | Counts reporting |
|---|---|---|
| 2003–2004 | 87 | 14 |
| 2004–2005 | 124 | 11 |
| 2005–2006 | 102 | 16 |
| 2006–2007 | 68 | 13 |
| 2007–2008 | 72 | 16 |

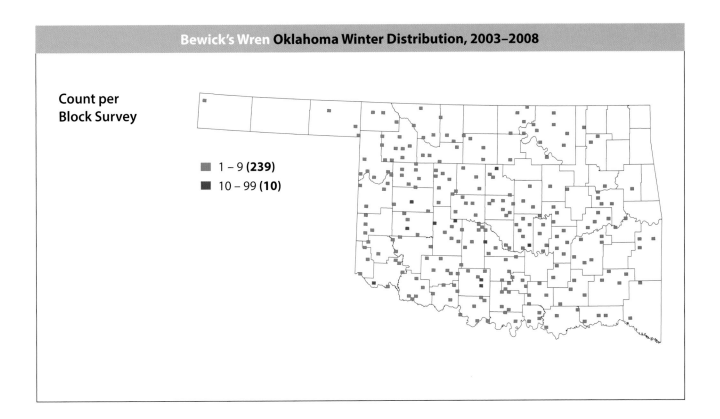

**Count per
Block Survey**

■ 1 – 9 **(239)**
■ 10 – 99 **(10)**

### References

Kennedy, E. Dale, and Douglas W. White. 1997. Bewick's Wren (*Thryomanes bewickii*). *The Birds of North America Online*, edited by A. Poole. Ithaca, N.Y.: Cornell Laboratory of Ornithology. http://bna.birds.cornell.edu.

National Audubon Society. 2011. The Christmas Bird Count historical results. http://www.christmasbirdcount.org.

Oklahoma Bird Records Committee. 2009. *Date Guide to the Occurrences of Birds in Oklahoma*. 5th ed. Norman: Oklahoma Ornithological Society.

Reinking, D. L., ed. 2004. *Oklahoma Breeding Bird Atlas*. Norman: University of Oklahoma Press.

# Blue-gray Gnatcatcher
## *Polioptila caerulea*

Bob Gress

**Occurrence:** Mid-March through early October. Rare in winter.

**Habitat:** Wooded areas.

**North American distribution:** Breeds across much of the southern two-thirds of the lower 48 states. Resident year round or winters in the southernmost United States and Mexico.

**Oklahoma distribution:** Recorded in one survey block straddling Greer and Beckham Counties on February 14, 2005. Also reported as a special interest species from Red Slough Wildlife Management Area in McCurtain County in early December 2007. The summer distribution recorded by the Oklahoma Breeding Bird Atlas Project was nearly statewide except for Texas County.

**Behavior:** Blue-gray Gnatcatchers are usually solitary outside the breeding season. They forage in the outer branches of trees and shrubs for insects and spiders.

## Christmas Bird Count (CBC) Results, 1960–2009

$R^2 = 0.0041$

## CBC Results, 2003–2008

| Winter | Number recorded | Counts reporting |
|--------|-----------------|------------------|
| 2003–2004 | 2 | 1 |
| 2004–2005 | 2 | 1 |
| 2005–2006 | 2 | 1 |
| 2006–2007 | 0 | — |
| 2007–2008 | 1 | 1 |

**Count per Block Survey**

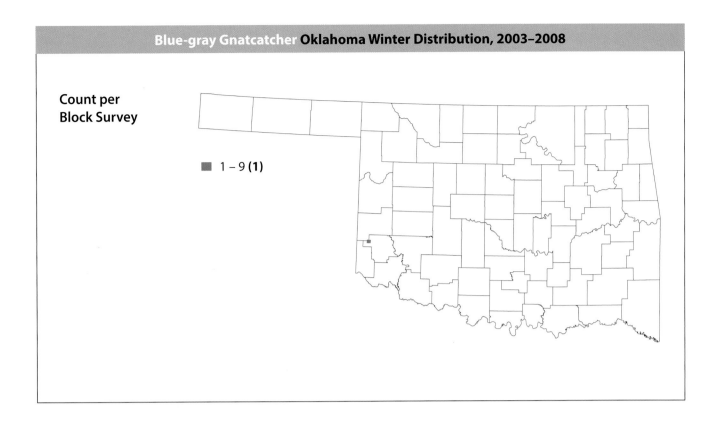

■ 1 – 9 **(1)**

### References

Ellison, Walter G. 1992. Blue-gray Gnatcatcher (*Polioptila caerulea*). *The Birds of North America Online*, edited by A. Poole. Ithaca, N.Y.: Cornell Laboratory of Ornithology. http://bna.birds.cornell.edu.

Heller, V. J. 1978. Second winter sighting of Blue-gray Gnatcatcher in Oklahoma. *Bulletin of the Oklahoma Ornithological Society* 11:32.

National Audubon Society. 2011. The Christmas Bird Count historical results. http://www .christmasbirdcount.org.

Oklahoma Bird Records Committee. 2009. *Date Guide to the Occurrences of Birds in Oklahoma*. 5th ed. Norman: Oklahoma Ornithological Society.

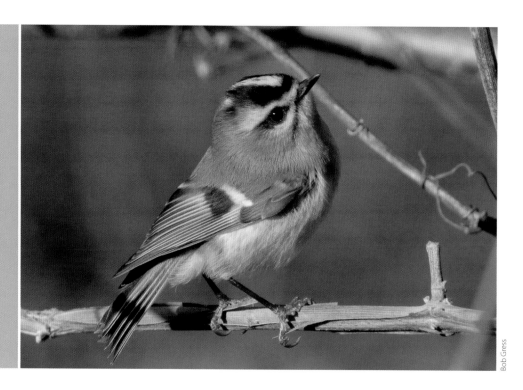

ORDER **PASSERIFORMES**

# Golden-crowned Kinglet
*Regulus satrapa*

Bob Gress

**Occurrence:** October through early April.

**Habitat:** Wooded areas, especially those with cedars or pines.

**North American distribution:** Breeds across much of Canada, resident in parts of the northeastern and western United States, and winters broadly across most of the lower 48 states.

**Oklahoma distribution:** Widely recorded across the main body of the state, especially the eastern two-thirds. Highest concentrations occurred in the southeastern counties where pine trees are prevalent.

**Behavior:** Golden-crowned Kinglets may be seen singly or in small flocks. They often join foraging flocks of chickadees, titmice, nuthatches, and other small songbirds. They forage for insects, spiders, and their eggs in the tips of branches, in clusters of pine needles, and within bark crevices.

## Christmas Bird Count (CBC) Results, 1960–2009

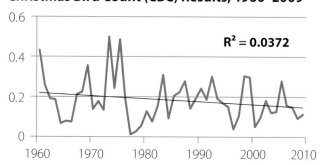

$R^2 = 0.0372$

## CBC Results, 2003–2008

| Winter | Number recorded | Counts reporting |
|---|---|---|
| 2003–2004 | 117 | 17 |
| 2004–2005 | 121 | 14 |
| 2005–2006 | 307 | 18 |
| 2006–2007 | 165 | 17 |
| 2007–2008 | 117 | 15 |

Count per
Block Survey

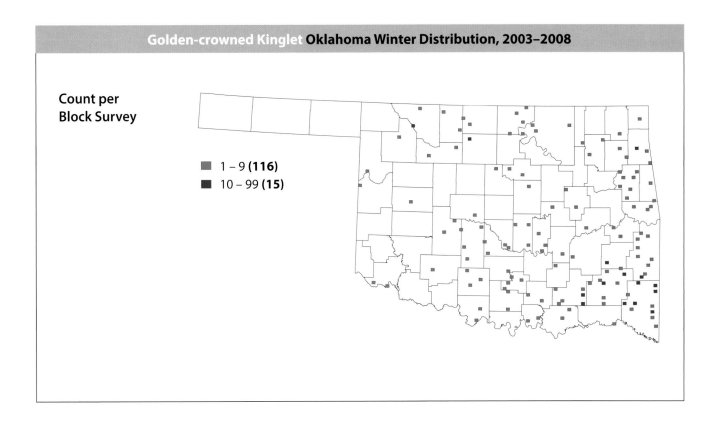

■ 1 – 9 **(116)**
■ 10 – 99 **(15)**

### References

Ingold, James L., and Robert Galati. 1997. Golden-crowned Kinglet (*Regulus satrapa*). *The Birds of North America Online*, edited by A. Poole. Ithaca, N.Y.: Cornell Laboratory of Ornithology. http://bna.birds .cornell.edu.

National Audubon Society. 2011. The Christmas Bird Count historical results. http://www .christmasbirdcount.org.

Oklahoma Bird Records Committee. 2009. *Date Guide to the Occurrences of Birds in Oklahoma*. 5th ed. Norman: Oklahoma Ornithological Society.

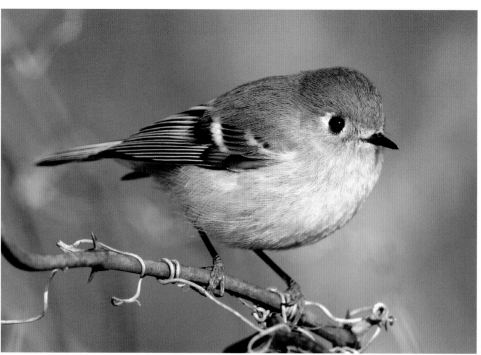

## Ruby-crowned Kinglet
### ORDER PASSERIFORMES

*Regulus calendula*

**Occurrence:** Mid-September through mid-May.

**Habitat:** Pine forests and brushy deciduous woodlands in both rural areas and towns.

**North American distribution:** Breeds in Alaska, much of Canada, and parts of the northern and western lower 48 states. Winters broadly in the western and southern United States and in Mexico.

**Oklahoma distribution:** Recorded commonly in survey blocks statewide, although least frequently in the Panhandle, where brushy woodlands are scarce. The largest abundances were recorded in McCurtain County pine forests.

**Behavior:** Ruby-crowned Kinglets can be seen in small groups, especially early in the winter, but may become more territorial by late winter. They are often seen in mixed-species foraging flocks with chickadees and other species. They forage for insects, spiders, and the eggs of both on branch tips and at the base of pine needles.

**Christmas Bird Count (CBC) Results, 1960–2009**

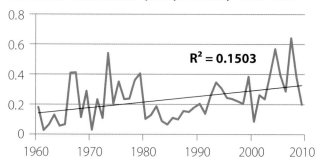

$R^2 = 0.1503$

**CBC Results, 2003–2008**

| Winter | Number recorded | Counts reporting |
| --- | --- | --- |
| 2003–2004 | 413 | 18 |
| 2004–2005 | 593 | 19 |
| 2005–2006 | 436 | 19 |
| 2006–2007 | 295 | 17 |
| 2007–2008 | 597 | 20 |

**Count per Block Survey**

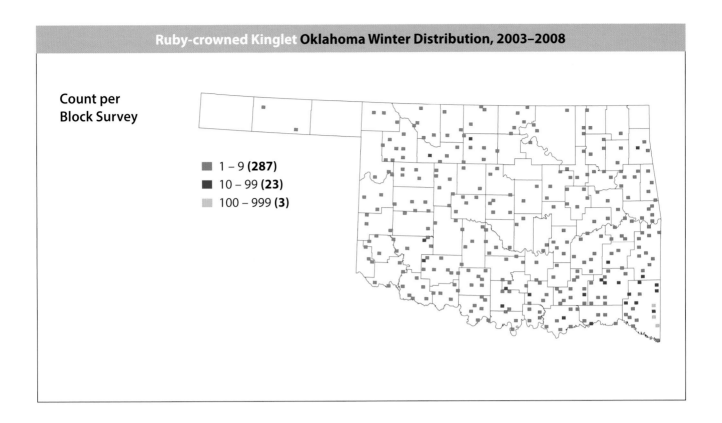

■ 1 – 9 **(287)**
■ 10 – 99 **(23)**
■ 100 – 999 **(3)**

### References

National Audubon Society. 2011. The Christmas Bird Count historical results. http://www
.christmasbirdcount.org.

Oklahoma Bird Records Committee. 2009. *Date Guide to the Occurrences of Birds in Oklahoma.* 5th ed.
Norman: Oklahoma Ornithological Society.

Swanson, David L., J. L. Ingold, and G. E. Wallace. 2008. Ruby-crowned Kinglet (*Regulus calendula*). *The
Birds of North America Online*, edited by A. Poole. Ithaca, N.Y.: Cornell Laboratory of Ornithology.
http://bna.birds.cornell.edu.

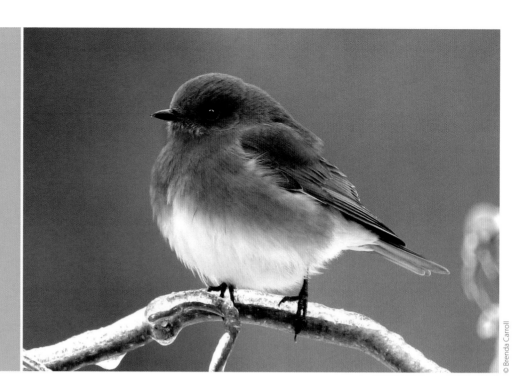

ORDER **PASSERIFORMES**

# Eastern Bluebird
## *Sialia sialis*

© Brenda Carroll

**Occurrence:** Present year round, although numbers may be supplemented by northern breeding migrants during spring and fall.

**Habitat:** Open woodlands, parks, rural homesteads, and country roadsides with scattered trees.

**North American distribution:** Breeds in the eastern half of southern Canada and the United States, where it is mostly a permanent resident south of New York. Also resident in parts of Mexico, and winters in parts of west Texas.

**Oklahoma distribution:** Recorded statewide in most survey blocks, although somewhat less prevalent in the Panhandle, where trees are less common. The summer distribution recorded by the Oklahoma Breeding Bird Atlas Project was very similar, although no records were reported from Texas or Cimarron Counties, suggesting that northern breeding birds may be migrating to the Panhandle for the winter.

**Behavior:** Eastern Bluebirds are usually seen in pairs or small family groups during the winter, and they defend breeding or feeding territories. They forage for insects on the ground in bare or grassy areas, and also for fruit in bushes or trees.

**Christmas Bird Count (CBC) Results, 1960–2009**

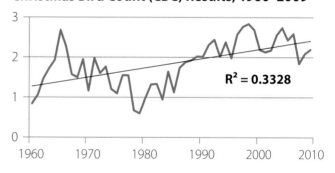

$R^2 = 0.3328$

**CBC Results, 2003–2008**

| Winter | Number recorded | Counts reporting |
| --- | --- | --- |
| 2003–2004 | 2,727 | 20 |
| 2004–2005 | 2,772 | 20 |
| 2005–2006 | 2,462 | 20 |
| 2006–2007 | 2,621 | 19 |
| 2007–2008 | 1,569 | 20 |

Count per
Block Survey

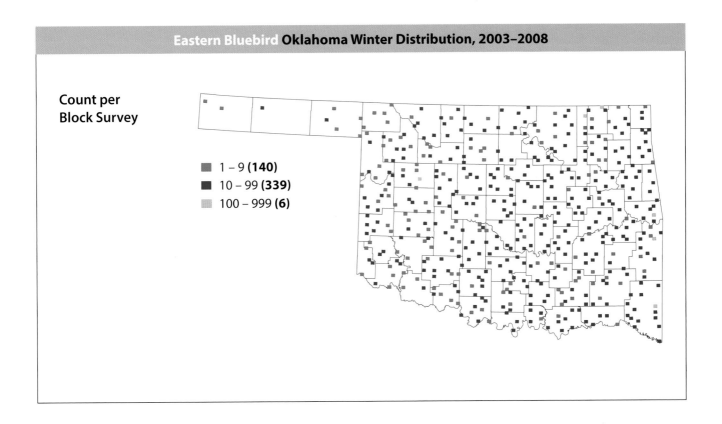

■ 1 – 9 **(140)**
■ 10 – 99 **(339)**
▓ 100 – 999 **(6)**

**References**

Gowaty, Patricia Adair, and Jonathan H. Plissner. 1998. Eastern Bluebird (*Sialia sialis*). *The Birds of North America Online*, edited by A. Poole. Ithaca, N.Y.: Cornell Laboratory of Ornithology. http://bna.birds .cornell.edu.

National Audubon Society. 2011. The Christmas Bird Count historical results. http://www .christmasbirdcount.org.

Oklahoma Bird Records Committee. 2009. *Date Guide to the Occurrences of Birds in Oklahoma*. 5th ed. Norman: Oklahoma Ornithological Society.

Reinking, D. L., ed. 2004. *Oklahoma Breeding Bird Atlas*. Norman: University of Oklahoma Press.

# Western Bluebird
*Sialia mexicana*

Bob Gress

**Occurrence:** Rare in winter.

**Habitat:** Woodlands with fruit-producing trees and shrubs such as junipers.

**North American distribution:** Breeder or resident in parts of southwestern Canada, the western lower 48 states, and Mexico.

**Oklahoma distribution:** Not recorded in survey blocks. A special interest species report came from Cimarron County on December 7 and December 28, 2007 (up to six birds in two locations; also see Oklahoma Bird Records Committee 2009a).

**Behavior:** Western Bluebirds usually form winter flocks that may include Mountain Bluebirds or American Robins. They forage for berries in trees or on the ground.

## Christmas Bird Count (CBC) Results, 1960–2009

$R^2 = 0.0000$

## CBC Results, 2003–2008

| Winter | Number recorded | Counts reporting |
|--------|-----------------|------------------|
| 2003–2004 | 0 | — |
| 2004–2005 | 0 | — |
| 2005–2006 | 0 | — |
| 2006–2007 | 0 | — |
| 2007–2008 | 6 | 1 |

Count per
Block Survey

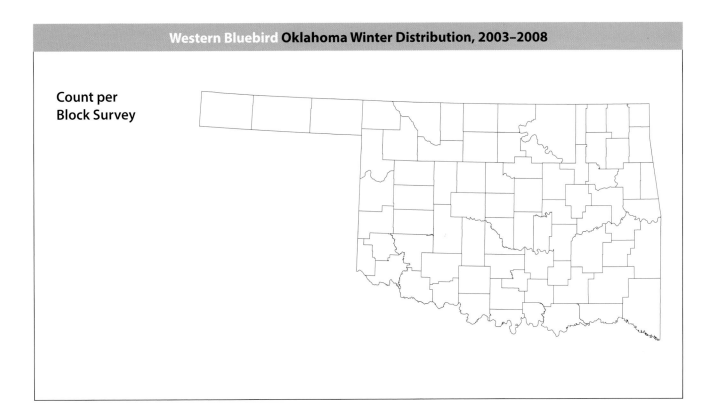

### References

Carter, W. A. 1971. Another new bird for Oklahoma: Western Bluebird. *Bulletin of the Oklahoma Ornithological Society* 4:36–37.

———. 1972. Second Western Bluebird record for Oklahoma. *Bulletin of the Oklahoma Ornithological Society* 5:33.

Guinan, Judith A., Patricia A. Gowaty, and Elsie K. Eltzroth. 2008. Western Bluebird (*Sialia mexicana*). *The Birds of North America Online*, edited by A. Poole. Ithaca, N.Y.: Cornell Laboratory of Ornithology. http://bna.birds.cornell.edu.

National Audubon Society. 2011. The Christmas Bird Count historical results. http://www.christmasbirdcount.org.

Oklahoma Bird Records Committee. 2009a. 2007–2008 winter season. *The Scissortail* 59:4–8.

———. 2009b. *Date Guide to the Occurrences of Birds in Oklahoma*. 5th ed. Norman: Oklahoma Ornithological Society.

# Mountain Bluebird
## *Sialia currucoides*

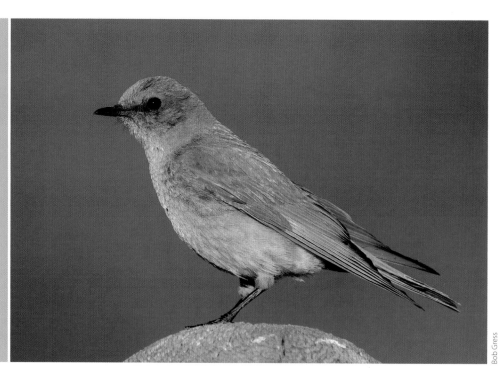

Bob Gress

**Occurrence:** October through early April. There are contemporary nest records in Cimarron County.

**Habitat:** Open grasslands with scattered trees or cedar groves.

**North American distribution:** Breeds in southern Alaska, western Canada, and the northwestern United States. Resident in parts of the western United States, and winters slightly east and south of its breeding range.

**Oklahoma distribution:** Recorded at scattered locations in the western half of the state, with the highest concentration of reports and the largest abundances coming from northwestern counties. This species is somewhat irregular in its occurrence in the state. The number of survey blocks reporting Mountain Bluebirds in each of the five winters of surveys was 3, 14, 0, 18, and 4, respectively. Two nest records were recorded in western Cimarron County during the Oklahoma Breeding Bird Atlas Project.

**Behavior:** Mountain Bluebirds are gregarious during winter, usually occurring in groups of a few to dozens of birds. They forage on bare ground or in short vegetation but often look for food from a perch. Their winter diet is made up largely of insects when available, and fruits including cedar and sumac berries.

**Christmas Bird Count (CBC) Results, 1960–2009**

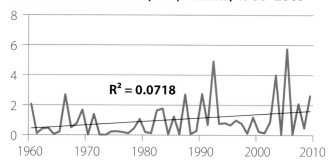

$R^2 = 0.0718$

**CBC Results, 2003–2008**

| Winter | Number recorded | Counts reporting |
|---|---|---|
| 2003–2004 | 2,964 | 2 |
| 2004–2005 | 26 | 4 |
| 2005–2006 | 5,737 | 1 |
| 2006–2007 | 70 | 4 |
| 2007–2008 | 1,591 | 2 |

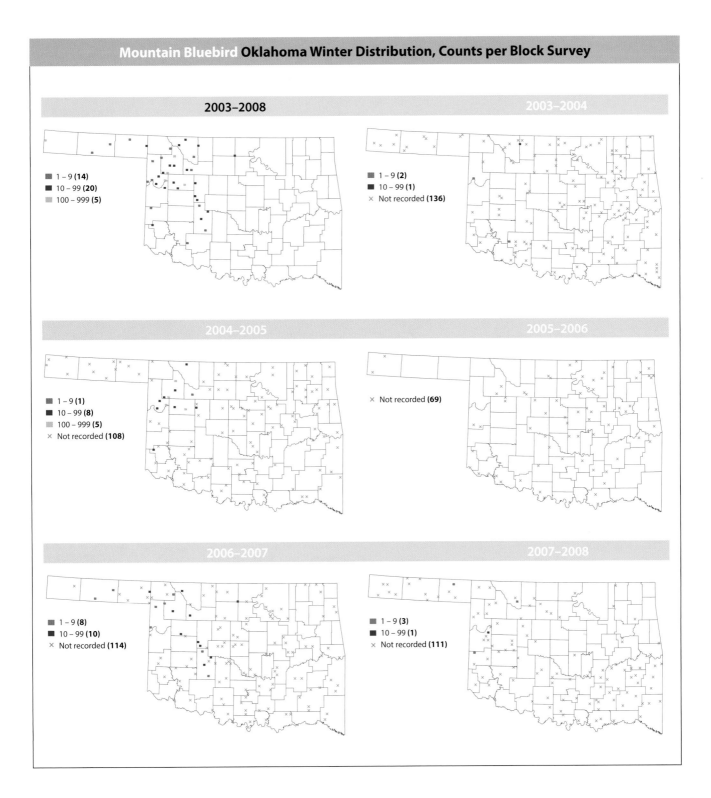

2003–2008

1 – 9 **(14)**
10 – 99 **(20)**
100 – 999 **(5)**

2003–2004

1 – 9 **(2)**
10 – 99 **(1)**
× Not recorded **(136)**

2004–2005

1 – 9 **(1)**
10 – 99 **(8)**
100 – 999 **(5)**
× Not recorded **(108)**

2005–2006

× Not recorded **(69)**

2006–2007

1 – 9 **(8)**
10 – 99 **(10)**
× Not recorded **(114)**

2007–2008

1 – 9 **(3)**
10 – 99 **(1)**
× Not recorded **(111)**

## References

National Audubon Society. 2011. The Christmas Bird Count historical results. http://www
.christmasbirdcount.org.

Oklahoma Bird Records Committee. 2009. *Date Guide to the Occurrences of Birds in Oklahoma*. 5th ed.
Norman: Oklahoma Ornithological Society.

Power, Harry W., and Michael P. Lombardo. 1996. Mountain Bluebird (*Sialia currucoides*). *The Birds of North
America Online*, edited by A. Poole. Ithaca, N.Y.: Cornell Laboratory of Ornithology. http://bna.birds
.cornell.edu.

Reinking, D. L., ed. 2004. *Oklahoma Breeding Bird Atlas*. Norman: University of Oklahoma Press.

Tyler, J. D., and J. Bechtold. 1996. Statuses of four avian species in southwestern Oklahoma. *Bulletin of the
Oklahoma Ornithological Society* 29:27–34.

# Townsend's Solitaire
## *Myadestes townsendi*

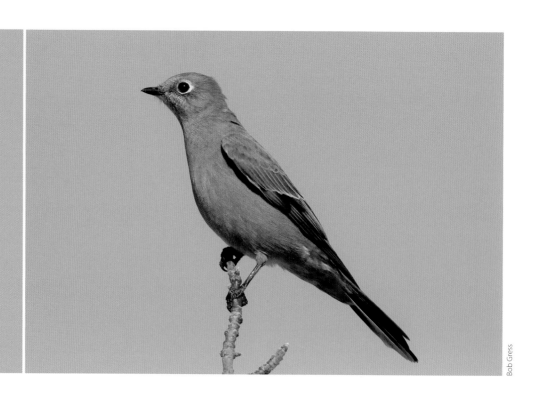

Bob Gress

**Occurrence:** November through April in western counties and slightly earlier and later in the Panhandle.

**Habitat:** Woodlands or stands of junipers or cedar trees.

**North American distribution:** Breeds in Alaska and western Canada. Resident in parts of the western lower 48 states and Mexico. Winters somewhat east of its year-round range.

**Oklahoma distribution:** Recorded in scattered survey blocks in the Panhandle as well as in northwestern and north-central counties.

**Behavior:** True to its name, the Townsend's Solitaire is usually seen singly, and individuals aggressively defend winter feeding territories from others. These territories include berry-producing patches of junipers or cedars on which the solitaires forage during the winter. Those with larger or more productive territories have higher winter survival.

## Christmas Bird Count (CBC) Results, 1960–2009

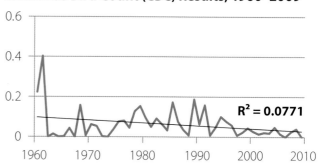

$R^2 = 0.0771$

## CBC Results, 2003–2008

| Winter | Number recorded | Counts reporting |
|---|---|---|
| 2003–2004 | 15 | 2 |
| 2004–2005 | 40 | 3 |
| 2005–2006 | 14 | 2 |
| 2006–2007 | 0 | — |
| 2007–2008 | 21 | 4 |

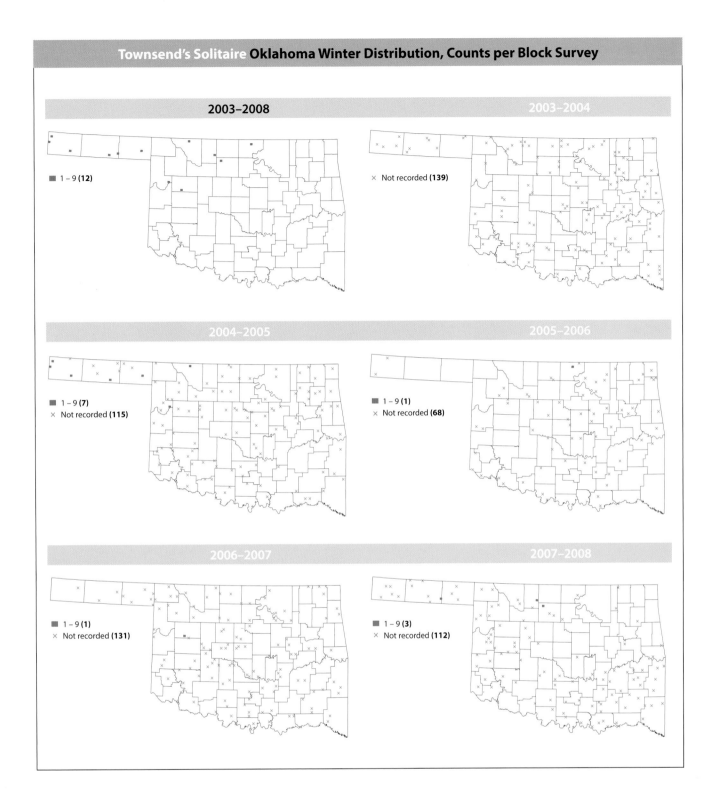

**2003–2008**

■ 1 – 9 **(12)**

**2003–2004**

× Not recorded **(139)**

**2004–2005**

■ 1 – 9 **(7)**
× Not recorded **(115)**

**2005–2006**

■ 1 – 9 **(1)**
× Not recorded **(68)**

**2006–2007**

■ 1 – 9 **(1)**
× Not recorded **(131)**

**2007–2008**

■ 1 – 9 **(3)**
× Not recorded **(112)**

### References

Bowen, Rhys V. 1997. Townsend's Solitaire (*Myadestes townsendi*). *The Birds of North America Online*, edited by A. Poole. Ithaca, N.Y.: Cornell Laboratory of Ornithology. http://bna.birds.cornell.edu.

National Audubon Society. 2011. The Christmas Bird Count historical results. http://www .christmasbirdcount.org.

Oklahoma Bird Records Committee. 2009. *Date Guide to the Occurrences of Birds in Oklahoma*. 5th ed. Norman: Oklahoma Ornithological Society.

# Hermit Thrush
## *Catharus guttatus*

Bill Horn

**Occurrence:** Mid-October through late April. Absent from the Panhandle in January and February.

**Habitat:** Wooded areas with a brushy understory.

**North American distribution:** Breeds in much of Alaska and Canada, the northeastern United States, and much of the western United States. Winters across much of the southern United States and in Mexico.

**Oklahoma distribution:** Recorded in scattered locations in the eastern two-thirds of the state, with the highest concentrations of records and the most birds recorded in the heavily wooded southeastern counties.

**Behavior:** Hermit Thrushes are usually seen singly. They forage in low vegetation or on the ground for berries and insects. When on the ground, they hop in the manner of American Robins.

## Christmas Bird Count (CBC) Results, 1960–2009

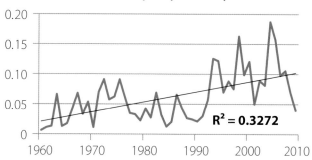

$R^2 = 0.3272$

## CBC Results, 2003–2008

| Winter | Number recorded | Counts reporting |
|--------|-----------------|------------------|
| 2003–2004 | 86 | 12 |
| 2004–2005 | 186 | 15 |
| 2005–2006 | 151 | 17 |
| 2006–2007 | 93 | 14 |
| 2007–2008 | 84 | 12 |

**Count per Block Survey**

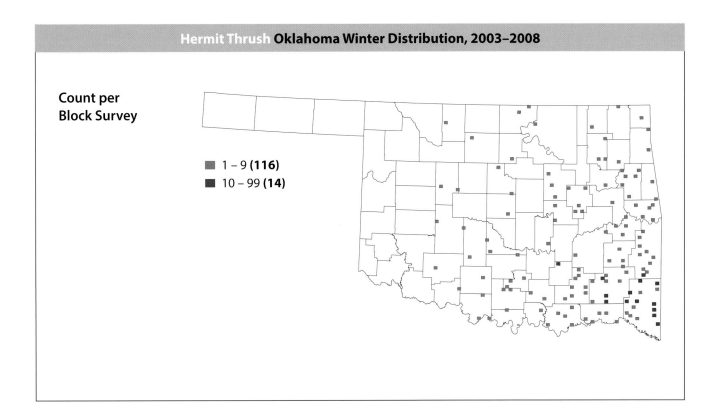

1 – 9 **(116)**

10 – 99 **(14)**

**References**

Jones, Peter W., and Therese M. Donovan. 1996. Hermit Thrush (*Catharus guttatus*). *The Birds of North America Online*, edited by A. Poole. Ithaca, N.Y.: Cornell Laboratory of Ornithology. http://bna.birds .cornell.edu.

National Audubon Society. 2011. The Christmas Bird Count historical results. http://www .christmasbirdcount.org.

Oklahoma Bird Records Committee. 2009. *Date Guide to the Occurrences of Birds in Oklahoma*. 5th ed. Norman: Oklahoma Ornithological Society.

# American Robin
## *Turdus migratorius*

© Brenda Carroll

**Occurrence:** Present year round and more abundant during winter, although there is large seasonal turnover of individuals.

**Habitat:** Parks, woodlands, roadsides, cities, and towns.

**North American distribution:** Breeds across Alaska and Canada and is a year-round resident across most of the lower 48 states and Mexico.

**Oklahoma distribution:** Robins were recorded in all counties, with a fairly even distribution except for the western Panhandle, where they were less common. This distribution closely resembles that found during the Oklahoma Breeding Bird Atlas surveys. The large number of blocks with hundreds to thousands of robins reflects their tendency to form large winter flocks where food and cover are available. An estimated flock of 100,000 was reported on December 21, 2006, in Broken Bow in McCurtain County, and another estimate of 1.25 million birds came from Payne County on February 2, 2008.

**Behavior:** Many robins move into Oklahoma for the winter months from breeding areas farther north, while Oklahoma's nesting robins also move south for the winter. Their diet shifts to one of primarily fruit during the winter months, and large but transient flocks can form in local areas where berries are plentiful.

**Christmas Bird Count (CBC) Results, 1960–2009**

$R^2 = 0.026$

**CBC Results, 2003–2008**

| Winter | Number recorded | Counts reporting |
|---|---|---|
| 2003–2004 | 18,272 | 19 |
| 2004–2005 | 56,022 | 20 |
| 2005–2006 | 24,590 | 20 |
| 2006–2007 | 21,463 | 19 |
| 2007–2008 | 42,513 | 20 |

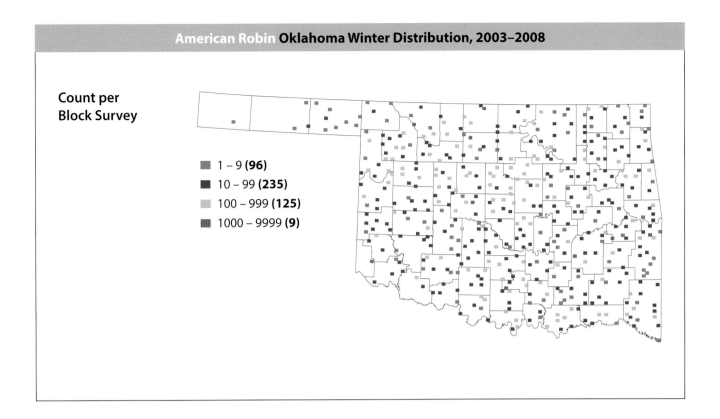

Count per
Block Survey

- 1 – 9 **(96)**
- 10 – 99 **(235)**
- 100 – 999 **(125)**
- 1000 – 9999 **(9)**

### References

Harden, W. D. 1981. Robins banded in summer in central Oklahoma and recovered at same locality in winter. *Bulletin of the Oklahoma Ornithological Society* 14:8.

National Audubon Society. 2011. The Christmas Bird Count historical results. http://www .christmasbirdcount.org.

Oklahoma Bird Records Committee. 2007. 2006–2007 winter season. *The Scissortail* 57:24–27.

———. 2009a. 2007–2008 winter season. *The Scissortail* 59:4–8.

———. 2009b. *Date Guide to the Occurrences of Birds in Oklahoma.* 5th ed. Norman: Oklahoma Ornithological Society.

Sallabanks, Rex, and Frances C. James. 1999. American Robin (*Turdus migratorius*). *The Birds of North America Online,* edited by A. Poole. Ithaca, N.Y.: Cornell Laboratory of Ornithology. http://bna.birds .cornell.edu.

# Gray Catbird
## *Dumetella carolinensis*

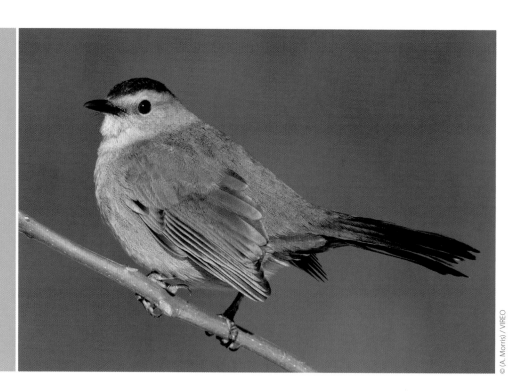

© (A. Morris) / VIREO

**Occurrence:** Mid-April through mid-October.

**Habitat:** Dense, shrubby areas.

**North American distribution:** Breeds widely from British Columbia to the east and southeast. Resident along much of the Atlantic Coast and in parts of the southeastern United States. Winters along the Gulf Coast, throughout Florida, and along the east coast of Mexico.

**Oklahoma distribution:** Not a typical wintering species in the state. It was recorded in a Logan County survey block on January 19, 2005, as well as in McCurtain County on December 30, 2003, and on February 13, 2004, at another location. Gray Catbirds were found during summer in the eastern half of the state as part of the Oklahoma Breeding Bird Atlas Project, but they typically leave the state in the fall.

**Behavior:** Because of their rarity in Oklahoma during the winter, Gray Catbirds are likely to be seen singly if at all. They forage both on the ground and in trees for insects and fruits.

## Christmas Bird Count (CBC) Results, 1960–2009

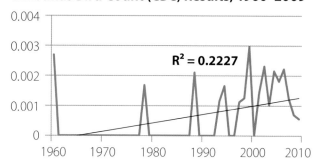

$R^2 = 0.2227$

## CBC Results, 2003–2008

| Winter | Number recorded | Counts reporting |
|---|---|---|
| 2003–2004 | 1 | 1 |
| 2004–2005 | 2 | 1 |
| 2005–2006 | 2 | 2 |
| 2006–2007 | 2 | 1 |
| 2007–2008 | 1 | 1 |

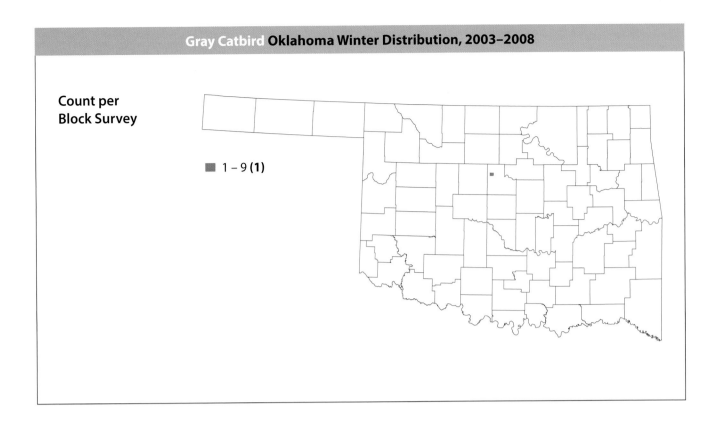

**Count per
Block Survey**

■ 1 – 9 **(1)**

### References

Dingman, S. 1989. Gray Catbird in Tulsa County, Oklahoma, in winter. *Bulletin of the Oklahoma Ornithological Society* 22:15–16.

National Audubon Society. 2011. The Christmas Bird Count historical results. http://www .christmasbirdcount.org.

Oklahoma Bird Records Committee. 2004. 2003–2004 winter season. *The Scissortail* 54:25–27.

———. 2009. *Date Guide to the Occurrences of Birds in Oklahoma.* 5th ed. Norman: Oklahoma Ornithological Society.

Reinking, D. L., ed. 2004. *Oklahoma Breeding Bird Atlas.* Norman: University of Oklahoma Press.

Smith, Robert J., Margret I. Hatch, David A. Cimprich, and Frank R. Moore. 2011. Gray Catbird (*Dumetella carolinensis*). *The Birds of North America Online,* edited by A. Poole. Ithaca, N.Y.: Cornell Laboratory of Ornithology. http://bna.birds.cornell.edu.

# Curve-billed Thrasher

## *Toxostoma curvirostre*

ORDER **PASSERIFORMES**

Steve Metz

**Occurrence:** Year-round resident.

**Habitat:** Mesquite grasslands, brushy areas with cacti, and farm and ranch yards.

**North American distribution:** Resident in the southwestern United States and in Mexico.

**Oklahoma distribution:** Not recorded in survey blocks. In contrast, the summer distribution recorded by the Oklahoma Breeding Bird Atlas Project included 11 survey blocks in Cimarron, Greer, Harmon, Jackson, and Texas Counties. This suggests either that some seasonal movements out of these areas actually do take place (somewhat contrary to published sources), or perhaps that this species is present but much less detectable during the winter months. The number of birds recorded on the Kenton Christmas Bird Count (Cimarron County) in each of the five atlas project winters was 6, 10, 5, 0, and 0, respectively.

**Behavior:** In most of their range, Curve-billed Thrashers remain paired and territorial year round. They forage on the ground or in low shrubs for insects, seeds, and fruits.

## Christmas Bird Count (CBC) Results, 1960–2009

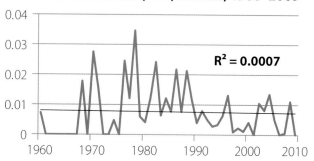

$R^2 = 0.0007$

## CBC Results, 2003–2008

| Winter | Number recorded | Counts reporting |
|--------|-----------------|------------------|
| 2003–2004 | 6 | 1 |
| 2004–2005 | 10 | 1 |
| 2005–2006 | 5 | 1 |
| 2006–2007 | 0 | — |
| 2007–2008 | 1 | 1 |

Count per
Block Survey

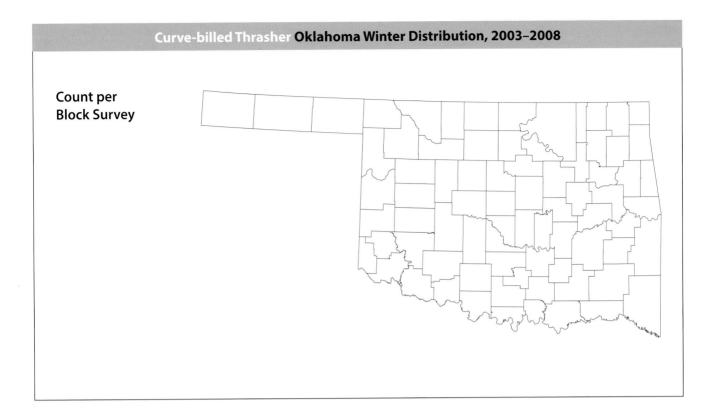

### References

Ault, J. W., III. 1984. The Curve-billed Thrasher in southwestern Oklahoma. *Bulletin of the Oklahoma Ornithological Society* 17:12–14.

Baumgartner, F. M., and A. M. Baumgartner. 1992. *Oklahoma Bird Life*. Norman: University of Oklahoma Press.

National Audubon Society. 2011. The Christmas Bird Count historical results. http://www .christmasbirdcount.org.

Oklahoma Bird Records Committee. 2009. *Date Guide to the Occurrences of Birds in Oklahoma*. 5th ed. Norman: Oklahoma Ornithological Society.

Reinking, D. L., ed. 2004. *Oklahoma Breeding Bird Atlas*. Norman: University of Oklahoma Press.

Sutton, G. M. 1968. Curve-billed Thrasher in Jackson County, southwestern Oklahoma. *Bulletin of the Oklahoma Ornithological Society* 1:19.

Tweit, Robert C. 1996. Curve-billed Thrasher (*Toxostoma curvirostre*). *The Birds of North America Online*, edited by A. Poole. Ithaca, N.Y.: Cornell Laboratory of Ornithology. http://bna.birds.cornell.edu.

# Brown Thrasher
*Toxostoma rufum*

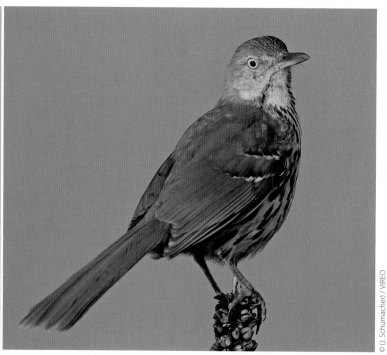

© (J. Schumacher) / VIREO

**Occurrence:** Year round, though seasonal movements make them scarce in northern and northwestern counties in winter.

**Habitat:** Wooded areas, including towns with hedgerows or sufficient shrub cover.

**North American distribution:** Breeds across roughly the eastern two-thirds of the United States and much of southernmost Canada. Present year round in the southeastern United States and along much of the Atlantic Coast.

**Oklahoma distribution:** Well represented in central and southern counties during winter, but scarce in northern counties and absent from northwestern counties and the Panhandle. This contrasts with the Oklahoma Breeding Bird Atlas surveys, in which they were common virtually statewide during summer.

**Behavior:** Usually seen singly in areas with shrub cover. Brown Thrashers do the majority of their foraging on the ground in search of seeds, berries, and insects.

## Christmas Bird Count (CBC) Results, 1960–2009

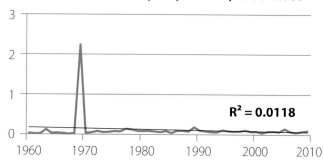

$R^2 = 0.0118$

## CBC Results, 2003–2008

| Winter | Number recorded | Counts reporting |
|--------|-----------------|------------------|
| 2003–2004 | 86 | 12 |
| 2004–2005 | 82 | 10 |
| 2005–2006 | 141 | 14 |
| 2006–2007 | 71 | 13 |
| 2007–2008 | 86 | 12 |

Count per
Block Survey

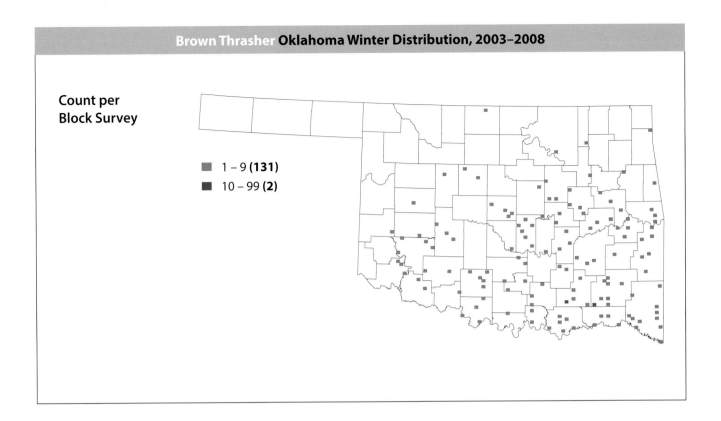

■ 1 – 9 **(131)**
■ 10 – 99 **(2)**

### References

Cavitt, John F., and Carola A. Haas. 2000. Brown Thrasher (*Toxostoma rufum*). *The Birds of North America Online*, edited by A. Poole. Ithaca, N.Y.: Cornell Laboratory of Ornithology. http://bna.birds.cornell.edu.

National Audubon Society. 2011. The Christmas Bird Count historical results. http://www.christmasbirdcount.org.

Oklahoma Bird Records Committee. 2009. *Date Guide to the Occurrences of Birds in Oklahoma*. 5th ed. Norman: Oklahoma Ornithological Society.

Reinking, D. L., ed. 2004. *Oklahoma Breeding Bird Atlas*. Norman: University of Oklahoma Press.

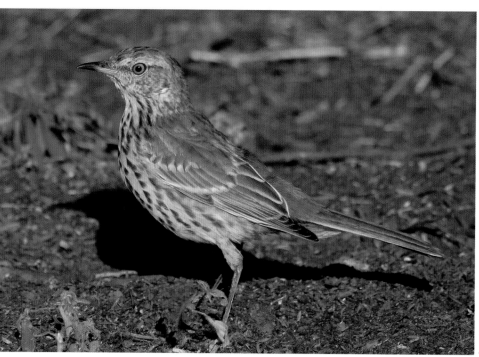

ORDER **PASSERIFORMES**

# Sage Thrasher
*Oreoscoptes montanus*

Steve Metz

**Occurrence:** September through March in Cimarron County, and rarely from mid-October through February in southwestern counties.

**Habitat:** Open, arid country with scattered shrubs.

**North American distribution:** Breeds throughout much of the western United States. Winters in the southwestern United States and in Mexico.

**Oklahoma distribution:** Recorded in one Nowata County survey block in late December 2006, which is well east of its expected range. Additional special interest species records fit the expected distribution pattern and came from Greer, Harmon, Jackson, Kiowa, and Cimarron (two locations) Counties in the winter of 2003–2004, Kiowa County in December 2004, and Cimarron County (two locations) in December 2007.

**Behavior:** In other parts of their range, Sage Thrashers winter in flocks, but they are uncommon in Oklahoma and are more likely to be seen singly or in small groups. They forage on the ground, but little is known regarding their winter diet.

**Christmas Bird Count (CBC) Results, 1960–2009**

$R^2 = 0.0178$

**CBC Results, 2003–2008**

| Winter | Number recorded | Counts reporting |
|--------|-----------------|------------------|
| 2003–2004 | 9 | 1 |
| 2004–2005 | 0 | — |
| 2005–2006 | 12 | 1 |
| 2006–2007 | 0 | — |
| 2007–2008 | 5 | 1 |

**Count per
Block Survey**

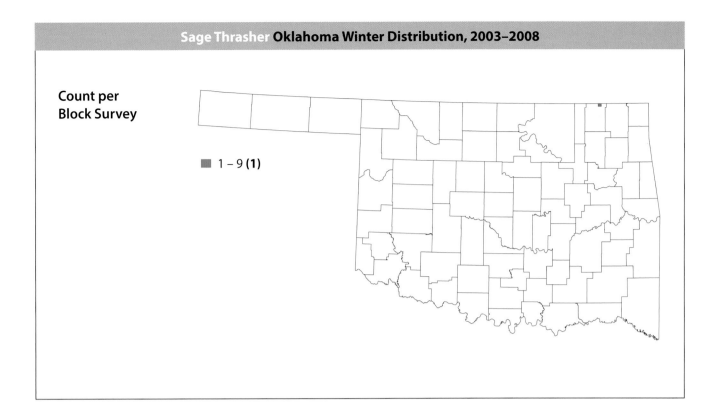

■ 1 – 9 **(1)**

### References

Carter, W. A., and J. D. Tyler. 1970. Extralimital Sage Thrasher records for Oklahoma. *Bulletin of the Oklahoma Ornithological Society* 3:4–5.

National Audubon Society. 2011. The Christmas Bird Count historical results. http://www .christmasbirdcount.org.

Oklahoma Bird Records Committee. 2005. 2004–2005 winter season. *The Scissortail* 55:18–20.

———. 2009. *Date Guide to the Occurrences of Birds in Oklahoma.* 5th ed. Norman: Oklahoma Ornithological Society.

Reynolds, Timothy D., Terrell D. Rich, and Daniel A. Stephens. 1999. Sage Thrasher (*Oreoscoptes montanus*). *The Birds of North America Online*, edited by A. Poole. Ithaca, N.Y.: Cornell Laboratory of Ornithology. http://bna.birds.cornell.edu.

Tyler, J. D. 1978. Sage Thrasher in Comanche and Jackson counties, Oklahoma. *Bulletin of the Oklahoma Ornithological Society* 11:32.

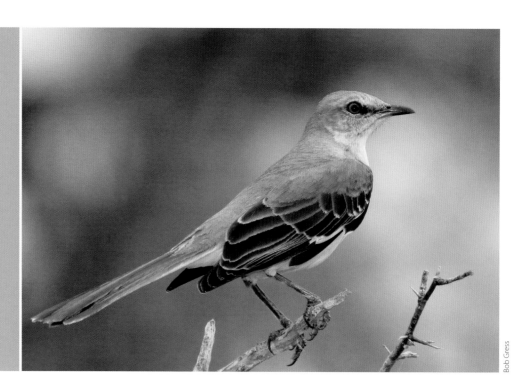

ORDER **PASSERIFORMES**

# Northern Mockingbird
*Mimus polyglottos*

Bob Gress

**Occurrence:** Year-round resident.

**Habitat:** Open, shrubby areas including roadsides, parks, farmsteads, and towns.

**North American distribution:** Resident from New Brunswick southwest through the eastern, south-central, and southwestern United States and Mexico. Breeds somewhat north of its year-round range.

**Oklahoma distribution:** Recorded statewide, though less frequently observed in the northwestern and Panhandle counties and most abundant in the eastern half of the state. The summer distribution recorded by the Oklahoma Breeding Bird Atlas Project was largely similar but was denser in the northwestern and Panhandle counties, suggesting the possibility of seasonal movements to and from these areas.

**Behavior:** Northern Mockingbirds are usually seen singly or in pairs, which defend a territory all year. They are known for dive-bombing cats and dogs within their territory. They forage for insects on the ground in short, grassy areas, and in trees and shrubs for fruits that make up most of their winter diet.

### Christmas Bird Count (CBC) Results, 1960–2009

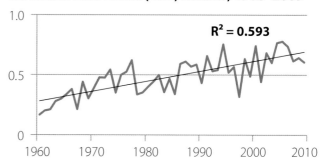

$R^2 = 0.593$

### CBC Results, 2003–2008

| Winter | Number recorded | Counts reporting |
|--------|-----------------|------------------|
| 2003–2004 | 719 | 19 |
| 2004–2005 | 946 | 18 |
| 2005–2006 | 968 | 18 |
| 2006–2007 | 884 | 18 |
| 2007–2008 | 505 | 17 |

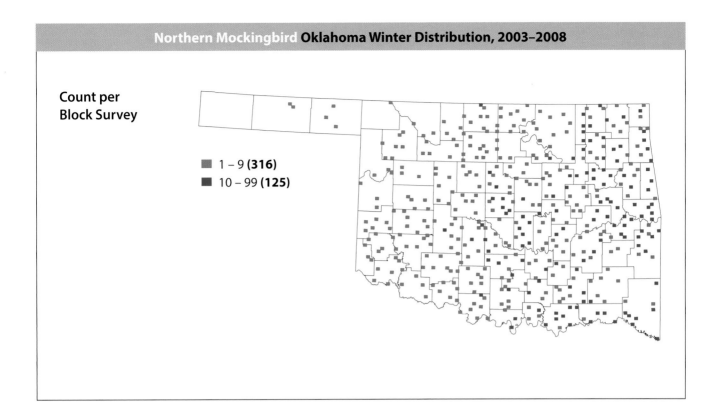

Count per
Block Survey

■ 1 – 9 **(316)**
■ 10 – 99 **(125)**

### References

Derrickson, K. C., and R. Breitwisch. 1992. Northern Mockingbird (*Mimus polyglottos*). *The Birds of North America Online*, edited by A. Poole. Ithaca, N.Y.: Cornell Laboratory of Ornithology. http://bna.birds .cornell.edu.

National Audubon Society. 2011. The Christmas Bird Count historical results. http://www .christmasbirdcount.org.

Oklahoma Bird Records Committee. 2009. *Date Guide to the Occurrences of Birds in Oklahoma*. 5th ed. Norman: Oklahoma Ornithological Society.

Reinking, D. L., ed. 2004. *Oklahoma Breeding Bird Atlas*. Norman: University of Oklahoma Press.

# European Starling

## *Sturnus vulgaris*

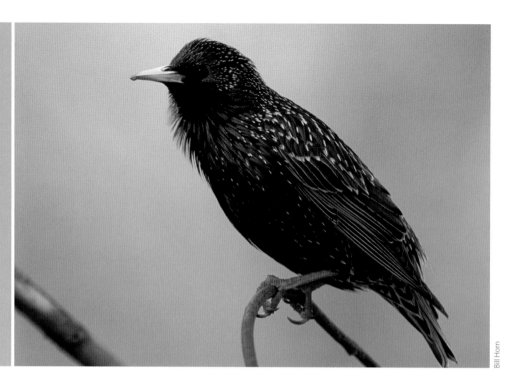

Bill Horn

**Occurrence:** Most are year-round residents in Oklahoma, although migratory movements take place in certain northern and midwestern populations.

**Habitat:** Frequently found near residential or commercial buildings, as well as parks, grassy areas, and feedlots.

**North American distribution:** Breeds across the central latitudes of Canada, and resident from southern Canada south to northern Mexico.

**Oklahoma distribution:** Widespread throughout the state, with slightly lower concentrations in the heavily forested southeastern counties. Very large concentrations were noted in scattered locations, primarily in northern counties. As expected for a resident species, the summer distribution recorded during the Oklahoma Breeding Bird Atlas Project was very similar.

**Behavior:** European Starlings are highly gregarious, frequently feeding and roosting in large flocks. They forage mostly on the ground in bare or grassy areas in search of grain, seeds, fruits, and insects. They often associate with blackbirds while foraging, particularly near feedlots or under bird feeders.

### Christmas Bird Count (CBC) Results, 1960–2009

$R^2 = 0.054$

### CBC Results, 2003–2008

| Winter | Number recorded | Counts reporting |
|--------|-----------------|------------------|
| 2003–2004 | 33,703 | 18 |
| 2004–2005 | 34,616 | 20 |
| 2005–2006 | 42,881 | 19 |
| 2006–2007 | 27,304 | 18 |
| 2007–2008 | 71,773 | 20 |

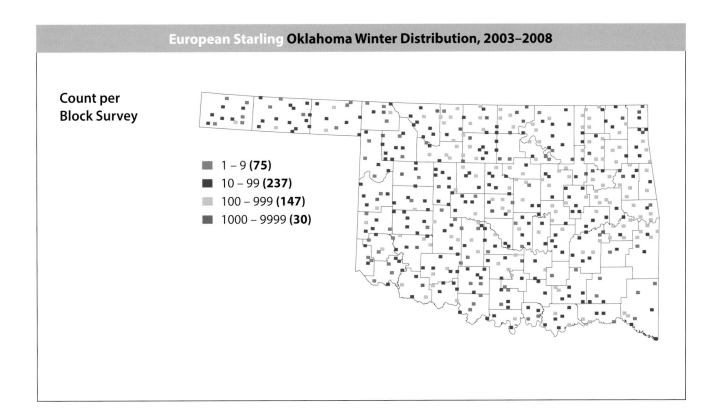

Count per
Block Survey

■ 1 – 9 **(75)**
■ 10 – 99 **(237)**
■ 100 – 999 **(147)**
■ 1000 – 9999 **(30)**

**References**

Cabe, Paul R. 1993. European Starling (*Sturnus vulgaris*). *The Birds of North America Online*, edited by
   A. Poole. Ithaca, N.Y.: Cornell Laboratory of Ornithology. http://bna.birds.cornell.edu.
National Audubon Society. 2011. The Christmas Bird Count historical results. http://www
   .christmasbirdcount.org.
Oklahoma Bird Records Committee. 2009. *Date Guide to the Occurrences of Birds in Oklahoma*. 5th ed.
   Norman: Oklahoma Ornithological Society.
Reinking, D. L., ed. 2004. *Oklahoma Breeding Bird Atlas*. Norman: University of Oklahoma Press.

# Bohemian Waxwing
*Bombycilla garrulus*

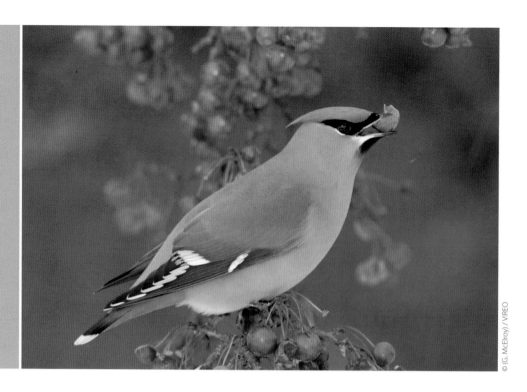

© (G. McElroy) / VIREO

**Occurrence:** Rare in winter.

**Habitat:** Wooded areas with fruit-producing trees or shrubs.

**North American distribution:** Breeds in Alaska and parts of northern and western Canada. Winters in parts of the north-central United States.

**Oklahoma distribution:** Not recorded in survey blocks. Reported as a special interest species in Guymon (Texas County) in early December 2004 (two birds), and in Carter County in late December 2004 (two birds).

**Behavior:** Bohemian Waxwings are gregarious and often associate with Cedar Waxwings and American Robins at food sources. They forage in trees and shrubs for fruits as well as insects when available.

## CBC Results, 2003–2008

| Winter | Number recorded | Counts reporting |
|---|---|---|
| 2003–2004 | 0 | — |
| 2004–2005 | 0 | — |
| 2005–2006 | 0 | — |
| 2006–2007 | 0 | — |
| 2007–2008 | 0 | — |

**Count per
Block Survey**

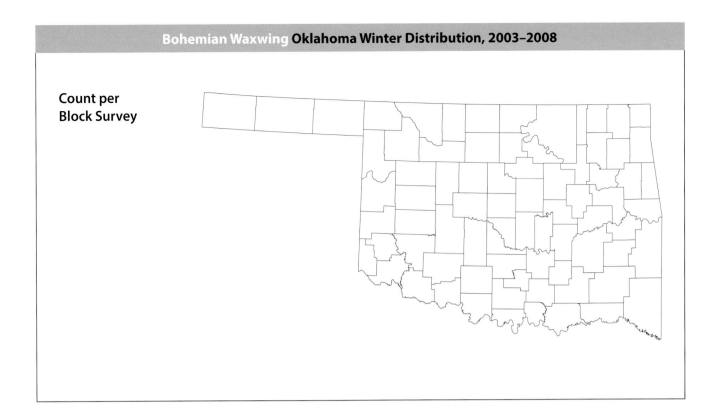

### References

National Audubon Society. 2011. The Christmas Bird Count historical results. http://www
.christmasbirdcount.org.

Oklahoma Bird Records Committee. 2009. *Date Guide to the Occurrences of Birds in Oklahoma*. 5th ed.
Norman: Oklahoma Ornithological Society.

Witmer, Mark C. 2002. Bohemian Waxwing (*Bombycilla garrulus*). *The Birds of North America Online*, edited
by A. Poole. Ithaca, N.Y.: Cornell Laboratory of Ornithology. http://bna.birds.cornell.edu.

# Cedar Waxwing
## *Bombycilla cedrorum*

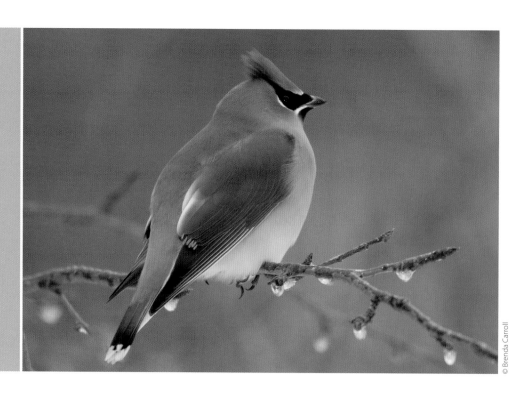

© Brenda Carroll

**Occurrence:** Present year round, but vastly more numerous from fall through spring.

**Habitat:** Woodlands, parks, cities, and towns where berries are available.

**North American distribution:** Breeds across southern Canada, present year round in the northern half of the lower 48 states, and winters in the southern half of the United States and in Mexico.

**Oklahoma distribution:** Recorded nearly statewide, though less commonly in the Panhandle, where trees and shrubs are less plentiful. No regions within the main body of the state appeared to have greater concentrations of waxwings than others, and both small and large flocks appeared evenly distributed. Two exceptionally large concentrations were reported from Garfield and Greer Counties. There are only a few widely scattered historical records of waxwings nesting in the state, and only one confirmed breeding record, in Ottawa County, during the Oklahoma Breeding Bird Atlas Project.

**Behavior:** Cedar Waxwings are gregarious in winter, with flock sizes ranging from a few individuals to more than 1,000. Their winter diet of sugary fruits forces them to be nomadic as they move from place to place in search of berry-producing trees. Fermentation of the sugars in berries occasionally produces alcohol, which can render waxwings drunk or even fatally poison them.

**Christmas Bird Count (CBC) Results, 1960–2009**

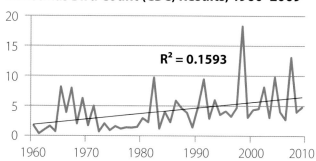

$R^2 = 0.1593$

**CBC Results, 2003–2008**

| Winter | Number recorded | Counts reporting |
|--------|-----------------|------------------|
| 2003–2004 | 3,333 | 16 |
| 2004–2005 | 10,702 | 20 |
| 2005–2006 | 4,391 | 17 |
| 2006–2007 | 3,166 | 18 |
| 2007–2008 | 8,429 | 19 |

**Count per Block Survey**

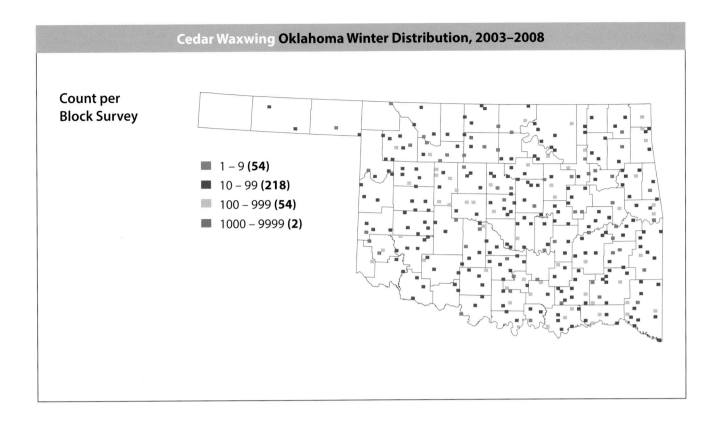

■ 1 – 9 **(54)**
■ 10 – 99 **(218)**
■ 100 – 999 **(54)**
■ 1000 – 9999 **(2)**

**References**

Muzny, P. L. 1982. Goldfinches and waxwing drinking maple sap. *Bulletin of the Oklahoma Ornithological Society* 15:8.

National Audubon Society. 2011. The Christmas Bird Count historical results. http://www .christmasbirdcount.org.

Oklahoma Bird Records Committee. 2009. *Date Guide to the Occurrences of Birds in Oklahoma*. 5th ed. Norman: Oklahoma Ornithological Society.

Reinking, D. L., ed. 2004. *Oklahoma Breeding Bird Atlas*. Norman: University of Oklahoma Press.

Witmer, M. C., D. J. Mountjoy, and L. Elliot. 1997. Cedar Waxwing (*Bombycilla cedrorum*). *The Birds of North America Online*, edited by A. Poole. Ithaca, N.Y.: Cornell Laboratory of Ornithology. http://bna.birds .cornell.edu.

# House Sparrow
## *Passer domesticus*

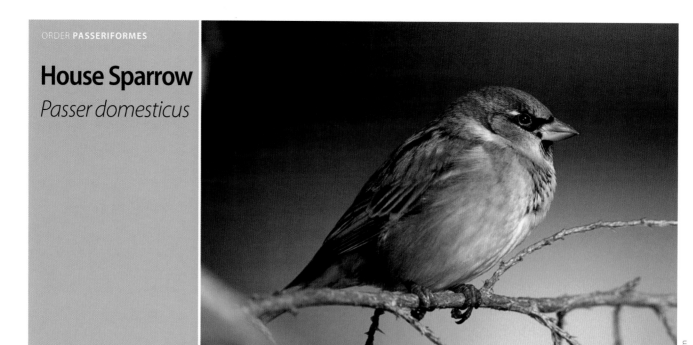

Bill Horn

**Occurrence:** Year-round resident.

**Habitat:** Farms, feedlots, cities, and towns.

**North American distribution:** Resident from the central Canadian latitudes south through Mexico.

**Oklahoma distribution:** Recorded at moderate densities in a majority of survey blocks statewide. As expected for a resident species, the summer distribution recorded by the Oklahoma Breeding Bird Atlas Project was similar.

**Behavior:** House Sparrows are gregarious, especially during the winter, when they are typically seen in flocks. They defend small areas around individual roost sites under building eaves or in nest boxes, but they forage and loaf in groups. Foraging for seeds takes place mostly on the ground, although they will also readily visit bird feeders.

**Christmas Bird Count (CBC) Results, 1960–2009**

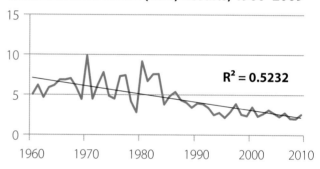

$R^2 = 0.5232$

**CBC Results, 2003–2008**

| Winter | Number recorded | Counts reporting |
|---|---|---|
| 2003–2004 | 3,369 | 19 |
| 2004–2005 | 3,163 | 20 |
| 2005–2006 | 2,954 | 20 |
| 2006–2007 | 3,620 | 18 |
| 2007–2008 | 1,487 | 20 |

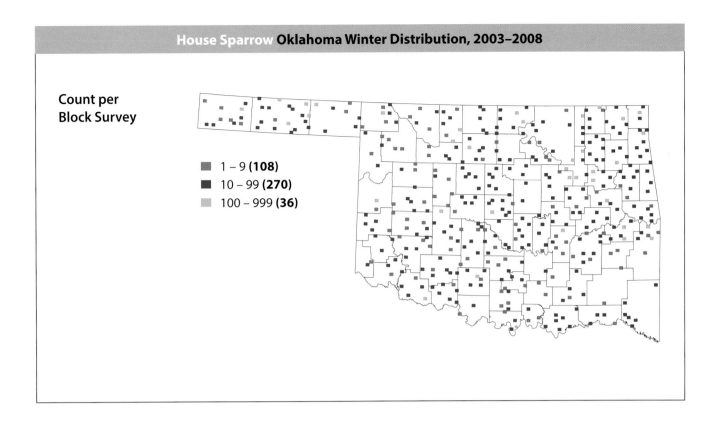

**Count per
Block Survey**

■ 1 – 9 **(108)**
■ 10 – 99 **(270)**
■ 100 – 999 **(36)**

### References

Lowther, Peter E., and Calvin L. Cink. 2006. House Sparrow (*Passer domesticus*). *The Birds of North America Online*, edited by A. Poole. Ithaca, N.Y.: Cornell Laboratory of Ornithology. http://bna.birds.cornell.edu.

National Audubon Society. 2011. The Christmas Bird Count historical results. http://www.christmasbirdcount.org.

Oklahoma Bird Records Committee. 2009. *Date Guide to the Occurrences of Birds in Oklahoma*. 5th ed. Norman: Oklahoma Ornithological Society.

Reinking, D. L., ed. 2004. *Oklahoma Breeding Bird Atlas*. Norman: University of Oklahoma Press.

# American Pipit
*Anthus rubescens*

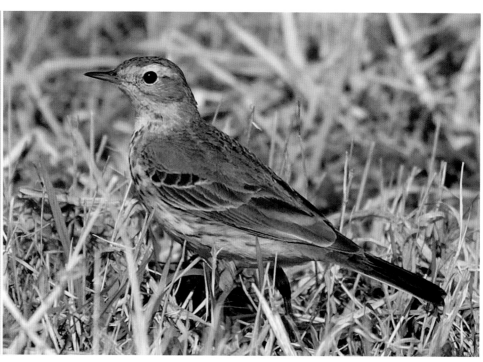

James Arterburn

**Occurrence:** Late September through April.

**Habitat:** Prairies, plowed fields, and lakeshores.

**North American distribution:** Breeds in Alaska, Canada, and parts of most western states. Winters along the East and West Coasts and in the southern third of the lower 48 states as well as in Mexico.

**Oklahoma distribution:** There was little pattern to its winter distribution, with widely scattered records coming from all regions of the state. Many blocks with moderate abundance and several blocks with high abundance reflect its tendency to form winter flocks. An estimated 600–800 were reported on January 21, 2007, at Hackberry Flat Wildlife Management Area in Tillman County.

**Behavior:** Pipits are found on the ground or seen in flight and can be observed singly or in small to large flocks. They eat insects and seeds obtained by walking or running.

**Christmas Bird Count (CBC) Results, 1960–2009**

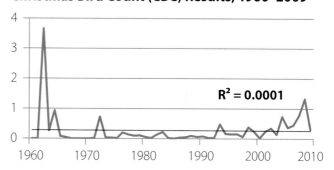

$R^2 = 0.0001$

**CBC Results, 2003–2008**

| Winter | Number recorded | Counts reporting |
|---|---|---|
| 2003–2004 | 222 | 10 |
| 2004–2005 | 548 | 10 |
| 2005–2006 | 427 | 11 |
| 2006–2007 | 474 | 14 |
| 2007–2008 | 603 | 8 |

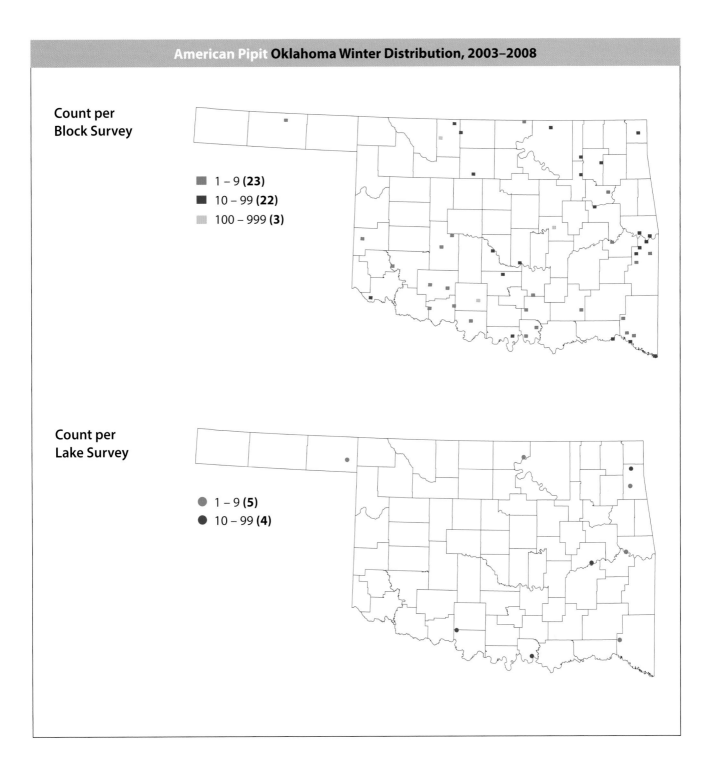

Count per
Block Survey

■ 1 – 9 **(23)**
■ 10 – 99 **(22)**
▨ 100 – 999 **(3)**

Count per
Lake Survey

● 1 – 9 **(5)**
● 10 – 99 **(4)**

**References**

National Audubon Society. 2011. The Christmas Bird Count historical results. http://www
      .christmasbirdcount.org.

Oklahoma Bird Records Committee. 2007. 2006–2007 winter season. *The Scissortail* 57:24–27.

———. 2009. *Date Guide to the Occurrences of Birds in Oklahoma.* 5th ed. Norman: Oklahoma
      Ornithological Society.

Verbeek, N. A., and P. Hendricks. 1994. American Pipit (*Anthus rubescens*). *The Birds of North America Online,*
      edited by A. Poole. Ithaca, N.Y.: Cornell Laboratory of Ornithology. http://bna.birds.cornell.edu.

# Sprague's Pipit
## *Anthus spragueii*

Bob Gress

**Occurrence:** Late September through late December, and late February through early May.

**Habitat:** Open, short grasslands lacking shrubs, and agricultural fields.

**North American distribution:** Breeds in south-central Canada and the north-central United States. Winters in the south-central United States and in Mexico.

**Oklahoma distribution:** Not recorded in survey blocks. A special interest species report was received for Kiowa County on December 21, 2004. The Sooner Lake Christmas Bird Count (CBC) recorded one bird in December 2006 and two birds in December 2007. The Stillwater CBC recorded one bird in December 2006. The Tallgrass Prairie Preserve CBC in Osage County recorded four birds in late December 2005, eight birds in late December 2006, and two birds in early January 2008 (National Audubon Society 2011).

**Behavior:** Sprague's Pipits are usually seen singly. They forage on the ground for arthropods and seeds.

**Christmas Bird Count (CBC) Results, 1960–2009**

$R^2 = 0.0891$

**CBC Results, 2003–2008**

| Winter | Number recorded | Counts reporting |
|--------|-----------------|------------------|
| 2003–2004 | 0 | — |
| 2004–2005 | 0 | — |
| 2005–2006 | 4 | 1 |
| 2006–2007 | 10 | 3 |
| 2007–2008 | 4 | 2 |

**Count per
Block Survey**

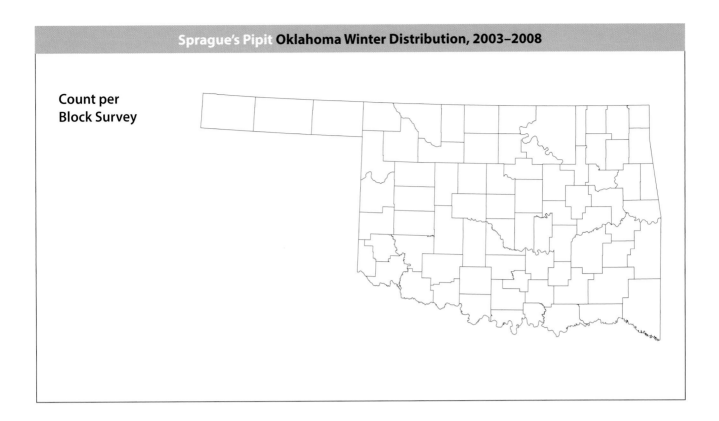

### References

National Audubon Society. 2011. The Christmas Bird Count historical results. http://www
.christmasbirdcount.org.

Oklahoma Bird Records Committee. 2009. *Date Guide to the Occurrences of Birds in Oklahoma*. 5th ed.
Norman: Oklahoma Ornithological Society.

Robbins, Mark B., and Brenda C. Dale. 1999. Sprague's Pipit (*Anthus spragueii*). *The Birds of North America
Online*, edited by A. Poole. Ithaca, N.Y.: Cornell Laboratory of Ornithology. http://bna.birds.cornell.edu.

# Pine Grosbeak
## *Pinicola enucleator*

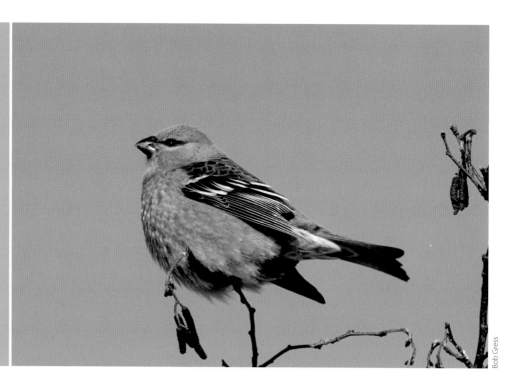

Bob Gress

**Occurrence:** Rare in winter.

**Habitat:** Conifers and broad-leaved woodlands.

**North American distribution:** Breeds in northern Alaska and Canada. Resident across central Alaska and Canada and parts of the western lower 48 states. Winters irregularly south of these areas.

**Oklahoma distribution:** Not recorded in survey blocks. Special interest species reports documented one male in Texas County (Sunset Lake in Guymon) from December 31, 2004, through January 25, 2005.

**Behavior:** Pine Grosbeaks often occur in small flocks, although because the species is rare in Oklahoma, single birds may be more likely here. They forage on the ground or in trees and shrubs for seeds and fruits during the winter. They sometimes also visit bird feeders for sunflower seeds.

## CBC Results, 2003–2008

| Winter | Number recorded | Counts reporting |
|---|---|---|
| 2003–2004 | 0 | — |
| 2004–2005 | 0 | — |
| 2005–2006 | 0 | — |
| 2006–2007 | 0 | — |
| 2007–2008 | 0 | — |

**Count per Block Survey**

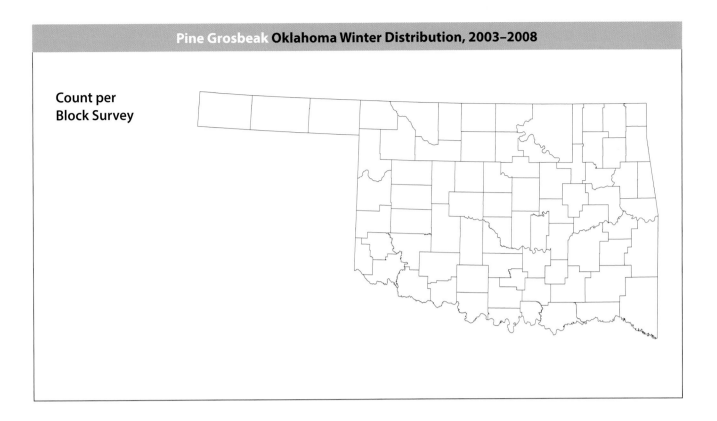

### References

Adkisson, Curtis S. 1999. Pine Grosbeak (*Pinicola enucleator*). *The Birds of North America Online*, edited by A. Poole. Ithaca, N.Y.: Cornell Laboratory of Ornithology. http://bna.birds.cornell.edu.

Flowers, T. L. 1980. Pine Grosbeak in Cimarron County, Oklahoma. 1980. *Bulletin of the Oklahoma Ornithological Society* 13:33–34.

National Audubon Society. 2011. The Christmas Bird Count historical results. http://www .christmasbirdcount.org.

Oklahoma Bird Records Committee. 2005. 2004–2005 winter season. *The Scissortail* 55:18–20.

———. 2009. *Date Guide to the Occurrences of Birds in Oklahoma*. 5th ed. Norman: Oklahoma Ornithological Society.

Reinking, D. L. 1993. Pine Grosbeak in Tulsa County, Oklahoma. *Bulletin of the Oklahoma Ornithological Society* 26:32.

———, ed. 2004. *Oklahoma Breeding Bird Atlas*. Norman: University of Oklahoma Press.

Ruggiers, P. G., and E. Ruggiers. 1971. Pine Grosbeak in Cleveland County, Oklahoma. *Bulletin of the Oklahoma Ornithological Society* 4:37–38.

# House Finch
## *Haemorhous mexicanus*

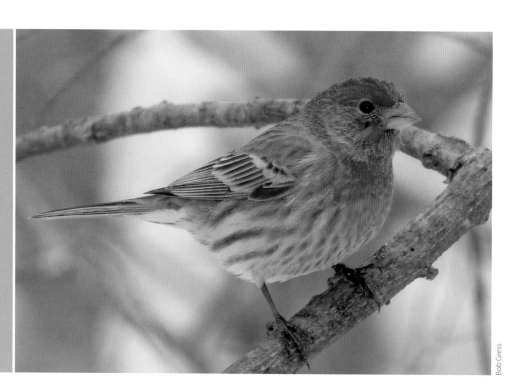

Bob Gress

**Occurrence:** Year-round resident.

**Habitat:** Woodlands, weedy fields, farms, and neighborhoods.

**North American distribution:** Resident from southernmost Canada through Mexico.

**Oklahoma distribution:** Recorded statewide, with slightly fewer records from southern portions of the state. The summer distribution recorded during the Oklahoma Breeding Bird Atlas Project was similar.

**Behavior:** House Finches are usually seen in small flocks during the winter and often associate with groups of House Sparrows and American Goldfinches. They forage on the ground or in trees for seeds, buds, and fruits. They readily come to bird feeders for seeds.

**Christmas Bird Count (CBC) Results, 1960–2009**

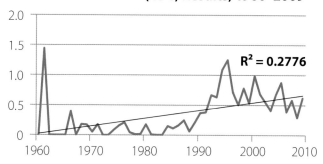

$R^2 = 0.2776$

**CBC Results, 2003–2008**

| Winter | Number recorded | Counts reporting |
|---|---|---|
| 2003–2004 | 550 | 15 |
| 2004–2005 | 713 | 19 |
| 2005–2006 | 1,000 | 18 |
| 2006–2007 | 481 | 14 |
| 2007–2008 | 571 | 20 |

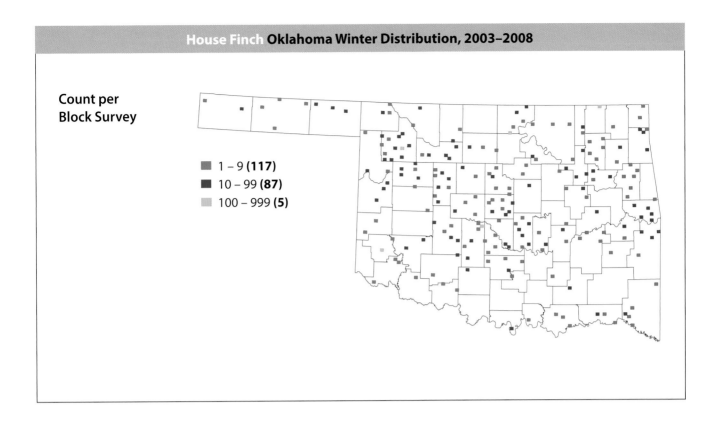

Count per
Block Survey

■ 1 – 9 **(117)**
■ 10 – 99 **(87)**
▨ 100 – 999 **(5)**

**References**

Hill, Geoffrey E. 1993. House Finch (*Carpodacus mexicanus*). *The Birds of North America Online*, edited by A. Poole. Ithaca, N.Y.: Cornell Laboratory of Ornithology. http://bna.birds.cornell.edu.

National Audubon Society. 2011. The Christmas Bird Count historical results. http://www .christmasbirdcount.org.

Oklahoma Bird Records Committee. 2009. *Date Guide to the Occurrences of Birds in Oklahoma.* 5th ed. Norman: Oklahoma Ornithological Society.

Oliphant, M., and I. S. Brown. Eastward expansion of the House Finch's range in Oklahoma. *Bulletin of the Oklahoma Ornithological Society* 17:9–12.

Reinking, D. L., ed. 2004. *Oklahoma Breeding Bird Atlas.* Norman: University of Oklahoma Press.

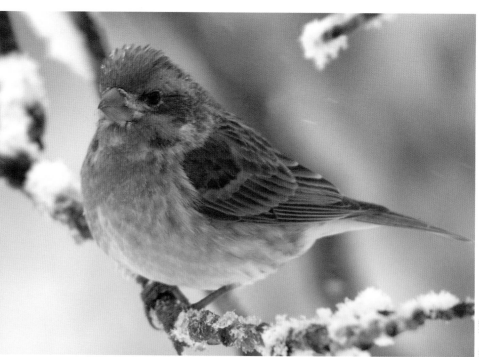

ORDER **PASSERIFORMES**

# Purple Finch
*Haemorhous*
*purpureus*

**Occurrence:** Late October through late April.

**Habitat:** Woodlands and towns.

**North American distribution:** Breeds across much of Canada. Resident in parts of the northeastern and western United States. Winters broadly throughout the eastern United States.

**Oklahoma distribution:** Recorded in survey blocks statewide except for southwestern and Panhandle counties. The greatest frequency of occurrence and the highest abundances were in southeastern counties. Purple Finches are known as an irruptive species, occurring more frequently and in greater numbers in some winters than in others based on the availability of conifer seed crops. Surveys captured considerable year-to-year variation in the frequency and scope of their distribution in the state.

**Behavior:** Purple Finches are seen singly or in small groups, and they often associate with flocks of American Goldfinches and Pine Siskins. They forage on outer tree branches and on the ground for seeds, as well as buds and fruits when available. They readily visit bird feeders for sunflower seeds.

**Christmas Bird Count (CBC) Results, 1960–2009**

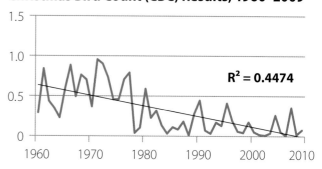

$R^2 = 0.4474$

**CBC Results, 2003–2008**

| Winter | Number recorded | Counts reporting |
|---|---|---|
| 2003–2004 | 39 | 5 |
| 2004–2005 | 299 | 18 |
| 2005–2006 | 53 | 10 |
| 2006–2007 | 9 | 5 |
| 2007–2008 | 307 | 18 |

# Purple Finch Oklahoma Winter Distribution, Counts per Block Survey

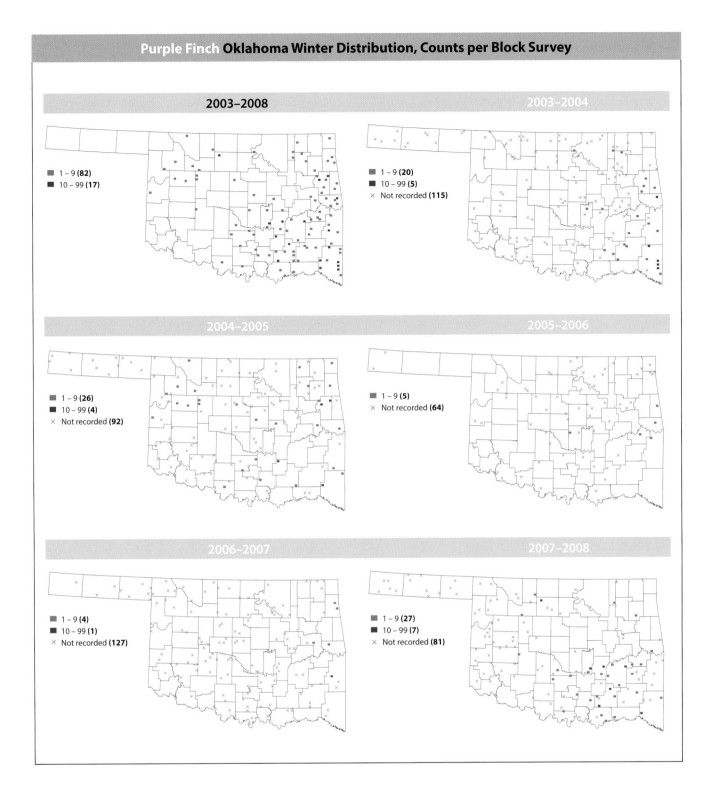

## 2003–2008

- ■ 1 – 9 (82)
- ■ 10 – 99 (17)

## 2003–2004

- ■ 1 – 9 (20)
- ■ 10 – 99 (5)
- × Not recorded (115)

## 2004–2005

- ■ 1 – 9 (26)
- ■ 10 – 99 (4)
- × Not recorded (92)

## 2005–2006

- ■ 1 – 9 (5)
- × Not recorded (64)

## 2006–2007

- ■ 1 – 9 (4)
- ■ 10 – 99 (1)
- × Not recorded (127)

## 2007–2008

- ■ 1 – 9 (27)
- ■ 10 – 99 (7)
- × Not recorded (81)

**References**

Droege, M. 1988. Unusual food of Purple Finches. *Bulletin of the Oklahoma Ornithological Society* 21:7–8.

Isted, D. 1985. A xanthochroistic male Purple Finch. *Bulletin of the Oklahoma Ornithological Society* 18:31.

National Audubon Society. 2011. The Christmas Bird Count historical results. http://www .christmasbirdcount.org.

Oklahoma Bird Records Committee. 2009. *Date Guide to the Occurrences of Birds in Oklahoma.* 5th ed. Norman: Oklahoma Ornithological Society.

Wootton, J. Timothy. 1996. Purple Finch (*Carpodacus purpureus*). *The Birds of North America Online*, edited by A. Poole. Ithaca, N.Y.: Cornell Laboratory of Ornithology. http://bna.birds.cornell.edu.

# Cassin's Finch
## *Haemorhous cassinii*

Bob Gress

**Occurrence:** Late November through February in northwestern Cimarron County.

**Habitat:** Pinyon-juniper woodlands and nearby areas with bird feeders.

**North American distribution:** Found across much of the western United States in higher-elevation coniferous forests, but moves to lower elevations and areas to the east and south of its main range during the winter.

**Oklahoma distribution:** Recorded in a single survey block in northwestern Cimarron County. Also reported from two additional locations in Cimarron County (up to 16 birds) in December 2007, and from Texas County (Sunset Lake in Guymon) in December 2007 (3 birds) and February 2008.

**Behavior:** Cassin's Finches often form winter flocks, although Cimarron County is at the eastern edge of the species' winter range and single birds are possible. They forage mostly on the ground for buds, berries, and seeds and can be found under bird feeders, where they consume spilled seeds.

### Christmas Bird Count (CBC) Results, 1960–2009

$R^2 = 0.0932$

### CBC Results, 2003–2008

| Winter | Number recorded | Counts reporting |
|---|---|---|
| 2003–2004 | 0 | — |
| 2004–2005 | 2 | 1 |
| 2005–2006 | 0 | — |
| 2006–2007 | 0 | — |
| 2007–2008 | 16 | 1 |

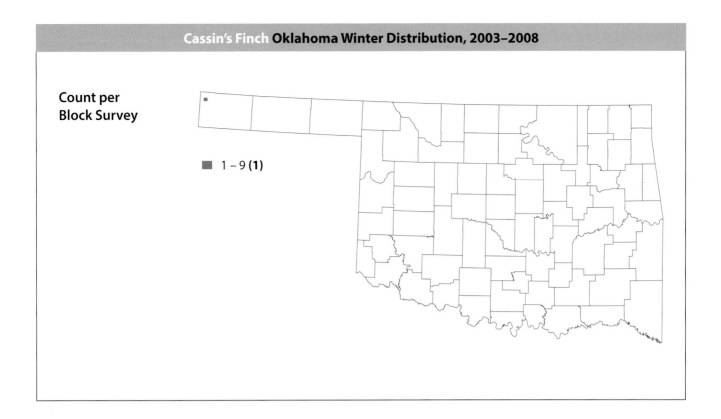

**Count per Block Survey**

■ 1 – 9 **(1)**

## References

Hahn, Thomas Peter. 1996. Cassin's Finch (*Carpodacus cassinii*). *The Birds of North America Online*, edited by A. Poole. Ithaca, N.Y.: Cornell Laboratory of Ornithology. http://bna.birds.cornell.edu.

National Audubon Society. 2011. The Christmas Bird Count historical results. http://www.christmasbirdcount.org.

Oklahoma Bird Records Committee. 2009a. 2007–2008 winter season. *The Scissortail* 59:4–8.

———. 2009b. *Date Guide to the Occurrences of Birds in Oklahoma*. 5th ed. Norman: Oklahoma Ornithological Society.

# Red Crossbill
## *Loxia curvirostra*

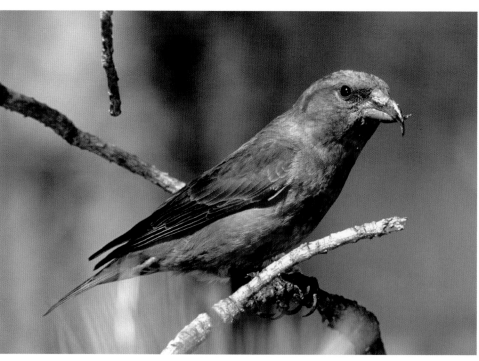

Bob Gress

**Occurrence:** November through early April.

**Habitat:** Coniferous trees.

**North American distribution:** Resident in southern Alaska, much of Canada, parts of the northeastern United States, and large parts of the western United States and Mexico. Wanders widely eastward from fall through spring in search of cone crops.

**Oklahoma distribution:** Recorded in just three survey blocks in Blaine, Garfield, and Cherokee Counties in January 2005, December 2004, and December 2003, respectively. Additional reports came from Blaine, Carter, Choctaw, Cimarron, and Payne Counties in December 2004; from Blaine, Cherokee, and Mayes Counties in January 2005; from Comanche and Texas Counties in December 2007; and from Comanche County in January 2008 (special interest species reports and Oklahoma Bird Records Committee 2005, 2009a). Over 60 birds were reported from Sunset Lake in Guymon for the December 2007 Texas County record (Oklahoma Bird Records Committee 2009a). This species is rare but regular in Oklahoma during the winter.

**Behavior:** Red Crossbills can be found either singly or in small flocks, and they often associate with Pine Siskins. Their unusual crossed mandibles are adapted for opening cones to extract the seeds. They will also come to bird feeders for sunflower seeds.

## Christmas Bird Count (CBC) Results, 1960–2009

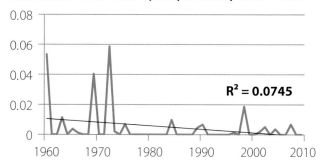

$R^2 = 0.0745$

## CBC Results, 2003–2008

| Winter | Number recorded | Counts reporting |
|--------|-----------------|------------------|
| 2003–2004 | 0 | — |
| 2004–2005 | 3 | 2 |
| 2005–2006 | 0 | — |
| 2006–2007 | 0 | — |
| 2007–2008 | 9 | 2 |

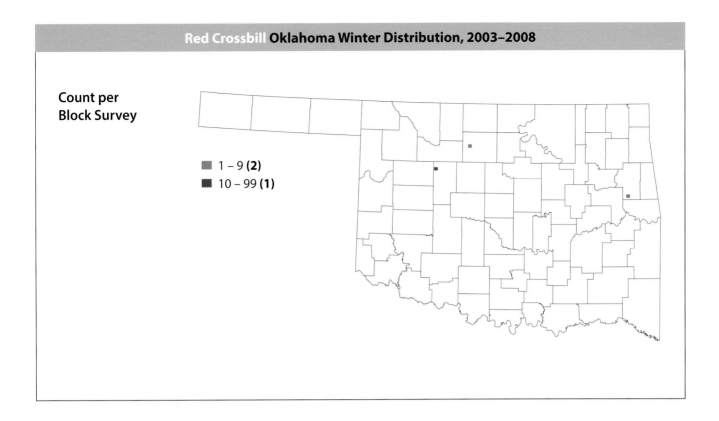

Count per
Block Survey

■ 1 – 9 **(2)**
■ 10 – 99 **(1)**

## References

Adkisson, Curtis S. 1996. Red Crossbill (*Loxia curvirostra*). *The Birds of North America Online*, edited by A. Poole. Ithaca, N.Y.: Cornell Laboratory of Ornithology. http://bna.birds.cornell.edu.

McFarland, S. L. 1992. Red Crossbills in Oklahoma during the winter of 1990–91. *Bulletin of the Oklahoma Ornithological Society* 25:1–3.

National Audubon Society. 2011. The Christmas Bird Count historical results. http://www .christmasbirdcount.org.

Oklahoma Bird Records Committee. 2005. 2004–2005 winter season. *The Scissortail* 55:18–20.

———. 2009a. 2007–2008 winter season. *The Scissortail* 59:4–8.

———. 2009b. *Date Guide to the Occurrences of Birds in Oklahoma*. 5th ed. Norman: Oklahoma Ornithological Society.

Sutton, G. M. 1976. On the feeding behavior of the Red Crossbill. *Bulletin of the Oklahoma Ornithological Society* 9:3–6.

# Pine Siskin
## *Spinus pinus*

**Occurrence:** October through May.

**Habitat:** Pine trees, weedy areas, and bird feeders.

**North American distribution:** Breeds in southern Alaska and much of Canada. Resident in parts of southern Canada, the northern and western United States, and parts of Mexico. Winters broadly across most of the United States and in parts of Mexico.

**Oklahoma distribution:** Recorded at scattered locations statewide, with most records coming from northwestern and Panhandle counties. This species is irruptive in nature, moving greater distances in greater numbers during winters when seed supplies are scarce, as reflected in the considerable year-to-year variation in the number and distribution of Oklahoma records.

**Behavior:** Pine Siskins are gregarious during the winter, although single birds are occasionally seen as well. They frequently associate with American Goldfinches at bird feeders while seeking sunflower seeds or niger (also called nyjer or thistle) oilseeds. Seeds from many grasses and forbs are also eaten.

**Christmas Bird Count (CBC) Results, 1960–2009**

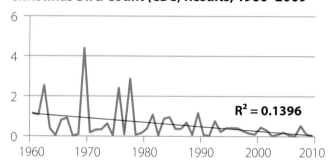

$R^2 = 0.1396$

**CBC Results, 2003–2008**

| Winter | Number recorded | Counts reporting |
|--------|-----------------|------------------|
| 2003–2004 | 96 | 4 |
| 2004–2005 | 226 | 9 |
| 2005–2006 | 82 | 8 |
| 2006–2007 | 10 | 5 |
| 2007–2008 | 550 | 17 |

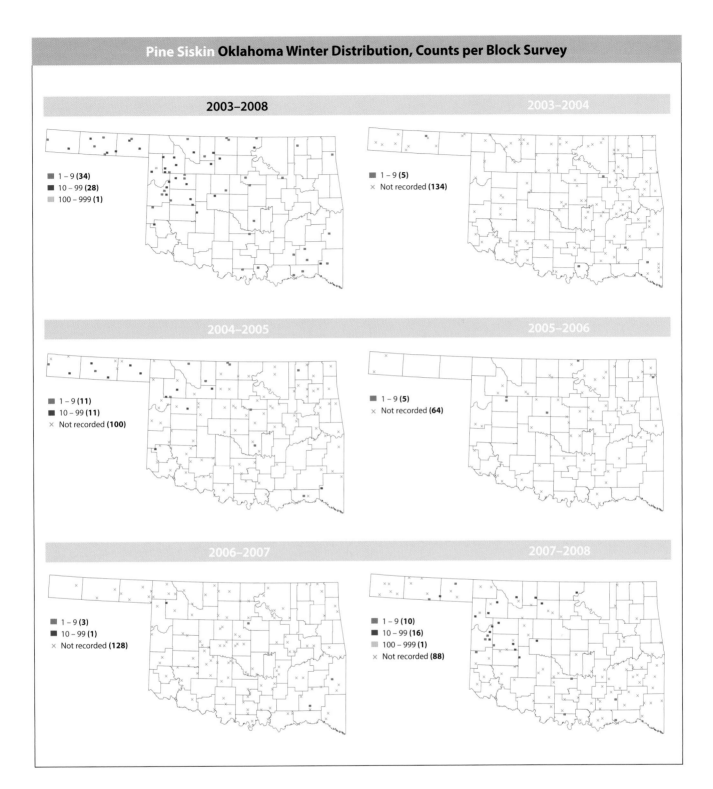

## 2003–2008

■ 1 – 9 **(34)**
■ 10 – 99 **(28)**
▨ 100 – 999 **(1)**

## 2003–2004

■ 1 – 9 **(5)**
× Not recorded **(134)**

## 2004–2005

■ 1 – 9 **(11)**
■ 10 – 99 **(11)**
× Not recorded **(100)**

## 2005–2006

■ 1 – 9 **(5)**
× Not recorded **(64)**

## 2006–2007

■ 1 – 9 **(3)**
■ 10 – 99 **(1)**
× Not recorded **(128)**

## 2007–2008

■ 1 – 9 **(10)**
■ 10 – 99 **(16)**
▨ 100 – 999 **(1)**
× Not recorded **(88)**

**References**

Dawson, William R. 1997. Pine Siskin (*Spinus pinus*). *The Birds of North America Online*, edited by A. Poole.
    Ithaca, N.Y.: Cornell Laboratory of Ornithology. http://bna.birds.cornell.edu.
National Audubon Society. 2011. The Christmas Bird Count historical results. http://www
    .christmasbirdcount.org.
Oklahoma Bird Records Committee. 2009. *Date Guide to the Occurrences of Birds in Oklahoma*. 5th ed.
    Norman: Oklahoma Ornithological Society.
Waters, L. S. 1990. Meadowlarks prey on Pine Siskins and American Goldfinches. *Bulletin of the Oklahoma
    Ornithological Society* 23:7–8.

# Lesser Goldfinch
*Spinus psaltria*

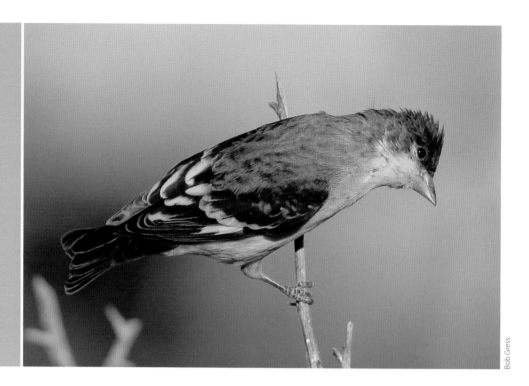

Bob Gress

**Occurrence:** Late April through late October. Not a regular wintering species.

**Habitat:** Foothills, woodlands, and towns.

**North American distribution:** Breeds in parts of the western United States. Resident in parts of the western and southwestern United States and in Mexico.

**Oklahoma distribution:** Not recorded in survey blocks. Up to two birds reported from Comanche County (Lawton) in January and February 2008 (Oklahoma Bird Records Committee 2009a). The summer distribution recorded by the Oklahoma Breeding Bird Atlas Project was limited to Cimarron, Comanche, and Kiowa Counties.

**Behavior:** Lesser Goldfinches are gregarious year round, but because of their rarity in Oklahoma during winter, single birds or small groups are more likely to be seen than large groups. They forage for seeds on the ground or from plant stems, trees, or shrubs and will readily visit bird feeders for sunflower seeds or niger (also called nyjer or thistle) seeds.

**Christmas Bird Count (CBC) Results, 1960–2009**

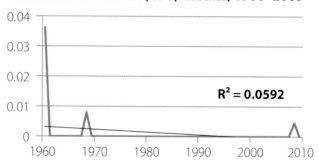

$R^2 = 0.0592$

**CBC Results, 2003–2008**

| Winter | Number recorded | Counts reporting |
|---|---|---|
| 2003–2004 | 0 | — |
| 2004–2005 | 0 | — |
| 2005–2006 | 0 | — |
| 2006–2007 | 0 | — |
| 2007–2008 | 0 | — |

**Count per Block Survey**

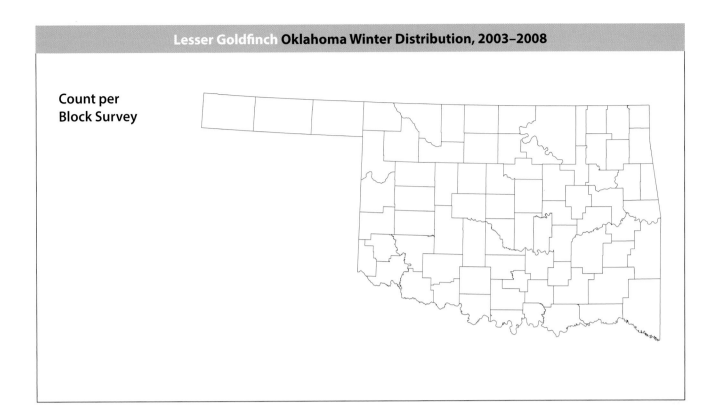

### References

National Audubon Society. 2011. The Christmas Bird Count historical results. http://www .christmasbirdcount.org.

Oklahoma Bird Records Committee. 2009a. 2007–2008 winter season. *The Scissortail* 59:4–8.

———. 2009b. *Date Guide to the Occurrences of Birds in Oklahoma*. 5th ed. Norman: Oklahoma Ornithological Society.

Payne, R. B. 1969. Lesser Goldfinch in Comanche County, Oklahoma, in winter. *Bulletin of the Oklahoma Ornithological Society* 2:24.

Reinking, D. L., ed. 2004. *Oklahoma Breeding Bird Atlas*. Norman: University of Oklahoma Press.

Watt, Doris J., and Ernest J. Willoughby. 1999. Lesser Goldfinch (*Spinus psaltria*). *The Birds of North America Online*, edited by A. Poole. Ithaca, N.Y.: Cornell Laboratory of Ornithology. http://bna.birds.cornell.edu.

# American Goldfinch
*Spinus tristis*

© Brenda Carroll

**Occurrence:** Year-round resident, but more numerous during winter as northern breeders move into Oklahoma.

**Habitat:** Weedy fields, woodlands, suburban and rural backyards, and prairie edges.

**North American distribution:** Breeds across southern Canada, breeds and winters across the northern two-thirds of the lower 48 states, and winters in the southern United States and in Mexico.

**Oklahoma distribution:** Almost uniformly distributed across the state in winter, more so than during the Oklahoma Breeding Bird Atlas surveys in which larger occurrence gaps were noted in western and southern Oklahoma at the margins of the species' breeding range.

**Behavior:** Goldfinches are typically seen in flocks during the winter and frequently come to bird feeders for sunflower seeds and niger (also called nyjer or thistle) seeds. Flocks may also include Pine Siskins. Goldfinches fly with an undulating pattern and frequently give a three- or four-note flight call.

**Appearance:** Goldfinches molt in the fall, with males transitioning from the brilliant breeding-season yellow and black to a drabber brownish-olive plumage much more similar to that of the females. The females also change somewhat, going from mostly yellowish to mostly brownish, although the difference is less pronounced.

### Christmas Bird Count (CBC) Results, 1960–2009

$R^2 = 0.1252$

### CBC Results, 2003–2008

| Winter | Number recorded | Counts reporting |
|--------|-----------------|------------------|
| 2003–2004 | 2,429 | 19 |
| 2004–2005 | 3,479 | 20 |
| 2005–2006 | 3,045 | 20 |
| 2006–2007 | 2,235 | 18 |
| 2007–2008 | 3,372 | 20 |

Count per
Block Survey

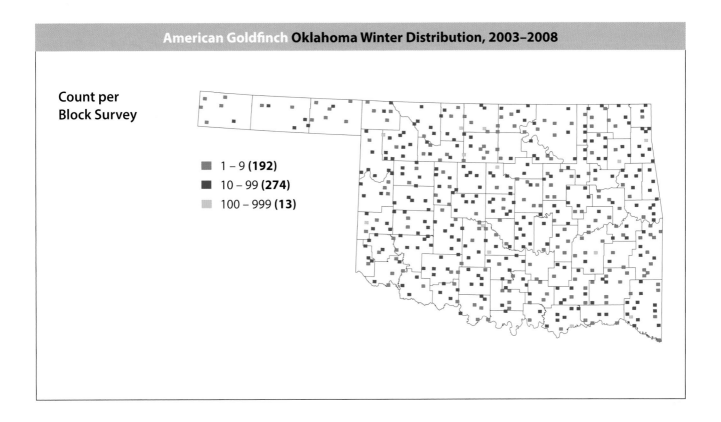

■ 1 – 9 **(192)**
■ 10 – 99 **(274)**
▦ 100 – 999 **(13)**

### References

Bell, P. M. 1990. Eastern Meadowlark predation on American Goldfinches. *Bulletin of the Oklahoma Ornithological Society* 23:20–22.

Dirck, M. 1986. Loggerhead Shrike takes American Goldfinch. *Bulletin of the Oklahoma Ornithological Society* 19:29–30.

McGraw, Kevin J., and Alex L. Middleton. 2009. American Goldfinch (*Carduelis tristis*). *The Birds of North America Online*, edited by A. Poole. Ithaca, N.Y.: Cornell Laboratory of Ornithology. http://bna.birds .cornell.edu.

Muzny, P. L. 1982. Goldfinches and waxwing drinking maple sap. *Bulletin of the Oklahoma Ornithological Society* 15:8.

National Audubon Society. 2011. The Christmas Bird Count historical results. http://www .christmasbirdcount.org.

Oklahoma Bird Records Committee. 2009. *Date Guide to the Occurrences of Birds in Oklahoma*. 5th ed. Norman: Oklahoma Ornithological Society.

Reinking, D. L., ed. 2004. *Oklahoma Breeding Bird Atlas*. Norman: University of Oklahoma Press.

Waters, L. S. 1990. Meadowlarks prey on Pine Siskins and American Goldfinches. *Bulletin of the Oklahoma Ornithological Society* 23:7–8.

# Lapland Longspur
## *Calcarius lapponicus*

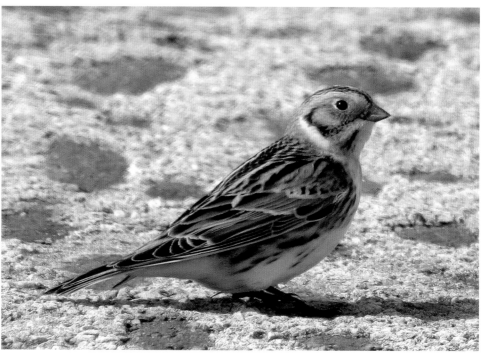

Steve Metz

**Occurrence:** November through mid-March.

**Habitat:** Open country, including grasslands and agricultural areas.

**North American distribution:** Breeds in Alaska and arctic Canada. Winters over a large portion of the lower 48 states.

**Oklahoma distribution:** Recorded statewide, but least frequently in eastern counties and most frequently in north-central and Panhandle counties. The regions with the most records were also where the largest aggregations were noted, including Garfield County, in which over 10,000 birds were recorded in one survey block.

**Behavior:** Lapland Longspurs are very gregarious during the winter and are typically seen in small to extremely large flocks. They often associate with other longspur species and Horned Larks. They forage on bare or sparsely vegetated ground in search of grass seeds and wheat.

**Christmas Bird Count (CBC) Results, 1960–2009**

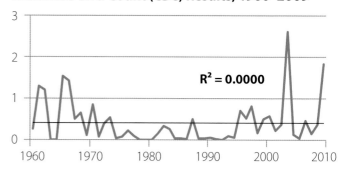

$R^2 = 0.0000$

**CBC Results, 2003–2008**

| Winter | Number recorded | Counts reporting |
|---|---|---|
| 2003–2004 | 2,496 | 7 |
| 2004–2005 | 155 | 6 |
| 2005–2006 | 38 | 4 |
| 2006–2007 | 439 | 5 |
| 2007–2008 | 204 | 10 |

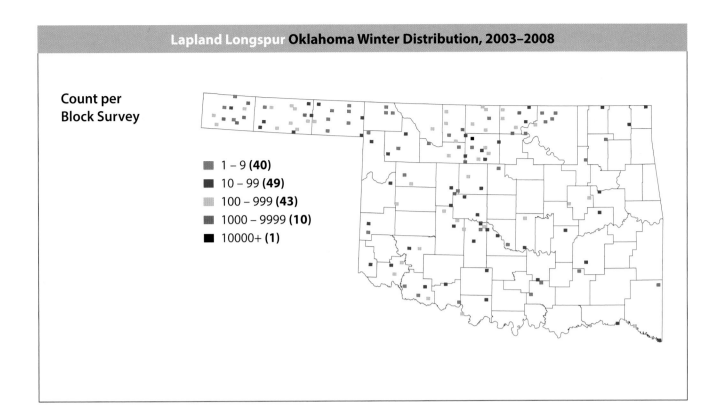

**Count per Block Survey**

- 1 – 9 **(40)**
- 10 – 99 **(49)**
- 100 – 999 **(43)**
- 1000 – 9999 **(10)**
- 10000+ **(1)**

### References

Hussell, David J., and Robert Montgomerie. 2002. Lapland Longspur (*Calcarius lapponicus*). *The Birds of North America Online*, edited by A. Poole. Ithaca, N.Y.: Cornell Laboratory of Ornithology. http://bna .birds.cornell.edu.

National Audubon Society. 2011. The Christmas Bird Count historical results. http://www .christmasbirdcount.org.

Oklahoma Bird Records Committee. 2009. *Date Guide to the Occurrences of Birds in Oklahoma*. 5th ed. Norman: Oklahoma Ornithological Society.

# Chestnut-collared Longspur
## *Calcarius ornatus*

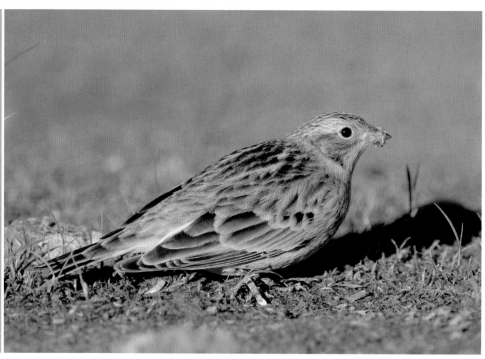

© (B. Steele) / VIREO

**Occurrence:** Mid-October through mid-April.

**Habitat:** Semiarid grasslands and agricultural areas.

**North American distribution:** Breeds in the northern plains states and southern provinces, and winters in the southern plains states and in Mexico.

**Oklahoma distribution:** Most common in the western half of the state, with concentrations in the Panhandle and southwestern Oklahoma, although large numbers were also reported from Alfalfa and Garfield Counties in the north-central region.

**Behavior:** Chestnut-collared Longspurs are gregarious in winter, and small to large flocks may associate with other longspur species or Horned Larks. They forage by picking seeds from the ground or by plucking them from low vegetation.

**Christmas Bird Count (CBC) Results, 1960–2009**

$R^2 = 0.0472$

**CBC Results, 2003–2008**

| Winter | Number recorded | Counts reporting |
|---|---|---|
| 2003–2004 | 738 | 5 |
| 2004–2005 | 285 | 2 |
| 2005–2006 | 1,545 | 2 |
| 2006–2007 | 24 | 2 |
| 2007–2008 | 953 | 4 |

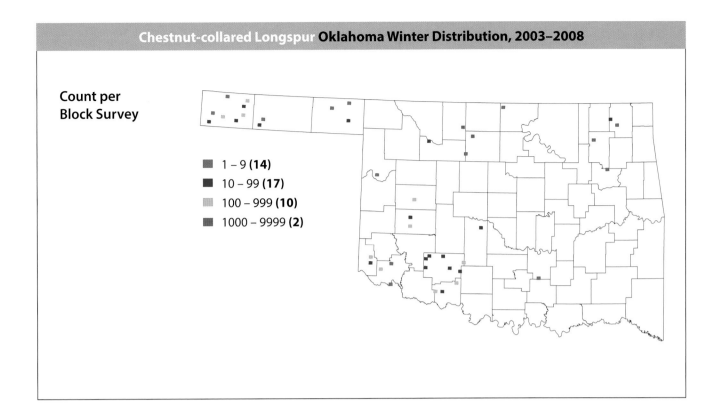

**Count per Block Survey**

■ 1 – 9 **(14)**
■ 10 – 99 **(17)**
▦ 100 – 999 **(10)**
▦ 1000 – 9999 **(2)**

### References

Hill, Dorothy P., and Lorne K. Gould. 1997. Chestnut-collared Longspur (*Calcarius ornatus*). *The Birds of North America Online*, edited by A. Poole. Ithaca, N.Y.: Cornell Laboratory of Ornithology. http://bna .birds.cornell.edu.

National Audubon Society. 2011. The Christmas Bird Count historical results. http://www .christmasbirdcount.org.

Oklahoma Bird Records Committee. 2009. *Date Guide to the Occurrences of Birds in Oklahoma*. 5th ed. Norman: Oklahoma Ornithological Society.

# Smith's Longspur
## *Calcarius pictus*

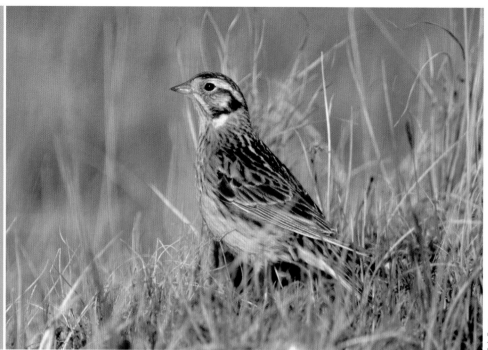

Bob Gress

**Occurrence:** November through late March.

**Habitat:** Grasslands either grazed or mowed to a relatively short height.

**North American distribution:** Breeds in Alaska and northern Canada, and winters in a small region centered in Oklahoma and including parts of Kansas, Arkansas, Texas, and Louisiana.

**Oklahoma distribution:** Recorded within survey blocks scattered throughout the main body of the state, but records were concentrated in northeastern, central, and south-central counties.

**Behavior:** Smith's Longspurs are gregarious during migration and winter and are typically seen in flocks ranging from a few to over 100 birds. They forage on the ground for seeds of weeds and grasses, especially in areas with seed-bearing *Aristida* grasses.

**Christmas Bird Count (CBC) Results, 1960–2009**

$R^2 = 0.0391$

**CBC Results, 2003–2008**

| Winter | Number recorded | Counts reporting |
|---|---|---|
| 2003–2004 | 233 | 7 |
| 2004–2005 | 212 | 9 |
| 2005–2006 | 671 | 5 |
| 2006–2007 | 260 | 6 |
| 2007–2008 | 340 | 6 |

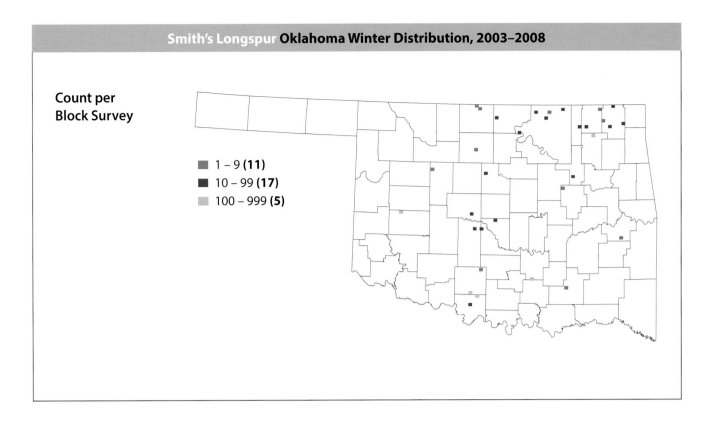

**Count per
Block Survey**

- ■ 1 – 9 **(11)**
- ■ 10 – 99 **(17)**
- ▨ 100 – 999 **(5)**

## References

Briskie, James V. 2009. Smith's Longspur (*Calcarius pictus*). *The Birds of North America Online*, edited by A. Poole. Ithaca, N.Y.: Cornell Laboratory of Ornithology. http://bna.birds.cornell.edu.

Dunn, E. H., and R. B. Dunn Jr. 1999. Notes on behavior of Smith's Longspurs wintering in Oklahoma. *Bulletin of the Oklahoma Ornithological Society* 32:13–20.

Grzybowski, J. A. 1982. Population structure in grassland bird communities during winter. *Condor* 84 (2): 137–52.

———. 1983a. Patterns of space use in grassland bird communities during winter. *Wilson Bulletin* 95 (4): 591–602.

———. 1983b. Sociality of grassland birds during winter. *Behavioral Ecology and Sociobiology* 13 (3): 211–19.

National Audubon Society. 2011. The Christmas Bird Count historical results. http://www .christmasbirdcount.org.

Oklahoma Bird Records Committee. 2009. *Date Guide to the Occurrences of Birds in Oklahoma*. 5th ed. Norman: Oklahoma Ornithological Society.

Ormston, C. G. 2000. Winter habitat of the Smith's Longspur in Oklahoma. *Bulletin of the Oklahoma Ornithological Society* 33:6–12.

Tomer, J. S. 1982. Smith's Longspur in breeding plumage in December in Oklahoma. *Bulletin of the Oklahoma Ornithological Society* 15:27–29.

# McCown's Longspur
## *Rhynchophanes mccownii*

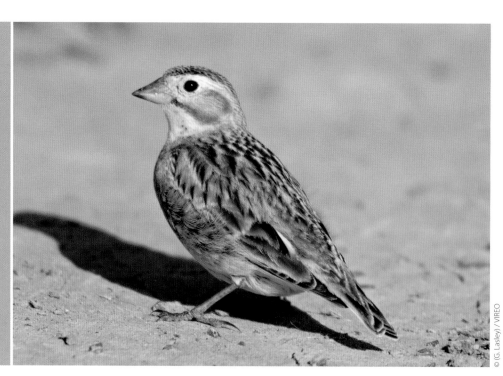

© (G. Lasley) / VIREO

**Occurrence:** Late October through early April.

**Habitat:** Plowed fields and sparsely vegetated grasslands.

**North American distribution:** Breeds in south-central Canada and the north-central United States. Winters in parts of the southwestern United States and northern Mexico.

**Oklahoma distribution:** Recorded at scattered locations in the western half of the state in low to moderate densities, with most records coming from southwestern and Panhandle counties.

**Behavior:** McCown's Longspurs are gregarious from fall through spring and are typically seen in flocks ranging in size from a few to hundreds of birds. They are often associated with flocks of other longspur species and Horned Larks. They forage on the ground for grass seeds, other plant seeds, and waste grain.

### Christmas Bird Count (CBC) Results, 1960–2009

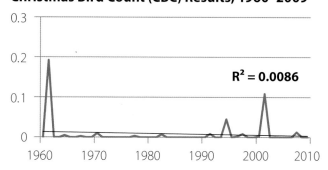

$R^2 = 0.0086$

### CBC Results, 2003–2008

| Winter | Number recorded | Counts reporting |
|---|---|---|
| 2003–2004 | 1 | 1 |
| 2004–2005 | 0 | — |
| 2005–2006 | 0 | — |
| 2006–2007 | 0 | — |
| 2007–2008 | 20 | 1 |

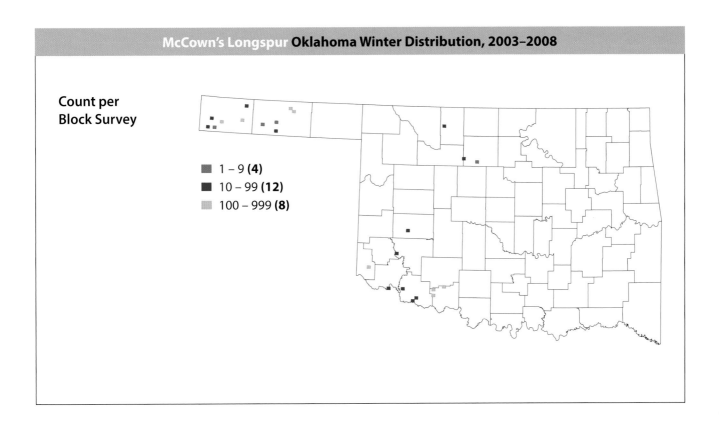

**Count per Block Survey**

■ 1 – 9 **(4)**
■ 10 – 99 **(12)**
▦ 100 – 999 **(8)**

### References

National Audubon Society. 2011. The Christmas Bird Count historical results. http://www
.christmasbirdcount.org.

Oklahoma Bird Records Committee. 2009. *Date Guide to the Occurrences of Birds in Oklahoma.* 5th ed.
Norman: Oklahoma Ornithological Society.

With, Kimberly A. 2010. McCown's Longspur (*Rhynchophanes mccownii*). *The Birds of North America Online,*
edited by A. Poole. Ithaca, N.Y.: Cornell Laboratory of Ornithology. http://bna.birds.cornell.edu.

# Snow Bunting
## *Plectrophenax nivalis*

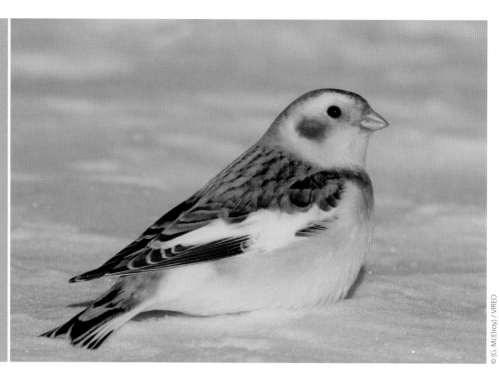

© (G. McElroy) / VIREO

**Occurrence:** Rare in late fall and winter.

**Habitat:** Fallow fields and other open areas.

**North American distribution:** Breeds in Alaska, northern Canada, and Greenland. Winters across much of Canada and the northern lower 48 states.

**Oklahoma distribution:** Not recorded in survey blocks. Not reported during the winter season, but reported from McCurtain County (Red Slough Wildlife Management Area) in early November 2007 (Oklahoma Bird Records Committee 2008).

**Behavior:** Snow Buntings are gregarious during fall and winter, but because of their rarity in Oklahoma, single birds are usually found here. They often associate with longspurs while foraging on the ground for seeds.

### Christmas Bird Count (CBC) Results, 1960–2009

$R^2 = 0.054$

### CBC Results, 2003–2008

| Winter | Number recorded | Counts reporting |
|--------|-----------------|------------------|
| 2003–2004 | 0 | — |
| 2004–2005 | 0 | — |
| 2005–2006 | 0 | — |
| 2006–2007 | 0 | — |
| 2007–2008 | 0 | — |

**Count per
Block Survey**

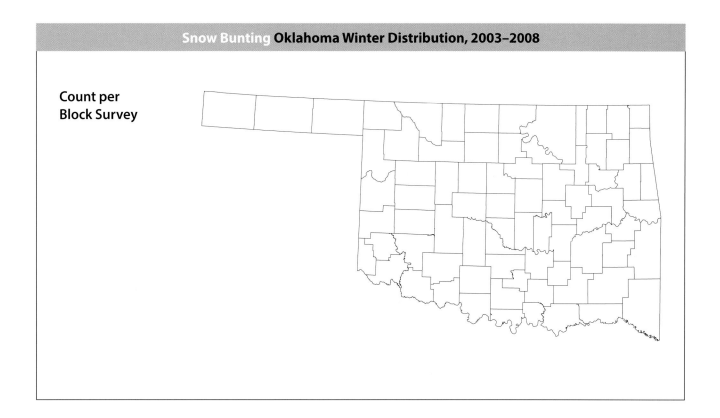

### References

Davis, C. 1973. Snow Bunting in Craig County, Oklahoma. *Bulletin of the Oklahoma Ornithological Society* 6:33–34.

Heck, B. A. 2010. First record for Snow Bunting in southeastern Oklahoma. *Bulletin of the Oklahoma Ornithological Society* 43:11.

Montgomerie, Robert, and Bruce Lyon. 2011. Snow Bunting (*Plectrophenax nivalis*). *The Birds of North America Online*, edited by A. Poole. Ithaca, N.Y.: Cornell Laboratory of Ornithology. http://bna.birds .cornell.edu.

National Audubon Society. 2011. The Christmas Bird Count historical results. http://www .christmasbirdcount.org.

Oklahoma Bird Records Committee. 2008. 2007 fall season report. *The Scissortail* 58:66–74.

———. 2009. *Date Guide to the Occurrences of Birds in Oklahoma*. 5th ed. Norman: Oklahoma Ornithological Society.

Parker, T. A., III. 1973. First Snow Bunting specimen for Oklahoma. *Bulletin of the Oklahoma Ornithological Society* 6:33.

# Orange-crowned Warbler
## *Oreothlypis celata*

Bob Gress

**Occurrence:** Mid-September through mid-May.

**Habitat:** Brushy woodlands and thickets.

**North American distribution:** Breeds in Alaska, much of Canada, and the western United States. Winters in the southern United States and in Mexico.

**Oklahoma distribution:** Recorded in scattered survey blocks over much of the main body of the state, with most records coming from the southern half.

**Behavior:** Orange-crowned Warblers are usually seen singly, although they frequently associate with winter foraging flocks of other species such as chickadees, titmice, and kinglets. They forage near the tips of branches in trees and shrubs looking for insects, spiders, and berries and will sometimes visit bird feeders for suet.

## Christmas Bird Count (CBC) Results, 1960–2009

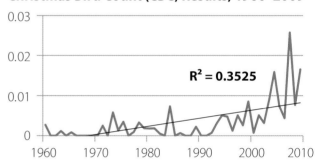

$R^2 = 0.3525$

## CBC Results, 2003–2008

| Winter | Number recorded | Counts reporting |
|--------|-----------------|------------------|
| 2003–2004 | 8 | 3 |
| 2004–2005 | 24 | 8 |
| 2005–2006 | 6 | 6 |
| 2006–2007 | 4 | 4 |
| 2007–2008 | 18 | 9 |

**Count per Block Survey**

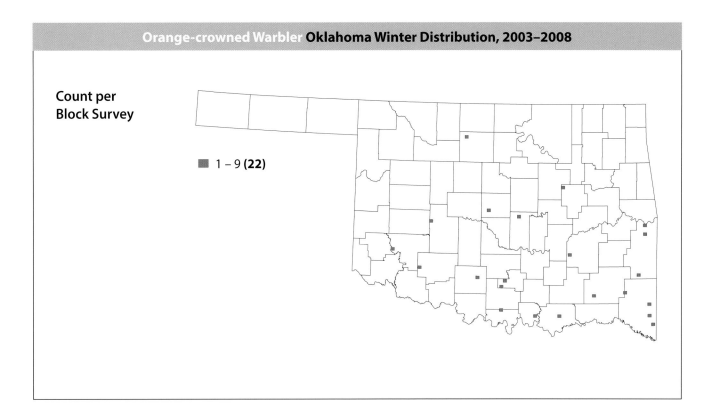

■ 1 – 9 **(22)**

**References**

Gilbert, W. M., M. K. Sogge, and C. Van Riper III. 2010. Orange-crowned Warbler (*Oreothlypis celata*). *The Birds of North America Online*, edited by A. Poole. Ithaca, N.Y.: Cornell Laboratory of Ornithology. http://bna.birds.cornell.edu.

National Audubon Society. 2011. The Christmas Bird Count historical results. http://www .christmasbirdcount.org.

Oklahoma Bird Records Committee. 2009. *Date Guide to the Occurrences of Birds in Oklahoma*. 5th ed. Norman: Oklahoma Ornithological Society.

# Common Yellowthroat
## *Geothlypis trichas*

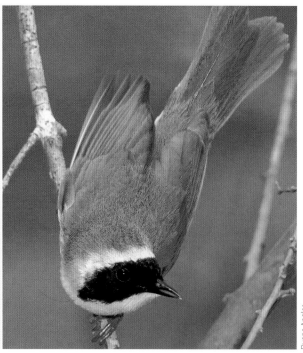

Duane Angles

**Occurrence:** Present year round, although more common in the summer. Seasonal migrations probably result in a turnover of individuals.

**Habitat:** Moist or dense grasslands, brushy areas, and marshes.

**North American distribution:** Breeds across most of Canada and the lower 48 states. Present year round in the southernmost United States and central Mexico.

**Oklahoma distribution:** Recorded in just three widely scattered survey blocks. The summer distribution recorded by the Oklahoma Breeding Bird Atlas Project was much more extensive, covering most blocks in the eastern half of the state and scattered locations in the western half.

**Behavior:** Common Yellowthroats are seen singly and usually remain within thick cover. They forage for insects and spiders by gleaning them from vegetation.

## Christmas Bird Count (CBC) Results, 1960–2009

$R^2 = 0.013$

## CBC Results, 2003–2008

| Winter | Number recorded | Counts reporting |
|--------|-----------------|------------------|
| 2003–2004 | 6 | 3 |
| 2004–2005 | 9 | 4 |
| 2005–2006 | 1 | 2 |
| 2006–2007 | 5 | 4 |
| 2007–2008 | 8 | 5 |

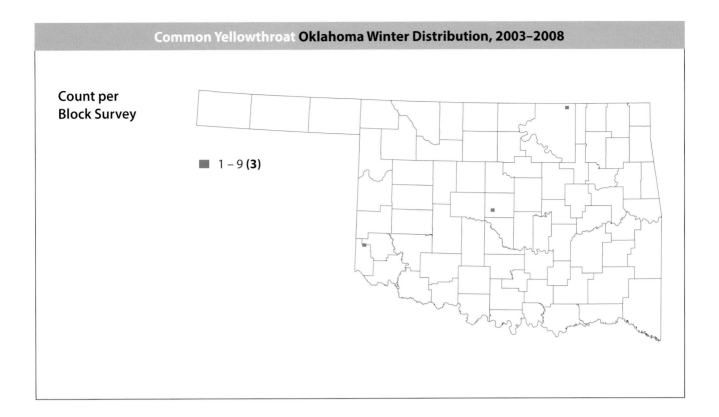

Count per
Block Survey

■ 1 – 9 **(3)**

**References**

Guzy, Michael J., and Gary Ritchison. 1999. Common Yellowthroat (*Geothlypis trichas*). *The Birds of North America Online*, edited by A. Poole. Ithaca, N.Y.: Cornell Laboratory of Ornithology. http://bna.birds.cornell.edu.

National Audubon Society. 2011. The Christmas Bird Count historical results. http://www.christmasbirdcount.org.

Oklahoma Bird Records Committee. 2009. *Date Guide to the Occurrences of Birds in Oklahoma*. 5th ed. Norman: Oklahoma Ornithological Society.

Reinking, D. L., ed. 2004. *Oklahoma Breeding Bird Atlas*. Norman: University of Oklahoma Press.

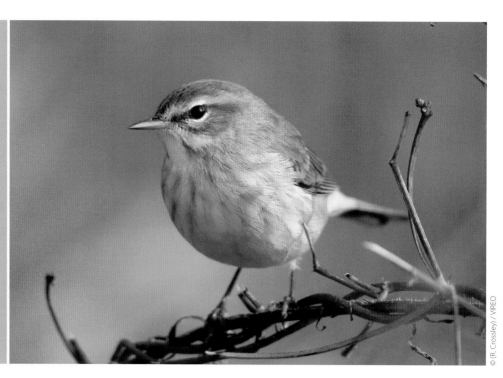

# Palm Warbler
## *Setophaga palmarum*

© (R. Crossley) / VIREO

**Occurrence:** Spring and fall migrant, but not a regular wintering species.

**Habitat:** Woodlands, brushy areas, and marshes.

**North American distribution:** Breeds across much of Canada and parts of the northern lower 48 states. Winters in the southeastern United States.

**Oklahoma distribution:** Not recorded in survey blocks. One special interest species report came from McCurtain County (Red Slough Wildlife Management Area) on December 16, 2003.

**Behavior:** Palm Warblers are rare in Oklahoma during the winter, but in other places they are sometimes seen in small, loose groups, and they often join mixed-species foraging flocks made up of chickadees, Yellow-rumped Warblers, and other species. They forage for insects, mostly on the ground but also in trees and shrubs.

### Christmas Bird Count (CBC) Results, 1960–2009

$R^2 = 0.0206$

### CBC Results, 2003–2008

| Winter | Number recorded | Counts reporting |
|---|---|---|
| 2003–2004 | 0 | — |
| 2004–2005 | 0 | — |
| 2005–2006 | 0 | — |
| 2006–2007 | 0 | — |
| 2007–2008 | 0 | — |

**Count per
Block Survey**

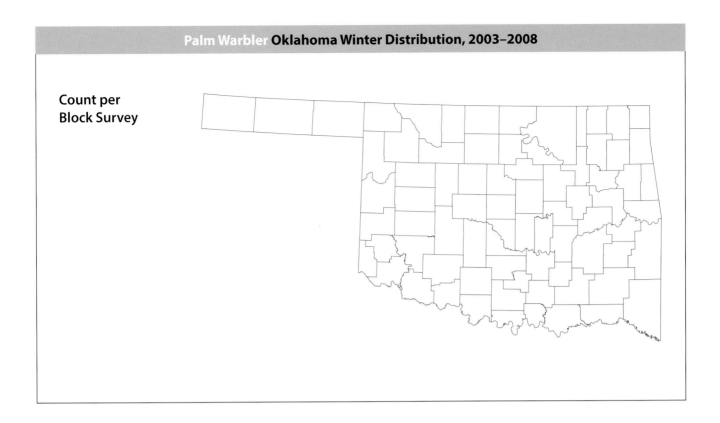

**References**

National Audubon Society. 2011. The Christmas Bird Count historical results. http://www
.christmasbirdcount.org.

Oklahoma Bird Records Committee. 2009. *Date Guide to the Occurrences of Birds in Oklahoma.* 5th ed.
Norman: Oklahoma Ornithological Society.

Wilson, W. Herbert, Jr. 1996. Palm Warbler (*Dendroica palmarum*). *The Birds of North America Online*, edited
by A. Poole. Ithaca, N.Y.: Cornell Laboratory of Ornithology. http://bna.birds.cornell.edu.

# Pine Warbler
## *Setophaga pinus*

Bob Gress

**Occurrence:** Present year round, with some seasonal movements out of northern counties.

**Habitat:** Pine forests and deciduous woodlands that include a mix of coniferous trees.

**North American distribution:** Breeds in portions of southeastern Canada and the eastern United States, and largely resident throughout the southeastern United States.

**Oklahoma distribution:** Recorded in numerous survey blocks in southeastern counties with a high proportion of coniferous forest, and most abundant in McCurtain County survey blocks. The summer distribution recorded by the Oklahoma Breeding Bird Atlas Project was similar.

**Behavior:** Pine Warblers may be seen singly, but they often form flocks during the winter months. These flocks regularly associate with foraging groups that may include chickadees, titmice, Downy Woodpeckers, kinglets, and other species. Pine Warblers forage on the ground and in pine trees for insects, and unlike other warblers they also consume significant amounts of seeds during the winter. They even visit bird feeders for sunflower seeds, cracked corn, peanuts, or suet.

### Christmas Bird Count (CBC) Results, 1960–2009

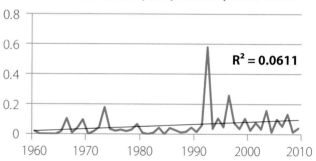

$R^2 = 0.0611$

### CBC Results, 2003–2008

| Winter | Number recorded | Counts reporting |
| --- | --- | --- |
| 2003–2004 | 155 | 1 |
| 2004–2005 | 12 | 5 |
| 2005–2006 | 71 | 3 |
| 2006–2007 | 57 | 2 |
| 2007–2008 | 68 | 6 |

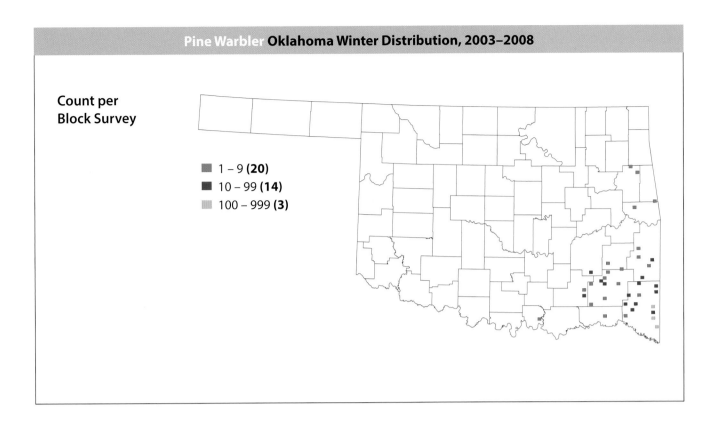

Count per
Block Survey

- 1 – 9 **(20)**
- 10 – 99 **(14)**
- 100 – 999 **(3)**

### References

National Audubon Society. 2011. The Christmas Bird Count historical results. http://www
.christmasbirdcount.org.

Oklahoma Bird Records Committee. 2009. *Date Guide to the Occurrences of Birds in Oklahoma*. 5th ed.
Norman: Oklahoma Ornithological Society.

Reinking, D. L., ed. 2004. *Oklahoma Breeding Bird Atlas*. Norman: University of Oklahoma Press.

Rodewald, Paul G., James H. Withgott, and Kimberly G. Smith. 1999. Pine Warbler (*Dendroica pinus*). *The
Birds of North America Online*, edited by A. Poole. Ithaca, N.Y.: Cornell Laboratory of Ornithology.
http://bna.birds.cornell.edu.

Sutton, G. M. 1982. Pine Warbler in Cleveland County, Oklahoma. *Bulletin of the Oklahoma Ornithological
Society* 15:32–33.

# Yellow-rumped Warbler

*Setophaga coronata*

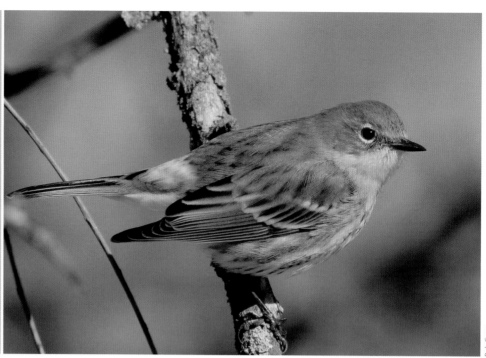

Bob Gress

**Occurrence:** October through mid-May.

**Habitat:** Wooded areas.

**North American distribution:** Breeds in Alaska, across much of Canada, and in parts of the northern and western lower 48 states. Winters across much of the southern United States and in Mexico.

**Oklahoma distribution:** Recorded statewide in survey blocks at low to moderate abundances, but infrequently in some southwestern and Panhandle counties. Of the two distinctive forms, "Myrtle" Warblers are most common, but small numbers of "Audubon's" Warblers also occur, mainly in western counties.

**Behavior:** Yellow-rumped Warblers are frequently seen in small flocks, and they often join mixed-species foraging groups of chickadees and other species. They forage in trees and shrubs, mostly for fruits, but also for insects when available.

**Christmas Bird Count (CBC) Results, 1960–2009**

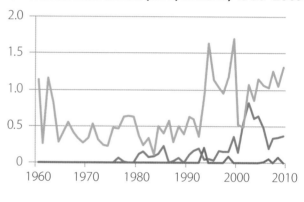

— Yellow-rumped Warbler
— Audubon's Warbler
— Myrtle Warbler

**CBC Results, 2003–2008**

| Winter | Number recorded | Counts reporting |
|---|---|---|
| 2003–2004 | 510 | 7 |
| 2004–2005 | 699 | 10 |
| 2005–2006 | 538 | 8 |
| 2006–2007 | 183 | 6 |
| 2007–2008 | 345 | 8 |

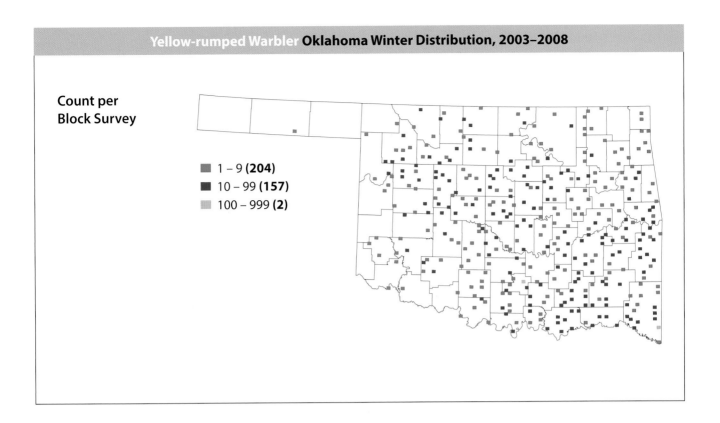

Count per
Block Survey

1 – 9 **(204)**
10 – 99 **(157)**
100 – 999 **(2)**

### References

Hunt, P. D., and David J. Flaspohler. 1998. Yellow-rumped Warbler (*Dendroica coronata*). *The Birds of North America Online*, edited by A. Poole. Ithaca, N.Y.: Cornell Laboratory of Ornithology. http://bna.birds .cornell.edu.

National Audubon Society. 2011. The Christmas Bird Count historical results. http://www .christmasbirdcount.org.

Oklahoma Bird Records Committee. 2009. *Date Guide to the Occurrences of Birds in Oklahoma*. 5th ed. Norman: Oklahoma Ornithological Society.

# Green-tailed Towhee
## *Pipilo chlorurus*

Bob Gress

**Occurrence:** Typically seen only during September and early May migration periods and only in Cimarron County.

**Habitat:** Shrubby areas.

**North American distribution:** Breeds in a large portion of the western lower 48 states. Winters in the southwestern United States and in Mexico.

**Oklahoma distribution:** Recorded in a single survey block in Kingfisher County in mid-January 2005. This species does not normally winter in the state. There is a historical nest record for Oklahoma, but no nests were detected during the Oklahoma Breeding Bird Atlas Project.

**Behavior:** Green-tailed Towhees are usually seen singly or in pairs during the winter. They forage on the ground or in low vegetation in search of seeds and insects.

## Christmas Bird Count (CBC) Results, 1960–2009

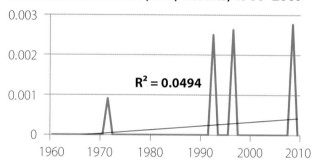

$R^2 = 0.0494$

## CBC Results, 2003–2008

| Winter | Number recorded | Counts reporting |
|---|---|---|
| 2003–2004 | 0 | — |
| 2004–2005 | 0 | — |
| 2005–2006 | 0 | — |
| 2006–2007 | 0 | — |
| 2007–2008 | 0 | — |

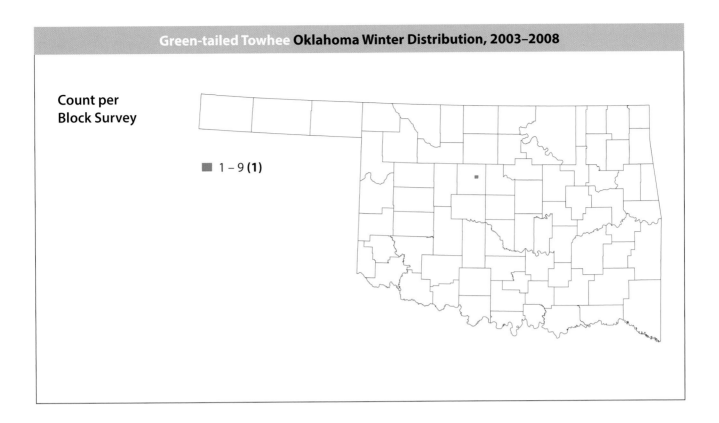

**Count per
Block Survey**

■ 1 – 9 **(1)**

## References

Carter, R. M. 1983. Green-tailed Towhee in Johnston County, Oklahoma. *Bulletin of the Oklahoma Ornithological Society* 16:33.

Dobbs, R. C., P. R. Martin, and T. E. Martin. 1998. Green-tailed Towhee (*Pipilo chlorurus*). *The Birds of North America Online*, edited by A. Poole. Ithaca, N.Y.: Cornell Laboratory of Ornithology. http://bna.birds .cornell.edu.

National Audubon Society. 2011. The Christmas Bird Count historical results. http://www .christmasbirdcount.org.

Oklahoma Bird Records Committee. 2009. *Date Guide to the Occurrences of Birds in Oklahoma*. 5th ed. Norman: Oklahoma Ornithological Society.

Reinking, D. L., ed. 2004. *Oklahoma Breeding Bird Atlas*. Norman: University of Oklahoma Press.

Shackford, J. S. 1972. Green-tailed Towhee in central Oklahoma in winter. *Bulletin of the Oklahoma Ornithological Society* 5:25–26.

# Spotted Towhee
## *Pipilo maculatus*

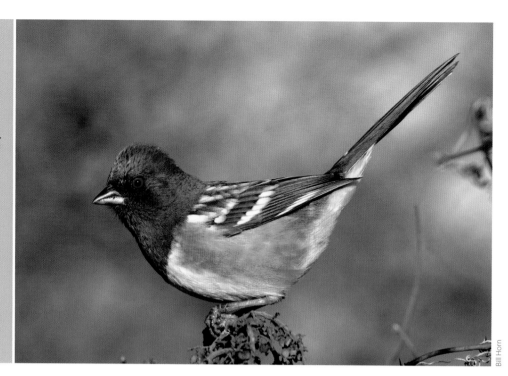

Bill Horn

**Occurrence:** Late September through late May.

**Habitat:** Woodland edges and brushy areas.

**North American distribution:** Breeds in southwestern Canada and parts of the western lower 48 states. Resident in large parts of the western United States and Mexico. Winters somewhat south and east of breeding range.

**Oklahoma distribution:** Recorded in survey blocks statewide at low to moderate abundances, but more common in central and western counties. The summer distribution recorded by the Oklahoma Breeding Bird Atlas Project included just two records from western Cimarron County; this comparison indicates the significant eastward movements made by this species during fall and winter.

**Behavior:** Spotted Towhees may be seen singly or in loose groups utilizing appropriate habitat. They often associate with other sparrows such as Dark-eyed Juncos. They forage mostly on the ground, often scratching backward with both legs simultaneously to reveal seeds and fruits within dead leaves and other litter.

### Christmas Bird Count (CBC) Results, 1960–2009

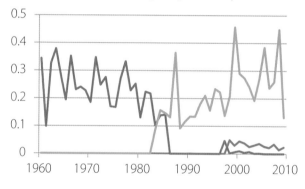

— Eastern Towhee
— Rufous-sided Towhee
— Spotted Towhee

### CBC Results, 2003–2008

| Winter | Number recorded | Counts reporting |
|--------|-----------------|------------------|
| 2003–2004 | 282 | 16 |
| 2004–2005 | 356 | 16 |
| 2005–2006 | 594 | 16 |
| 2006–2007 | 243 | 15 |
| 2007–2008 | 373 | 16 |

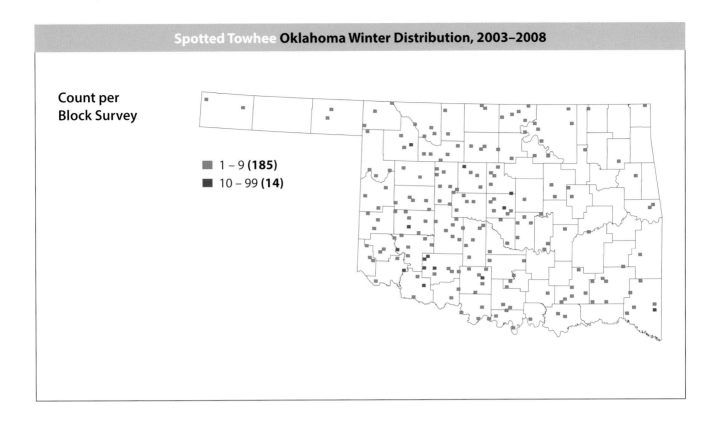

Count per
Block Survey

■ 1 – 9 **(185)**
■ 10 – 99 **(14)**

### References

Baumgartner, F. M. 1988. Winter status of the Rufous-sided Towhee in Oklahoma. *Bulletin of the Oklahoma Ornithological Society* 21:27–28.

Greenlaw, Jon S. 1996. Spotted Towhee (*Pipilo maculatus*). *The Birds of North America Online*, edited by A. Poole. Ithaca, N.Y.: Cornell Laboratory of Ornithology. http://bna.birds.cornell.edu.

National Audubon Society. 2011. The Christmas Bird Count historical results. http://www .christmasbirdcount.org.

Oklahoma Bird Records Committee. 2009. *Date Guide to the Occurrences of Birds in Oklahoma*. 5th ed. Norman: Oklahoma Ornithological Society.

Reinking, D. L., ed. 2004. *Oklahoma Breeding Bird Atlas*. Norman: University of Oklahoma Press.

# Eastern Towhee

*Pipilo erythrophthalmus*

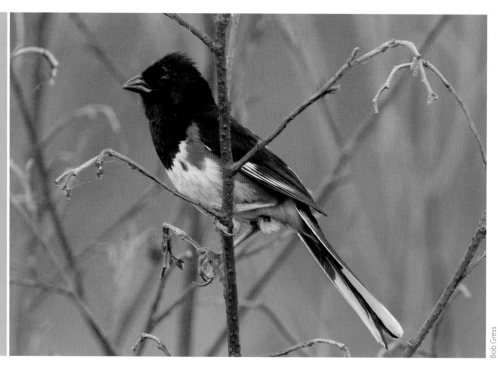

Bob Gress

**Occurrence:** Possibly present year round in northeastern Oklahoma, but much more widespread and common in the winter.

**Habitat:** Brushy fields, streamside thickets, and woodland edges.

**North American distribution:** Breeds across roughly the eastern half of the lower 48 states, where it is resident from Iowa south. Winters somewhat farther west of its breeding range into eastern Oklahoma and Texas.

**Oklahoma distribution:** Recorded in scattered locations in the eastern two-thirds of the state, with the highest concentration of records in the southeastern quarter of the state. The summer distribution as recorded by the Oklahoma Breeding Bird Atlas Project was much smaller, consisting of just a few records in northeastern Oklahoma.

**Behavior:** Eastern Towhees can be seen singly or in small groups during the winter. They also join mixed-species flocks that may include Spotted Towhees or other sparrows such as Dark-eyed Juncos, White-throated Sparrows, or Song Sparrows. They forage on the ground under cover and where moderate grass or leaf litter is present. Using both legs, they hop up while scratching backward to expose seeds or fruit.

## Christmas Bird Count (CBC) Results, 1960–2009

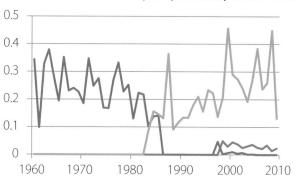

—— Eastern Towhee

—— Rufous-sided Towhee

—— Spotted Towhee

## CBC Results, 2003–2008

| Winter | Number recorded | Counts reporting |
|---|---|---|
| 2003–2004 | 33 | 10 |
| 2004–2005 | 42 | 7 |
| 2005–2006 | 35 | 9 |
| 2006–2007 | 28 | 8 |
| 2007–2008 | 30 | 8 |

**Count per Block Survey**

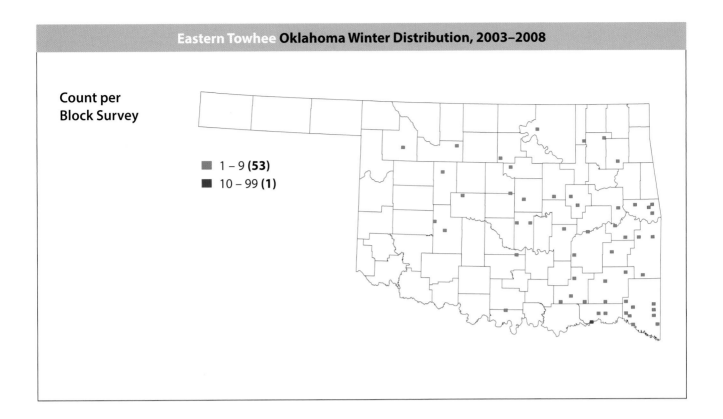

■ 1 – 9 **(53)**
■ 10 – 99 **(1)**

**References**

Baumgartner, F. M. 1988. Winter status of the Rufous-sided Towhee in Oklahoma. *Bulletin of the Oklahoma Ornithological Society* 21:27–28.

Greenlaw, Jon S. 1996. Eastern Towhee (*Pipilo erythrophthalmus*). *The Birds of North America Online*, edited by A. Poole. Ithaca, N.Y.: Cornell Laboratory of Ornithology. http://bna.birds.cornell.edu.

National Audubon Society. 2011. The Christmas Bird Count historical results. http://www .christmasbirdcount.org.

Oklahoma Bird Records Committee. 2009. *Date Guide to the Occurrences of Birds in Oklahoma*. 5th ed. Norman: Oklahoma Ornithological Society.

Reinking, D. L., ed. 2004. *Oklahoma Breeding Bird Atlas*. Norman: University of Oklahoma Press.

# Rufous-crowned Sparrow
## *Aimophila ruficeps*

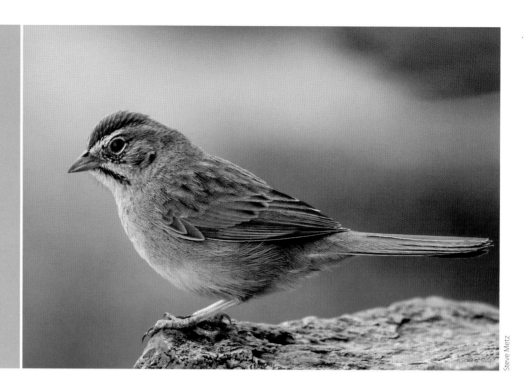

Steve Metz

**Occurrence:** Year-round resident.

**Habitat:** Rocky outcrops within grassy or brushy slopes.

**North American distribution:** Resident in parts of the south-central, southwestern, and western United States and in Mexico.

**Oklahoma distribution:** Recorded in eight survey blocks scattered in the western half of the state. The summer distribution recorded by the Oklahoma Breeding Bird Atlas Project was similar, although birds were reported in 15 blocks, probably because breeding-season singing made birds more detectable than they were during the winter months.

**Behavior:** Rufous-crowned Sparrows are seen singly, in pairs, or in small family groups. They maintain territories year round and forage on the ground within cover for their main winter diet of grass and forb seeds.

## Christmas Bird Count (CBC) Results, 1960–2009

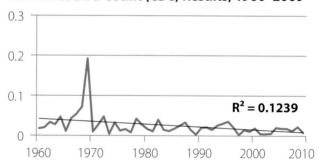

$R^2 = 0.1239$

## CBC Results, 2003–2008

| Winter | Number recorded | Counts reporting |
|--------|-----------------|------------------|
| 2003–2004 | 6 | 2 |
| 2004–2005 | 32 | 2 |
| 2005–2006 | 28 | 2 |
| 2006–2007 | 16 | 1 |
| 2007–2008 | 20 | 1 |

**Count per Block Survey**

■ 1 – 9 **(8)**

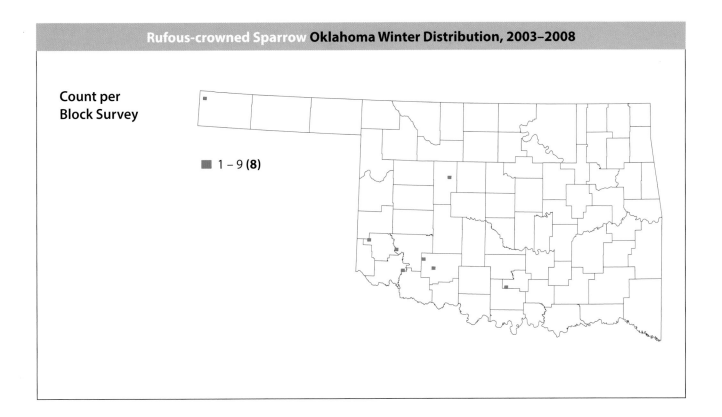

### References

Collins, Paul W. 1999. Rufous-crowned Sparrow (*Aimophila ruficeps*). *The Birds of North America Online*, edited by A. Poole. Ithaca, N.Y.: Cornell Laboratory of Ornithology. http://bna.birds.cornell.edu.

National Audubon Society. 2011. The Christmas Bird Count historical results. http://www .christmasbirdcount.org.

Oklahoma Bird Records Committee. 2009. *Date Guide to the Occurrences of Birds in Oklahoma*. 5th ed. Norman: Oklahoma Ornithological Society.

Reinking, D. L., ed. 2004. *Oklahoma Breeding Bird Atlas*. Norman: University of Oklahoma Press.

# Canyon Towhee

*Melozone fusca*

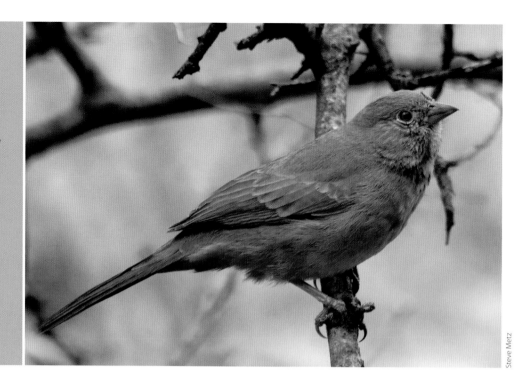

Steve Metz

**Occurrence:** Year-round resident.

**Habitat:** Pinyon-oak-juniper woodlands, grasslands with mesquite or cacti, and farmsteads or towns.

**North American distribution:** Resident in parts of Oklahoma, Colorado, Texas, New Mexico, Arizona, and much of Mexico.

**Oklahoma distribution:** Recorded only in the northern half of Cimarron County. Not surprisingly for a resident species, this distribution closely matches that found in summer during the Oklahoma Breeding Bird Atlas surveys.

**Behavior:** Canyon Towhees typically mate for life and maintain territories year round, although they tend to move over a slightly larger area in the winter. They forage for a wide variety of seeds on the ground and often use the standard towhee technique of jumping up while scratching backward with both feet to remove litter and expose seeds. They will forage under bird feeders as well as under objects such as cars, trailers, and fences.

## Christmas Bird Count (CBC) Results, 1960–2009

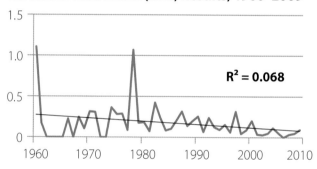

$R^2 = 0.068$

## CBC Results, 2003–2008

| Winter | Number recorded | Counts reporting |
|---|---|---|
| 2003–2004 | 36 | 1 |
| 2004–2005 | 85 | 1 |
| 2005–2006 | 54 | 1 |
| 2006–2007 | 0 | — |
| 2007–2008 | 27 | 1 |

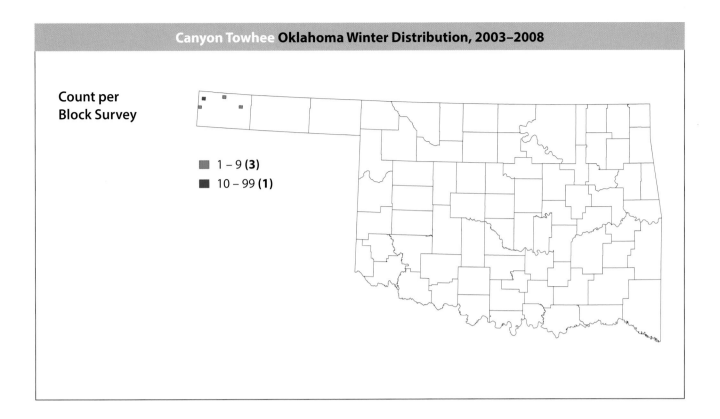

**Count per Block Survey**

■ 1 – 9 **(3)**
■ 10 – 99 **(1)**

### References

Johnson, R. Roy, and Lois T. Haight. 1996. Canyon Towhee (*Melozone fusca*). *The Birds of North America Online*, edited by A. Poole. Ithaca, N.Y.: Cornell Laboratory of Ornithology. http://bna.birds.cornell.edu.

National Audubon Society. 2011. The Christmas Bird Count historical results. http://www .christmasbirdcount.org.

Oklahoma Bird Records Committee. 2009. *Date Guide to the Occurrences of Birds in Oklahoma*. 5th ed. Norman: Oklahoma Ornithological Society.

Reinking, D. L., ed. 2004. *Oklahoma Breeding Bird Atlas*. Norman: University of Oklahoma Press.

# American Tree Sparrow
## *Spizelloides arborea*

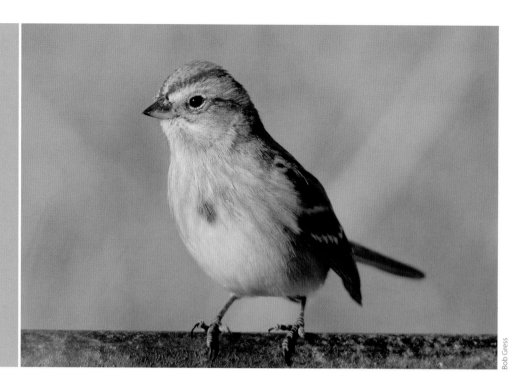

Bob Gress

**Occurrence:** November through March in most regions.

**Habitat:** Open areas with brushy cover, pasture edges, and thickets.

**North American distribution:** American Tree Sparrows vacate their arctic breeding grounds for the winter months, moving into a broad region encompassing roughly the northern three-fourths of the lower 48 states, including Oklahoma and northern Texas. Christmas Bird Count data suggest that they reach greatest winter abundance in Kansas and Nebraska.

**Oklahoma distribution:** Tree sparrows were clearly least abundant in southeastern Oklahoma, which forms the southern edge of the winter range and is where forested habitats begin to predominate. Tree sparrows were present in greatest abundance in the northern tier of Oklahoma counties, which are well within the core of their winter range where their favored habitat is plentiful.

**Behavior:** Tree sparrows are often found in large, loose flocks that may include other sparrow species. Although their winter diet is based largely on a variety of weed seeds, they do not often come to bird feeders.

## Christmas Bird Count (CBC) Results, 1960–2009

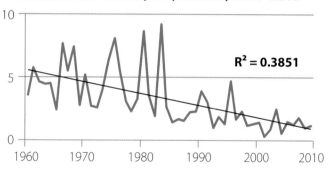

$R^2 = 0.3851$

## CBC Results, 2003–2008

| Winter | Number recorded | Counts reporting |
|--------|-----------------|------------------|
| 2003–2004 | 2,575 | 16 |
| 2004–2005 | 571 | 16 |
| 2005–2006 | 1,356 | 16 |
| 2006–2007 | 1,016 | 15 |
| 2007–2008 | 2,019 | 15 |

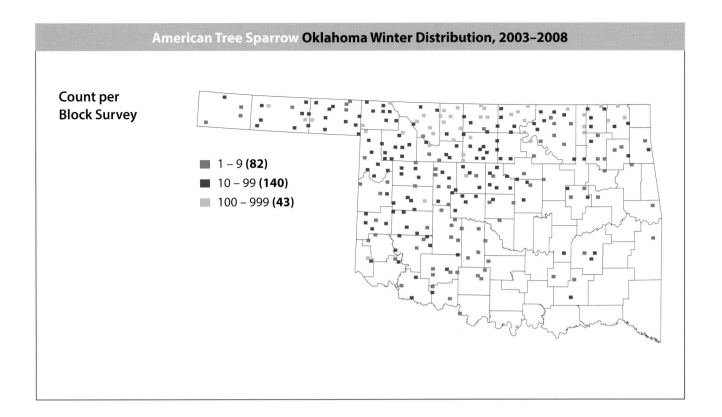

Count per
Block Survey

1 – 9 **(82)**
10 – 99 **(140)**
100 – 999 **(43)**

### References

National Audubon Society. 2011. The Christmas Bird Count historical results. http://www
.christmasbirdcount.org.

Naugler, Christopher T. 1993. American Tree Sparrow (*Spizella arborea*). *The Birds of North America Online*,
edited by A. Poole. Ithaca, N.Y.: Cornell Laboratory of Ornithology. http://bna.birds.cornell.edu.

Schrick, M. P. 1979. Tree Sparrows killed and eaten by meadowlarks. *Bulletin of the Oklahoma
Ornithological Society* 12:33–34.

# Chipping Sparrow
## *Spizella passerina*

Bob Gress

**Occurrence:** Year-round resident, although numbers increase during spring and fall migrations as northern breeding birds move to and from their winter ranges.

**Habitat:** Open woodlands, weedy fields, agricultural areas, parks, and towns.

**North American distribution:** Breeds from southeastern Alaska through much of Canada and the northern two-thirds of the lower 48 states. Year-round resident in parts of the southeastern United States and in parts of central Mexico. Winters in the southern United States and in Mexico.

**Oklahoma distribution:** Recorded statewide, but concentrated in the southeastern and central regions. Summer distribution recorded by the Oklahoma Breeding Bird Atlas Project was similar, although it yielded more records in the northeast than did the winter surveys.

**Behavior:** Chipping Sparrows are gregarious during migration and winter, and flocks of several birds to dozens of birds can be seen. Foraging takes place on the ground or in low vegetation, where seeds and occasionally fruit are eaten. Flocks of Chipping Sparrows often start out perched in a tree before flying to the ground one by one to forage. They will visit bird feeders to take advantage of spilled seed.

### Christmas Bird Count (CBC) Results, 1960–2009

$R^2 = 0.2542$

### CBC Results, 2003–2008

| Winter | Number recorded | Counts reporting |
| --- | --- | --- |
| 2003–2004 | 490 | 11 |
| 2004–2005 | 538 | 13 |
| 2005–2006 | 499 | 11 |
| 2006–2007 | 556 | 8 |
| 2007–2008 | 531 | 13 |

Count per
Block Survey

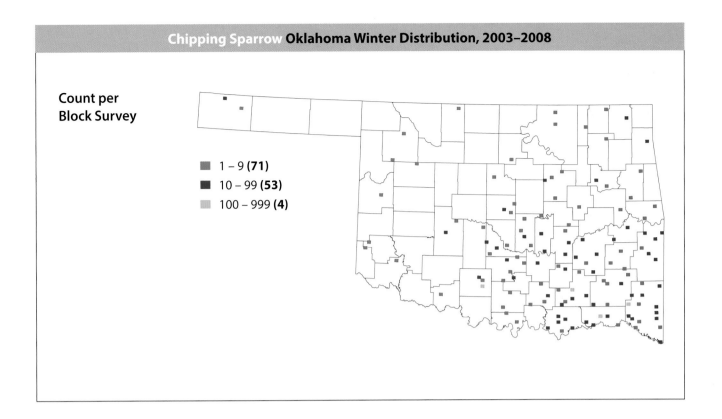

■ 1 – 9 **(71)**
■ 10 – 99 **(53)**
■ 100 – 999 **(4)**

**References**

Middleton, Alex L. 1998. Chipping Sparrow (*Spizella passerina*). *The Birds of North America Online*, edited by
 A. Poole. Ithaca, N.Y.: Cornell Laboratory of Ornithology. http://bna.birds.cornell.edu.
National Audubon Society. 2011. The Christmas Bird Count historical results. http://www
 .christmasbirdcount.org.
Oklahoma Bird Records Committee. 2009. *Date Guide to the Occurrences of Birds in Oklahoma*. 5th ed.
 Norman: Oklahoma Ornithological Society.
Reinking, D. L., ed. 2004. *Oklahoma Breeding Bird Atlas*. Norman: University of Oklahoma Press.

# Field Sparrow
## *Spizella pusilla*

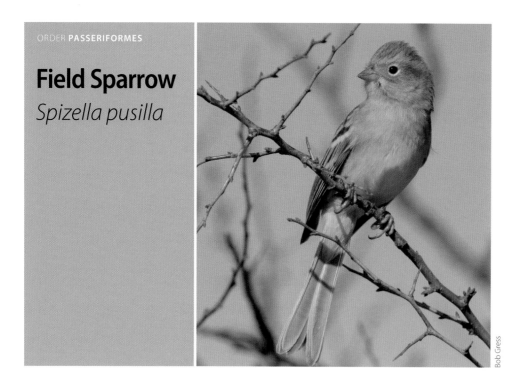

Bob Gress

**Occurrence:** Present year round, but some individuals may make short southern movements for winter, and northern breeding birds may move south into or through Oklahoma for the winter.

**Habitat:** Brushy fields and woodland edges.

**North American distribution:** Breeds across much of the eastern two-thirds of the lower 48 states, where it occurs in summer in the north, is a resident across central latitudes, and winters in the southern United States and northern Mexico.

**Oklahoma distribution:** Widespread and common statewide, with a slightly lower concentration in the Panhandle, where trees and brushy habitats are less common. The summer distribution recorded by the Oklahoma Breeding Bird Atlas Project was very similar.

**Behavior:** Field Sparrows may be seen singly, although they also form small flocks during the winter. They are sometimes seen among groups of other sparrows such as American Tree Sparrows. They forage on the ground or in low vegetation, primarily for small seeds.

**Christmas Bird Count (CBC) Results, 1960–2009**

$R^2 = 0.0537$

**CBC Results, 2003–2008**

| Winter | Number recorded | Counts reporting |
| --- | --- | --- |
| 2003–2004 | 1,066 | 19 |
| 2004–2005 | 1,164 | 19 |
| 2005–2006 | 953 | 19 |
| 2006–2007 | 944 | 18 |
| 2007–2008 | 951 | 19 |

Count per
Block Survey

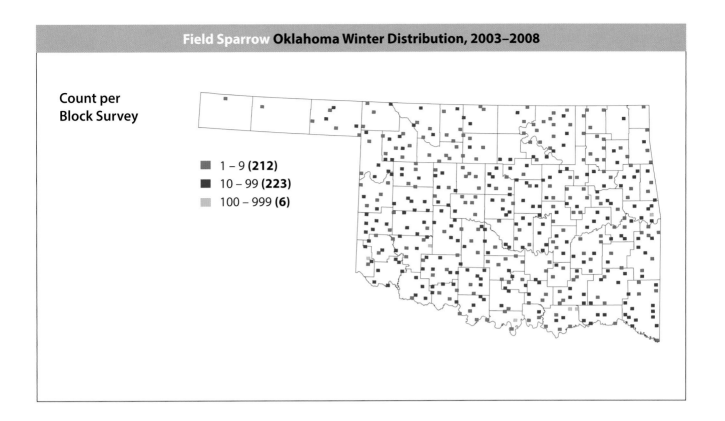

- 1 – 9 **(212)**
- 10 – 99 **(223)**
- 100 – 999 **(6)**

### References

Carey, Michael, M. Carey, D. E. Burhans, and D. A. Nelson. 2008. Field Sparrow (*Spizella pusilla*). *The Birds of North America Online*, edited by A. Poole. Ithaca, N.Y.: Cornell Laboratory of Ornithology. http://bna.birds.cornell.edu.

National Audubon Society. 2011. The Christmas Bird Count historical results. http://www.christmasbirdcount.org.

Oklahoma Bird Records Committee. 2009. *Date Guide to the Occurrences of Birds in Oklahoma*. 5th ed. Norman: Oklahoma Ornithological Society.

Reinking, D. L., ed. 2004. *Oklahoma Breeding Bird Atlas*. Norman: University of Oklahoma Press.

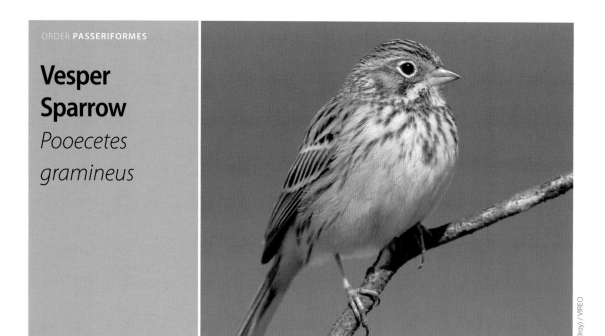

# Vesper Sparrow

*Pooecetes gramineus*

**Occurrence:** Late September through early May, except in northwestern and Panhandle counties, where it is reported to be a spring and fall migrant.

**Habitat:** Grasslands and agricultural areas.

**North American distribution:** Breeds across western and southern Canada, and the northern half of the lower 48 states. Winters in the southern United States and in Mexico.

**Oklahoma distribution:** Recorded in scattered survey blocks statewide, with the highest concentration of reports and the highest abundances coming from south-central counties. Several records from northwestern counties and the Panhandle indicate the presence of wintering birds where they have been considered only migrants.

**Behavior:** Vesper Sparrows can be seen singly or in groups and are often found along roadsides, from which they may flush to perch on a nearby fence. They forage on the ground for a variety of small seeds.

## Christmas Bird Count (CBC) Results, 1960–2009

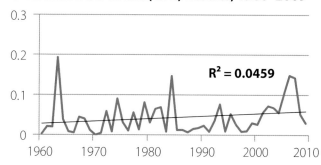

$R^2 = 0.0459$

## CBC Results, 2003–2008

| Winter | Number recorded | Counts reporting |
|---|---|---|
| 2003–2004 | 104 | 9 |
| 2004–2005 | 87 | 7 |
| 2005–2006 | 146 | 9 |
| 2006–2007 | 143 | 5 |
| 2007–2008 | 179 | 7 |

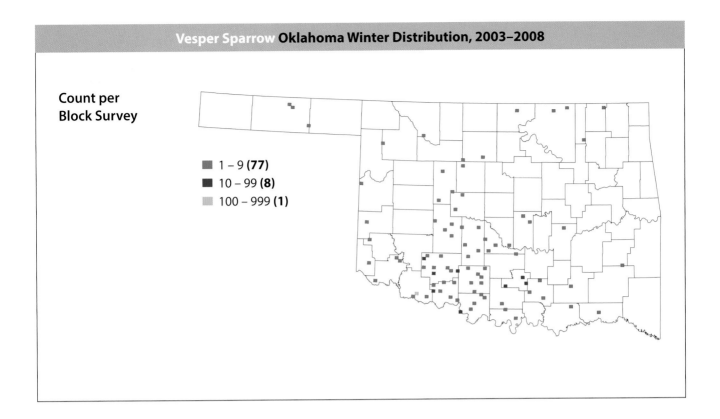

Count per
Block Survey

■ 1 – 9 **(77)**
■ 10 – 99 **(8)**
▨ 100 – 999 **(1)**

### References

Jones, Stephanie L., and John E. Cornely. 2002. Vesper Sparrow (*Pooecetes gramineus*). *The Birds of North America Online*, edited by A. Poole. Ithaca, N.Y.: Cornell Laboratory of Ornithology. http://bna.birds .cornell.edu.

National Audubon Society. 2011. The Christmas Bird Count historical results. http://www .christmasbirdcount.org.

Oklahoma Bird Records Committee. 2009. *Date Guide to the Occurrences of Birds in Oklahoma*. 5th ed. Norman: Oklahoma Ornithological Society.

## ORDER PASSERIFORMES

# Lark Sparrow
*Chondestes grammacus*

Terry Mitchell

**Occurrence:** Mid-March through October.

**Habitat:** Open woodlands and grassy areas.

**North American distribution:** Breeds throughout much of the central and western United States and south-central Canada. Resident in parts of California, Texas, and Mexico.

**Oklahoma distribution:** Not a regular wintering species, but recorded in two survey bocks. The Hughes County record (three birds) is from December 1, 2007, and the Kingfisher County report is from January 23, 2006, but was not documented. Also reported from Alfalfa County on February 9, 2004 (Oklahoma Bird Records Committee [OBRC] 2004), and from Comanche County on December 28, 2006 (two birds; OBRC 2007). The summer distribution recorded during the Oklahoma Breeding Bird Atlas Project was statewide, including 496 survey blocks.

**Behavior:** Lark Sparrows frequently gather in flocks, especially during fall and winter, but the winter rarity of this species in Oklahoma makes seeing a single bird as likely as seeing a group. They forage on the ground, mainly for seeds during the winter months.

## Christmas Bird Count (CBC) Results, 1960–2009

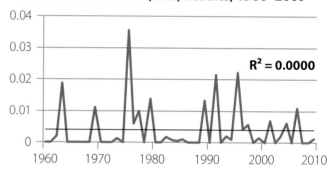

$R^2 = 0.0000$

## CBC Results, 2003–2008

| Winter | Number recorded | Counts reporting |
|--------|-----------------|------------------|
| 2003–2004 | 2 | 2 |
| 2004–2005 | 7 | 3 |
| 2005–2006 | 0 | — |
| 2006–2007 | 12 | 2 |
| 2007–2008 | 0 | — |

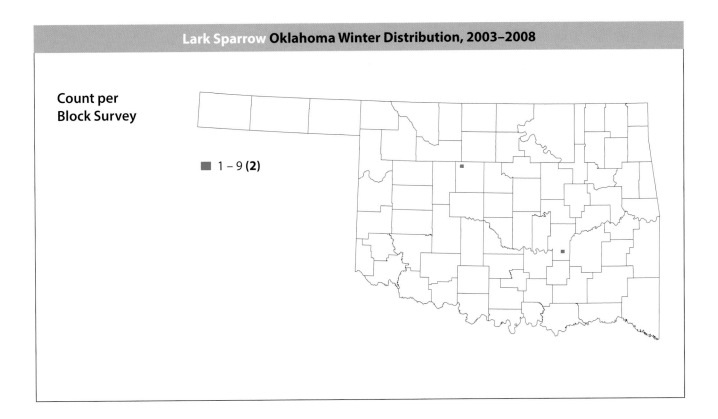

Count per
Block Survey

■ 1 – 9 **(2)**

### References

Martin, John W., and Jimmie R. Parrish. 2000. Lark Sparrow (*Chondestes grammacus*). *The Birds of North America Online*, edited by A. Poole. Ithaca, N.Y.: Cornell Laboratory of Ornithology. http://bna.birds .cornell.edu.

National Audubon Society. 2011. The Christmas Bird Count historical results. http://www .christmasbirdcount.org.

Oklahoma Bird Records Committee. 2004. 2003–2004 winter season. *The Scissortail* 54:25–27.

———. 2007. 2006–2007 winter season. *The Scissortail* 57:24–27.

———. 2009. *Date Guide to the Occurrences of Birds in Oklahoma.* 5th ed. Norman: Oklahoma Ornithological Society.

Reinking, D. L., ed. 2004. *Oklahoma Breeding Bird Atlas.* Norman: University of Oklahoma Press.

# Lark Bunting
## *Calamospiza melanocorys*

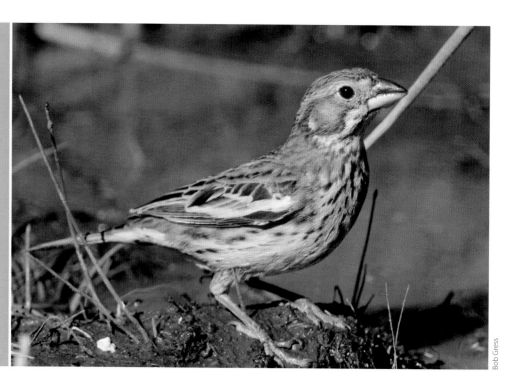

Bob Gress

**Occurrence:** Present year round in the Panhandle, and from November through mid-May in the western half of the main body of the state.

**Habitat:** Grasslands and fallow fields.

**North American distribution:** Breeds in the central plains of the United States and southern Canada. Winters in the southwestern United States and in Mexico.

**Oklahoma distribution:** Recorded sparsely in northwestern Oklahoma and the Panhandle and more commonly in southwestern counties. Its tendency to gather in flocks during the winter can be seen in the number of blocks where it was recorded in moderate rather than low densities. A report estimating 1,500 birds was received from Tillman County on January 26, 2008 (Oklahoma Bird Records Committee 2009a). The summer distribution recorded during the Oklahoma Breeding Bird Atlas Project was largely limited to the Panhandle, with this contrast in summer versus winter range highlighting the short-distance seasonal migrations made by Lark Buntings.

**Behavior:** Lark Buntings gather into small to large flocks during the winter. They forage on the ground in open areas for seeds and grain.

## Christmas Bird Count (CBC) Results, 1960–2009

$R^2 = 0.0067$

## CBC Results, 2003–2008

| Winter | Number recorded | Counts reporting |
|--------|-----------------|------------------|
| 2003–2004 | 0 | — |
| 2004–2005 | 0 | — |
| 2005–2006 | 0 | — |
| 2006–2007 | 0 | — |
| 2007–2008 | 0 | — |

**Count per
Block Survey**

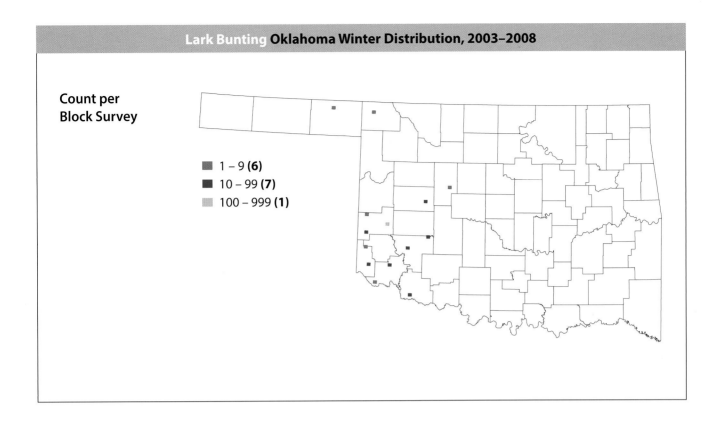

■ 1 – 9 **(6)**
■ 10 – 99 **(7)**
▨ 100 – 999 **(1)**

## References

National Audubon Society. 2011. The Christmas Bird Count historical results. http://www
.christmasbirdcount.org.

Oklahoma Bird Records Committee. 2009a. 2007–2008 winter season. *The Scissortail* 59:4–8.

———. 2009b. *Date Guide to the Occurrences of Birds in Oklahoma.* 5th ed. Norman: Oklahoma
Ornithological Society.

Reinking, D. L., ed. 2004. *Oklahoma Breeding Bird Atlas.* Norman: University of Oklahoma Press.

Shane, Thomas G. 2000. Lark Bunting (*Calamospiza melanocorys*). *The Birds of North America Online,* edited
by A. Poole. Ithaca, N.Y.: Cornell Laboratory of Ornithology. http://bna.birds.cornell.edu.

Tyler, J. D. 1985. The Lark Bunting in Oklahoma. *Bulletin of the Oklahoma Ornithological Society* 18:25–28.

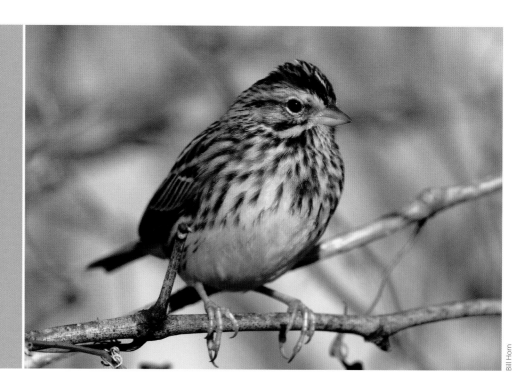

ORDER **PASSERIFORMES**

# Savannah Sparrow
*Passerculus sandwichensis*

**Occurrence:** Mid-September through mid-May.

**Habitat:** Grasslands and agricultural areas, where they are often seen along fence lines.

**North American distribution:** Breeds in Alaska, Canada, and the northern lower 48 states. Resident along parts of the Pacific Coast and in parts of Mexico. Winters in the southern United States and in most of Mexico.

**Oklahoma distribution:** Recorded commonly in survey blocks statewide, with a relatively even distribution of abundance categories. Somewhat fewer records and smaller numbers reported from the Panhandle counties.

**Behavior:** Savannah Sparrows can be seen singly or in small, loose flocks. They often associate with Vesper Sparrows or several other grassland sparrows. They forage on the ground for small seeds of grasses and forbs.

### Christmas Bird Count (CBC) Results, 1960–2009

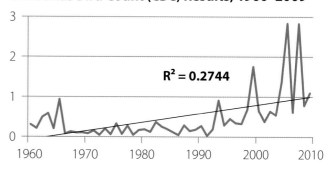

$R^2 = 0.2744$

### CBC Results, 2003–2008

| Winter | Number recorded | Counts reporting |
|--------|-----------------|------------------|
| 2003–2004 | 658 | 17 |
| 2004–2005 | 1,414 | 17 |
| 2005–2006 | 3,123 | 18 |
| 2006–2007 | 689 | 15 |
| 2007–2008 | 2,158 | 15 |

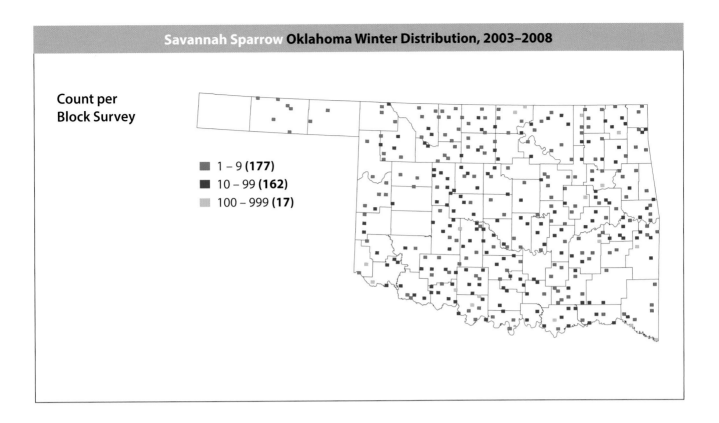

**Count per Block Survey**

■ 1 – 9 **(177)**
■ 10 – 99 **(162)**
▨ 100 – 999 **(17)**

### References

National Audubon Society. 2011. The Christmas Bird Count historical results. http://www
    .christmasbirdcount.org.

Oklahoma Bird Records Committee. 2009. *Date Guide to the Occurrences of Birds in Oklahoma*. 5th ed.
    Norman: Oklahoma Ornithological Society.

Shackford, J. S. 1988. Merlin preys on Savannah Sparrow. *Bulletin of the Oklahoma Ornithological Society*
    21:31.

Wheelwright, N. T., and J. D. Rising. 2008. Savannah Sparrow (*Passerculus sandwichensis*). *The Birds of North
    America Online*, edited by A. Poole. Ithaca, N.Y.: Cornell Laboratory of Ornithology. http://bna.birds
    .cornell.edu.

# Grasshopper Sparrow
## *Ammodramus savannarum*

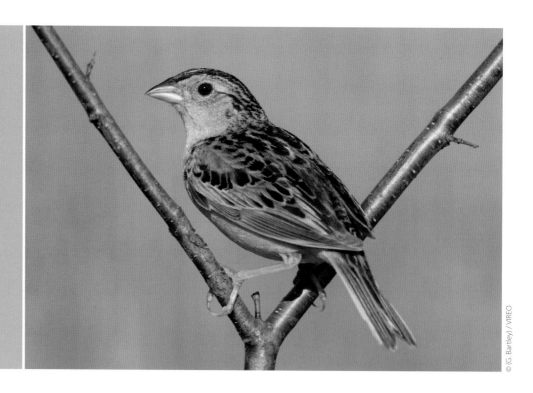

© (G. Bartley) / VIREO

**Occurrence:** April through October, except in southern counties, where it can uncommonly be present year round.

**Habitat:** Grasslands.

**North American distribution:** Breeds across the eastern two-thirds of the lower 48 states north of Louisiana, as well as in California and portions of southern Canada. Winters in the Carolinas, Georgia, the Gulf Coast states, parts of the southwestern United States, and much of Mexico.

**Oklahoma distribution:** Not recorded in survey blocks. Published reports during the project period came from Wichita Mountains National Wildlife Refuge in Comanche County on December 20, 2005 (five birds; Oklahoma Bird Records Committee 2006), and Red Slough Wildlife Management Area in McCurtain County on January 7, 2006 (two birds; Oklahoma Bird Records Committee 2007). The Oklahoma Breeding Bird Atlas Project recorded Grasshopper Sparrows virtually statewide during summer, except in heavily forested southeastern counties.

**Behavior:** Grasshopper Sparrows do not form flocks, although they are not known to be territorial during the winter and multiple birds may be found in the same general area. They forage on the ground, mainly for seeds during the winter, but also for insects when available.

**Christmas Bird Count (CBC) Results, 1960–2009**

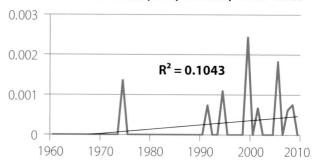

$R^2 = 0.1043$

**CBC Results, 2003–2008**

| Winter | Number recorded | Counts reporting |
|---|---|---|
| 2003–2004 | 0 | — |
| 2004–2005 | 0 | — |
| 2005–2006 | 3 | 2 |
| 2006–2007 | 0 | — |
| 2007–2008 | 1 | 1 |

Count per
Block Survey

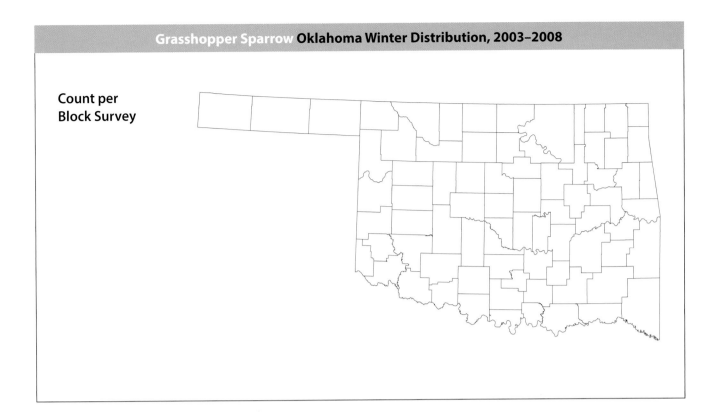

## References

National Audubon Society. 2011. The Christmas Bird Count historical results. http://www
.christmasbirdcount.org.

Oklahoma Bird Records Committee. 2006. 2005–2006 winter season. *The Scissortail* 56:14–15.

———. 2007. 2006–2007 winter season. *The Scissortail* 57:24–27.

———. 2009. *Date Guide to the Occurrences of Birds in Oklahoma*. 5th ed. Norman: Oklahoma
Ornithological Society.

Reinking, D. L., ed. 2004. *Oklahoma Breeding Bird Atlas*. Norman: University of Oklahoma Press.

Vickery, Peter D. 1996. Grasshopper Sparrow (*Ammodramus savannarum*). *The Birds of North America
Online*, edited by A. Poole. Ithaca, N.Y.: Cornell Laboratory of Ornithology. http://bna.birds.cornell.edu.

# Henslow's Sparrow
## *Ammodramus henslowii*

Bob Gress

**Occurrence:** Early April through mid-October. Recently found wintering in southeastern McCurtain County.

**Habitat:** Grassy understory within pine savannah.

**North American distribution:** Breeds in parts of the central and eastern United States. Winters in the southeastern United States.

**Oklahoma distribution:** Not recorded in survey blocks. One to three individuals reported from McCurtain County (Red Slough Wildlife Management Area) throughout the winters of 2005–2006 (Oklahoma Bird Records Committee 2006) and 2006–2007 (special interest species reports and Oklahoma Bird Records Committee 2007) represent the first winter records for the state, apart from a 1999 Stillwater Christmas Bird Count report that lacks documentation. The summer distribution recorded by the Oklahoma Breeding Bird Atlas Project was limited to Craig, Osage, Tulsa, and Washington Counties.

**Behavior:** Henslow's Sparrows are usually seen singly or in small groups during the winter. They forage on the ground for seeds, berries, and insects.

**Christmas Bird Count (CBC) Results, 1960–2009**

$R^2 = 0.0206$

**CBC Results, 2003–2008**

| Winter | Number recorded | Counts reporting |
|---|---|---|
| 2003–2004 | 0 | — |
| 2004–2005 | 0 | — |
| 2005–2006 | 0 | — |
| 2006–2007 | 0 | — |
| 2007–2008 | 0 | — |

**Count per
Block Survey**

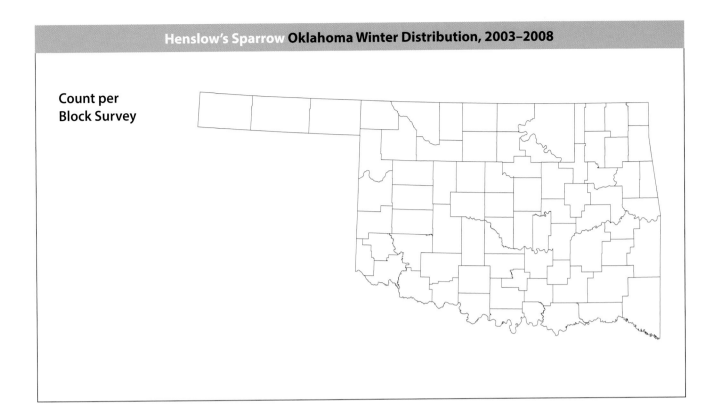

### References

Arbour, D., and D. R. Wood. 2006. Henslow's Sparrow wintering in McCurtain County, Oklahoma. *Bulletin of the Oklahoma Ornithological Society* 39:25–26.

Herkert, James R., Peter D. Vickery, and Donald E. Kroodsma. 2002. Henslow's Sparrow (*Ammodramus henslowii*). *The Birds of North America Online*, edited by A. Poole. Ithaca, N.Y.: Cornell Laboratory of Ornithology. http://bna.birds.cornell.edu.

National Audubon Society. 2011. The Christmas Bird Count historical results. http://www .christmasbirdcount.org.

Oklahoma Bird Records Committee. 2006. 2005–2006 winter season. *The Scissortail* 56:14–15.

———. 2007. 2006–2007 winter season. *The Scissortail* 57:24–27.

———. 2009. *Date Guide to the Occurrences of Birds in Oklahoma.* 5th ed. Norman: Oklahoma Ornithological Society.

Reinking, D. L., ed. 2004. *Oklahoma Breeding Bird Atlas.* Norman: University of Oklahoma Press.

# Le Conte's Sparrow
## *Ammodramus leconteii*

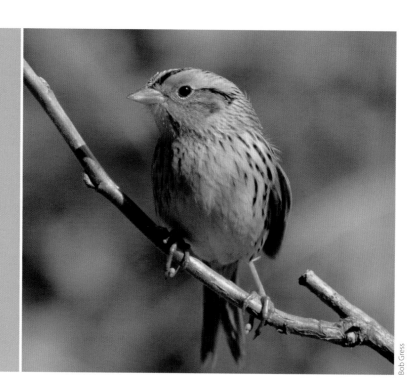

Bob Gress

**Occurrence:** Mid-October through April.

**Habitat:** Grasslands and wet meadows.

**North American distribution:** Breeds across much of Canada and the north-central lower 48 states. Winters in the south-central and southeastern United States

**Oklahoma distribution:** Recorded at scattered locations throughout the main body of the state. It is probably somewhat more common and widespread than indicated but usually requires extensive searching on foot to locate. A count of 50 birds was reported from Red Slough Wildlife Management Area in McCurtain County on January 15, 2008 (Oklahoma Bird Records Committee 2009a).

**Behavior:** Le Conte's Sparrows are solitary during winter. They forage on the ground for seeds, spending much of their time walking through thick grass. If flushed, they typically fly a short distance before disappearing into cover once more.

## Christmas Bird Count (CBC) Results, 1960–2009

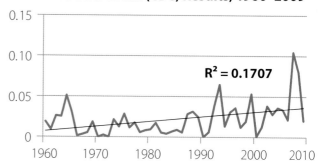

$R^2 = 0.1707$

## CBC Results, 2003–2008

| Winter | Number recorded | Counts reporting |
|--------|-----------------|------------------|
| 2003–2004 | 43 | 9 |
| 2004–2005 | 42 | 8 |
| 2005–2006 | 48 | 7 |
| 2006–2007 | 23 | 9 |
| 2007–2008 | 96 | 14 |

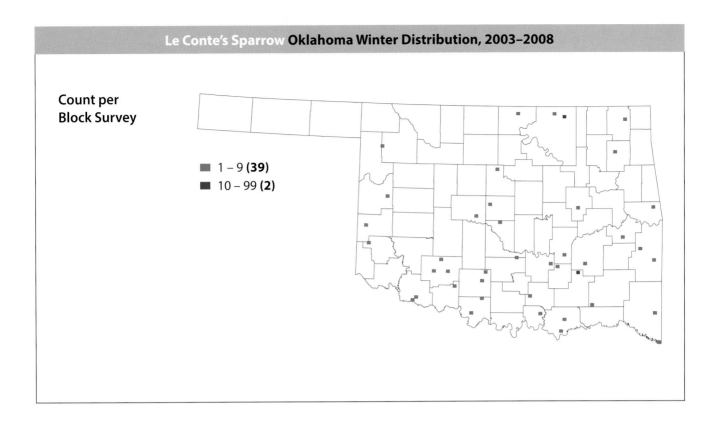

**Count per Block Survey**

- 1 – 9 **(39)**
- 10 – 99 **(2)**

### References

Lowther, Peter E. 2005. Le Conte's Sparrow (*Ammodramus leconteii*). *The Birds of North America Online*, edited by A. Poole. Ithaca, N.Y.: Cornell Laboratory of Ornithology. http://bna.birds.cornell.edu.

National Audubon Society. 2011. The Christmas Bird Count historical results. http://www.christmasbirdcount.org.

Oklahoma Bird Records Committee. 2009a. 2007–2008 winter season. *The Scissortail* 59:4–8.

———. 2009b. *Date Guide to the Occurrences of Birds in Oklahoma*. 5th ed. Norman: Oklahoma Ornithological Society.

**Occurrence:** Mid-October through early April.

**Habitat:** Woodlands, thickets, and brushy areas.

**North American distribution:** Breeds from Alaska to Newfoundland as well as in parts of the western lower 48 states. Resident or wintering species along the west coast of Canada and the United States. Winters broadly in the southeastern United States and in parts of the Desert Southwest.

**Oklahoma distribution:** Widespread at low densities in the main body of the state, with only one record from the Panhandle, where trees and brush are less common.

**Behavior:** Fox Sparrows are usually seen singly or in small groups. They often associate with White-crowned Sparrows, White-throated Sparrows, or other sparrow species. They forage on the ground in leaf litter for seeds, fruit, and insects, using both feet to scratch backward in a rapid hopping motion.

## Christmas Bird Count (CBC) Results, 1960–2009

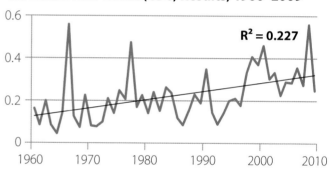

$R^2 = 0.227$

## CBC Results, 2003–2008

| Winter | Number recorded | Counts reporting |
|--------|-----------------|------------------|
| 2003–2004 | 273 | 17 |
| 2004–2005 | 352 | 18 |
| 2005–2006 | 316 | 19 |
| 2006–2007 | 365 | 17 |
| 2007–2008 | 281 | 18 |

# Fox Sparrow
## *Passerella iliaca*

© Brenda Carroll

**Count per Block Survey**

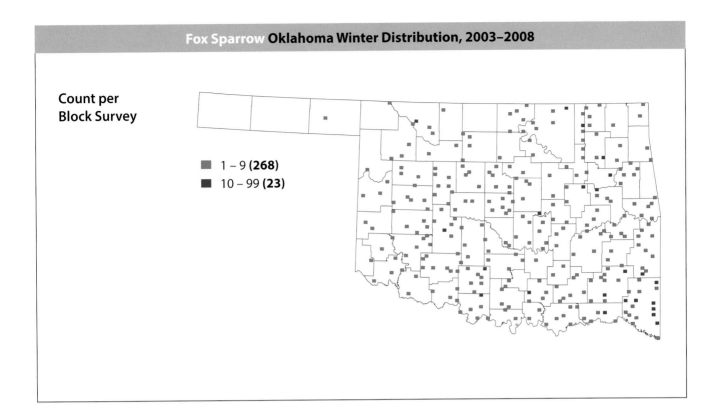

■ 1 – 9 **(268)**
■ 10 – 99 **(23)**

**References**

National Audubon Society. 2011. The Christmas Bird Count historical results. http://www
.christmasbirdcount.org.

Oklahoma Bird Records Committee. 2009. *Date Guide to the Occurrences of Birds in Oklahoma*. 5th ed.
Norman: Oklahoma Ornithological Society.

Weckstein, Jason D., Donald E. Kroodsma, and Robert C. Faucett. 2002. Fox Sparrow (*Passerella iliaca*).
*The Birds of North America Online*, edited by A. Poole. Ithaca, N.Y.: Cornell Laboratory of Ornithology.
http://bna.birds.cornell.edu.

# Song Sparrow
*Melospiza melodia*

ORDER PASSERIFORMES

Bob Gress

**Occurrence:** October through early May.

**Habitat:** Weedy or brushy areas and marshes.

**North American distribution:** Breeds in much of Canada and in parts of the lower 48 states. Resident across a large swath of the northern and central United States and along the Pacific Coast. Winters in the southern United States and northern Mexico.

**Oklahoma distribution:** Recorded in 506 survey blocks statewide (ranking seventh) and occurred in the highest abundances in southwestern counties. Survey blocks recording low to moderate abundances were evenly dispersed throughout the state.

**Behavior:** Song Sparrows are often seen in small, loose groups during the winter, and they associate with many other sparrow species, including Lincoln's and White-throated. They forage on the ground near thick cover in search of seeds and fruits and will readily visit backyard bird feeders for spilled seeds if brushy cover is available nearby.

### Christmas Bird Count (CBC) Results, 1960–2009

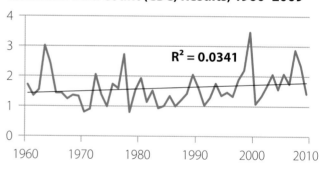

$R^2 = 0.0341$

### CBC Results, 2003–2008

| Winter | Number recorded | Counts reporting |
|--------|-----------------|------------------|
| 2003–2004 | 2,239 | 19 |
| 2004–2005 | 1,717 | 20 |
| 2005–2006 | 2,512 | 20 |
| 2006–2007 | 1,745 | 19 |
| 2007–2008 | 2,468 | 20 |

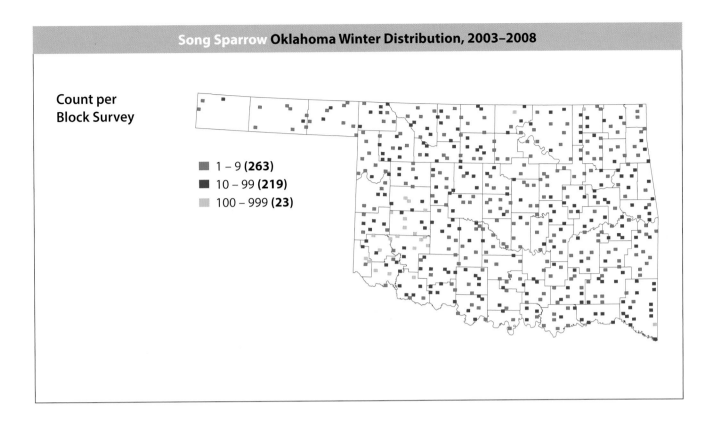

**Count per
Block Survey**

■ 1 – 9 **(263)**
■ 10 – 99 **(219)**
■ 100 – 999 **(23)**

**References**

Arcese, Peter, Mark K. Sogge, Amy B. Marr, and Michael A. Patten. 2002. Song Sparrow (*Melospiza melodia*). *The Birds of North America Online*, edited by A. Poole. Ithaca, N.Y.: Cornell Laboratory of Ornithology. http://bna.birds.cornell.edu.

National Audubon Society. 2011. The Christmas Bird Count historical results. http://www .christmasbirdcount.org.

Oklahoma Bird Records Committee. 2009. *Date Guide to the Occurrences of Birds in Oklahoma*. 5th ed. Norman: Oklahoma Ornithological Society.

# Lincoln's Sparrow
## *Melospiza lincolnii*

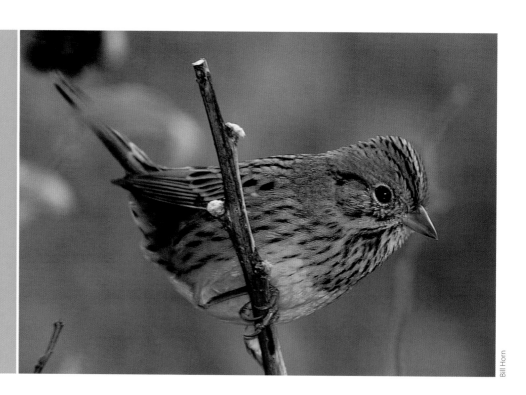

Bill Horn

**Occurrence:** Late September through late May.

**Habitat:** Woodland edges and brushy or weedy areas.

**North American distribution:** Breeds in Alaska, much of Canada, and parts of the northeastern and western lower 48 states. Winters along the Pacific Coast, across the southern United States, and in Mexico.

**Oklahoma distribution:** Recorded nearly statewide except for the western Panhandle counties, and though widespread, it was generally not abundant.

**Behavior:** Lincoln's Sparrows are usually seen singly, or sometimes in small, loose groups. They are sometimes found in association with other sparrows such as Song Sparrows or White-throated Sparrows. Foraging for seeds takes place mostly on the ground or in low vegetation. They will also visit backyards with bird feeders to forage for spilled seeds.

**Christmas Bird Count (CBC) Results, 1960–2009**

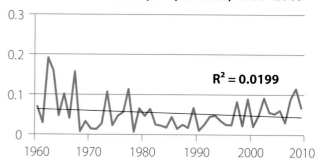

$R^2 = 0.0199$

**CBC Results, 2003–2008**

| Winter | Number recorded | Counts reporting |
|--------|-----------------|------------------|
| 2003–2004 | 65 | 14 |
| 2004–2005 | 59 | 12 |
| 2005–2006 | 86 | 13 |
| 2006–2007 | 37 | 11 |
| 2007–2008 | 98 | 15 |

**Count per Block Survey**

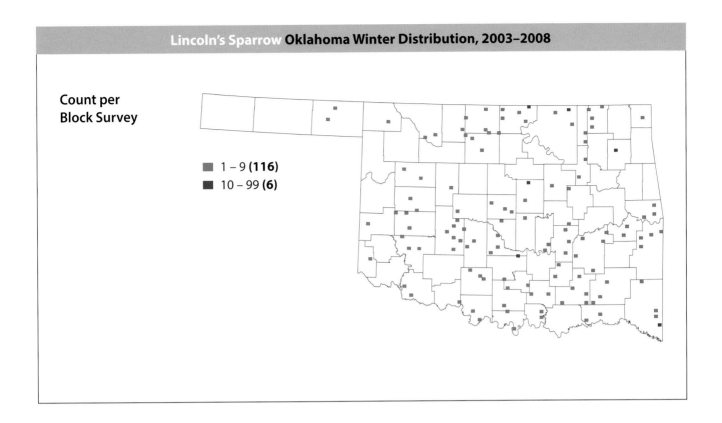

■ 1 – 9 **(116)**
■ 10 – 99 **(6)**

### References

Ammon, Elisabeth M. 1995. Lincoln's Sparrow (*Melospiza lincolnii*). *The Birds of North America Online*, edited by A. Poole. Ithaca, N.Y.: Cornell Laboratory of Ornithology. http://bna.birds.cornell.edu.

National Audubon Society. 2011. The Christmas Bird Count historical results. http://www.christmasbirdcount.org.

Oklahoma Bird Records Committee. 2009. *Date Guide to the Occurrences of Birds in Oklahoma*. 5th ed. Norman: Oklahoma Ornithological Society.

# Swamp Sparrow
*Melospiza georgiana*

Bob Gress

**Occurrence:** Early October through early May.

**Habitat:** Dense grassy or brushy areas, often near water.

**North American distribution:** Breeds in much of Canada and parts of the northeastern United States. Winters along the Pacific Coast and broadly throughout the southeastern United States and eastern Mexico.

**Oklahoma distribution:** Recorded fairly commonly in survey blocks throughout the main body of the state, mostly in low abundance. Somewhat more widespread and abundant in eastern counties.

**Behavior:** Swamp Sparrows are often found in loose groups of several to a dozen or more birds. They are frequently found in areas where Song Sparrows and other sparrows may also be present. Foraging for seeds and fruits takes place on the ground or at the edges of standing water.

**Christmas Bird Count (CBC) Results, 1960–2009**

$R^2 = 0.3053$

**CBC Results, 2003–2008**

| Winter | Number recorded | Counts reporting |
|--------|-----------------|------------------|
| 2003–2004 | 158 | 14 |
| 2004–2005 | 184 | 13 |
| 2005–2006 | 204 | 13 |
| 2006–2007 | 188 | 11 |
| 2007–2008 | 156 | 13 |

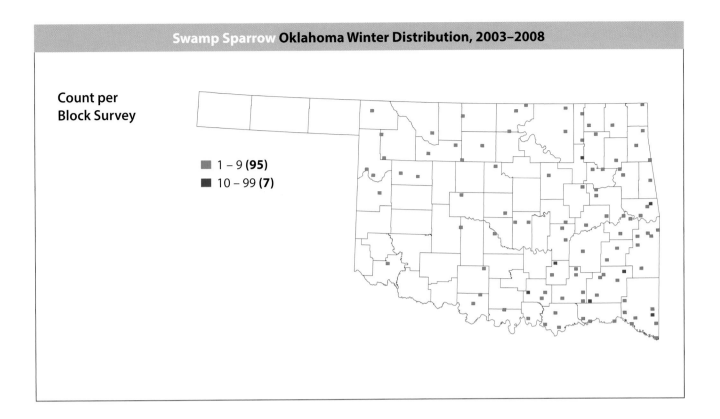

Count per
Block Survey

■ 1 – 9 **(95)**
■ 10 – 99 **(7)**

### References

Mowbray, Thomas B. 1997. Swamp Sparrow (*Melospiza georgiana*). *The Birds of North America Online*, edited by A. Poole. Ithaca, N.Y.: Cornell Laboratory of Ornithology. http://bna.birds.cornell.edu.

National Audubon Society. 2011. The Christmas Bird Count historical results. http://www .christmasbirdcount.org.

Oklahoma Bird Records Committee. 2009. *Date Guide to the Occurrences of Birds in Oklahoma*. 5th ed. Norman: Oklahoma Ornithological Society.

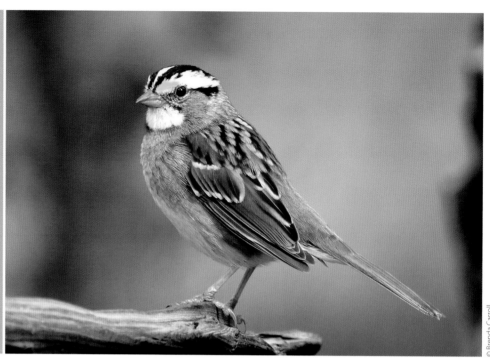

# White-throated Sparrow
## *Zonotrichia albicollis*

**Occurrence:** October through mid-May.

**Habitat:** Woodlands and brushy areas.

**North American distribution:** Breeds in much of Canada and parts of the northeastern United States. Winters broadly throughout the eastern and southwestern United States and along the Pacific Coast.

**Oklahoma distribution:** Commonly recorded in survey blocks throughout the main body of the state, but much more widespread and abundant in the eastern half, where brushy woodlands are more prevalent. Locally common in western counties where suitable habitat is present.

**Behavior:** White-throated Sparrows are typically seen in small, loose flocks, and they often associate with other species such as Dark-eyed Juncos, White-crowned Sparrows, and Song Sparrows. They forage on the ground by scratching away leaf litter to locate seeds and fruits, and they will visit bird feeders near brushy cover to look for spilled seeds.

**Christmas Bird Count (CBC) Results, 1960–2009**

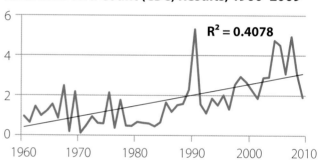

$R^2 = 0.4078$

**CBC Results, 2003–2008**

| Winter | Number recorded | Counts reporting |
|---|---|---|
| 2003–2004 | 2,754 | 15 |
| 2004–2005 | 4,601 | 17 |
| 2005–2006 | 4,106 | 18 |
| 2006–2007 | 3,146 | 17 |
| 2007–2008 | 3,004 | 18 |

**Count per Block Survey**

■ 1 – 9 **(135)**
■ 10 – 99 **(163)**
■ 100 – 999 **(24)**

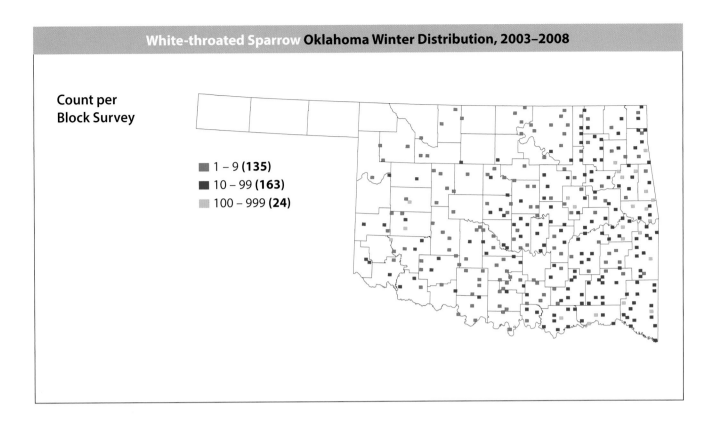

### References

Falls, J. B., and J. G. Kopachena. 2010. White-throated Sparrow (*Zonotrichia albicollis*). *The Birds of North America Online*, edited by A. Poole. Ithaca, N.Y.: Cornell Laboratory of Ornithology. http://bna.birds.cornell.edu.

National Audubon Society. 2011. The Christmas Bird Count historical results. http://www.christmasbirdcount.org.

Oklahoma Bird Records Committee. 2009. *Date Guide to the Occurrences of Birds in Oklahoma*. 5th ed. Norman: Oklahoma Ornithological Society.

# Harris's Sparrow
## *Zonotrichia querula*

David Arbour / USDA Forest Service

**Occurrence:** Mid-October through mid-May (early November through early May in southern counties).

**Habitat:** Weedy areas, thickets, and woodland edges.

**North American distribution:** Breeds in arctic Canada and winters in the south-central plains of the United States.

**Oklahoma distribution:** Recorded statewide at moderate densities, with fewer records from heavily forested southeastern counties and the western Panhandle counties, where brushy habitats are scarce. The largest concentrations were in the western half of the state.

**Behavior:** Harris's Sparrows are gregarious during the winter. They are usually seen in small flocks that often include other species such as White-crowned, White-throated, and Song Sparrows. When startled, they typically fly up to the top of thickets for a look around, unlike many other sparrows, which quickly seek thick cover. They forage on the ground for seeds and fruits and will come to spilled bird seed below feeders.

### Christmas Bird Count (CBC) Results, 1960–2009

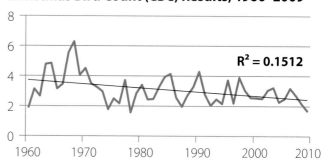

$R^2 = 0.1512$

### CBC Results, 2003–2008

| Winter | Number recorded | Counts reporting |
| --- | --- | --- |
| 2003–2004 | 3,549 | 17 |
| 2004–2005 | 2,547 | 18 |
| 2005–2006 | 2,890 | 19 |
| 2006–2007 | 3,390 | 18 |
| 2007–2008 | 2,693 | 19 |

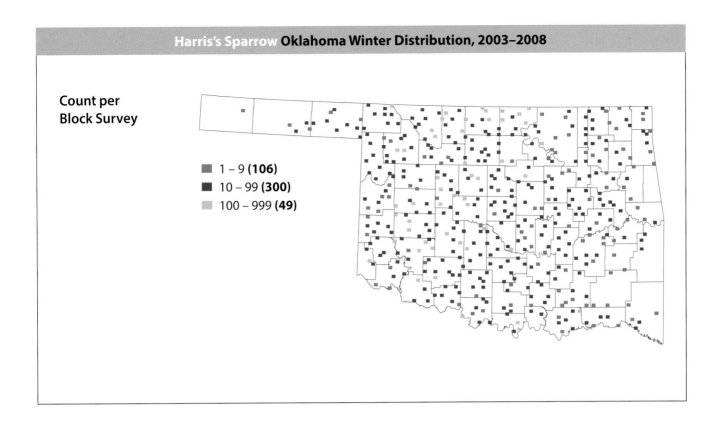

Count per
Block Survey

■ 1 – 9 **(106)**
■ 10 – 99 **(300)**
▨ 100 – 999 **(49)**

**References**

National Audubon Society. 2011. The Christmas Bird Count historical results. http://www
.christmasbirdcount.org.
Norment, C. J., and S. A. Shackleton. 2008. Harris's Sparrow (*Zonotrichia querula*). *The Birds of North America
Online,* edited by A. Poole. Ithaca, N.Y.: Cornell Laboratory of Ornithology. http://bna.birds.cornell.edu.
Oklahoma Bird Records Committee. 2009. *Date Guide to the Occurrences of Birds in Oklahoma.* 5th ed.
Norman: Oklahoma Ornithological Society.

# White-crowned Sparrow

*Zonotrichia leucophrys*

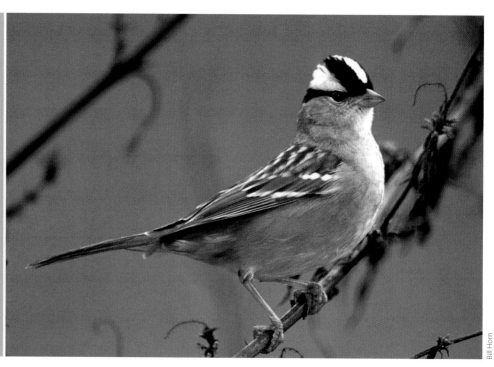

Bill Horn

**Occurrence:** October through mid-May.

**Habitat:** Weedy or brushy areas including parks and yards.

**North American distribution:** Breeds in Alaska, parts of northern and western Canada, and parts of the western lower 48 states. Resident in parts of the western lower 48 states and winters broadly across the southern half of the United States and into Mexico.

**Oklahoma distribution:** Recorded commonly and at moderate to high abundances in survey blocks statewide. Somewhat fewer records are evident from the open prairies of Osage County and the heavily forested southeastern counties, though even there they are present where suitable habitat can be found.

**Behavior:** White-crowned Sparrows are gregarious during the winter months and are usually seen in flocks that often contain White-throated Sparrows, Harris's Sparrows, and other sparrow species. They forage on the ground near cover in search of seeds, fruits, and insects when available. They will readily visit backyard bird feeders near suitable cover to scavenge spilled seeds.

**Christmas Bird Count (CBC) Results, 1960–2009**

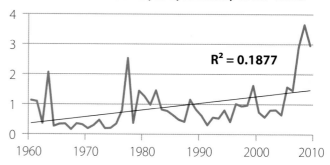

$R^2 = 0.1877$

**CBC Results, 2003–2008**

| Winter | Number recorded | Counts reporting |
|---|---|---|
| 2003–2004 | 856 | 18 |
| 2004–2005 | 641 | 19 |
| 2005–2006 | 1,672 | 20 |
| 2006–2007 | 1,432 | 19 |
| 2007–2008 | 2,208 | 20 |

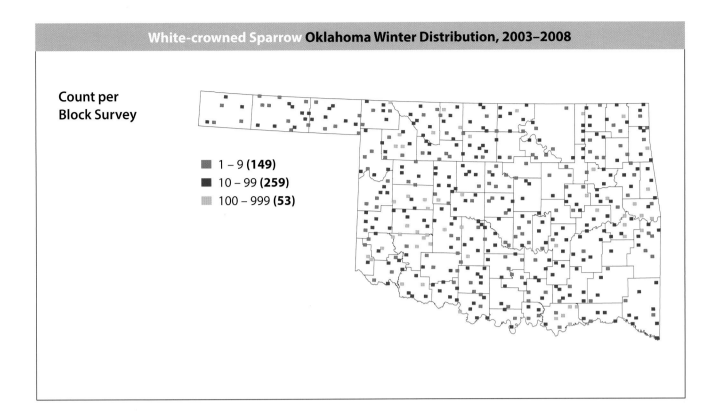

Count per
Block Survey

■ 1 – 9 **(149)**
■ 10 – 99 **(259)**
▦ 100 – 999 **(53)**

### References

Chilton, G., M. C. Baker, C. D. Barrentine, and M. A. Cunningham. 1995. White-crowned Sparrow (*Zonotrichia leucophrys*). *The Birds of North America Online*, edited by A. Poole. Ithaca, N.Y.: Cornell Laboratory of Ornithology. http://bna.birds.cornell.edu.

National Audubon Society. 2011. The Christmas Bird Count historical results. http://www.christmasbirdcount.org.

Oklahoma Bird Records Committee. 2009. *Date Guide to the Occurrences of Birds in Oklahoma*. 5th ed. Norman: Oklahoma Ornithological Society.

# Dark-eyed Junco
## *Junco hyemalis*

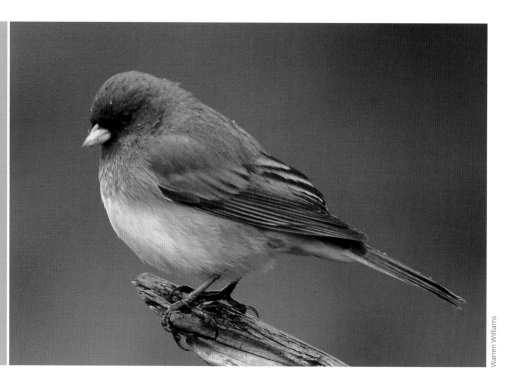

Warren Williams

**Occurrence:** Late September through late April.

**Habitat:** Brushy areas, open woodlands, parks, and towns.

**North American distribution:** Breeds throughout much of Alaska and Canada. Present year round in parts of the northeastern and western United States, and winters broadly across the remainder of the lower 48 states except Florida.

**Oklahoma distribution:** Recorded in nearly all blocks statewide, and at moderate to high densities in most of them. Dark-eyed Juncos were found in 535 survey blocks, giving them the number two ranking among the most widespread species. They were slightly less common in the Panhandle, where brushy habitats are less available.

**Behavior:** Juncos are gregarious during the winter and are typically seen in small groups. These flocks often associate with other sparrow species. They forage on the ground for seeds and will readily come to bird feeders for spilled seeds.

**Christmas Bird Count (CBC) Results, 1960–2009**

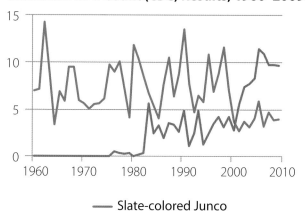

— Slate-colored Junco

— Dark-eyed Junco

**CBC Results, 2003–2008**

| Winter | Number recorded | Counts reporting |
|---|---|---|
| 2003–2004 | 7,502 | 13 |
| 2004–2005 | 9,397 | 15 |
| 2005–2006 | 14,538 | 15 |
| 2006–2007 | 9,511 | 15 |
| 2007–2008 | 8,137 | 15 |

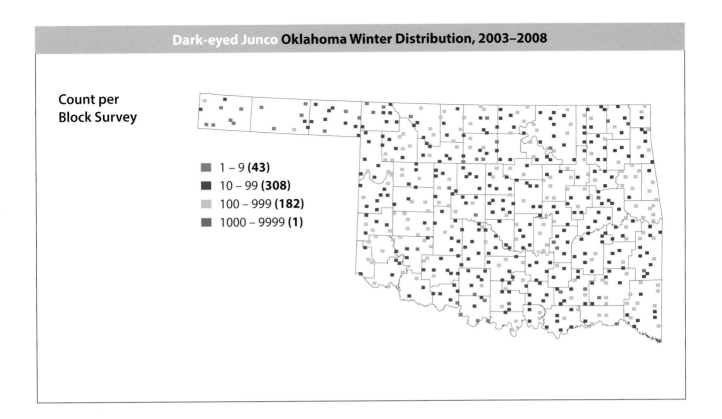

## Dark-eyed Junco Oklahoma Winter Distribution, 2003–2008

**Count per Block Survey**

- 1 – 9 **(43)**
- 10 – 99 **(308)**
- 100 – 999 **(182)**
- 1000 – 9999 **(1)**

### References

National Audubon Society. 2011. The Christmas Bird Count historical results. http://www
.christmasbirdcount.org.

Nolan, V., Jr., E. D. Ketterson, D. A. Cristol, C. M. Rogers, E. D. Clotfelter, R. C. Titus, S. J. Schoech, and
E. Snajdr. 2002. Dark-eyed Junco (*Junco hyemalis*). *The Birds of North America Online*, edited by A. Poole.
Ithaca, N.Y.: Cornell Laboratory of Ornithology. http://bna.birds.cornell.edu.

Oklahoma Bird Records Committee. 2009. *Date Guide to the Occurrences of Birds in Oklahoma*. 5th ed.
Norman: Oklahoma Ornithological Society.

Van Els, P., C. M. Walker, and T. J. O'Connell. 2009. Capture of Gray-headed Junco (*Junco hyemalis caniceps*)
in Payne County, Oklahoma. *Bulletin of the Oklahoma Ornithological Society* 42:9–12.

# Summer Tanager
*Piranga rubra*

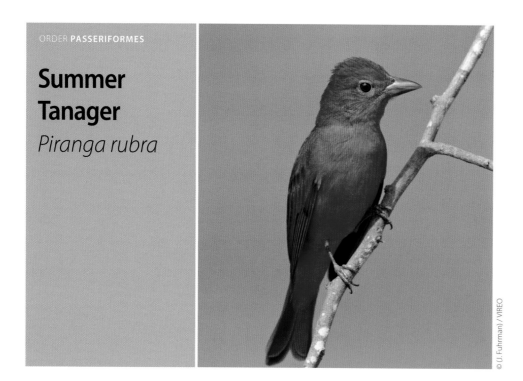

© (J. Fuhrman) / VIREO

**Occurrence:** Mid-April through mid-October.

**Habitat:** Deciduous and mixed coniferous woodlands.

**North American distribution:** Breeds from southern Iowa and southern Pennsylvania south to northern Mexico, extending west through parts of southern New Mexico, Arizona, California, and Nevada. Winters in southern Florida and Mexico as well as farther south.

**Oklahoma distribution:** Not recorded in survey blocks, and not a regular wintering species. Published reports of this species during the project period include Broken Bow in McCurtain County from January 17 through February 29, 2004 (Oklahoma Bird Records Committee [OBRC] 2004); also recorded at a Cherokee County residence in Cookson from December 2004 through February 2005 (OBRC 2005), and again in Cherokee County in Fort Gibson on December 17 and 21, 2007 (OBRC 2009a). The spike in the Christmas Bird Count graph is from a bird recorded on the Fort Gibson count in January 1965. The Oklahoma Breeding Bird Atlas Project recorded the species commonly during summer throughout the eastern half of the state.

**Behavior:** Summer Tanagers capture bees, wasps, and other insects but also eat fruits, especially during the winter. They are often seen in pairs during the summer, but because of the rarity of this species in Oklahoma during the winter, even a single bird is very unusual.

**Christmas Bird Count (CBC) Results, 1960–2009**

$R^2 = 0.0412$

**CBC Results, 2003–2008**

| Winter | Number recorded | Counts reporting |
|--------|-----------------|------------------|
| 2003–2004 | 0 | — |
| 2004–2005 | 0 | — |
| 2005–2006 | 0 | — |
| 2006–2007 | 0 | — |
| 2007–2008 | 0 | — |

**Count per
Block Survey**

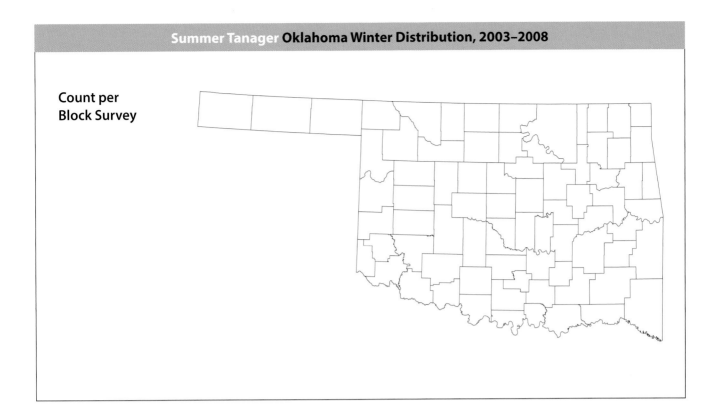

### References

Heck, B. A. 2005. Summer Tanager winters in Oklahoma. *Bulletin of the Oklahoma Ornithological Society*
    38:15–16.
National Audubon Society. 2011. The Christmas Bird Count historical results. http://www
    .christmasbirdcount.org.
Oklahoma Bird Records Committee. 2004. 2003–2004 winter season. *The Scissortail* 54:25–27.
———. 2005. 2004–2005 winter season. *The Scissortail* 55:18–20.
———. 2009a. 2007–2008 winter season. *The Scissortail* 59:4–8.
———. 2009b. *Date Guide to the Occurrences of Birds in Oklahoma*. 5th ed. Norman: Oklahoma
    Ornithological Society.
Reinking, D. L., ed. 2004. *Oklahoma Breeding Bird Atlas*. Norman: University of Oklahoma Press.
Robinson, W. Douglas. 1996. Summer Tanager (*Piranga rubra*). *The Birds of North America Online*, edited by
    A. Poole. Ithaca, N.Y.: Cornell Laboratory of Ornithology. http://bna.birds.cornell.edu.

# Northern Cardinal
## *Cardinalis cardinalis*

© Brenda Carroll

**Occurrence:** Year-round resident.

**Habitat:** Woodlands, brushy areas, parks, and towns.

**North American distribution:** Resident in southeastern Canada, the eastern United States, and parts of the southwestern United States and Mexico.

**Oklahoma distribution:** Recorded statewide in 521 survey blocks (ranking fifth), but noticeably sparse in the Panhandle, where brushy habitats are less common, and most abundant in northeastern counties. As expected for a resident species, the summer distribution recorded during the Oklahoma Breeding Bird Atlas Project was similar.

**Behavior:** Northern Cardinals form small, loose flocks during the winter, the membership of which often changes. They forage on the ground and in trees and shrubs for seeds and fruits. Their heavy bills are effective at cracking harder seeds. They will readily visit bird feeders as well as the ground under bird feeders for seeds.

## Christmas Bird Count (CBC) Results, 1960–2009

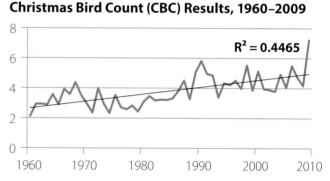

$R^2 = 0.4465$

## CBC Results, 2003–2008

| Winter | Number recorded | Counts reporting |
| --- | --- | --- |
| 2003–2004 | 4,256 | 18 |
| 2004–2005 | 5,099 | 19 |
| 2005–2006 | 4,470 | 19 |
| 2006–2007 | 5,302 | 18 |
| 2007–2008 | 3,698 | 20 |

**Count per Block Survey**

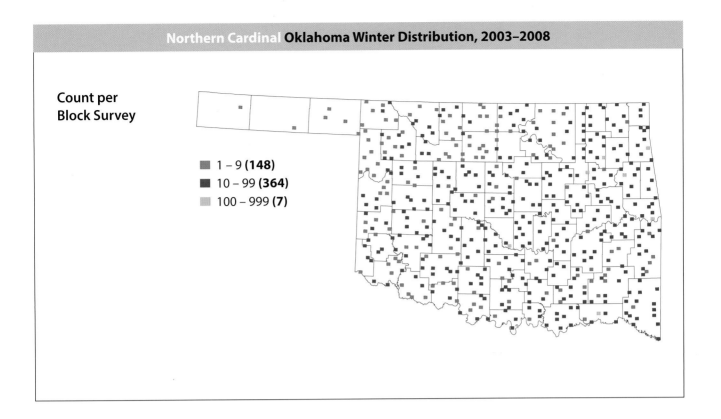

- ■ 1 – 9 **(148)**
- ■ 10 – 99 **(364)**
- ▨ 100 – 999 **(7)**

**References**

Halkin, Sylvia L., and Susan U. Linville. 1999. Northern Cardinal (*Cardinalis cardinalis*). *The Birds of North America Online*, edited by A. Poole. Ithaca, N.Y.: Cornell Laboratory of Ornithology. http://bna.birds .cornell.edu.

National Audubon Society. 2011. The Christmas Bird Count historical results. http://www .christmasbirdcount.org.

Oklahoma Bird Records Committee. 2009. *Date Guide to the Occurrences of Birds in Oklahoma*. 5th ed. Norman: Oklahoma Ornithological Society.

Reinking, D. L., ed. 2004. *Oklahoma Breeding Bird Atlas*. Norman: University of Oklahoma Press.

Sutton, G. M. 1984. Singing of female Northern Cardinal in winter. *Bulletin of the Oklahoma Ornithological Society* 17:33.

# Pyrrhuloxia
## *Cardinalis sinuatus*

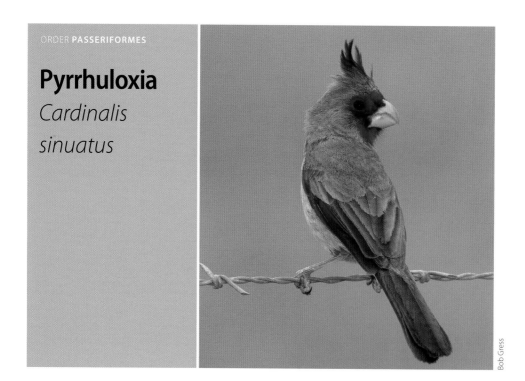

Bob Gress

**Occurrence:** Rare visitor, with both winter and summer records.

**Habitat:** Mesquite grasslands and thickets.

**North American distribution:** Resident in the southwestern United States and in Mexico. Occasionally wanders north of its regular range, most often between November and March.

**Oklahoma distribution:** Recorded in a single survey block in Jackson County during the winter of 2005–2006. Previous winter records are from Cimarron County during the winter of 1975–1976, the Kenton Christmas Bird Count in January 1983 and December 1991, and Comanche County during the winter of 2001–2002.

**Behavior:** Pyrrhuloxias are gregarious during the winter, although because of their rarity in Oklahoma, single birds are more likely to be seen. They often associate with flocks of Northern Cardinals in other parts of their range during winter. They forage both on the ground and in vegetation for seeds and fruits.

## Christmas Bird Count (CBC) Results, 1960–2009

$R^2 = 0.0000$

## CBC Results, 2003–2008

| Winter | Number recorded | Counts reporting |
|--------|-----------------|------------------|
| 2003–2004 | 0 | — |
| 2004–2005 | 0 | — |
| 2005–2006 | 0 | — |
| 2006–2007 | 0 | — |
| 2007–2008 | 0 | — |

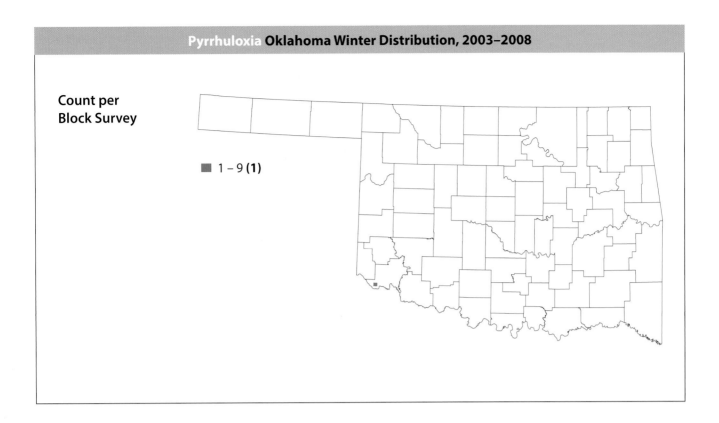

**Count per Block Survey**

■ 1 – 9 **(1)**

### References

National Audubon Society. 2011. The Christmas Bird Count historical results. http://www .christmasbirdcount.org.

Oklahoma Bird Records Committee. 2009. *Date Guide to the Occurrences of Birds in Oklahoma*. 5th ed. Norman: Oklahoma Ornithological Society.

Patten, M. A. 2006. Dispersal and vagrancy in the Pyrrhuloxia. *Western Birds* 37:37–44.

Patti, S. T. 1976. Another new bird for Oklahoma: Pyrrhuloxia. *Bulletin of the Oklahoma Ornithological Society* 9:28–30.

Tweit, Robert C., and Christopher W. Thompson. 1999. Pyrrhuloxia (*Cardinalis sinuatus*). *The Birds of North America Online*, edited by A. Poole. Ithaca, N.Y.: Cornell Laboratory of Ornithology. http://bna.birds .cornell.edu.

# Red-winged Blackbird
*Agelaius phoeniceus*

Bob Gress

**Occurrence:** Year-round resident, but many additional individuals from northern breeding areas winter here.

**Habitat:** Wetlands, pastures, and agricultural areas.

**North American distribution:** Breeds in southern Alaska, much of Canada, and the northern lower 48 states. Resident across most of the lower 48 states and in parts of Mexico.

**Oklahoma distribution:** Recorded at moderate to high abundances statewide, including survey blocks with more than 1,000 birds reported in all regions of the state, and three Kay County blocks where over 10,000 birds were reported. As expected for a resident species, the summer distribution recorded by the Oklahoma Breeding Bird Atlas Project was similar.

**Behavior:** As can be seen clearly from the abundance map, Red-winged Blackbirds are very gregarious, especially from fall through spring, when they can occur in flocks of many thousands at roosts and foraging areas. These flocks frequently include other species such as grackles, cowbirds, and starlings. Their winter diet includes mostly grains and weed seeds that are gathered from the ground or from vegetation.

## Christmas Bird Count (CBC) Results, 1960–2009

$R^2 = 0.0505$

## CBC Results, 2003–2008

| Winter | Number recorded | Counts reporting |
|--------|-----------------|------------------|
| 2003–2004 | 60,395 | 18 |
| 2004–2005 | 69,265 | 20 |
| 2005–2006 | 883,501 | 20 |
| 2006–2007 | 8,073,857 | 19 |
| 2007–2008 | 5,130,773 | 20 |

**Count per
Block Survey**

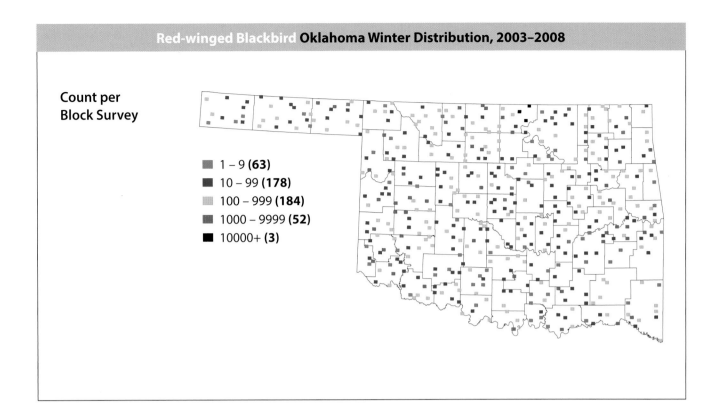

1 – 9 **(63)**
10 – 99 **(178)**
100 – 999 **(184)**
1000 – 9999 **(52)**
10000+ **(3)**

### References

National Audubon Society. 2011. The Christmas Bird Count historical results. http://www
.christmasbirdcount.org.

Oklahoma Bird Records Committee. 2009. *Date Guide to the Occurrences of Birds in Oklahoma*. 5th ed.
Norman: Oklahoma Ornithological Society.

Reinking, D. L., ed. 2004. *Oklahoma Breeding Bird Atlas*. Norman: University of Oklahoma Press.

Yasukawa, Ken, and William A. Searcy. 1995. Red-winged Blackbird (*Agelaius phoeniceus*). *The Birds of North
America Online*, edited by A. Poole. Ithaca, N.Y.: Cornell Laboratory of Ornithology. http://bna.birds
.cornell.edu.

# Eastern Meadowlark
## *Sturnella magna*

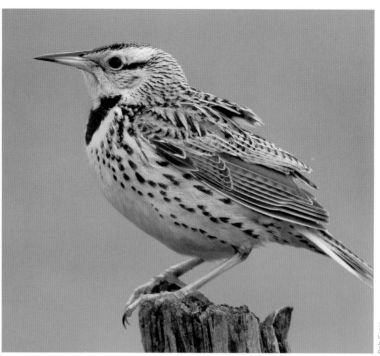

Bob Gress

**Occurrence:** Year-round resident, with additional birds migrating to Oklahoma for the winter from northern breeding areas.

**Habitat:** A variety of grasslands and weedy fields. Generally found in thicker cover than Western Meadowlarks.

**North American distribution:** Breeds from eastern Canada southwest to Arizona. Resident throughout most of the southeastern United States and parts of the southwestern United States and Mexico.

**Oklahoma distribution:** Widespread and abundant throughout the main body of the state, although somewhat less common in the forested southeastern counties, arid western counties, and the Panhandle. The summer distribution recorded by the Oklahoma Breeding Bird Atlas Project was very similar.

**Behavior:** Eastern Meadowlarks become gregarious during the fall and winter and may be seen in flocks of dozens to a hundred or more. They are often seen perched on fence posts, or flying low with rapid wing beats followed by glides. They forage on the ground by walking in search of waste grain, seeds, and insects, using their long bills to probe the soil and flip clods out of their way. They are known to occasionally kill and eat small songbirds or rodents, particularly after snow covers the ground and makes foraging difficult.

## Christmas Bird Count (CBC) Results, 1960–2009

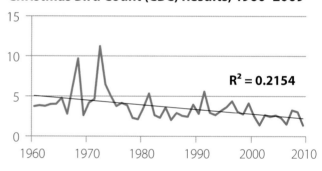

$R^2 = 0.2154$

## CBC Results, 2003–2008

| Winter | Number recorded | Counts reporting |
|---|---|---|
| 2003–2004 | 2,333 | 16 |
| 2004–2005 | 2,339 | 19 |
| 2005–2006 | 2,632 | 17 |
| 2006–2007 | 1,652 | 18 |
| 2007–2008 | 2,204 | 18 |

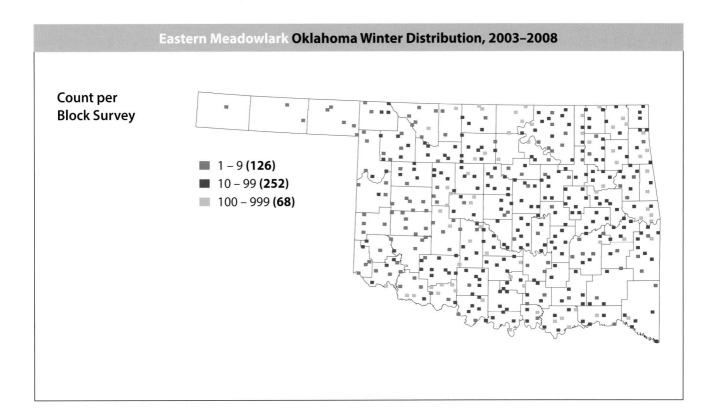

Count per
Block Survey

■ 1 – 9 **(126)**
■ 10 – 99 **(252)**
▦ 100 – 999 **(68)**

### References

Bell, P. M. 1990. Eastern Meadowlark predation on American Goldfinches. *Bulletin of the Oklahoma Ornithological Society* 23:20–22.

Lanyon, Wesley E. 1995. Eastern Meadowlark (*Sturnella magna*). *The Birds of North America Online*, edited by A. Poole. Ithaca, N.Y.: Cornell Laboratory of Ornithology. http://bna.birds.cornell.edu.

National Audubon Society. 2011. The Christmas Bird Count historical results. http://www.christmasbirdcount.org.

Oklahoma Bird Records Committee. 2009. *Date Guide to the Occurrences of Birds in Oklahoma*. 5th ed. Norman: Oklahoma Ornithological Society.

Reinking, D. L., ed. 2004. *Oklahoma Breeding Bird Atlas*. Norman: University of Oklahoma Press.

Schrick, M. P. 1979. Tree Sparrows killed and eaten by meadowlarks. *Bulletin of the Oklahoma Ornithological Society* 12:33–34.

Waters, L. S. 1990. Meadowlarks prey on Pine Siskins and American Goldfinches. *Bulletin of the Oklahoma Ornithological Society* 23:7–8.

# Western Meadowlark
## *Sturnella neglecta*

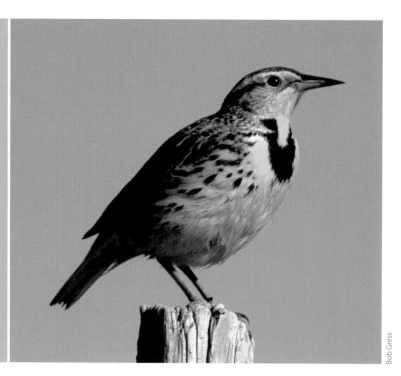

Bob Gress

**Occurrence:** Year-round resident, although additional individuals move into the state from northern breeding areas to spend the winter, including far eastern Oklahoma, where it does not breed.

**Habitat:** Grasslands, cultivated fields, and feedlots.

**North American distribution:** Breeds in southern Canada and parts of the northern lower 48 states. Resident across much of the western United States and Mexico, and winters somewhat east and south of its year-round range.

**Oklahoma distribution:** Recorded in survey blocks statewide, but far more commonly and abundantly in the western half of the state. The summer distribution recorded by the Oklahoma Breeding Bird Atlas Project was concentrated in the western third to half of the state, with a few records from as far east as the central counties.

**Behavior:** Western Meadowlarks are gregarious during the winter and are commonly seen in flocks that may also include Eastern Meadowlarks. They forage on the ground by gleaning and probing for grains and seeds.

**Christmas Bird Count (CBC) Results, 1960–2009**

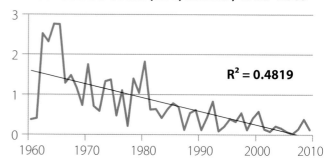

$R^2 = 0.4819$

**CBC Results, 2003–2008**

| Winter | Number recorded | Counts reporting |
| --- | --- | --- |
| 2003–2004 | 197 | 13 |
| 2004–2005 | 102 | 11 |
| 2005–2006 | 87 | 10 |
| 2006–2007 | 18 | 8 |
| 2007–2008 | 137 | 11 |

**Count per Block Survey**

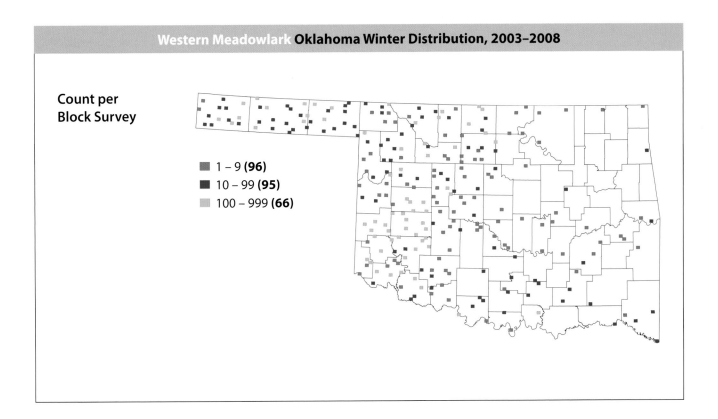

■ 1 – 9 **(96)**
■ 10 – 99 **(95)**
■ 100 – 999 **(66)**

### References

Davis, Stephen K., and Wesley E. Lanyon. 2008. Western Meadowlark (*Sturnella neglecta*). *The Birds of North America Online*, edited by A. Poole. Ithaca, N.Y.: Cornell Laboratory of Ornithology. http://bna.birds .cornell.edu.

National Audubon Society. 2011. The Christmas Bird Count historical results. http://www .christmasbirdcount.org.

Oklahoma Bird Records Committee. 2009. *Date Guide to the Occurrences of Birds in Oklahoma*. 5th ed. Norman: Oklahoma Ornithological Society.

Reinking, D. L., ed. 2004. *Oklahoma Breeding Bird Atlas*. Norman: University of Oklahoma Press.

Schrick, M. P. 1979. Tree Sparrows killed and eaten by meadowlarks. *Bulletin of the Oklahoma Ornithological Society* 12:33–34.

Waters, L. S. 1990. Meadowlarks prey on Pine Siskins and American Goldfinches. *Bulletin of the Oklahoma Ornithological Society* 23:7–8.

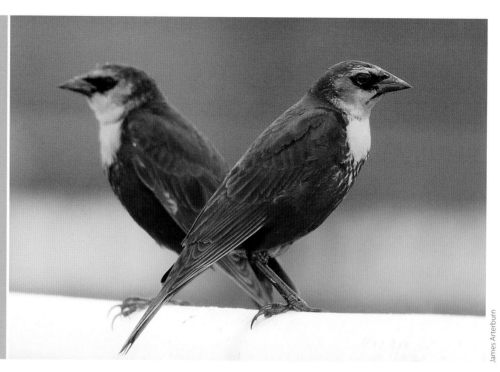

# Yellow-headed Blackbird

*Xanthocephalus xanthocephalus*

ORDER **PASSERIFORMES**

James Arterburn

**Occurrence:** Primarily a spring and fall migrant. Not a regular wintering species.

**Habitat:** Marshes and agricultural areas.

**North American distribution:** Breeds in western Canada and much of the western and midwestern United States. Winters in the southwestern United States and in Mexico.

**Oklahoma distribution:** Recorded in one Alfalfa County survey block. One additional published report during the project period came from Tillman County in December 2005 (Oklahoma Bird Records Committee 2006). The Oklahoma Breeding Bird Atlas Project found several nesting records in the Panhandle. Widespread but generally uncommon as a migrant.

**Behavior:** Yellow-headed Blackbirds are gregarious in all seasons and often associate with other blackbird species. During the winter they forage mostly on the ground for grains and seeds.

### Christmas Bird Count (CBC) Results, 1960–2009

$R^2 = 0.0178$

### CBC Results, 2003–2008

| Winter | Number recorded | Counts reporting |
|---|---|---|
| 2003–2004 | 0 | — |
| 2004–2005 | 0 | — |
| 2005–2006 | 0 | — |
| 2006–2007 | 1 | 1 |
| 2007–2008 | 2 | 2 |

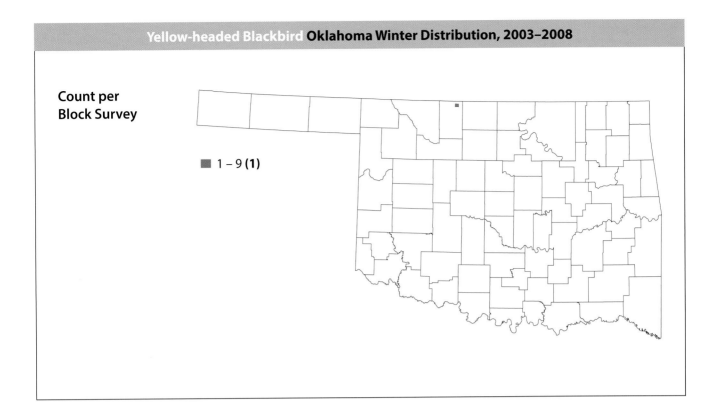

**Count per Block Survey**

■ 1 – 9 **(1)**

**References**

National Audubon Society. 2011. The Christmas Bird Count historical results. http://www .christmasbirdcount.org.

Oklahoma Bird Records Committee. 2006. 2005–2006 winter season. *The Scissortail* 56:14–15.

———. 2009. *Date Guide to the Occurrences of Birds in Oklahoma.* 5th ed. Norman: Oklahoma Ornithological Society.

Reinking, D. L., ed. 2004. *Oklahoma Breeding Bird Atlas.* Norman: University of Oklahoma Press.

Rogers, L. 1971. Winter records for Yellow-headed Blackbird in Oklahoma. *Bulletin of the Oklahoma Ornithological Society* 4:18–19.

Twedt, Daniel J., and Richard D. Crawford. 1995. Yellow-headed Blackbird (*Xanthocephalus xanthocephalus*). *The Birds of North America Online,* edited by A. Poole. Ithaca, N.Y.: Cornell Laboratory of Ornithology. http://bna.birds.cornell.edu.

# Rusty Blackbird
## *Euphagus carolinus*

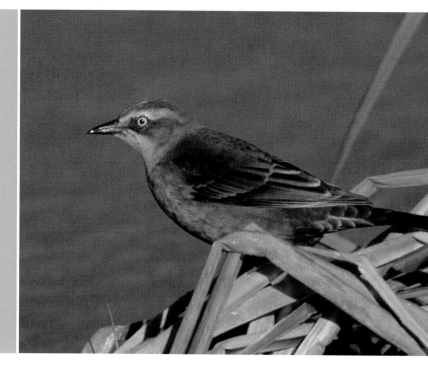

Bob Gress

**Occurrence:** Late October through early April.

**Habitat:** Moist woodlands.

**North American distribution:** Breeds in Alaska, much of Canada, and parts of the northeastern United States. Winters in the southeastern United States. The population is thought to have declined by over 90 percent during the past 50 years.

**Oklahoma distribution:** Recorded fairly commonly in survey blocks, primarily in the eastern half of the state.

**Behavior:** Rusty Blackbirds are commonly seen in small to medium-sized flocks, and they often associate with Red-winged Blackbirds, grackles, and cowbirds. They forage mostly on the ground near water or in feedlots or agricultural areas in search of winter food items including nuts and seeds, waste grains, and fruits.

### Christmas Bird Count (CBC) Results, 1960–2009

$R^2 = 0.0424$

### CBC Results, 2003–2008

| Winter | Number recorded | Counts reporting |
|---|---|---|
| 2003–2004 | 487 | 5 |
| 2004–2005 | 2,432 | 8 |
| 2005–2006 | 269 | 8 |
| 2006–2007 | 573 | 8 |
| 2007–2008 | 1,914 | 8 |

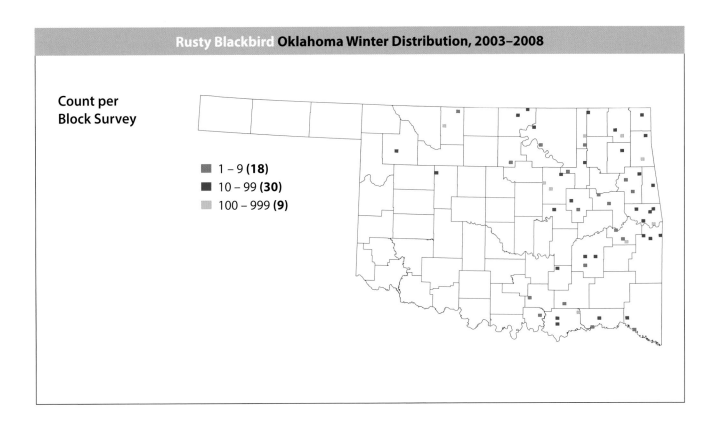

Count per
Block Survey

■ 1 – 9 **(18)**
■ 10 – 99 **(30)**
▨ 100 – 999 **(9)**

### References

Avery, Michael L. 1995. Rusty Blackbird (*Euphagus carolinus*). *The Birds of North America Online*, edited by
A. Poole. Ithaca, N.Y.: Cornell Laboratory of Ornithology. http://bna.birds.cornell.edu.

Droege, M. 1991. Unusual food of Rusty Blackbirds. *Bulletin of the Oklahoma Ornithological Society* 24:7–8.

Greenberg, Russ. 2007. Decline of the Rusty Blackbird. Smithsonian Migratory Bird Center.
https://nationalzoo.si.edu/scbi/migratorybirds/blog/?id=334.

Messerly, E. H. 1979. Rusty Blackbird feeds on American Goldfinch. *Bulletin of the Oklahoma Ornithological
Society* 12:6–7.

National Audubon Society. 2011. The Christmas Bird Count historical results. http://www
.christmasbirdcount.org.

Oklahoma Bird Records Committee. 2009. *Date Guide to the Occurrences of Birds in Oklahoma.* 5th ed.
Norman: Oklahoma Ornithological Society.

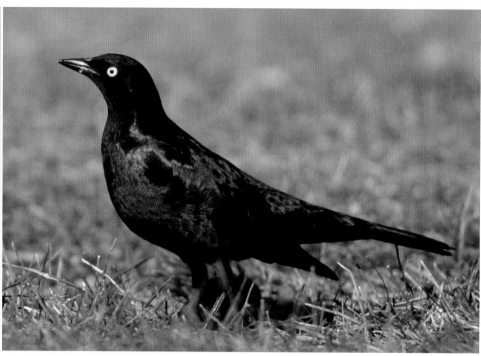

# Brewer's Blackbird

## *Euphagus cyanocephalus*

**Occurrence:** Mid-September through April.

**Habitat:** Rural areas, particularly near livestock.

**North American distribution:** Breeds in much of southern and southwestern Canada, the northern United States, and much of the western United States. Winters in the western and southern United States and in Mexico.

**Oklahoma distribution:** Common and widely distributed statewide, often in large to very large numbers. Somewhat fewer records came from heavily forested southeastern counties. The Oklahoma Breeding Bird Atlas Project recorded just one summer record, in far western Cimarron County.

**Behavior:** Brewer's Blackbirds are highly gregarious in winter, with some flocks numbering in the thousands. They often form mixed-species foraging and roosting flocks with other blackbird species or European Starlings. Brewer's Blackbirds forage primarily on bare or sparsely vegetated ground in search of waste grain, seeds, and insects if available.

## Christmas Bird Count (CBC) Results, 1960–2009

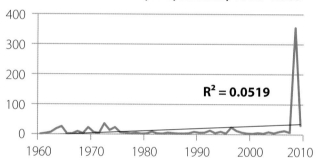

$R^2 = 0.0519$

## CBC Results, 2003–2008

| Winter | Number recorded | Counts reporting |
|---|---|---|
| 2003–2004 | 7,198 | 16 |
| 2004–2005 | 4,871 | 15 |
| 2005–2006 | 10,830 | 16 |
| 2006–2007 | 10,938 | 17 |
| 2007–2008 | 8,447 | 14 |

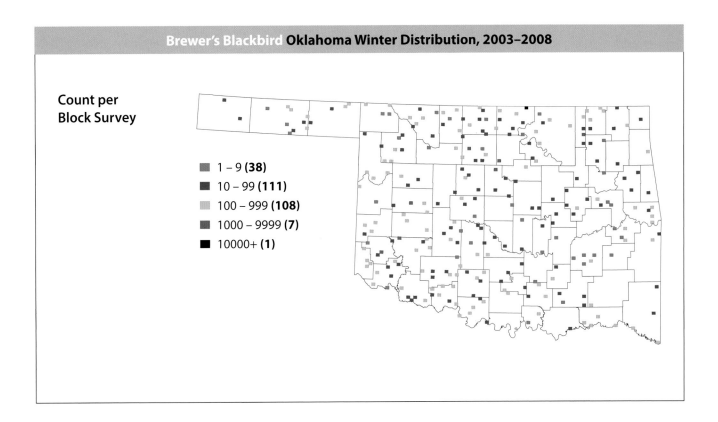

## Brewer's Blackbird Oklahoma Winter Distribution, 2003–2008

**Count per Block Survey**

- ■ 1 – 9 **(38)**
- ■ 10 – 99 **(111)**
- ■ 100 – 999 **(108)**
- ■ 1000 – 9999 **(7)**
- ■ 10000+ **(1)**

### References

Martin, Stephen G. 2002. Brewer's Blackbird (*Euphagus cyanocephalus*). *The Birds of North America Online*, edited by A. Poole. Ithaca, N.Y.: Cornell Laboratory of Ornithology. http://bna.birds.cornell.edu.

National Audubon Society. 2011. The Christmas Bird Count historical results. http://www .christmasbirdcount.org.

Oklahoma Bird Records Committee. 2009. *Date Guide to the Occurrences of Birds in Oklahoma*. 5th ed. Norman: Oklahoma Ornithological Society.

Reinking, D. L., ed. 2004. *Oklahoma Breeding Bird Atlas*. Norman: University of Oklahoma Press.

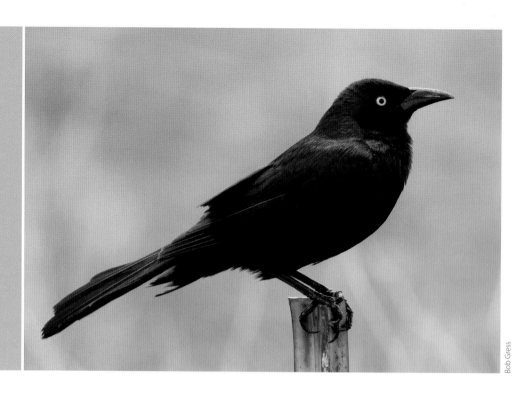

# Common Grackle
*Quiscalus quiscula*

Bob Gress

**Occurrence:** Year-round resident.

**Habitat:** Towns, farms, open woods, and parks.

**North American distribution:** Breeds across the eastern two-thirds of the United States and Canada and is a year-round resident from Iowa south through Texas and east to the Atlantic Coast.

**Oklahoma distribution:** Recorded statewide, with somewhat higher concentrations in the northeastern, central, and southwestern regions. This species' propensity to form large flocks can be seen by the 16 blocks recording over 1,000 individuals. An estimated flock of 20,000 was reported from Red Slough Wildlife Management Area in McCurtain County on December 19, 2006 (Oklahoma Bird Records Committee 2007). The summer distribution recorded by the Oklahoma Breeding Bird Atlas Project was more widespread and even, except for parts of the heavily forested southeastern region.

**Behavior:** Common Grackles are gregarious and are frequently seen in flocks. Large roosting aggregations form during the winter months, and grackles often associate with other blackbird species. Grackles forage mostly on the ground, using their heavy bills to uncover grains and seeds. They readily forage below backyard bird feeders, where their large numbers can sometimes overwhelm the hospitality of the seed provider.

## Christmas Bird Count (CBC) Results, 1960–2009

$R^2 = 0.0574$

## CBC Results, 2003–2008

| Winter | Number recorded | Counts reporting |
|---|---|---|
| 2003–2004 | 29,043 | 15 |
| 2004–2005 | 13,719 | 16 |
| 2005–2006 | 25,174 | 16 |
| 2006–2007 | 43,649 | 15 |
| 2007–2008 | 39,422 | 16 |

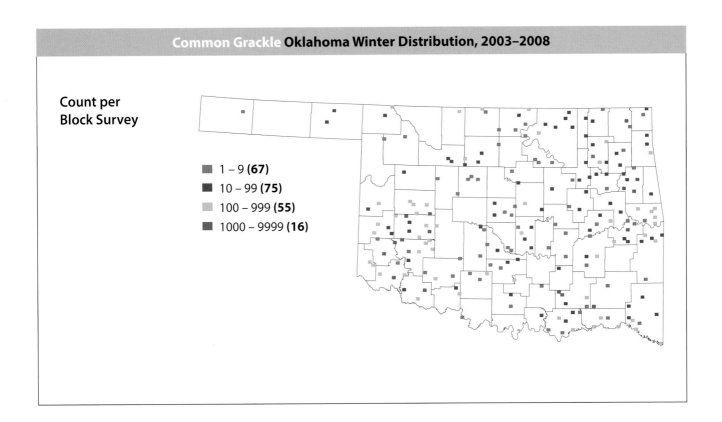

Count per
Block Survey

■ 1 – 9 **(67)**
■ 10 – 99 **(75)**
░ 100 – 999 **(55)**
■ 1000 – 9999 **(16)**

## References

National Audubon Society. 2011. The Christmas Bird Count historical results. http://www
.christmasbirdcount.org.

Oklahoma Bird Records Committee. 2007. 2006–2007 winter season. *The Scissortail* 57:24–27.

———. 2009. *Date Guide to the Occurrences of Birds in Oklahoma.* 5th ed. Norman: Oklahoma
Ornithological Society.

Peer, Brian D., and Eric K. Bollinger. 1997. Common Grackle (*Quiscalus quiscula*). *The Birds of North America
Online,* edited by A. Poole. Ithaca, N.Y.: Cornell Laboratory of Ornithology. http://bna.birds.cornell.edu.

Reinking, D. L., ed. 2004. *Oklahoma Breeding Bird Atlas.* Norman: University of Oklahoma Press.

# Great-tailed Grackle
*Quiscalus mexicanus*

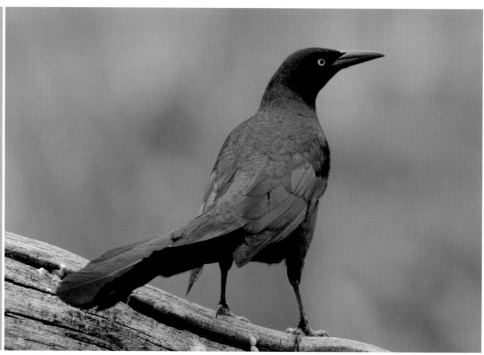

Bob Gress

**Occurrence:** Year-round resident over much of the state, with some movement out of northwestern counties in winter.

**Habitat:** Marshes, agricultural areas, towns, and urban areas.

**North American distribution:** Resident across a large area of the south-central and southwestern United States and Mexico. Breeds somewhat north of the range where it is resident.

**Oklahoma distribution:** Recorded at scattered locations nearly statewide, with fewer records in southeastern and western counties. The summer distribution found during the Oklahoma Breeding Bird Atlas Project was largely similar but included many more records in the Panhandle and northwestern counties, suggesting some seasonal movements from these portions of the species' range.

**Behavior:** Great-tailed Grackles are very gregarious and roost in large flocks year round. They forage mostly on the ground, often in the company of starlings and other blackbird species. Insects, grains, and grass seeds make up much of the diet, but food waste from parking lots is also consumed.

## Christmas Bird Count (CBC) Results, 1960–2009

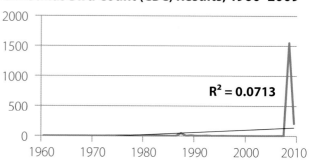

$R^2 = 0.0713$

## CBC Results, 2003–2008

| Winter | Number recorded | Counts reporting |
| --- | --- | --- |
| 2003–2004 | 2,350 | 7 |
| 2004–2005 | 1,830 | 8 |
| 2005–2006 | 2,130 | 5 |
| 2006–2007 | 5,421 | 5 |
| 2007–2008 | 3,466 | 9 |

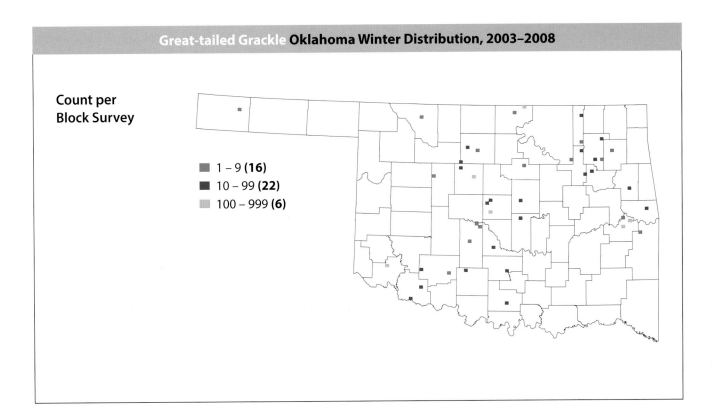

**Count per Block Survey**

- ■ 1 – 9 **(16)**
- ■ 10 – 99 **(22)**
- ▦ 100 – 999 **(6)**

### References

Clyde, G. A. 1990. Red-tailed Hawk captures Great-tailed Grackle in mid-air. *Bulletin of the Oklahoma Ornithological Society* 23:12–13.

Davis, W. M. 1975. The Great-tailed Grackle in Oklahoma. *Bulletin of the Oklahoma Ornithological Society* 8:9–18.

Johnson, Kristine, and Brian D. Peer. 2001. Great-tailed Grackle (*Quiscalus mexicanus*). *The Birds of North America Online*, edited by A. Poole. Ithaca, N.Y.: Cornell Laboratory of Ornithology. http://bna.birds .cornell.edu.

National Audubon Society. 2011. The Christmas Bird Count historical results. http://www .christmasbirdcount.org.

Oklahoma Bird Records Committee. 2009. *Date Guide to the Occurrences of Birds in Oklahoma*. 5th ed. Norman: Oklahoma Ornithological Society.

Reinking, D. L., ed. 2004. *Oklahoma Breeding Bird Atlas*. Norman: University of Oklahoma Press.

# Brown-headed Cowbird
## *Molothrus ater*

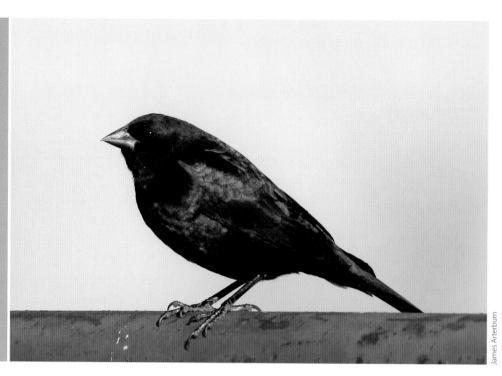

James Arterburn

**Occurrence:** Year-round resident with some turnover of individuals because of migration.

**Habitat:** Woodlands, suburbs, and open country with scattered trees, especially near livestock.

**North American distribution:** Either breeds or is a year-round resident across most of southern Canada and all of the lower 48 states as well as Mexico.

**Oklahoma distribution:** Recorded statewide in a majority of survey blocks, with somewhat fewer records in heavily forested southeastern counties and largely treeless western Panhandle counties. The highest abundances recorded were somewhat weighted to the northern counties. The Oklahoma Breeding Bird Atlas Project recorded cowbirds in a larger percentage of blocks and in a more even distribution.

**Behavior:** Cowbirds can be seen singly but are often seen in small to large groups during the winter, and they frequently associate with other blackbird species while foraging and roosting. This gregarious behavior is clear from the large number of blocks recording more than 100 birds, and even several with over 1,000 birds. Cowbirds forage on the ground for weed seeds, waste grain, and insects and occasionally visit the ground below bird feeders for spilled seeds.

## Christmas Bird Count (CBC) Results, 1960–2009

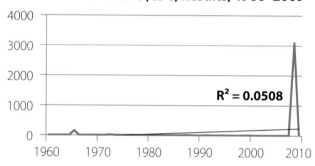

$R^2 = 0.0508$

## CBC Results, 2003–2008

| Winter | Number recorded | Counts reporting |
|--------|-----------------|------------------|
| 2003–2004 | 1,186 | 17 |
| 2004–2005 | 989 | 17 |
| 2005–2006 | 3,625 | 16 |
| 2006–2007 | 4,900 | 17 |
| 2007–2008 | 1,999 | 17 |

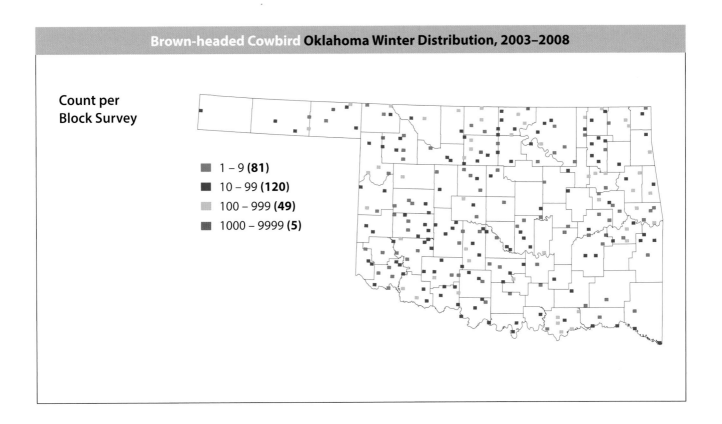

Count per
Block Survey

■ 1 – 9 **(81)**
■ 10 – 99 **(120)**
■ 100 – 999 **(49)**
■ 1000 – 9999 **(5)**

### References

Lowther, Peter E. 1993. Brown-headed Cowbird (*Molothrus ater*). *The Birds of North America Online*, edited by A. Poole. Ithaca, N.Y.: Cornell Laboratory of Ornithology. http://bna.birds.cornell.edu.

National Audubon Society. 2011. The Christmas Bird Count historical results. http://www.christmasbirdcount.org.

Oklahoma Bird Records Committee. 2009. *Date Guide to the Occurrences of Birds in Oklahoma*. 5th ed. Norman: Oklahoma Ornithological Society.

Reinking, D. L., ed. 2004. *Oklahoma Breeding Bird Atlas*. Norman: University of Oklahoma Press.

# Photography Credits

Duane Angles, 20, 28, 108, 142, 202, 226, 236, 248, 274, 450

David Arbour / USDA Forest Service, 498

James Arterburn, 26, 48, 68, 74, 78, 84, 86, 102, 112, 124, 148, 156, 158, 160, 174, 190, 196, 216, 218, 222, 224, 230, 246, 418, 516, 526

G. Bailey / VIREO, 214

P. Bannick / VIREO, 362

G. Bartley / VIREO, 350, 482

Brenda Carroll, 282, 294, 326, 388, 398, 414, 436, 488, 496, 506

R. Crossley / VIREO, 64, 198, 452

R. Curtis / VIREO, 94, 278

J. Fuhrman / VIREO, 200, 298, 504

D. Grall / VIREO, 242

Bob Gress, i, 1, 17, 18, 22, 32, 34, 36, 40, 46, 50, 54, 56, 58, 60, 62, 66, 76, 80, 90, 98, 110, 114, 116, 118, 120, 122, 132, 134, 136, 138, 140, 150, 154, 162, 168, 210, 228, 240, 252, 254, 256, 258, 260, 262, 264, 270, 272, 286, 288, 290, 300, 302, 304, 316, 320, 322, 324, 330, 340, 342, 344, 346, 356, 360, 364, 366, 370, 372, 374, 376, 378, 382, 384, 390, 392, 394, 408, 420, 422, 424, 428, 430, 434, 442, 448, 454, 456, 458, 462, 468, 470, 472, 478, 484, 486, 490, 494, 508, 510, 512, 514, 518, 520, 522, 524

Bill Horn, 30, 44, 52, 82, 100, 128, 176, 178, 206, 266, 284, 306, 310, 332, 380, 386, 396, 410, 416, 460, 480, 492, 500

M. Hyett / VIREO, 334

J. Jantunen / VIREO, 42

S. J. Lang / VIREO, 164

G. Lasley / VIREO, 292, 444

G. McElroy / VIREO, 412, 446, 474

J. McKean / VIREO, 296

Steve Metz, 24, 38, 70, 72, 92, 106, 152, 166, 170, 180, 182, 184, 188, 194, 208, 212, 220, 232, 244, 268, 280, 352, 402, 406, 432, 438, 464, 466

M. Meyers / VIREO, 204

Terry Mitchell, 476

A. Morris / VIREO, 146, 312, 338, 400

Laure Neish / VIREO, 104

J. Poklen / VIREO, 172, 186, 192

Dan Reinking, 126, 358

G. Schneider / VIREO, 250

J. Schumacher / VIREO, 238, 404

Brian E. Small / VIREO, 130, 276, 308, 314, 328, 354

B. Steele / VIREO, 440

Patricia Velte, 96, 318, 368

Warren Williams, 144, 234, 348, 426, 502

D. and M. Zimmerman / VIREO, 336

# Species Index

*Accipiter*

    *cooperi*, 240–41

    *gentilis*, 242–43

    *striatus*, 238–39

*Actitus macularius*, 166–67

*Aechmophorus*

    *clarkii*, 110–11

    *occidentalis*, 108–9

*Aegolius acadicus*, 13

*Agelaius phoeniceus*, 510–11

*Anser albifrons*, 18–19

*Aimophila ruficeps*, 464–65

*Aix sponsa*, 34–35

*Ammodramus*

    *henslowii*, 484–85

    *leconteii*, 486–87

    *savannarum*, 482–83

*Anas*

    *acuta*, 54–55

    *americana*, 40–41

    *clypeata*, 52–53

    *crecca*, 56–57

    *cyanoptera*, 50–51

    *discors*, 48–49

    *fulvigula*, 46–47

    *penelope*, 38–39

    *platyrhynchos*, 44–45

    *rubripes*, 42–43

    *strepera*, 36–37

Anhinga, 208–9

*Anhinga anhinga*, 208–9

*Anthus*

    *rubescens*, 418–19

    *spragueii*, 420–21

*Antigone canadensis*, 142–43

*Aphelocoma woodhouseii*, 328–29

*Aquila chrysaetos*, 254–55

*Ardea*

    *alba*, 218–19

    *herodias*, 216–17

*Asio*

    *flammeus*, 272–73

    *otus*, 270–71

*Athene cunicularia*, 266–67

*Auriparus flaviceps*, 352–53

Avocet, American, 144–45

*Aythya*

    *affinis*, 66–67

    *americana*, 60–61

    *collaris*, 62–63

    *marila*, 64–65

    *valisineria*, 58–59

*Baeolophus*

    *atricristatus*, 350–51

    *bicolor*, 348–49

    *ridgwayi*, 346–47

Bittern, American, 214–215

Blackbird

    Brewer's, 520–21

    Red-winged, 510–11

    Rusty, 518–19

    Yellow-headed, 516–17

Bluebird

    Eastern, 388–89

    Mountain, 392–93

    Western, 390–91

Bobwhite, Northern, 90–91

*Bombycilla*

    *cedrorum*, 414–15

    *garrulus*, 412–13

*Botaurus lentiginosus*, 214–15

Brant, 24–25

*Branta*

    *bernicula*, 24–25

    *canadensis*, 28–29

    *hutchinsii*, 26–27

*Bubo*

    *scandiacus*, 264–65

    *virginianus*, 262–63

*Bubulcus ibis*, 220–21

*Bucephala*

    *albeola*, 76–77

    *clangula*, 78–79

    *islandica*, 80–81

Bufflehead, 76–77

Bunting

    Lark, 478–79

    Snow, 444–45

Bushtit, 354–355

*Buteo*

    *jamaicensis*, 248–49

    *lagopus*, 250–51

    *lineatus*, 246–47

    *regalis*, 252–53

*Calamospiza melanocorys*, 478–479

*Calcarius*

    *lapponicus*, 438–39

    *ornatus*, 440–41

    *pictus*, 442–43

*Calidris*

    *alpina*, 152–53

    *mauri*, 158–59

    *melanotos*, 156–57

    *minutilla*, 154–55

*Callipepla squamata*, 92–93

Canvasback, 58–59

Caracara, Crested, 298–99

*Caracara cheriway*, 298–99

Cardinal, Northern, 506–7

*Cardinalis*

    *cardinalis*, 506–7

    *sinuatus*, 508–9

Catbird, Gray, 400–401

*Cathartes aura*, 228–29

*Catharus guttatus*, 396–97

*Catherpes mexicanus*, 368

*Certhia americana*, 364–65

*Charadrius vociferous*, 148–49

*Chen*

    *caerulescens*, 20–21

    *rossii*, 22-23

Chickadee

    Carolina, 342–43

    Mountain, 344–45

Chicken. *See* Prairie-Chicken

*Chondestes grammacus*, 476–77

*Chordeiles minor*, 126–27

*Chroicocephalus philadelphia*, 174–75

*Circus cyaneus*, 236–37

*Cistothorus*

    *palustris*, 376–37

    *platensis*, 374–75

*Clangula hyemalis*, 74–75

*Colaptes auratus*, 294–95

*Colinus virginianus*, 90–91

Collared-Dove, Eurasian, 114–15

*Columba livia*, 112–13

*Columbina*

    *inca*, 116–17

    *passerina*, 118–19

Coot, American, 140–41

*Coragyps atratus*, 226–27

Cormorant, Double-crested, 206–7

*Corvus*

    *brachyrhychos*, 332–33

    *corax*, 338–39

    *cryptoleucus*, 336–37

    *ossifragus*, 334–35

*Coturnicops noveboracensis*, 130–31

Cowbird, Brown-headed, 526–27

Crane, Sandhill, 142–43

Creeper, Brown, 364

Crossbill, Red, 430–31

Crow
    American, 332–33
    Fish, 334–35
Curlew, Long-billed, 150–51
*Cyanocitta*
    *cristata*, 326–27
    *stelleri*, 324–25
*Cygnus*
    *buccinator*, 30–31
    *columbianus*, 32–33

Dove
    Collared. *See* Collared-Dove, Eurasian
    Ground. *See* Ground-Dove, Common
    Inca, 116–17
    Mourning, 122–23
    White-winged, 120–21
Dowitcher, Long-billed, 160–61
*Dryocopus pileatus*, 296–97
Duck
    American Black, 42–43
    Long-tailed, 74–75
    Mottled, 46–47
    Ring-necked, 62–63
    Ruddy, 88–89
    Wood, 34–35
*Dumatella carolinensis*, 400–401
Dunlin, 152–153

Eagle
    Bald, 234–35
    Golden, 254–55
Egret
    Cattle, 220–21
    Great, 218–19
*Elanus leucurus*, 232–33
*Eremophila alpestris*, 340–41
*Eudocimus albus*, 224–25
*Euphagus*
    *carolinus*, 518–19
    *cyanocephalus*, 520–21

*Falco*
    *columbarius*, 302–3
    *mexicanus*, 306–7
    *peregrinus*, 304–5
    *sparverius*, 300–1
Falcon
    Peregrine, 304–5
    Prairie, 306–7
Finch
    Cassin's, 428–29
    House, 424–25
    Purple, 426–27
Flicker, Northern, 294–95
Flycatcher, Ash-throated, 314–15
*Fulica americana*, 140–41

Gadwall, 36–37
*Gallinago delicata*, 162–63
*Gallinula galeata*, 138–39
Gallinule, Common, 138–39
*Gavia*
    *adamsii*, 204–5
    *immer*, 202–3
    *pacifica*, 200–201
    *stellata*, 198–99
*Geococcyx californianus*, 124–25
*Geothlypis trichas*, 450–51
Gnatcatcher, Blue-gray, 382–83
Goldeneye
    Barrow's, 80–81
    Common, 78–79
Goldfinch
    American, 436–37
    Lesser, 434–35
Goose
    Cackling, 26–27
    Canada, 28–29
    Greater White-fronted, 18–19
    Ross's, 22–23
    Snow, 20–21
Goshawk, Northern, 242–43

Grackle
    Common, 522–23
    Great-tailed, 524–25
Grebe
    Clark's, 110–11
    Eared, 106–7
    Horned, 104–5
    Pied-billed, 102–3
    Western, 108–9
Grosbeak, Pine, 422–23
Ground-Dove, Common, 118–19
Gull
    Bonaparte's, 174–75
    California, 186–87
    Franklin's, 180–81
    Glaucous, 194–95
    Herring, 188–89
    Laughing, 178–79
    Lesser Black-backed, 192–93
    Little, 176–77
    Mew, 182–83
    Ring-billed, 184–85
    Thayer's, 190–91
*Gymnorhinus cyanocephalus*, 322–23

*Haemorhous*
    *cassinii*, 428–29
    *mexicanus*, 424–25
    *purpureas*, 426–27
*Haliaeetus leucocephalus*, 234–35
Harrier, Northern, 236–37
Hawk
    Cooper's, 240–41
    Ferruginous, 252–53
    Harris's, 244–45
    Red-shouldered, 246–47
    Red-tailed, 248–49
    Rough-legged, 250–51
    Sharp-shinned, 238–39

Heron
    Great Blue, 216–17
    Night. *See* Night-Heron, Black-
        crowned
Hummingbird, Rufous, 128–29
*Hydrocoloeus minutus*, 176–77

Ibis, White, 224–25

Jay
    Blue, 326–27
    Pinyon, 322–23
    Scrub. *See* Scrub-Jay, Woodhouse's
    Steller's, 324–25
Junco, Dark-eyed, 502–3
*Junco hyemalis*, 502–3

Kestrel, American, 300–301
Killdeer, 148–49
Kingfisher, Belted, 274–75
Kinglet
    Golden-crowned, 384–85
    Ruby-crowned, 386–87
Kite, White-tailed, 232–33
Kittiwake, Black-legged, 172–73

*Lanius*
    *excubitor*, 318–19
    *ludovicianus*, 316–17
Lark, Horned, 340–41
*Larus*
    *argentatus*, 188–89
    *californicus*, 186–87
    *canus*, 182–83
    *delawarensis*, 184–85
    *fuscus*, 192–93
    *hyperboreus*, 194–95
    *thayeri*, 190–91
*Leucophaeus*
    *atricilla*, 178–79
    *pipixcan*, 180–81
*Limnodromus scolopaceus*, 160–61

Longspur
    Chestnut-collared, 440–41
    Lapland, 438–39
    McCown's, 444–45
    Smith's, 442–43
Loon
    Common, 202–3
    Pacific, 200–201
    Red-throated, 198–99
    Yellow-billed, 204–5
*Lophodytes cucullatus*, 82–83
*Loxia curvirostra*, 430–31

Magpie, Black-billed, 330–31
Mallard, 44–45
Meadowlark
    Eastern, 512–13
    Western, 514–15
*Megaceryle alcyon*, 274–75
*Megascops*
    *asio*, 260–61
    *kennicottii*, 258–59
*Melanerpes*
    *aurifrons*, 280–81
    *carolinus*, 282–83
    *erythrocephalus*, 278–79
    *lewis*, 276–77
*Melanitta*
    *americana*, 72–73
    *fusca*, 70–71
    *perspicillata*, 68–69
*Meleagris gallopavo*, 100–101
*Melospiza*
    *georgiana*, 494–95
    *lincolnii*, 492–93
    *melodia*, 490–91
*Melozone fusca*, 466–67
Merganser
    Common, 84–85
    Hooded, 82–83
    Red-breasted, 86–87

*Mergus*
    *merganser*, 84–85
    *serrator*, 86–87
Merlin, 302–3
*Mimus polyglottos*, 408–9
Mockingbird, Northern, 408–9
*Molothrus ater*, 526–27
*Myadestes townsendi*, 394–95
*Myiarchus cinerascens*, 314–15

Nighthawk, Common, 126–27
Night-Heron, Black-crowned, 222–23
*Numenius americanus*, 150–51
Nuthatch
    Brown-headed, 362–63
    Pygmy, 360–61
    Red-breasted, 356–37
    White-breasted, 358–59
*Nycticorax nycticorax*, 222–23

*Oreoscoptes montanus*, 406–7
*Oreothlypis celata*, 448–49
Osprey, 230–31
Owl
    Barn, 256–57
    Barred, 268–69
    Burrowing, 266–67
    Great Horned, 262–63
    Long-eared, 270–71
    Northern Saw-whet, 13
    Screech. *See* Screech-Owl
    Short-eared, 272–73
    Snowy, 264–65
*Oxyura jamaicensis*, 88–89

*Pandion haliaetus*, 230–31
*Parabuteo unicinctus*, 244–45
*Passerculus sandwichensis*, 480–81
*Passer domesticus*, 416–17
*Passerella iliaca*, 488–89

Pelican
 American White, 210–11
 Brown, 212–13
*Pelicanus*
 *erythrorhynchos*, 210–11
 *occidentalis*, 212–13
*Phalacrocorax auritus*, 206–7
*Phasianus colchicus*, 94–95
Pheasant, Ring-necked, 94–95
Phoebe
 Black, 308–9
 Eastern, 310–11
 Say's, 312–13
*Pica hudsonia*, 330–31
*Picoides*
 *borealis*, 292–93
 *pubescens*, 288–89
 *scalaris*, 286–87
 *villosus*, 290–91
Pigeon, Rock, 112–13
*Pinicola enucleator*, 422–23
Pintail, Northern, 54–55
*Pipilo*
 *chlorurus*, 458–59
 *erythrophthalmus*, 462–63
 *maculatus*, 460–61
Pipit
 American, 418–19
 Sprague's, 420–21
*Piranga rubra*, 504–5
*Plectrophenax nivalis*, 444–45
Plover, Black-bellied, 146–47
*Pluvialis squatarola*, 146–47
*Podiceps*
 *auritus*, 104–5
 *nigricollis*, 106–7
*Podilymbus podiceps*, 102–3
*Poecile*
 *carolinensis*, 342–43
 *gambeli*, 344–45
*Polioptila caerulea*, 382–83

*Pooecetes gramineus*, 474–75
*Porzana carolina*, 136–37
Prairie-Chicken
 Greater, 96–97
 Lesser, 98–99
*Psaltriparus minumus*, 354–55
Pyrrhuloxia, 508–9

Quail, Scaled, 92–93
*Quiscalus*
 *mexicanus*, 524–25
 *quiscula*, 522–23

Rail
 King, 132–33
 Virginia, 134–35
 Yellow, 130–31
*Rallus*
 *elegans*, 132–33
 *limicola*, 134–35
Raven
 Chihuahuan, 336–37
 Common, 338–39
*Recurvirostra americana*, 144–45
Redhead, 60–61
*Regulus*
 *calendula*, 386–87
 *satrapa*, 384–85
*Rhynchophanes mccownii*, 444–45
*Rissa tridactyla*, 172–73
Roadrunner, Greater, 124–25
Robin, American, 398–99

*Salpinctes obsoletus*, 366
Sandpiper
 Least, 154–55
 Pectoral, 156–57
 Spotted, 166–67
 Western, 158–59
Sapsucker, Yellow-bellied, 284–85

*Sayornis*
    *nigricans*, 308–9
    *phoebe*, 310–11
    *saya*, 312–13
Scaup
    Greater, 64–65
    Lesser, 66–67
*Scolopax minor*, 164–65
Scoter
    Black, 72–73
    Surf, 68–69
    White-winged, 70–71
Screech-Owl
    Eastern, 260–61
    Western, 258–59
Scrub-Jay, Woodhouse's, 328–29
*Selasphorus rufus*, 128–29
*Setophaga*
    *coronata*, 456–57
    *palmarum*, 452–53
    *pinus*, 454–55
Shoveler, Northern, 52–53
Shrike
    Loggerhead, 316–17
    Northern, 318–19
*Sialia*
    *currucoides*, 392–93
    *mexicana*, 390–91
    *sialis*, 388–89
Siskin, Pine, 432–33
*Sitta*
    *canadensis*, 356–57
    *carolinensis*, 358–59
    *pusilla*, 362–63
    *pygmaea*, 360–61
Snipe, Wilson's, 162–63
Solitaire, Townsend's, 394–95
Sora, 136–37
Sparrow
    American Tree, 468–69
    Chipping, 470–71
    Field, 472–73

    Fox, 488–89
    Grasshopper, 482–83
    Harris's, 498–99
    Henslow's, 484–85
    House, 416–17
    Lark, 476–77
    Le Conte's, 486–87
    Lincoln's, 492–93
    Rufous-crowned, 464–65
    Savannah, 480–81
    Song, 490–91
    Swamp, 494–95
    Vesper, 474–75
    White-crowned, 500–501
    White-throated, 496–97
*Sphyrapicus varius*, 284–85
*Spinus*
    *pinus*, 432–33
    *psaltria*, 434–35
    *tristis*, 436–37
*Spizella*
    *passerina*, 470–71
    *pusilla*, 472–73
*Spizelloides arborea*, 468–69
Starling, European, 410–11
*Sterna forsteri*, 196–97
*Streptopelia decaocto*, 114–15
*Strix varia*, 268–69
*Sturnella*
    *magna*, 512–13
    *neglecta*, 514–15
*Sturnus vulgaris*, 410–11
Swan
    Trumpeter, 30–31
    Tundra, 32–33

Tanager, Summer, 504–5
Teal
    Blue-winged, 48–49
    Cinnamon, 50–51
    Green-winged, 56–57
Tern, Forster's, 196–97

Thrasher
  Brown, 404–5
  Curve-billed, 402–3
  Sage, 406–7
Thrush, Hermit, 396–97
*Thryomanes bewickii*, 380–31
*Thryothorus ludovicianus*, 378–79
Titmouse
  Black-crested, 350–51
  Juniper, 346–37
  Tufted, 348–49
Towhee
  Canyon, 466–67
  Eastern, 462–63
  Green-tailed, 458–59
  Spotted, 460–61
*Toxostoma*
  *curvirostre*, 402–3
  *rufum*, 404–5
*Tringa*
  *flavipes*, 170–71
  *melanoleuca*, 168–69
*Troglodytes*
  *aedon*, 370–71
  *hiemalis*, 372–73
*Turdus migratorius*, 398–99
Turkey, Wild, 100–101
*Tympanuchus*
  *cupido*, 96–97
  *pallidicinctus*, 98–99
*Tyto alba*, 256–57

Verdin, 352
Vireo, Blue-headed, 320–21
*Vireo solitarius*, 320–21
Vulture
  Black, 226–27
  Turkey, 228–29

Warbler
  Orange-crowned, 448–49
  Palm, 452–53

  Pine, 454–55
  Yellow-rumped, 456–57
Waxwing
  Bohemian, 412–13
  Cedar, 414–15
Wigeon
  American, 40–41
  Eurasian, 38–39
Woodcock, American, 164–65
Woodpecker
  Downy, 288–89
  Golden-fronted, 280–81
  Hairy, 290–91
  Ladder-backed, 286–87
  Lewis's, 276–77
  Pileated, 296–97
  Red-bellied, 282–83
  Red-cockaded, 292–93
  Red-headed, 278–79
Wren
  Bewick's, 380–81
  Canyon, 368–69
  Carolina, 378–79
  House, 370–71
  Marsh, 376–77
  Rock, 366–67
  Sedge, 374–75
  Winter, 372–73

*Xanthoceplalus xanthocephalus*, 516–17

Yellowlegs
  Greater, 168–69
  Lesser, 170–71
Yellowthroat, Common, 450–51

*Zenaida*
  *asiatica*, 120–21
  *macroura*, 122–23
*Zonotrichia*
  *albicollis*, 496–97
  *leucophrys*, 500–501
  *querula*, 498–99